PHOTOGRAPHY
IN
NINETEENTH-CENTURY
AMERICA

PHOTOGRAPHY

IN

NINETEENTH-CENTURY AMERICA

EDITED BY

MARTHA A. SANDWEISS

WITH ESSAYS BY

ALAN TRACHTENBERG · BARBARA MCCANDLESS

MARTHA A. SANDWEISS · KEITH F. DAVIS

PETER BACON HALES · SARAH GREENOUGH

AMON CARTER MUSEUM
FORT WORTH

HARRY N. ABRAMS, INC., PUBLISHERS
NEW YORK

LIBRARY OF CONGRESS CATALOGING-IN-PUBLICATION DATA

Amon Carter Museum of Western Art
 Photography in nineteenth-century America / edited by Martha A. Sandweiss:
 with essays by Martha A. Sandweiss . . . [et al.].
 p. cm.
 Includes index.
 ISBN 0-8109-3659-3 (cloth)
 ISBN 0-88360-067-6 (paper)
 1. Photography—United States—History—19th century.
 I. Sandweiss, Martha A. II. Amon Carter Museum of Western Art.
TR23.P48 1991 91-301
770'.973'09034—dc20 CIP

Published in 1991 by Amon Carter Museum, Fort Worth, and
Harry N. Abrams, Incorporated, New York. A Times Mirror Company

Printed and bound in Japan

The Amon Carter Museum was established through the generosity of Amon G. Carter, Sr. (1879-1955) to house his collection of paintings and sculpture by Frederic Remington and Charles M. Russell; to collect, preserve, and exhibit the finest examples of American art; and to serve an educational role through exhibitions, publications, and programs devoted to the study of American art and cultural history.

CONTENTS

FOREWORD

In the mid-1980s, as the Amon Carter Museum staff began planning an exhibition of nineteenth-century American photography, it became evident that the project warranted much more than a brief catalogue. The last thorough examination of nineteenth-century photography and its influence on American culture was Robert Taft's pioneering text, *Photography and the American Scene*, published in 1938, and it was time for a fresh interpretation of the subject. To that end, the Museum invited six noted scholars to explore the interconnections between photography and other aspects of American culture between 1839 and 1900 and to provide a more integrated approach to the study of nineteenth-century America. Martha Sandweiss, who conceived the project while she was Curator of Photographs at the Amon Carter Museum, agreed to oversee the writing of this volume. Generous support from the Henry R. Luce Foundation, Inc., assured that the authors and curators would have the resources necessary to produce a lasting contribution to the literature on American photography and culture.

Between 1987 and 1989, five of the authors and William Stapp, then of the National Portrait Gallery, held several discussions defining the ideas and themes that should be addressed in the publication and offering critical reviews of each other's essays. Then in 1989, the Amon Carter Museum's Curator of Photographs, Thomas W. Southall, and Assistant Curator of Photographs, Barbara McCandless, began searching major photography collections around the country for nineteenth-century photographs for the exhibition. Barbara McCandless also agreed to contribute an essay on the development of photographic portraiture. Meanwhile, in addition to completing her own essay and the introduction, Martha Sandweiss carefully read multiple drafts by each author, always encouraging the contributors as they developed new insights and flashes of inspiration that emerged during the writing process, yet also assuring that each writer had addressed his or her assigned topic thoroughly.

Since current understanding of nineteenth-century American photography rests upon the relatively few images that have been reproduced repeatedly, the curators and authors, in most cases, selected less familiar pictures to show the breadth of photographic work by a wide range of photographers. The result is a more expansive review than has previously been offered, a view that focuses less on celebrated masters of photography than on the special quality and diverse character of American work in the nineteenth century. The Amon Carter Museum, with its own collection of 300,000 photographic prints and negatives, is only one of the fifty-two institutions that provided photographs for this publication; public institutions and private collectors have generously shared their own collections of photographs and research materials and provided the broadest possible resources for both the book and the exhibition. The Mead Art Museum of Amherst College, one of the lending institutions, will also provide a second venue for the exhibition in 1992. The enthusiastic support of its director, Martha Sandweiss, throughout the life of this project, is gratefully acknowledged.

It is our hope that *Photography in Nineteenth-Century America* and the issues it raises will inspire further exploration. We are indebted to the Henry R. Luce Foundation for helping us provide this substantial framework for future inquiries by students and scholars.

JAN KEENE MUHLERT
Director

ACKNOWLEDGMENTS

A project of this scope and complexity does not come to fruition without a great deal of collaboration. The authors and curators wish to express their deep appreciation to the many individuals and institutions who have helped with the research and selection of images for this book and the accompanying exhibition.

Our thanks go first and foremost to The Henry R. Luce Foundation, Inc., which provided generous support for all phases of the extensive research and preparation required for this book and exhibition. The Foundation's early and enthusiastic endorsement of this project provided a welcome challenge to the authors, at the same time guaranteeing the success of their endeavors.

Twenty-nine institutions and their staffs graciously agreed to share selected photographs and other material for the exhibition. These include the Bancroft Library, University of California, Berkeley, particularly Robert Hirst and Sunny Gottberg; the Beinecke Rare Book and Manuscript Library, Yale University, and George Miles; the Library of the Boston Athenaeum, especially Rodney Armstrong, Sally Pierce, and Harry Katz; the Boston Museum of Fine Arts and Clifford S. Ackley, Sue W. Reed, Nancy Rich, and Karen L. Otis; the Canadian Centre for Architecture in Montreal, particularly David Harris, Marie-Agnès Benoit, and Gilles Lessard; the Custer County Historical Society of Broken Bow, Nebraska, and Grace Varney; the J. Paul Getty Museum in Malibu, California, especially Weston J. Naef, Judith Keller, Gordon Baldwin, Joan Dooley, and Louise Stover; the Gilman Paper Company, New York, and Pierre Apraxine and Lee Marks; the Harvard College Observatory and Martha L. Hazen; the Hirschhorn Museum and Sculpture Garden, Smithsonian Institution, and Phyllis Rosenzweig; the Historic New Orleans Collection and Dode Platou and John Lawrence; the Harry Ransom Humanities Research Center, University of Texas at Austin, especially Tom Staley, Sally Leach, Roy Flukinger, Carey Thornton, Prentiss Moore, and May Ellen MacNamara; the International Museum of Photography at George Eastman House, Rochester, New York, including James Enyeart, Janet Buerger, Marianne Fulton, Rachel Stuhlman, Ann McCabe, David Wooters, Barbara Puorro Galasso, and Pat Musolf; the Matthew Isenburg Collection of Norwich, Connecticut; the Janet Lehr Collection of New York; the Library Company of Philadelphia and Kenneth Finkel; the Library of Congress, particularly Steven Ostrow, Bernard Reilly, Verna Curtis, Beverly Brannon, Mary Ison, Carol Johnson, Tambra Johnson, Ford Peatross, George Hobart, and Lee Carpenter; the Mead Art Museum, Amherst College, and Linda Best; the Metropolitan Museum of Art, especially Colta Ives, Suzanne Boorsch, Jeff Rosenheim, Marceline McKee, Beatrice Epstein, and Deanna Cross; the Missouri Historical Society, Saint Louis, and Duane R. Sneddeker and Jill Sherman; the Museum of Modern Art, New York, particularly John Szarkowski, Susan Kismaric, Nicole Friedler, and Thomas Grischkowsky; the Museum of the City of New York, particularly Bonnie Yochelson, Anna Cozzi, and Gretchen Viehmann; the National Gallery of Art, Washington, and Andrew Robison, Carlotta Owens, and Ira Bartfield; the National Museum of American History, Smithsonian Institution, and Eugene Ostroff, Mary Grassick, and Michelle Delaney; the National Portrait Gallery, Smithsonian Institution, particularly William Stapp, Claire Kelly, Suzanne Jenkins, and Pamela Kirschner; the Peabody Museum of Archaeology and Ethnology, Harvard University, and Barbara Isaacs and Genevieve Fisher; the Staten Island Historical Society, New York, including Barnett Shepherd, Sarah B. Clark, and Carlotta DeFillo; the Tex Treadwell Collection, College Station, Texas; and the Worcester Art Museum, Massachusetts, and Stephen Jareckie and Sally Freitag.

Other institutions and individuals have provided invaluable assistance in the research and illustrations for the essays, including the Arizona Historical Society and Deborah Shelton; the Julian Bach Literary Agency and Itzik Becher, on behalf of Mrs. Joanna Steichen; the H. H. Bennett Studio and Jean D. Reese; the Colorado State Historical Society, Denver, and Eric Paddock; the DeGolyer Library of Southern Methodist University, Dallas, particularly David Farmer and Kay Bost; the Fraenkel Gallery, San Francisco, and Amanda Doenitz; the Hampden-Booth Theatre Library at the Players, New York, and Raymond Wemmlinger; the Montana Historical Society, Helena, and Lory Morrow; Seikyo Shimbun, Tokyo, and Eijiro Yoshioka; the Curt Teich Collection in the Lake County Museum, Wauconda, Illinois, and Katherine Hamilton-Smith; the U.S. Army Military History Institute, Carlisle Barracks, Pennsylvania, and Michael J. Winey; the West Point Museum, U.S. Military Academy, and David Meschutt; the U.S. Geological Survey Photo Library, Denver, and Chloe McDonald; the Western Reserve Historical Society, Cleveland, and Ann K. Sindehar; and the staff members of the University of California at Los Angeles; the Western History Collection of the Denver Public Library; the Interlibrary Loan Division of the University of Illinois, Chicago; the Southwest Harbor Library, Southwest Harbor, Maine; and Texas Christian University Library.

We would also like to acknowledge others who extended professional courtesies and critical support during various stages of this project, including Dolores Kilgo, Assistant Dean of the College of Fine Arts, Illinois State University; Tony Troncale of the Camera Club of New York and the Museum of Modern Art, New York; John E. Carter; Ann Fabian; Robert Horowitz; Howard R. Lamar; Peter Palmquist; Eric T. Sandweiss; Terry Toedtemeier; Susan Williams; and the University Scholars Program of the University of Illinois, Chicago. Tom Dawson of DUO Design Group provided the sensitive design and skillful production art for this volume, and Paul Gottlieb and Margaret Kaplan of Harry N. Abrams, Inc., gave their enthusiastic and unflagging support to its publication.

It is impossible to list all of the staff at the Amon Carter Museum who have assisted in this project. Those who have contributed substantially include Rynda Lemke, Steven Watson, Gayle Herr-Mendoza, and Linda Lorenz of the photography laboratory; Jeanie Lively, Helen Plummer, and Niccol Graf of the department of photographs; Editorial Assistants Jane Posey and Karen Reynolds; Registrar Melissa Thompson and Associate Registrar Julie Causey; librarians Milan Hughston, Sherman Clarke, and Nancy Wynne; and Chris Rauhoff, Scott Stockton, Mark Murphy, and Michael Howell, who provided installation and preparation services. Curators Doreen Bolger and Rick Stewart and Assistant Director Irvin Lippman reviewed each essay and provided additional valuable suggestions. The particular thanks of the authors go to Curator of Photographs Tom Southall, who oversaw the selection of images for the exhibition and wrote the portfolio introductions included in this book; and to curatorial assistant Paula Stewart, who wrote the photographers' biographies included with the appendix. Our final debt of gratitude is to the Museum's editor, Nancy Stevens, who skillfully worked with each of us and gracefully coordinated all the myriad details of this project.

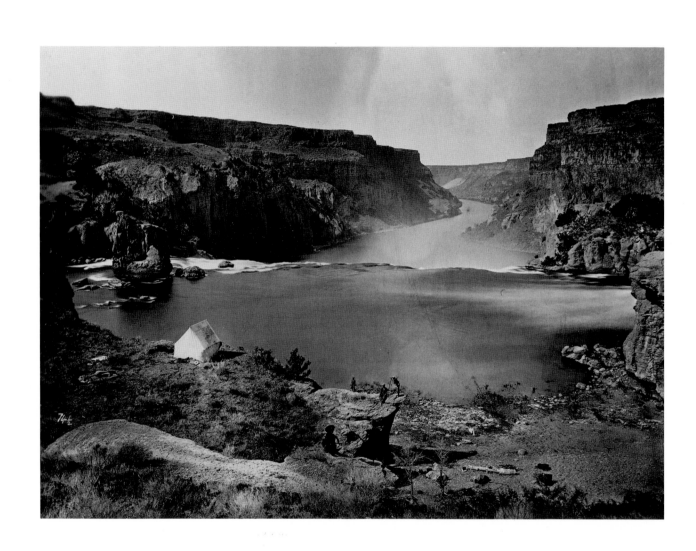

PHOTOGRAPHY IN NINETEENTH-CENTURY AMERICA

The Faithful Image of Our Time

Histories based on photographs and histories of the photographic medium—one generally concerned with subject matter, the other with practitioners and formal or technical developments—have rarely had much to do with each other. Not long after the invention of photography, it was widely acknowledged that photographs had a particular utility as historical documents, capable of bringing the distant near and preserving the past for the future. "Posterity, by the agency of photography, will view the faithful image of our times," Englishman Lake Price wrote in 1858; "the future students, in turning the pages of history, may at the same time look on the very skin, into the very eyes, of those long since mouldered to dust, whose lives and deeds he traces in the text."[1] For American essayist Oliver Wendell Holmes, writing the following year, the extraordinary detail preserved in a photographic image made a "perfect photograph . . . absolutely inexhaustible" as a source of information.[2] Late-twentieth-century advances in electronic imaging, which permit the manipulation and alteration of photographic images, make it difficult for us to maintain this faith in the fundamental authenticity of contemporary photographs. But the close visual correspondence between the subject photographed and the photographic image makes most nineteenth-century photographs apt subjects for historical inquiry.

Historians and other students of American culture have generally used these pictures for the most narrow and literal of purposes, focusing on the *subject* of the image above all else. The first American book illustrated with an original photograph was *Homes of American Statesmen*, published in late 1853 with a salt print of John Hancock's Boston house tipped in as a frontispiece. Subsequent historians have likewise tended to turn to photographs for physical evidence about the appearance of things, from the physiognomy of Billy the Kid to the terrain of a Civil War battlefield. Despite their face-to-face encounter with the visage of the past, they have used these pictures as secondary sources, just as Lake Price predicted, to supplement and illustrate the lives and deeds already "traced in the text."

The history of American photography (as opposed to American history told through photographs) took off as a field of study much later, around the time of the medium's centennial in 1939, with the almost simultaneous appearance of two texts: Beaumont Newhall's *Photography, 1839-1937* (1937) and Robert Taft's *Photography and the American Scene* (1938). Both were remarkable books that used enormous amounts of primary source material to fashion fresh, new narrative histories of the medium. Newhall, then curator of photographs at the Museum of Modern Art in New York, prepared his book to accompany a major retrospective exhibition of photography's first hundred years. His text covered developments in Europe as well as America, but the exhibition and book both gave ample attention to those Newhall perceived as the American masters of the medium. Writing from the context of his own work in an art museum, Newhall related the history of photography to the history of art; he treated photography as an art with master practitioners, seminal images, and a particular logic of pictorial and stylistic development.

Working at the same time, but independently of Newhall, Robert Taft, a professor of chemistry at the University of Kansas, created a different sort of history. The very title of his book, *Photography and the American Scene: A Social History 1839-1889*, conveyed his approach. His history touched on particular photographers and stylistic developments in other arts, but also examined technological developments, issues of patronage, marketing strategies, events in American history, and the cultural uses of photography. If the history

OPPOSITE PAGE:
Timothy O'Sullivan. *Shoshone Falls, Looking over Southern Half of Falls.* Albumen silver print, 1868. International Museum of Photography, George Eastman House.

of photography as outlined in Newhall's text seemed to have an internal logic of its own, Taft's history of the medium seemed enmeshed in the social and cultural fabric of nineteenth-century American life. His intent, he wrote, was to trace "the effect of photography upon the social fabric of America, and in turn the effect of social life upon the progress of photography."[3]

Newhall's text had an enormous influence on subsequent photo-historical scholarship—a mention in his book seemed to assure that a photographer would become the subject of a monographic study—and his approach to the medium helped pave the way for the widespread acceptance of photography in the art world. All of us who labor in this field are indebted to him. But the inspiration for this particular project has been Taft, who so ably suggested that an intriguing field for further study would be how photographs were created, used, and perceived by their original audiences.

The authors of the following essays first came together in Fort Worth, Texas, in 1987, shortly after The Henry Luce Foundation, Inc., gave the Amon Carter Museum a generous grant to support a major book and exhibition on nineteenth-century American photography. Well-publicized exhibitions of nineteenth-century English and French photography had recently toured the country but, despite a recent outpouring of monographic and thematic texts on American photography, there had been no ambitious survey exhibition of American work of the period. Nor, with the exception of William Welling's 1978 text, *Photography in America: The Formative Years, 1839-1900*, which focused heavily on technical developments, had there been any written surveys of the subject.

We planned a series of essays on nineteenth-century American photography that we hoped would begin to meet the challenge laid down by Taft half a century before. We wanted to write about nineteenth-century American culture by writing about nineteenth-century American photography; we wanted to recover the context in which photography first came to the United States and explore how it took hold here during its first sixty years. The topics we decided upon matched our own interests. Some were thematic, others chronological. Taken as a whole, they touched upon the major concerns, movements, and events in nineteenth-century American photography—the cultural reception of photography; the emergence of portraiture as the predominant mode of the time; the uses of photography to document the Civil War, westward expansion, and changing visions of national character; the growing popularity of amateur photography; and the emergence of photography as a form of social recreation.

We exchanged drafts of our essays and met again to discuss the chapters. As is clear from the texts that follow, a number of common concerns emerged in our writings. While engaging in some close analysis of individual images, all of us have also tried to address why photographs were made, how they were seen and displayed at the time, what people thought and wrote about them, how they used these images, how—in brief—photography became an important and ubiquitous form of American cultural expression.

As these essays show, the novelty of photography and the apparent excitement over its invention did not translate into a quick and easy acceptance of the new medium or an immediate understanding of how it might be used. An audience and market for photography had to be *created*, and photography had to find a place for itself in a society accustomed to other forms of graphic representation. Furthermore, these newly created nineteenth-century audiences often encountered photographs in particular contexts—in photographic albums, studio windows, commercial advertising, family scrapbooks, public lectures—that greatly influenced their understanding of particular images. This fact was well understood by those who commissioned, made, and published photographs. But the unsystematic, if not quirky, way in which nineteenth-century photographs have survived or passed into institutions for study means that many images have been wrenched from the context of their original presentation, not only skewing our perception of historical events but diminishing our ability to understand them as a contemporary audience did.

Photographers emerge from these essays not only as artists, scientists, or historians, but as businessmen—independent entrepreneurs or hired hands commissioned to execute a job for a particular private, commercial, or government client. The economic history of nineteenth-century American photography is linked to many broader areas of social

concern. For example, to win a broader audience, early portrait photographers helped create and foster a cult of personality that we may, in retrospect, see as a beginning of the frenzied celebrity cult that marks modern American culture. And, though with hindsight we view photography positively as a "democratic art," whose relatively low cost made it accessible to a wide audience, this, in fact, was a point that caused considerable anxiety at the time; many nineteenth-century practitioners sought to protect their own economic interests by keeping the fraternity of photographers a small, closed group. Photography did not become a truly democratic art until the end of the nineteenth century, when anyone really could "push the button" while Kodak did the rest.

We arbitrarily set the cut-off dates for our essays at or around the close of the nineteenth century. Histories (and historians) always seek closure, and it is tempting to dismiss the story related here as a tale that simply had to be brought to conclusion somewhere. But the 1890s do emerge in several essays as a decisive decade of change within the photographic profession and among American audiences for photographic views, as photographic technologies and reproduction techniques changed, new segments of the population took up photography, and America redefined its own sense of national history and purpose. A cultural history of twentieth-century photography would tell a different story altogether.

Photographs do, indeed, form a "faithful image of our past." But they do so in a broad way that extends well beyond the simple documentary record anticipated in the early years of the medium. They not only preserve material images of particular subjects, but provide rich images or cultural symbols of many less concrete aspects of our past. As the essays presented here suggest, we can use photographs (and the ideas expressed about photography) to understand cultural anxieties about technology, the rapidly changing business and economic climate of nineteenth-century America, the dispersion of cultural nationalism, the political agendas of the nation's leaders, and the development of a new form of mass education. By reading photographs as primary source documents, by paying attention to how they were produced and viewed in their own time, we come closer to a real history of photography—a history that embraces photography as both an art and one of the most powerful cultural forces of the last 150 years.

MARTHA A. SANDWEISS

NOTES

[1] Lake Price, *American Journal of Photography*, n.s. 1 (1858-59): 148, cited in Robert Taft, *Photography and the American Scene, A Social History, 1839-1889* (1938; reprint, New York: Dover Publications, 1964), p. 137.

[2] Oliver Wendell Holmes, "The Stereoscope and the Stereograph," *Atlantic Monthly* 3 (June 1859): 738-748, quoted in Beaumont Newhall, ed., *Photography: Essays and Images* (New York: Museum of Modern Art, 1980), p. 58.

[3] Taft, *Photography and the American Scene*, p. viii.

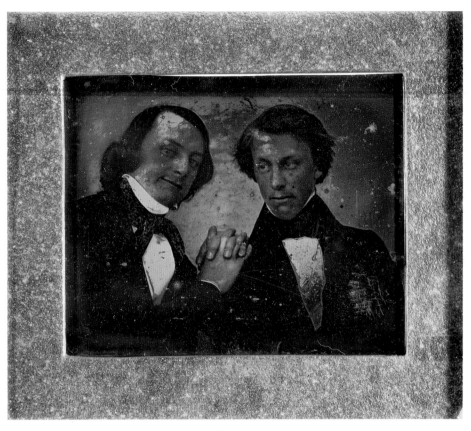

Plate 1
UNKNOWN PHOTOGRAPHER. *Two Men*. Daguerreotype, c. 1840. Amon Carter Museum.

Plate 2
George Barnard. *Fire in the Ames Mills, Oswego, New York*. Daguerreotype with applied color, 1853.
International Museum of Photography, George Eastman House.

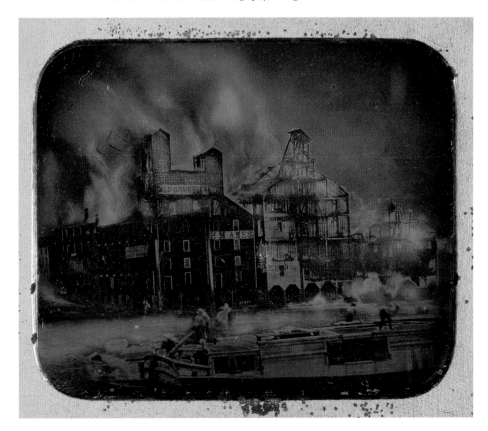

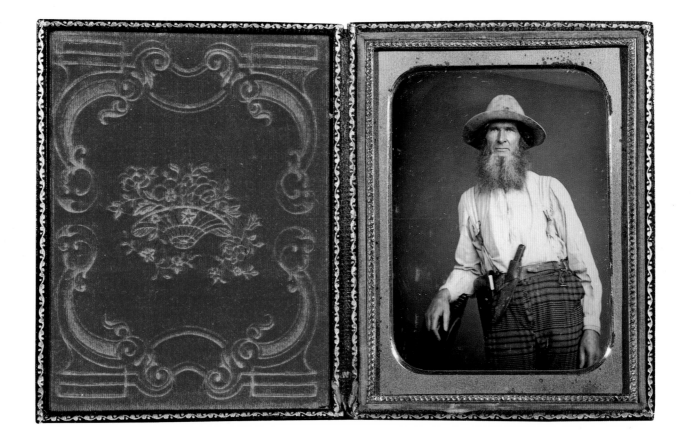

Plate 3
UNKNOWN PHOTOGRAPHER. *California Forty-Niner*. Daguerreotype with applied coloring, c. 1850. Amon Carter Museum.

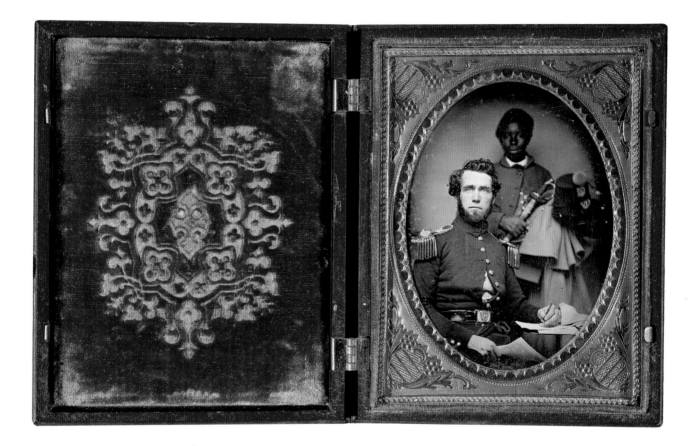

Plate 4
UNKNOWN PHOTOGRAPHER. *Officer and Manservant.* Daguerreotype with applied coloring, c. 1851. Amon Carter Museum.

4

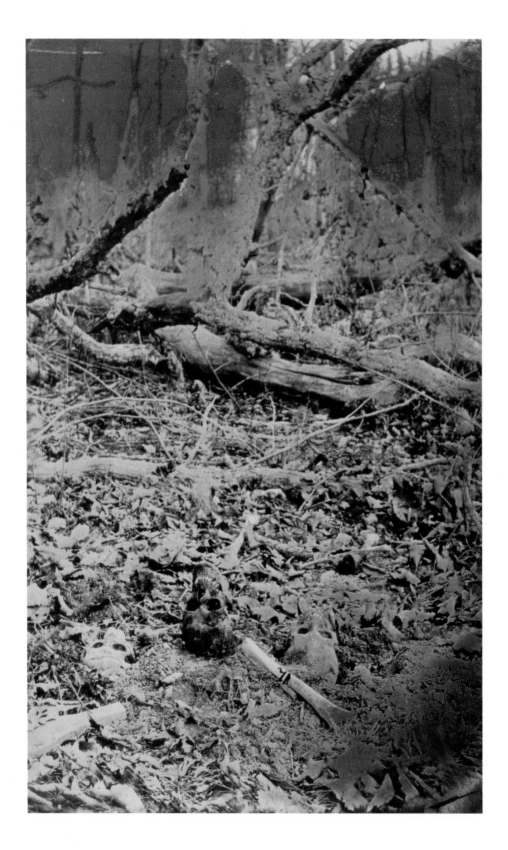

Plate 5
ALEXANDER GARDNER. *Wilderness Battlefield Scene*. Albumen silver print, 1863. Gilman Paper Company.

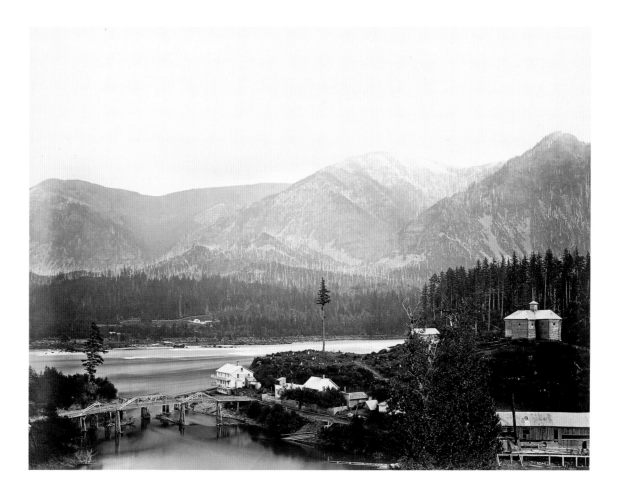

Plate 6
CARLETON WATKINS. *The Rapids with Indian Block House. Cascades.* Albumen silver print, 1867. Amon Carter Museum.

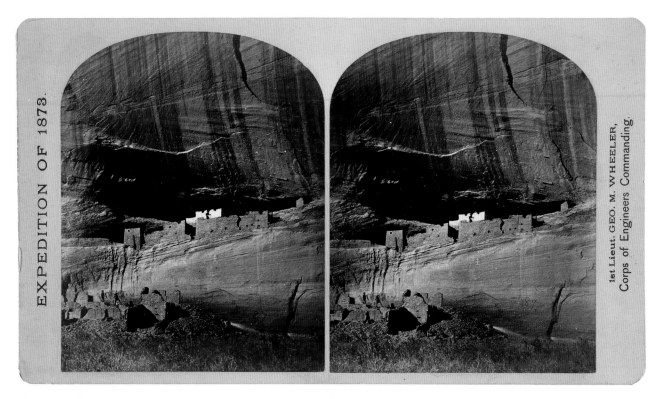

EXPEDITION OF 1873.

1st Lieut. GEO. M. WHEELER, Corps of Engineers Commanding.

Plate 7
TIMOTHY O'SULLIVAN. *No. 21. Ruins in Cañon de Chelle, N. M., in a cavity in the wall, 60 feet above present bed of Cañon. Height of walls about 700 feet. The present race of Indians knows nothing of the age of these buildings or who occupied them.* Stereograph in *Geographical Explorations and Surveys West of the 100th Meridian.* Albumen silver print, negative 1873, print 1875. Amon Carter Museum.

Plate 8
UNKNOWN PHOTOGRAPHER. *The Brigade de Shoe Black—City Hall Park.* Stereograph published by E. and H. T. Anthony and Co. in *Anthony's Instantaneous Views.* Albumen silver print, 1867 or before. Private collection.

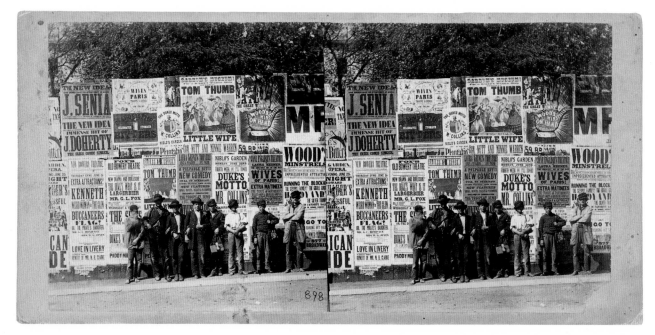

Plate 9
JOHN HILLERS. *Tewa, Cicomavi, Wolpi, Mokitowns, Arizona.* Albumen silver print, c. 1879. Amon Carter Museum.

Plate 10
LATON ALTON HUFFMAN. *The Night Hawk in His Nest.* Gelatin silver print, c. 1885-90. Amon Carter Museum.

Plate 11
F. JAY HAYNES. *Cascades of Columbia.* Albumen silver print, c. 1885. Amon Carter Museum.

Plate 12
WILLIAM HENRY JACKSON. *Excursion Train and Niagara Rapids, Lewiston Branch, N.Y.* Albumen silver print, 1890. Amon Carter Museum.

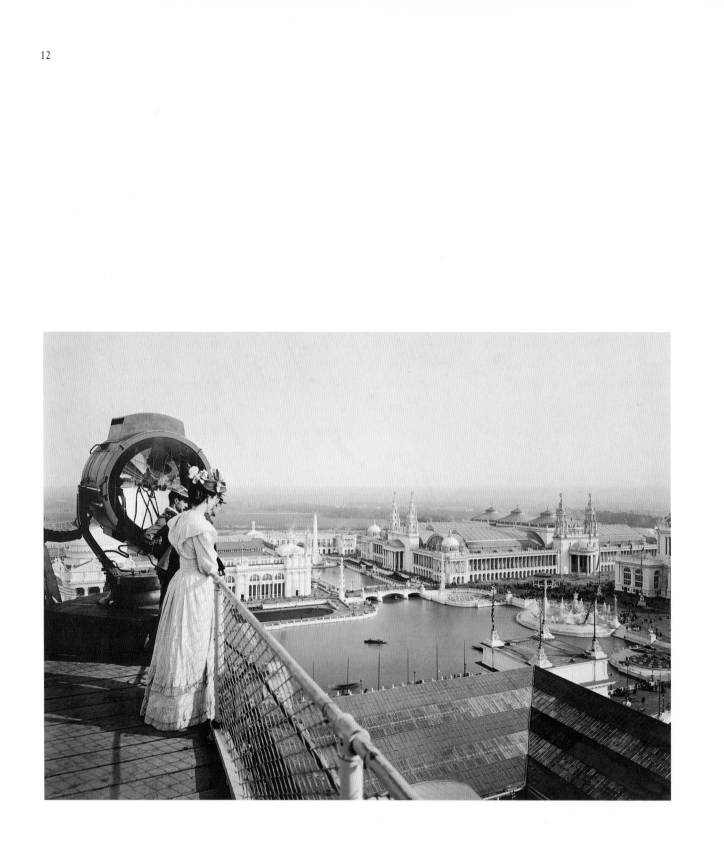

Plate 13
CHARLES DUDLEY ARNOLD. *World's Columbian Exposition, Chicago.* Platinotype, 1893.
Gernsheim Collection, Harry Ransom Humanities Research Center, University of Texas at Austin.

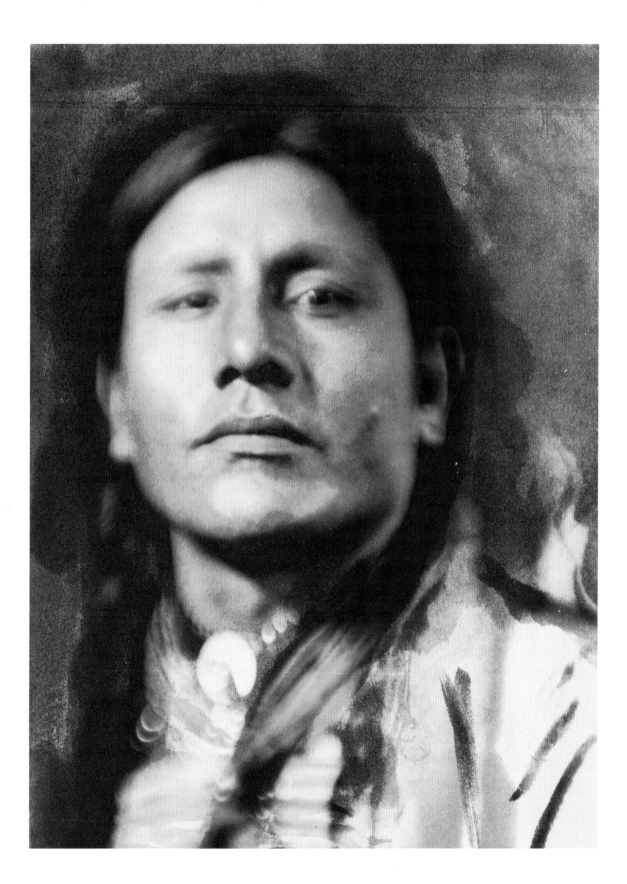

Plate 14
JOSEPH KEILEY. *A Sioux Chief.* Glycerine platinum print with wash, c. 1898. Metropolitan Museum of Art.

14

Plate 15
ALFRED STIEGLITZ. *Savoy Hotel, New York.* Platinum print with pigment, 1897. National Gallery of Art, Washington; Alfred Stieglitz Collection.

Plate 16
F. HOLLAND DAY. *Ebony and Ivory*. Platinum print, 1897. Metropolitan Museum of Art.

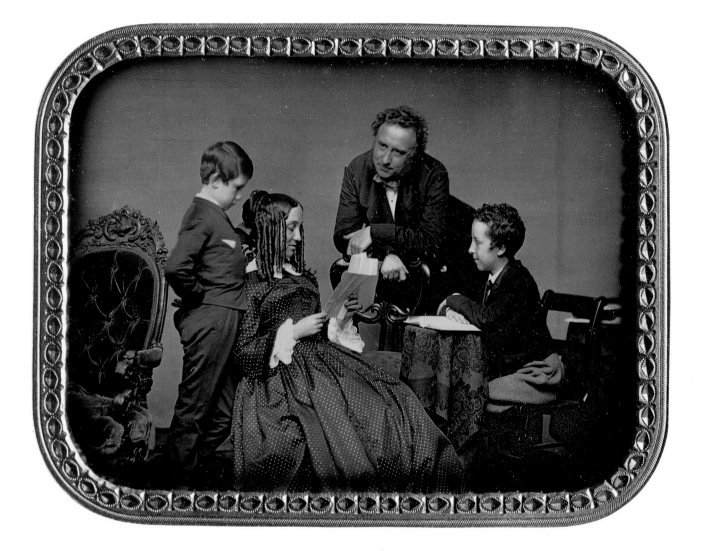

I

PHOTOGRAPHY

The Emergence of a Keyword

In 1847, eight years after Daguerre in Paris and Talbot in England had made public the discovery of photography, a publisher in Boston launched a new journal called the *Daguerreotype*. It would be a journal of letters and ideas, not of photography except in the figurative sense; as the "Prospectus" explained, it would offer "a series of striking pictures of the constantly varying aspect of public affairs, of the state of the public taste, and the bent of public opinion." The first number elaborated: "The DAGUERREOTYPE is, as the name imports, designed to reflect a faithful image of what is going on in the Great Republic of Letters . . . a picture in which the characteristic features will all be reflected, and of which, though the lights and shades may at time[s] be somewhat strongly marked, the general fidelity will be unquestionable."[1]

Cultivated readers in Boston in 1847 could be reckoned to enjoy the pun in words like *image, reflect, light* and *shade, faithful* and *fidelity*—words whose commonplace meanings had been infused with new life after the appearance of photography. The word "daguerreotype" exemplified the process: serving as the title of the journal, it took on another life as a metaphor, a sign of something else and a source for meanings beyond itself. "Daguerreotype" had already come to stand for a certain kind of truth, for objectivity, the impartial representation of facts, which Francis Bacon in the Renaissance claimed as the only basis of true knowledge. The Prospectus continued:

> Our name implies that we must portray every important feature. No partial or sectarian views must govern our choice, and even opinions from which we dissent must (when not of irreligious or immoral tendency) often find a place in our pages. A painting may omit a blemish, or adapt a feature to the artist's fancy, but a reflected image must be faithful to its prototype.[2]

The analogy works both ways. Fidelity to a prototype or original links the daguerreotype (and photography) with the highest intellectual activity—the written expression of ideas. And writing associated with photography shares with the medium the value of dispassionate objectivity.

Photography (which means literally "writing or drawing with light") entered the world not just as a practice of picture-making but as a word, a linguistic practice. It was not very long before "daguerreotype" became a common verb that meant telling the literal truth of things. With its subset of terms, like *image* and *reflect*, *lens* and *shutter*, *light* and *shade*, the words *photography* and *daguerreotype* provided a way of expressing ideas about how the world can be known—about truth and falseness, appearance and reality, accuracy, exactitude, and impartiality. The power attributed to the medium made the name into a keyword, a potential analogy for other human activities.[3]

It is significant that such ideas about the medium arose initially in the ambiance of the daguerreotype, the form of photography practiced most commonly in America for close to twenty years. In its brilliance and clarity of detail, this small, hand-held cased image seemed an almost magical reproduction of a prototype. The daguerreotype lent special authority to

ALAN TRACHTENBERG

the notion that a photograph *repeats* its original—not so much a copy as a simulacrum, another instance of the same thing.

Indeed the notion of photography as an "authority" drew from the crystalline illusion of the daguerreotype. In 1864, shortly after the daguerreotype had been superceded by the wet-plate (or collodion) process, in an essay titled "Photography as an Authority" in the *Philadelphia Photographer*, the Reverend H. J. Morton, D.D., revealed a religious idea at its heart:

> What we want in a witness are capacity and opportunity for accurate observation, and entire honesty. Now the camera of the Photographer has exactly these qualifications. To exquisite acuteness of vision and instantaneous comprehension of minutest details, its adds perfect freedom from all partiality and hypocrisy. It sees everything, and it represents just what it sees. It has an eye that cannot be deceived, and a fidelity that cannot be corrupted. We have abundant ocular delusions, but the camera is never under any hallucination. Behind the most accurate human there is often a very prejudiced human mind, refracting its vision; and the most skillful human hand is often moved by motives which lead it to misrepresent what it professes to delineate. But the camera's eye of microscopic minuteness and exactness of vision has behind it a crystal plate that has no partiality, and the fingers of the sun that paint the pictures which that crystal surface bears, are vibrations from a great burning heart that throbs with no human passions. Hence the camera seeing with perfect accuracy and microscopic minuteness, and representing with absolute fidelity, is a witness on whose testimony the most certain conclusions may be confidently founded.[4]

The camera as the eye of God: it is hard to imagine a stronger, more fervent evangelical expression of the idea of the camera's infallibility.

On what grounds were such notions founded? The Reverend Morton's language imagines the camera as a moral necessity, seeing everything, endowing everything with a reality that only an absolute Archimedean point of vision makes credible. But there was little evidence to support this view; in fact, in 1869 the *Philadelphia Photographer* published a quite different view, by Dr. Hermann Vogel, the distinguished German expert in optical science. In "Photography and Truth" he writes: "We often hear from admirers of Photography that this young art represents the pure truth, the true counterpart of nature."[5] The view has "almost become a dogma," and like most dogmas, it is untrue. With the authority of science Vogel points out typical errors. Lenses distort shapes and perspective. Tonal gradations are usually wrong: "generally speaking, the lights are too white and the shadows are too black in photographic representations." Different colors reproduce differently, cold tones too light, warm tones (like red and yellow) too dark. He could go on, "but what I have said will be sufficient to enlighten those who pretend that a photographic representation must, under all circumstances, be a correct one." Errors might be mitigated by choice of lens and control of light, and "photography applied at the right place and in the right manner will furnish representations more correct than any other, but absolutely true they are not." The art of photography, he concludes, is "to present the reality true and beautiful." That is to say, authority rests finally not in the medium but in the human agency employing it.[6]

Vogel's skepticism only underscores the obvious point, that the conventional idea of photography's infallibility is not a demonstrable truth but a belief, held with the irrational conviction of a myth. The persistence of this popularly held idea in the face of counter-evidence makes it especially interesting to historians, for the depth of conviction implies that it answers a cultural need. Ideas cannot be understood as historical forces except in relation to their immediate contexts—how they arise, gain expression, and function as pictures of reality. The context of the daguerreotype, for example, was a time of vast social change in America. Between 1820 and 1860 a whole way of life changed, as a predominantly rural, agrarian, and craft-centered society became, almost overnight, an urban, industrial-capitalist, market-centered society, increasingly ridden with conflicts of region and section, party and class, race and gender. Photography acquired its meanings and myths in the tense

setting of troubled times, an era in which hymns to "progress" barely concealed doubts, anxieties, and fears about the future.[7]

The use of "daguerreotype" as the name of a new periodical and an analogy for its policy points to a particular context: the rise of new forms of social communication. The "Introduction" to the *Daguerreotype* links the new medium of picture-making to other new media: "The periodical literature of the present age is in fact one of its distinctive features; a feature belonging to the same class as railroads, and steamboats, and electric telegraphs. It is a mighty engine for the diffusion of ideas among the masses of mankind, so for the education of the people."[8] Scores of commentators made similar connections with other inventions altering the structure of space-time relations.[9]

Throughout the century photography would be viewed as an agent of mass education, a way of bringing the distant near and making the strange familiar. As a metaphor, it extended beyond the name of a journal into new forms of writing as well. In 1854 Nathaniel Parker Willis, a popular New York journalist and novelist with a long-standing interest in photography, issued a book titled *Hurry-graphs; or, Sketches of Scenery, Celebrities and Society, Taken from Life*. Using unmistakable analogies with photography, Willis explained in the Preface that hurry-graphs are pieces written at one sitting, for immediate publication, like editorials. Defined by the "nearness at hand" of their subjects, "they are copies from the

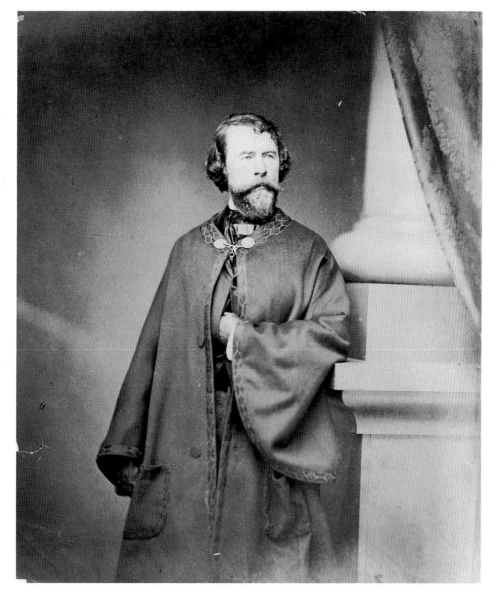

Figure I-2
MATHEW BRADY. *Nathaniel Willis.* Salt print, c. 1860. National Portrait Gallery, Smithsonian Institution.

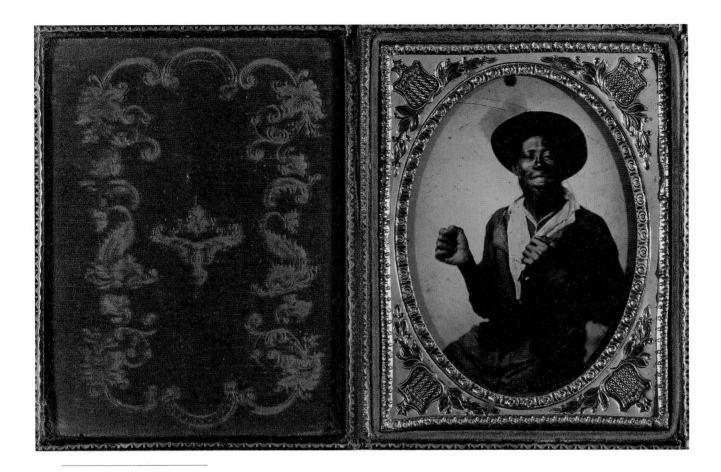

Figure I-3

UNKNOWN PHOTOGRAPHER.

The Smiling Man. Ambrotype,
c. 1860. J. Paul Getty Museum.

kaleidoscope of the hour . . . one man's imprint from parts of the world's doings at one place
and time." Hurry-graphs embodied the conviction that "the Past and Future were
overvalued—and the Immediate and Present, and what one saw occurring and could
truthfully describe, were as well worth the care and pains of authorship as what one could
only imagine or take from hearsay."[10]

How photography became available for such analogies, and what further issues lay
entangled in the nexus between the medium and its culture, are the central questions to be
pursued here. It was during the era of the daguerreotype, between 1839 and the end of the
1850s, that the image and the idea of the photographic medium took shape in America.
Although the daguerreian era has sometimes been described as a "primitive" moment in the
history of photography, daguerreotypes were in fact more intricate physical artifacts than
later photographs; they combined precious metals, glass, wood, and often velvet and leather.
The image lay on the brilliant mirror-like silver surface of a copper plate resting in a small
case adorned with floral designs or genre scenes drawn from popular graphics and statuary.
Sophisticated in its artistry yet essentially a work of craft, the daguerreotype developed in
America as a vernacular folk art of the first industrial age. Typically small enough to hold
in one's hand or carry in a pocket, it permitted an intimate experience of exact represen-
tation—a kind of magic realism—unique to photography at the time. The paper prints
which succeeded the metal image in the 1850s lost those original daguerreian qualities of
brilliance, vividness, and presence. Moreover, as a one-of-a-kind image produced directly
on the plate, without the mediation of a negative, the daguerreotype defied mass production;
it possessed the aura of a unique thing. It was that uniqueness, the magical verisimilitude
and mirror-like presence of an astonishingly new kind of image, that the word photography
brought to the common vocabulary.

On February 2, 1841, Henry David Thoreau recorded in his journal a sentiment much on
the mind of young New Englanders at the time: "It is easy to repeat, but hard to originate."[11]
The times seemed to demand innovation and reform, an overthrow of the past and a
reconstruction of the present based on what Thoreau's friend and mentor Ralph Waldo
Emerson had called "an original relation to Nature."[12] Young northern intellectuals dreamed

of originations, of bringing something new and unprecedented into existence. Jacksonian democracy, industrialization and economic expansion, and the erosion of formal religious convictions all seemed to offer new opportunities for human life, for self-realization and a liberated society. Emerson had attacked retrospection and reverence for "fathers," and Thoreau's pithy remark in 1841 made the choice between repetition and origination a matter of courage and resolution—a choice between easy compliance and difficult independence.

It was into such a climate—of eagerness for change weighted with underlying anxiety about its consequences and uncertainty about its directions—that photography appeared in America in 1839. As in Europe, Daguerre's announcement was greeted instantly with rhapsodies of praise for science, invention, and progress. Daguerre himself was hailed as something of an American national hero. Inventor of a repeatable formula for fixing the transitory image cast by light through a lens upon the ground glass of a camera obscura, he seemed to substantiate the American creed of Franklin and Jefferson, the belief that human intelligence, once freed from the hold of superstition and the mindless repetition of past formulas, would emerge as the creative center of enlightened existence. Itself an origination—"something new under the sun"—photography opened a prospect of endless novelty, of infinitely variable discoveries of new vistas, new relations to the world.

The daguerreotype whetted an appetite for the new. Yet it also posed a dilemma associated with the newness of modern mechanical devices. The daguerreotype was, Emerson remarked, a "great engine" (calling up images of steam-driven machines such as railroads), yet what was its power but the unsurpassed ability to copy something, to *repeat* the world rather than originate something new? Thoreau seized upon this predicament—a new thing capable only of repeating old things—to explore the deeper connections between repetition and origination, between easy conformity to the past (even to one's own old habits) and the harder demands of being authentically original. Introducing the daguerreotype into his journal meditation, Thoreau assists us in finding a point of view toward the subject of photography as a keyword, an image and idea—the history of meanings found in and projected upon photography in nineteenth-century America.

The daguerreotype helped Thoreau formulate something abstract, complex, and paradoxical:

> It is easy to repeat, but hard to originate. Nature is readily made to repeat herself in a thousand forms, and in the daguerreotype her own light is amanuensis, and the picture too has more than a surface significance,— a depth equal to the prospect,— so that the microscope may be applied to the one as the spy-glass to the other. Thus we may easily multiply the forms of the outward; but to give the within outwardness, that is not easy.

In this opening paragraph of his journal entry Thoreau alludes to the most commonplace idea of photography, that by its mediation nature becomes her own "amanuensis," her own scribe. Photography revealed, it was held, that light is analogous to ink, a material for writing or drawing; William Henry Fox Talbot called it "the pencil of nature." But in Thoreau's view, even if the external world were endlessly reproducible in accurate detail down to the nth degree of minuteness, the ability to reproduce or copy or repeat is by itself nothing new or astonishing. It is the act of outwarding the inward, like the act of originating something, that is hard.

Thoreau alludes to an issue already controversial at the time: could a photograph qualify as a work of art, something more than a mere copy of the world? Unlike a painter's brushes or an engraver's cutting tools, the camera seemed to its first commentators capable of producing a picture automatically, in disregard of its operator. For those who believed that art required more than skill and craft, that it demanded an ineffable quality of emotion and spirituality, the invention disqualified itself simply by definition. If artists were those who brought inert matter to life by reshaping it according to their individual genius, how could the operator of a machine which merely copies the world be considered an artist?

But Thoreau ultimately turns this view on its head. Reversing the drift of the first paragraph, he regards the daguerreotype as an analogy for exactly the originality he seeks,

something difficult and strenuous and new: "That an impression may be taken, perfect stillness, though but for an instant, is necessary. There is something analogous in the birth of all rhymes." Unexpectedly Thoreau shifts, or rather extends, the analogy between photography and writing (the amanuensis) away from light—the medium through which photography was generally understood as an automatic process (in which nature writes or records or pictures herself)—toward the act over which the operator does indeed have full control; the physical stillness of the camera, requisite for an exposure, becomes analogous to an inner quality such as tranquility, balance, harmony.

The entry concludes by elaborating this quality, renaming it "sympathy" and "communion":

> Our sympathy is a gift whose value we can never know, nor when we impart it. The instant of communion is when, for the least point of time, we cease to oscillate, and coincide in rest by as fine a point as a star pierces the firmament.

Having served its purpose as an exemplum or illustration, the daguerreotype as such seems to evaporate from Thoreau's meditation. But words like *oscillate, rest,* and *point* underscore photography's ability to dissolve the distancing effects of space and time, for example, by preserving the past look of things and people into the present. Through its extended metaphor, the journal entry offers an account of how, through stillness and sympathy, a person might achieve a point of coincidence or communion between an inner state and an outer sense experience, might "give the within outwardness" and thus make it communicable. The daguerreotype provides the core metaphor and in the process achieves an idea of its own—that repetition or copy of the world might, under certain circumstances of inward balance, also be a way of outwarding the inward, bringing something new into being. Most important for Thoreau is the analogy to writing: the daguerreotype reveals how an exact and accurate description of facts can release symbolic resonances and implications. Under the right circumstances a copy—a repetition or reproduction of things in the world—might be an original, and originating, experience.

Thoreau's perception of this paradox exemplifies metaphoric uses of the new medium in its first decades in America—uses of photography as metaphor, as image and idea. While his elaboration of the image of the daguerreotype may be unusually complex and linguistically sophisticated, his treatment of the medium as a metaphor relevant to contemporary matters (the relation between repeating the past and transcending it) was not. Just as Americans began at once in 1839 to make daguerreotypes, they began to write about the medium. In letters, private journals, newspaper articles, magazine essays, fiction, and poetry, they began to shape a literary record which both reflected and influenced the emerging forms of the medium, its proliferating uses as practical and fine art. People who made their living as writers—Hawthorne, Poe, Whitman, Melville, Oliver Wendell Holmes, and scores of lesser known figures—contributed to a sizeable body of writing about the new medium. Throughout the century and especially in the antebellum years, when the medium remained novel and the patterns of acceptance and interpretation were most vivid, writings that directly or obliquely addressed photography or employed the medium for figurative purposes make up a heterogeneous and often contradictory collective image of photography in America. This record of speculation and imagining plays an important and neglected role in the history of the medium, in the history of its reception and also its conception: a history of picturing photography in the medium of language.

What place does this history of verbalizations have within the history of picture-making in the medium of photography? Standard histories of nineteenth-century photography typically follow the categories of academic art history; they organize the field by process (daguerreotype, collodion wet-plate, albumen prints, etc.), by genre and format (portrait, landscape, carte-de-visite, cabinet card, etc.), by icon, by style.[13] Such a history, while it may be set within or against a "background" of social and cultural history, is assumed to follow a logic of its own, a logic of pictorial development effectively insulated from currents of social, political, and cultural history.

One effect of this typical procedure has been to diminish the importance of novelty as a factor in the medium's development—a novelty that resides as much in the character

of the photographic image as in its radically new method of production. Standard histories tend to ignore philosophical and aesthetic questions, such as Thoreau's concerning the relation between copies and originals, or how the medium challenged definitions of the artist as one possessed of manual skills coupled with imagination and sensibility. Replacing the hand with the eye as the prime organ of aesthetic production, photography implied a new and revolutionary notion of art as craft. The categories of art history tend to normalize the medium, as if it were only another method of print-making, another way of achieving works of fine art, and to neglect the wider cultural work of the medium.

Indeed efforts to normalize photography, to contain its untested possibilities within familiar modes, began almost at once in 1839; even in the very naming of the medium, the suffixes "-type" and "-graph" both link the invention to printing, writing, and drawing. Of course all new things require names, and names imply familiarity. "Whatever new object we see," wrote Emerson, "we perceive to be only a new version of our familiar experience, and we set about translating it at once into our parallel facts. We have thereby our vocabulary."[14] What is notable, and notably overlooked in standard histories of the medium, is how the name of the medium entered the cultural vocabulary as a keyword linked to modernity itself—a word by which, especially in its metaphoric extensions, people attempted to comprehend the new world of steam engines, factories, and cities. A study of meanings imputed to the medium can help place its history within the broader history of modern culture.

"I don't much like pictures of that sort—they are so hard and stern; besides dodging away from the eye, and trying to escape altogether. They are conscious of looking very unamiable, I suppose, and therefore hate to be seen. . . . I don't wish to see it any more." This is Phoebe Pyncheon, the rustic heroine of Hawthorne's *The House of the Seven Gables* (1851), turning away from a daguerreotype portrait which seems to her uninitiated eyes too true a copy of an original sitter.[15] The small cased image had been handed to her by Holgrave, the novel's daguerreotypist-hero. The exchange takes place in a garden behind the once-stately but now decrepit mansion with seven gables, near a bubbling fountain known as Maule's Well.

Hawthorne's novel, the major treatment of a daguerreotypist and his craft in American writing, is concerned with how the past continues to live and do its mischief in the present. Thomas Maule, once owner of the land on which the house of the seven gables has stood since the seventeenth century, ended his life on the gallows, convicted of witchcraft. His accuser and judge, Colonel Pyncheon, claimed the land for his own and hired Maule's son to build the house, a symbol of wealth and power. But in founding a line Pyncheon also perpetuated the curse Maule uttered from the gallows, that the false accuser would have blood to drink. When the Colonel was found dead in his study the very day the house was to be opened in pomp and ceremony, the curse seemed a prophecy, and many Pyncheons since had died in mysterious seizures with gurgling sounds in their throats. This history of the tangled relations between two families, one patrician and prominent, the other plebeian and powerless, lies behind the encounter between Phoebe and Holgrave in the garden, for as it will turn out in the end, Holgrave is the last of the Maules, and the portrait he shows her is of Judge Pyncheon, contemporary avatar of the original hard-hearted and ill-fated Pyncheon.

The artful plot not only sets present persons and events within a history made up of legend, gossip, old portraits, and old habits—a weighty inheritance from the past, symbolized by the house and garden themselves—but also confronts the question of repetition and origination. Like Thoreau, Hawthorne finds in the daguerreotype an apt device to bring the issues into focus. The daguerreotype he employs is not simply the object that had come into existence with Daguerre's announcement in 1839, but a verbal object already defined in certain specific ways. As Phoebe's disconcerted reaction to Holgrave's portrait indicates, Hawthorne's daguerreotype is itself the locus of a difference of outlook, not just toward photography but toward an entire set of issues regarding the relation of past to present, self to community, art to life.

What happens in the garden near Maule's Well reenacts a situation common in the closing years of the 1840s. A daguerreotype arouses a strange response, a shudder rather than

a smile of pleasure, and the daguerreotypist responds with a self-justifying pedagogy. The fault lies not with the picture—the copy—but the sitter himself. "There is a wonderful insight in heaven's broad and simple sunshine," Holgrave explains to Phoebe. "While we give it credit only for depicting the merest surface, it actually brings out the secret character with a truth that no painter would ever venture upon, even could he detect it" (p. 91). Here is the sun acting as its own amanuensis, writing by means of the daguerreotype to make truths visible. What is within can be made outward, and even "secret character," unhappy truths disguised by outward appearance, will show through the mask:

> Now, the remarkable point is, that the original wears, to the world's eye—and, for aught I know, to his most intimate friends—an exceedingly pleasant countenance, indicative of benevolence, openness of heart, sunny good humor, and other praiseworthy qualities of that cast. The sun, you see, tells quite another story....Here we have the man, sly, subtle, hard, imperious, and withal, cold as ice. Look at that eye! Would you like to be at its mercy? At that mouth! Could it ever smile? And yet, if you could only see the benign smile of the original! It is so much the more unfortunate, as he is a public character of some eminence, and the likeness was intended to be engraved. (p. 92)

Between the world's eye and the daguerreian eye lies the difference between appearance and reality, mere fact and fact charged with inner truth.

Holgrave speaks in a language similar to Thoreau's. He agrees that in a daguerreotype "the picture too has more than a surface significance." But what Thoreau sees as "not easy"— "to give the within outwardness"—Holgrave sees as a simple, automatic act. Or so he would have Phoebe believe. But is Holgrave trustworthy? Being a Maule who hides his family identity from Phoebe and the other inhabitants of the house, isn't he also a manipulator of appearance, hugging to himself his own "secret character"? Would Hawthorne himself have us believe Holgrave's line that the daguerreotype, by itself, can tell such weighty truths?

Holgrave's conveniently placed camera ultimately lifts Maule's curse and the charge of witchcraft by recording the judge's death scene, and at the novel's end, Holgrave's circumstances and his views on virtually all matters undergo a change. Through its play of ironies and ambiguities, the novel qualifies the optimistic view of the daguerreotype Holgrave exclaims in the garden. For example, Holgrave's ode to the sun's "wonderful insight" assumes that there is an original—the Judge sitting before the lens—and a copy which matches it even more perfectly than the image projected by the sitter's normal everyday look. But Phoebe remarks at one point during this exchange: "I know the face, for its stern eye has been following me about, all day. It is my Puritan ancestor, who hangs in yonder parlor" (p. 92). She mistakes the daguerreotyped Judge for the painted, long-deceased Puritan ancestor. Her innocent mistake reveals a truth, for what the narrative will show—and what Holgrave already knows, as part of his Maule inheritance—is that the Pyncheon "character" has reproduced itself, its wicked traits along with its pride of class and wealth. The contemporary Judge is, in a manner of speaking, a replica of the old Puritan colonel.

Questioning whether an original picture is ever original enough—whether the present is not always a repetition of the past—the novel subtly calls into question whether the knowledge that Holgrave possessed before taking the picture can be validly attributed to the sun and the daguerreotype. One legend has it that the "posterity of Matthew Maule," through "a sort of mesmeric process," can make the "inner region" of the Pyncheon family looking-glass, which hangs near the portrait of the ancient Puritan, come "all alive with the departed Pyncheons; not as they had shown themselves to the world, nor in the better and happier hours, but as doing over again some deed of sin, or in the crisis of life's bitterest sorrow" (p. 21). As a Maule, has Holgrave somehow caused the Judge's face to reenact such an emotion during the daguerreotype sitting? Just how coy is his remark, on introducing himself to Phoebe in garden, that "I misuse Heaven's blessed sunshine by tracing out human features, through its agency" (p. 46). Lust for revenge remains, after all, a hereditary trace in Holgrave's blood.

The novel attaches two distinct associations to the daguerreotype, and questions whether photography is the sun's amanuensis, scientific truth exact and accurate, or a magic

mirror, the work of witchcraft (including the mystery of mesmerism, or hypnotism). When Phoebe says that the picture seems "conscious of looking very unamiable," she implies something animate, like the figures evoked by a wizard in a mirror. Holgrave counters with an explanation based on strictly rational and enlightened causes: the sun's wonderful insight. Both of these views of the daguerreotype belonged to the public discourse about the medium. By incorporating these alternate views into the novel and setting them against each other so that each seems credible and at least partly right, Hawthorne helps us recognize that the identity or "meaning" of the medium was less an intrinsic given, something "natural" to it, than a matter of belief, a cultural invention in a time of need.

In July 1846, there appeared in the *Brooklyn Daily Eagle* an article by its editor, Walt Whitman, on a visit to "Plumbe's Daguerreotype establishment" on lower Broadway, New York.[16] John Plumbe was then perhaps the best known daguerreotypist in the United States, a fantastic entrepreneur who had already set up a chain of galleries across the country.[17] Whitman's account gives some indication of the kind of place the daguerreotype establishment had become—a new public space in the city for the display of pictures, and for the self-display of promenading visitors and clients. Whitman senses in the account something new in the making, a place set aside for open unembarrassed looking, for an exchange of looks and, more important, of *images*. "You will see more of *life* there—more variety, more human nature, more artistic beauty. . .than in any spot we know of." The crowds themselves are spell-binding, "but they are not the first thing." It is "the pictures [which] address themselves before all else. . . . What a spectacle! In whatever direction you turn your peering gaze, you see naught but human faces! There they stretch, from floor to ceiling—hundreds of them. Ah! what tales might those pictures tell if their mute lips had the power of speech! How romance then, would be infinitely outdone by fact . . . a great legion of human faces," with all those "eyes gazing silently but fixedly upon you," gives Whitman the impression "of an immense Phantom concourse—speechless and motionless, but yet [of] *realities*. You are indeed in a new world—a peopled world, though mute as the grave."[18]

Whitman's urban eye is caught not so much by single pictures but by the sheer mass of images, the "spectacle" of a crowd of images, each "mute," as if dead, and yet eloquent, projecting a life of its own and, collectively, a new sort of reality. His language hints at a reality beyond the grave, at forces mysterious and preternatural, but this remains only the slightest hint, a rhetorical gesture to underscore the message of an extraordinary and novel effect produced by walls lined with daguerreotype likenesses. Through Whitman's words we glimpse a new urban phenomenon—not just the photograph portrait gallery of which Broadway would boast scores by the early 1850s, but a new form of collective being, a concourse of images which are also realities.

Efforts to grasp the character and possible meanings of the daguerreotype were also efforts to comprehend a new aspect of everyday human relations during this period of major urban growth. The sense of a weirdly animate character in the daguerreotype likeness, an uncanny sense of something both already dead and still alive, provided an occasion and a form for perceptions of the new social authority. Moreover, the character of these particular images, their origin in an automatic and seemingly magical act, and the peculiarly intense clarity of their surface detail, made them seem apt exemplifications of what Whitman called a "new world" of images, "a peopled world, though mute as the grave."[18]

The importance of the American daguerreotype as a cultural force as well as emblem— a word as well as a thing—has yet to be gauged by historians. For at least fifteen years the daguerreotype had virtually exclusive claim to the meaning of "photography"; it was the predominant process practiced in America, for views, landscapes, genre scenes, and even staged allegories, along with the most popular of its modes, the portrait. During this period photography took hold in the United States as a familiar practice, a commercial enterprise, and by the 1850s, a profession. And it was the daguerreotype that formed the earliest American conceptions of photography and thus helped shape the further development of the medium as a social practice.

The absence of a negative made each daguerreotype image unique; when Holgrave remarked that his picture of Judge Pyncheon was "intended to be engraved," he referred to

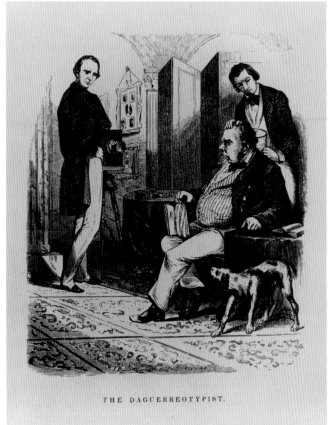

THE DAGUERREOTYPIST.

Figure I-4

UNKNOWN ARTIST.

The Daguerreotypist. In T. S.
Arthur, "American Characteristics:
The Daguerreotypist." *Godey's
Lady's Book* 38 (May 1848): 353.

the most common method of reproducing the image for publication, through engraving or lithographing a hand-drawn copy of the image. Before the age of multiple prints (in the 1850s) and photo-mechanical reproduction (introduced in the late 1880s), the daguerreotype offered a direct and intimate experience with a unique object.[19]

Moreover, the daguerreotype's physical properties encouraged the idea of photography as a "mirror-image," for the plate that held the image was a silver-plated copper sheet burnished to a bright mirror effect—literally a kind of looking-glass. Holding the object produces strange effects: slightly shifting optical focus, from the image to the ground upon which the image appears, allows the viewer to see his or her own image superimposed over the photographic one. In "The Inconstant Daguerreotype," a short story in *Harper's Monthly* in 1855, the hero standing before a framed daguerreotype on a wall—a picture of himself—"adjusted his cravat in the mirror which was conveniently formed, in his present position, by the daguerreotype."[20] In addition to its sartorial convenience, the mirror effect also contributes to that apparitional effect of which Phoebe complained: at the merest tilt of the plate, the actual image seems to flicker away, then reappears in negatively reversed tones, making the portrayed sitter look literally like a shade or shadow of himself or herself. Many viewers remarked on the evanescent quality of daguerreian portraits.

No wonder, then, that responses to the earliest daguerreotypes (even before the process of buffing the silver surface of the plate to a high mirror-polish had been perfected) drew on a vocabulary of the preternatural. "More like some marvel of a fairy tale or delusion of necromancy than a practical reality," wrote a London commentator in the *Spectator*, unable to decide between benign or black magic.[21] "It looks like fairy work," wrote one witness of the first American daguerreotype on public display in a New York shop window; another, after seeing the first French daguerreotypes exhibited in New York in December 1839, wrote: "While looking on the Daguerreotype picture we can scarcely persuade ourselves, in some cases, that it is really a plane surface before us." Images of the inexplicable flowed from the pens of enthusiasts: "the drawings come forth as if by enchantment,"[22] or "we can find no language to express the charm of these pictures, painted by no mortal hand."[23] In "My Lost Art," a short story published in the *Atlantic* in 1852, the daguerreotype process is linked directly with alchemy and other esoteric rites; the hero claims he has magnified a daguerreotype of Jupiter to reveal a tower, a spaceship, and mortal beings looking him straight in the eye.[24]

Reminiscing on "The Lost Art of Daguerreotype" in the *Century* in 1904, Abraham Bogardus recalled that "in its early days the general public looked upon the daguerreotype as a wonder." He quoted various early explanations of the picture-making process: "'You look in the machine, and the picture comes—if you look long enough.' 'It is not so much the looking that does it; the sun burns it in, if you keep still.' 'The plate is a looking-glass, and when you sit in front of it your shadow sticks on the plate.'"[25] Anecdotes appeared often enough in the press in the 1840s and early 1850s to suggest that sitting for a photographic portrait could be an odd experience. During the 1840s the popular press made much of the perils of having a daguerreian likeness taken; in this running comedy the humor cut both ways, toward the primitive devices of the medium and toward the wounded vanity of a public increasingly aware—and the new medium fostered this to an incalculable extent—of "image," of social self-presentation. Writing in *Godey's Lady's Book* in 1849, T. S. Arthur describes a rural sitter scared out of his wits by the camera and its mysteries, who "dashed down stairs as if a legion of evil spirits were after him." Arthur also reported that "many good ladies actually feel their eyes 'drawn' toward the lens while the operation is in progress!"[26]

In many minds the daguerreian experience came uncomfortably close to mesmerism or hypnotism—one of the fads popular in eastern cities in the 1840s. To be "drawn" toward

the lens implied a more than faintly erotic surrender to another's will, and the lens itself, a rigid tubular protuberance with a large glass eye at its tip, represented a redoubtably masculine will. Such conflicted responses as Arthur describes imply a powerful ambivalence toward the daguerreian camera and the gaze of the operator, a current of feeling comprised of erotic attraction, moral revulsion, and physical fear. As if to give vent to precisely such a cathected surge of feeling, in 1855 the *Photography and Fine-Art Journal* published an extraordinary tale of sexual horror and guilt suggestively titled "The Magnetic Daguerreotypes."[27] The narrator brings his intended bride (what else but "Elora" is her name?) to the atelier of Professor Ariovistus Dunkleheim, who has just perfected a new way of making daguerreotypes. Instead of a lens he employs a mirror; by "electro-galvanic" or "magnetic" action, the sitters transfer their living image to the polished steel plate in a miraculously instantaneous process. The link between the daguerreotype and the mirror is nowhere in the literature of the day made more explicit, and more explicitly uncanny and transgressive, than here. For the retained image is indeed a "living" image, a true mirror of the sitter. The narrator discovers this profoundly arousing and disturbing fact that very night, when he looks at the portrait of the lovely Elora. As his passions come to life he realizes that the picture he gazes upon is really a picture of the woman as she appears at that very moment, asleep in bed. The image is animate; he can see her breathing. "How superior to the cold, ghastly, shadowy immobility of the mere daguerreotype, were these living portraits of Dunkelheim's" (p. 355).

But Dunkleheim had insisted that the couple make two pictures each, and the aroused narrator realizes with dawning horror that the evil genius must be watching his own copies with illicit pleasure at both the woman's sleeping body and her lover's growing desire. The innocent act of sitting for a daguerreotype has made both of them absolutely vulnerable to the visual scrutiny and violation of the Doctor's "bottle-green eyes." The young man feels trapped; he (or his image, for they are now one) lies before the Doctor as "an open book," forever subject to an excruciating moral espionage!" Even as he shrinks from this scrutiny, his own excitement over the image of Elora rises into a "a fever of impatient love"; he continues "to gaze and gaze with an intense and burning ardor" (p. 355).

The erotic tangle and charged triangulation of image and desire in this astonishing piece of gothicized fancy reveals a significant pattern of psychic anxiety: guilt about sexual desire displaced upon the evil father-doctor; Oedipal anxieties heightened by the Faustian behavior of the artist-inventor and his mysterious apparatus; fear of the invasion of privacy, even of intimacy, by new techniques of science and mechanics. "A detested stranger can, at will, become a witness of our most rapturous moments, our most secret delights, our—," exclaims the near-deranged hero, who eventually tracks down the bad father and slays him, recovering the incriminating proto-home-video pictures in the process. "Hence-forth we are at least our own masters," Elora cries in relief, "and not puppets, acting for the amusement of a detestable old necromancer!" (p. 359).

An isolated tale, perhaps, but such words imply a responsive chord among readers, even those of a photographic journal, and a much broader pattern of popular anxiety about early photography in America than has been registered by historians. Its "magnetic" quality links photography both to the demonism of Faustian science and to the anxious fascination aroused by mesmerism and its hint of the occult and forbidden. Photography's mirror-like qualities also added to this ambivalence. The mirror—associated with wizardry, black magic, divination, and transgressive encounters with the dead or absent—served perfectly as a metaphor for the new medium. Mirrors stood simultaneously for truth and deception, and it is no surprise that in a period of very rapid change, in which new technologies seemed to challenge and overthrow ancient perceptions of time and space and human relatedness, such a traditional image should surface in popular responses to something new and strange and inexplicable.

One of the first, if not the very earliest, extended discussions of photography in America was in an article titled "The Pencil of Nature," published in a New York periodical in April 1839. In it, the popular author and editor N. P. Willis spoke of "the phantasmagoria of inventions," of which photography was only the latest breathtaking assault upon the public's credulity.[28] Arriving fast on the heels of the steam engine, railroad, and telegraph, this new upstart

Figure I-5
UNKNOWN ARTIST. *Experiments in Photography.* In *Harper's New Monthly Magazine* 13 (August 1856): 429-430.

Experiments in Photography.

Mr. N. BONAPARTE STUBBS *wishing his Daguerreotype, the Operator being out, his Boy tries his hand.*

First Trial.—Boy doesn't hit Stubbs at all.

Second Trial.—Hits Stubbs's Hat.

Third Trial.—Stubbs's Cravat in Focus.

Fourth Trial.—Half of Stubbs's Body in Focus.

Fifth Trial.—Body in Focus—Head out.

Sixth Trial.—A Fly alights on Stubbs's Nose.

Seventh Trial.—A Spot in the Plate.

Eighth Trial.—Stubbs sits ten seconds too long.

VOL. XIII.—No. 75—D d*

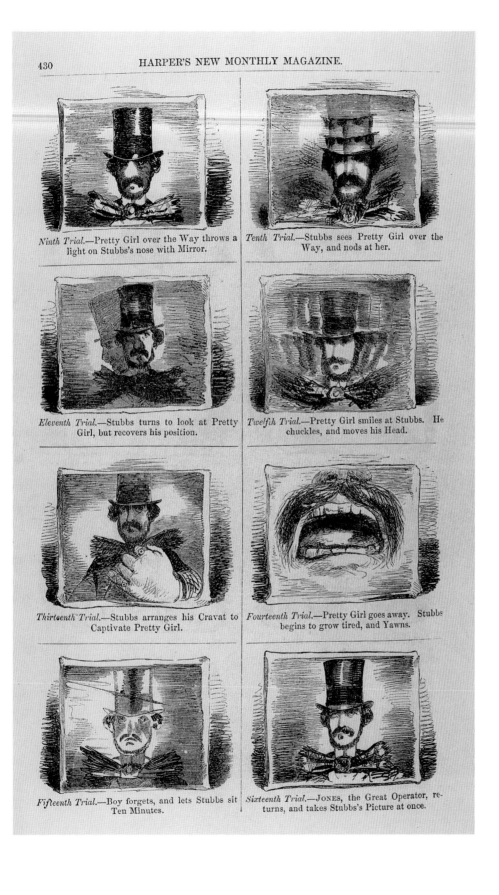

Ninth Trial.—Pretty Girl over the Way throws a light on Stubbs's nose with Mirror.

Tenth Trial.—Stubbs sees Pretty Girl over the Way, and nods at her.

Eleventh Trial.—Stubbs turns to look at Pretty Girl, but recovers his position.

Twelfth Trial.—Pretty Girl smiles at Stubbs. He chuckles, and moves his Head.

Thirteenth Trial.—Stubbs arranges his Cravat to Captivate Pretty Girl.

Fourteenth Trial.—Pretty Girl goes away. Stubbs begins to grow tired, and Yawns.

Fifteenth Trial.—Boy forgets, and lets Stubbs sit Ten Minutes.

Sixteenth Trial.—JONES, the Great Operator, returns, and takes Stubbs's Picture at once.

threatened to "stay" the human hand as a factor in the making of art. Willis saw a "revolution in art" in the making, one in which there were would be losers as well as winners:

> Vanish equa[sic]-tints and mezzotints—as chimneys that consume their own smoke, devour yourselves. Steel engravers, copper engravers, and etchers, drink up your aquafortis and die! There is an end of your black art —"Othello's occupation gone." The real black art of true magic arises and cries avaunt. All nature shall paint herself—fields, rivers, trees, houses, plains, mountains, cities, shall all paint themselves at a bidding, and at a few moment's notice. (pp. 70-71)

Willis could not yet have seen any examples of the new pictures—his article was based on William Henry Fox Talbot's report of his discovery (published in the *London Literary Gazette* of February 2, 1839) and appeared a week before Samuel F. B. Morse's eyewitness account of Daguerre's invention appeared in the New York press—but he instantly grasped their revolutionary potential. A major collapse in the economy in 1837 had led to America's first modern depression, and New York still suffered hard times when news of photography arrived in 1839.[29] In the background of Willis' response to the news was his anticipation of technological displacement leading to further unemployment.

Willis also reached right for the key image of the mirror to describe the new medium's cultural effects: "Talk no more of 'holding the mirror up to nature'—she will hold it up to herself, and present you with a copy of her countenance for a penny" (p. 71). The notion of nature repeating itself (as Thoreau would put it) and handing out copies for a penny is a piece of wit with grim intimations. While "the poetry of the mind" will not be hurt by the new method of copying, "the hand[s] must be crippled": losing the experience of "correct drawing" would deny them their opportunity to develop "their utmost power." Although at present "it is what man can do by his extraordinary manual dexterity that we are so prone to admire," Willis feared that such inventions as photography could produce "indifference" to the skills of handcrafts. This could diminish the number of serious artists, though perhaps a greater excellence might result from their willingness "to be schooled to severe discipline" by the "new discovery," the discipline of "most accurate forms" (pp. 71-72). For the pictorial arts, then, the mechanism of a self-mirroring nature promises an ambiguous future.[30]

Even more troubling ambiguities await in the realm of daily life:

> What would you say to looking in a mirror and having the image fastened!! As one looks sometimes, it is really quite frightful to think of it; but such a thing is possible—nay, it is probable—no, it is certain. What will become of the poor thieves, when they shall see handed in as evidence against them their own portraits, taken by the room in which they stole, and in the very act of stealing! (p. 71)

The humor is black indeed. Willis perceives a growing conflation of losing one's "image" by stealth and one's property by theft. Here is a new kind of predicament: while the magic mirror offers security through surveillance, it also threatens to take something away from people—their own image. Property owners will become as vulnerable to surveillance as thieves.

In December 1839, Philip Hone recorded in his famous diary that he visited a Broadway gallery where French daguerreotypes, including examples by the master, Daguerre himself, were on display. He noted his curiosity about the invention, his pleasure in the pictures, and his enthusiasm for this example of "the wonders of modern times." This entry appears sandwiched between two less happy observations of roaming "gangs of hardened wretches, born in the haunts of infamy," and of an upstate tenant revolt, "of a piece with the vile disorganizing spirit which overspreads the land like a cloud."[31] Photography appeared in America amidst a period of turmoil and conflict. Many thought of the depression and the ensuing hard times, which lasted until the discovery of gold in California in 1849, as a crisis of the first order. In writing about the new invention of photography, many authors, perhaps unconsciously, invested their language with feelings and perceptions about the historical moment itself.

Popular fiction is especially rich in suggestive representations of photography's evolving meanings. The daguerreotype appeared just at the time, in the 1830s and 1840s,

Figure I-6
JOHN PLUMBE. *Sausage Maker.*
Daguerreotype, c. 1845. Amon
Carter Museum.

when American publishing was beginning to develop a popular market for fiction both in pulp novels and in new journals and periodicals that catered to a growing appetite for sentimental and gothic fiction. The short story became a distinct mode of fiction during these years, arising from the same changes in urban culture that lay behind the emergence of the daguerreotype gallery; it was a new form of easily consumable and immediately gratifying collective experience. Popular fiction, responding directly to new fashions in everyday life, increasingly included allusions to photography, and in some instances in the late 1840s and 1850s, their typically flimsy plots centered on daguerreian situations. The most common of these situations, neatly contrived to fit the sentimental mode of fiction, has someone, usually the hero, fall in love with the image in a daguerreotype, then meet the beloved by coincidence in some accidental circumstance. Marriage is the usual result. Typically the hero is a young professional afloat in the city, who glimpses the cased image in a store window and becomes obsessed with meeting its "original." In some cases the beloved turns out to be a friend's sister or cousin. The daguerreian love-at-first-sight brings the wandering hero into the peace and security of a domestic relation—the kind of solution to urban alienation and drift typically offered in sentimental fiction. Using the daguerreotype as a device to bring the hero into the family circle suggests an interesting variant of Holgrave's view that through the photograph the sun reveals true character.[32]

Another variant, based on the same convention of the daguerreian image as a surrogate for an original, inspiring love, occurs in a fascinating pulp novel of 1846, *The*

Figure I-7
JOHN PLUMBE. *Portrait of Couple.*
Daguerreotype, c. 1845.
Amon Carter Museum.

Daguerreotype Miniature; or, Life in the Empire City,[33] by the labor radical Augustine Joseph Hockney Duganne. Duganne's novel, perhaps the earliest appearance of photography in American fiction, is dedicated to "Professor Plumbe." At the street-level window of the "Plumbe National Daguerrian Gallery" at Broadway and Murray Streets (an actual place), the hero, a country lad, falls hopelessly in love with a daguerreotype. It is a portrait of the beautiful heiress whose life he had saved a few days before by stopping the runaway horses of her carriage on Broadway. Injured in the rescue (the carriage continued on its way, allowing him only a fleeting glimpse of the heroine), he is kidnapped by a group of rogues who had already had their eyes on him and the inheritance of which he himself remains ignorant. Freed for an afternoon for a stroll on Broadway, the hero sees the daguerreotype, has Plumbe take his own picture in exchange for it, and like a true Romantic chevalier, puts the daguerreotype around his neck as an amulet. In the end it saves his life, when one of the villains tries to stab him in the heart, and preserves him for the inevitable marriage with the grateful heiress.

The plot is thin, but *Life in the Empire City* mixes romance and adventure with social commentary; its texture is more revealing than its action. The story is essentially about life on Broadway, a never-ceasing drama of people watching each other. Apart from the

sentimental romantic situation, the plot consists of several acts of deception; there are false identities, disguises, betrayals of trust. The villains are all deceivers, a Jacksonian roster of the wicked of the world: gamblers, speculators, confidence men, and lawyers. The tale plunges us at once into the "river of life" of Broadway, with "the heated speculator" and "the anxious tradesman," sailors, bankers, ministers, the merchant's daughter, the "flaunting courtezan" and the "half-dying seamstress"—all unaware of "men with cunning eyes . . . watchful and observing, glancing at each and all" (p. 5). *Seeing* is the overriding activity of Broadway, and Duganne's prose as much as drowns in such terms as *survey, glance, gaze, observe, view, detect, penetrate, look, behold, inspect, stare, scrutinize, appear,* and *disappear.* With its plate glass windows everywhere, and eyes constantly at work, it is something like a hall of mirrors.

In the midst of it all is Plumbe's Daguerrian Gallery, sitting high above street level, where "ladies and their attendant gentlemen . . . promenaded the floor, or paused admiringly beneath some elegant frame" (p. 35). Duganne describes an actual place, just as Walt Whitman did the same year in a newspaper account; both emphasized the crowds coming and going and the walls hung with images. Duganne evokes a similar sense of the gallery as a place with a new kind of power. His emphasis falls, however, on the pedagogical powers of the image. The function of the Plumbe establishment in the narrative is really symbolic. Its images are different from those of Broadway, in the sense that Plumbe's daguerreotypes stand for truth, in the very place of falsehood and deceit.

The Plumbe gallery offers "a perfect study of character," where one may view pictures of distinguished Americans: "statesmen, the renowned soldiers, the distinguished litterateurs of the country, [who] looked down, life-like, from their frames" (p. 35). In a world of rogues and false-seemers, the gallery serves as a true mirror of what ought to be. The narrative's young hero saves and redeems himself by fixing "indelibly within my bosom" the "image" of his true love. And citizens might take a lesson by studying "character" from Plumbe's images—a lesson much wanted, Duganne's didactic tale argues, in "the life of the empire city."

Duganne's fiction alludes to a cultural program for photography already established in public discourse by 1846. The fixed image of the photograph is different in kind from that which catches the eye in the flowing crowds of the street, and in its difference lies a hope for control, for a moral pedagogy from above, from gallery walls: a teaching by images which mirror to the city the virtue missing on its streets and in its shops and halls of public office.

A writer in the *Christian Watchman* in the same year described daguerreotypes as "indices of human character," "so many exponential signs of disposition, desire, character." They represent "a great revolution in the morals" of portraiture.[34] Unlike the flattery of a painted portrait, the daguerreotype makes no compromise with actual appearances. "Expression is a direct emanation of the face," a writer in the *Daguerreian Journal* put it a few years later.

> Years spent in coquetry and caprice, in folly and frivolity, the entire abandonment to self-worship, and the entire neglect of mental culture, cannot pass without leaving an unlovely record on the face, and a background of embittered feeling, which no artistic power can render attractive. Stereotyped then, are the motives of the past.[35]

Like Willis' thieves in the night and Hawthorne's Judge Pyncheon, no rogue or scoundrel, hypocrite or criminal, can hope to escape the unrelenting truth of the camera eye. As the Philadelphia daguerreotypist Marcus Aurelius Root would put it in *The Pencil and the Camera* (1864), photography assures civic order and public safety.

Root argues for the moral necessity of photography on positive grounds as well:

> In this competitious [sic] and selfish world of ours, whatever tends to vivify and strengthen the social feelings should be hailed as a benediction. With these literal transcriptions of features and forms, once dear to us, ever at hand, we are scarcely more likely to forget, or grow cold to their originals, than we should in their corporeal presence. How can we exaggerate the value of an art which produces affects like these?[36]

Figure I-8

Unknown Artist. *Family Daguerreotypes, found every where.* In *Harper's New Monthly Magazine* 15 (July 1857): 285-286.

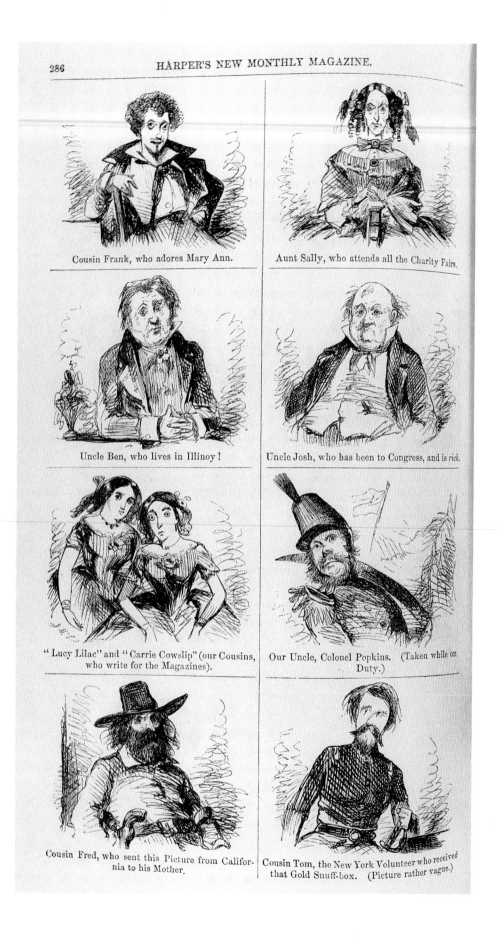

Cousin Frank, who adores Mary Ann.

Aunt Sally, who attends all the Charity Fairs.

Uncle Ben, who lives in Illinoy !

Uncle Josh, who has been to Congress, and is *rich*.

"Lucy Lilac" and "Carrie Cowslip" (our Cousins, who write for the Magazines).

Our Uncle, Colonel Popkins. (Taken while on Duty.)

Cousin Fred, who sent this Picture from California to his Mother.

Cousin Tom, the New York Volunteer who received that Gold Snuff-box. (Picture rather vague.)

Figure 1-9
Marcus Root. *Portrait of Couple.*
Daguerreotype, c. 1850.
Amon Carter Museum.

Portraits made for domestic consumption assure harmony at home. But living likenesses of eminent, "illustrious" Americans (Mathew Brady's term), made for public viewing in galleries and for engraving, provide models for emulation, like Roman busts, and buttress the stability of the republic.

But not alone our near and dear are thus kept with us; the great and the good, the heroes, saints, and sages of all lands and all eras are, by these life-like "presentments," brought within the constant purview of the young, the middle-aged, and the old. The pure, the high, the noble traits beaming from these faces and forms,—who shall measure the greatness of their effect on the impressionable minds of those who catch sight of them at every turn?[37]

Eighteen years before Root penned these words, Duganne and the *Christian Watchman* had articulated an emerging consensus about the moral lessons of the photographic portrait. In a world where money transactions, the marketplace, and competitive individualism encourage the currency of false images (similar to inflated paper money), the daguerreotype portrait provides a corrective. It offers true coin against false, sincere and faithful images against false-seeming. In vain shall the wicked hide. The quasi-magical mirror of the

daguerreotype miniature provides an amulet against the menace hidden within the Broadway spectacle, the threat of counterfeit in the traffic of images at the market center of the Empire City.

In an 1859 article on the stereograph in the *Atlantic Monthly*, Oliver Wendell Holmes, distinguished Harvard doctor of medicine, novelist, savant, and Boston Brahman (a term he coined), observed that "the daguerreotype, perfect and cheap as it is, and admirably adapted for miniatures, has almost disappeared from the field of landscape, still life, architecture, and genre painting, to make room for the photograph."[38] Within a few years photographs or "sun-pictures"—paper prints made from a negative—would drive the older process from the market altogether. Three essays by Holmes, published in the *Atlantic Monthly* between 1859 and 1863, mark the end of the daguerreotype era and inaugurate a new phase in the history of the word *photography* in America.

This is so in two senses. First, the word *daguerreotype* stood mainly for portraits, likenesses, pictures of people taken under controlled studio conditions—a fact that profoundly influenced the meanings imputed to the medium. Taking the stereograph as his topic, Holmes expanded the meaning of photography to encompass a new world of subject-matter—indeed the entire visible world. Second, the very fact that the nation's most prestigious journal of arts and letters and opinion published serious essays on photography by one of America's most respected intellectuals—who, though an ardent amateur, was neither a member of the craft nor part of the photographic community—signified that photography had arrived at the level of culture. From the point of view of what was accepted as "high" culture at the time, Holmes' wit and learning raised the subject of photography beyond the hermetic circle of professional practitioners and their spokesmen and above the sentimental-gothic rhetoric of popular fiction in which the daguerreotype had thrived. Addressing "the general reader"—a figure only recently invented as periodical literature burgeoned—Holmes stripped photography of the metaphysic of light and shade, surface and depth, silence and speech. Adopting a Baconian stance, he demystified and naturalized the rhetoric and devoted more attention to describing actual images than to speculating about the moral or parapsychic nature of the medium.

Holmes wanted his readers to enjoy photographs. In his essays he transposed the medium into a new language of reception—a language of cultivated appreciation. He looked closely and lovingly at specific pictures and surrendered to their visual and imaginative delights. The way he looked at and described the effects of pictures is not exactly a way of reading photographs, nor a method of critical analysis, but a method of expressing one's pleasure, when that pleasure is informed by knowledge of the process. Holmes wanted to reawaken wonder in the medium now some twenty years old. Photography "has become such an everyday matter with us, that we forget its miraculous nature, as we forget that of the sun itself, to which we owe the creations of our new art" (3:738). What lies waiting as the future of the medium in Holmes' pre-Kodak meditations is "popular photography," an idea of the medium as an all-consuming pastime. Photography and leisure made their first joint appearance in Holmes' three *Atlantic* articles.

Part of the pastime is devoted to sheer verbal play, the pleasure of figures of speech and turns of phrase by which Holmes displays his thinking about photography. Significant here is his diminishment of the mirror metaphor, which daguerreotypy charged with paradox, entrancement, and anxiety. While he still speaks of "the mirror with a memory" and alludes to mirrors in his opening account of the medium, he is enthralled mostly by the photographic image as such—by how, as image, it represents its referent. Rather than the technical explanation he is certainly capable of, Holmes offers his "general reader" a figurative explanation from an older science—Democritus' notion that "all bodies were continually throwing off certain images like themselves, which subtile emanations, striking on our bodily organs, give rise to our sensations" (3:738).

Holmes plays Lord Bacon, interpreting the old fables as parables of exact science. The way to understand the concept of "these effluences" is by terms such as "forms, effigies, membranes, or *films*" (3:738). In the second article, "Sun-Painting and Sun-Sculpture," he writes that the "true significance" of the story of Apollo flaying Marsyas is that the God of Light "took a *photograph*, a sun-picture, of him. This thin film or *skin* of light and shade was

absurdly interpreted as being the *cutis*, or untanned leather integument of the young shep-
herd."[39] The discovery of photography helps us "rectify the error." Holmes cannot repress
making the old myth into a new figure. "We are now flaying our friends and submitting to
be flayed ourselves. . . . All the world has to submit to it,—kings and queens with the rest.
The monuments of Art and the face of Nature herself are treated in the same way" (8:13).
Thus the game of photography begins in wordmanship.

Holmes employs the mirror image to explain the Democritan theory of effluence, the
images in reflective surfaces being one of the aspects of "these evanescent films." But Holmes
wants his reader to move beyond the fascination of the reflected image itself, toward "the
consciousness behind the eye in the ordinary act of vision" (3:738). The science of vision
replaces older concerns about sorcery and black magic, and the *logic* of the mirror effect
provides a lesson in the mechanics of vision—for example, how distance from a mirror
determines the size of the perceptible image as the subject moves further away from the fixed
reflective surface.

To leap to photography and to show how Democritus' image of the effluence helps
describe (though not actually explain) the medium, Holmes writes:

> The man beholdeth himself in the glass and goeth his way, and straightway both the
> mirror and the mirrored forget what manner of man he was. These visible films or
> membranous *exuviae* of objects, which the old philosophers talked about, have no real
> existence, separable from their illuminated source, and perish instantly when it is
> withdrawn. (3:738)

What the daguerreotype accomplishes is the fixing of "the most fleeting of our illusions, that
which the apostle and the philosopher and the poet have alike used as the type of instability
and unreality" (3:738). And after the daguerreotype, the photograph or sun-picture "has
completed the triumph, by making a sheet of paper reflect images *like a mirror* and hold them
as a picture" (my emphasis, 3:738). The analogy to membrane or skin makes short shrift of
the paradox which bothered Thoreau, between repetition and origination. And "picture"
seems to end the practice of taking the mirror-image as "the type of instability and unreality"
(3:738). Effluences are not copies but things in their own right; impalpable and insubstantial
in themselves, in the photograph they achieve a fixed body, a materiality. Thus the mirror,
the foremost instrument for copying the world, has a limited applicability. Having done its
job of helping the reader place the photograph in the history of thought and appreciate how
"audacious, remote, improbable, incredible" this "triumph of human ingenuity" is, the
mirror gives way to the picture, to actual representations Holmes will lavish his attention on.

Holmes' essays stand at the threshhold of a new world of pictures introduced by paper
photography. He focuses on the stereograph and stereoscope not only because of a scientific
fascination with the three-dimensional image (he himself invented one of the most popular
viewers), but because this was the mode in which "the greatest number of sun-pictures," in
the early wet-plate years of the late 1850s and 1860s, "were intended to be looked at" (3:742).
Just as properties peculiar to the daguerreotype had shaped the dominant ideas of photog-
raphy in the earlier era, so the stereograph experience provided the major terms for Holmes'
conception of the medium and its metaphoric implications. It is an experience of spatial
depth, achieved when a viewing instrument, the stereoscope, brings two images, each made
from the position of one eye, into a field of focus. A sliding bar allows the viewer to move
the flat (sometimes curved) card or stereograph into position so the eyes can focus the two
images as one picture. The principle derives from normal vision: "our two eyes see two
somewhat different pictures, which our perception combines to form one picture, representing
objects in all their dimensions, and not merely as surfaces" (3:743). The stereoscope
heightens the illusion of reality, of our being present to a scene, and adds a dimension to the
daguerreian idea of fidelity to prototypes in the world.

Describing actual stereo images, Holmes drops the language of representation and
speaks as if the picture were the real thing, the actual experience. Thus transport is his major
theme.

> The first effect of looking at a good photograph through the stereoscope is a surprise
> such as no painting ever produced. The mind feels its way into the very depth of the

picture. The scraggy branches of a tree in the foreground run out at us as if they would scratch our eyes out. The elbow of a figure stands forth so as to make us almost uncomfortable. Then there is such a frightful amount of detail, that we have the same sense of minute complexity which Nature gives us. (3:744)

This illusion of material presence—Holmes avoids the word *copy*—is based in fact on a dematerialization of the actual photograph. While the daguerreotype possesses weight and mass of its own, the stereograph is the thinnest of cards, something like a skin itself. It merely carries the image, or the potential of the full dimensional image that is waiting to be formed in the brain once the eyes have perceived it through the mechanical viewer. In "Sun-Painting and Sun-Sculpture" Holmes describes the effect precisely as a loss of body:

> At least the shutting out of surrounding objects, and the concentration of the whole attention, which is a consequence of this, produce a dream-like exaltation, in which we seem to leave the body behind us and sail away into one strange scene after another, like disembodied spirits. (8:14-15)

By this figure of enchantment—of the pleasure of transport, of submitting to external stimuli, of abandoning the mind as well as the body, and of losing any skepticism toward the illusion—Holmes contributes a theory to the growing commercialization of such experiences in the mass production of stereographs.

His Baconian positivism, the physiological premise of his explanations, has its lyric side, and it is by his particular braiding of the language of science and the language of art (or aesthetic experience) that he revises the word *daguerreotype* into the word *photograph*. Holmes devotes the bulk of his essays to accounts of specific disembodied experiences, chiefly of distant places:

> The stereoscopic views of the arches of Constantine and of Titus give not only every letter of the old inscriptions, but render the grain of the stone itself . . . Here is Alloway Kirk, in the church yard of which you may read a real story by the side of the ruin that tells of more romantic fiction . . . I pass, in a moment, from the banks of the Charles to the ford of the Jordan, and leave my outward frame in the arm-chair at my table, while in spirit I am looking down upon Jerusalem from the Mount of Olives. (3:745)

The second article presents "a brief stereographic trip,—describing, not from places, but from the photographic pictures of them which we have in our own collection" (8:16). Holmes is the tour-guide:

> We are bound for Europe, and are to leave via New York immediately. Here we are in the main street of the great city. . . . Here is the harbor; and there lies the Great Eastern at anchor. . . . Here are the towers of Westminster Abbey. . . . That is St. Paul's, the Boston State-House of London. . . . Here we are at Athens, looking at the buttressed Acropolis and the ruined temples. . . . The Great Pyramid and the Sphinx! . . . as we look across the city to the Mount of Olives, we know that these lines which run in graceful curves along the horizon are the same that He looked upon as he turned his head sadly over Jerusalem. (8:17-28)

Broadway and the Battery in New York, Niagara, Charleston, Charing Cross and London Bridge, the Shakespeare House, Tintern Abbey, the ruins of Rome, and so on in a simulacrum of the Grand Tour—with the obligatory pious note which confirms the "high" cultural instrumentality of the stereographic device:

> This is no toy, which thus carries us into the very presence of all that is most inspiring to the soul in the scenes which the world's heroes and martyrs, and more than heroes, more than martyrs, have hallowed and solemnized by looking on. It is no toy: it is a divine gift, placed in our hands nominally by science, really by that inspiration which is revealing the Almighty through the lips of the humble students of Nature. (8:28)

Missing is any question why these particular views have been made, what cultural premises lead suppliers of these touristic pictures to choose these scenes and not others, what associations of value and preciosity attached to the names of places, what social implications

Figure I-10

UNKNOWN ARTIST.
Stereoscopic Slides. In *Harper's
New Monthly Magazine* 21
(October 1860): 717-718.

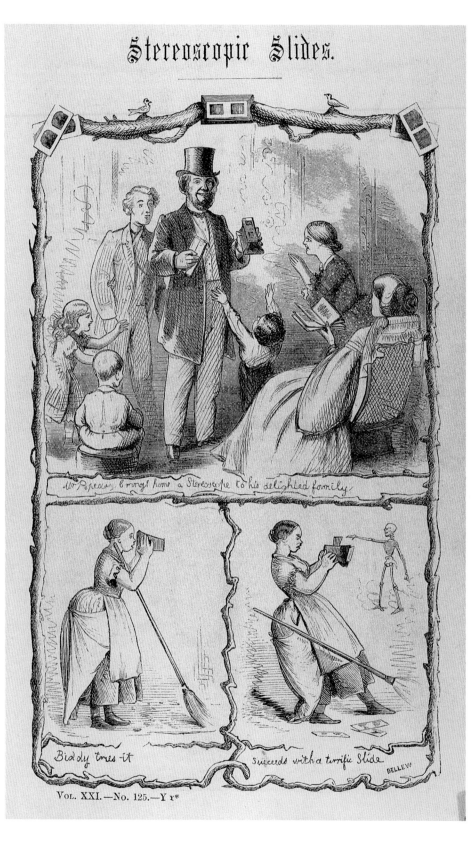

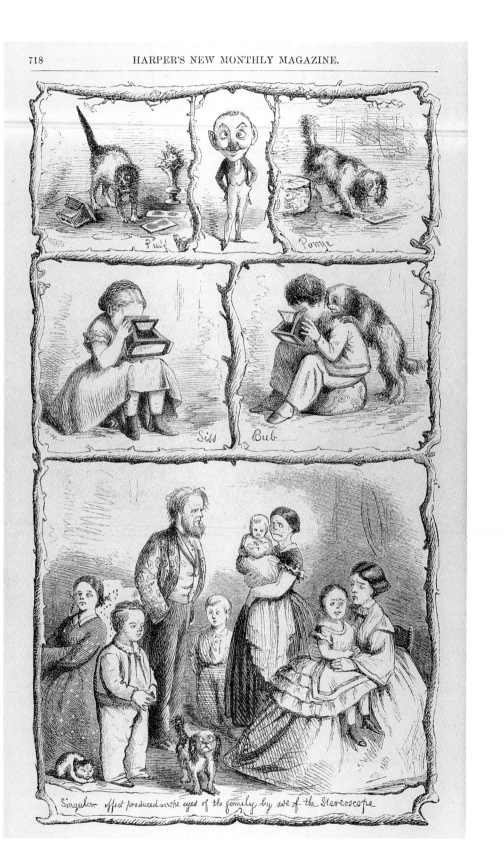

Singular effect produced on the eyes of the family by use of the Stereoscope

lay in the possibility of such a tour, and so on. Holmes has us accept the photograph absolutely, not as surrogate reality, which might lead to wondering why this particular illusion is offered as real and worth viewing, but as reality in its own right. In one of the essays' frequent unconscious flashes into buried motives and sources of value, Holmes writes: "Damascus makes but a poor show, with its squalid houses, and glaring clayed roofs. We always wanted to invest in real estate there in Abraham Street or Noah Place . . . but are discouraged since we have had these views of the old town" (8:28).

Reality and real estate: the solid-seeming images perform an act of ownership, of taking possession—an imagined proprietorship of the world. The images invite fantasies of power:

> In the lovely glass stereograph of the Lake of Brienz, on the left-hand side, a vaguely hinted female figure stands by the margin of the fair water; on the other side of the picture she is not seen. This is life; we seem to see her come and go. All the longings, passions, experiences, possibilities of womanhood animate that gliding shadow which has flitted through our consciousness, nameless, dateless, featureless, yet more profoundly real than the sharpest of portraits traced by a human hand. (3:745)

It is a genteel mode of reading, repressing knowledge of the sources of the "profoundly real" in its own projected fantasies—in this case, of "womanhood" and the masculine sense of power which flows from the gazing eye.

The power Holmes attributes to the medium is the power of a particular cultural outlook projecting "reality" as it knows and wishes it. His playful intellectualizing of the medium as effluence of skins and membranes becomes, in the elaboration of this figure with which Holmes closes his first article, a serious theory of world-making, a way of placing the power of determining reality within institutional structures employing photography. Photography finally is not just a way of making pictures but of storing and communicating knowledge. In their exactitude as traces of the actual shape of visible things, photographs can serve as surrogates for the things themselves, a way of knowing them absolutely. By aid of the stereoscope, "form is henceforth to make itself seen through the world of intelligence, as thought has long made itself heard by means of the art of printing. The morphotype, or form-print, must hereafter take its place by the side of the logotype or word-print" (3:744). The photograph endows the picture not only with a power equal to that of language, but superior in that the picture becomes the very thing it represents.

> Form is henceforth divorced from matter. In fact, matter as a visible object is of no great use any longer, except as the mould on which form is shaped. Give us a few negatives of a thing worth seeing, taken from different points of view, and that is all we want of it. Pull it down or burn it up, if you please. (3:747)

The wit deflects from the underlying point. Obviously photography has not replaced the real world or destroyed it, but so conceived it has assumed the power to say what the real world is, and what is "worth seeing" in it. In a moment of prophecy Holmes imagines the world of *National Geographic*, *Life* magazine, and spy satellites:

> Every conceivable object of Nature and Art will soon scale off its surface for us. Men will hunt all curious, beautiful, grand objects, as they hunt the cattle in South America, for their skins, and leave the carcasses as of little worth. (3:748)

The theory of the consumption of images as experience of the world is born.

Holmes adds a final turn to this uncritical vision of the photographic accumulation and construction of reality—of photography as reality. Forms will accumulate in such quantity that they will need to be classified "and arranged in vast libraries," places where one can go "to see any object, natural or artificial"—not the picture of the object, the copy or repetition of it, but its actual skin or form. And further,

> as a means of facilitating the formation of public and private stereographic collections, there must be arranged a comprehensive system of exchanges, so that there may grow up something like a universal currency of these bank-notes, or promises to pay in solid substance, which the sun has engraved for the great Bank of Nature. (3:748)

Just as the number printed on a banknote represents a promise on the part of the bank to exchange the note for silver or gold, so the photograph proclaims that somewhere out in the world lies an original for which the image might be cashed in. He tells of a traveling salesman taking orders from stereographic views of furniture—another prophecy of the coming role of photography, to fabricate a world produced by consumer capitalism, in which images emerge as the enchantment of commodity-objects.[40]

Holmes' essays represent a transition in thinking about photography, from the era of the unique daguerreian object to that of the mass-produced image. In the daguerreotype, the whole object—case and plate and mat—and its aura of association were precious. In the photograph, particularly the stereograph, value resided not in the object as such but in the impalpable image adhering to it, as a potential ocular experience. While daguerreotypes were produced as commodities, manufactured objects to be exchanged for money in a market transaction, each remained a unique possession. The manufactured stereograph, on the other hand, provided identical images to all customers; one did not possess the stereograph itself, but the image it showed. Thus exchange value and use value coincided, allowing Holmes to analogize the paper photograph with paper money.

But where did sun-pictures come from? Out of what acts of labor? Holmes' third article, "Doings of the Sunbeam," opens with an event which might point to agencies other than the charming figure of the title—a visit to the establishment of the nation's principal producer of stereographs, Messrs. E. & H. T. Anthony of Broadway, New York. What Holmes encounters is a scene of mass production, a factory devoted to making and packaging images. He sees steam-powered machines for manufacturing albums, cases, and camera parts, and "a row of young women before certain broad, shallow pans filled with glairy albumen" (used to attach the emulsion to printing paper, hence "albumen paper").[41] He sees assembly-line methods and comments that "the workmen in large establishments, where labor is greatly subdivided, become wonderfully adroit in doing a fraction of something. They always remind us of the Chinese or the old Egyptians" (12:2). One young person mounting photographs on cards all day "confessed to having never, or almost never, seen a negative developed, though standing at the time within a few feet of the dark closet where the process was going on all day long" (12:2). Another "forlorn individual" cleans glass plates of negatives all day long, standing next to a toning bath about which he knows nothing and cares less.

Alienated labor at the site where "the doings of the sunbeam" are manufactured does not, however, disturb Holmes' equanimity: "we left the great manufacturing establishment of the Messrs. Anthony, more than ever impressed with the vast accession of happiness conferred upon mankind by this art." He has either forgotten or repressed what he has seen in the faces of the "operatives," or perhaps he does not count them among "mankind." Holmes sees but does not register how human labor under conditions of industrial capitalism bears upon "the doings of the sunbeam." He turns next, as if silently offering reproach to the listless lack of curiosity among the young "operatives," to a lengthy account of how he produces a picture himself, from its exposure to its development and printing. His "general reader" will have no doubt about whose labor to identify with: "Everyone is surprised to find how little time is required for the acquisition of skill enough to make a passable negative and print a tolerable picture" (12:3). Holmes describes himself donning protective overalls "such as plain artisans are wont to wear" (12:3). He treats the process like a literary game, complete with allusions to "the shadowy realm where Cocytus flows in black nitrate of silver and Acheron stagnates in the pool of hyposulphite, and invisible ghosts, trooping down from the world of day, cross a Styx of dissolved sulphate of iron, and appear before the Rhadamanthus of that lurid Hades" (12:5).

In repressing the significance of industrial labor at the base of the photography industry, Holmes treats his visit to the factory as part of his strategy throughout the three essays, to make photography enjoyable, in this instance by looking behind the scenes. The subsequent account of himself performing the process makes it seem as if the stereographic images which overwhelmed him with wonder came into the world simply for his pleasure, with no less innocent purpose than to provide pictures of interesting places and persons, for private delectation. He concludes the third essay with an account of a new form of social

Figure I-11

OLIVER W. HOLMES. *At the Doorway*. Albumen silver print, c. 1864. Museum of Fine Arts, Boston; bequest of Mrs. Edward Jackson Holmes, Edward Jackson Holmes Collection.

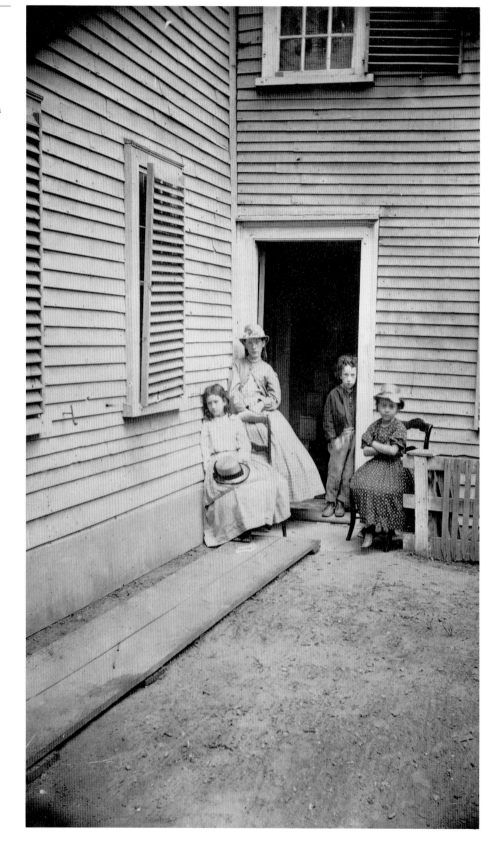

intercourse—the exchange of images by mail, among "gentlemen" amateurs eager to share their pleasures. "A photographic intimacy between two persons who never saw each other's faces (that is, in Nature's original positive, the principle use of which, after all, is to furnish negatives from which portraits may be taken) is a new form of friendship" (12:15). In this linguistic device—which considers commonsense reality as the "positive" from which a more real reality, the photographic portrait, can be produced—lies an uncritical prophecy of a world in which images rather than persons provide friendship and intimacy.

Holmes' essays mark a turning point in the evolution of popular meanings of photography. Although he seems a prophet of consumerist attitudes and practices with his anticipation of the mass practice of photography, inaugurated by George Eastman in the later 1880s, he probably reflects views already emerging in the era of mass-produced paper images. His playful metaphors articulate a cultivated point of view, turning popular photography into a quasi-serious subject. In his essays, the word *photography* becomes the possession of a wide public, the name of a wonderful way to spend one's leisure time. By his manner as a man of the world, he naturalizes photography, removing the mystery along with the mystique of craft. As he defines it, photography now means pleasure and charm, a way of appropriating the world as dematerialized experience, without the expense of active effort or of critical thought.

Holmes delivers to the next generation a concept of photography as an amateur pastime—and sets the stage for the Kodak. Significant developments in the medium in the following decades included a growing division between commercial and amateur photography, as dry plates and hand-held cameras helped make it a leisure-time hobby or avocation outside the realm of work. The older journeyman ideas of craft remained in place in commercial and professional photography, but amateur clubs and societies fostered a growing notion of photography as a fine art, with a wish for aesthetic legitimacy. The closing years of the nineteenth century witnessed increasing confusion about the status and meaning of the keyword. Was there one photography, or were there many versions of the medium and the word? By the end of the century a "secessionist" group among amateurs, led by Alfred Stieglitz in New York, would launch a battle over the word and idea of photography. Stieglitz' campaign for photography as fine art, and the modern movement in the medium which followed, would revive older debates over the relation between copy and original, fact and meaning, art and science, and would restore the critical edge in the keyword, making it seem once again a word worth fighting over.

NOTES

I would like to thank Susan Williams for her indispensable contribution to the research for this essay.

[1] "Prospectus"; "Introduction," *Daguerreotype* 1 (1847): 5.

[2] Ibid., p. 8.

[3] My concern is less with dictionary definitions or with etymology as such than with the cultural semantics of photographic terminology. See Raymond Williams, "Introduction," *Keywords: A Vocabulary of Culture and Society* (New York: Oxford University Press, 1976), especially pp. 19-22.

[4] Rev. H. J. Morton, "Photography as an Authority," *Philadelphia Photographer* 1 (1864): 180-181.

[5] Dr. H. [Hermann] Vogel, "Photography and Truth," *Philadelphia Photographer* 6 (1869): 262.

[6] Ibid., pp. 263-264.

[7] See, for example, Fred Somkin, *Unquiet Eagle: Memory and Desire in the Idea of American Freedom, 1815-1860* (Ithaca, New York: Cornell University Press, 1967), and Karen Halttunen, *Confidence Men and Painted Women: A Study of Middle-Class Culture in America, 1830-1870* (New Haven: Yale University Press, 1982). For a general cultural history of the period, see Russel Blaine Nye, *Society and Culture in America, 1830-1860* (New York: Harper and Row, 1974).

[8] *Daguerreotype*, 1: 7.

[9] William H. Gilman and J. E. Parsons, eds., *The Journals and Miscellaneous Notebooks of Ralph Waldo Emerson* (Cambridge, Massachusetts: Belknap Press of Harvard University Press, 1971), 9: 14. References to the railroad and the telegraph "annihilating space and time" abound in the period. For an excellent discussion of this figure of speech, see Wolfgang Schivelbusch, *The Railway Journey: Trains and Travel in the Nineteenth Century* (New York: Urizen Press, 1979).

[10] N. Parker Willis, *Hurry-Graphs; or, Sketches of Scenery, Celebrities and Society* (New York: Charles Scribner, 1851), p. iv.

[11] Bradford Torrey and Francis H. Allen, eds., *The Journal of Henry D. Thoreau, 1837-1846* (Boston: Houghton Mifflin Company, 1949) 1: 89. All quotations by Thoreau are from this text and page.

[12] Robert E. Spiller and Alfred R. Ferguson, eds., *The Collected Works of Ralph Waldo Emerson* (Cambridge, Massachusetts: Belknap Press of Harvard University Press, 1971), 1: 7.

[13] See, for example, Beaumont Newhall, *Photography: A Short Critical History* (New York: Museum of Modern Art, 1938), and subsequent enlarged and revised editions of this influential work, and Helmut and Alison Gernsheim, *The History of Photography, 1685-1914* (New York: McGraw Hill, 1969).

[14] R. W. Emerson, "Art and Criticism," in *Natural History of Intellect and Other Papers* (Boston: Houghton, Mifflin and Company, 1904), p. 300.

[15] Nathaniel Hawthorne, *The House of the Seven Gables* (New York: Norton Critical Edition, 1967), p. 91. Subsequent citations in the text are to this edition.

[16] Walt Whitman, *The Gathering of the Forces*, ed. by Cleveland Rodgers and John Black (New York: G. P. Putnam's Sons, 1920), 2: 113-117.

[17] Alan Fern and Milton Kaplan, "John Plumbe, Jr. and the First Architectural Photographs of the Nation's Capital," *Quarterly Journal of the Library of Congress* 31 (January 1974): 3-20.

[18] Whitman, *Gathering of the Forces*, 2: 116.

[19] On technological changes in the medium, see Reese Jenkins, *Images and Enterprise: Technology and the American Photographic Industry, 1839-1925* (Baltimore: Johns Hopkins University Press, 1975). On the effects of the halftone process on pictorial representation, see Estelle Jussim, *Visual Communication and the Graphic Arts: Photographic Technologies in the Nineteenth Century* (New York: R. R. Bowker Company, 1983.

[20] "The Inconstant Daguerreotype," *Harper's Monthly* 10 (May 1855): 824.

[21] "Self-Operating Processes of Fine Art: The Daguerotype [sic]," reprinted in *Museum of Foreign Literature, Science and Art* 7 (January-June 1839): 341.

[22] Quoted in William F. Stapp, *Robert Cornelius: Portraits from the Dawn of Photography* (Washington, D.C.: Smithsonian Institution Press, 1983), p. 136.

[23] Quoted in Helmut and Alison Gernsheim, *L.J.M. Daguerre* (New York: Dover Edition, 1968), p. 138.

[24] M. D. Conway, "My Lost Art," *Atlantic Monthly* 10 (August 1862): 228-235.

[25] Abraham Bogardus, "The Lost Art of the Daguerreotype," *Century Magazine* 68 (May 1904): 89-91.

[26] T. S. Arthur, "American Characteristics: The Daguerreotypist," *Godey's Lady's Book* 38 (May 1849): 353.

[27] *Photographic Art Journal* 4 (June 1852): 353-359. Citations in the text are to this edition.

[28] N. P. Willis, "The Pencil of Nature," *Corsair* 1 (April 13, 1839): 70. All quotations in the text are from this edition.

[29] See Samuel Rezneck, "The Social History of an American Depression, 1837-1843," *American Historical Review* 40 (1934-35): 662-687.

[30] For a brief account of early examples of lithographs made from daguerreotypes, see Beaumont Newhall and Robert Doty, "The Value of Photography to the Artist, 1839," *Image* 11 (No. 6, 1962): 25-28. I thank Marni Sandweiss for calling this article to my attention.

[31] Allan Nevins, ed., *The Diary of Philip Hone, 1828-1851* (New York: Dodd, Mead, 1927), pp. 434-436.

[32] I am indebted to Susan Williams' excellent unpublished paper, "Exploring the Shoe Box"—a provocative discussion of the daguerreotype in sentimental and Gothic short fiction in the popular press.

[33] Augustine Joseph Hockney Duganne, *The Daguerreotype Miniature; or, Life in the Empire City* (Philadelphia: G. B. Zieber & Co., 1846). Page numbers in the text refer to this edition.

[34] Reprinted in *Lyttle's Living Age* 9 (June 1846): 552.

[35] Y. T. S., "Life in the Daguerreotype. No. II. The Operating Room," *Daguerreian Journal* 2 (November 1851): 374.

[36] Marcus Aurelius Root, *The Camera and the Pencil, or, The Heliographic Art* (Philadelphia: J. P. Lippincott and Co., 1864), pp. 43-44.

[37] Idem.

[38] Oliver Wendell Holmes, "The Stereoscope and the Stereograph," *Atlantic Monthly* 3 (June 1859): 742. Page numbers for subsequent citations from this article are included in the text.

[39] "Sun-Painting and Sun-Sculpture; With a Stereoscopic Trip Across the Atlantic," *Atlantic Monthly* 8 (July 1861): 13. Page numbers for subsequent citations from this article are included in the text.

[40] See Harvey Green, "'Paste-Board Masks': The Stereograph in American Culture, 1865-1910," in Edward W. Earle, ed., *Points of View: The Stereograph in America, A Cultural History* (Rochester, N.Y.: Visual Studies Workshop Press, 1979), pp. 109-115, and Allan Sekula, "Traffic in Photographs," *Art Journal* 41 (Spring 1981): 21-23.

[41] "Doings of the Sunbeam," *Atlantic Monthly* 12 (July 1863): 1. Page numbers for subsequent citations from this article are included in the text.

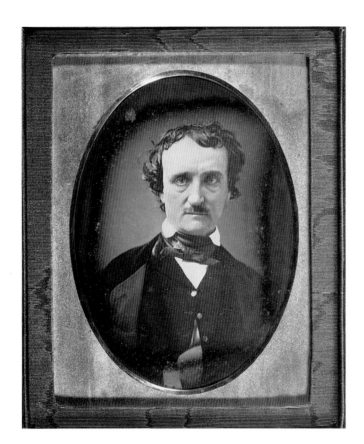

THE PORTRAIT STUDIO AND THE CELEBRITY

II

Promoting the Art

Ever since the early years of the photographic medium, observers have noted its distinctly democratic potential to make photographic portraits available to almost everyone. These portraits were not only relatively inexpensive but served a wide range of social needs. In the first serious treatise on photography, published in *The Camera and the Pencil* in 1864, Marcus Aurelius Root articulated some of the then-accepted theoretical beliefs about photography's social virtues. Root, who since 1846 had operated one of the largest daguerreotype studios, saw democratic portraiture as a healthful antidote to such socially destabilizing phenomena as massive immigration from Europe and geographic redistribution of the population into newly acquired western territories. In America of the 1840s and 1850s, where "the exigencies of life, in most cases, necessitate the dispersion of relatives, born and reared under the same roof, towards various points of the compass, and often to remote distances," Root saw affordable photographic portraits as a means of bringing "our loved ones, dead or distant," near again.[1]

Yet photographic portraiture had a second, less democratic function. Root also described the moral benefit to be derived from viewing portraits of America's political and social elite—"the great and the good, the heroes, saints and sages." Particularly in the early years of the medium, advocates of the new technology regarded photographic portraits of the upper class as a means of moral education for the American public, who could view images of the "representative man and woman" through public exhibitions, mass publications, or copies displayed in their own homes and, by example, be inspired by "the noble traits beaming from those faces and forms." As Root speculated, "who shall measure the greatness of their effect on the impressionable minds of those who catch sight of them at every turn?"[2] Implicitly, viewing portraits of the nation's elite could provide moral edification for all its citizens who needed to learn how to present themselves as good Americans in a quest for upward mobility.

Although both types of portraiture—both the personal images of family and friends and the morally instructive images of society's leaders—existed from the earliest days of photography, they were distinguished from one another by such issues as the class of the sitter, the audience intended for the portrait, and frequently, the experience and the philosophical intent of the photographer. Poorly trained daguerreotypists were able to find clients from the lower classes, who could not afford painted portraits but were attracted to crude yet inexpensive daguerreotype portraits. Skillful photographers, seeking clients from the more affluent classes, had to compete with portrait painters for their clientele by presenting photographic portraits as "artistic." These enterprising photographers also exhibited and published photographs of the nation's leaders to gain public credibility for their own work, to assuage popular anxieties about photography, and to communicate, to socially prominent and ordinary citizens alike, the power and the possibilities of the photographic image. As the market for portraits of the nation's social and political leaders (FIG. 2) developed, many makers of celebrity images also seized the opportunity to improve their own social standing through their profession, and a few even became as famous as their photographic subjects.

BARBARA M^cCANDLESS

Figure II-1
UNKNOWN PHOTOGRAPHER.
Edgar Allan Poe. Daguerreotype,
1848. J. Paul Getty Museum.

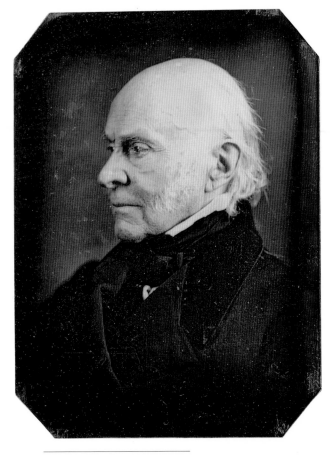

Figure II-2

Philip Haas. *John Quincy Adams.*
Daguerreotype, c. 1843. Mead Art
Museum.

Ultimately, the divisions between elite and democratic portraiture strengthened the entire profession. As demonstrated in the long careers of Mathew Brady, who dominated celebrity portraiture from the daguerreian period to the Civil War, and Napoleon Sarony, whose theatrical portraits became the aesthetic standard from the late 1860s to the end of the century, the dialogue between the two sides produced an evolution in attitudes among photographers, celebrities, and the general public about the potential and intricacies of the portrait. Portraits by the best photographers stimulated and improved the democratic trade, as the quality of lighting, posing, and clarity in more expensive celebrity portraits encouraged photographers making cheaper images to improve their work as well. At the same time, the higher class studios took a lesson from their less artistic counterparts and marketed their product to the general public by making portraits more affordable and more desirable to a mass market.

Early Photographic Portraiture

From the beginning, most observers both in the United States and abroad saw portraiture as the most practical, profitable application of the camera. Before there could be any economic benefits from photography, however, a few obstacles had to be overcome. The technology had to be perfected, its practicality demonstrated, and a market developed for photographic portraits. Daguerre himself had been unable to procure a portrait likeness and openly stated that he did not believe the new process would be practical for portraiture. Nonetheless, making the first successful "likeness from life" became the primary goal of various experiments in both Europe and America. By the end of September 1839, M. Jobard in Brussels and Dr. Alfred Donne in Paris had succeeded in photographing models by dusting their faces with flour and posing them immobilized, with their eyes closed, in brilliant sunlight for the fifteen or twenty minutes then required for an adequate exposure. These images, although technically "from life," undoubtedly left a great deal to be desired as likenesses.[3]

In America, the drive to adapt Daguerre's invention to practical use was directed towards reducing exposure times. The earliest attempts tried, by various optical means, to maximize the amount of light reaching the plate. In New York, Alexander Wolcott, a multi-talented inventor and dentist, and John Johnson, a chemist, fitted a small optical speculum, a reflector lens, into a matchbox-size camera and used it to take a tiny silhouette likeness of Johnson in early October 1839—less than a month after the first American daguerreotype had been taken in New York. Only a few months later, in the early spring of 1840, Wolcott and Johnson opened a commercial portrait gallery—the first in the world—in New York. Using a larger version of the same camera design and Daguerre's original chemistry, they supplemented the theoretically improved light-gathering ability of the speculum with adjustable mirrors mounted outside their studio's windows to throw as much sunlight as possible onto their sitters.

The practical advantage of their camera system seems questionable, however, since very few photographers adopted it then or later. Indeed, according to a first-person recounting, a sitting at the Wolcott and Johnson studio required an exposure time of eight minutes in the brightest sunlight, with "tears trickling down [the sitter's] cheeks"—a process almost as lengthy as that required for a plate of the same size, using the same chemistry, in a conventional camera.[4] No extant daguerreotypes can be positively ascribed to their studio, which closed after about a year, so even the technical quality of their work is uncertain.

Chemical modifications to the plates themselves proved far more useful for adapting Daguerre's invention to portraiture. The first and most important development was by Paul Beck Goddard, a Philadelphia physician and chemist, who discovered that exposing a

daguerreotype plate, sensitized with iodine according to Daguerre's formula, to bromine fumes significantly increased its effective response to light.　Goddard shared his discovery with Robert Cornelius, a Philadelphia manufacturer of cast- and plated-metal wares, who had begun experimenting with the daguerreotype process in late September or early October 1839.　By the end of the year Cornelius had used bromine to achieve successful exposures of less than a minute.

The exceptional technical and artistic quality of Cornelius' plates apparently made his studio considerably more successful than those of his New York counterparts, Wolcott and Johnson, Samuel F. B. Morse, and John Draper, all of whom established studios in 1840. Cornelius opened his studio in May 1840 and operated it as a commercial enterprise well into 1842, improving the technical quality of his product to such a degree that only details of costume distinguish late Cornelius daguerreotypes (c. 1842) from the best plates of the 1850s.　When his studio finally closed, it apparently was not because of increasing competition from newer, entrepreneurial studios but because a rebounding economy and the introduction of gas lighting in Philadelphia had increased the demand for lamps and fixtures from Cornelius' primary business, the foundry.　Although his seemingly easy abandonment of photography suggests that Cornelius never intended the studio to be a self-sustaining, profit-making venture, its survival and aesthetic vitality during the first three years of the medium's history demonstrated that Daguerre's invention could find a substantial public market and could survive as a business enterprise.　In the short course of his career, Robert Cornelius, more than any of his immediate contemporaries, set the high technical standards that came to distinguish American daguerreotypes.　The advances he introduced, particularly in polishing and sensitizing plates, became standard practices.[5]

Once Cornelius had demonstrated that a portrait studio could be economically viable, many tradespeople were driven to enter the new field of daguerreotypy.　A severe economic depression in the late 1830s had forced many skilled tradesmen to seek work in related fields, and a number of them took up the new technology of daguerreotypy.[6]　No theoretical knowledge was required, only acquired skill.　Furthermore, equipment was fairly inexpensive and frequently could be purchased secondhand as people experimenting with photography moved in and out of the business.　Many of the earliest practitioners gave training in the technology, and those interested in learning the skill frequently outnumbered customers.[7]

Public curiosity was also high, so it was easy to find clients at first.　New photographers who were relatively unskilled at the art could charge a cheap price, make satisfactory portraits some of the time, and earn a modest profit for a while.　The technology was fairly finicky, however, and the absence of standardized supplies and processing made it difficult to maintain a consistent proficiency.　Public expectations and superstition surrounding the seemingly magical product also complicated the business of the unskilled photographers; some subjects were suspicious of the process, and many noted a contrast between their own self-image and the frequently unflattering image on the daguerreotype.　When the public's expectations outstripped a photographer's skill, he could move on to a new, unsuspecting market.　An itinerant class of daguerreotypists soon developed and began traveling from community to community, both to find new markets and to escape dissatisfied customers.[8]

These itinerant daguerreotypists began to encroach upon the territory of another group of artists, the miniature portrait painters, who also had been affected by the depression and were experiencing difficulties finding enough work.　The portrait painting trade in America commanded little social status; for the most part, miniature portrait painters were considered craftspeople and artisans rather than artists, and most had to endure the indignity of catering to their clients' vanity.　Most miniaturists were also itinerants, and they found it difficult to compete with the itinerant daguerreotypists, who could provide likenesses at a fraction of the cost of a painted portrait.[9]　One miniaturist, Ambrose Andrews, wrote in 1846: "It is seldom that I have any miniatures to paint now-a-days, since that the Daguerrotype [sic] invention has spread throughout the length & breadth of the land. People everywhere go in now for 'cheap things' & a truly moderate price for a well-painted miniature on ivory 'seems enormous.'"[10]　By 1851 Andrews' business was virtually nonexistent, so he decided to take up daguerreotype portraiture himself.　For a few years he did "tolerably well" but found that photography business in New York was "entirely overdone.

It is so easy for one to learn the process that thousands upon thousands have jumped in it and the number is still increasing everyday."[11]

As practitioners with widely differing educational backgrounds and experience rushed to take up daguerreotype photography, they produced a wide variety of results. The vast majority of photographs were technically mediocre but affordable and available to the masses. Itinerant daguerreotypists rarely had any artistic training; many had come from another trade, such as jeweler or druggist, and were attracted to photography by the hope of making money. They frequently devoted much of their business to making copies from other daguerreotypes; their work rarely showed any awareness of aesthetic principles and was held in low esteem by critics. But their low prices of one dollar or less (and sometimes as little as twenty-five cents) made daguerreotype portraits much more affordable than any painted portrait (which could easily cost fifteen dollars for a moderately priced miniature) and thus enabled a whole class of society to have portraits of themselves made for the first time.

While this huge untapped market was what undoubtedly attracted many would-be daguerreotypists to the field, Robert Cornelius, one of the first experimenters to successfully take a portrait from life, may also have been the first to grasp the importance of having respected citizens pose for portraits. He then displayed these images to demonstrate not only the practicality of portraiture but also the superior quality of his own work. In May of 1840, after experimenting on himself and his scientific colleagues and exhibiting those results at regular meetings of the American Philosophical Society and the Franklin Institute, Cornelius and his partner Paul Beck Goddard invited many of Philadelphia's most respected citizens to visit their newly established studio and sit for portraits. Within a month, newspaper articles mentioned that the studio walls displayed Cornelius' daguerreotypes "of so many well known citizens." Just as its technical innovations improved photography, so the Cornelius studio brought a new understanding of publicity to the field.[12]

During the early years of the profession, as photographers struggled to find a market for their work, they also struggled to find stability and professionalism in their new careers. Many of the earliest practitioners were stimulated merely by the desire for financial stability. Like Cornelius, many lost interest in photographic ventures once the economy improved enough for them to pursue their true vocations. A sense of professionalism began to develop, however, as improvements in the economic climate during the mid-1840s encouraged entrepreneurs with a keen sense of business to enter the field. They began to transform the nature and organization of photography from an experimental practice into an integrated business system managed by dedicated and respected individuals.

Responsibility for this transformation is generally given to John Plumbe, an ambitious, British-born visionary who took up daguerreotypy to finance his dream of establishing a transcontinental railroad. Plumbe opened his first gallery in Boston in 1840 and soon began to offer daguerreotype instruction and to manufacture and sell cameras, plates, cases, and other necessary supplies. He subsequently opened studios in other major metropolitan centers and in several important summer resort towns. In 1846, at the height of his prosperity, he claimed to own sixteen galleries in the United States, Cuba, and Europe, but the Plumbe studios were in fact franchises. The individual galleries undoubtedly received an attractive discount on supplies bought from Plumbe's depot, as well as the use of his well-publicized name to certify that their product conformed to standards of finish and pose. In return, Plumbe was to receive a generous share of the earnings. Unfortunately, the profitability of this extended organization depended upon the integrity of the franchise owners, and that proved difficult to police. By 1847, Plumbe was bankrupt and had to sell out, although several of the studios continued to advertise their earlier association with him well after his departure from the field. Plumbe's concept of a complex organization—with multiple outlets run by individual managers, but in a standardized fashion, all supplied and overseen by a centralized distribution center and with a guarantee of identical quality—was a sophisticated idea, well ahead of its time.[13]

One way that Plumbe and his operators strengthened the gallery's business was by photographing the leaders of society. These portraits could be displayed not only in the city studios in which they were taken, but also in the smaller studios to advertise the quality and prestige associated with the name "Plumbe." A New York *Morning News* review in February

1846 directed New Yorkers' attention to the portraits of President John Quincy Adams and of senators and representatives, "which Professor Plumbe has recently taken in Washington and transmitted to his extensive gallery in Broadway for exhibition."[14] As Robert Cornelius had already discovered, displaying portraits of eminent citizens brought new customers to the gallery to gaze upon the faces of the country's leaders. Once they witnessed the caliber of portraits made in the studio, visitors might desire to be similarly photographed and stay to have their own portraits made.[15]

While Cornelius and Plumbe introduced Americans to the possibilities of celebrity photography, no two photographers did more to expand this market and educate the general public about its possibilities than Mathew Brady and Napoleon Sarony. By marketing their photographic skills through celebrity portraiture, they influenced the image and status of the photographer, the evolution of photographic aesthetics, and the public's perception of portraiture, and helped to create a vast new market for photography itself.

MATHEW BRADY: PORTRAITS OF THE ELITE TO EDUCATE THE MASSES

More than any other nineteenth-century portrait photographer, Mathew Brady enhanced the respectability of the profession and created a vast public market for portraiture. Improving the quality of his portraits and catering to a privileged class of patrons, he marketed portraits of celebrities to the public in a way that made him a celebrity in his own right. Ultimately, however, he misjudged his creation and was victimized by his own success. In his ambition to become the preeminent studio photographer, he failed to remember the importance of the broader market for his portraits of celebrities and society's leaders. Throughout his career he snubbed the general public who bought those portraits, and in the end, when he truly needed popular support, he was unable to gather it.

Figure II-3
UNKNOWN ARTIST. *M.B. Brady's New Photographic Gallery, Corner of Broadway and Tenth Street, New York. From Frank Leslie's Illustrated Newspaper,* January 5, 1861, p. 108.

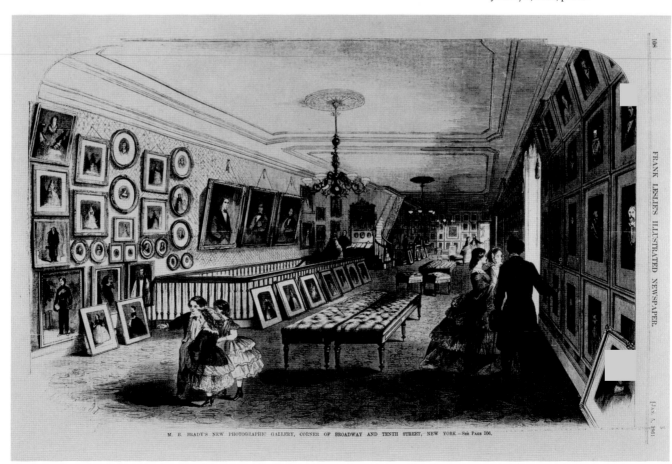

M. B. BRADY'S NEW PHOTOGRAPHIC GALLERY, CORNER OF BROADWAY AND TENTH STREET, NEW YORK.—SEE PAGE 106.

The Brady family emigrated from Ireland—where drought, famine, and changes in the social structure caused by the Industrial Revolution brought severe economic hardship between 1820 and 1850—and arrived in America shortly before Mathew was born "in 1823 or 24 [he himself was unsure] in Warren County, in the woods above Lake George."[16] Although the later waves of Irish immigration would bring mostly indigent peasants who could no longer pay rent, tithes, and taxes and were therefore shipped to North America, those who arrived in the early 1820s were mostly artisans and better-off peasants who still had enough money to start over in the New World.[17] As a first-generation American, Brady had an enormous ambition to create his own fortune, possibly to regain whatever status his family may have had in Ireland.

Brady's father was a farmer, and it is likely that Brady himself might have continued in farming. However, a chronic childhood disease, which Brady described as "inflammation of the eyes" that had left him almost blind, ostensibly forced his parents to send him to the nearby resort of Saratoga Springs, where people from all levels of society gathered for the reported curing benefits of natural spring waters.[18] While there, Brady apparently met the artist William Page, who gave the seventeen-year-old Brady some of his drawings to copy and offered encouragement in his artistic endeavors. Brady always attributed much importance to this meeting, but he is not listed in any of Page's papers, so it is unlikely that they were actually friends, as many contemporary accounts claim. It is more likely that Brady witnessed the respect given to an artist and determined that someday he would be accorded the same distinction.[19]

Brady moved to New York City shortly after his fateful encounter with Page and later claimed that Page provided him with an introduction to Samuel F. B. Morse, who was instructing interested parties in the new technology of photography; if this is true, Brady exhibited great social skill at a very early age. He worked as a clerk at a dry goods store and manufactured cases for jewelry, surgical instruments, and miniatures, but by 1844, at the age of twenty-one, he was ready to open up his first daguerreotype studio.

At the time, the general public still regarded daguerreotypes "only as the results of a mechanical process . . . satisfactory chiefly to persons of crude and uncultivated taste." Furthermore, as C. Edwards Lester claimed in the first issue of the *Photographic Art Journal* (1850), "artists of genius and reputation were with few exceptions, unwilling to engage in the process"—suggesting that a class distinction had already developed within the technology. Brady, according to Lester, decided to elevate the daguerreotype to "the dignity and beauty of an art of taste."[20] Simply to compete with other competent daguerreotypists, he would have had to set his product above theirs in some way, but Brady sought more than their modest success and limited upward mobility. Determined to attain the social status of an artist, Brady set about raising his profession to the status of an art.

Having witnessed the environment of social mobility at Saratoga Springs, Brady must have realized the benefits of making contacts with the right people and then exploiting their status as well as their talents. He sought the best customers, rather than those of "crude and uncultivated taste," and set about improving the aesthetic quality of the daguerreotype image in order to appeal to the wealthy and privileged class. Brady actively pursued the best operators and chemists and offered the highest salaries to attract them, and he hired a large staff to handle the various aspects of producing daguerreotypes. He also made several improvements in studio design, such as installing skylights to increase the overall light on the face and eliminate the unpleasant shadows which characterized many early daguerreotypes. He took on the role of stylist or designer of the portrait, posing his subjects and talking to them to coax the appropriate dignified expression, then telling the operator when to make the exposure. Although he did not actually operate the camera or do the chemical processing, he was considered the controlling aesthetic intellect in the creation of the portraits. In his first year of operation he entered samples of his work in a competition of the American Institute and came away with the highest honor—a distinction he would repeat for the next five years.[21]

Brady was so adept at posing his clients artistically that early reviewers noted the superiority of his portraits from the 1840s to most work being done elsewhere. An unidentified writer in the *Spirit of the Times* wrote in 1846: "We have always disliked the art

(and we doubt not that there are many more like us), in consequence of the shabby-looking things that are met with on every block on Broadway," but he praised Brady's work as "brilliantly clear and beautiful," exhibiting a quality of lighting and coloring that "surpasses anything we have ever seen in daguerreotypes."[22] In 1848 a reviewer for the *Evening Post* reiterated that "it is an opinion universally prevalent that less opportunity is afforded for the display of artistic skill and genius in producing daguerreotype portraits than in those executed with the brush and pencil." The reviewer went on to argue for the artistic possibilities of the medium and said that some photographers "have acquired such a decided superiority over others . . . [F]oremost among this number stands Mr. Brady, who seems to have attained the ne plus ultra in his profession."[23]

Brady was at the forefront of the professionalism that began to emerge during the first decades after the invention of photography. As critics provided guidelines for judging the quality of photographic images, a hierarchy of photographers developed, based upon their abilities and social status. Most of the earliest literature about photography in the 1840s had discussed only the chemical and technical aspects of the process, but gradually, as more and more people in the field became technologically competent, reviews in the journals and newspapers began to rate daguerreotypists' skill in terms of their ability to obtain a good "likeness." By the early 1850s, the standard for a truly accurate likeness had become not merely to reproduce the subject's physical characteristics but to express the inner character as well.[24]

The faith that a portrait could express the essence of the subject—the sitter's true moral character—was largely based on popular beliefs of physiognomy and phrenology.[25] Rhetoric about portraiture seems to have derived from a naive belief that outer physical features could be clues to inner character, and much of the advice to photographers and prospective subjects described ways to pose and carry oneself, so as to emulate the desired characteristics.[26] For example, H. J. Rodgers, describing the philosophical and economic beliefs of early photographers in *Twenty-Three Years Under a Sky-Light* (1872), articulated the commonly held belief that desirable attributes of personality could be approximated through the talents of a good portrait photographer. He advised that "a person with a small, narrow forehead could be posed to look highly intellectual by bringing the top of the head slightly forward. . . ."[27] Such discussions began to change the professional literature on portraiture from aesthetic treatises into a series of formulas, leading eventually to a certain sameness of approach and product. In addition, during the process of posing, photographers showed their customers ways to emulate the characteristics associated with breeding and education.

Brady's work demonstrated the power of a good photographic image, and displays of his portraits of public figures not only satisfied the public's desire to see the faces of the country's leaders but also showed the public that eminent people saw value in good daguerreotypes. Skillful portraits by artists like Brady also suited their elite subjects, who could communicate their own public image to this broader audience.

Brady quickly followed the example of the early daguerreotypists who endeavored to collect as many photographs as possible of public figures. Edward Anthony and J. M. Edwards had photographed all the members of Congress in 1843 by setting up a temporary studio in the committee room. This collection formed the basis for what the photographers called the National Daguerreotype Miniature Gallery, which they exhibited in New York City for several years before it was destroyed in a fire in 1852.[28] John Plumbe, who had a studio in Washington, D.C., also photographed most of the nation's leaders and sent this collection to his Plumbe National Daguerrian Gallery on Broadway for exhibition; in 1845 this gallery claimed to contain more than a thousand portraits of the most distinguished individuals in the country. Characteristically, Brady decided to create his own collection on an even grander scale. As early as 1845, only a year after he opened his first studio in New York, he supposedly conceived of a plan to collect all the portraits of distinguished citizens he could get to sit for him.[29]

Brady used many techniques to amass his collection of celebrity portraits. The simplest method was to collect daguerreotypes by other photographers and then, once they were in his collection, to copy and market them under his own name (FIG. 4). When distinguished

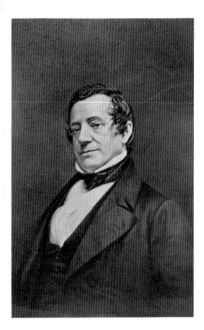

Figure II-4

MATHEW BRADY. *Washington Irving.* Albumen silver print, c. 1860; copy from daguerreotype probably made by John Plumbe studio, New York, 1849, and marketed as carte-de-visite by Brady. Photography Collection, Harry Ransom Humanities Research Center, University of Texas at Austin.

citizens did sit for portraits in Brady's studios, they were not always clients in the true sense of the word, for they frequently did not pay for their portraits but instead accepted a free daguerreotype from among several produced at a sitting. In this way, the celebrity and photographer worked in a mutually beneficial partnership: political and other public figures could develop a public image, while photographers enhanced their own reputations with collections of celebrity portraits and developed a lucrative sideline making copy daguerreotypes of their portraits. Copies of celebrity portraits commanded high prices; while a normal portrait sitting could earn the daguerreotypist one to three dollars, copy daguerreotype portraits of a celebrity like Jenny Lind, who would sit for photographers in every city she visited, sold for five to twenty-five dollars. Most importantly, the availability of copy daguerreotypes helped to develop a popular market not only for celebrity portraits but for portraiture in general.

Both Anthony and Plumbe had galleries in Washington, which made it easy for them to accumulate portraits of the country's leaders. In 1849, Brady too opened a studio in Washington in order to take advantage of his growing national reputation and to be closer to the elite clientele he wanted to attract. Competition from another daguerreotypist, Blanchard P. Paige, who had been the operator in Plumbe's earlier studio and had already built up a local reputation and clientele, proved to be too much for Brady, however, and he closed the Washington gallery within the year.[30]

His Daguerrian Miniature Gallery on Broadway, on the other hand, was extremely successful and continued to gain prestige as Brady's collection of celebrity portraits grew. At the time, Broadway was the nation's cultural center, and the fashion was to promenade up and down the avenue on weekends and evenings. One of the most popular diversions during these promenades was to stop in one of the many daguerreian galleries.[31] Brady's was considered the most fashionable and opulent of all; newspaper articles called it one of the wonders of the world and encouraged the public to view his collection of celebrity portraits. The main emphasis was on the entertainment and educational value of seeing the great portraits on display as examples of art. On July 4, 1846, the *Spirit of the Times* published a brief review of Brady's daguerreotypes, stating, "We resolved to absent ourselves an hour or so from business last week, for the purpose of examining some of the specimens of this wonderful art by this clever artist." The reviewer favorably compared Brady's work to that of painters: "The coloring on Mr. B's pictures surpasses anything we have ever seen in daguerreotype; some of them are so artistical that we rarely see them excelled in the productions of our best miniature painters." Likewise, a reviewer in the New York *Evening Post*, August 7, 1848, stated that Brady's "likenesses of distinguished public men . . . seem almost to stand out of the plate, like sculpture, so perfectly distinct is every line and feature of their countenances. But let all, both strangers and citizens, visit Mr. Brady's gallery and judge for themselves." Once the viewer had seen those portraits and realized that he or she could be photographed in the same grand manner for only a couple of dollars, and the resulting portrait possibly displayed in the studio right next to the faces of the country's leaders, the visit frequently turned into another sale.[32]

By 1851, Brady had become so successful that he was able to turn the operation of his studio over to his competent manager, George Cook. He traveled through Europe for a year to expand his reputation internationally and collect portraits of foreign leaders. He also brought some of his best work with him and entered forty-eight portraits of illustrious Americans in the first World's Fair in the Crystal Palace of London. American daguerreotypes were declared the best overall in the exhibition and won three of the five medals awarded to the medium. John Whipple's daguerreotype of the moon and Gabriel Harrison's metaphorical arrangement of three women, titled "Past, Present, and Future," won bronze medals for their contributions to science and art respectively.[33] Brady's entire collection of forty-eight portraits of distinguished Americans won a third bronze medal for overall excellence, as if the group made one collective statement about the American character through the faces of its most distinguished citizens.

Following the example of John Plumbe, who in 1847 had published several of his portraits as lithographic "Plumbeotypes" in the National Plumbeian Gallery, Brady decided to embark upon a similar venture in 1850. To market the prints to a more elite audience than would have appreciated Plumbe's primitive-looking lithographs, Brady teamed up with

Francis D'Avignon, one of the best portrait lithographers of the time, who could produce prints of the highest possible technical quality. D'Avignon had been trained as a painter in Saint Petersburg and had operated studios there and in Hamburg before emigrating to America in 1843. He could replicate the tonal scale of daguerreotypes better than anyone had previously done, by rubbing the crayon on the stone to obtain continuous tone. This technique was perfectly suited to reproducing photographic images, and many prominent daguerreotypists preferred his work to reproduce the character of their portraits; his stones, however, were extremely difficult to print, and printers frequently made him pull his own prints.[34]

As Brady had intended, his partnership with D'Avignon created the most faithful printed renditions of his portraits that were possible at the time (FIG. 5). Through these prints, Brady could disseminate the experience of seeing his unique daguerreotypes nationally and internationally. His *Gallery of Illustrious Americans* was issued semi-monthly with one lithographic portrait and an accompanying biography by C. Edwards Lester. In virtually every city in the nation and in other countries as well, reviewers praised the project. "This is a great national work—one of which the country can be justly proud. . . . It marks the growing wealth and intelligence of a country," wrote the *Two Worlds*. The *Journal of Commerce* noted: "The grouping together of the most distinguished men of the Nation into a Gallery like this, and at a period like this, is not only a noble and patriotic design, but it will furnish a monument of art and patriotism for coming times." "We cannot too highly recommend this superb work to the patronage of every patriotic American—it should be found in every society, town and state of the Union," added the *American Courier* of Philadelphia.[35]

Many of the reviews stressed how affordable the publication was considering the quality of production; the collection of twelve cost thirty dollars. "It is sold at the lowest price at which so expensive a work can possibly be afforded, and should be in the hands of all true Americans," wrote *Farmer and Mechanic*. Still, production costs were exorbitant for the time, for in their commitment to quality, Brady and D'Avignon refused to consider cutting expenses anywhere. They purchased the best lithographic stones, and for his superlative work on them, D'Avignon received one hundred dollars per stone. If a print was defective in any way, it was destroyed. Ultimately, although the work was considered indispensable in every respectable library, and those subscribers who felt a patriotic duty to support the work included "the President, his Cabinet, the Senate, and many members of the House of Representatives, Judges of the Supreme Courts, Governors of states, university libraries, and men of taste and patriotic spirit in every part of the country,"[36] still the work proved too expensive to complete. Of the twenty-four issues originally intended, only twelve were published. Even considering the quality, Brady had overestimated the marketability of such an expensive project.

The *Gallery of Illustrious Americans* had not succeeded economically, but it enhanced Brady's reputation measurably. He had several galleries in New York and Washington run by different operators, and they were all in the regular business of making individual portraits as well as selling copies of celebrity portraits. Although Brady's individual portraits ranged in price from one to three dollars and his portraits of the elite encouraged a more democratic market for his work, his reputation for celebrity images was so great, at least in the press, that people tended to forget about anything else. One Washington, D.C., reviewer stated: "I have never been photographed by Brady. I do not expect ever to attain such a distinction."[37] A New York writer recommended going to his gallery to see "all the leading celebrities of the day, from Presidents [FIG. 6] to prima donnas; from distinguished authors down to members of Congress and 'municipal authorities.' Lower in the scale of social distinction, I believe Mr. Brady does not descend. Like Dickens's barber, who refused to shave coal-heavers, our great photographer finds it 'necessary to stop somewhere,' and so leaves the murderers, prize fighters, sensation-patrons and other newspaper notorieties to the 'execution' of less fastidious artists."[38]

Figure II-5
FRANCIS D'AVIGNON. *John Frémont.* Lithograph after daguerreotype by Mathew Brady, c. 1850. From *Gallery of Illustrious Americans.* National Portrait Gallery, Smithsonian Institution.

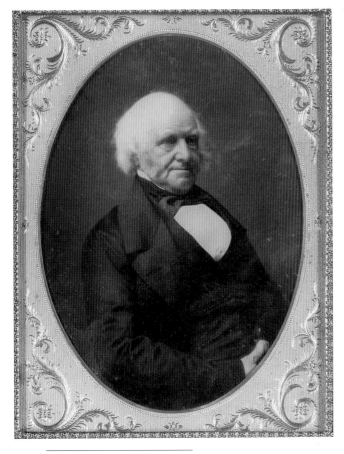

Figure II-6
MATHEW BRADY. *Martin Van Buren.* Daguerreotype, c. 1856. National Portrait Gallery, Smithsonian Institution.

Although Brady did not encourage the poorer customers, he worried about his competitors who would ultimately produce their pictures. Along with many others in the field, he was deeply concerned about "cheap johns," those daguerreotypists who were mass-producing portraits for as little as twenty-five cents. Although some reports claimed that "these 'factory' portraits . . . were as fine Daguerreotypes as could be produced anywhere,"[39] most critics believed that cheap prices would mean an end to the craft's respectability. In 1850 the editor of the newly created *Daguerreian Journal*, S. D. Humphrey, claimed that "were it not for the enterprising few engaged, our art would sink into deep insignificance. Thanks to the noble and generous who are striving to promote the interest of the Daguerreian Art, by keeping pictures up to such prices as will demand respect. We may almost look in vain to see our art elevated to its deservedly high eminence, until the public shall be enabled to discriminate between a fifty cent and a three dollar daguerreotype. We look upon a person visiting a Daguerreian Artist's Room for the purpose of obtaining a cheap picture, as one who thinks little of the art, and less of his friends."[40]

In addition to rising competition from the growing multitudes of cheap johns, another threat to artist-daguerreotypists like Brady came in the early 1850s with the development of collodion technology. The new paper process was much cheaper and easier to use, and it relied on simple everyday materials, such as ordinary writing paper and guncotton. Its biggest advantage, however, was its reproducibility, for the process created a negative from which multiple prints could be made. As more and more photographers turned to the new process, the daguerreotype, with its complexity and uniqueness, fell from favor. Brady began to switch over to the negative/positive process about 1855, but he resisted the transition, especially for his celebrity portraits, believing that daguerreotypes could capture the nobility and dignity of his eminent American clientele with more opulence than could paper prints. Furthermore, although the negative process was more practical for the profession as a whole, it eliminated the uniqueness that made the daguerreotype so appealing as an objet d'art.

The collodion process required a glass plate coated with a gummy, wet photosensitive emulsion, and sometimes it was difficult to get an even coating, especially with larger glass negatives. Brady's earliest paper prints, done in 1855, were small in format and were not technically accomplished, sometimes exhibiting streaks from the coating of the collodion plate. However, just as he had improved the daguerreotype to make it more marketable to a wealthy clientele, Brady also took measures to remedy the inadequacies of the paper process and create an aristocratic paper photograph. He began to experiment with large-size, seventeen-by-twenty-one-inch paper portraits (named Imperials after the large daguerreotype plate size called "Imperial"), and hired a new operator, Alexander Gardner, who was already adept with a large-format plate camera and had learned the collodion process in Glasgow, Scotland. Soon after Gardner began working in his New York studio, Brady began to advertise his new Imperial prints. These portraits could be printed straight, but most often they were worked over into what is known as India ink portraits, retouched on the surface of the print with inks and gouaches and sometimes with oil paint to give them the status and wall-presence of a painting (FIG. 7). As unique objects they, of course, commanded a higher price and sold for fifty to five hundred dollars, depending upon the amount of work done on them. The public and critics alike admired these Imperial portraits, and Brady continued to produce them through 1860. However, their high cost seems ultimately to have inhibited their marketability.

About the time that Brady began to produce the Imperials, he began to suffer economically. He still appeared to be financially solvent in 1852, even after the failure of the *Gallery of Illustrious Americans*. Financial reports prepared by R. G. Dun and Company

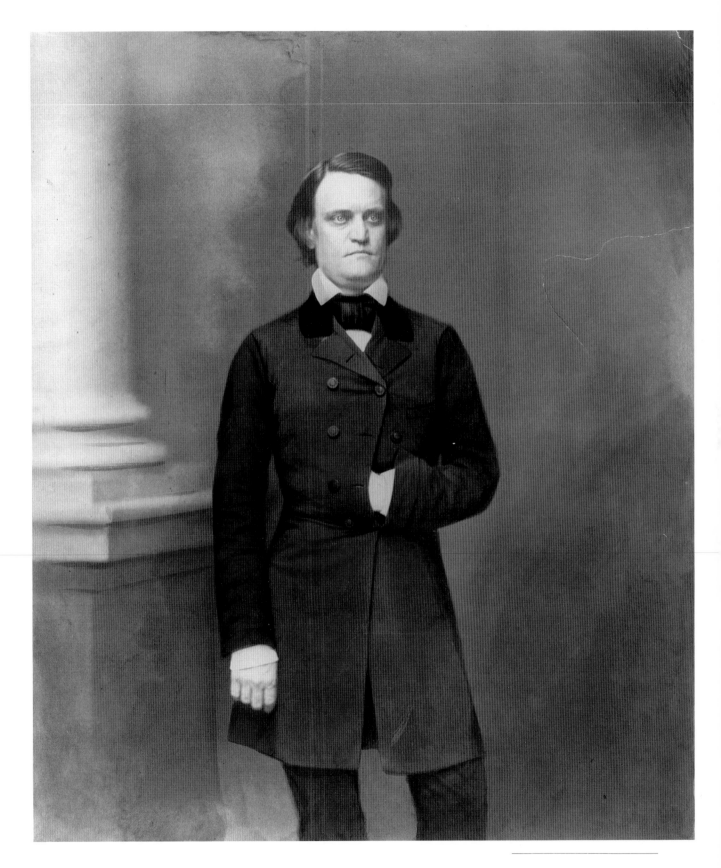

noted that Brady "likes to live pretty fast, enjoys life, and spends his money freely," but they also said that he was prompt and punctual in paying his debts and was worthy of all confidence. In 1856, however, a credit report stated that "he was formerly in some difficulty and has not got entirely out of it." By the end of that year, he was "still slow to pay and his credit has not improved any. Has long standing claims vs: him which he is compelled to satisfy and which absorb his profits as soon as earned." His finances continued to decline

Figure II-7
MATHEW BRADY.
John Cabell Breckenridge.
Imperial salt print, c. 1857-59.
Gilman Paper Company.

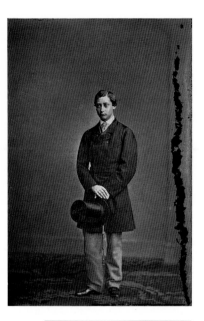

Figure II-8

MATHEW BRADY. *Albert Edward, Prince of Wales.* 1860. Modern print from glass plate negative in Meserve Collection, National Portrait Gallery, Smithsonian Institution.

Figure II-9 (opposite page) Cartes-de-visite, clockwise from top left:

GEORGE WARREN. *Frederick Douglass.* Albumen silver print, May 1876. Photography Collection.

MATHEW BRADY. *Oliver Wendell Holmes.* Published by E. & H. T. Anthony in *Brady's National Portrait Gallery.* Albumen silver print, c. 1860. Photography Collection.

JEREMIAH GURNEY. *Henry Ward Beecher and Harriet Beecher Stowe.* Albumen silver print, c. 1870. Photography Collection.

UNKNOWN PHOTOGRAPHER. *Phineas T. Barnum.* Albumen silver print, c. 1870. Gernsheim Collection. All in Harry Ransom Humanities Research Center, University of Texas at Austin.

throughout the late 1850s, and by 1858 some parties refused to sell to him on credit. In March of 1859 creditors began to look at the worth of his property, saying "he is worth considerable . . . but it is all in pictures and furniture which might realize handsomely if sold to some man of means in his line, but if brought to a forced sale might scarcely pay his indebtedness." A few months later one of his creditors said, "Brady is not worth twenty cents," and in March of 1860 he could buy only for cash, and did not pay well.[41]

Brady's reputation with his creditors may have been troubled in the years just before the Civil War, but his public reputation had climbed to such heights that he apparently began to believe he truly was "the god of Sun" and could accomplish anything. He may have overestimated the marketability of his reputation and of his Gallery of National Portraiture collection, however, for he continued to overextend his resources and refused to believe that he was in financial difficulty. In 1859 he reopened his Washington gallery, in a dual effort to capitalize on his reputation and improve his access to those in the national eye, and sent his competent assistant, Alexander Gardner, to manage it. Then in 1860 he opened a new, expanded National Portrait Gallery on Broadway (see FIG. 3). Sparing no expense in designing and furnishing this studio, Brady made sure that it was the most opulent gallery ever. An account in *Frank Leslie's Illustrated Magazine* described the "costly carpet . . . elegant and luxurious couches . . . elegant and artistic gas fixtures . . . of the finest materials." Brady included heaters "to promote the health and comfort of visitors, a desideratum in such establishments seldom found." He also installed a private entrance that led directly to the operators' rooms for ladies arriving in formal dress, "to obviate the necessity of passing through the public gallery."[42] To publicize the opening of this grand gallery, Brady gave a reception and private preview for the press, invited guests, and leading art connoisseurs— an occasion which must have been another expensive undertaking.

Brady reached his peak of social status just a month after the new gallery opened, when the eighteen-year-old Prince of Wales, Albert Edward, paid a royal visit. The prince was the first royal Briton to visit America, and people were excited and curious to see him. A crowd of half a million cheering people welcomed him to New York. After attending a ball in his honor at the American Music Academy, he decided to see the city's two most well-known sights, P. T. Barnum's American Museum and Brady's gallery. After spending some time admiring Brady's portraits of eminent Americans, the prince and all the members of his entourage took turns sitting for individual and group portraits (FIG. 8). The newspaper account of the visit stated the prince "visited no other photographic gallery, that special honor being reserved for that establishment acknowledged on all hands to be the first and finest of its kind in America."[43] Brady later recalled asking him why he had chosen to honor that studio, to which the Prince replied: "Are you not the Mr. Brady who earned the prize nine years ago in London [the Crystal Palace exhibition]? You owe it to yourself. We had your place of business down in our notebooks before we started."[44]

The contrast between Brady's public reputation and his personal financial standing at this point is poignantly ironic. Brady's biographers have normally claimed that it was his grand scheme to document the Civil War that destroyed his finances, because the conflict lasted longer than expected and drained all of his resources.[45] However, he clearly was in financial trouble long before then; apparently changes in the technology and the market were more devastating to his portrait business than previously has been acknowledged. Brady's motivations for covering the war may have been partly an effort to recover what he had lost in earlier ventures.

Once the country entered the Civil War, battles and campaigns, rather than the national character as symbolized by the faces of the nation's leaders, dominated the thoughts of Americans, who hungered to know what was happening. Brady had always specialized in faces rather than views or events, but he nonetheless believed he was the only one to document the conflict. He decided to direct a staff of operators, just as he always had, and use his reputation to get some creditor to finance the operation.

He moved to Washington to oversee his studio there while directing the documentation of the war, but he soon began to have disagreements with Gardner, who had been managing the gallery well without Brady and may have resented the latter's domineering interference. Brady had always assumed that his gallery operators were subservient to him

Figure II-10
MATHEW BRADY. *Edward McPherson*. Albumen silver print, c. 1860. Carte-de-visite. Photography Collection, Harry Ransom Humanities Research Center, University of Texas at Austin.

and did not deserve recognition, but in Gardner, a strong-willed Scotsman, he met his match. They disagreed over many issues financial and strategic. Gardner was a very canny businessman with an affinity for mass-merchandising photography, while Brady continued to argue for an elitist approach. Brady favored the higher-priced Imperial portraits and composite group portraits, while Gardner embraced the new carte-de-visite craze. Brady never liked the small, 2-1/4 by 4-inch photographs, which were cheaply produced and cheaply sold.

Cartes sold phenomenally well, however, and Brady's studios sold tens of thousands of them in the early 1860s, as the habit of collecting small portraits of celebrities and organizing them into albums became so popular that the public almost saw it as a social responsibility to collect images of the nation's leaders (FIG. 9).[46] On January 1, 1863, the editor of the *American Journal of Photography* reviewed the year 1862, concluding that "the most noticeable thing in connection with the holydays [sic] this year is the great display of photographic albums." He described "these most beautiful and acceptable presents" as "a sign and proof of the best feature of our civilization."[47] By 1864, John Towles, the editor of *Humphrey's Journal*, wrote that "Everybody keeps a photographic album, and it is a source of pride and emulation among some people to see how many cartes de visite they can accumulate from their friends and acquaintances.... But the private supply of cartes de visite is nothing to the deluge of portraits of public characters which are thrown upon the market" (FIG. 10).[48] Although Brady was reluctant to cater to a democratic market, the celebrity portraits he had championed had also created a popular demand he could not have foreseen and, ironically, did not appreciate until it was too late.

Brady did not stay long to direct his company of photographers on the front. He eventually returned to New York but no longer managed his studios with the same enthusiasm as he had in earlier days. He continued to put more of his money (and that of any creditor who would support him) into the war effort, sensing that this was the story the public wanted to see. He underestimated the length of the war, however, as well as the marketability of war views in comparison to celebrity portraiture. Instead of recovering financially by documenting the war, he fell deeper and deeper into debt.

By 1864 Brady had completely lost control of his finances and had stopped paying his bills. A small legal claim against him was just the first of many, and one after another, claimants won judgments against him until he finally filed for bankruptcy. For the next ten years Brady, trying to regain his economic and social stability, attempted to sell his extensive collection of portraits and Civil War views, first to the New York Historical Society and then to Congress. Prior to the Civil War, critics had called his collection a national treasure and had wished that the American government would preserve it for the future. Mary Abigail Dodge, a regular contributor to the antislavery journal *National Era* and governess to its editor's children—and the same writer who in 1859 had observed that she did not expect ever to have the distinction of being photographed by Brady—called his celebrity portraits "treasures which are beyond price." She hoped that the collection, "which he has taken so much pains to make, will not be suffered abroad, but will pass into the hands of the Government, that a memorial of their fathers may be handed down to our children and our children's children."[49] However, Brady's attempts to sell the collection to a public agency all failed. The support of the press and his elite clientele was not enough. In order for the New York Historical Society to purchase his collection, the general public would have had to contribute to a subscription fund; although his portraits were considered a public treasure, Brady was unable to get the support he needed from the public he had always snubbed. His debts rose to such a level that when he was unable in 1874 to pay the rent on a warehouse where he stored his negatives, the contents were seized and sold at auction to the War Department. Only then did Congress agree to award Brady $25,000 for the rights to the negatives.[50]

Some years before his death in 1896, Brady sank into virtual obscurity. His economic deterioration mirrored that of his social status and of his emotional health. The enthusiasm he once had for photographing the country's elite was entirely gone. Although he continued to run his Washington studio, most of his portraits from the post-Civil War period lack the emotional intensity of the earlier ones, suggesting that Brady was no longer involved in

staging the pictures. (A notable exception is his carte-de-visite of actor Edwin Booth—brother of John Wilkes Booth—and his daughter [FIG. 11]; Booth's importance probably inspired Brady to give this image more aesthetic direction than he provided for the general customer.) Having lost faith in himself, Brady drank heavily, eventually lost the Washington studio, and finally lived on the kindness of friends.

Brady's career is sadly ironic, because although he helped create a broad market for portraiture, he himself refused to cater to such a market. In his efforts to distinguish himself from the field, he apparently came to believe that he was distinct from the mass of photographers and that his style of portraiture had no relation or responsibility to the rest of photographic portraiture. Instead of recognizing the reciprocal nature of influence and learning from the popular market, Brady failed to understand the breadth of the market for his celebrity portraits and continued to try to sell only to an elite class. While his portraits were intended to act as inspiration and education for the general public, especially new immigrants and members of the lower class who needed examples to emulate, he apparently forgot about that audience and the importance of building a market with them. Brady's fatal error was his failure to distinguish between the different needs of his subjects and of his audience.

<div style="text-align:center">

POST-WAR PORTRAITURE:
NAPOLEON SARONY AND THEATRICAL PORTRAITS

</div>

While Brady's career and reputation were plummeting, another photographer was just entering the business, and critics soon considered him to be Brady's replacement as the most prominent American portrait photographer.[51] Napoleon Sarony was born in 1821, just two years before Brady, and died in 1896, the same year as Brady, making the two men virtual contemporaries. However, they dominated different epochs, and their purposes were quite different. Brady, undoubtedly the most famous portrait photographer of the daguerreian era, specialized in portraits of the country's political and intellectual elite—portraits meant to inspire and educate—while Sarony, who began his photographic career just after the war ended, specialized in portraits of theatrical stars—portraits that offered entertainment and recreation. Sarony did not attempt to expand his business through multiple studios or grand photographic series; instead, he became highly successful by marketing his portraits to a large audience, first through the popular, small-scale formats of cartes-de-visite and later through cabinet cards.

Brady and Sarony had much in common. Both made technical improvements and stylistic innovations that soon became the standard for all other portrait photographers. Both developed reputations for their celebrity portraits and became celebrities themselves. Both also yearned for the social status of an artist rather than an artisan and priced their portraits accordingly. Despite their many similarities, however, the differences between their careers tell us much about the changes in cultural attitudes towards portraiture and the celebrity.

Napoleon Sarony was born in Quebec, Canada, to a French mother and an Austrian father. In 1831, after the family moved to New York City, both of his parents died, and the large family of eight brothers and sisters were split up. Napoleon, just ten years old, was apprenticed to a lithographic firm. He showed a great talent at drawing and worked for several years for the caricaturist Henry R. Robinson, then for Nathaniel Currier, who later achieved success in the firm of Currier and Ives. Sarony was so successful at lithography that in 1846 he formed a partnership with Henry Major, also from the Currier studio. The firm

Figure II-11

MATHEW BRADY. *Edwin Booth and His Daughter, Edwina.* Albumen silver print, 1866. National Portrait Gallery, Smithsonian Institution.

of Sarony and Major—later Sarony, Major and Knapp, after Joseph F. Knapp joined them—became one of the most successful in the business, producing illustrations for books and government reports, prints of the Mexican War and Commodore Perry's expedition to Japan, and popular and sentimental subjects such as music covers and theater posters.[52]

Sarony continued to draw, and like many lithographers of the time, he frequently produced work from daguerreotypes. Although successful as a lithographer, he became dissatisfied with his career in the late 1850s; considering lithography to be of minor artistic importance, he yearned to rise above the level of a popular artist. He appears to have dabbled in photography as early as 1857, perhaps in an effort to find an alternative career; he produced ambrotypes and was listed as a daguerreotypist in the Yonkers business directory of 1857-58. His real ambition, however, was to pursue painting, the most respected of the arts, but other than six lessons in drawing the human head from Baron de Belfor, a French artist in New York in 1854, Sarony was completely self-taught. Deciding in 1858 to abandon his lithography career for serious artistic study, he moved to Europe, where he traveled and studied for the next six years. He retained his interest in his lithographic firm back in New York and occasionally produced lithographs to support himself and his family, but in 1864, when poor management forced the firm to close, Sarony had to return to work. One of his many siblings, a brother Oliver, had earlier moved to England and had become one of that country's most successful photographers, operating a regional studio in the northern town of Scarborough. Napoleon visited with him, and after seeing how much money Oliver made in the field of photography, decided to embark on a new career as a portrait photographer. He opened his own studio in Birmingham, England, in partnership with Silvestre Laroche, another Canadian-born photographer.

While studying in Europe and operating his studio in England, Sarony was exposed to the portrait styles of French portrait photographers such as Nadar (Gaspard Felix Tournachon) and Étienne Carjat. Both had begun their careers as caricaturists and, as such, knew the value of expression in portraying character; they became particularly well known for their talent at expressing a subject's psychological character through the face, gesture, and pose. Both were also involved with writers, artists, and theatrical personalities and made photographic portraits of these celebrities. They rejected the style of the popular carte-de-visite portraits, which frequently showed the subject full-figure against elaborate painted backdrops and surrounded by studio props; since these photographs were only four inches high, there was little concentration on the face of the subject. Nadar and Carjat, in contrast, created larger-size prints and posed their subjects against plain backgrounds; by showing primarily the upper body or head only, they could focus on the emotional intensity of their artistic clientele.

Napoleon Sarony incorporated the styles of Nadar and Carjat and of European cartes in his own work. He frequently used elaborate backdrops, but he posed his subjects in ways that would bring out their character, rather than utilizing the standardized poses in vogue at the time. His brother Oliver designed a new posing machine that allowed for more flexibility in a sitter's posture. Rather than requiring that the subject sit or stand straight and erect for the duration of the exposure, this new machine had separate controls for the back, arms, sides, and head, allowing the photographer to contort the subject into a variety of "natural" poses and then immobilize the body to hold that position. Although this was truly the iron instrument of torture that made many subjects fear a portrait sitting, it was perfect for capturing the dramatic (and melodramatic) actions of the popular theatrical celebrities that Sarony photographed.

One of Sarony's earliest subjects was the new American theatrical sensation Adah Isaacs Menken, who visited his Birmingham studio in 1865 during a tour of England. Menken shocked and tantalized audiences with her performance in *Mazeppa*; at its climax, she wore a scandalous costume of pink tights that made her appear nude, and she was tied on the back of a horse which was led up a narrow plank onto the stage. Her voluptuous figure impressed critics and audiences much more than her acting ability, and Menken knew how to use photographs, particularly carte-de-visite portraits of herself, for publicity. As her theatrical company toured the countryside, she frequently visited the local photographers to have new portraits made, and both she and the photographers benefitted from this

Figure II-12

NAPOLEON SARONY. *Ada* [sic] *Isaacs Menken* [in her role as Mazeppa]. Albumen silver print, 1865. Albert Davis Collection, Theatre Arts Collection, Harry Ransom Humanities Research Center, University of Texas at Austin.

collaboration. Menken was disappointed with those made of her in the character of Mazeppa, however, and insisted on being allowed to pose herself when she visited Sarony. He agreed only if she would allow him to pose her for some photographs as well, and Sarony's poses (FIG. 12) succeeded where all others, including her own, had failed. He photographed her lying down, lounging on the floor and almost writhing in a suggestive way (although her pose and costume seem tame by modern standards).[53]

The popularity of the theater in England and the United States and his success with the portraits of Adah Isaacs Menken persuaded Sarony in 1866 that the time was right to move back to America. New York was its theatrical center, and Sarony set up a studio on Broadway to take advantage of the same fashion of promenading on the "Ladies Mile" that had made Mathew Brady a celebrity. He brought with him Oliver's posing machine and began to market it out of his studio. When his competition witnessed the greater variety of poses and the increased naturalness possible with this new machine, they all flocked to buy it and incorporate the Sarony style into their portraits. Sales of the posing machine and his innovative style of theatrical portraits made his new studio an immediate success.

Unlike Brady, who had resisted changes in technology, Sarony welcomed change because it could create a new market. He adopted the new cabinet card size, which produced a print 4 by 6-1/2 inches, slightly larger than the carte-de-visite. In 1866 Edward Wilson, editor of the *Philadelphia Photographer*, wrote that the market for cartes-de-visite had almost completely dried up; the fad had run its course and people already had albums full of the smaller portraits. Meanwhile, the larger cards, developed in England, were catching on because they allowed for greater attention to detail and expression of character.[54] The collecting frenzy began anew as albums incorporating the new size came out and people began to assemble new sets of portraits.

Figure II-13

UNKNOWN PHOTOGRAPHER. *Lobby of Napoleon Sarony's Studio.* 1882. From Robert Taft, *Photography and the American Scene: A Social History* (New York: Macmillan Co., 1938), p. 340.

By 1871 Sarony was doing such a good business that he moved to a larger studio on Union Square. This area was becoming the center of the theatrical district, not only because of the number of theaters, but also because of the growing support industry there. Sarony's studio was soon considered another theatrical support industry. When an article about the Union Square area listed "dramatic agencies, Seer's theatrical printshop, Koehler's costume shop, the publication offices of Byrne's *Dramatic News* and *Sporting and Dramatic Times*, Sarony's, Samuel French's play publishing and theatre bookshops,"[55] only Sarony's studio was considered sufficiently well known to require no additional explanation. The name said it all.

Just as Brady situated his studio on Broadway to catch the promenading crowds in the 1850s, so Sarony situated his stra-

Figure II-14
Napoleon Sarony. *Edwin Booth as Iago in Othello.* Albumen silver print, c. 1875. Harry Ransom Humanities Research Center, University of Texas at Austin.

Figure II-15
Mathew Brady. *Charles Dickens.* 1867. Modern print from glass plate negative in Meserve Collection, National Portrait Gallery, Smithsonian Institution. This portrait of Dickens was made during his 1867 visit to the United States, when he began to charge photographers for the right to photograph him.

tegically to attract the theater crowd of the 1870s. Theatergoers crowded in front of the studio windows to see the latest photographs of theater idols—and perhaps one of their favorites posing for a new portrait. They also came to see Sarony himself, and his studio was an attraction in its own right. While Brady had furnished his studio to appeal to clients with sophisticated and dignified tastes, Sarony seems to have followed the example of Barnum and furnished his to appeal to those looking for the bizarre and eccentric. The studio (Fig. 13) was filled with curiosities such as Egyptian mummies, Japanese and medieval armor, Russian sleighs, and Eastern draperies—"a sort of dumping ground of the dealers in unsaleable idols, tattered tapestry, and indigent crocodiles."[56] It was, like Brady's studio in the 1850s, regarded as the showplace of New York, but the taste of New York seemed to have changed in the intervening Civil War years.

Sarony's public persona was appropriate for this time of popular fascination with all things flamboyant and eccentric. Like his namesake, the Emperor Napoleon Bonaparte, Sarony was of diminutive size, only five feet tall, but he seemed to compensate for his size

with a colorful and energetic personality. He dressed in theatrical and Bohemian clothing at all times; one favorite costume was an astrakhan cap (a Russian hat made from curly lamb's hair), a calfskin waistcoat with the hairy side out, and trousers tucked into cavalry boots. "Sarony was one of the sights of the 'Boulevard de Broadway' as he used to call it. About 4 o'clock, in company with his tall, handsome wife (who also delighted in wearing outlandish costumes) and his little doll of a daughter, he would swagger along with his sailor walk, saluting right and left as everybody seemed to know him."[57]

Although Sarony's eccentricity and flamboyance were self-promoting, it was his talent at capturing theatrical personalities in character, displaying the emotional intensity of their fictional roles, and freezing them in a photographic instant, that insured the success of his portraits (FIG. 14). Like Brady, Sarony was the artistic designer of the portraits, but not the technician. He knew nothing of the chemical processing and employed a full-time camera operator who knew how to respond to Sarony's commands. But he controlled all posing of the subjects, and his theatrical style aided in this endeavor. He would go to great lengths to help a subject recreate the mood of a characterization; in one case he sparred with a prizefighter, dancing around and around him, until the desired expression appeared on the startled boxer's face. As a contemporary account enticingly revealed, "Some of his expedients in handling unmanageable sitters, especially of the gentler sex, simply cannot be adequately described in cold type. He was absorbed in his subject, and often, in his impulsive efforts to secure pictorial effects, overturned conventionalities in laughter-provoking ways."[58]

Sarony's theatrical and Bohemian manner and his success at coaxing or provoking his celebrities into reproducing their dramatic characterizations made him trusted and popular with the sitters. He pursued celebrities zealously in efforts to build up his collection of theatrical portraits, and since the sales of such portraits could generate huge profits, he began paying large royalties to his sitters for the opportunity to photograph them. As the session with Menken suggests, a complex symbiotic relationship was developing between photographer and celebrity. Whereas in the 1840s and 1850s Brady had been able to build up his collection of celebrity portraits by offering a free portrait from the sitting, celebrities by the late 1860s could demand a fee for sitting. Charles Dickens (FIG. 15), on a lecture tour of America in 1867, refused to sit for Jeremiah Gurney of New York until he was paid. News of this arrangement spread throughout the community of writers and theatrical personalities, who were becoming increasingly reliant on the publicity of photographic portraits, and soon payment of a royalty became fairly common practice.[59]

Although the celebrities frequently expressed a desire to be photographed only by Sarony, their preference may have been motivated by his reputation for paying the highest fees as well as by respect for the quality of his portraits. Sarah Bernhardt claimed that one of the main inducements for her to come to New York was the opportunity to be photographed by the great Sarony, but she was paid $1500 for that opportunity (FIG. 16). Lillie Langtry was a very difficult subject, talking and laughing all through the sitting, then returning the first set of proofs to Sarony in disappointment, saying "You have made me pretty; I am beautiful!" Sarony paid her $5000 for that sitting and did not worry about her dissatisfaction with the portraits because he already had an order from France for five hundred of them and they were selling briskly in America for five dollars each (FIG. 17).[60]

Figure II-16
NAPOLEON SARONY.
Sarah Bernhardt. Albumen silver print, 1880. Albert Davis Collection, Theatre Arts Collection, Harry Ransom Humanities Research Center, University of Texas at Austin.

Figure II-17
NAPOLEON SARONY. *Lillie Langtry.*
Albumen silver print, c. 1882.
Albert Davis Collection, Theatre
Arts Collection, Harry Ransom
Humanities Research Center,
University of Texas at Austin.

Whatever their motivation, theatrical celebrities frequently preferred Sarony to other photographers, and he soon built up the largest supply of marketable portraits. He claimed a collection of 40,000 theatrical portraits and 170,000 of people in other professions. The American public still collected portraits of statesmen and politicians, but Sarony's theatrical portraits were clearly more popular. At the same time his portraits of Lillie Langtry were commanding good prices, his photographs of Grover Cleveland and Charles Folger, who were rival candidates in New York's gubernatorial race, were not selling at all.[61]

The demand for celebrity cabinet cards created new types of professions in the industry. By the 1880s these portraits were being sold not only by the photographers themselves, but by shopkeepers, street peddlers, and specialized dealers. In 1882 there were six dealers in New York City who dealt exclusively in portraits of celebrities, including theatrical personalities, authors, lecturers, soldiers, preachers, statesmen, and politicians. The annual sales by these dealers amounted to several hundred thousand dollars. Street peddlers hawking cheap portraits brought in an additional annual market value of over one million dollars in New York City alone.[62] While Mathew Brady had resisted such a public market, only reluctantly allowing Edward Anthony to market his celebrity cartes-de-visite, Napoleon Sarony welcomed the ability to extend the market potential of his work and sold his celebrity portraits almost exclusively through dealers.

The potential for huge profits from the sale of celebrity images was great, and piracy by other photographers had always been fairly common. Mathew Brady regularly copied other photographers' work to build up his collection of celebrity portraits and then marketed them under his own name. He made no distinction between those for which he acted as stylist and designer and those which he merely purchased and then copied. In 1865 Congress extended copyright protection to photographs, but it was several years before commercial photographers commonly claimed copyright. Because the market for celebrity portraits was so profitable and tempting, however, Napoleon Sarony regularly copyrighted his photographs and conspicuously displayed a copyright notice on his card mounts, right next to his distinctive signature.

In 1882 the Irish author Oscar Wilde toured America and went to Sarony's studio in New York for a photograph to promote his lecture tour. Because of Sarony's reputation as the best celebrity photographer, Wilde's manager waived the customary fee for the sitting, in hopes that a portrait by Sarony could help to promote Wilde's fame. The American public was curious and fascinated by Wilde, whose eccentric habits promoting aestheticism attracted so much attention that the popular Gilbert and Sullivan opera *Patience* contained a satirization of his character. Sarony's portrait (FIG. 18) became a favorite with the celebrity portrait collectors—and was so popular that a lithographic company made 85,000 prints of it. Sarony sued the Burrow-Giles Lithographic Company for violation of his copyright and spent the next four years resolving the issue. During the court proceedings Sarony described how even though he had an agreement with Oscar Wilde to produce and market the photograph, Sarony alone was the "author, inventor, designer and proprietor of the photograph in suit. . . . that the same is a useful, new, harmonious, characteristic and graceful picture . . . (and that he made it) entirely from his own original mental conception, to which he gave visible form by posing the said Oscar Wilde in front of the camera, selecting and arranging the costume, draperies and other various accessories in said photograph, arranging the subject so as to present light and shade, suggesting and evoking the desired expression."[63]

Sarony won the original lawsuit, only to be countersued by the Burrow-Giles Company, who challenged the copyright protection of photographs by claiming that they

OSCAR WILDE.

Copyright 1882 by N. Sarony.

37 UNION SQR., N. Y.

Figure II-18
NAPOLEON SARONY. *Oscar Wilde.*
Albumen silver print, 1882.
Albert Davis Collection, Theatre
Arts Collection, Harry Ransom
Humanities Research Center,
University of Texas at Austin.

were the product of mechanical production and therefore not entitled to the same protection as the work of artists. Sarony won that judgment also, and that lawsuit was the first legal test of the claim that photography was art. In the countersuit, the court ruled "that if, in general, the reproduction of a picture or of a portrait by photographic process may not constitute a work of art in the spirit of the law, it is otherwise when there is joined to the ordinary labor of the photographer that of the designer, or any other artistic combination; in particular, the fact of a photographic negative having been touched up by a draughtsman and having undergone important modifications, gives to it, unquestionably, the character of a work of art. . . . [P]articularly, in a portrait, the pose, the arrangement of the clothing, and the

accessories, may give to the work the imprint of the personality of the photographer."[64] The fact that Sarony was not the camera operator, but was instead the designer who controlled the aesthetic product, made him, in the eyes of the law, an artist worthy of copyright protection of his work. By fighting to protect his copyright, Sarony used the legal system to confirm photography's status as a true art form.[65]

Since its invention, the field of photography had been plagued by philosophical discussion about whether photographs were merely the product of a mechanical process or also of a creative intelligence. Sarony and other portrait photographers of public figures had all worked to promote photographic portraiture as an art form, but in a way that linked it to the traditional arts. Brady and other daguerreotypists frequently applied paint to the portrait. Sarony also continued to yearn for the painterly arts. As late as 1893, when asked if he preferred working with a camera, Sarony said: "Think what I must suffer; fancy my despair. All day long I must pose and arrange for these eternal photographs . . . while I burn, I ache, I die, for something that is truly art. All my art in the photograph I value as nothing. I want to make pictures out of myself, to group a thousand shapes that crowd my imagination. This relieves me, the other oppresses me."[66] To satisfy his craving for artistic expression, Sarony contributed to the artistic community in a number of ways: helping struggling artists,[67] setting up an art gallery in the reception room of his studio to exhibit his own charcoal sketches and oil paintings as well as sculpture and paintings by other artists, and remaining active in several art clubs, including the Salmagundi Club (FIG. 19) and the Tile Club, which met regularly in his reception room.[68] With his contributions to these art clubs, Sarony helped to draw associations between photography and the painterly arts—a concern of many photographers at the turn of the century.

When Napoleon Sarony died in 1896, the *Photographic Journal of America* devoted twelve pages to eulogistic pieces written by his friends and critics. Praised as the father of artistic photography and "the personification of all that is summed up in the words Bohemian and artist," Sarony commanded the admiration and tears of his peers. The *New York Journal* wrote: "No man who has ever lived has done so much to promote photography from the domain of the mechanical arts to that of art proper as Napoleon Sarony."[69]

In contrast, when Mathew Brady died the same year, it took some time for the press to realize who he was and what he had meant to photography. An obituary in the *Photo-American* (which misspelled his first name) stated: "Twenty years ago it would have been impossible for Brady to have gone to a hospital or for his death to have occurred without attracting widespread public notice at once, but in the last fifteen years he has been dropping further and further out of sight, so that he was remembered more than occasionally only in Washington, the scene of his greatest triumphs, and it was not until yesterday afternoon that it was learned that the Brady who died at the Presbyterian Hospital on Wednesday night was the once famous photographer."[70] Brady was remembered primarily for his Civil War documentation more than thirty years earlier. Although his collection of portraits of illustrious Americans was praised as probably the largest and most complete collection ever made, there was no mention that these images once had been considered the measure of national character. It was almost as if the world had to be reminded that Brady had once been the preeminent portrait photographer.

Today Mathew Brady is undoubtedly the most well-known, and to many people, the only known nineteenth-century American photographer. Ironically, history often rewards those who

Figure II-19

NAPOLEON SARONY. Invitation from the Salmagundi Sketch Club to George Inness, December 17, 1880. Drawing. Reproduced in *The Salmagundi Club*, by William Henry Shelton, 1918. Courtesy of Penn State University Art Library. Each member of the club would add a drawing to another's invitation.

are abandoned by their contemporaries. After 1900, publications about the Civil War brought renewed attention to Brady's documentation of it, and a continued public fascination with the war has kept his work in the forefront of the popular market. Brady was correct in his opinion that historical personalities and events were vital to the development of a popular market. His failure was in realizing how vital that popular market was to his own success.

Conversely, the name Napoleon Sarony is a footnote at most, virtually unknown to contemporary Americans. Just as history frequently rewards those abandoned by contemporaries, the fleeting nature of fame determines that those who are popular in their own time sometimes are abandoned by history. Photohistorians know Sarony as an eccentric popular theatrical photographer, but his work is not well respected by contemporary standards. Although critics praised him when he died and the general public still was collecting his celebrity portraits, his style of portraiture had already begun to fall out of favor among new photographers. Some of his contemporaries and competitors, including Frederick Gutekunst and Benjamin Falk, still followed his style, but Sarony's brand of celebrity portraiture created a popular hunger for collectable portraits that could no longer be satisfied by just one photographer or one style of celebrity portraiture. By the end of the century there was a broader range of styles for celebrity portraiture, from the flatteringly formal style of Frances Benjamin Johnston, who catered to dignitaries in Washington, to the more naturalistic style inspired by amateur photography and practiced by photographers Thomas Eakins and George Cox.

Although their motivations and styles of working differed, both Mathew Brady and Napoleon Sarony had worked their whole lives to distinguish their craft from that of the mass of photographers and had used their profession to raise themselves socially. How well Brady and Sarony succeeded in their personal ambitions is quite different from how well they advanced the field of photography. In achieving notoriety and fame for their portrait styles, they contributed to the education of the public and of photographers with less skill than their own. Ironically, however, their success in raising the quality of the entire field of portraiture made it impossible for any one photographer to dominate the field, including themselves, and that led to a deterioration of their own social status and business dominance.

The true success of the celebrity portraits was in creating a market. Brady's portraits of illustrious Americans were intended to provide moral education, giving American citizens examples to emulate as they attempted to better themselves in a new country. But the desire for education went only so far; Sarony extended the celebrity market by satisfying the country's hunger for entertainment. Brady's portraits of illustrious Americans may have been good for the American public's moral improvement, but Sarony's portraits made the public feel comfortable and amused, and entertainment was something the country needed after the strains of the Civil War. Sarony's portraits not only made the fad of collecting celebrity portraits fun; they also conditioned the popular market to an awareness that portraiture in general could be enjoyable, and they set the stage for the greater success of amateur photography.

Celebrity portraiture taught Americans how to present themselves to public view. The lesson of phrenology and physiognomy was that people would tend to assume personality traits based upon first impressions—whether or not the inner essence could be truly perceived from viewing the physical countenance. As H. J. Rodgers stated in *Twenty-Three Years Under a Skylight*: "Cultivated minds and keen discernment can very readily read us by our faces, and it is this, oftentimes, which grants us success, fame and popularity in our worldly aspirations and attainments." Yet Rodgers also admitted that the power to control one's face, and thus one's destiny, was attainable: "Notwithstanding expression is ever at our command, and under our control and guidance, yet there are few people who exercise this privilege of becoming sole proprietors of the emotional changes of expression."[71]

This control could be learned. Just as early portrait rhetoric described the photograph's ability to reveal inner moral character and instructed the photographer in the ways of approximating those characteristics, Sarony began to use portraiture to enter into and reproduce a fictional moment with artificial emotional intensity. In so doing, he brought the rhetorical advice to its logical conclusion. The public appreciated his portraits for their

honest approach to the artificiality of the celebrity portrait, and in a way his success is a measure of his audience's maturity, showing that they no longer believed in the necessary integrity of a facial expression.

Brady's portraits showed the American public the noble expression to be emulated; Sarony's demonstrated that not only actors but anyone could imitate those noble and animated expressions. Brady's work provided the standard; Sarony's the possibility and the inspiration. By the end of the century, with the advent of amateur photography and easier technology, the control of one's portrait was truly within the grasp of everyone. The personal aspirations of those portrait photographers who had marketed an elite style of portraiture helped to prepare the American public for a truly democratic portrait.

The amateur snapshot, made possible after the introduction of the Kodak hand camera, was the culmination of the efforts of nineteenth-century studio photographers to create a popular market for portraits. Mathew Brady, Napoleon Sarony, and all such photographers who marketed their products to the American public had created an enormous market, one whose demands could no longer be filled by professional photographers. Camera-toting amateurs discovered that they could satisfy their own urges to make historical documents, as Brady had, and to use portraits as entertainment, as Sarony had encouraged. The portrait photographers who created this huge popular market thus became expendable, a quaint reminder of an earlier time when the American public was dependent upon a small group of professional photographers for the manufacture of public faces that could inspire and entertain.

NOTES

I am indebted to William Stapp, Curator of Photographs, National Portrait Gallery, Smithsonian Institution, for his assistance with the conception and research for this essay.

[1] Marcus Root, *The Camera and the Pencil* (Philadelphia: 1864; reprint, Pawlett, Vt.: Helios, 1971), p. 414.

[2] Ibid., p. 27.

[3] New York *Evening Post*, December 23, 1839, p. 2, quoted in William Stapp, *Robert Cornelius: Portraits from the Dawn of Photography* (Washington, D.C.: National Portrait Gallery and Smithsonian Institution Press, 1983), p. 43.

[4] "G.," "The First Photographic Gallery," *American Journal of Photography*, n.s. 4 (June 15, 1861): 41.

[5] Stapp, *Robert Cornelius*, p. 40.

[6] Richard C. Rudisill, *Mirror Image: The Influence of the Daguerreotype on American Society* (Albuquerque: University of New Mexico Press, 1971), pp. 121-123.

[7] Robert Taft, *Photography and the American Scene: A Social History, 1839-1889* (New York: Macmillan Co., 1938), p. 39.

[8] Photographic literature is filled with accounts of people who were suspicious and frequently unsatisfied with the results of their daguerreotype portraits. See, for example, Taft, *Photography and the American Scene*, pp. 46 and 65-67; Rudisill, *Mirror Image*, pp. 130-132; and Sybil Miller, *Itinerant Photographer: Corpus Christi 1934* (Albuquerque: University of New Mexico Press, 1987), pp. 8-9.

[9] Neil Harris, *The Artist in American Society: The Formative Years, 1790-1860* (New York: Simon and Schuster, 1966), pp. 56-90.

[10] Ambrose Andrews, letter to Mrs. Lydia Partridge, June 25, 1846; Thomas J. Watson Library, Metropolitan Museum of Art. Andrews kept handwritten copies of the letters he wrote between 1844 and 1856. I am grateful to Doreen Bolger, Curator of Paintings and Sculpture at the Amon Carter Museum and formerly Curator of American Paintings and Sculpture and manager of the Henry R. Luce Center for the Study of American Art at the Metropolitan Museum of Art, for bringing this collection of letters to my attention.

[11] Ambrose Andrews, letter to his sister, Mrs. Sarah Blackmer, April 14, 1853; Watson Library, Metropolitan Museum of Art.

[12] "Daguerreotype Miniatures" in *National Gazette*, June 26, 1840, p. 2, col.4, quoted in William Stapp, *Robert Cornelius: Portraits from the Dawn of Photography* (Washington, D.C.: National Portrait Gallery, Smithsonian Institution Press, 1983), p. 38.

[13] Robert Taft, "John Plumbe, America's First Nationally Known Photographer," *American Photographer* 30 (January 1936): 1-10.

[14] Ibid., p. 8.

[15] Rudisill, *Mirror Image*, pp. 203-204, discusses the overall benefits of displaying portraits of public figures in the studio, to make the environment feel more domestic and suggest the possibility of seeing one's portrait hanging next to that of a president.

[16] George Alfred Townsend, interview with Mathew Brady, *New York World*, April 12, 1891. The Brady family is not listed in the 1820 census and does not appear in census records until 1830, but Brady was born in 1823 or 1824, so the family had to have arrived between 1820 and 1823. My thanks to William Stapp for providing this census data.

Information on Brady is sparse and frequently inadequate. Townsend's interview with Brady (the only major interview done in Brady's lifetime) took place when Brady was almost seventy years old, and he may have embellished or forgotten details. He also was very adept at embellishing (and even fabricating) stories of his life to add interest and prestige to his image. Much of the biographical information in this essay is taken from this interview, but it must be read with a certain amount of suspicion.

[17] William Forbes Adams, *Ireland and Irish Emigration to the New World from 1815 to the Famine* (New York: Russell and Russell, 1932), pp. 128-157.

[18] Dixon Wecter, *The Saga of American Society: A Record of Social Aspiration, 1607-1937* (New York: Charles Scribner and Sons, 1937), p. 436. "Hundreds who, in their own towns, could not find admittance into the circles of fashionable society there . . . come to Saratoga, where . . . they may be seated at the same table, and often side by side, with the first families of the country."

[19] Townsend, interview with Mathew Brady, 1891; C. Edwards Lester, "M. B. Brady and the Photographic Art," *Photographic Art-Journal* 1 (No. 1, 1851): 37.

[20] Lester, "M. B. Brady," p. 37.

[21] Ibid.; *Dictionary of American Biography* (New York: Charles Scribner's Sons, 1936), 1: 585.

[22] "Daguerreotypes—The Art Perfected," *Spirit of the Times*, July 4, 1846, p. 228.

[23] "Brady's Gallery of Portraits," New York *Evening Post*, August 7, 1848.

[24] Henry Hunt Snelling, *Photographic Art-Journal* 6 (July 1853): 63.

[25] See Alan Trachtenberg's extensive discussion on the subject in "Illustrious Americans," in *Reading American Photographs: Images as History, Mathew Brady to Walker Evans* (New York: Hill and Wang, 1989), pp. 27-29.

[26] Karen Halttunen, *Confidence Men and Painted Women: A Study of Middle-Class Culture in America, 1830-1870* (New Haven and London: Yale University Press, 1982). Halttunen discusses these complex attitudes and how "an audience of aspiring men and women who hoped to fulfill the promise of the allegedly open society of Jacksonian America, either by entering the ranks of the middle class from below or by rising within those ranks to higher and higher levels of gentility" (p. xv), was advised by sentimental conduct and fashion manuals to affect sincerity. This somewhat hypocritical attitude began to be abandoned later in the 1850s, when these manuals taught, through the techniques of physiognomy and phrenology, how to use fashion and hairstyles to hide one's flaws and emphasize one's good points (p. 60). I am grateful to Martha Sandweiss for bringing this sudy to my attention.

[27] H. J. Rodgers, *Twenty-Three Years Under a Skylight* (Hartford: H. J. Rodgers, 1872; reprint, New York: Arno Press, 1973), p. 99.

[28] "Burning of the National Daguerreotype Miniature Gallery," *Humphrey's Journal* 4 (April 15, 1852): 12.

[29] Townsend, interview with Brady, 1891; and Lester, "M. B. Brady," p. 38.

[30] Josephine Cobb, "Mathew B. Brady's Photographic Gallery in Washington," *Records of the Columbian Historical Society*, vols. 53-56 (Washington, D.C., 1955): 1; quoted in Floyd Rinhart and Marion Rinhart, *The American Daguerreotype* (Athens, Ga.: University of Georgia Press, 1981), p. 4.

[31] Beaumont Newhall, *The Daguerreotype in America* (New York: Dover Publications, 1976, rev. ed.), p. 55; Cornelius Mathews, *A Pen-and-Ink Panorama of New York City* (New York: n.p., 1853), pp. 35-37.

[32] Rudisill, *Mirror Image*, pp. 203-204.

[33] Martin Lawrence actually received the award. Harrison was the camera operator in Lawrence's studio, but it was standard practice at the time for the studio owner to take credit for all work done in the studio.

[34] William Stapp, "Daguerreotypes onto Stone: The Life and Work of Francis D'Avignon," in Wendy Wick Reaves, ed., *American Portrait Prints: Proceedings of the Tenth Annual American Print Conference* (Charlottesville: University Press of Virginia, 1984), pp. 194-231.

[35] Reviews were published in the *Fly Leaf of Art and Criticism*, the semimonthly journal published by C. Edwards Lester, which was issued with the lithographs.

[36] C. Edwards Lester, "Completion of the First Part of the Gallery of Illustrious Americans," *Fly Leaf of Art and Criticism*, no. 12.

[37] Gail Hamilton [pseud. for Mary Abigail Dodge], "Brady's Gallery," *National Era* 13 (March 24, 1854).

[38] "To the Editor of Transcript" [letter from New York, November 20, 1858], *Boston Transcript*, November 22, 1858.

[39] John Werge, *The Evolution of Photography* (London: Piper and Carter, 1890), pp. 200-203.

[40] S. D. Humphrey, *Daguerreian Journal*, November 15, 1850, pp. 49-50.

[41] Reports on Brady's credit rating are taken from R. G. Dun and Co., *Dun and Bradstreet Reports*, vol. 368. I am grateful to William Stapp for bringing this information to my attention.

[42] "Brady's New Photographic Gallery," *Frank Leslie's Illustrated Newspaper*, January 5, 1861.

[43] Ibid.

[44] Townsend, interview with Mathew Brady, 1891.

[45] See James Horan, *Mathew Brady, Historian with a Camera* (New York: Crown Publishers, 1955); Roy Meredith, *Mathew Brady's Portrait of an Era* (New York: W. W. Norton, 1982); Roy Meredith, *Mr. Lincoln's Camera Man: Mathew Brady* (New York: Dover, 1974); and Dorothy Meserve Kunhardt and Philip Kunhardt, Jr., *Mathew Brady and His World* (Alexandria, Va.: Time-Life Books, 1977).

[46] Kunhardt and Kunhardt, *Mathew Brady and His World*, pp. 53-56.

[47] *American Journal of Photography* 5 (January 1, 1863): 312.

[48] John Towles, "Photographic Eminence," *Humphrey's Journal* 16 (June 15, 1864): 93.

[49] Gail Hamilton [pseud. for Mary Abigail Dodge], "Brady's Gallery."

[50] Helena Zinkham, "Pungent Salt: Mathew Brady's 1866 Negotiations with the New-York Historical Society," *History of Photography* 10 (January-March 1986): 1-8.

[51] The *Daily Evening Transcript* of Boston, on January 10, 1868, described "the photographic portraits of American artists executed by Sarony of 630 Broadway, New York, for the illustrated edition of the 'Book of the Artists'" as "a great improvement on all previous works of the kind executed in this country." In 1893 *Wilson's Photographic Magazine*, one of the leading journals of art photography, instituted a regular feature for the magazine called "Our Picture." The editors decided that Sarony should "take the place of honor by illustrating our first number," and after choosing a portrait he had just made of Madame Modjeska in the character of Queen Catherine of Aragon, they described it as "about as perfect as modern photography can produce"; 30 (January 1893): 5. A special section devoted to Sarony, which appeared in the *Photographic Journal of America* in January 1897, following Sarony's death, stated that "in 1876 [Sarony] was recognized as the leading photographer of the western world"; 34: 66.

[52] Biographical data on Napoleon Sarony is taken primarily from a special section devoted to him, following his death, in *Photographic Journal of America* 34 (January 1897): 65-75, and from Ben L. Bassham, *The Theatrical Photographs of Napoleon Sarony* (Kent, Ohio: Kent State University Press, 1978).

[53] Bassham, *Theatrical Photographs*, p. 11.

[54] Edward Wilson, *Philadelphia Photographer* 3 (1866): 311-313, 357.

[55] *New York World*, April 12, 1878, quoted in Bassham, *Theatrical Photographs*, pp. 12-13.

[56] William Henry Shelton, "Artist Life in New York in the Days of Oliver Horn," *Critic* 43 (1903): 34.

[57] James Edward Kelly, "Sarony, the Photographer," unpublished manuscript in James Edward Kelly papers, Archives of American Art.

[58] W. A. Cooper, "A Few Words About Sarony," *Photographic Journal of America* 34 (1897): 69.

[59] Lloyd Lewis and Henry J. Smith, *Oscar Wilde Discovers America* (New York: Harcourt, Brace and Co., 1936), pp. 39, 418-419.

[60] Ibid.

[61] Ibid.

[62] *New York Times*, February 25, 1883.

[63] Justice Miller, "Burrow-Giles Lithographic Company *v.* Napoleon Sarony," *United States Reports*, Vol. 111 (1884): 55. A description of the series of lawsuits is contained in William Allen, "Legal Tests of Photography-as-Art: Sarony and Others," *History of Photography* 10 (July-September 1986): 221-228.

[64] "Sarony *v.* Burrow-Giles Lithographic Company," *Federal Reporter*, Vol. 17 (1883): 600.

[65] Sarony continued to fight for the copyright rights of photographers, later acting as president of the Photographers' Copyright League of America. The league sent a large floral wreath to his funeral; *Photographic Journal of America* 34 (1897): 68.

[66] *Wilson's Photographic Magazine* 30 (January 1893): 11.

[67] Shelton, "Artist Life in New York," p. 36. Shelton's discussion of *The Fortunes of Oliver Horn* (1902), by Francis Hopkinson Smith, explains: "Most of the artists who figure in 'Oliver Horn' are characters drawn from members of the Tile Club. Some of them are composite in character or are treated with such freedom as to be unrecognizable as real persons, while other Stone Mugs represent unmistakable prototypes. Fred Stone is Hal. Bispham the animal painter. . . . Julius Bianchi is the late Napoleon Sarony." Shelton then describes particulars about Bianchi that are not in the book and must be assumed to be references to Sarony, describing him as "always the generous enthusiast ready to help the struggling artist—lavish in his favors when he was flush and improvident in giving when his affairs were under a cloud" (p. 34).

[68] Kelly, "Sarony, the Photographer."

[69] "Sarony: As Seen by His Contemporaries," *Photographic Journal of America* (1897): 74.

[70] "Matthew [sic] B. Brady Dead," *Photo-American* 7 (February 1896): 114-115.

[71] Rodgers, *Twenty-Three Years Under a Skylight*, p. 64.

PORTFOLIO

ONE

Photography of the 1840s and 1850s reflects diverse American responses to the medium in the first decades after its introduction. Early applications of photography were broad and inventive—from pioneering scientific daguerreotypes to evocative landscapes of both familiar eastern scenes and the burgeoning West—but it was the desire for good, reasonably priced portraits that particularly caught the popular imagination, as noted in both Alan Trachtenberg's and Barbara McCandless' essays.

The Boston studio of Albert Southworth and Josiah Hawes is representative of the finest daguerreotype portraiture. The two partners excelled in the art of posing and lighting as well as the difficult craft of securing an image on the silver surface of the daguerreotype plate. The bold pose, hard lighting, and sharp shadows in their distinguished portrait of Daniel Webster (PLATE 21) contrast markedly with the soft, luminescent lighting and the demure but highly expressive pose in their portrait of a young woman (PLATE 18). Most daguerreotypists did not give such individual attention, however, and many early portraits are characterized by direct, hard lighting and a stiff frontal pose—evidence of the long, awkward exposures and the seriousness of the occasion. This was often the first and potentially the only time the subject had a likeness made, and many daguerreotype studios urged potential clients to "secure the shadow ere the substance perish."

Even seemingly conventional portraits by photographers whose identities have been lost, however, help to convey the distinctiveness and individuality of great and infamous Americans of the era. The portrait of young Samuel Clemens (PLATE 17), made when he was a printer's apprentice, is a typical daguerreotype in terms of pose and lighting, but his inventive use of backwards type blocks, which spell his name when reversed by the mirror image of the daguerreotype, demonstrates the lively imagination that would later create Tom Sawyer and Huck Finn. In the daguerreotype of John Brown (PLATE 19), made by another unknown photographer, the power of the image derives less from its artistic handling than from its directness in capturing the anger of the man. The portrait of a Liberian diplomat (PLATE 20) is also conventional in terms of pose and photographic technique, but the complex cultural significance of this image by Augustus Washington, a black photographer, transcends its visual simplicity.

While most daguerreotypes were commissioned portraits designed to please their subjects, this was not the case with J. T. Zealy's portrait of the slave Jack (PLATE 25), which Harvard scientist Louis Agassiz commissioned for his series of daguerreotypes of slaves. In spite of the painfully detached, anthropological posing of the subject, however, the daguerreotype insistently captures Jack's individuality and his unmistakable humanity, making him much more than a scientific stereotype.

Although the vast majority of daguerreotype portraits were set poses, many daguerreotypists broke through these conventions by staging occupational activities in the studio,

as in the comic scene with the dentist (PLATE 22), or by venturing out of the studio to record workers like the farrier (PLATE 23) and the machinist (PLATE 24). These records of common activities were closely allied to the genre interests of many contemporary painters; for example, there is a notable similarity between Gabriel Harrison's daguerreotype, *California News* (PLATE 27), which won a prize in the 1851 Crystal Palace exhibition in London, and a contemporary painting with the same title, by William Sidney Mount.

Although America's strongest initial response to the daguerreotype was for portraiture, other applications of the medium were remarkably diverse. John William Draper, for example, was a New York University scientist and early portraitist who made numerous innovations in scientific photography, including pioneering astronomical photographs and the world's first micrographic daguerreotype (PLATE 29). John Whipple was another versatile experimenter who produced not only portraits—such as his charming daguerreotype of the Sargent family (FIG. I-1)—but also won an award for his daguerreotype view of the moon at the 1851 Crystal Palace in London. His magnificent 1852 daguerreotype of the moon (PLATE 30), made at the Harvard Observatory, was regarded as a measure of America's excellence in photography and of the nation's increasing achievements in science in general.

Landscape and topographic daguerreotypes were much less common than portraits, because making images outside the controlled environment of the studio was more difficult. In addition, because they were small and not easily repeatable, these daguerreotypes could have only a limited impact on a large popular audience. Nonetheless, many adventurous photographers recorded the larger world on daguerreotypes. Some, like C. H. Gay's six-plate panorama of New London Harbor (PLATE 34), transcend the limits of the small individual image.

Popular interest in scenes of remote places was better served, however, by prints from glass negatives, as the collodion wet-plate process, perfected by the mid-1850s, began to dominate photography. Photographers such as James Wallace Black and Samuel Masury were early pioneers with this new process; they depicted New England landscape scenes similar to those explored by the painters who were their contemporaries, but they demonstrated photography's aesthetic potential through distinctive characteristics of light and detail. Others, including Jay Dearborn Edwards in New Orleans, captured the bustling activity of urban life. The greatest impact of the repeatable print process, however, was that it could give many viewers a chance to see exotic subjects that they probably would never view personally, such as Charles Weed's image of a California gold-mining field (PLATE 38) and George Fardon's photograph of the booming businesses of San Francisco (PLATE 37), which was published in the first compilation of photographic views of an American city.

Plate 17
UNKNOWN PHOTOGRAPHER. *Samuel Clemens*. Daguerreotype, c. 1850. Mark Twain Papers, Bancroft Library, University of California, Berkeley.

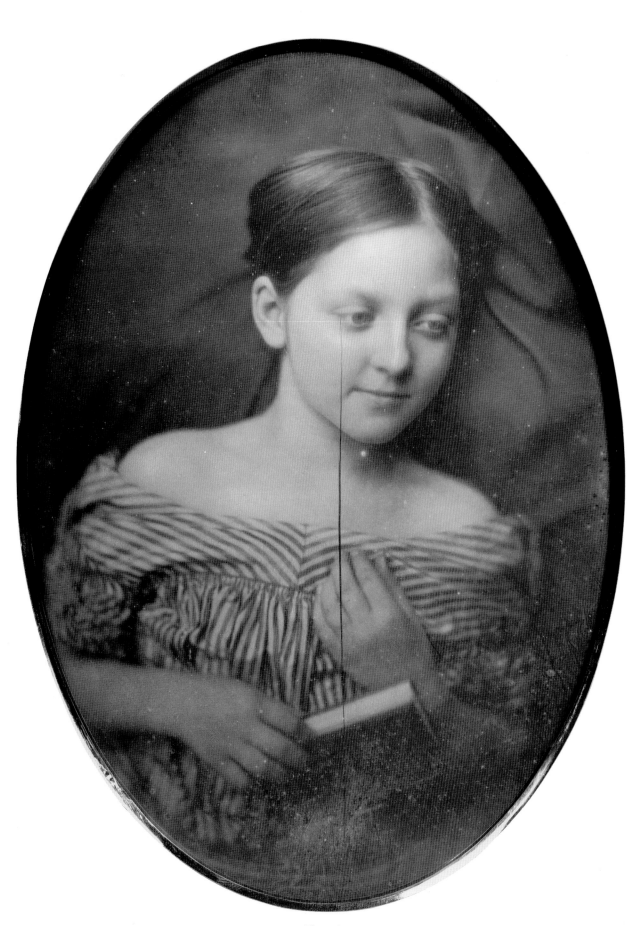

Plate 18
ALBERT SANDS SOUTHWORTH AND JOSIAH J. HAWES. *Young Girl*. Daguerreotype, c. 1845. Matthew Isenburg Collection.

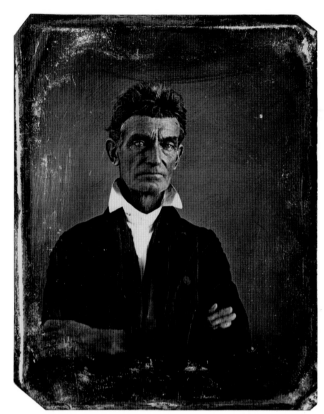

Plate 19
UNKNOWN PHOTOGRAPHER. *John Brown.* Daguerreotype, c. 1856. Library of the Boston Athenaeum.

Plate 20
AUGUSTUS WASHINGTON. *Liberian Diplomat.* Daguerreotype, c. 1853. Library of Congress.

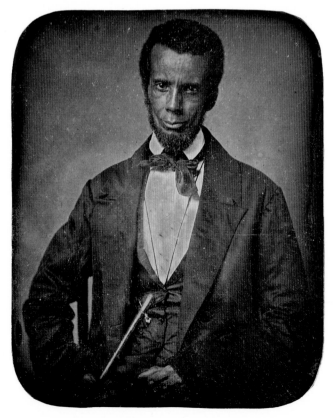

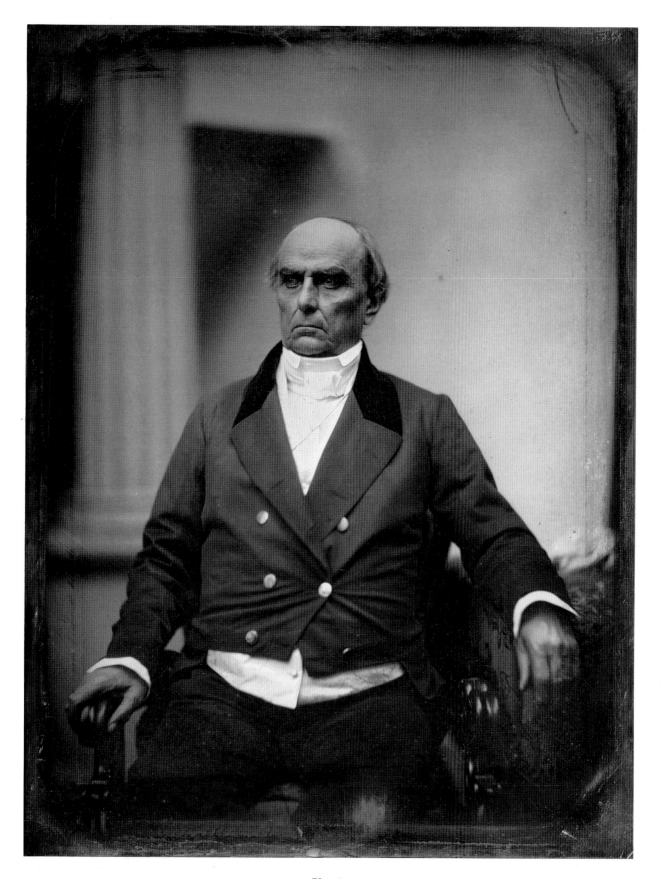

Plate 21
ALBERT SANDS SOUTHWORTH AND JOSIAH J. HAWES. *Daniel Webster*. Daguerreotype, c. 1845.
Museum of Fine Arts, Boston; gift of Edward Southworth Hawes in memory of his father, Josiah Johnson Hawes.

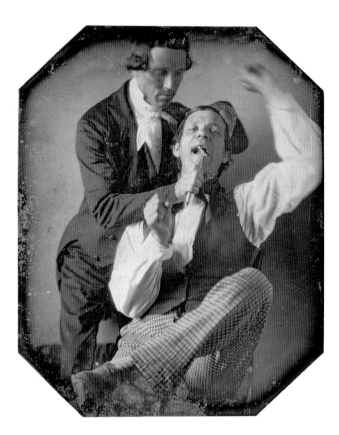

Plate 22
UNKNOWN PHOTOGRAPHER. *Dentist, Pulling Teeth.* Daguerreotype,
c. 1845. Matthew Isenburg Collection.

Plate 23
UNKNOWN PHOTOGRAPHER. *Farrier, with His Clients.* Daguerreotype, c. 1848. Matthew Isenburg Collection.

Plate 24
UNKNOWN PHOTOGRAPHER. *Machinist's Apprentice with File and Gear*. Daguerreotype, c. 1850. Matthew Isenburg Collection.

84

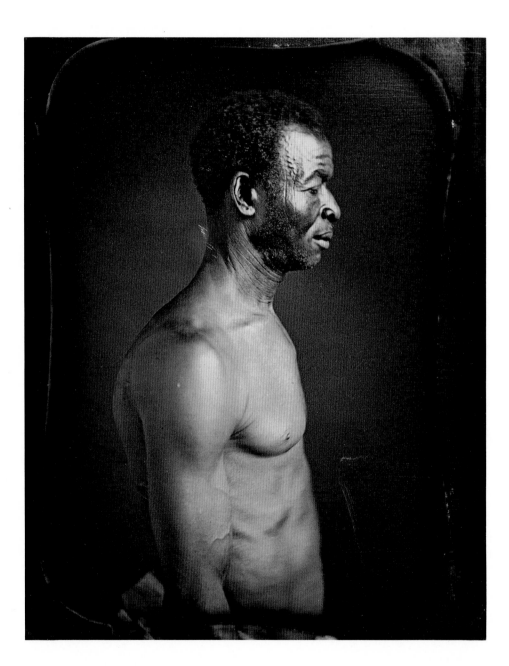

Plate 25
J.T. ZEALY. *Jack (Driver), Guinea. Plantation of B. F. Taylor, Esq. Columbia, S.C.* Daguerreotype, 1850. Peabody Museum, Harvard University.

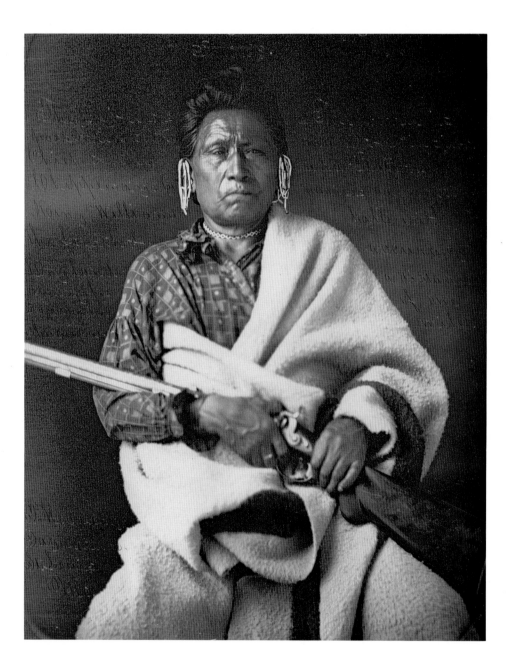

Plate 26
THOMAS M. EASTERLY. *Na-che-ninga, Chief of the Iowas.* Daguerreotype, 1845. Missouri Historical Society.

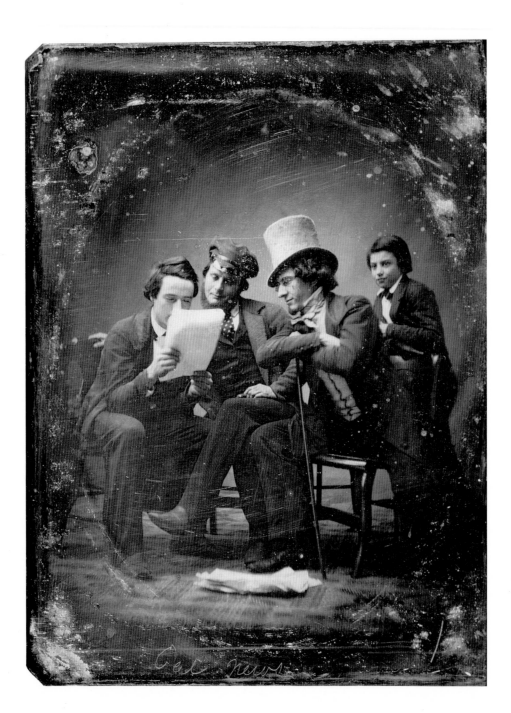

Plate 27
GABRIEL HARRISON. *California News*. Daguerreotype, c. 1850. Gilman Paper Company.

Plate 28
MATHEW BRADY. *James Brooks.* Salt print, c. 1857-59. Amon Carter Museum.

Plate 29
JOHN DRAPER. *Photomicrographic Daguerreotype.* Daguerreotype, 1856.
Division of Photographic History, National Museum of American History, Smithsonian Institution.

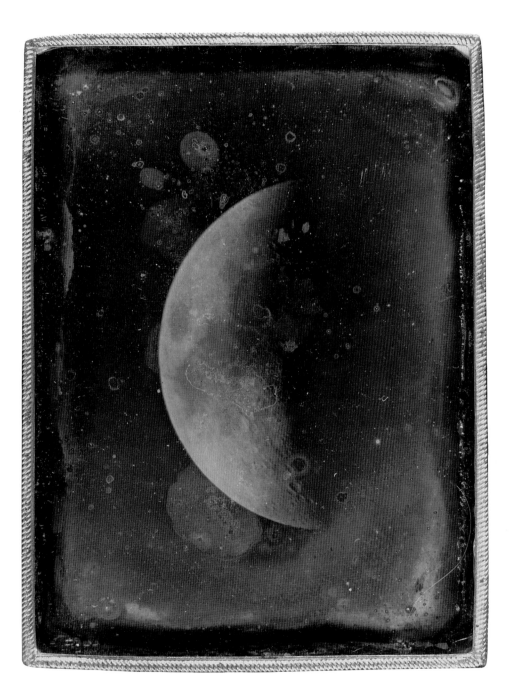

Plate 30
JOHN WHIPPLE. *Moon*. Daguerreotype, 1852. Harvard College Observatory.

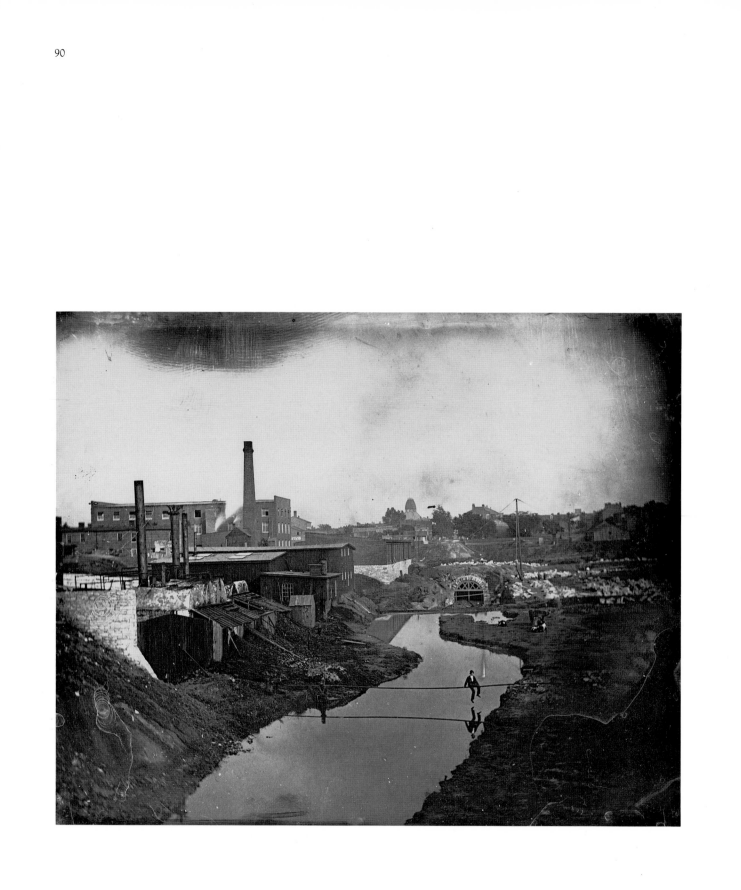

Plate 31
THOMAS M. EASTERLY. *Chouteau's Mill Creek, East from 13th and Gratiot, Construction of Sewer.* Daguerreotype, c. 1855. Missouri Historical Society.

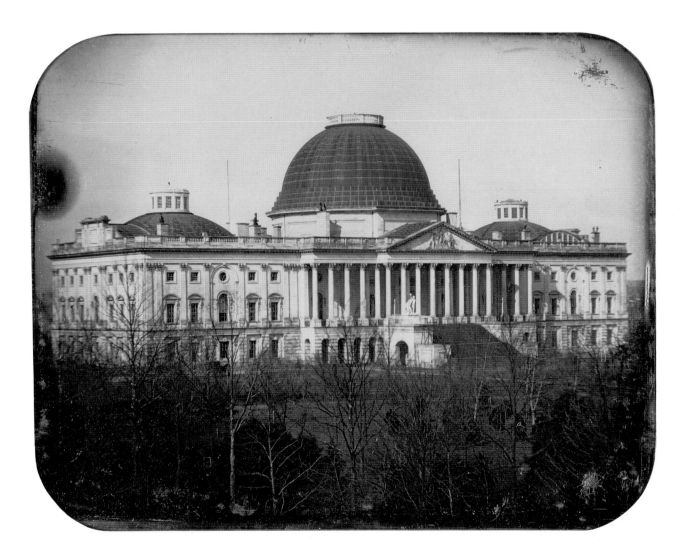

Plate 32
JOHN PLUMBE. *U.S. Capitol.* Daguerreotype, 1846. Matthew Isenburg Collection.

Plate 33
Jay Dearborn Edwards. *Princess Steamboat.* Salt print, 1857-60.
Historic New Orleans Collection.

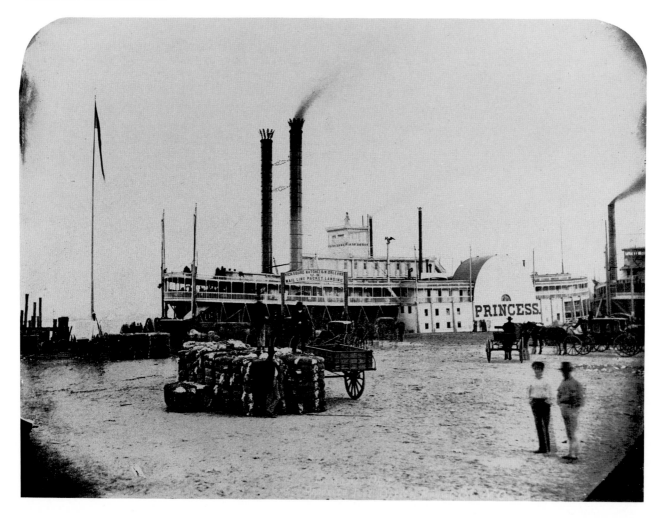

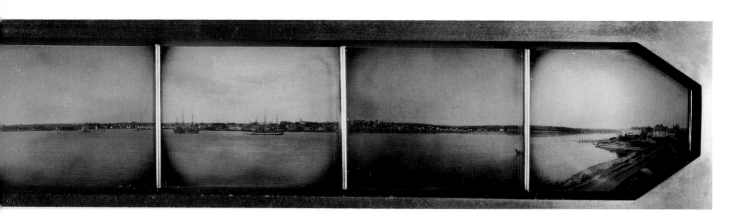

Plate 34
C.H. Gay. *Panorama of New London, Connecticut.* Six half-plate daguerreotypes, 1851. J. Paul Getty Museum.

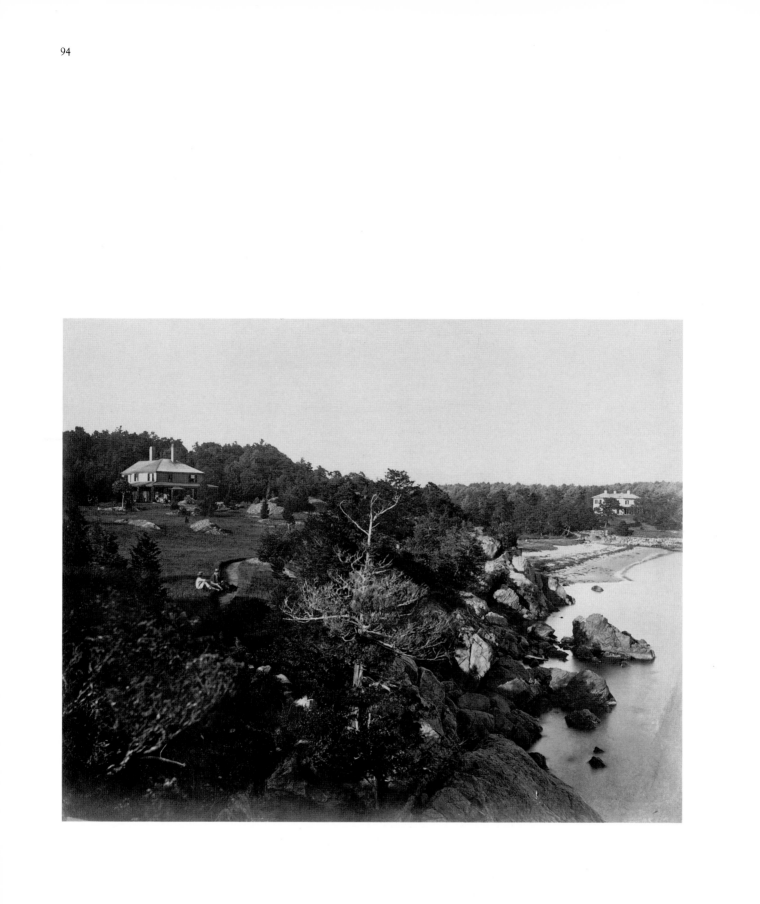

Plate 35
SAMUEL MASURY. *Loring Estate, Beverly, Massachusetts.* Salt print, c. 1857. Worcester Art Museum.

Plate 36
JAMES WALLACE BLACK. *Head of Artist's Falls, North Conway, New Hampshire.* Salt print, 1854. Metropolitan Museum of Art.

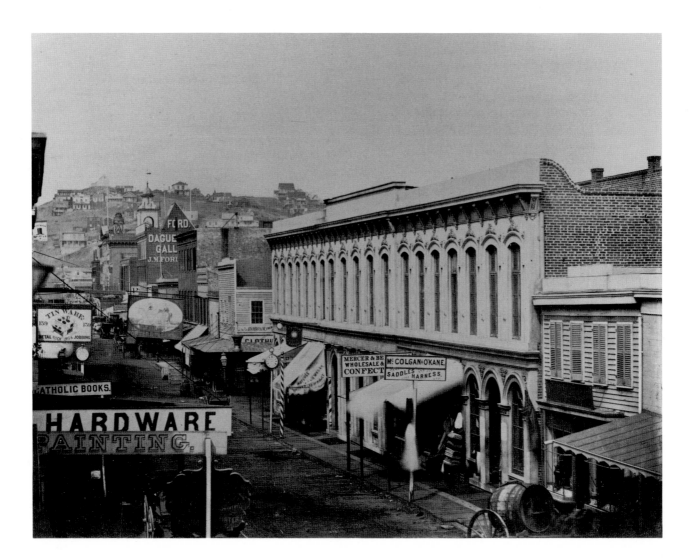

Plate 37
GEORGE FARDON. *Kearny Street, San Francisco.* Salt print, 1856. International Museum of Photography, George Eastman House.

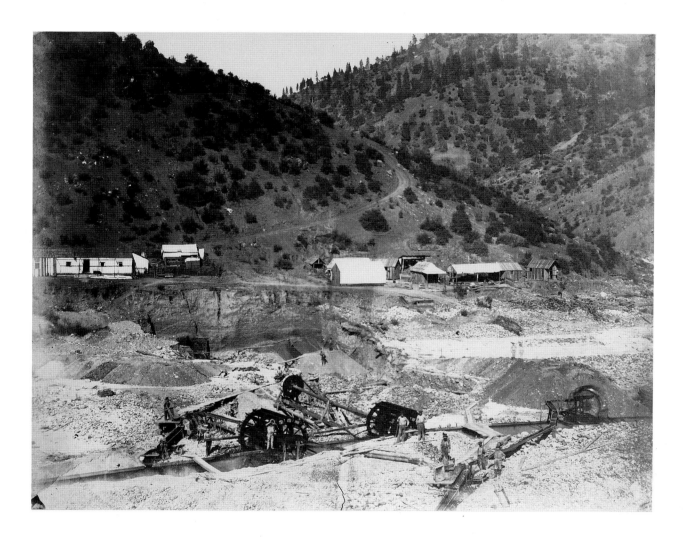

Plate 38
CHARLES WEED. *Poverty Bar, Middle Fork Mining Series.* Salt print, 1859. International Museum of Photography, George Eastman House.

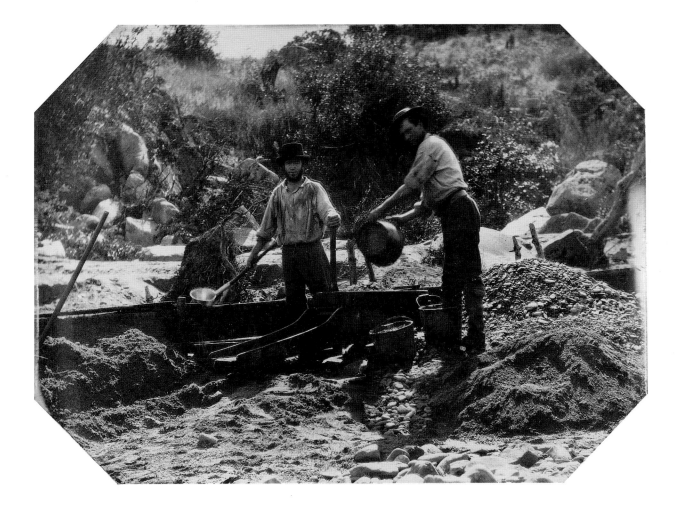

III

UNDECISIVE MOMENTS

The Narrative Tradition in Western Photography

MARTHA A. SANDWEISS

In 1952, French photojournalist Henri Cartier-Bresson gave a new and instantly popular name to a widely held idea about photography when he titled his new book "the decisive moment." Photography had long seemed uniquely suited to capturing those fleeting moments that emblemized or distilled complex activities extending far beyond the photographic frame. The very essence of photography, Cartier-Bresson argued, "is the simultaneous recognition, in a fraction of a second, of the significance of an event as well as a precise organization of forms which gave that event its proper expression."[1]

Yet even as Cartier-Bresson called attention to one of the central differences between photography and the other pictorial arts by noting the rapidity with which a camera could record a visual impression, he continued to present the photograph as a complete, internally coherent object that could be analyzed, like a painting, in terms of meaning, style, and iconography. This emphasis on the individual image, on the idea that photographs do represent significant decisive moments, has long been a hallmark of the traditional photographic history that has treated photography as simply a new subject for conventional art historical analysis, and has likewise characterized much of the critical writing on nineteenth-century American photography.

But this approach is, in fact, anachronistic and misses the real importance of photography to its nineteenth-century practitioners and viewers, particularly those in the sparsely settled American West. Early western photographers worked in a genre that was fundamentally different from most nineteenth-century painting or more modern photography. Their images were neither richly symbolic photographic equivalents of painting nor meaning-laden precursors of photographic "decisive moments." Instead, the photographic pioneers of the American West thought of their medium as a narrative one, whose richest potential was realized not by one picture but through a string of images augmented with literary text. Although they worked with awkward and bulky equipment and could not make instantaneous "snapshots" like Cartier-Bresson and his contemporaries, their approach was influenced less by equipment than by their deeply held ideas about the nature and business of photography. They thought of themselves as storytellers and had little faith in the descriptive usefulness of a single image. Struggling to give shape and order to their own westering experiences, these photographers, like other nineteenth-century chroniclers of the West, used narrative to give structure to their beliefs and experiences. Their photographic narratives resound with themes made familiar in contemporary literary texts: the taming of the wilderness, the subjugation of its native peoples, and the westward expansion of American culture. Such grand stories were not easily distilled into pictures of quintessential moments.

In creating their narratives, early western photographers were responding to the public's demands for visual images rich in symbolism and narrative detail. No single photograph could tell a sufficiently engaging story for an audience whose principal knowledge of the American West came from the more theatrical media of paintings and prints and the more descriptive language of literary texts.

Figure III-1
UNKNOWN PHOTOGRAPHER.
Gold Miners.
Daguerreotype, c.1850.
Amon Carter Museum.

Figure III-2
JOHN CAMERON AFTER AN
UNKNOWN ARTIST. *The Death
of Lieut. Col. Henry Clay Jr. of
the Second Regiment Kentucky
Volunteers at the Battle of
Buena Vista Feb. 23rd 1847.*
Lithograph, hand colored,
1847. Lithographed and
published by Nathaniel
Currier, New York.
Amon Carter Museum.

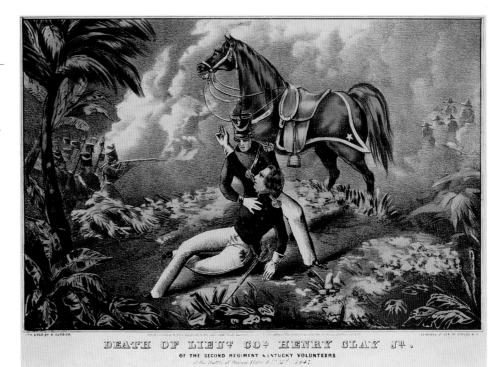

Early western photography acquired its peculiarly descriptive and narrative character in the 1840s and 1850s, as daguerreotypists first moved into the trans-Mississippi region. In the East, long-established artistic traditions and the sheer presence of great numbers of people assured even the earliest daguerreotypists of a ready market, mainly for portraits. But in the West, where photographers often preceded the line of settlement, early daguerreotypists made pictures for a distant audience. Like the painter-explorers who preceded them, they produced informative images, designed to enlighten would-be settlers, investors, and armchair travelers. While most of their eastern counterparts could support themselves with locally commissioned portraits, these pioneering photographers had to focus more on outdoor views that suggested the region's great potential—theirs was a photography of possibilities.

Early photographers of the West faced two critical problems, the first of which was economic. Unlike portrait photographers, who usually worked on commission, making pictures on request for paying clients, daguerreotypists operating outside of studios generally worked on speculation, first making a view and then seeking a buyer for it. Moreover, because a daguerreotype is a unique object, without a negative from which multiple images can be made, outdoor work could be especially risky. An expensive and difficult trip to obtain an interesting view might result in only a single image available for sale or exhibition. Landscape painters faced a similar problem but, with luck, could recoup some of their expenses through the public exhibition of their work. Daguerreotypes lent themselves less well to such public displays. Entrepreneurial photographers faced the challenge of transforming an essentially private kind of imagery into a more public medium.

The second and more troubling problem for these men (and with a few notable exceptions they were men) concerned public attitudes towards, and expectations for, their western views. Today, even the smallest details of these scenes—the framing of a window, the pattern of timber growth, the style of a goldminer's shirt—can seem of great historical interest (FIG. 1). But in the 1840s and 1850s, as photography established itself in newly settled areas of the West, the intrinsic value of such descriptive images was not immediately apparent. Americans accustomed to learning about the West through the more extravagant visual language of paintings and prints found the earliest photographs of the region disappointing, both as sources of information and as imaginative symbols of a compelling landscape.

Consider, for example, the fate of the daguerreotypes documenting American involvement in the Mexican War of 1846-48. This conflict, which ended with the Amer-

Figure III-3
UNKNOWN PHOTOGRAPHER.
Burial Place of Son of
Henry Clay in Mexico.
Daguerreotype, c. 1847.
Amon Carter Museum.

ican acquisition of a vast area of land stretching from Texas to the Pacific and north to Oregon, was the first major event to draw a group of American photographers west beyond the nation's settled cities. Though the photographers who followed the American army through the mountainous terrain of northern Mexico had to contend with limited equipment, inadequate supplies of photographic materials because of blockaded ports, and the general privations of military life, they would seem to have been in an enviable position as the first photographers ever to capture views of war. The American public had a seemingly insatiable desire for news from the front, and the daguerreotypists might have hoped to profit from it.

The few surviving daguerreian plates made by these enterprising photographers testify to the limitations imposed by their equipment. Formal military portraits and views of buildings predominate, suggesting the difficulty of capturing action scenes with the long exposure times that the daguerreian process required. Only a few plates offer evidence of the real business of war: a faint image of armed troops marching in formation through an occupied town, a picture of an artillery battalion, a haunting image of a young soldier's grave. The small, quarter- and sixth-plate daguerreotypes are difficult to view. But as delineations of particular scenes and as artifacts—images formed on sheets of silver-plated copper by the light reflected off American soldiers during the winter of 1847—they have an exciting immediacy that no other visual records of the war possess.

That these daguerreotypes never found a public audience reflects both the photographers' poor marketing skills and Americans' disinterest in the kind of imagery preserved on the daguerreian plate. The daguerreotypes made in Mexico never became the basis for woodcut prints appearing in the popular press, nor were they exhibited publicly or even mentioned in newspapers. With one exception, they were never copied as lithographic prints—the medium that helped shape public perceptions of the conflict. The world's first photographs of war—also the earliest photographic records of America's efforts to lay claim to the western lands beyond her borders—had no public audience whatsoever.[2]

As accurate, literal records of military figures and sites, the daguerreotypes lacked the imaginative impact and narrative detail of other popular art forms. Compared to Nathaniel Currier's stirring lithograph of the death of Henry Clay, Jr., at the Battle of Buena Vista (FIG. 2), the daguerreotype of the young soldier's grave seems flat, empty, and enigmatic (FIG. 3). In the daguerreotype's foreground, a crude wooden cross stands at the head of a

freshly dug grave. Behind it, bare-branched trees cast an eerie shadow across a simple adobe vault that protects another soldier's wooden coffin from human and animal scavengers. By contrast, Currier's print depicts a neatly dressed Clay cradled in a companion's arms, his right hand extended in an oratorical gesture as he bravely delivers his dying remarks. A riderless horse stands watch behind him while, in the distance, the Mexican Army flees the fire of American troops. The print relates an entire story, and its printed caption gives the details. The stark image of the daguerreotype, though evocative, has none of the specificity, drama, or narrative import of the more imaginatively conceived print.

Even more difficult competition for the daguerreian image came from the purely patriotic iconography of another popular art form, the painted "transparency." These paintings, on window shades or wax-primed sheets of linen or cotton, were hung from the sides of buildings during public celebrations of American military victories and were lit from behind with hundreds or even thousands of candles. Enormous crowds viewed them. Broadly painted with flags and eagles, troops and battleships, contemporary heroes and figures from America's military past, the transparencies created a grandly scaled iconography of war. The ornate painted transparency displayed on New Orleans' Municipal Hall in May 1847, for example, bore full-length likenesses of the Mexican War generals Taylor and Scott; separating them was a tablet recording the battles of the American Revolution and the War of 1812, and presiding over all was a painted bust of the original American military and political hero, George Washington. No daguerreotype of a military figure could so firmly root its subject in national myth or so boldly proclaim the significance of his military actions. Compared to these transparencies or to the less flamboyant lithographs, daguerreotypes might have seemed like technical marvels, but their small, finely detailed images failed the imagination.[3]

There was nothing self-evident about the meaning or importance of the war in these photographic images. The intended meaning of lithographic prints or painted transparencies could be clarified by descriptive captions or enhanced with value-laden images, but there seemed no way to provide a narrative or patriotic context for the stark, objective daguerreian records of the thing itself.

The visual culture that so valued the symbolic and theatrical representations of popular lithographs and transparencies also valued other artistic renderings of the West that seemed to have a particularly didactic and entertaining quality. George Catlin, for example, gave theatrical displays of his Indian paintings throughout the Midwest and East from 1833 to 1839, then organized an even more elaborate "Indian Gallery"—complete with artifacts and live Indians—to take to London and Paris. New York-born painter John Mix Stanley and Canadian artist Paul Kane displayed similar Indian galleries in 1845 and 1848. These artists mingled art with theater, entertainment with information. Catlin presented his paintings to his audience one by one, giving a brief lecture for each. Kane, recognizing that his paintings "would necessarily require explanations and notes," published the journal in which he had kept detailed records of his subjects.[4]

Even more popular than these exhibitions were painted panoramas, long detailed canvases unrolled from one reel to another in highly theatrical productions that included spoken narratives and music. Like the Indian galleries, these productions were designed to be both visually interesting and edifying. Indeed, having met with little financial success from his Indian gallery, Stanley himself painted a long, detailed panorama from sketches made on his last western expedition of 1853; a printed pamphlet describing the scenes accompanied his painting. Catlin, undoubtedly influenced by the popularity of the panoramas, painted a series of forty sequential canvases designed to give a continuous view of the Missouri River from the mouth of the Yellowstone to its entry into the Mississippi.[5]

"Westering" was among the most popular themes for American panoramas of the 1840s. At least five panoramas of the Mississippi River toured the country—the shortest of them still an astonishing 425 yards long—and as Americans moved farther west, the subjects of the panoramas changed to keep pace. John C. Frémont's western explorations of the mid-1840s inspired a panorama, as did the Mexican War. The pressure to be topical was so intense that the Frémont panorama, first exhibited in 1849, was updated in 1850 to show the most recent events in gold-rush California, which had already spawned a host of panoramic paintings. As early as mid-September 1849, a panorama depicting the voyage

to California around Cape Horn was shown in New York. The following year, "James Wilkins' Moving Mirror of the Overland Trail" became the popular prototype for numerous panoramas showing the overland route to the goldfields. The local press also promoted panoramas of California itself. In late 1849 a writer in the San Francisco *Alta California* wondered "why some clever artist doesn't undertake a stupendous painting of California scenery—her rising cities and mountain mining and trading posts. Placing its leading features on canvas it would be quite a Placer in itself, opened for exhibition in the States to those who may never have conceived an idea of 'Going to California, its gold mines for to see.'" By the spring of 1850, painter William Cogswell was at work meeting the challenge, and by late fall he was ready to take his detailed panorama of San Francisco east for exhibition. When the crowds in one town waned he, like other producers, would move on to the next. These popular panoramic "westerns," requiring up to three hours to view in their entirety, preceded Hollywood's film versions by more than a half-century.[6]

It is hard to imagine two visual media more different than the grandiose painted panoramas and the small, difficult-to-view photographic images on daguerreotype plates. While the panoramas were hundreds of yards long and could be viewed in huge, public halls, the daguerreotypes were only a few inches square and could be studied by only one person at a time. Furthermore, daguerreotypes could be viewed clearly only under special light conditions that minimized the plate's characteristic surface glare. Finally, while the panoramas were designed to convey a sense of movement across space and time, the specific place and particular moment preserved in the daguerreian image were fixed forever.

Yet by mimicking the narrative structure and public quality of the panoramic paintings and, to a lesser extent, of the Indian galleries, enterprising daguerreotypists in gold-rush California created a forum for their work. Unlike the hapless daguerreotypists of the Mexican War, who failed to find a niche in a market crowded with other, more dramatic visual representations of the conflict, these gold-rush daguerreotypists succeeded precisely because they adopted the strategies of artists working in other media. They transformed photography into a narrative storytelling medium that could describe events stretching across space and time, but in doing so they strained against the technical and conceptual limitations of a medium that could capture only a particular moment and place. There was an inherent tension between the photograph's technological capacity and the cultural demands these men placed upon it.

The connections between photography and public narrative painting were as old as photography itself. Louis-Jacques-Mandé Daguerre, the Frenchman who announced the first practical photographic process to the world in 1839, was best known before then as the creator of large transparent paintings known as dioramas. Viewed in specially constructed theaters, these dioramas were popular throughout France in the 1820s and 1830s and were also seen in England and America. The paintings were stationary, but cleverly managed lighting gave the illusion of movement and the passage of time: weather seemed to change, fires seemed to burn, the sun seemed to set. Daguerre's dioramas competed not only with the painted panoramas that unrolled across a stage (demonstrating another way in which still images could become moving pictures), but with a host of other popular "oramas" whose precise form can in many cases only be guessed at: betanioramas, cosmoramas, cycloramas, georamas, kaloramas, physioramas, and the oddly named "nausorama," with its suggestion of a multisensory extravaganza.[7]

Numerous early photographers in the American West had similar experiences with theatrical narrative painting. Benajah J. Antrim, a maker of mathematical instruments who traveled west across Mexico with a company of Philadelphia gold-seekers in 1849, prepared sketches and narrative notes for a detailed, 112-part painted panorama documenting the Mexican route to the California goldfields. By 1852, after a brief career as a miner, Antrim had become a daguerreotypist in Sierra County, California, and he remained a professional photographer for the next twenty-five years.[8]

Robert Vance, gold-rush California's leading photographer, was undoubtedly familiar with painted panoramas from his days in Boston, where he operated a daguerreian gallery from 1845 to 1847. Indeed, few artists in town could have been unaware of the April 1847 opening of John Banvard's celebrated and highly popular panorama of the Mississippi River; based on sketches made from a traveling flatboat, the panorama reportedly measured

twelve feet high by three miles long. The popularity of western panoramas and Vance's awareness of the eastern interest in California probably inspired his ambitious daguerreian project and exhibition, "Views of California."[9] Having traveled to San Francisco, probably by sea around Cape Horn, in late 1850, at about the time William Cogswell was readying his panorama of the city for public display, Vance systematically photographed San Francisco, Sacramento, and the outlying gold camps between January and July 1851. That fall he took his collection of three hundred whole-plate daguerreotypes east.

The New York exhibition of Vance's "Views of California" was, like the Indian gallery displays, a combination of education and entertainment, art and theater. In the small exhibition catalogue he published to accompany the show, Vance seemed to suggest that his production was superior to any sort of painting exhibition. "To such a pitch has public curiosity been excited (concerning California), that the smallest item of news in regard to this newly discovered El Dorado, is eagerly seized upon. . . . These views are no exaggerated and high-colored sketches, got up to produce effect, but are as every daguerreotype must be, the stereotyped impression of the real thing itself." Like George Catlin, who acted as an impresario for his Indian Gallery by presenting and describing his paintings himself, Vance was at his exhibition to describe individual images and give firsthand information about California to would-be immigrants.[10]

If the arrangement of thematically related images resembled the popular Indian galleries, most reviewers compared Vance's work to the painted panoramas of California. The photographer seemed to overcome the inherently static quality of the daguerreotype by creating a series of images that, like a painted panorama, gave the viewer the sensation of spatial and temporal movement. The *Photographic Art Journal* reported, "This collection comprises a complete panorama of the most interesting scenery in California. There are over three hundred daguerreotypes so arranged that a circuit of several miles of scenery can be seen at a glance. . . . On looking upon these pictures, one can imagine himself among the hills and mines of California, grasping at the glittering gold that lies before him; wandering over the plains, along the beautiful rivers that flow into the California Gulf, or through the streets of San Francisco, Sacramento, and Monterey." The act of looking at this sequentially arranged series of views mimicked the experience of travel itself.[11]

One unnamed landscape painter quoted in the same journal thought that Vance's framed daguerreotypes even surpassed the great panoramas in detail and general effect. "I have seen nearly all of the painted panoramas that have been before the public for the last six years, and have frequently had occasion to express my delight at the many beauties which they possessed. . . . We speak understandingly on this subject, and do not hesitate to say that Mr. Vance's views of California created in us a greater degree of admiration than did Banvard's or Evers' great productions of the Mississippi and noble Hudson."[12]

Despite these glowing reviews, Vance lost money on this venture. The pictures were all "elegantly framed in rosewood and gilding," which added another $700 to the $3,000 he had spent to get the views. When the collection was put up for sale, the catalogue announcement noted, "Mr. Vance was disappointed in the realization of his hopes, and although they are the best daguerreotype views ever taken, they failed to attract that attention necessary to the support of an exhibition of any character." New York daguerreotypist Jeremiah Gurney purchased the collection in 1852 and the next year sold it to Saint Louis' leading daguerreian, John W. Fitzgibbon, a man who had once hoped to photograph the California gold rush for himself. Fitzgibbon exhibited the collection in his Saint Louis gallery as late as 1856, and there all record of Vance's magnificent collection ends.[13]

In the summer of 1851, just as Vance was completing his picture-taking and preparing to take his grand exhibition to New York, another California photographer began work on an even more ambitious project. On July 7, 1851, J. Wesley Jones left Sacramento with a small troupe of nine or ten men to retrace the route east to Illinois, which he had left just a year before. Many had made a similar trek back across the plains after discovering that California was not the El Dorado of their dreams. But Jones and his party went east with a mission. They intended to photograph the entire route, thus becoming the first photographers ever to document the Rocky Mountain West (FIG. 4).[14]

Figure III-4
UNKNOWN ARTIST AFTER A DAGUERREOTYPE BY J. WESLEY JONES. *Steeple Rocks.* Pencil on paper, c. 1852. California Historical Society.

Jones, an attorney attracted to California by the lure of gold, had, like many others, made more money from the miners than from the mines. He worked as a lawyer and as an assistant for the 1850 state census, and there is no indication of where or when he learned the art of photography or how he was inspired to create his "pantoscope." Before he left Oquawka, Illinois, in 1850, Jones may have heard that James Wilkins was working on an ambitious overland trail panorama in nearby Peoria. Or perhaps he learned of Vance's project once he was in California, although he began organizing his own project as early as April 1851, before news of Vance's plan was widely known.[15]

Jones's photographs of the Sierras, the Great Salt Lake, and the Rockies might have attracted great public interest as the first daguerreotypes of these much-described sites. But Jones never sought an audience for his remarkable photographic views; he regarded them as mere sketches for a grand panorama of "the Plains, Salt Lake and California" to be painted "upon one mile of canvass" and presented to the public in a carefully staged manner. A lecturer would "accompany the expedition, collecting everything in a legendary and scientific point of view, calculated to make the exhibition interesting and mentally profitable."[16]

By the first of November 1851, after numerous adventures with broken wagons, rattlesnakes, and hostile Indians, Jones and his party had reached Saint Louis with a reported 1500 daguerreotypes documenting a trail across the American continent from the Pacific to the Mississippi River. By the fall of 1852, Jones was in Boston, transforming his extraordinary daguerreotype collection into the painted "Pantoscope of California."[17]

Following its debut that year in Boston, "where it met with the most triumphant success, for six months," Jones' pantoscope moved to "New York City, for upwards of eleven months, everywhere attracting enthusiastic audiences of the elite, and intellectual, and winning the highest encomiums of the press." Designed "to combine instruction and intellectual culture with amusement" the painting was presented with Jones' own lengthy narration of thirty-five printed pages and "appropriate music" (FIG. 5).[18]

The long painting was divided into four sections: Nebraska and the Rockies, the Desert and Sierras, California gold towns and mines, and California valleys and cities. Jones' narrative led the viewer along the Platte River trail to Scottsbluff and Fort Laramie, through South Pass, and on to Salt Lake City. From there he continued on across the great American Desert to the Sierra Nevadas and down into the gold-mining town of Hangtown. There the painting loses its linear organization and becomes more episodic in its description of Sutter's Fort, Sacramento, and the process of gold mining. After leading his viewers through a detailed tour of San Francisco, Jones closed the presentation with an extravaganza described only as a "Mexican Bullfight."[19]

Figure III-5
Broadside for *Jones's Great Pantoscope of California.* c. 1852. California Historical Society.

Jones exhibited his pantoscope until 1854, when he attempted to dispose of it in a grandly conceived lottery that offered such other prizes as three-story dwellings in Boston, New York, and Philadelphia; pianos; watches; and newspaper subscriptions. The lottery was apparently shut down as an illegal operation, and as late as 1863 Jones was still trying to sell his painting. Its ultimate fate, and that of his daguerreotypes, is unknown.[20]

Jones' ambitious undertaking imaginatively addressed the major marketing problems that faced enterprising daguerreotypists in the West. Although his initial expedition was financed with a reported $30,000 in capital, he understood that it would be impossible to recoup his costs simply by selling the daguerreian images. Until the development of a negative/positive process with which photographers could make multiple prints from a single negative, landscape and travel photography would remain unprofitable. Jones also understood that daguerreotypes themselves—despite their literal accuracy—could not satisfy a public that wanted more dramatic, narrative, and entertaining representations of the West. The daguerreotype, which had to be viewed in private or at least up close, without the controlling structure provided by a narrator or the mass enthusiasm generated by a crowd, could be disappointing. Its astounding visual accuracy alone did not win it instant popularity.[21]

Although it seems ironic that Jones should devote so much time and effort to making accurate photographic views of the West only to convert them to a painted panorama, his ambitious effort was not unique. In the mid-1850s John W. Fitzgibbon, the Saint Louis photographer who had purchased the Vance daguerreotypes, made a photographic tour of Kansas Territory to gather landscapes and scenes of Kansas life. Incorporating these views into a panorama that "possesses the merits of accuracy and beauty," he took his "photographic diorama" east in 1857, no doubt hoping that his exhibition would prove more profitable than Vance's had been.[22]

In 1861 the Fraser River gold rush in British Columbia inspired a still more ambitious project that, even after the advent of photographic negatives and paper prints, continued to use public narrative painting as its model. In the spring of that year, J. A. Miller, "President of the World's Panorama Company," outfitted a sloop—appropriately named the *Photograph*—to secure photographic views of Puget Sound, Vancouver Island, and the northwest coast of British Columbia. These views, possibly to be made on glass negatives rather than daguerreian plates, were to "be forwarded to the States, transferred to canvas by a clever artist, and exhibited in the form of a panorama in the United States, Canada, and Europe." Miller was an ambitious entrepreneur, who planned to exploit the enduring public interest in the Holy Land even as he fed public curiosity about the western Canadian goldfields. He not only intended "to commence, mature, complete, and publicly exhibit, a panorama of the entire route from New York to some point on the Fraser River . . . including the West Indies, Aspinwall, Panama, Acapulco, San Francisco, Straits of San Juan del Fuca, Vancouver Island, Victoria City, Puget Sound, San Juan (Island), Frazer River, British Columbia & &," but this panorama would connect with a "panorama of such portions of the Eastern Hemisphere as may be deemed advisable, especially Palestine and its associations." It is unclear whether Miller ever carried through on his plan; no photographs from this venture have ever been identified. Six months after the announcement of the project, the *Photograph* was put up for sale, and before a buyer could be found she was robbed of her sails and ballast.[23]

In the United States the close connections between the making of panoramas and the making of photographs continued into the 1860s, even though theatrical paintings had declined in popularity and the technology of the daguerreotype had been supplanted by the negative/positive process. A deaf-mute artist named W. Delavan spent the summer of 1868 photographing and sketching along the route of the partially finished Union Pacific Railway for a painted panorama of the railroad route called "Across the Continent." Connecticut artist Alfred A. Hart painted moving panoramas of biblical scenes before going to California and becoming the official photographer of the Central Pacific Railroad in 1864. Andrew J. Russell also made panoramas before he took up the camera, first to document the Civil War and later to chronicle the construction of the Union Pacific Railroad in 1868-70. Indeed, Russell painted a "Panorama of the War for the Union," based

Figure III-6
A. J. RUSSELL. *Train on Embankment, Granite Cañon.* Albumen silver print, 1868-70. Beinecke Rare Book and Manuscript Library, Yale University.

on Mathew Brady's war photographs, less than a year before going off to join the Union Army as a photographer himself. If Russell personally appreciated the "enterprising and earnest" photographers who captured "truth-telling illustrations" of the war, he nonetheless understood the greater public impact of narrative painting. After the war he returned to his New York studio and, with the aid of descriptive materials supplied by travelers, painted two additional panoramas in 1868: "Dr. Kane's discoveries in the Polar Seas" and "Dr. Livingston's travels in the interior of Africa." Later that same year he again picked up his camera and went west.[24]

If their previous work as panorama painters gave both Hart and Russell relevant experience in marketing art and working with complicated mechanical equipment, it also provided them with a model for approaching their work as railroad photographers. The linear format of the panorama suggested a sequential organization of scenes that mimicked a traveler's passing views—an arrangement well adapted to depicting the overland trails or rail routes, which settlers followed in a set, orderly way from one landmark to the next. Hart and Russell could organize their railroad photographs just as they had their panoramic scenes, recording one section of track after another, only occasionally turning their cameras to sights out of view from the rails themselves (FIG. 6). This linear approach to photographic documentation was adapted not just by their fellow railroad photographers, but also by the photographers who accompanied the great government surveys into the West, recording information along the invisible parallel and meridian lines that crisscrossed the land. The ways their views were marketed—as sequentially ordered stereograph sets, carefully arranged albums, or individual prints labeled with precise locations along a

Figure III-7

<small>UNKNOWN ARTIST.</small>
Cover of announcement for
*Prof. Sedgwick's Illuminated
Lectures Across the Continent,
1879-'80*, fourth edition
(Newtown, N.Y.: S. J.
Sedgwick). Courtesy of
University of California,
Los Angeles, Library.

railroad line—offer evidence that the didactic narrative structure of the painted panorama continued to influence the presentation of photographic prints.

One of the last photographers with a strong connection to the older tradition of panoramas, Russell also provides a direct link to the photographic medium that supplanted the panorama—the magic lantern slide show. These slide shows, facilitated by technological advances in the mid-1850s that permitted the manufacture of positive images on glass, gave photographers yet another way to transform their craft into a medium for public entertainment. Moreover, in a slide show photographers could continue using spoken language to make explicit the story they were telling with their pictures, and shape and control how the public interpreted their images. With words, the enigmatic image could become a precious icon, the fragmentary photograph an important scene in a longer story.

In 1869, Russell provided copies of his western photographs, made for the Union Pacific Railroad, to New York lecturer and photographic sales agent Stephen Sedgwick, who made glass slides from these pictures and gave illustrated talks throughout New York, New England, and Pennsylvania from 1870 to 1879. As he operated his slide projector, Sedgwick led his listeners west on an imaginary trip from Omaha to Sacramento. Underscoring the similarities between his lantern slide show and earlier moving paintings, Sedgwick advertised that succeeding pictures moved "in panoramic form, in their relative and proper order" (FIG. 7).[25]

The lantern slide lecture proved a popular format for photographers in the West as well the East, as they sought a financially remunerative way of exhibiting their western views. As early as 1859, an enterprising lecturer in Colorado was using hand-tinted photographic lantern slides in talks on the Pikes Peak goldfields, and by 1874 lantern slide shows were a popular fund-raising event in Denver social circles. By 1878, however, San Francisco photographer Eadweard Muybridge found that public enthusiasm for the productions was beginning to fade, at least in California. Even in smaller cities like Stockton and Sacramento, Muybridge was unable to muster much interest in his lantern slides of Alaska, Yosemite Valley, and Central America or his pictures of animals in motion.[26]

By the turn of the century, however, there seemed to be a renewed interest in lantern slide lectures, particularly on Indians, who were by then seen as a safely romantic part of America's past. In southern California, Frederick Monsen and Frederic Maude developed lantern slide lectures on southwestern Indians. In New York, Walter McClintock gave lantern slide lectures with his photographs of the Blackfeet. Across America, clubwomen watched these instructive lectures to be entertained with tales of exotic lore.[27]

Spoken commentaries were an important part of these lantern slide shows, as they were in the sequentially arranged exhibitions and photographically based panoramas that photographers devised to make photography a narrative medium. But photographers also developed ways to tell stories that did not depend so heavily on language or on the linear arrangement of the painted panorama. There were other ways to get around the insistent borders and fixed image of the single photographic view. Saint Louis daguerreotypist Thomas Easterly, for example, constructed historical narratives by methodically photographing local sites over an extended period of time, thus creating a sequential chronicle of urban development in the old "Gateway to the West." His daguerreotypes are unmatched as a visual record of western city growth and unique in their elegiac description of urban change.

Born near Brattleboro, Vermont, in 1809, Easterly arrived in Saint Louis in late 1847 or early 1848, after a brief career as a photographer in rural Liberty, Missouri. Within the year he was advertising his "likenesses of Distinguished Statesmen, Eminent Divines, Prominent Citizens, Indian Chiefs, and Notorious Robbers and Murderers. Also— Beautiful Landscapes, Perfect Clouds, and Bona Fide Streak of Lightning, Taken on the Night of June 18th, 1847." Shortly thereafter, he embarked on the project that would distinguish him from his colleagues. For the next twenty-five years he documented the city's growth, stubbornly holding on to his daguerreotype apparatus long after it had been superseded by more modern equipment that would accommodate glass negatives. It was a labor of love, anticipating Eugène Atget's documentation of Paris half a century later. Like

Figure III-8
THOMAS M. EASTERLY.
*Big Mound at 5th & Mound
Streets.* Daguerreotype, 1852.
Missouri Historical Society.

Figure III-9
THOMAS M. EASTERLY.
Big Mound, 5th & Mound Sts.
Daguerreotype, 1869.
Missouri Historical Society.

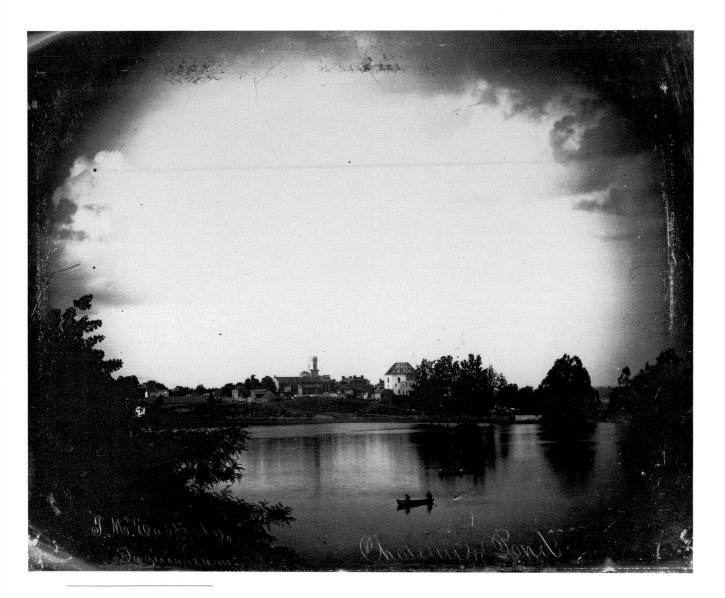

Figure III-10

THOMAS M. EASTERLY.
Chouteau's Pond. (South
from 8th & Clark Sts.).
Daguerreotype, 1850.
Missouri Historical Society.

many of the doomed buildings he photographed, Easterly gradually became a historical anachronism himself and slipped deeper and deeper into poverty. In 1864 and 1865 he was the only photographer in Saint Louis still using the daguerreotype process. In 1867 he sold twelve "views" to the state historical society for twelve dollars each, and when he died in 1882 he received a pauper's burial. His pictures of the city's disappearing past charted his own psychic displacement from modern life.[28]

The daguerreotypes chronicle the transformations of particular downtown blocks and the construction of the Saint Louis Courthouse. Easterly's particular concern, however, was documenting the rapidly disappearing vestiges of the city's French and Indian past. A series of fourteen daguerreotypes made between 1852 and 1869 records the destruction of the Big Mound, the largest of several Indian burial mounds along the northern city limits and a site of great archeological importance. In the earliest views, one sees a massive mound of dirt and glimpses the restaurant erected on top of the mound in 1844 (FIG. 8). Subsequent views show the mound being destroyed and carted off for railroad fill, a fitting metaphor for the grand subject of Easterly's life work. In the final image of the series, one figure perches precariously on a splinter of rock — all that remained of the once imposing landmark (FIG. 9). The elegiac tone of the work makes it feel less like a muckraking indictment of development than a solemn testimony to the inevitability of change and the eradication of the city's Indian heritage.

A similar series of views records the draining of Choteau's Pond, a bosky area at the edge of town named for one of the city's leading French fur trading families, and its subsequent transformation from an idyllic recreation spot to a site for industrial development.

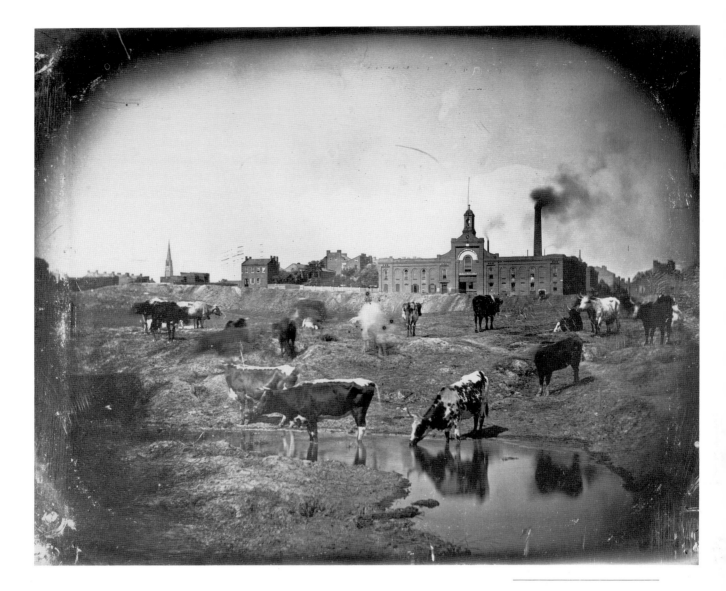

In the first views, made around 1850, canoes float across the lake and a boy poses with a fishing pole (FIG. 10). A subsequent view shows cows drinking from a small muddy hole in front of a white lead factory that spews thick black smoke into the air (FIG. 11). The daguerreian image seems neatly divided into two parts: the lower half suggests Saint Louis' rural French past, the upper half her inevitable Americanization and industrial future.

In style and content Easterly's work suggests a kind of industrial pictorialism. Pastoral foregrounds frame scenes of encroaching development. Old creole houses stand on the outskirts of crowded city streets. With these carefully framed shots and the meticulously planned series of views chronicling the disappearance of old Saint Louis, Easterly created a rich narrative of historical change. In some cases, he even scratched descriptive captions onto the surface of his daguerreian plates to underscore the narrative function of his work. In an age when most urban photography testified to the beneficence of economic growth and development, Easterly's historical chronicles bore witness to the real cost of this change.

Few early photographers of the western towns and cities photographed their subjects for as long as Easterly did. But even without the sorts of "then" and "now" photographs he amassed, they could create narratives of urban change and economic growth through the juxtaposition of images. In 1857, for example, French-born photographer Alphonse Liebert created a collage-like image of Nevada City, California, (FIG. 12) that drew its inspiration and visual model from popular lithographic city views. The standardized format of such lithographs consisted of a bird's-eye view of a town surrounded by renderings of individual houses or business establishments that suggested the town's growth and

Figure III-11
THOMAS M. EASTERLY.
Chouteau's Pond, drained.
Daguerreotype, 1851.
Missouri Historical Society.

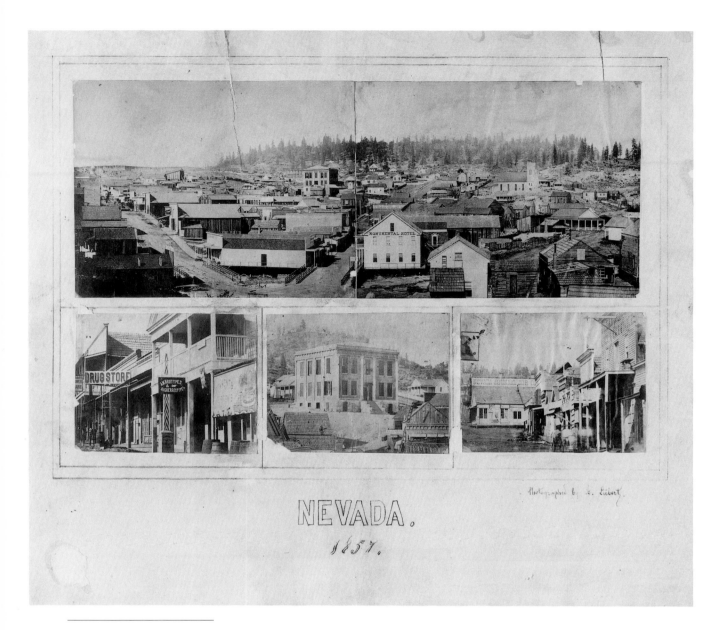

NEVADA.

1857.

Figure III-12

ALPHONSE LIEBERT.
Nevada City, California.
Albumen silver print, 1857.
Western Americana
Collection, Beinecke Rare
Book and Manuscript Library,
Yale University.

commercial sophistication. Lithographers had a free hand to invent, as photographers did not, yet in borrowing the pictorial arrangement of the city view print, Liebert was able through photographs to tell a similar tale of boundless commercial potential. His panoramic overview of the small mining town is accompanied by individual images of three business establishments that suggest the town's certain growth: a surveyor's office, a newspaper office, and a photography gallery. The town view alone could not so fully meet Liebert's own ambitions for the town or the interests of the would-be settlers and investors for whom the piece was intended.[29]

Liebert's derivative format was not widely adapted by other photographers. More popular were city view albums, which suggested a solid basis for future growth through the building by building, street by street documentation of a city's development, and the multi-part city view photographs that in their long, linear format again echoed the painted panorama. The single photographic image simply could not convey enough information.

If early photographers, like the daguerreotypists of the Mexican War, failed to find a market for pictures that seemed too literal, lacking the symbolic power of a truly iconic image, later photographers of the West's towns and cities often found the single image disappointing because it was not sufficiently descriptive of physical facts. On March 3, 1860, the Omaha *Nebraskian* published an elaborate woodcut view of the town (FIG. 13), made from a daguerreotype taken in January 1859 that showed small clusters of buildings stretching across a rolling plain to the banks of the Missouri River. But even as the paper

proclaimed the source and (implicitly) the veracity of the view, "From a photograph by P. Golay," it apologized for its inadequacy:

> The picture is not, perhaps, as perfect as could be wished, while it probably presents as good a view as could be obtained from a single point. It should be remarked that this is merely a representation of the central portion of this city, and that many elegant private residences are not shown at all, while much of the business part of the town is obscured by the larger buildings. In presenting this picture to the world, a few words concerning the location, history and resources of the city it represents may not be inappropriate.[30]

The picture demanded words because the image alone could not convey a sufficient impression of the town's setting, its social sophistication, or its thriving central business district. Too static and limited in its perspective to suggest the town's economic development and potential, this print based on a photograph could not convey the imaginative possibilities so apparent to the unnamed journalist.

When Omaha photographer Louis R. Bostwick sat down in the early twentieth century to compile photographic scrapbooks of early Omaha from pictures made by William Henry Jackson and others, he used this clipping from the *Nebraskian* as his frontispiece. His choice seemed to suggest that his albums would be an antidote to the inadequacy of the single photographic view. By including pictures of public and private buildings of note, major commercial intersections, and in some cases juxtaposing views of the same site before and after new construction, his albums related a narrative of Omaha's solid economic growth and increasing social sophistication, of triumphant development and unlimited potential. Countless such albums were compiled by photographers in the towns and cities of the nineteenth-century West, but none included such a specific acknowledgment of the limitations of the photographic medium.[31]

Multi-plate panoramic city views had a purpose similar to these urban albums. Conceived as a means of breaking the confining borders of the individual photographic view, they were designed to celebrate urban growth and prosperity. Their narrative function was implicit: a less prosperous past was implied by a grandiose present. In form and presentation, the photographic panoramas echoed their painted counterparts and underscored the continuing efforts to transform photography into a narrative medium. Too long to be taken in at a single glance, these panoramic views had to be scanned from left to right like a line of text or a painting moving on rollers. Subtle differences in the shadows from section to section of the panorama hinted at the passage of time. These long images invited the viewer to become a kind of pedestrian stroller. Even as static images, they suggested a kind of movement that the single photographic print could not.

The earliest panoramic photographs of a western city were probably those made in San Francisco, where hills provided perfect spots for unobstructed views. A five-plate daguerreian panorama of the city and her harbor, made by a former dentist named S. C. McIntyre, was displayed in San Francisco in January 1851. The following year, William Shew exhibited his own five-plate panorama, and at about the same time an unidentified

Figure III-13

After a daguerreotype by P. Golay. *Omaha, Nebraska.* Woodcut, 1860. From an Omaha *Nebraskian* newspaper clipping of March 3, 1860, glued as frontispiece in William Henry Jackson album, *Photographs of Omaha, Nebraska* (1866-187?). Western Americana Collection, Beinecke Rare Book and Manuscript Library, Yale University.

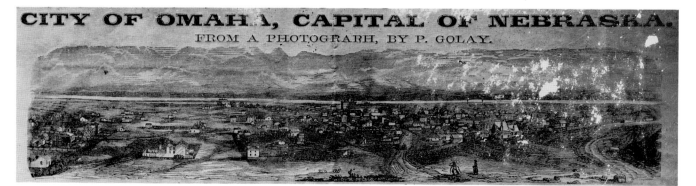

CITY OF OMAHA, CAPITAL OF NEBRASKA.
FROM A PHOTOGRAPH, BY P. GOLAY.

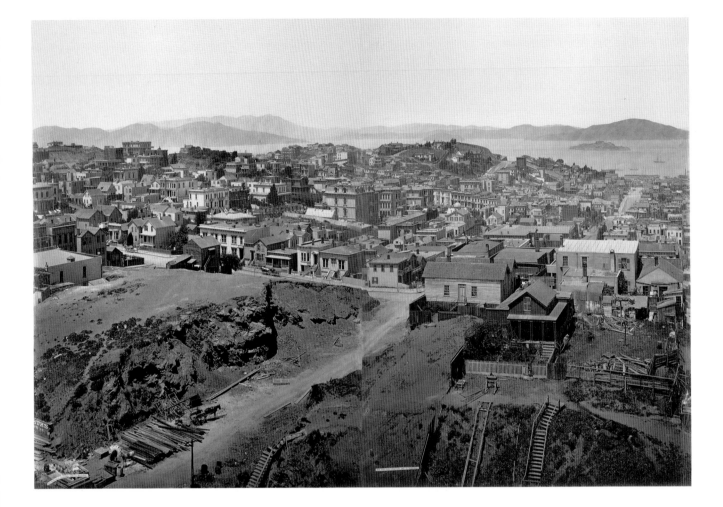

Figure III-14

EADWEARD MUYBRIDGE.
Panorama of San Francisco.
Panels 4-7 in a series of
13 mammoth plate
albumen prints, 1878.
Courtesy of Fraenkel
Gallery, San Francisco.

photographer unveiled a formidable seven-plate panorama nearly seven feet in length. Altogether, at least eight multi-part daguerreian panoramas of the city were executed between 1850 and 1853.[32]

These long panoramic views became even more popular after the advent of the negative/positive process. In about 1865, Denver photographer William Chamberlain stood on a rooftop to make a five-part panorama of his city. In Saint Louis in 1867, photographer Robert Benecke stood on the east side of the Mississippi River to make a multi-plate panorama of his city's waterfront. William Henry Jackson was making similar panoramas of Colorado mining towns in the early 1880s. Still, San Francisco seemed to inspire the most ambitious of these projects. Carleton Watkins, who had experimented with multi-part panoramas as early as 1858 (when he documented a quicksilver mine for a legal dispute), made a five-part panorama of the city in 1864. Each of the mammoth plate segments measured 14-1/2 by 20-1/2 inches, for an overall length of more than eight feet. Watkins' rival Eadweard Muybridge, who had made an eleven-part panorama of Guatemala City during his Central American travels of 1875, made three extraordinary panoramas of San Francisco in 1877 and 1878; each embraced a 360-degree view from his vantage point on Nob Hill. The first two consisted of eleven parts each and were executed on relatively small 7-3/8 x 8-1/4-inch negatives. The third, a thirteen-part panorama shot on mammoth plates, measured an astounding 17 feet 4 inches in length (FIG. 14). When Muybridge made one of the eleven-part versions available unmounted, "properly secured upon a roller," he underscored the perceived similarities between these photographic prints and their painted predecessors.[33]

The popular mania for multi-part panoramas of urban scenes achieved its most absurd expression in the production of stereographic panoramas. J. G. Evans of Muscatine, Iowa, produced a five-part panorama of this Mississippi River town in stereographs. Placed end

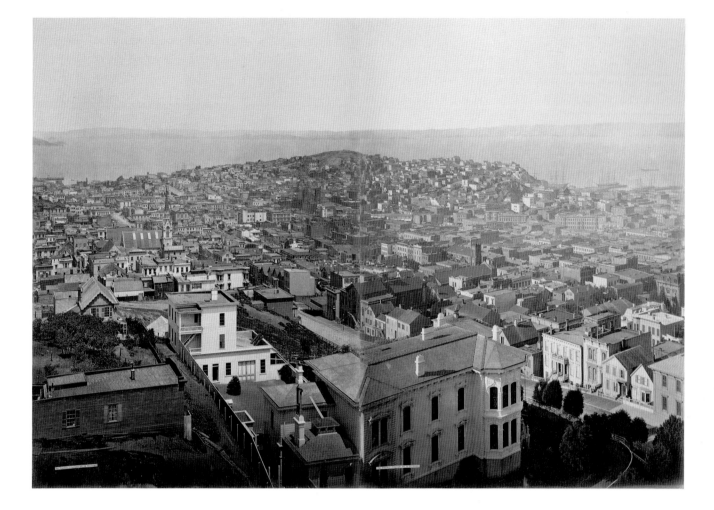

to end, his stereo halves form a fairly good panoramic view. But when one looks at the stereos as they were meant to be seen—one at a time through a stereo viewer—the panoramic effect is lost.[34]

The ability to make paper prints from glass negatives, a skill most western photographers acquired in the late 1850s or early 1860s, enhanced the photographer's ability to construct photographic narratives. The new technology not only permitted him to juxtapose and combine images in new ways, but also allowed him to link language and image in ways that had never before been possible. Once photographers could make paper prints to be sold on paper or board mounts, they could provide a narrative structure for their photographs simply by attaching a suggestive title or text to the picture—something that was hard to do with a cased image such as a daguerreotype, tintype, or ambrotype. The titles and texts affixed to most professionally made paper prints of the nineteenth-century West suggest that images of the social and natural landscape were conceived in series, much as lantern slides were. Through printed words, viewers could appreciate the photographer's intent (or the publisher's purpose) without the mediating presence of the photographer or lecturer. The public, narrative entertainment of the panorama could move inside the parlor.

One reason for marketing photographic views in series was economic. A photographer could produce and promote an entire series more economically than individual pictures. For example, all of the titles in a series could be printed on the back of a card, then one title underlined to match the image glued to the other side. This obviated the need for individually printed mounts for each picture.

But the emphasis on serial views underscored a philosophical presumption as well: photographers continued to doubt the efficacy of the individual image and instead used photography as a narrative or story-telling medium. When Charles D. Kirkland wanted to

Figure III-15
Charles D. Kirkland.
Cutting Out. Albumen
silver print, c. 1895.
Amon Carter Museum.

KIRKLAND'S
⇒VIEWS OF COW-BOY LIFE⇐
AND THE CATTLE BUSINESS.

The photographs, of which the following is a list, were taken on the line of the Union Pacific Railroad (the Overland Route), and illustrate graphically and truthfully the cattle business of the Great West. The views have been taken instantaneously from life, and are finely finished and elegantly mounted on five-inch by eight-inch cards.

No.	SUBSECT.		
1	Supper on Round-Up.	41	Dragging Calf to Brand.
2	Cowboy and Pony.	42	Group of Cowboys.
3	Bunch of Trail Cattle.	43	Roping a Beef Steer.
4	Group of Hereford Calves.	44	Throwing a Steer.
5	Cowboy and Pony.	45	Chasing a Yearling.
6	Cowboy.	46	Cutting Out.
7	Calf Branding.	47	Inspecting Brand.
8	After Dinner.	48	Pitching Broncho.
9	General View of Round-Up.	49	General View of Round-Up.
10	Dinner on Round-Up.	50	Round-Up No. 7.
11	Ready for Cutting Out.	51	Branding on Prairie.
12	Cowboy Sports.	52	Pitching Broncho.
13	Group of Cowboys.	53	Pitching Broncho.
14	A Bucker from Way Back.	54	Branding on Prairie.
15	Dinner on Round-Up.	55	Skinning a Beef.
16	Cow Pony.	56	General View of Round-Up.
17	Roping a Calf.	57	Cowboys.
18	Jim Kid.	58	Killing a Beef.
19	Pitching Broncho.	59	Roping a Maverick.
20	Just in from Herding.	60	Thoroughbred Hereford Bulls.
21	Roping and Cutting Out.	61	Thoroughbred Hereford Calves.
22	Group of Cowboys.	62	A Bull-Fight on the Plains.
23	Roping a Calf.	63	Roping a Bony from the Herd.
24	Working a Cayuse.	64	Throwing a Calf.
25	Mess Wagon.	65	Playing Mumble-Peg.
26	Inspecting a Herd of Half-Breeds.	66	Cowboys at Rest.
27	Taking Up the Back Cinch.	67	Mess Wagon—"Making Pies."
28	Branding a Maverick.	68	Roping Ponies.
29	After Dinner.	69	Cutting Out.
30	Rounding 'em Up.	70	Branding a Calf.
31	Roping a Steer.	71	Bringing in the Horse Covoy.
32	Ginning	72	Dragging a Calf from the Herd.
33	Cow Ponies.	73	Hitting the Breeze.
34	Laramie Kid.	74	A Hard Bucker.
35	Calf Branding.	75	Inspecting Brand.
36	Branding a Steer.	76	Riding a Yearling.
37	Horse Herd.	77	Waiting for a Cavoy.
38	Roping a Steer to Inspect Brand.	78	Just Branded.
39	Group of Cowboys.	79	Calf Branding.
40	Cowboy Race.	80	Cowboy Race.

Any one of the above, thirty-five cents; per dozen, four dollars Sent post-paid to all countries in Universal Postal Union. Order by number and subject.

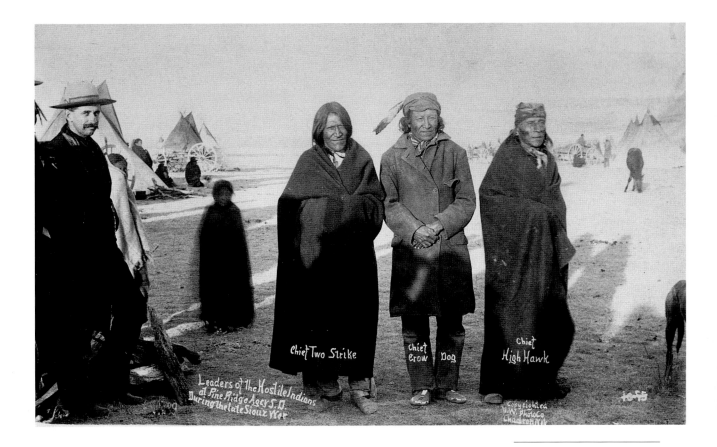

Chief Two Strike

Chief
Crow Dog

Chief
High Hawk

Leaders of the Hostile Indians
at Pine Ridge Agency S.D.
During the late Sioux War

Copyrighted
N.W. PhotoCo
Chadron N.Y

market the views of cowboy life that he had made along the route of the Union Pacific Railroad during the 1880s and 1890s, he produced printed mounts listing all eighty titles in his series, "Views of Cow-Boy Life and the Cattle Business." Individual photographs mounted on the face of the card bore a title written onto the negative (FIG. 15). Although the views were available individually, Kirkland's list suggested that each one was really a part of a coherent series of views describing a typical day or season in a cowpuncher's life. The pictures showed roundups and brandings, broncos and chuck wagons. If the series was amusing to tourists, it was instructive to would-be cowboys.[35]

There were many ways to affix a text that would clarify the intended meaning of a picture with numerous potential interpretations. A descriptive title, for example, might be drawn directly onto the negative. A title like that on one of George Trager's Wounded Knee photographs—*Leaders of the Hostile Indians at Pine Ridge Agency, S. D. During the Late Sioux War* (1891) (FIG. 16)—implied a complex story to contemporary viewers, who could be expected to read the image as a newsworthy tale of the military's triumphs at Wounded Knee, the subjugation of traditional Indian cultures, and the conquest of the American frontier. The image alone suggested no such glorious tale. Three Indian men, two wrapped in blankets and a third in an old coat, stand meekly in the foreground of an Indian village. Their acquiescent posture contrasts sharply with the self-confident stance of the military officer at the edge of the frame. Nothing in the image suggests that these Sioux were warriors, much less leaders of warriors. They are simply beaten men. Only the title of the print (and the names carefully written onto the negative across their legs) gives them an identity, a specific history, and a particular place in the history of the West. And only this specific context for the print makes it a marketable image. It was sold as a part of Trager's series documenting the battlefield at Wounded Knee, a series that included gruesome images of dead Sioux lying on the frozen earth. Viewed with these other pictures, the image of the Sioux warriors represents the sad denouement of battle.

Photographers were usually less flexible than painters, who could always improvise when unable to observe a scene they desired to depict, but they could also be resourceful

Figure III-16
GEORGE TRAGER, NORTHWEST PHOTO CO. *Leaders of the Hostile Indians at Pine Ridge Agency, S.D. During the Late Sioux War.* Albumen silver print, 1891.
Amon Carter Museum.

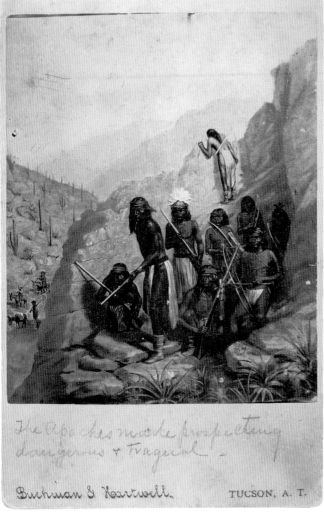

The Apaches made prospecting
dangerous + tragical. —

Buehman & Hartwell. TUCSON, A. T.

Figure III-17
HENRY BUEHMAN AND F. A.
HARTWELL. *Apaches in
Ambush.* Albumen silver print,
1885. Arizona Historical
Society, photo collection
no. 9645.

in their efforts to construct coherent photographic narratives. In the mid-1880s, Tucson photographers Henry Buehman and F. A. Hartwell actually photographed a painting for inclusion in their series on Arizona Territory Indian life when they could not themselves photograph an event that seemed crucial to their narrative (FIG. 17). Only a brush could depict the Indian ambush of an unsuspecting prospector engaged in "dangerous and tragical pursuit," and the didactic function of the image in their photographic narrative overruled any concern about its authenticity.[36]

More literary ways of linking images and words inevitably developed with the advent of paper prints. Entire stories could be printed on or affixed to photographic mounts. On the verso of his photographs of New Mexico's Indian pueblos, Santa Fe photographer W. Henry Brown included lengthy histories of the villages and extended descriptions of their architecture. Together, the images comprised a kind of guided historical tour of the Rio Grande Valley; individually, they were imputed with rich narrative significance that only a text could elucidate.[37]

Similarly, William Henry Jackson's captions, written in 1877, gave both individual and collective meanings to the photographic portraits of Indians in the United States Geological Survey of the Territories collection (FIG. 18). Each individual caption suggested a personal history and interpretation for its subject, informing the viewer whether the subject was crafty or brave, lacking in character or possessed of superior intelligence. Those looking at the images needed only to find visual confirmation of these impressions; there was no need to fashion an independent appraisal of the subject. Using printed language, Jackson thus shaped the public perception of these photographic Indian portraits much as Catlin had done forty years before, when he provided spoken comments with the painted portraits in his traveling Indian gallery.

Read as a group in the USGS's published catalogue, Jackson's captions relate a much more complex tale of Anglo-Indian affairs from the point of first contact to the present. Tribes surrendered; warriors became farmers; "restless young raiders" moved into log houses; pagans became Christianized and accordingly more advanced in civilization. It is a complex but predictable story that the visual imagery alone could not bear.[38]

If individual entrepreneurs tended to publish their photographs with descriptive captions, on individual mounts that advertised an entire series, published photographic albums proved the more common form for presenting photographs made on the great government surveys and railroad expeditions of the nineteenth century. Here, as with the public panoramas or lantern slide shows, the deliberate and set arrangement of the pictures could be amplified by a textual narrative, which gave a kind of literary shape to the images. Alexander Gardner even stressed the literary form of his album of Kansas Pacific Railroad photographs (1867-68) by appending a Shakespearian quote to his final image of the Seal Rocks off the coast of San Francisco (FIG. 19): "Last scene of all in this strange, eventful history."[39]

Although the texts in these albums were designed to provide specific meanings for particular images and groups of views, they also suggest the mutability of photographic meaning and the difficulty of understanding the actual intent of the photographer, patron, or publisher, as well as the problems inherent in trying to recover contemporary perceptions of images. For if a text can ascribe a particular meaning to a photograph whose

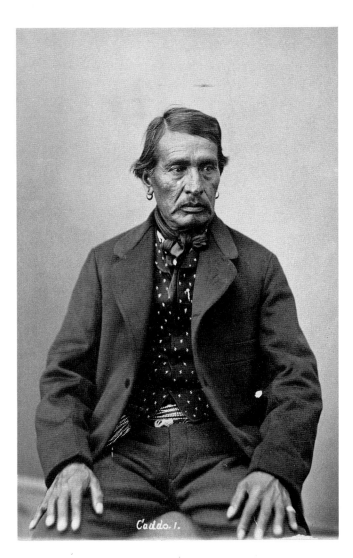

Figure III-18
ALEXANDER GARDNER. *Sho-E-Tat.* Albumen silver print, 1872. Amon Carter Museum. Text from W. H. Jackson, *Descriptive Catalogue of Photographs of North American Indians* (Washington, D.C.: Government Printing Office, 1877), p. 101. Courtesy of DeGolyer Library, Southern Methodist University.

significance might otherwise be difficult to understand, different texts can ascribe divergent meanings to the same image.

 Consider, for example, the photographs that Timothy O'Sullivan made of Shoshone Falls in Idaho in 1868 and 1874. O'Sullivan, who worked under Alexander Gardner's direction as a photographer during the Civil War, photographed the West for Clarence King's geological survey of the fortieth parallel from 1867-69 and again in 1872. In 1871, 1873, and 1874, he worked with Lt. George M. Wheeler's geographical survey of the lands west of the one hundredth meridian. O'Sullivan photographed Shoshone Falls on two occasions: once for King in 1868 and again for Wheeler in 1874. The views made on the latter trip were to be the last western pictures he would ever make.

 O'Sullivan made a total of twenty full-plate and more than thirty stereoscopic views of Shoshone Falls, more pictures than he made of any other western site. On both trips, he circled the falls and photographed them from different angles, moving in close and pulling his camera back to show the Snake River Canyon. In an article published in 1869, O'Sullivan noted that "below the falls, one may obtain a bird's-eye view of one of the most sublime of Rocky Mountain scenes" (FIG. 20). The entire region of the falls seemed to possess "such wildness of beauty that a feeling pervades the mind almost unconsciously that you are, if not the *first* white man who has ever trod that trail, certainly one of the very few who have ventured so far. From the island above the falls you may not see the great leap

Figure III-19

ALEXANDER GARDNER. *Seal Rocks.* No. 127 from *Across the Continent on the Kansas Pacific Railroad (Route of the 35th Parallel).* Albumen silver print, 1868. Missouri Historical Society.

that the water takes, but you will certainly feel sensible of the fact that you are in the presence of one of Nature's greatest spectacles as you listen to the roar of the falling water and gaze down the stream over the fall at the wild scene beyond."[40]

Instead of the glorious and inviting scene that O'Sullivan described, Clarence King saw the falls as a repellent, churning inferno. King was a believer in the scientific theory of "catastrophism," which held that sudden catastrophic changes in the natural environment—rather than the slow, gradual processes of evolution—were responsible for the changing life forms evident on the planet. In the black gorge, steep canyon walls, and pounding waters of Shoshone Falls he saw deeply unsettling reminders of God's terrible wrath. "After sleeping on the nightmarish brink of the falls," King wrote, "it was no small satisfaction to climb out of this Dantean gulf and find myself once more upon a pleasantly prosaic foreground of sage." Even in the early morning light, "dead barrenness" was "the whole sentiment of the scene. The mere suggestion of trees clinging here and there along the walls serves rather to heighten than to relieve the forbidding gloom of the place."[41]

In the various albums of original photographic prints issued by the King Survey, O'Sullivan's images of Shoshone Falls appeared without narrative captions. Despite the close collaboration of King and O'Sullivan in the field, O'Sullivan's albumen prints were never used to visualize King's words and King's text was never used to explain O'Sullivan's pictures. Two lithographs based on O'Sullivan's photographs of the falls did appear in King's official report, *Systematic Geology* (1878) (FIG. 21), but while King acknowledged that the cataract was "one of the most picturesque in the world," he devoted most of his text to dry geological descriptions of the terrain. The chief interest of the river below the falls, he wrote, "besides the evident relations of the two types of volcanic rocks, is the great horizontal extent of the basaltic beds." O'Sullivan's images are merely factual adjuncts to the text, and King's words give them little power.[42]

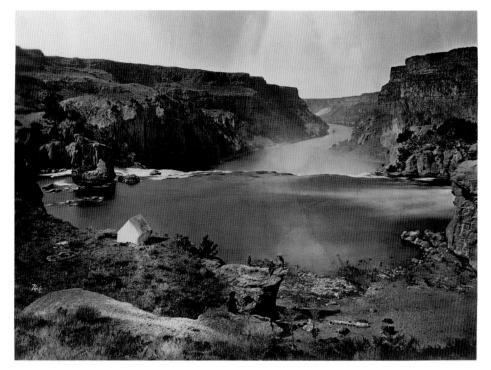

Figure III-20
Timothy O'Sullivan.
Shoshone Falls, Looking over Southern Half of Falls. Albumen silver print, 1868. International Museum of Photography at George Eastman House.

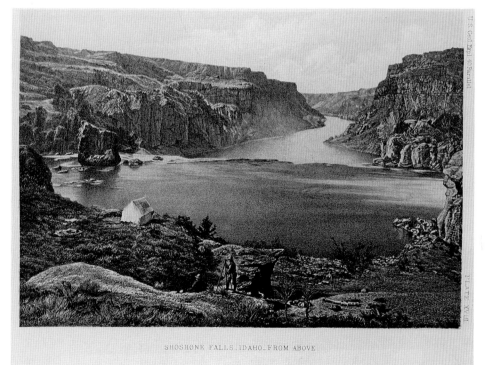

SHOSHONE FALLS. IDAHO. FROM ABOVE

Figure III-21
After a photograph by Timothy O'Sullivan.
Shoshone Falls From Above. Lithograph, 1878. Plate 18 in Clarence King, *Systematic Geology* (Washington, D.C.: Government Printing Office, 1878). Courtesy of Texas Christian University Library.

O'Sullivan's Shoshone Falls photographs of 1874 are visually similar to his earlier views. But in an official album of 1871-74 (one of at least six different albums issued by the Wheeler Survey),[43] they appear with descriptive captions that profoundly alter our perceptions of the views. To Wheeler, Shoshone Falls compared favorably to Niagara Falls, the most popular American symbol of nature's grandeur. Where King could not wait to escape the mad inferno of the falls, Wheeler thought "without doubt it is destined to become, in time, a favorite place of summer resort for the tourist and artist." He even included directions on how to reach the falls from the nearest railroad line. Where King saw "dead barrenness," Wheeler observed "diminutive isles . . . clothed with moss and cedar

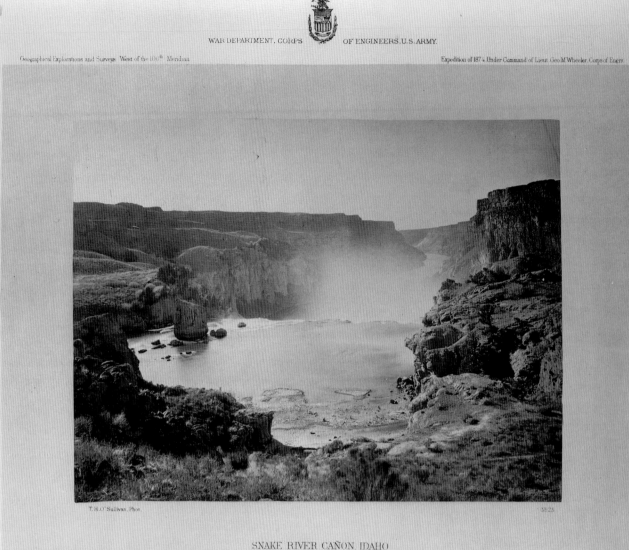

WAR DEPARTMENT, CORPS OF ENGINEERS, U.S. ARMY.

Geographical Explorations and Surveys West of the 100ᵗʰ Meridian Expedition of 1874, Under Command of Lieut. Geo. M. Wheeler, Corps of Engrs.

T. H. O'Sullivan, Phot. Nº 25

SNAKE RIVER CAÑON, IDAHO

View from above Shoshone Falls.

Figure III-22

TIMOTHY O'SULLIVAN.
Snake River Cañon, Idaho.
View from above Shoshone Falls.
Albumen silver print, 1874.
Plate 25 in album by United
States Army Corps of Engi-
neers, *Photographs Showing*
Landscapes, Geological and
Other Features . . . Obtained
in Conjunction with Geograph-
ical and Geological Explorations
and Surveys West of the 100th
Meridian (1871-74). Western
Americana Collection,
Manuscript S-744, Beinecke
Rare Book and Manuscript
Library, Yale University.

trees, whose deep green is in vivid and pleasing contrast with the white foam of the fretting and dashing water."

This markedly different view of the same scene reflected strong differences between the two survey leaders. Wheeler, an army man, was a bitter rival of King and the other civilian scientists, Ferdinand V. Hayden and John Wesley Powell, who were leading major surveys of the western lands. Wheeler insisted that his survey would be more practical. While the scientists' maps were "controlled by the theoretical considerations of the geologists," his army maps would stress "astronomical, geodetic, and topographic obser-vations." His reports would include useful information for the establishment of roads and rail routes and examine in detail the exploitable economic resources of the country.[44] Thus his extended photographic captions for O'Sullivan's pictures recount the history and difficulties of western exploration and the geological history of the land, but also stress that the West is a hospitable place for settlers. A photograph of Apache Lake in Arizona is offered as evidence "that Arizona, in its entirety, is not the worthless desert that by many it has been supposed to be." Other pictures illustrate the civility of the Navajo Indians and the lush grazing land awaiting settlers in southern Colorado's Conejos Valley.[45]

In the album of 1871-74, four of O'Sullivan's photographs of Shoshone Falls provide the conclusion and climax of the series of views. The final image, *Snake River Cañon, Idaho, View from above Shoshone Falls*, looks out over the falls into the river canyon that winds to the northwest through a steep volcanic plateau (FIG. 22). This view was made from almost the same spot as the view in *Systematic Geology* that afforded King the opportunity to speculate about the geological character of the river below the falls. The terrain is rocky, rough, and apparently uninhabited, but Wheeler's caption makes the picture a suitably climactic ending for his forward-looking tale of western exploration and settlement. The river flows through an area, he tells us, that "has been freed from the terror of hostile Indians" and can now be used for hunting and grazing. Farther down the river "a small colony of Chinamen are engaged in washing gold from the sands of the river, and at Shoshone Falls also; on the beach of the cove which is represented in the immediate foreground of the picture there are good diggings" that, when exhausted, are miraculously renewed "by the agency of the river." Underscoring the beneficence of this entire landscape, Wheeler concludes with a warm, domestic scene: "Near the left side of the stream, just above the falls, stands Eagle Rock, an isolated boulder 60 feet high, on whose summit an eagle has established its home and built its nest, interweaving the branches of trees into a basket for the protection of the young."[46]

O'Sullivan's Shoshone Falls photographs thus present an interpretive problem. What intention can we ascribe to O'Sullivan himself? How can we know whether he was expressing his own vision or that of his patrons? How could such similar images have three divergent but simultaneous meanings as a delightful and awe-inspiring scene, a hellish inferno, and a beneficent landscape ripe for economic exploitation? O'Sullivan, King, and Wheeler each constructed different stories about the West they encountered, and in each story the Shoshone Falls pictures sustain a different narrative burden. Contemporary viewers could not help but derive their understanding of a Shoshone Falls photograph from the context (and text) in which it appeared: as a reproduction in the 1869 article that expressed O'Sullivan's views, in King's 1878 book, or as an actual albumen print in the Wheeler Survey album.

A single picture was not only subject to differing interpretations by different people, but also by one person, as his needs and purposes changed. Several O'Sullivan photographs from the Wheeler album issued in 1876 appeared also as tinted lithographic reproductions in the geographical report on the survey that Wheeler published belatedly in 1889. During the intervening years, as the West changed, Wheeler's narrative and his narrative needs for the pictures had changed accordingly. In the mid-1870s his audience needed to be reassured that the western Indian tribes had indeed been subdued, making most areas of the West and Southwest safe for settlement. By 1889, his audience assumed this; Indians had been transformed from a potential threat into a romantic symbol of the old untamed West that was fast becoming more a legend than a place.

O'Sullivan's *Aboriginal Life Among the Navajoe Indians. Near Old Fort Defiance, N. M.* (1873), plate 10 in Wheeler's 1876 album, depicts a group of four Indians around an outdoor loom on which a woman weaves a blanket (FIG. 23). The accompanying text is at once respectful of the subjects and reassuring to would-be settlers and travelers. It describes the Navajos as "an intelligent and fierce people by nature," who had made "good progress towards civilization" since their defeat by U. S. troops in 1859-60. It acknowledges their talent at raising livestock, their success at cultivating the soil "and raising enough of grain and vegetables to satisfy their own needs," and praises the "excellent quality and close texture" of their famous blankets. The photograph thus shows a hard-working, self-supporting people, the sort of industrious neighbors any American settler might appreciate.[47]

Two Navajos appear beside a similar outdoor loom in the variant of this photograph reproduced in Wheeler's 1889 book as *Aboriginal Life in the Navajo Country Near Old Fort Defiance, Arizona* (FIG. 24). But now they are merely quaint, dependent figures whose glorious past has long since disappeared. They have been reduced by the accompanying text from good farmers to exotic anachronisms. "The head and lord of the family looks on with phlegmatic equanimity at the patient industry of the squaw and indulges in day

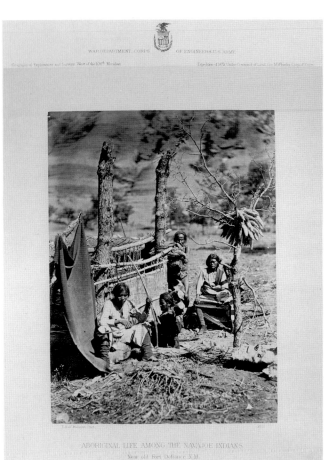

Figure III-23
TIMOTHY O'SULLIVAN.
*Aboriginal Life Among the
Navajoe Indians Near Old
Fort Defiance, N.M.*
Albumen silver print, 1873.
Plate 10 in album by United
States Army Corps of
Engineers, *Photographs Showing
Landscapes, Geological and
Other Features . . . Obtained
in Conjunction with
Geographical and Geological
Explorations and Surveys
West of the 100th Meridian*
(1871-74). Western
Americana Collection,
Manuscript S-744, Beinecke
Rare Book and Manuscript
Library, Yale University.

dreams, undoubtedly of victories of war or excitement of the chase, performed by him or his ancestors. They gather a scant harvest of corn and grain, but depend now for the greater part upon government rations."[48]

An O'Sullivan photograph of *Cooley's Park*, in the Sierra Blanca range of Arizona, is similarly invested with different meanings in the two Wheeler narratives. In the 1879 album, we are told that the scenic field surrounded by tall pines is the ranch of "Cooley, a white man" who has served as head farmer of the White River Reservation for many years, supplying the Apaches with food. The narrative describes the subjugation of the Apaches by General Crook and outlines their current state. "After their conquest they were put under discipline upon different reservations, on one of which the accompanying picture is located. There, through the agency of General Crook, whose excellent policy still continues in force, they have been instructed in the various arts of peaceful self-support." By 1889, the Indian past of the region was too remote even to mention. O'Sullivan's photograph, now cropped to a vertical format, is presented only as a "typical scene" showing the "park-like valleys scattered almost indiscriminately along the flanks of the Sierra Blanca Range." Even the image could not adequately describe "the rugged grandeur of the broken surrounding mesa and mountain or the gentle valley-like glade, finally grassed and interspersed with pine groves."[49]

Wheeler thus used language to shape the public understanding of O'Sullivan's images. His changing needs for the pictures and the apparent changes in the pictures' meaning make it harder than ever for us to understand what O'Sullivan might have intended when he made them or how his original nineteenth-century audiences might have understood the photographs. But Wheeler's texts demonstrate the importance of looking at nineteenth-century photographs in their original narrative contexts: American audiences had become accustomed to seeing western landscape photographs presented in this way and to interpreting the images with the verbal or visual clues provided by the photographers or their publishers.

The text of Wheeler's 1889 report, which transforms O'Sullivan's straightforward photograph of Navajo weavers into a romantic scene from the western past and reduces his descriptive picture of a government agent's farm into a "typical scene" of rugged beauty, heralds a major change in the character of photography in the nineteenth-century West. Since the mid-1840s, western photographers had pursued an essentially descriptive style of art whose subject was much concerned with the West itself—her land, her resources, and her distinctly new and different social communities. By turning to descriptive language and the serial presentation of imagery to supplement the information that a single photograph could convey, these photographers had transformed photography into a narrative medium and had created an art of information, whose purpose was to communicate particular facts about the social and physical landscape of the American West. But as the West became more and more like the rest of America—as her frontier culture receded into the past, her Indian populations were subdued, her cities grew in size and sophistication—there were fewer unusual features to describe. Photographers intent upon describing the "West" turned their attention from the present to the past, describing a place of history and myth. Where they had once tried to report, they were now forced to recreate.

In his celebrated pronouncement of 1893, historian Frederick Jackson Turner confirmed what the 1890 census had already indicated: the frontier West was gone. Wheeler's 1889 descriptions of O'Sullivan's photographs suggested a similar conclusion; a place that once presented particular physical challenges and economic opportunities had been transformed into a place of idealized beauty with a storied and romantic past.

Viewed from this perspective, George Trager's photographs of Wounded Knee, taken in late December 1890 and early January 1891, neatly mark the end of the first half-century of western photography. In a documentary style that would soon seem obsolete, they record an event that in retrospect would come to signify the closing of the old West. Trager marketed his straightforward pictures of frozen bodies and captured warriors as news to an audience that wanted information about distant events. Simple, descriptive titles shaped his series of views into narrative reportage about what would prove to be the last U.S. Army-Indian battle—an event that symbolically made the West, at last, completely safe for white settlement.

Within the next ten to fifteen years, as Indians ceased to be a perceived threat and became in the popular imagination a romantic and dimly seen part of America's frontier past, photographers began to recreate the native world that Trager and his predecessors had been able to capture in a more straightforward manner. Style took precedent over content as many photographers, from Edward Curtis and Roland Reed in the West to Gertrude Käsebier and Joseph Keiley in New York, found native Americans perfect subjects for their pictorial portraits. While Käsebier and Keiley permitted their simply titled portraits of Indians from Buffalo Bill's Wild West Show to be enigmatic representatives of their race, Curtis and Reed worked in the more didactic narrative style that had characterized earlier western photography. But even the narrative texts they wrote to accompany their pictures could not disguise what was so apparent in their images: fiction prevailed over fact. What was special about the West, what was unique about Indian culture, lay in the past, and only an act of the imagination could recover it for the camera.[50]

It does not seem surprising that pictorialism should first emerge as an important stylistic convention for western photographers in California, where enterprising gold-rush photographers had struggled to create markets for their landscape views. If California was where photographers had first transformed photography into a narrative medium to describe the frontier West, it was also the place where the frontier receded the fastest, as mines played out, cities grew, new industries emerged, and immigration exploded. The California Camera Club, a lively organization of amateurs and professionals founded in San Francisco in 1890, became the center of activities for the new breed of pictorialist photographer who photographed for his or her own pleasure and valued the idealized depiction of beauty over the detailed description of a particular site. The club-sponsored Sunday photo excursions to scenic spots soon became so popular that the railroads provided special cars. In 1892, the club's official magazine, the *Pacific Coast Photographer*, listed a half-dozen resorts that had installed darkrooms for their photographer guests to use. The landscape remained a popular subject for these western photographers, but it was a stylized landscape that conveyed none of the information about natural history, mineral resources, or economic possibilities that earlier photographers had found so important. At the same time, it was a personalized landscape which emphasized the emotional response of the photographer over the physical qualities of the site.[51]

The narrative tradition of early western photography generally has been ignored by critics, in part because art historians have applied the formal critical vocabulary developed for painting to their photographic criticism, in part because the rising photographic art market has placed a premium on the aesthetic qualities of the individual print. But the problem also stems from the ways in which photographs have been collected. As prints are removed from albums, photographs are cut from illustrated books, and series of views—

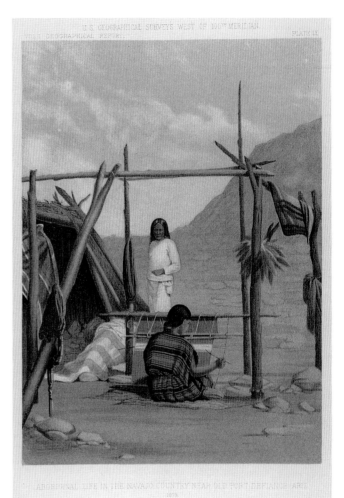

Figure III-24
AFTER A PHOTOGRAPH BY
TIMOTHY O'SULLIVAN.
*Aboriginal Life in the Navajo
Country near Old Fort Defiance,
Arizona.* Lithograph, 1889.
Plate IX in Geo. M. Wheeler,
(Engineer Dept., U.S. Army),
*Report upon United States
Geographical Surveys West of the
100th Meridian* (Washington,
D.C.: Government Printing
Office, 1889). Courtesy of
Texas Christian University
Library.

designed to be sold and seen together—are split up, the original narrative context of the work is lost. We are free, of course, to read early western photographs however we wish. But much remains to be learned about the business of nineteenth-century western photography; the role of private, commercial, and government patronage; and the ways in which photographs were published, marketed, and exhibited. Not until we have recovered this lost economic history and reconstructed the original narrative context in which so much work appeared can we really begin to understand what photography meant to its nineteenth-century practitioners or to the vast public audiences who saw, in photographs, their first real glimpse of the great American West.

NOTES

[1] Henri Cartier-Bresson, *The Decisive Moment* (New York: Simon & Schuster, 1952), n.p.

[2] For a more extended discussion of Mexican War daguerreotypes, see Martha A. Sandweiss, Rick Stewart, and Ben W. Huseman, *Eyewitness to War: Prints and Daguerreotypes of the Mexican War* (Washington, D.C.: Smithsonian Institution Press and Amon Carter Museum, 1989).

[3] New Orleans *Daily Picayune*, May 16, 1847.

[4] For general information on Catlin's Indian Gallery, see William H. Truettner, *The Natural Man Observed: A Study of Catlin's Indian Gallery* (Washington, D.C.: Smithsonian Institution Press, 1979); for Kane, see J. Russell Harper, *Paul Kane's Frontier* (Austin: University of Texas Press, 1971); for Stanley, see Julie Schimmel, "John Mix Stanley and Imagery of the West in Nineteenth-Century American Art," Ph.D. diss. (New York University, 1983). Kane's comments on the necessity for descriptive notes are in the preface to his book, *Wanderings of an Artist* (London, 1859), reprinted in Harper, *Paul Kane's Frontier*, p. 51.

[5] Schimmel, "John Mix Stanley," pp. 117-120; Truettner, *The Natural Man Observed*, pp. 107-110.

[6] San Francisco *Alta California*, December 19, 1849; November 14, 1850. The best overview of the gold-rush panoramas is John Francis McDermott, "Gold Rush Movies," *California Historical Society Quarterly* 33 (March 1954): 29-38. For information on the Frémont and Wilkins panoramas, see Joseph Earl Arrington, "Skirving's Moving Panorama: Colonel Frémont's Western Expeditions Pictorialized," *Oregon Historical Society Quarterly* 65 (June 1964): 133-172, and John Francis McDermott, ed., *An Artist on the Overland Trail: The 1849 Diary and Sketches of James F. Wilkins* (San Marino, Cal.: The Huntington Library, 1968).

[7] Helmut and Alison Gernsheim, *L. J. M. Daguerre: The History of the Diorama and the Daguerreotype* (New York: Dover Publications, 1968), pp. 14-46.

[8] Antrim's sketches and notes from his trip across California are in the Manuscripts Division of the Library of Congress. Subsequent biographical information is courtesy of Peter Palmquist, Arcata, California, whose directory of nineteenth-century California photographers is in process.

[9] For general biographical information on Vance, see Peter E. Palmquist, "Robert Vance, Pioneer in Western Landscape Photography," *American West* 18 (September/October 1981): 22-27. I have also consulted a typescript draft of Palmquist's forthcoming biography of Vance. For information on the Boston showing of Banvard's panorama, see the clippings reproduced in John Banvard, *Banvard's Geographical Panorama of the Mississippi River, with the Adventures of the Artist* (Boston: John Putnam Printer, 1847).

[10] R. H. Vance, *Catalogue of Daguerreotype Panoramic Views in California* (New York: Baker, Goodwin & Company, 1851), p. 4. Vance's presence at the exhibitions is noted in the *Photographic Art-Journal* (October 1851): 253.

[11] *Photographic Art-Journal* (October 1851): 252-253.

[12] Ibid., p. 253.

[13] *Photographic Art-Journal* (February 1853): 126. The sale of Vance's collection is summarized in Robert Taft, *Photography and the American Scene* (1938; reprint New York: Dover Publications, 1964), p. 489. Fitzgibbon's aspirations to become a California photographer himself are recorded in Charles Van Ravenswaay, "The Pioneer Photographers of St. Louis," *Missouri Historical Society Bulletin* 10 (October 1953): 58.

[14] Sacramento *Daily Union*, July 8, 1851.

[15] Basic (if somewhat exaggerated) information on Jones and his photographic project can be found in John Ross Dix (pseud.), *Amusing and Thrilling Adventures of a California Artist While Daguerreotyping a Continent* (Boston: published for the author, 1854) and in summaries in Richard Rudisill, *Mirror Image: The Influence of the Daguerreotype on American Society* (Albuquerque: University of New Mexico Press, 1971), pp. 142-149, and in Taft, *Photography and the American Scene*, p. 489. Jones' work as a census agent in Calaveras County is recorded in a document of February 12, 1851, copied from the original 1850 census and included in the "California Information Index," a microfiche collection of file cards from the California State Library. The earliest mention of his daguerreotyping project is in the San Francisco *Alta California*, April 19, 1851. I am at work on an extended study of Jones and his daguerreian project.

[16] *Oquawka Spectator and Keithsburg Observer*, May 7, 1851.

[17] *Daily Missouri Republican*, November 1, 1851. Excerpts from various Boston newspapers charting the progress of the project are reproduced in Dix, *Amusing and Thrilling Adventures*, pp. 41-50.

[18] *Boston Bee*, cited in Dix, *Amusing and Thrilling Adventures*, p. 43; *New York Herald*, October 30, 1853.

[19] Jones' lecture notes with accompanying pencil sketches are in the collection of the California Historical Society and reproduced in "Jones' Pantoscope of California," *California Historical Society Quarterly* 6 (June 1927): 109-129; (September 1927): 238-253.

[20] A circular for the lottery is reproduced in ibid., opp. p. 110. A similar advertisement can be found in the *New York Herald*, December 10, 1853. Jones' own views on the lottery are voiced in "A Chapter on Gift Enterprises," an addendum to Dix, *Amusing and Thrilling Adventures*, pp. 88-92.

[21] *Oquawka Spectator and Keithsburg Observer*, May 7, 1851.

[22] Van Ravenswaay, "Pioneer Photographers," p. 59; *Photographic and Fine Art Journal* (June 1857), p. 192. The ambiguity of the phrase "photographic diorama" leaves some uncertainty as to the precise form of Fitzgibbon's display.

[23] David Mattison, "The World's Panorama Company," *History of Photography* 8 (January 1984): 47-48.

[24] Opal M. Harber, "A Few Early Photographers of Colorado," *Colorado Magazine* (October 1956): 291; Glenn G. Willumson, "Alfred Hart: Photographer of the Central Pacific Railroad," *History of Photography* 12 (January-March 1988): 61-63; Susan Danley Walther, "The Landscape Photographs of Alexander Gardner and Andrew Joseph Russell," Ph.D. diss. (Brown University, 1982): 63-66.

[25] Walther, "Landscape Photographs", 76-77; William D. Pattison, "Westward by Rail with Professor Sedgwick: A Lantern Journey of 1873," *Historical Society of Southern California Quarterly* 42 (December 1960): 335-349 (quote: 340).

[26] Terry Wm. Mangan, *Colorado on Glass: Colorado's First Half-Century as Seen by the Camera* (Denver: Sundance Ltd., 1975), p. 86; Robert Bartlett Haas, *Muybridge: Man in Motion* (University of California Press, 1976), p. 116.

[27] A collection of brochures advertising Monsen's lectures can be found in the photographic collections of the Henry E. Huntington Library, San Marino. Maude's lantern slides and lecture notes are in the photographic archives of the Southwest Museum, Los Angeles. On Maude, see also Stephen G. Maurer, "Frederic Hamer Maude: Photographer of the Southwest," *Masterkey* 59 (Spring 1985): 12-17. McClintock's lecture notes and slides are in the collection of the Beinecke Rare Book and Manuscript Library, Yale University. As an ironic footnote to this phenomenon, it should be noted that while white audiences across America were looking at exotic slides of Indians, the native American students at the Carlisle Indian School were being shown lantern slides on Japanese life (Still Picture Division, National Archives, RG 75-SL and 75-SJ).

[28] On Easterly, see John C. Ewers, "Thomas M. Easterly's Pioneer Daguerreotypes of Plains Indians," *Missouri Historical Society Bulletin* 24 (July 1968): 329-341; Carla Davidson, "The View from Fourth and Olive," *American Heritage* (December 1979): 76-93; Van Ravensway, "Pioneer Photographers," 56-57; and the catalogue information in the photographic archives of the Missouri Historical Society, Saint Louis. While it has often been reported that Easterly sold his daguerreotypes to the Historical Society for only twelve *cents* each, this misimpression has been corrected by Dolores Kilgoe, Illinois State University, Normal, the author of a forthcoming (and much-needed) biography of Easterly.

[29] Liebert worked in America from 1851 to 1863, mainly in Nevada City. He then returned to Paris and wrote a popular technical text, *La Photographie en Amerique* (1864), that went through three editions. The text reveals little about Liebert's experiences in America, and he remains an intriguing figure for further study.

[30] Omaha *Nebraskian*, March 3, 1860.

[31] There are at least two Bostwick albums that follow this format: one in the Beinecke Rare Book and Manuscript Library, Yale University, and a second in the Center for Great Plains Studies Art Collection, University of Nebraska, Lincoln. Jon Nelson to Marni Sandweiss, October 20, 1988.

[32] *Sea Letter* (San Francisco Maritime Museum) 2, Nos. 2 and 3 (October 1964); Peter E. Palmquist, "The Daguerreotype in San Francisco," *History of Photography* 4 (July 1980): 207-238.

[33] Haas, *Muybridge*, p. 86.

[34] The Evans stereographs can be found in the Western Americana collection of the Beinecke Rare Book and Manuscript Library, Yale University.

[35] A complete collection of the Kirkland views, along with a selection of negatives, can be found in the Amon Carter Museum.

[36] A large selection of views from this series is in the collection of the Arizona Historical Society, Tucson.

[37] A significant collection of Brown's pueblo photographs can be found in the Photo Archives of the Palace of the Governors, Museum of New Mexico.

[38] W. H. Jackson, *Descriptive Catalogue of Photographs of North American Indians* (Washington, D.C.: Government Printing Office, 1877).

[39] A nearly complete collection of Gardner's series is in the Missouri Historical Society, Saint Louis.

[40] John Samson, "Photographs from the High Rockies," *Harper's New Monthly Magazine* 39 (September 1869): 475. It is generally accepted that this article, which is illustrated with wood engravings from O'Sullivan's photographs, fairly represents O'Sullivan's point of view. According to Rick Dingus, "some believe that O'Sullivan actually wrote the article himself . . . he was most certainly interviewed in order to obtain the information within it and was often quoted and paraphrased during the course of the narrative" (*The Photographic Artifacts of Timothy O'Sullivan* [Albuquerque: University of New Mexico Press, 1982], 145 n.23). Dingus' book contains the fullest description of O'Sullivan's work at the falls (and elsewhere).

[41] Clarence King, *Mountaineering in the Sierra Nevada* (1872; reprint, Lincoln: University of Nebraska Press, 1970), pp. 192-193, 189.

[42] Clarence King, *Systematic Geology* (Washington, D.C.: Government Printing Office, 1878), p. 593.

[43] At least six different kinds of photographic albums were issued by the Wheeler Survey, only three of which were printed in editions of any size. The two different albums documenting the seasons of 1871-73, one with twenty-five prints, the other fifty, contain no descriptive text. But the text in the volume of twenty-five prints chronicling the 1871-74 seasons provides the key to understanding the logic of all the albums and gives us a clue as to how Wheeler understood O'Sullivan's pictures. See *Photographs Showing Landscapes, Geological and Other Features, of Portions of the Western Territory of the United States, Obtained in Connection with Geographical and Geological Explorations and Surveys West of the 100th Meridian Seasons of 1871, 1872, 1873, and 1874. 1st Lieut. Geo. M. Wheeler, Corps of Engineers, U.S. Army in Charge* (Washington, D.C.: War Department, Corps of Engineers, c. 1876). The copy I consulted is in the Western Americana collection of the Beinecke Rare Book and Manuscript Library.

The fullest accounting of the Wheeler Survey's photographic publications is in Jonathan Heller's brief compilation, "O'Sullivan Albumen Prints in Official Publications," in Joel Snyder, *American Frontiers: The Photographs of Timothy H. O'Sullivan, 1867-1874* (Millerton, N.Y.: Aperture, 1981), p. 117.

[44] Richard A. Bartlett, *Great Surveys of the American West* (Norman: University of Oklahoma Press, 1962), p. 338.

[45] See *Photographs Showing Landscapes*.

[46] Descriptive legend for view 25 in *ibid.*, n. p.

[47] Descriptive legend for view 10 in *ibid.*, n. p.

[48] Engineer department, U. S. Army, *Report upon United States Geological Surveys West of the One Hundredth Meridian in Charge of Captain Geo. M. Wheeler*, Vol. 1, Geographical Report (Washington, D.C.: Government Printing Office, 1889), p. 75 and plate IX.

[49] Descriptive legend for view 9 in *Photographs Showing Landscapes; Report upon U.S. Geological Surveys*, p. 76.

[50] There is no comprehensive overview of the photography of American Indians during this period. In addition to the standard biographical works on individual photographers, see T. C. McLuhan, *Dream Tracks: The Railroad and the American Indian, 1890 - 1930* (New York: Harry N. Abrams, Inc., 1985); and Paula Richardson Fleming and Judith Luskey, *The North American Indians in Early Photographs* (New York: Harper and Row, 1986).

[51] See Margery Mann, *California Pictorialism* (San Francisco: Museum of Modern Art, 1977), pp. 7-29.

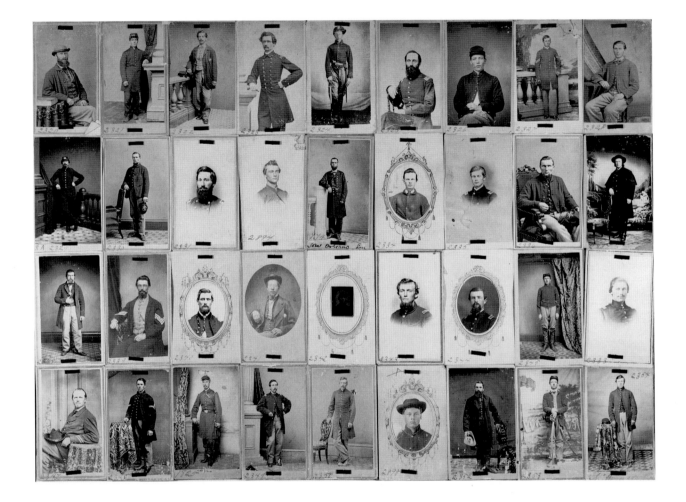

"A TERRIBLE DISTINCTNESS"

Photography of the Civil War Era

KEITH F. DAVIS

Americans have had an unending fascination with the Civil War, the event that most clearly defined the meaning of American nationalism and society. Given the historic and ideological importance of the conflict, Civil War photographs have been among the most respected and often-reproduced images in the history of the medium. However, our collective use of these photographs over the past 125 years inevitably reflects needs and interests increasingly removed from the context of the war itself. Most typically, Civil War photographs have been considered simple, unimpeachable bits of visual fact and used as mere adjuncts to historical texts. In more recent years these same images have been regarded by some photographic historians as autonomous works of "art" most revealing of the medium's inherently "fictional" nature and the self-expressive subjectivities of "artists."

While individually useful, neither of these admittedly simplified approaches conveys the rich complexity of Civil War photography and the intentions and ambitions of the era's practitioners. To begin that task requires a new emphasis on the cultural context of these pictures. This essay attempts to suggest some of the original meanings and functions of Civil War photography by examining what audiences of the period expected from the medium, and what photographers themselves intended to achieve. This investigation begins with such fundamental questions as what photographers did in the years of the war, and for whom they worked. Any meaningful answers require that we acknowledge the diverse applications of the medium in this period and the economic realities of the profession. Civil War photographs stem from a complex range of individual motivations, including a sense of contemporary history, patriotism, adventure, and professional or social prestige. However, entrepreneurship and the simple need to earn a living dominate all other concerns. It is therefore particularly important to survey the primary audiences for Civil War photographs and to examine the process by which these images were produced, disseminated, and appreciated.

The four primary audiences to be discussed in this essay are the civilian public, individual soldiers, the illustrated press, and the official military hierarchy—with special attention given to the last of these groups. While each of these audiences had distinct photographic needs and interests, the networks that arose to service them had significant areas of overlap. Civil War photography is, to a large extent, the result of the complex web of personal and commercial relationships between businessmen such as Mathew Brady, Edward Anthony, and Alexander Gardner; influential politicians and military figures; and the individuals who actually made the photographs. This network of patrons, entrepreneurs, and employees must then be perceived within a larger context of historic incident, economic forces, and social values. While this essay alone cannot accomplish this enormously complex task, the following pages will attempt to provide a fresh perspective on this inexhaustibly rich subject.

Figure IV-1

UNKNOWN PHOTOGRAPHERS. *Soldiers' Photographs Received at Dead Letter Office.* Albumen silver prints and tintypes, 1861-65. International Museum of Photography, George Eastman House.

A century and a quarter after its conclusion, the Civil War remains uniquely compelling to many Americans. As the single most important episode in our national history—indeed, as the event that challenged and defined the very concept of nationhood—the war is profoundly meaningful to both professional historians and large segments of the general public. This importance is reflected in the vast body of scholarly literature devoted to the war and its causes and effects.[1] General histories of the period continue to be widely read, and a seemingly endless number of more specialized works pour from the nation's presses every year.[2]

Interest in the war permeates our culture. Across the country thousands of citizens meet regularly in Civil War Roundtables. Monthly magazines devoted to the conflict are widely popular, and every year hundreds of thousands of Americans visit Gettysburg, Antietam, Chickamauga, Vicksburg, Shiloh, Fort Sumter, and similar sites in a national ritual of reverence and remembrance. In addition, thousands of history enthusiasts participate annually in Civil War "reenactments"; after celebrating the spartan simplicity of mid-nineteenth-century camp life and the bonds of the military fraternity, they face off against the "enemy" amid clouds of black-powder smoke on a bloodless field.[3] The treatment of the war in literature and film has been well documented. Less well understood, perhaps, is the resilient symbolism of the Confederate flag. Its continued display, in the South and elsewhere, suggests that the war and its aftermath still hold a complex range of personal, political, and mythical meanings for Americans on the eve of the twenty-first century.

The importance of the Civil War derives in large part from its overwhelming scale. From a national population of 31,440,000 in 1860, some 2.1 million men served in the Union army, while 800,000 joined in the defense of the Confederacy. These 2.9 million men in uniform suffered over one million casualties and at least 623,000 deaths. Bullets and disease claimed as many casualties between 1861 and 1865 as in all other American wars combined, from the Revolution to Vietnam.[4] Most mid-nineteenth-century American households suffered the loss of a family member, relative, or friend, and that collective trauma left an indelible mark on the culture.

In the four years of war some 10,455 military actions took place, ranging from the huge battles of Antietam and Gettysburg to thousands of smaller skirmishes, raids, and occupations. These events occurred at an average rate of 6.5 per day and were scattered over at least eighteen states and territories.[5] This was the only significant conflict ever fought on American soil, and the physical proximity of its sites only adds to the continued prominence of the war in our national memory.

While the conflict itself lasted four years—from the shelling of Fort Sumter on April 12, 1861, to the surrender at Appomattox on April 9, 1865—the roots and ramifications of the war dominate decades of nineteenth-century American history. The religious and political issue of slavery, for example, was a major source of debate throughout the 1840s and 1850s, and the trauma of Reconstruction shaped the South for a generation or more after 1865. The war bankrupted the South, and the region did not regain its prewar economic levels for fifty years.[6]

In addition to ending slavery and preserving the Union, the war changed forever the fundamental character of the American nation. The South had represented a distinct way of life: a rural, agricultural, labor-intensive, and poorly educated culture founded on a belief in racial inequality, a central government of limited power, and the traditional values of family, hierarchy, and patriarchy. The North, on the other hand, was rapidly developing into an urban and industrial capitalist society characterized by egalitarian principles, economic competition, a strong central government, free workers, factories, mass production, and a heterogeneous population. The clash between these contending visions of American society lies at the heart of the war's larger historical and cultural implications.

In retrospect, the Civil War represented a watershed in the nature of war itself. It may be suggested metaphorically that this conflict began in the eighteenth century and ended in the twentieth. In 1861 the chivalrous dreams of heroic hand-to-hand (or sabre-to-sabre) combat ended forever with the brutal reality of anonymous killing on a previously unimagined scale. The Civil War was the first major conflict to demonstrate the lethal

result of the application of industrial technology and mass production to the military art. The results irrevocably changed the experience of combat and modern society's attitude toward war itself. The war saw the first extensive combat use of such important new weapons as rifled muskets and artillery, explosive shells, iron-clad vessels, and naval mines. It also marked the first sustained use of railroads to move and supply troops in the field and combat applications of observation balloons and the telegraph. In addition, the war introduced crude and largely unsuccessful prototypes of the machine gun, submarine, hand grenade, and rocket, all of which would make their full impact in wars of the next century.

Individually and in concert, these new technologies radically reshaped the rules and strategies of war.[7] The rifled musket, for example, with a far greater range and accuracy than earlier smooth-bores, greatly expanded the "killing zone" of the battlefield, doomed the time-honored heroics of the open frontal assault, and made field fortifications essential. This pragmatic respect for defensive action challenged the traditional military emphasis on offense and led to new strategic options. In the Atlanta Campaign, for example, Sherman's advance rested largely on repeated flanking moves that threatened the enemy's lines of supply and communication, rather than direct tests of strength.

It seems entirely appropriate that, in the first "modern" conflict to combine mass armies, industrial technology, factory production, engineering skills, and mechanical invention, photography also played an important role. While the camera had been used to document selected aspects of such earlier conflicts as the Mexican War (1846-48), the Second Burma War (1852-53), and the Crimean War (1854-55), the people, events, and places of the Civil War were recorded in a manner completely unprecedented. Some 1500 individual photographers produced tens of thousands of images in urban studios and locations in the field. These images permeated American culture in a manner akin to the later ubiquity of the movies and television. Indeed, the Civil War has been described as the first "living room" war, brought home to viewers through ambrotypes of individual soldiers, mass-produced cartes-de-visite and stereographs of political leaders and noted sites, and photographically derived wood engravings in the pages of such popular journals as *Harper's Weekly* and *Leslie's Illustrated*.[8] Photography provided the ideal picture-making tool for American society during the war, and a century and a quarter later, the camera's fragile artifacts provide vital touchstones for our national memory.

Figure IV-2
UNKNOWN PHOTOGRAPHER.
Lieut. Gen. Grant, Wife and Son,
at His Head Quarters City Point,
Va. Stereograph published
by E. and H. T. Anthony and Co.
in *The War for the Union.*
Albumen silver print, negative
c. 1864-65, print c. 1872-73.
T. K. Treadwell Collection.

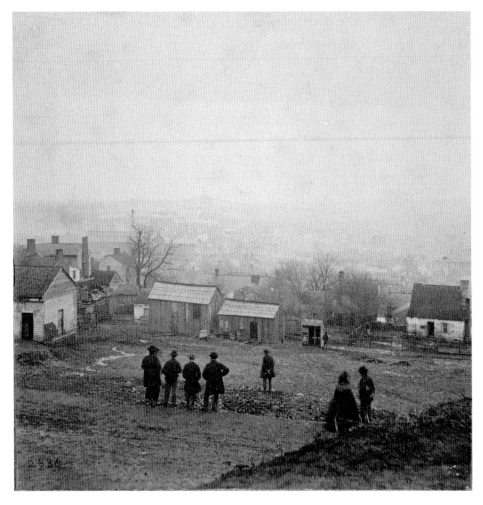

While these photographs exist in remarkable quantity, they do not—and of course could not—represent all facets of the conflict. The great bulk of Civil War photographs are tintypes, ambrotypes, and carte-de-visite portraits of individual (and now often unidentified) soldiers (FIG. 1). With few exceptions, these are unremarkable in physical presence and visual sophistication. Of course, their intended function was not artistic originality so much as the objective and inexpensive preservation of likenesses. Another large category of Civil War photographs encompasses mass-produced stereographic views and carte-de-visite portraits of leading politicians, military officers, and war scenes (FIG. 2). Large-format group portraits also exist in significant quantity. Prints of bridges, buildings, vessels, and equipment of various kinds comprise a discrete but smaller category of images, and even less frequent are battlefield photographs taken shortly after military action.

The visual record represented by this large quantity of images is remarkably fragmentary. Indeed, William A. Frassanito has stated flatly that "the vast majority of campaigns during the Civil War went completely unrecorded by any photographers."[9] Most photographers quite naturally recorded subjects within convenient reach and those for which an immediate market existed. Thus the eastern theater of the war and the Army of the Potomac in particular were heavily documented, while remote episodes like General Philip H. Sheridan's Shenandoah Campaign went completely unphotographed.

Although a few photographs were made within the sound of gunfire, no clear image of an actual battle has been identified.[10] Hampered by heavy equipment and relatively insensitive plates, photographers invariably maintained a healthy distance from scenes of conflict. Jacob F. Coonley's depiction of the Battle of Nashville (FIG. 3) is emblematic of the limitations that Civil War photographers faced. In this image, made from the safety of the fortified city, the battle itself has been completely obscured by distance and atmospheric haze (or smoke). The importance of the moment is conveyed only by the presence of Coonley's fellow observers and the photograph's authoritative caption.

The characteristic absence of photographers from actual battles was a function of time as well as distance. After a major engagement the dead were typically buried within about two days by the forces that retained control of the contested area. Thus photographs of unburied battle casualties could only be made by cameramen arriving almost immediately after hostilities concluded, and many logistical factors made such timely arrivals difficult. However, it remains surprising—particularly given the notoriety of photographs of Civil War dead—that such powerful scenes were recorded on only half a dozen different occasions in the four years of conflict.[11]

In addition, it must be emphasized that the great bulk of Civil War images are records of Union activities and personnel. Confederate war photographers such as J. D. Edwards and the team of Osborn and Durbec were active in the early months of the war. However, the Union blockade of Southern ports and the region's accelerating economic crisis severely curtailed photography in the fledgling Confederate nation and created many unfortunate gaps in the visual record of Confederate forces. Remarkably few group portraits of Southern officers were made. While William T. Sherman, for example, was recorded numerous times during the conflict, only two wartime photographs of his Confederate opponent Joseph E. Johnston have been documented. The single identified photograph of Fort Sumter prior to its bombardment is a scratched and ghostly ambrotype.[12] Surprisingly, too, no photograph seems to exist of the C.S.S. Virginia, the famed Confederate ironclad that battled the U.S.S. Monitor near Norfolk, Virginia, on March 9, 1862.[13] One historian has accurately written that "Confederate field photography almost ceased to exist after 1861."[14] Clearly, the surviving photographic documentation of the war is grossly one-sided from a political and military point of view.

This inevitably partial record has shaped our memory of the war in curious ways. The people or incidents that were not photographed may, for many of us, have a less specific kind of historical reality than those that were pictured frequently and memorably. Conversely, the relative importance of an event can be artificially elevated by the quality and quantity of depictions of it. For example, the massive 13-inch mortar Dictator remains well known to us through several impressive photographs made in the summer of 1864 (FIG. 4), although the Dictator had little historical significance. It saw limited action in the siege of Petersburg and appears to have spent the final six months of the war in storage. Without these photographs, the Dictator would most likely have remained an obscure military footnote.[15]

In 1860, on the eve of the Civil War, 3,154 Americans were employed as photographers.[16] In the previous half-decade these men (and a few women) had witnessed rapid and often unsettling changes in their profession. In the 1840s and early 1850s competent photographers had generally been able to earn a respectable and consistent income through the production of daguerreotype portraits. By 1860 this long-admired process was nearly extinct, replaced by a variety of cheaper techniques such as the ambrotype, tintype, and paper print. Professional competition and changing public tastes resulted in a steady downward pressure on retail prices and a demand for photographic novelties. The apparent volatility of the profession was magnified by the threat of a fluctuating economy; only a few years earlier, for example, the Panic of 1857 had forced many photographers into bankruptcy and created a lingering climate of financial insecurity.

A leaner and more diverse profession emerged in the late 1850s. Many studio operators continued to service the portrait needs of their immediate communities, following the pattern established in the daguerreotype era. Now, however, they advertised their skills with a variety of photographic processes. Others drew an increasing portion of their income from such new areas of specialization as the photography of items of commerce (machines, tools, and other products) or the practice of photography-on-wood for use in illustrated periodicals.

A mass audience for photography was forming on the eve of the Civil War, due in part to the low cost of paper prints and the merchandizing efforts of such firms as the Edward A. Anthony Company. Anthony had learned the daguerreotype process from Samuel F.B. Morse before opening a studio in New York City in 1842. In 1847 he established a

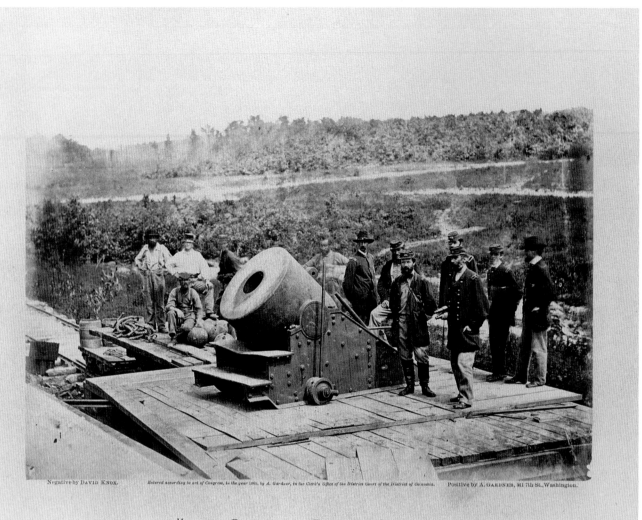

Negative by DAVID KNOX. *Entered according to act of Congress, in the year 1865, by A. Gardner, in the Clerk's Office of the District Court of the District of Columbia.* Positive by A. GARDNER, 511 7th St., Washington.

MORTAR DICTATOR, IN FRONT OF PETERSBURG.

Figure IV-4

DAVID KNOX. *Mortar Dictator,*
in Front of Petersburg. From
Gardner's Sketch Book of the
Civil War. Albumen silver print,
negative 1864, print 1865
by Alexander Gardner.
Amon Carter Museum.

daguerreotype supply business to provide cameras, plates, cases, chemicals, and studio equipment to photographers throughout the country. An astute businessman, Anthony responded effectively to competition from other suppliers and the changing needs of the profession.[17] By 1859 he had begun using this extensive marketing operation to sell original photographs as well as supplies. Stereographs were just coming to prominence, and in the early summer of 1859 he commissioned and published a set of 175 original views. Among these images of scenic and historic subjects were photographs of Broadway, made with the very rapid exposure of about one-tenth of a second. These "instantaneous" views drew particular praise from critics and the public, and significantly, were the only images Anthony consistently protected by legal copyright.[18] Public interest in stereos mounted rapidly, and the Anthony firm soon became the nation's leading producer of these images. A short time later, when cartes-de-visite became widely popular, the Anthony firm again led the way in producing and selling photographs in this format to a broad audience.[19]

 Several factors besides cost also influenced the new mass market for photographs. The unique characteristics of the paper process made it possible to replicate photographs almost endlessly. In addition, these thin mounted images could be stored compactly, sent through the mail, and (in the case of cartes-de-visite) inserted neatly into albums. A common cultural denominator for entertaining, educational, and newsworthy photographs was developing as the nation's steadily growing network of transportation and communication encouraged a shared familiarity with contemporary issues and personalities.

 This mass market responded favorably to photographic novelties. During the 1860 presidential campaign a New York firm sold 100,000 "medallion badges," each containing

one or two dime-size tintypes.[20] This high-volume approach was also used to sell tiny paper-print portraits of newsmakers in the early days of the war. These photo-buttons were sold wholesale for two dollars per thousand and to customers on the street for about five cents each. Speed was essential in producing these novelties. In the two or three days it took to replicate negatives, make prints, and cut and mount each image, there was always the danger that the hero of the previous day would make a fool of himself and fall from public favor.[21] These cheap photo-buttons suggest, albeit in a simple and exaggerated manner, the potentials and drawbacks of this new mass market. A decade earlier daguerreotypists had earned a living producing luminous, one-of-a-kind images for individual clients. Now, for the first time, second and third generation photographs (images of images) were produced in enormous quantity for sale through middlemen to an unseen audience.

No firm was better prepared than the Anthonys (Edward had formed a partnership with his brother Henry) to supply photographs to this broad new audience. Early in 1861 the company signed a contract with Mathew B. Brady to mass-produce and distribute carte-de-visite prints from Brady's renowned portrait collection of artists, celebrities, and political leaders. During the winter of 1860-61, George N. Barnard and Jacob F. Coonley rephotographed on carte-de-visite negatives the most significant portraits in Brady's New York and Washington, D.C., establishments. Under the terms of an agreement suggested by Alexander Gardner, the able manager of Brady's Washington gallery, Brady received about four thousand dollars for these negatives, which became the property of the Anthonys.[22] The Anthonys acquired similar collections from other sources; later in 1861, for example, they purchased a large quantity of carte-de-visite negatives from the Charleston, South Carolina, photographer George S. Cook.[23]

The increasingly tense months leading up to war provided a large and unprecedented market for inexpensive images of newsmakers. On February 8, 1861, during the lengthy standoff between the Federal defenders of Fort Sumter and the surrounding Confederates blockading Charleston harbor, George S. Cook went to the fort to photograph its commander, Major Robert Anderson. He immediately sold the negative to the Anthonys, who before the end of the month issued a humorous advertisement for portraits of this Northern hero under the banner headline: "MAJOR ANDERSON TAKEN!"

> On the 8th inst., about 12 hours before midnight under cover of a bright sun, Col. George S. Cook, of the Charleston Photographic Light Artillery, with a strong force, made his way to Fort Sumter. On being discovered by the vigilant sentry, he ran up a flag of truce. The gate of the fortress being opened, Col. Cook immediately and heroically penetrated to the presence of Maj. Anderson, and levelling a double barrelled Camera, demanded his unconditional surrender in the name of E. Anthony and the Photographic community.
>
> Seeing that all resistance would be in vain, the Major at once surrendered, and was borne in triumph to Charleston, forwarded to New York, and is now for sale in the shape of exquisite Card Photographs at 25 cts per copy, by E. ANTHONY, 501 Broadway.[24]

As the nation's attention remained focused on Fort Sumter through the middle of April, the Anthonys printed up to one thousand copies per day of the Anderson portrait.[25]

While the market for stereographs declined somewhat at the end of 1861, the demand for carte-de-visite (or card) photographs remained strong throughout the war. In April 1862 Coleman Sellers reported:

> Photographic art in this city [New York] is having a large share of patronage. . . . Card pictures are all the rage, and there are many novelties in the way of card albums. Mr. E. Anthony tells me that . . . they are now printing 100 sheets of paper each day, producing 3600 card pictures. The ones that sell best are soldiers and popular statesmen; but literary and theatrical characters are in demand, as are also small copies of engravings. They have published two small pictures, one called *Young America*, and the other *Young Africa, or the Bone of Contention*. This latter is a first-rate picture of a young darky, and is in great demand both north and south.

One curious circumstance in relation to the sale of these pictures is that in many of the cities of the northern slave states, where there is said to be a strong union feeling, portraits of the southern generals are very much more in demand than are those of the union army.

Sellers further noted that, even at the frantic pace of 3600 images per day, the firm remained "behindhand in supplying some orders."[26]

As indicated above, the popular market for photographs embraced a wide variety of subjects and formats. The Anthony firm published periodic catalogues of both their stereoscopic and card photographs. The October 1862 stereo listing, for example, described an enormous number of "instantaneous" and regular views. Domestic subjects were grouped into such series as "Fourth of July In and About New York," "Hills and Dales of New England," "Beauties of the Hudson," "The Picturesque on the Pennsylvania Central R.R.," and "California Views." International views of Japan, the Danube River, and Cuba were also offered.[27] By mid-1865 the Anthonys' catalogue of stereographs would list thousands of titles in forty-six different classifications. These groupings included domestic subjects such as West Point, Niagara Falls, the White Mountains, Greenwood Cemetery, and Central Park, as well as foreign views made in France, England, Ecuador, China, Egypt, and Venezuela. In addition, over 1,100 views were grouped under the heading "Photographic History: The War for the Union."[28]

The firm's November 1862 catalogue of card photographs listed not only reproductions of engravings and statuary, but also war views from Brady's negatives. Carte-de-visite size prints, which sold for twenty-five cents each, included scenes in Washington, Manassas, and Bull Run; camp scenes and groups near Yorktown; views near Fair Oaks (including the inflation of Professor Lowe's balloon *Intrepid*); the Antietam battlefield; and numerous portraits of leading officers. In addition to the "Brady Album Gallery" series, the Anthonys distributed a group of larger Brady prints under the collective title "Incidents of the War." Ironically, while Brady never gave individual credit to his own photographers, he insisted that all views that the Anthonys published from his negatives bear the "Brady & Co." imprint.[29]

The great majority of the Anthonys' titles represented images originally produced under the direction of Alexander Gardner, a complex and fascinating man born in Scotland in 1821.[30] During his apprenticeship to a Glasgow jeweler, from 1835 to 1842, Gardner developed "quite scholarly" tastes and became interested in social issues and the welfare of the working class. He subsequently wrote essays on science, art, and social problems and became editor of the *Glasgow Sentinel*. An interest in chemistry led him to take up photography, first as an amateur and then professionally. By 1848 he was involved in planning a utopian community in the United States, and many of his relatives subsequently settled in such a "cooperative society" in Iowa. Gardner himself arrived in New York in 1856, but rather than following his family to Iowa, he began working for Mathew Brady.

In addition to being a fine photographer, Gardner was skilled in the principles of business management. In February 1858 he was chosen to direct Brady's prestigious new gallery in Washington, D.C., which he operated with great autonomy and success. By mid-1860 Gardner's staff in this gallery included his brother, James Gardner, as well as Timothy O'Sullivan and James F. Gibson. Other New York-based photographers associated with Brady's gallery, including George N. Barnard and Jacob F. Coonley, spent time in the Washington studio beginning in early 1861.

From the first months of that year Washington was frantic with political and military activity. Lincoln was inaugurated on March 4, and five weeks later Fort Sumter fell. As thousands of newly enlisted troops filled Washington, many came to the Brady gallery to sit for a portrait. This activity drew Brady himself to the city in the early summer of 1861, although the flamboyant gallery owner socialized with political and military leaders in the capital and probably contributed little to the immediate work of the studio. When word spread through the city that Union troops would march to Bull Run to quash the nascent rebellion, Brady joined hundreds of other civilians who went out to watch, traveling to

within a mile or two of the engagement. When the expected Northern victory turned instead into a panicked rout, Brady and his companions, including Alfred Waud, the noted sketch artist for *Harper's Weekly*, were caught up in a chaotic and exhausting trek twenty-five miles back to Washington. It appears that no photographs were made that day, although Brady claimed the contrary many years later.[31]

Brady's continued presence in the Washington gallery probably irritated Gardner, whose magnanimous sensibilities may also have been offended by Brady's refusal to credit individual photographers for their images. Gardner apparently left his full-time duties in the Brady gallery in 1862 to become the official photographer for General George McClellan's Army of the Potomac. Given the honorary title of captain, Gardner served loyally in McClellan's "military family," perhaps on a free-lance basis.[32] In this period he specialized in the photographic duplication of maps and drawings for the army's topographic engineers. He also worked extensively in the field in the fall of 1862, and Brady published Gardner's views of Warrenton, Antietam, and Aquia Creek.

When Lincoln demoted McClellan in November of that year, Gardner returned to private practice in Washington, although he continued to bill himself as "Photographer to the Army of the Potomac." By the spring of 1863 he severed all ties with Brady and established his own studio.[33] He reclaimed many of the war views made during his tenure with Brady, evidently in lieu of unpaid wages or other obligations. Renowned for his kindly nature and liberal wages, Gardner easily attracted the best of Brady's former employees.

In addition to the portrait business and his distribution agreement with the Anthonys, Gardner began promoting his firm's war views. In September 1863 he issued a twenty-eight-page catalogue listing 568 images, the most recent of which documented the aftermath of the July 1863 battle of Gettysburg. Folio-size prints (seven by nine inches) were available for $1.50 each, while stereographs and album cards sold for fifty cents and twenty-five cents, respectively. Gardner used the Washington firm of Philp and Solomons to publish these views, which were distributed most broadly by Anthony but were also available by mail from Gardner's Washington address.[34]

Known for his great integrity, generosity, and fairness, Gardner was also meticulously organized, "a man of great system and much firmness in maintaining and carrying forward his plans."[35] His catalogue, unlike similar listings of the period, gave precise credit to his photographers for their views, an act that suggests both Gardner's respect for his employees' labors and his understanding of the personal nature of photographic picture-making. (Historians can only regret that the Anthonys, and others, had not been equally enlightened.) These listings provide much information on the activities of the photographers associated with the Brady and Gardner studios between March 1862 and July 1863. Gardner's 1863 catalogue lists views by eight individuals, with Gardner himself, Timothy O'Sullivan, James F. Gibson, and George N. Barnard the most prolific.

The catalogue's earliest extended series features images that Barnard and Gibson made in March 1862 at Centreville, Manassas, and Bull Run, the site of the previous summer's Union debacle, where they recorded noteworthy aspects of the battlefield and the recently abandoned Confederate fortifications nearby. Both photographers subsequently went to Yorktown to record McClellan's much-heralded Peninsula Campaign. There, in May 1862 (with some assistance from John Wood), Gibson made images of the largest Union artillery batteries, groups of Union officers, and a few historic residences (FIG. 5). He then followed McClellan's slow advance toward Richmond and photographed details of the battlefield of Fair Oaks. Barnard was in the Yorktown-Hampton area in early July and recorded former Confederate fortifications and the damage inflicted on various historic structures.

Timothy O'Sullivan, Gardner's most prolific employee during the war, had accompanied Mathew Brady to Bull Run in July 1861. From December of that year through May 1862 O'Sullivan photographed in Union-occupied areas of the southern coast. In South Carolina (Port Royal Island, Hilton Head Island, and Beaufort) he recorded troops on parade, bridges, forts, and noted residences. He also traveled a short distance farther south to photograph the ruins of Fort Pulaski, Georgia, which had been occupied by Federal forces on April 11, 1862. After his return north he worked at Manassas in July 1862 before

Figure IV-5

JAMES F. GIBSON. *Battery No. 4— Near Yorktown, Mounting 10 13- inch Mortars, Each Weighing 20,000 Pounds.* Albumen silver print, 1862. U.S. Military Academy, West Point.

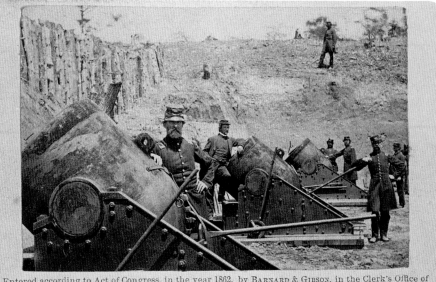

Entered according to Act of Congress, in the year 1862, by BARNARD & GIBSON, in the Clerk's Office of the District Court of the District of Columbia.

Figure IV-6

ALEXANDER GARDNER. *President Lincoln on Battle-field of Antietam.* From *Gardner's Sketch Book of the Civil War.* Albumen silver print, negative 1862, print 1866. Amon Carter Museum.

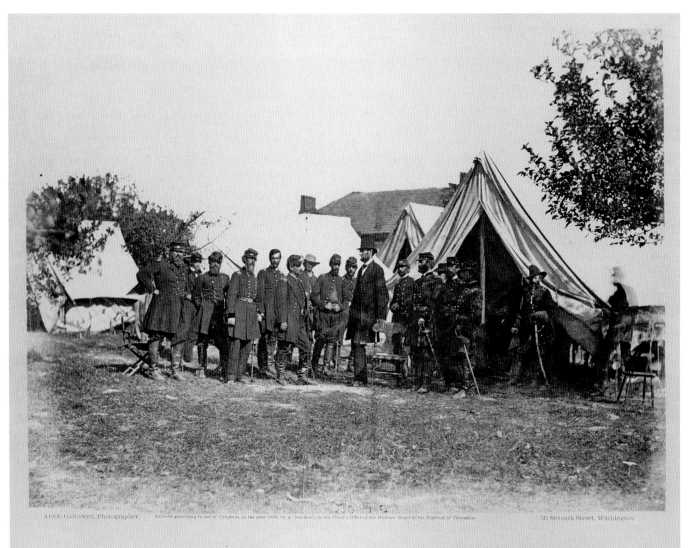

PRESIDENT LINCOLN ON BATTLE-FIELD OF ANTIETAM.

accompanying Union troops to Warrenton, Culpeper, and the crossing of the Rappahannock River. In mid-August he made thirteen views at Cedar Mountain, shortly after the engagement of August 9, 1862.

The catalogue credited Alexander Gardner with a great number of views. In July and August 1862 he made numerous portraits of officers at Union bases at Westover Landing and Harrison's Landing. On September 19-22, 1862, accompanied by James F. Gibson, Gardner produced a remarkable series of photographs on the battlefield of Antietam. Their gritty images, the first American photographs of battle dead, attracted great interest from the public and press.[36] On October 3-4 Gardner returned to McClellan's headquarters at Antietam to record the general's meeting with his commander-in-chief, Abraham Lincoln (FIG. 6 AND PLATE 43). The overly cautious McClellan, indifferent to Lincoln's pleas for action, was soon replaced, and in November Gardner photographed the new commander of the Army of the Potomac, General Burnside, in camp at Warrenton. The number of high-level portraits credited to Gardner reveals the photographer's special status with the military hierarchy and his desire to make such prestigious images himself.

In July 1863 Gardner, Gibson, and O'Sullivan traveled to the battlefield of Gettysburg to produce a memorable group of about sixty photographs. Gardner and his men were the

Figure IV-7
TIMOTHY H. O'SULLIVAN. *A Harvest of Death, Gettysburg, Pennsylvania.* From *Gardner's Sketch Book of the Civil War.* Albumen silver print, negative 1863, print 1865 by Alexander Gardner. Amon Carter Museum.

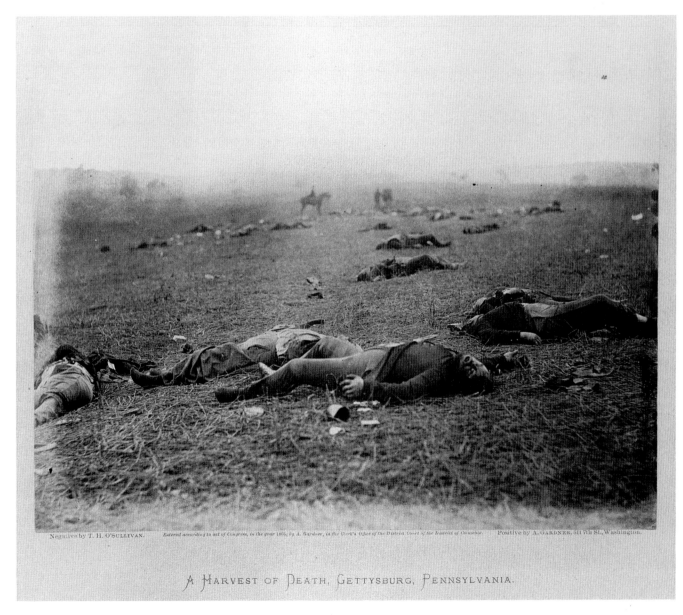

A HARVEST OF DEATH, GETTYSBURG, PENNSYLVANIA.

Figure IV-8
UNKNOWN PHOTOGRAPHER.
*General Grant at His Cold Harbor
Headquarters.* Albumen silver
print, June 1864. Published by
Brady and Co. Western Reserve
Historical Society.

first cameramen to arrive at the site; indeed, they were probably a full ten days ahead of Brady's photographers.[37] This disparity in arrival times influenced their respective bodies of work and fueled a spirit of competition between the two firms. Gardner and his men arrived on the morning of July 5, approximately thirty-six hours after the conclusion of the battle. Working quickly as Union burial parties cleaned up the battlefield, the trio focused their attention on the rapidly diminishing areas still containing corpses (FIG. 7 AND PLATE 41). When the interment process caught up with them, the photographers recorded the solemn task of digging and filling graves. Gardner's team, which had earlier found success with a series showing the dead at Antietam (see FIG. 14), devoted fully 75 percent of their plates to these subjects. The burials were completed by the evening of July 6, and the team returned to Washington the next morning.

The great majority of the battlefield views produced by Gardner and his men were stereographs. At Antietam, for example, seventy negatives were produced within five days of the battle: sixty-two in the stereographic format and eight as single-plate eight-by-ten-inch views.[38] At Gettysburg about 80 percent of the nearly sixty negatives were stereographs.[39] There were several reasons for this emphasis. The stereo camera was lighter than the eight-by-ten-inch and used plates that were smaller and easier to prepare. The operator of a stereo camera could thus work more rapidly and cover more ground than an equally skilled one with a larger instrument. In addition, the sales potential of these photographs varied in roughly inverse proportion to their retail cost (and size). Stereographs had a larger market than the more expensive single-plate views, and card photographs sold in the greatest quantity of all. Prints of the latter size were usually made simply by trimming individual prints from stereo negatives to fit the rectangular format of the carte-de-visite. Thus each print from a standard stereo negative produced either one mounted stereograph or two similar card photographs. This dual commercial potential explains the frequent use of the stereo camera.

The pattern established at Gettysburg continued until the end of the war. As Brady and Gardner strove to outdo one another, their photographers frequently crossed paths in the field. While Brady's men photographed the dead at Fredericksburg on May 20, 1864, Timothy O'Sullivan made a similar group of images at nearby Spotsylvania. On the following day O'Sullivan took his famous series of the meeting between Generals Grant and Meade at Massapanox Church. Brady's men subsequently made their notable portrait of Grant at Cold Harbor on June 11 or 12 (FIG. 8). On June 20, near Petersburg, O'Sullivan worked side by side with Brady's photographer as both recorded the execution of a black private accused of rape.[40]

Of course, other photographers were in the field during this period, also producing images for the Northern public. The Anthony firm had its own men near the front and acquired negatives from independent operators. Local photographers frequently took advantage of their proximity to important sites to produce significant bodies of work. In the weeks and months after Gettysburg, for example, several teams of Pennsylvania photographers visited the battlefield, including the Tyson brothers (from Gettysburg), Frederick Gutekunst (Philadelphia), and the Weaver brothers (Hanover). By the first week of August, Gutekunst had published a set of seven prints made with his ten-by-twelve-inch camera; all proceeds from the sale of this ten-dollar portfolio were allocated to benefit sick and wounded soldiers. By October the Tysons' views reportedly enjoyed "an immense sale."[41]

In addition to the public demand for images of battlefields and newsmakers, photographers profited from the immense market for individual portraits of servicemen. On February 1, 1862, Coleman Sellers noted that "with the professional operators the war has been quite a source of profit. What countless numbers of sun-pictures have been

exchanged at the anxious parting of friends from those whom the chances of battle may keep from ever meeting again on earth!"[42]

In May Sellers wrote that an unnamed photographer from New York state "has been for some time driving a brisk business at the camps below Washington," making ambrotypes and stereographs. It was reported that "the soldiers are very good customers as long as their money holds out." This photographer reported making fifty dollars per day with the ambrotype alone.[43] Photographers were equally busy in the major cities. Sellers reported that "photography, in a business point of view, has been benefitted by our troubles. The dealers in photographic stock and instruments are at their wits' end to meet their orders, and all the galleries are crowded with visitors."[44]

This great demand for portraits was a natural consequence of the departure of hundreds of thousands of young men for the uncertainties of war. Soldiers routinely exchanged portraits with their loved ones before they left for war, then transmitted later images by mail. With death an unignorable reality, many soldiers sat repeatedly for portraits in order to ensure the longevity of at least their image and memory. In the earliest days of the war Charles A. Seely wrote:

> For the few days . . . in which the military are being enrolled, some of the photographic galleries are thriving: the wise soldier makes his will, and seeks the photograph as possibly the last token of affection for the dear ones at home.[45]

Over a year later, during another round of recruitments, the desire for photographs remained unchanged.

> The streets are filled with bright uniforms, and the photographic galleries are crowded with soldiers and their friends. What a blessing it is that they who go to the war can not only leave behind them their images, but take with them the semblance of those they leave at home![46]

Encampments provided an ideal opportunity for enterprising photographers. In May 1861, George N. Barnard and C. O. Bostwick, then employed in Brady's Washington studio, recorded members of the colorful New York Seventh Regiment in one of the first camps of the war. Journeying a short distance from the city to Camp Cameron, the pair made dozens of images of soldiers who posed proudly before their tents and engaged in such "gymnastic field sports" as balancing in a human pyramid (FIG. 9). Both Anthony and Brady published some of these photographs in the form of stereographs and trimmed

Figure IV-9

GEORGE N. BARNARD AND C. O. BOSTWICK. *Gymnastic Field Sports of the Gallant 7th. The Human Pyramid.* Stereograph published by E. and H. T. Anthony and Co. Albumen silver print, 1861. Collection of Keith Davis.

(half-stereo) card photographs. Many members of the Seventh also came to Brady's gallery to pose in the more formal surroundings of the studio. Brady was an honorary member of the regiment and had close ties with many of its most prominent officers.

The huge military market attracted a remarkable number of cameramen. At one time or another, over three hundred civilian photographers worked in and around the Army of the Potomac alone.[47] Three brothers from Pennsylvania, A.J., S. L., and J. Bergstresser, stayed with this army for over two years, producing up to 160 portraits a day at a dollar apiece (FIG. 10).[48] Large semipermanent encampments in easily accessible locations attracted photographers by the score. For example, many freelance portraitists visited the Union camp at Brandy Station, Virginia, from December 1863 to May 1864, the period of its greatest activity. Such large captive audiences provided a bonanza for many photographic entrepreneurs, and a total of one thousand civilian photographers may have worked in or near Federal camps during the course of the war.[49]

Other photographers traveled considerable distances to profit from this huge market. G. H. Houghton of Brattleboro, Vermont, accompanied troops in the Army of the Potomac's 1862 Peninsula Campaign. McClellan's massive army provided a market nearly twenty times the size of Brattleboro, amply justifying Houghton's extended leave from home. In addition to making portraits of soldiers, Houghton recorded McClellan's headquarters and made several group portraits of officers.[50]

Henry P. Moore of Concord, New Hampshire, also journeyed far from home in search of business. In 1862-63 he operated a portable "DAGTYPS" gallery at Hilton Head, South Carolina, where a regiment of New Hampshire troops was stationed (FIG. 11). In addition to photographs of soldiers, Moore made numerous views of buildings, vessels, and island scenery. He recorded the former residences of noted Confederate generals, views of Hilton Head from the top of the Union signal tower, and various Federal warships and ironclads. Moore also captured characteristic Southern motifs in images of black fieldhands, flower gardens, majestic rows of live oaks, and encampments erected among groves of palm and palmetto trees. Issued as 5-1/2 by 8-inch prints after Moore returned to Concord, these images drew international notice.[51]

In several instances soldiers who had worked as photographers in civilian life set up temporary galleries in their camps. In the early months of the war, troops in one camp of the Army of the Potomac established a small weekly newspaper, a temperance league, various singing clubs, and, as a chaplain in the brigade noted,

> a photograph establishment, with all the modern appliances of this wonderful art, operated by practical artists who are members of the regiment. The design is to have not only the whole regiment photographed but also each individual member, together with the camp, its connected objects and scenery, with incidents and places on the march, thus obtaining a living history of the campaign for future use.[52]

It is also recorded that Lt. George H. Nickerson of Massachusetts photographed his companions in an army encampment at New Bern, North Carolina, in March 1863.[53]

Life was more challenging for those photographers who worked among troops on the move, or who themselves stayed in relatively continuous motion from one unit to the next. A few of these itinerants managed to carry all their equipment on horseback. In March 1862 Sellers noted:

> Photography is following the army south, and very many good operators are finding employment in portraiture in the camp, while at the same time occasionally very interesting camp scenes reach us. One of the camp photographers tells me that his dark box folds up so as to be readily carried on horseback, and he finds no trouble in managing his various solutions in the field. He has in his dark box two baths side by side—one containing the silver solution and the other salt water. After development with iron he immerses the plate in the salt bath, then coats it with glycerine, and fixes and strengthens at his leisure. His iron solution is carried in small bottles securely stopped to exclude all air, and contains, besides the usual amount of acetic acid, one drop to the ounce of formic acid. He treats his bath in a very simple way to keep it in good order—boiling it down in a porcelain bottle (which he carries for the purpose) to about one-half its bulk, then adding water and some fresh crystals of silver . . .[54]

Figure IV-11
Henry P. Moore. *Portrait Group Before "DAGTYPS" Gallery Tent.* Albumen silver print, c. 1862-63. Western Reserve Historical Society.

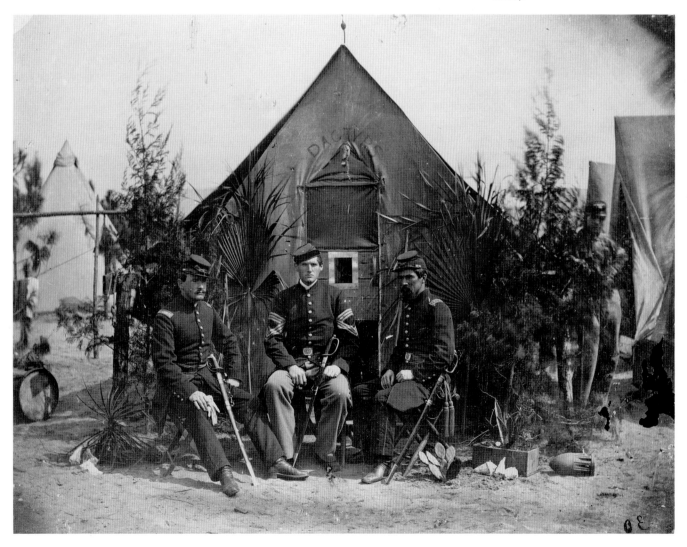

Sellers also observed that "the majority of the pictures made for soldiers in camp, or as they pass through any town, are ambrotypes. This is because their movements are too uncertain to allow for the delay of paper pictures; besides many of them have a liking for the fancy cases in which their portraits are enclosed—and, in addition to all this, they are *so cheap*."[55] However, it was not unusual for these cased images to be subsequently copied or enlarged on paper, producing additional employment for the photographic community.

The bulk of these individual portraits represent simple three-fourths or full-length poses. The most interesting, to our taste, record artifacts of the soldier's profession or personal interests. Some soldiers posed proudly with the tools of their trade: pistols, rifles, knives, or swords,[56] while others stood for studio portraits completely laden with backpack and rifle to show the folks at home how they marched. Other, relatively unusual, images include cooks working outside over portable stoves, musicians with their instruments, and topographic engineers beside their surveying equipment.

A smaller number of novelty photographs were also produced for the soldiers. High-spirited troops in camp staged at least one playful image of a gunfight.[57] Double-printed images carefully combined two views of the same individual, in both civilian and military dress, for example, contemplating the dual aspects of his life.[58] Among other such amusements was a "chess-board in which the white squares are photographic portraits of our leading generals."[59]

Figure IV-12

JAY DEARBORN EDWARDS. *Artillery Battery, Pensacola, Florida.* Albumen silver print, 1861. National Archives.

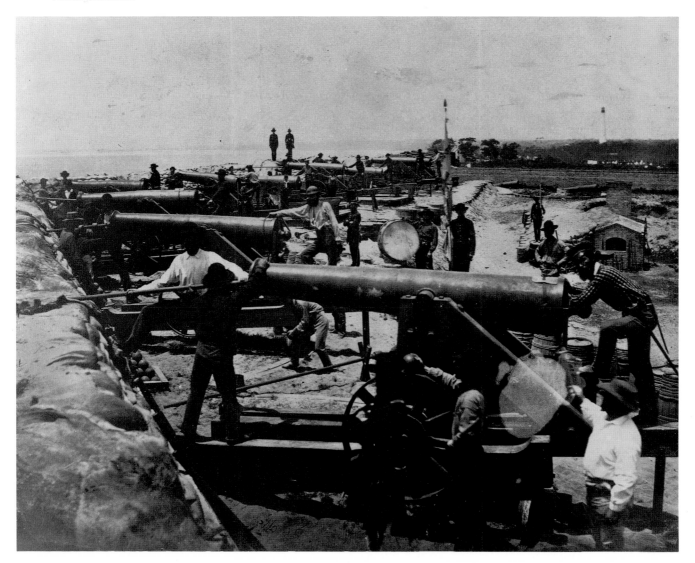

In the South, by contrast, few photographs of soldiers and encampments were made after the first months of the war. Of these scarce Southern images, some of the most remarkable were produced by New Orleans photographers. In early April 1861, J. D. Edwards made a series of outdoor photographs at the Confederate-held Warrington Navy Yard at Pensacola, Florida, documenting ships under construction and at anchor, troops manning artillery batteries (Fig. 12 and plate 39), and soldiers sitting, writing, or playing cards in camp. J.W. Petty and Mrs. E. Beachabard (the only identified woman gallery operator in the city at this time) also worked in Confederate camps in May and June 1861.[60] But the Union navy blockade of New Orleans on May 26, 1861, abruptly ended the city's trade with eastern suppliers. As nearly every commodity became scarce, prices skyrocketed. Photographers, dependent on supplies smuggled in from the North, were often unable to work. On January 1, 1862, *Humphrey's Journal* noted with only slight exaggeration that "the Photographic Art down South has completely died out in consequence of the war. The miserable rebels are shut up like a rat in a hole." The combined effects of the blockade and the deteriorating Confederate economy gave Confederate photographers "nothing to work with, and nobody to work for."[61]

In the North, unaffected by naval blockades and scarcity of supplies, the market for photographs overlapped with that for other kinds of popular prints. Commercial lithography, which came into its own as a profession in America in the 1820s, was in its heyday in the 1860s. Numerous firms competed to supply the public with a wide variety of printed pictures. During the war they supplemented their output of genre scenes, art reproductions, and religious subjects with lithographed and engraved prints of military leaders, battles, hospitals, ships, and patriotic allegories.[62] Some of these were derived from eyewitness sketches, while others were based loosely on verbal reports. Inevitably, a certain amount of competition arose between these two professions:

> A curious race is being run between the engravers and photographers in the publication of portraits of prominent men. Before the advent of card-pictures our generals and popular statesmen were either illustrated by expensive engravings or cheap coloured lithographs. The photographed card-portrait called for a smaller and a cheaper engraving to compete with it. Soon some very good copper-plate vignette heads were produced, and sold for about one-half the retail price of the photographs. These are now being copied by second-rate photographers, and sold to the retail dealers at about twenty for one dollar. What will be the ultimate effect of this competition on the art is hard to tell. It results now in the masses being furnished with plenty of good pictures at a low rate.[63]

Some photographers were employed full-time to copy engravings, a business described in mid-1863 as "very brisk".[64]

In a related application of photography to popular print imagery, the Langenheim brothers of Philadelphia began, in early 1862, to produce glass transparencies of engraved war scenes for projection in the magic lantern. As Coleman Sellers emphasized,

> these were *all* copies of well-executed engravings, which had been touched-up previous to being photographed. The sale of these copies exceeded [Mr. Langenheim's] most sanguine expectations, and now he has a large number of persons (mostly women) engaged colouring and mounting them ready for the lantern; whilst in almost every city and town are wonderful exhibitions of war scenes under the attractive name of "stereopticons." But the fun of the thing is that the innocent spectators for the most part imagine they are looking at photographic pictures "taken on the spot."

The Langenheims' offering of glass slides was subsequently expanded to include photographs "from nature" and a series of moralistic pictures such as *The Drunkard's Progress*. By November 1862 this group also included comic composite photographs of people and enlarged images of fleas; one of the most notable of these portrayed one of the Langenheims in mock terror, using a hatchet to fend off a gigantic insect.[65]

Although photographs of war scenes, important personalities, and individual soldiers occupied a significant niche in photographic commerce, other subjects also captured the popular imagination. In the summer of 1862, for example, carte-de-visite "spirit photographs" made their first appearance and generated considerable popular interest. Many believed that these double exposures depicted the translucent spirits of the dead. By March 1863 a letter in the *British Journal of Photography* noted that "the 'sensation' picture of the past few weeks has been the card-portraits of the dwarfs, Tom Thumb and his wife. The demand for them has been very great, and they are to be seen in almost every album."[66]

Photographs were also exhibited and offered for sale in the large fund-raising expositions of the United States Sanitary Commission. This Commission, officially established in June 1861, was an outgrowth of the American moral and social reform movement of the prewar years. Organized by Northern physicians and concerned women to supplement the meager capabilities of the Army Medical Bureau, the Commission devoted itself to improving the health and well-being of Federal soldiers through such activities as establishing a trained ambulance corps. The organization developed broad public support—some seven thousand local chapters were established by 1863—and organized a series of bazaars and Sanitary Fairs to raise money for medical supplies, clothing, food, and nurses. In the spring of 1864, the commission sponsored major fairs in Washington, New York, Baltimore, and Philadelphia.[67]

At the Philadelphia fair in June, photography was denied prime exhibition space among the "paintings, statuary, and articles of great curiosity, such as relics," but the photographic display, ultimately installed "between dry goods and the curiosity shop," was nonetheless deemed a success. Large framed portraits of prominent men and thousands of smaller landscapes, portraits, and copies of artwork were donated for sale, and Coleman Sellers noted the public's preference for "large portraits of generals," copies of engravings, landscape views of the Delaware River Gap and Susquehanna River, and inexpensive card photographs of all kinds. Typically, stereographs "could be sold only to those directly interested in the art—to amateurs, but not to the public generally." Sellers also noted with pleasure that photographs were prominently displayed in many other departments of the Fair.

> The sale of photographs has not been confined to the department of the [photography] committee, but thousands are scattered through the Fair at various tables. Thus photographers of Delaware have contributed to the Delaware department, and of New Jersey to their own subdivision. In the latter department there are two tables covered with very fine photographs, principally copies of fine engravings, in curious wooden frames, some also in frames made of relics, &c. In the children's department there were some copies of the *Madonna*. . . . There was a fine album filled with portraits of our generals, below each of which pictures a genuine autograph was contributed; this album was last night raffled for. In the machinery department photographs were for sale of the first steamboat which had run on the Hudson river . . . In the curiosity department are photographic copies of all kinds of curious manuscripts—letters from Shakespeare, &c; while in the William Penn parlour are pictures relating in some way to the early history of our state.[68]

The American appetite for images developed in tandem with a larger revolution in mass communication. A truly national press arose in the 1850s, and the war stimulated dramatic increases in the circulation of most newspapers. The revenues generated by this growing readership allowed editors to send unprecedented numbers of reporters into the field. The *New York Herald*, for example, had sixty-three correspondents in various theaters of the war and spent nearly one million dollars covering the conflict. In all some five hundred writers, including representatives of leading European papers, covered the war from a Northern perspective.[69]

A corresponding effort went into the pictorial depiction of the war. The genre of the American illustrated weekly had begun in December 1855 with the establishment of *Frank Leslie's Illustrated Newspaper*; at subsequent two-year intervals *Harper's Weekly* and

the *New York Illustrated News* were also founded. These papers featured wood engravings of noted personalities, disasters, scenic views, and other newsworthy events or subjects. Not unexpectedly, public demand for such timely images increased dramatically with the outbreak of the war. The illustrated papers responded to this interest by purchasing drawings from artistically inclined civilian and military eyewitnesses and by employing such noted sketch artists as Alfred and William Waud, Theodore R. Davis, Edwin Forbes, Thomas Nast, James Taylor, Arthur Lumley, and Winslow Homer. These professionals—typically young, resourceful, and personable, with a background in art or commercial illustration—accompanied the Northern armies through the most important campaigns and sent back thousands of sketches for publication.[70]

The illustrated weeklies also enjoyed a close relationship with the photographic community. In addition to publishing sketches by their own correspondents, these papers reproduced numerous photographs (mostly portraits) by many of the prominent photographic firms of the period, including Brady's and the Anthonys'. Photographs were copied by sketch artists onto the surface of wood printing blocks, then these inevitably simplified versions of the originals were carved free-hand by engravers to create a relief printing matrix. The early photographic engravings in *Leslie's* or *Harper's* were thus doubly removed from the mimetic specificity of the original photograph. But photographic technology itself became important to the production of illustrated papers in the late 1850s, when the photography-on-wood process was introduced. This method, in which a photographic image was printed directly on the smooth surface of the printing block, engendered a new visual accuracy on the printed page. While the hand of the engraver was not eliminated until the era of the halftone began in the late 1880s, photography-on-wood represented a significant improvement over the previous methodology and attracted such noted photographers as George N. Barnard, who devoted much effort to perfecting a version of the process in 1857-58. Barnard's technique was praised by leading wood-engravers and resulted in his enduring ties with the period's major publishers.[71]

The war strengthened and extended the relationship between the photographic and publishing professions. Publishing images in the illustrated weeklies gave photographic firms more national notice, an increased market for original prints, and in all probability a fee whenever their images were published. It is not surprising, then, that Brady, Anthony, and a number of other leading firms routinely offered photographs to *Leslie's*, *Harper's*, and the *Illustrated News*. Yet photographs could not replace sketches in these newspapers. Sketch artists recorded the great majority of sites and events that photographers depicted during the war, including leading officers, camp scenes, and topographic views. Moreover, the sketch artist could create scenes from memory, verbal reports, or pure imagination, and could hand-render views that were impossible to record on film, such as exploding shells, hand-to-hand combat, and moody nocturnes. Since artists were far less encumbered by equipment, they also could travel farther and faster than any photographer, and consequently witnessed innumerable incidents that went completely unphotographed.

Not surprisingly, photographers and sketch artists knew each other well and crossed paths repeatedly in the field. Alfred R. Waud, for example, who rode to Bull Run in the company of Mathew Brady, also visited Manassas in March 1862, when Barnard and Gibson were in the area, and was photographed by Timothy O'Sullivan at both Norfolk in early 1862 and Gettysburg in July 1863 (FIG. 13). O'Sullivan and Theodore R. Davis both recorded the activities of Federal forces near Savannah, Georgia, in early 1862. Davis and George N. Barnard were also well acquainted through their shared experiences in the war's eastern and western theaters and their mutual connection with *Harper's Weekly*. Among other links were Alexander Gardner's prewar experience as a newspaper editor, Brady's conscious emulation of the press ("I had men in all parts of the army, like a rich newspaper"),[72] and photographer A. J. Russell's later employment with *Leslie's Illustrated*.

Publishers found that translating photographs into wood-engravings took considerable time and labor. For example, the October 4, 1862, issue of *Harper's Weekly*, announcing the battle of Antietam on September 17, included four sketches by field artists. In the following issue, dated October 11, there were four additional sketches by Alfred Waud and a map of the battleground. Not until October 18 did *Harper's* publish photo-

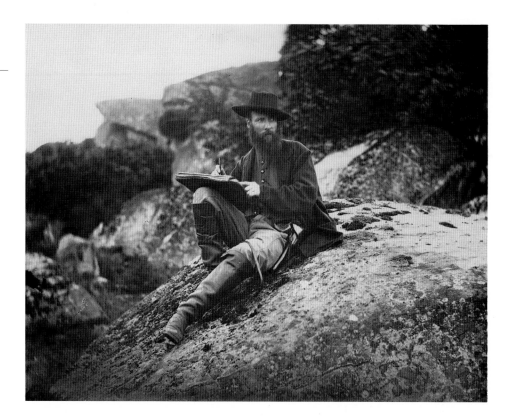

graphically derived pictures of the battlefield, on a dramatic double-spread that included eight engravings taken from the photographs that Alexander Gardner and James F. Gibson made between September 19-22. The same sort of delay occurred a year later, when Brady's images from the Gettysburg battlefield appeared in *Harper's Weekly* nearly five weeks after they had been taken.

This laborious translation from photographic original to printed engraving often produced disappointing results. The endless detail of the photograph—its appearance of factual transparency—was impossible to convey in a manually rendered image, and the content of the original image was inevitably simplified. In addition, the crude syntax of the relief printing block invariably flattened the infinite particularities of the photograph into a weightless screen of neutral dots and lines. And, of course, engravers were able to alter or rearrange the data of the photograph to make a more picturesque or timely image. Unfortunately, such conscious manipulation tended to strip the final picture of the original's gritty specificity.

This muting of the photograph's optical factuality created a corresponding loss of visual power, clearly evident when photographs of Antietam are compared with the wood-engravings taken from them (Figs. 14-15).[73] At the time the latter were published in *Harper's Weekly*, Brady opened a display of the original photographs in his fashionable New York gallery. The exhibition, which presented the first images of war dead for public viewing, created a sensation. On October 20, 1862, the *New York Times* ran a lengthy and sensitive review of the exhibition.

> Mr. BRADY has done something to bring home to us the terrible reality and earnestness of war. If he has not brought bodies and laid them in our dooryards and along the streets, he has done something very like it. At the door of his gallery hangs a little placard, "The Dead of Antietam." Crowds of people are constantly going up the stairs; follow them, and you find them bending over photographic views of that fearful battle-field, taken immediately after the action. Of all objects of horror one would think the battle-field should stand preeminent, that it should bear away the palm of repulsiveness. But, on the contrary, there is a terrible fascination about it that draws one near these pictures, and makes him loth to leave them. You will see hushed, reverend groups standing around these weird copies of carnage, bending down to look in the pale faces of the dead, chained by the strange spell that dwells in dead men's eyes. . . .

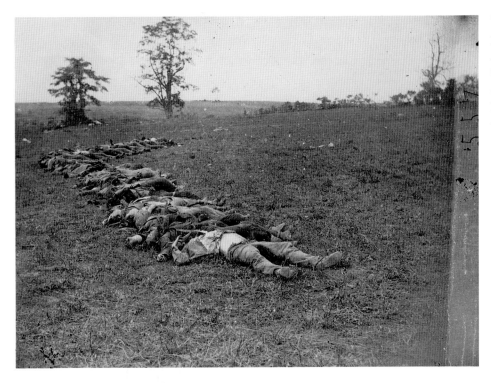

Figure IV-14
ALEXANDER GARDNER.
Confederate Dead Gathered for Burial. Stereograph #554, published by Brady and Co. Albumen silver print, September 1862. Library of Congress.

Figure IV-15
ARTIST UNKNOWN, AFTER PHOTOGRAPH BY ALEXANDER GARDNER. From *Scenes of the Battle-Field of Antietam.—From Photographs by Mr. M. B. Brady.* Wood engraving, 1862. In *Harper's Weekly* 6 (October 18, 1862): 664. Amon Carter Museum Library.

The ground whereon they lie is torn by shot and shell, the grass is trampled down by the tread of hot, hurrying feet, and little rivulets that can scarcely be of water are trickling along the earth like tears over a mother's face. It is a bleak, barren plain and above it bends an ashen sullen sky. . . .

These pictures have a terrible distinctness. By the aid of the magnifying glass, the very features of the slain may be distinguished.[74]

The faces and postures of these dead soldiers were shockingly expressive. With mouths agape and limbs crumpled in strange, unidealized positions, these corpses did not conform to contemporary notions of honorable or heroic sacrifice. The brutal inertness of death challenged ideological and political abstractions. It was, appropriately enough, often difficult to distinguish Confederate dead from Union dead in these photographs.

When *Harper's Weekly* published engravings of these images, the accompanying text testified (with, one must presume, unintended irony) to the "wonderfully lifelike" quality of the originals: "Minute as are the features of the dead, and unrecognizable by the naked eye, you can, by bringing a magnifying glass to bear on them, identify not merely the general outline, but actual expression."[75] Yet none of this detail was apparent in the printed illustrations. Perhaps it was sufficient to evoke the well-known descriptive power of photography in the minds of the readers, allowing each viewer to imaginatively interpret these bland transcriptions of the originals. In the pages of *Harper's Weekly* these images were moving, but not shocking.

Besides the civilian interest in images of battles and individual participants, the official military hierarchy represented one of the most important—and least analyzed—markets for Civil War photographs. This interest stemmed naturally from the military's need for precise information of all kinds; during the war, the various branches of the military commissioned a significant quantity of photographs, most of which were sent to Washington to supplement official reports. The army's particular enthusiasm for photography may also reflect the training in both science and aesthetics that leading officers received at West Point.

The program of the United States Military Academy at West Point significantly influenced both documentation of the Civil War and the nature of the war itself. Most leading officers on both sides had graduated from the Academy, which from its inception in 1802 had been under the direction of the army's Corps of Engineers. The curriculum was heavily weighted toward such technical and scientific disciplines as mathematics, chemistry, natural philosophy (mechanics, acoustics, optics, astronomy), mineralogy, and geology. In the final year, Professor Dennis Hart Mahan's popular course on "Military and Civil Engineering and the Science of War" provided the fundamentals of civil engineering: architecture, stone cutting, and permanent and field fortifications. The Academy's program in this period was clearly "to produce engineers capable of military command, rather than officers with engineering skills," and upon graduation, the best students almost invariably entered the elite Army Corps of Engineers.[76] As one member of the class of 1848 noted, "we were taught with every breath we drew at West Point . . . that the engineers were a species of gods."[77]

Prior to 1860 the War Department used its engineering expertise to undertake a variety of important projects across the nation. Army engineers made surveys for innumerable roads, canals, and rail lines, and planned and executed numerous river and harbor improvement projects. They designed and erected lighthouses, customhouses, and post offices. In Washington, military engineers supervised such important projects as the extension of the Capitol and the Washington Aqueduct. An elite branch of the Army's engineering ranks, the Corps of Topographic Engineers[78] (officially founded in 1838 and merged back into the Corps of Engineers in 1863) operated in every state and territory of the nation. This corps was instrumental in mapping and accurately describing the Great Lakes, the Ohio, Mississippi, and Tennessee rivers, and the western frontier; establishing the national boundaries; and conducting many surveys for transportation routes. All of these activities required precise visual information of all kinds—in maps, sketches, and

photographs—and the training at West Point was weighed toward providing engineers with the technical and scientific skills they would need.

Nonetheless, the curriculum of the military academy sought to unite technical and analytical knowledge with the refined artistic tastes of the gentleman and connoisseur. Courses in French, drawing, and ethics (constitutional and international law and logic) rounded out the typical cadet's classroom experience at West Point,[79] and in 1842 a group of students and faculty members formed a club "to cultivate a taste and knowledge of music" and to perform concerts throughout the winter months.[80] Accomplished professionals taught courses in mechanical, figure, and topographic drawing in the second and third years of study. One of these instructors, the painter Robert Walter Weir, was a friend of such noted American artists as Horatio Greenough, Washington Irving, Samuel F. B. Morse, Washington Allston, and Rembrandt Peale.[81] Another drawing instructor, Captain Truman Seymour, later contributed sketches to *Harper's Weekly* in early 1861. A number of students, including future generals Samuel P. Heintzelman and Montgomery C. Meigs, greatly enjoyed these classes and produced drawings of superb quality.[82] No sharp division was perceived between fine and applied arts; it was felt, for example, that pictures could be (and indeed, *should* be) at once beautiful and informative.

Volumes acquired for the academy's library in the decades prior to the war reflect this broad interest in the technology, application, and aesthetics of picture-making. Among the library's numerous books on painting, sculpture, and aesthetics were Ruskin's *Stones of Venice, Seven Lamps of Architecture, Modern Painters,* and *Pre-Raphaelitism.* There were also numerous publications on optics, photography, and art. Professor William Bartlett's *An Elementary Treatise on Optics* (1839), written as a textbook for his West Point classes, included chapters on the camera obscura and camera lucida; the latter, he emphasized, "is of great assistance in drawing from nature."[83] Appropriately, the library acquired a copy of Captain Basil Hall's *Forty Etchings, from Sketches Made with the Camera Lucida, in North America, in 1827 and 1828* (London: 1829), and in the 1850s a number of photographic manuals, Henry Hunt Snelling's *Photographic and Fine Art Journal,* and the monumental *Exhibition of the Works of Industry of All Nations, 1851: Reports by the Juries* (London: 1852).

Given the artistic and technological information available to the Academy's staff and students, it was natural that photography became a subject of considerable interest. One of the academy's most distinguished instructors was Jacob Whitman Bailey (1811-1857), who taught courses in chemistry, mineralogy, and geology and analyzed many of the samples sent back from the army's western surveys. A man of broad artistic interests, who read Goethe and Ruskin and frequented art exhibitions in New York City, Bailey apparently also experimented with the daguerreotype process at least as early as 1852 and may have taught the process to his fellow professor, Robert Weir.[84] Another professor, Edward C. Boynton (1824-1893), worked as an amateur photographer in the 1850s, first at West Point (until 1855) and then at the University of Mississippi (1856-61). Boynton made photograms of leaves, records of campus buildings and his laboratory, and portraits of friends, and later wrote on the military applications of photography.[85] At least one other prominent member of the West Point faculty, Theophile Marie D'Oremieulx (1815-1881), had an early interest in photography, and while it is not known whether he personally made photographic images, he was a close friend of Victor Prevost (1820-1881), an important early practitioner of the paper process in America. Prevost visited D'Oremieulx at West Point at least as early as 1854 and, with a camera of about eleven-by-fourteen-inch format, made scenic and architectural views of the area.[86]

This broad interest in the art and science of visual representation resulted in a mode of military picture-making characterized by both mathematical objectivity and aesthetic sophistication. The operational importance of military sketches and photographs derived primarily from their clarity and accuracy. However, professional standards of visual depiction also required that raw facts be shaped by aesthetic considerations.

Military pictures performed a consistently didactic function. Students and professional soldiers alike studied maps and photographs of battlefields to better understand the complexities of particular engagements and thus to be optimally prepared for life-and-death decisions in future conflicts. Similarly, pictures of forts, bridges, and artillery

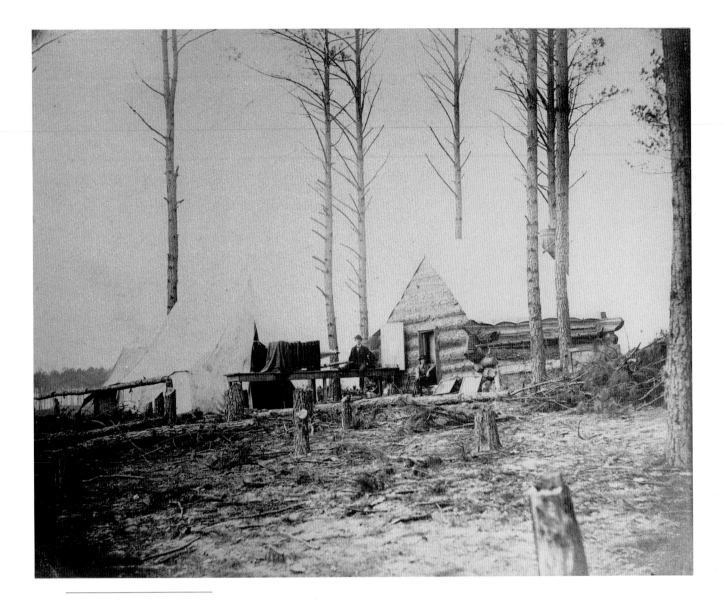

Figure IV-16

PHOTOGRAPHER UNKNOWN.
Quarters of Photographers Attached to Engineer Corps, Army of the Potomac. Albumen silver print, c. 1862-64. U.S. Army Military History Institute, Carlisle Barracks Pennsylvania.

batteries were important because they demonstrated accepted techniques of construction and deployment. The military use of photography in the Civil War developed naturally from the preexisting martial tradition of maps, diagrams, sketches, and prints. These diverse modes of representation served many functions, all centering on the desire to record militarily significant data with precision and craft.

The war with Mexico was documented in impressive collections of lithographs (now contained in the West Point Museum). One, the *Army Portfolio*, published in 1847, included five large (approximately twelve-by-nineteen-inch image size) lithographs by Captain Daniel P. Whiting, an 1832 graduate of the Academy who served in the war with the Seventh Infantry. Each of his views bears a precise title emphasizing the eyewitness nature of the representations.[87] Another, *The War Between the United States and Mexico Illustrated* (1851), contains a dozen beautifully rendered color lithographs after drawings by Carl Nebel. While Nebel apparently was not an eyewitness to the battles portrayed, he visited most of the sites later and carefully reviewed accounts by eyewitnesses as he created his drawings. The academy also acquired pictorial documents relating to the Crimean War: William Simpson's *The Seat of War in the East* (1855), which contained eighty-one large (approximately 11 by 15-1/2-inch image size) lithographic scenes rendering detailed views of battlefields, entrenchments, and ruins in a decidedly romantic and picturesque style;[88] and a simpler set of lithographed drawings by M. A. S. Biddulph, published as *A Series of Topographic Sketches of the Ground Before Sevastopol* (1855).[89]

Most of the views in these and similar publications presented elevated, panoramic, and wondrously unobstructed vistas of troops, battlefields, and field fortifications. This

vantage point of omniscient objectivity suggests a synthesis of two related experiences: that of an ideally located eyewitness in the actual landscape and of an analyst contemplating a map of the scene. The Academy's textbooks on topographic drawing outlined clearly the need for such views: "Every topographical drawing addresses itself to the eye as if the spectator were situated above [the scene depicted], and looking down equally upon every part of it . . ."[90] This vision would be evoked in countless Civil War landscapes and panoramas.

The first official military use of documentary photography appears to have been in a report on the Crimean War. In 1855 the U. S. War Department sent three officers to the Crimea to observe and report on the conflict: Majors Richard Delafield and Alfred Mordecai and Captain George B. McClellan, all noted West Point graduates. After a lengthy tour of Europe and a twenty-five-day visit to the battleground itself, the team returned to the United States to compose lengthy reports in their areas of individual specialization (fortifications, ordnance, and army organization, respectively). Accompanying the reports were thirty-one photographs of Sevastopol and vicinity, probably taken by Englishman James Robertson, which supplemented the team's eyewitness examination of the area and provided data on topography and the design of fortifications.[91]

The Crimean War was also the first to apply the photographic process to military surveying and map-making and to replicating other official documents. These engineering-based applications became increasingly important during the American Civil War. The photographic duplication of various documents, for example, allowed for rapid and inexpensive reproduction of accurate maps for the Union's large and highly mobile armies; albumen-print photographic copies could be produced with less labor and expense than lithographed maps.

The actual process was very simple. Original topographic renderings were tacked flat to a vertical surface (usually an exterior wall in direct sunlight) and photographed with a large-format camera (FIG. 16). These glass negatives (often eighteen by twenty-two inches in size) were then sun-printed in the normal manner, in contact with a sheet of albumen paper, to make sepia-colored positive copies. Large maps could be photographed in several parts, with copies subsequently pieced together from corresponding prints. This process allowed for rapid updating: when new information was added to the topographer's original drawing, a fresh negative and revised positive prints could be produced within hours.

In an even more basic method, photo copies could be made without a camera: the original drawing, on translucent or oiled paper, was printed in contact with albumen paper to make a negative paper print. Such negative copies (white lines on a dark ground) could be issued directly to the field or be used in turn to produce positive copies. This process invariably produced renderings inferior in quality to those from glass negatives, and the technique was very inflexible because copies could only be made the same size as the original. However, the simplicity and immediacy of the process made it invaluable in the field.

Some of the most noted photographers of the war devoted much of their time to map-copying. Alexander Gardner, for example, was employed in 1862 by the Department of Topographic Engineers attached to General McClellan's Army of the Potomac. George Barnard probably assisted Gardner in this work and was subsequently hired by the Department of Engineers, Military Division of the Mississippi, to perform similar duties in Nashville. Other photographers also worked to meet the demand for duplicates of renderings and drawings. In the Treasury Department, Lewis E. Walker was "constantly busy" copying drawings and maps for the Office of the Architect and other federal departments. In his work with the direct paper-negative process, Walker made duplicate prints at least as large as 24-1/2 by 36-1/2 inches in size.[92] In the Coast Survey Office, photographer George Mathiot copied numerous maps on twenty-four-by-twenty-four-inch glass negatives. The lens used for this work was so perfect that Mathiot observed no deviation from the original renderings greater than 1/200 of an inch.[93] The military routinely used photographic copies of architectural drawings and mechanical plans; it was reported in early 1864, for example, that "all the Northern engineering establishments building engines for the navy worked from photographic copies of the chief engineer's drawings."[94]

Photography also had its applications in materials research. Captain Thomas J. Rodman of the Ordnance Department used the camera to record his tests of the tensile strength of iron. Investigating methods of casting and cooling unusually large cannons, he subjected iron samples to tests of compression and explosion and carefully photographed the resulting fractures. These images were the basis for illustrations in Rodman's "valuable work on the subject of metal for cannon and on gunpowder."[95]

In addition to its usefulness in copying such documents, photography was an important aid in creating more accurate maps. In the early months of 1864, for example, George Barnard photographed Chattanooga and Knoxville at the request of Captain Orlando M. Poe, a West Point graduate and Topographic Engineer, who referred to these photographs while completing maps documenting the decisive battles of Chattanooga (November 23-25, 1863) and Knoxville (November 26-December 4, 1863). Using the topographer's characteristic elevated viewpoint, Barnard made a number of multi-plate panoramas in both areas. The largest of these was a seven-plate, 360-degree view of Knoxville and its surroundings taken from the cupola of the University of East Tennessee. These prints were subsequently submitted with Poe's official reports and reproduced as engravings in the atlas of the *Official Records*.[96]

The Department of Engineers also used field photography to record subjects of technical or strategic interest. When Richard Delafield went to the Crimea as an observer in 1855, Secretary of War Jefferson Davis instructed him to pay particular attention to such subjects as "the construction of permanent fortifications . . . the kind and quantity of ordnance . . . the engineering operations of a siege in all its branches, both attack and defense . . . and the construction of casemated forts, and the effects produced on them in attacks by land and water."[97] As head of the Department of Engineers during the Civil War, Delafield commissioned photographs of similar subjects from a variety of sources. In late 1863 and early 1864 his department in Chattanooga employed photographers H. Goldsticker and R. M. Cressey to record bridges, railroad lines, and battlegrounds (Fig. 17). In Atlanta in the summer of 1864, George Barnard exhaustively documented the former Confederate and new Union fortifications surrounding the recently captured city.[98] Delafield's officers in other areas of the occupied South hired local photographers to do similar work; for

Figure IV-17

R. M. Cressey. *Rail Road Bridge Across Chattanooga Creek, Chattanooga, Tenn.* Albumen silver print, c. 1863-64. U.S. Military Academy, West Point.

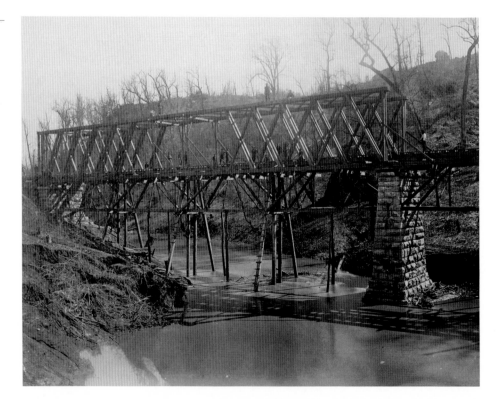

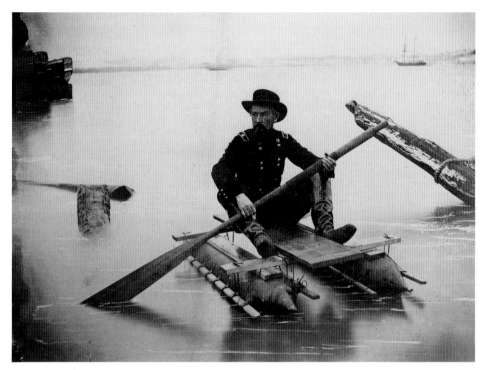

Figure IV-18
Andrew J. Russell. *General Herman Haupt Crossing Stream on a Pontoon.* Salt print, March 1863. J. Paul Getty Museum.

example, two teams of New Orleans photographers—McPherson and Oliver, and Gustave Moses and Eugene Piffet—were commissioned in 1864 to photograph Fort Morgan, in Alabama.[99] These and similar views were shipped back to Delafield in Washington as supplements to official reports.

Another important source of Civil War photographs was the Bureau of the U. S. Military Railroads. Between April 1862 and September 1863 this department was headed by the brilliant Herman Haupt (Fig. 18). An 1835 West Point graduate, Haupt entered a prestigious civilian career in railroading as a surveyor. Within a few years he began experiments in the engineering principles of bridge design and published several books on the subject.[100] Secretary of War Edwin Stanton called Haupt to Washington in early 1862 to reconstruct the Richmond, Fredericksburg and Potomac Railroad and to impose order on the Union's chaotic rail system as a whole. Haupt succeeded on both counts, bringing the trains closer to schedule (and thus conveying troops and supplies with unprecedented efficiency), and performing near-miracles as his men constructed bridges and lay track with astonishing speed.

Haupt ingeniously applied theory to real-world problems. He efficiently organized his staff and workers into a full-time Construction Corps organized on the industrial principle of the division of labor, with workers assigned to specific tasks based on their own skills and interests. Haupt further motivated his units of workers to compete against themselves in completing their assigned tasks. This corps reached its highest level of effectiveness when temporarily detailed soldiers were replaced by a full-time civilian workforce of "contrabands," or escaped slaves.

Haupt's research and instructional interests constituted a vital aspect of his wartime service. He began working on the manuscript for *Military Bridges*, a lengthy practical guide for staff officers, in January 1863. Between assignments he used his men to conduct a series of related investigations into problems of military engineering. These experiments involved the construction of bridges, floating docks and warehouses, and many tests of rail line construction, repair, and destruction. To document these investigations, Haupt located a camera and detailed the services of artist and photographer Andrew Joseph Russell, a captain in the 141st New York Volunteers who transferred to Haupt's headquarters in Alexandria, Virginia, in February 1863.[101] In addition to his photographic assignments, Russell served as "acting Quartermaster for the Military Railroad Construction Corps,

Figure IV-19

ANDREW J. RUSSELL. *Experimental Bridges.* Salt print, 1863. U.S. Military Academy, West Point. Caption in original album, plate 25, reads: "a truss for military bridges...composed of boards nailed and spiked together. The span is 60 feet, the height of truss 6 feet. The form is that of a fish or two arches curved in opposite directions. The lower arch is composed of six boards, the upper arch of five....These trusses were tested by forming a bridge of two of them, which was loaded with railroad iron until it broke...with 108,000 lbs."

Figure IV-20

ANDREW J. RUSSELL. *A Successful Attempt to Bend and Break Rails.* Salt print, 1863. U.S. Military Academy, West Point. Caption in original album, plate 53, reads: "A Rail was placed parallel to, and in contact with, one of the rails of the track; three spikes were then driven about three feet from the end to serve as a fulcrum; ten men carried the rail around, bending it at the place where it was spiked, and finally breaking it at that point."

ordnance officer of the military railroads, and occasional painter of railroad cars and engines."[102] Russell hired Baltimore photographer Egbert Guy Fowx as an assistant for three months, paying Fowx's hundred-dollar monthly salary from his own pocket and receiving only his regular captain's pay for his own varied labors.[103] Russell apparently agreed to these terms with the understanding that he would retain possession of the negatives he made.[104]

In the spring and summer of 1863, Russell remained busy photographing for Haupt at Alexandria and in the field, exhaustively recording Haupt's experiments with portable "blanket boats" (simple wooden frames covered with waterproof canvas or india rubber blankets) and prefabricated bridge trusses (FIG. 19).[105] He photographed devices for loosening and twisting rails (FIG. 20), as well as Haupt's innovative techniques for straightening

bent rails. Experiments with small explosive devices called "bridge torpedoes" were also conducted and documented.

Russell journeyed from Alexandria to record such subjects as the celebrated four-hundred-foot span over the gorge at Potomac Creek, which Haupt had constructed in only twelve days;[106] a trestle bridge across Bull Run Creek; and the aftermath of a March 28 train wreck. In the early days of May he also accompanied Haupt to the battlefield of Fredericksburg and, one day after the engagement of May 3, 1863, made his well-known images of an exploded artillery wagon and Confederate dead along the stone wall at Marye's Heights (see PLATE 42).[107]

Haupt liberally distributed Russell's photographs as soon as prints could be made. Fifteen sets of twenty-six pictures were issued on April 11, 1863, and by July 18 four additional groups had been produced, for a total of at least sixty-two different views and nearly 2500 individual prints. Varying quantities of these photographs were delivered to President Lincoln, the Secretaries of War and the Treasury, the "Admiral of [the] Russian fleet," and many military leaders, including Generals McDowell, Meade, Meigs, Hooker, Grant, Rosecrans, Burnside, and Heintzelman. Much of this high-level distribution was made by Haupt's superior, General H. W. Halleck, who also kept prints for himself.[108] Haupt dispersed these photographs for both political and didactic ends: to ensure high-level support for his work and to promote innovative techniques in military engineering.

A set of eighty-two of these experimental and instructional photographs was completed by the end of August 1863, just prior to Haupt's return to civilian life. The general's final report to Secretary of War Stanton, dated September 9, 1863, was accompanied by a "scrapbook" of these prints. Russell spent the following months producing these photographs in quantity while Haupt oversaw the printing of a twenty-seven-page pamphlet explaining each image. The resultant volume, entitled *Photographs, Illustrative of Operations in Construction and Transportation, As Used to Facilitate the Movements of the Armies of the Rappahannock, of Virginia, and of the Potomac, Including Experiments Made to Determine the Most Practical and Expeditious Modes to be Resorted to in the Construction, Destruction and Reconstruction of Roads and Bridges*, was distributed among leading generals in early February 1864, and by midmonth at least twenty-nine copies had been produced.[109] This album— at once an expensive, hand-assembled collector's item and a utilitarian military field manual—is important for its precise documentation of military engineering and its use of photography for instructional purposes.

At the end of Russell's first year of service in the Military Railroads Bureau, nearly six thousand prints had been produced and distributed (with orders for another three thousand remaining to be filled). By Russell's estimate the prints already delivered would have cost $7000 at standard trade prices, but he had produced them for the cost of camera, chemicals and paper, or scarcely more that $150 per month.[110]

While the pace of his work slowed somewhat with the completion of Haupt's album, Russell continued photographing for the Bureau of Military Railroads through the summer of 1865. In this time he made numerous large-format views in and around Alexandria, on the James River, at Dutch Gap Canal, in Washington, D.C., and elsewhere. In the weeks following the end of the war, he worked extensively in the ruined cities of Petersburg and Richmond.[111]

The use of photography for the documentation of techniques and experiments of various kinds was not limited to the Department of Engineers or the Bureau of Military Railroads. The U.S. Army Military Medical Department used the medium for similar purposes, constituting yet another important official source of war photographs. This department had numbered only 114 officers before the war but steadily expanded in size and influence as the conflict progressed.[112] The Medical Department, often in concert with the Sanitary Commission, developed a network of hospitals, ambulance corps, rehabilitation camps, and nursing services to care for an enormous number of sick, dying, or crippled soldiers. The war posed an enormous challenge to the medical profession of the 1860s: surgical techniques were extremely crude, diseases little understood, and the demand for medical services unprecedented.

Like their counterparts in other branches of the army, medical officers carefully documented the nature of this new war and the effectiveness of their methods of coping with its demands. To aid this historical and analytical effort, the Surgeon General of the Medical Department established the Army Medical Museum in 1862 to collect and study "all specimens of morbid anatomy, surgical or medical, which may be regarded as valuable; together with projectiles and foreign bodies removed, and such other matters as may prove of interest in the study of military medicine or surgery."[113] Commissioning and collecting photographs was an important part of the new institution's activity. A photographer accompanied the museum's first curator, Dr. John Hill Brinton, as he visited many field hospitals, and Brinton's successor, Dr. George Alexander Otis, oversaw the production of additional quantities of photographs. Physicians in outlying hospitals regularly contributed "photographic representations of extraordinary injuries . . . operations or peculiar amputations"—usually the work of local civilian photographers and typically made in the carte-de-visite format.[114]

The Museum's own photographic department was headed by William Bell. In mid-1866 the editor of the *Philadelphia Photographer* visited Bell and described his operations:

> A nicely arranged and convenient *atelier* adjoins the Museum, and all the conveniences of a well-regulated, first-rate gallery are there. . . . [T]he principal work of the photographer is to photograph shattered bones, broken skulls, and living subjects, before and after surgical operations have been performed on them. Of course, all these subjects were created by the war. In most cases the fatal ball is plainly visible in the bone that it had caused to be shattered and broken. . . . These bones are photographed principally to aid the engraver in making wood-cuts for the illustrations of works upon army surgery. We were shown some photographs of the wounded, before and after operations had been performed on them, and certainly photography is the only medium by which surgery could so plainly make known its handiwork. We saw a picture of one poor fellow as he came from the field, with his face almost torn asunder by a shell. After surgery had exercised its skill upon him, he was again photographed, and looked much better than any one could be expected to look with his lower jaw gone. We passed hastily through the Museum of mounted bones and shattered limbs. . . .[115]

When Bell left Washington in 1872 to accompany Lt. George Wheeler's survey to Utah and Arizona, his assistant, Edward J. Ward, assumed his duties at the Medical Museum.

Unlike other military photographic units, the Medical Museum's staff remained very active after the war. In many instances wounded soldiers first photographed and treated during the conflict were rephotographed in the late 1860s and 1870s as medical officers monitored their condition. Some of these later photographs were made as proof of disability for pension applications. These varied images were collated and circulated in several forms. The seven-volume *Photographic Catalogue of the Surgical Section of the Army Medical Museum*, begun in 1865, contained detailed case histories and fifty tipped-in albumen prints, four by six inches in size or larger, made from Bell's original ten-by-twelve-inch negatives. The monumental *Medical and Surgical History of the War of the Rebellion*, issued in six volumes between 1870 and 1888, contained thousands of engravings based on photographs, photomechanical illustrations by the heliotype process, and a few tipped-in woodburytype prints.[116]

Civil War medical photographs display an appropriately clinical approach to their subjects, who are usually displayed as dispassionately and objectively as machine parts. However, this "scientific" stance seems frequently at odds with the often grisly subject matter of these images. Unlike any other genre of Civil War photography, medical views are characterized by the immediacy of the close-up, producing an odd pictorial combination of emotional detachment, an unnerving physical intimacy, and a vision of formal (and often physical) fragmentation. The strangeness of these images (for laymen, at least) is compounded by the arcane language of such titles as "Aneurism of the Innominate Artery" and "Successful Intermediate Excision of the Head, Neck and Trochanters of the Right Femur." It was precisely this deadpan, documentary precision, however, that made such photographs useful (FIG. 21).

Figure IV-21
WILLIAM BELL. *Gunshot Wound of Left Femur*. Albumen silver print, 1865-67. Gilman Paper Company.

In addition to these most common examples of medical photography, photographers in the field documented nurses and ambulance workers in action, techniques of surgery and embalming, and made group portraits of medical personnel. At Douglas Hospital in Washington, doctors began pioneering work in photomicrography in 1864, achieving magnifications of 7000 power.[117] Other photographers paid particular attention to hospitals, which were consistently celebrated as evidence of a progressive and humane society. Such views produced for public sale included a series of army hospital interiors by Mr. Creemer, of the International Stereoscopic Company, and four-by-five-inch prints of a large military hospital near Philadelphia by John Moran.[118]

Perhaps the most important and enthusiastic patron of military photography was Montgomery C. Meigs, the Union Army's Quartermaster-General. At West Point, Meigs greatly enjoyed his classes in both drawing and engineering.[119] In 1853 he was placed in charge of engineering duties on two prestigious and complex projects: the extension of the national Capitol and the construction of the Washington Aqueduct. Meigs planned the foundation for the Capitol addition, designed the heating, ventilation, and acoustical systems, and oversaw the construction of a new dome.[120] Since his duties included the decoration and adornment of the Capitol, Meigs became an expert in art, reading widely on the subject, visiting galleries in New York and Philadelphia, and consulting critics and collectors before commissioning numerous paintings and sculptures for the new building. Meigs even designed the chairs for the new congressional chambers. These were widely admired for

their solid and distinguished style and were used by the Brady and Gardner galleries for prestigious portraits.[121]

Meigs also was an avid amateur photographer in the late 1850s. Working primarily in the stereo format, he conducted technical experiments with the wet-collodion process and made numerous scenic photographs and views of architecture and machinery.[122] Many of these images record aspects of his work on the capitol and aqueduct projects in 1859. These straightforward photographs combined Meigs' technical, aesthetic, and professional interests, and it is recorded that Meigs "considered three stereographs of a machine better than the most elaborate model."[123] Meigs also photographed his family at home and on picnic outings and made occasional records of newsworthy events, including the March 4, 1861, inauguration of Lincoln on the steps of the unfinished Capitol (FIG. 22).[124]

Through these interests Meigs became friends with such leading photographic personalities as Edward and Henry Anthony and Coleman Sellers, all of whom, interestingly enough, shared a background in civil engineering. The Anthonys had worked on the Croton Aqueduct in New York prior to entering the photographic profession, while Sellers—an amateur photographer and writer—earned his living as an engineer in Philadelphia. Meigs was also friends with such Washington photographers as Alexander Gardner and the U. S. Patent Office's Titian R. Peale, one of the city's most prominent amateurs.[125]

Meigs became Quartermaster-General of the U. S. Army in June 1861 and performed a difficult job brilliantly. His department was responsible for the procurement, transport, and storage of a vast array of essential items, including uniforms, shoes, blankets, tents, horses, forage, and wagons. As the war progressed, the Federal armies required the unimpeded flow and efficient storage of unprecedented quantities of supplies. A hundred-thousand-man army in enemy territory, for example, required six hundred tons of supplies per day. Meigs oversaw the expenditure of $1.5 billion, nearly half the total direct cost of the Union's war effort.[126] Meigs also served as a member of the War Board, a high-level group of officers who advised the Secretary of War on overall strategy. He thus had a uniquely broad, technical, and logistical understanding of the entire war effort.[127]

With his personal enthusiasm for photography, his contacts throughout the profession, and his powerful position in the military, Meigs played a vital role in the photographic documentation of the war. During the war years he collected photographs from the Anthonys, the Brady and Gardner galleries, and the military itself. In at least the final year of the conflict, he also directly commissioned original work.

Meigs sought in these images a comprehensive visual record of what he, as an engineer and logistical genius, understood as the heart of the war effort: a radically innovative system for the production, transportation, and storage of unprecedented quantities of supplies. Meigs, like others in his culture, continued to celebrate individual valor and initiative. However, the first war of the industrial era was, to an important degree, a war of numbers and abstractions: quantities of men and materiel, speed of production and conveyance, and engineering principles of structure and efficiency. The precision and rapidity of photography made it particularly useful for documenting such information.

Despite the demands of his official duties, Meigs kept abreast of the photographs that various departments of the military forwarded to Washington. In April 1864, for example, he saw the views of Chattanooga that Barnard had made for the Department of Engineers. Meigs found these images "interesting and beautiful" and wrote General Sherman in Nashville to inquire about the set and Barnard's more recent photographs of that city and Knoxville. He requested two sets of each group, "one for my office and one for myself."[128] The prints were sent immediately, and Barnard's supervisor, Captain Poe, noted in a letter to Meigs that "the deep interest you have always taken in military photography is well known."[129]

Meigs was so impressed by these prints that he requested permission for Barnard to take time from his normal duties to photograph for the Quartermaster's Department. At this time Nashville lay at the heart of the great build-up to the Atlanta Campaign. Enormous quantities of military supplies were being stockpiled in the city, and the Quartermaster's Department alone employed over fifteen thousand men there.[130] After Meigs' request was approved by General Delafield, the head of the Department of Engineers, Barnard worked intermittently on this assignment in the summer of 1864, recording storage warehouses and railroad depots in Nashville under the direction of Meigs' department (FIG. 23).

Figure IV-23
GEORGE N. BARNARD.
*Quartermaster's Buildings,
Nashville, Tenn.* Albumen silver
print, 1864. U.S. Army Military
Academy, West Point.

Meigs directed the work of at least four other photographers in 1864-65: A. J. Russell, Jacob F. Coonley, Samuel A. Cooley, and Thomas C. Roche. Coonley and Roche's services were obtained through the Anthony firm, Russell's through the Bureau of Military Railroads, while Cooley appears to have corresponded directly with the Quartermaster-General. Each of these photographers produced significant bodies of work in separate theaters of the war.

On June 18, 1864, Meigs requested through Russell's superior that the photographer make "both views and stereographs . . . showing the present condition of all buildings within the limits of the new military cemetery at Arlington, to be forwarded to this office when ready."[131] Russell may also have photographed a series of Union vessels on Meigs' orders.[132]

Jacob F. Coonley traveled considerably farther afield in his work for the Quartermaster's Department. Coonley, who had been introduced to photography by George Barnard in 1856-57, had begun working for the Anthony firm in 1858. When General Meigs contracted with the Anthonys in mid-1864 to send photographers to both the eastern and western theaters of the war, Coonley was selected for the latter assignment and instructed to make large-format views of "all bridges, tressles [sic], buildings, boats, etc., that were under [the] control, built or operated by" the Quartermaster's Department. The Anthony firm also paid Coonley five dollars each for "all the stereoscopic negatives I could make on the trip."[133]

Coonley traveled back and forth along the railroad lines connecting Louisville, Nashville, Chattanooga, Knoxville, and Atlanta in a specially equipped boxcar outfitted with darkroom facilities, a kitchen, and sleeping quarters for up to five men. Coonley later recalled that his work was frequently interrupted by the appearance of enemy cavalry or the destruction of track and bridges. He covered hundreds of miles in the fall of 1864, returning east shortly after witnessing the Battle of Nashville on December 15-16, 1864.

Figure IV-24
SAMUEL A. COOLEY. *Self-Portrait with Staff.* Albumen silver print, c. 1864. U.S. Army Military History Institute, Carlisle Barracks, Pennsylvania.

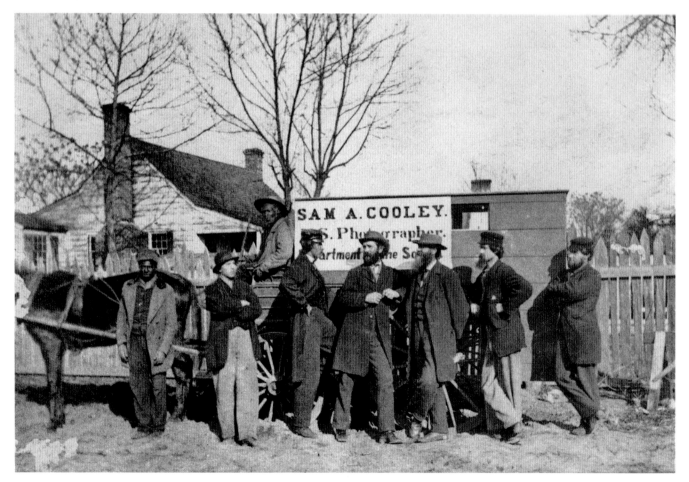

Samuel A. Cooley worked extensively for Meigs in late 1864 and early 1865, billing himself as "U. S. Photographer, Department of the South" and working primarily in the shoreline areas of South Carolina and northern Georgia then under Union control (FIG. 24). From Beaufort, South Carolina, on December 20, 1864, the photographer sent General Meigs a set of "albumen and plain photographs of all Public Buildings owned or occupied and vessels owned or chartered, by the United States in [the Quartermaster's] Department, to which I could gain access." The great majority of these were made at Beaufort and on Hilton Head Island. Included in the same package was a group of stereo views for Meigs' "private use." Cooley noted at that time that his men were busy recording Forts Pulaski and McAllister, on the Georgia coast, and that he would have them photograph "in Savannah and vicinity" if so instructed.[134] Cooley sent Meigs an additional package of stereo and full-plate views on January 9, 1865, with a bill for $2,670. Another large shipment from Cooley, with an invoice for $2,440, was received in Washington on March 8. The bulk of this latter group of 1475 prints was devoted to 244 sets of six prints ("2 mounted and 4 plain").[135] These quantities suggest that Meigs intended to distribute these sets widely to friends and officials.

In the last month of the war Thomas C. Roche was also employed to produce views under the "special orders" of General Meigs.[136] Roche, who had begun in photography as an amateur in 1858 and developed a close professional relationship with the Anthonys in 1862, was given several important assignments at the front. He photographed at City Point, Virginia, in early April 1865, producing views of "Barracks, Hospitals, Transports, & c." for Meigs, and then worked in the recently occupied cities of Petersburg and Richmond in May.[137] In all, Roche "secured several hundreds of 10 x 12 negatives for government use, and at the same time [made] thousands of stereoscopic views of war scenes, etc., for the Messrs. Anthony."[138]

Meigs' enthusiasm for military photographs continued after the conclusion of the war; for example, he bought copies of both the Gardner and Barnard albums in 1866. Meigs loved photographs, and his systematic commissioning of documentary images made him the medium's most important official patron during the war. His example undoubtedly encouraged an increased respect for photography at various levels of the military hierarchy, and his contacts with important civilian photographers raised the profession's awareness of, and pride in, the government's unprecedented use of their medium.

The end of the war brought immense relief to a war-weary nation and a brief renewal of civilian interest in historical photographs. The general market for war images seems to have slackened as the conflict dragged on, far longer and bloodier than anyone could have imagined in the spring of 1861. After the numbing duration of the war, the events of April and May 1865 occurred in rapid and bewildering succession: the occupation of Richmond and Petersburg on April 3, the surrender at Appomattox on April 9, the shooting of the president on the evening of April 14 and his death early the next day, Lincoln's mourning procession in the capital on April 19 and the departure of his funeral train for Illinois on April 21, the death of the assassin Booth on April 26, the capture of former Confederate President Davis and his staff on May 10, and the grand review of the Army of the Potomac in Washington on May 23. On June 30 the eight Lincoln conspirators were pronounced guilty, and four were hanged a week later.

The euphoria and tragedy of these weeks stimulated a flurry of photographic activity. Copyright records for the Washington, D.C., district court reveal the nearly instantaneous response of photographers to these dramatic events. On April 13 Brady registered three panoramic views of the ruins of Richmond, as well as portraits of the most respected Confederate generals, Robert E. Lee, Joseph E. Johnson, and Thomas J. ("Stonewall") Jackson; once the war was over, the trade in such portraits was apparently considered a matter of objective history rather than the celebration of unpatriotic foes. On May 1 Brady registered a portrait of President Johnson and seven portraits of the soldier credited with shooting John Wilkes Booth. On May 17 Alexander Gardner copyrighted three portraits of Johnson, two of Lincoln, and six of "Payne, alias Wood, alias Hall, arrested as an associate of Booth in the Conspiracy." In June at least two firms registered interior views of the

courthouse in which the conspirators were being tried.[139] Grant, Sherman, and other noted Union generals also were persuaded to sit for numerous formal portraits in these weeks.

The nation's photographers gave enormous attention to Lincoln's death and funeral (FIG. 25). On May 22, 1865, Coleman Sellers noted with only slight exaggeration:

> During the past month the whole labour of photographers has been in one direction—the collection and reproduction of portraits of Mr. Lincoln, and pictures of the localities and incidents connected first with the fearful tragedy itself, and then with the sublime spectacle of the funeral train passing over a route of more than a thousand miles to the final resting place in the distinguished dead amid the prairies of Illinois. In each city photographers have been reaping rich harvests from their pictorial representations of the funeral cars and instantaneous pictures of the various processions . . .
>
> Photography has furnished countless pictures of Mr. Lincoln, to be worn as badges and preserved as mementos of our late revered President. . . . One original photograph—entitled *Mr. Lincoln at Home,* showing him, with one of his sons, in the act of looking over a photograph album—is having an immense sale.[140]

At the same time Northern photographers rushed to the conquered cities of Richmond and Petersburg to record blackened ruins newly rich with moralistic meaning. The Philadelphia team of Levy and Cohen visited Richmond in June and produced a series of images judged "excellent," embracing "all the points of historical interest." Collectors of "mementos of the war" were advised to pay particular attention to these views.[141]

Figure IV-25

JOHN P. SOULE. *Lincoln, Skeleton Leaves.* Still life arrangement by J. L. Rogers. Stereograph. Albumen silver print, 1874. T. K. Treadwell Collection.

The process of keeping the war alive in memory began on the day the South surrendered. The activities of photographers in the months after the war reflected this larger social process of remembrance and commemoration. The erection of monuments on battlefields and in cemeteries began within weeks of Appomattox. Seemingly endless numbers of historical studies, memoirs, biographies, and apologia poured from the nation's presses as participants and observers alike attempted to make sense of the previous four years. Journalists traveled through the occupied South to observe and report on its people, cities, and hallowed battlefields.

Figure IV-26
UNKNOWN PHOTOGRAPHER. *Portrait of James Taylor, Soldier and Artist.* Gelatin silver print, c.1890s. U.S. Military Academy, West Point.

Veterans of the war organized a great variety of associations to maintain ties and regularly share stories. Individual batteries, regiments, and entire armies subsequently held reunions, and specialized groups such as Union Ex-Prisoners of War and the Signal Corps Society were established. The Grand Army of the Republic, an umbrella organization open to all who served in the Union Army, held its first national convention in 1866 and reached a peak membership of 409,484 in 1890. Other important national groups such as the Military Order of the Loyal Legion of the United States were also established. Civil War reunions were held annually through 1951, when three ancient Confederate veterans gathered in Richmond for the last time.[142]

While the public's interest in military photographs waned as the war outlasted the idealistic enthusiasm of 1861-62, a group of devoted collectors emerged from among those intimately involved in the conflict. For example, James E. Taylor, who had spent two years as a private in the army before becoming a noted correspondent and sketch artist for *Leslie's*,[143] amassed not only swords, rifles, and canteens (FIG. 26), but also a large group of photographs, some of which were used as reference material for his drawings.[144] Men like Taylor constituted a sophisticated, well-to-do, and influential group of collectors fascinated by all types of war "relics."

The appreciation of war photographs was, in important respects, part of a larger subjective and interpretive process. After 1865 the innumerable details of the war resolved themselves in the popular mind into clusters of metaphor and symbol. The war itself had been so overwhelming, complex, and tragic that unadorned "facts" of any kind could not

explain its meaning. Despite (or perhaps because of) their apparent specificity, war photographs were effortlessly woven into this communal narrative fabric. Increasingly in the years after 1865 war photographs were used for purposes often quite different from those for which they had originally been made.

Within eighteen months of the war's end the elite and specialized audience noted above provided the market for two lavish photographic volumes: Alexander Gardner's *Photographic Sketch Book* and George N. Barnard's *Photographic Views of Sherman's Campaign*. Both volumes were sold "by subscription," by soliciting commitments from wealthy patrons prior to actual publication. It is likely in both cases that editions were limited to about 100 (or at most 150) copies, with sales guaranteed in advance for at least half the final edition. The postwar public disinterest in war photographs had no impact on the reception of these volumes, which were priced far beyond the means of the average citizen. The consistently repeated "fact" that these publications were commercial failures is highly questionable. Both works were conceived as luxurious, limited-edition items with edition sizes fairly closely matched to the number of actual buyers. In the absence of evidence to the contrary (such as advertisements for either volume being "remaindered" at drastic discount), it is likely that these enterprises were, in fact, commercially successful.

Gardner's *Sketch Book*—one hundred original albumen prints beautifully bound into two matching volumes—appeared at the end of January 1866 at a price of $150. Because of his special relationship with the Army of the Potomac, Gardner's volumes were limited to the eastern theater of the war, with primary attention given to the campaigns in Virginia and Maryland. The plates in the *Sketch Book*, each credited to both photographer and printer, were organized in roughly chronological sequence, beginning with the site of the war's first casualty and concluding with the June 1865 dedication of a monument at Bull Run. The result is a brilliant distillation and recontextualization of the thousands of war photographs originally made under Gardner's direction into an elegantly symmetrical narrative.

Each of these one hundred photographs was paired with a lengthy text that explained the historic importance of the scene depicted, along with anecdotes, poetic musings, and choice adjectives to enhance the meaning of the picture. For example, a tranquil photograph of an army encampment at Culpeper, Virginia (FIG. 27) was accompanied by a text bristling with images of dynamism and danger: "the pulsations of battle . . . have throbbed through its streets. Cedar Mountain, blazing with conflict, looked down upon it, and Grant . . . shook its spires with the roar of his guns." Similarly, the lengthy and informative text for a distant, static image of rows of parked wagons in album plate 64 suggested the "lively times" of "harness-sewers working to distraction, and blacksmiths punishing their anvils day and night . . ."

The complexity of Gardner's volume derives in large part from this deliberate and expansive combination of words and pictures. Each *Sketch Book* photograph documents with unimpeachable precision the particularities of a specific site as seen at a singular moment, while the accompanying texts provide a larger network of historical fact, interpretive judgment, and colorful anecdote. This visual/literary combination evokes a remarkable narrative movement in both time and space. Events before and after the photographed moment are suggested, as well as geographic spaces beyond the image's fixed frame. In its entirety, the *Sketch Book* represents a powerfully evocative balance of words and pictures, revealing Gardner's deep understanding of both.

Barnard's decision to produce his *Photographic Views of Sherman's Campaign* was undoubtedly influenced by the positive reception of Gardner's work.[145] Within weeks of the *Sketch Book*'s release, Barnard determined to produce an album of views devoted to General William T. Sherman's celebrated campaigns in the war's western theater. Barnard had been allowed to keep many of the large-format negatives he made during 1864-65 for the Military Division of the Mississippi. In a separate trip to the South in the spring of 1866 to supplement this group, he retraced Sherman's route from Nashville to Atlanta, Savannah, and Charleston. Returning to New York, Barnard spent the summer and early fall printing over one hundred copies each of the album's sixty-one photographs. A small volume of historical text, printed by letterpress, and several official campaign maps were

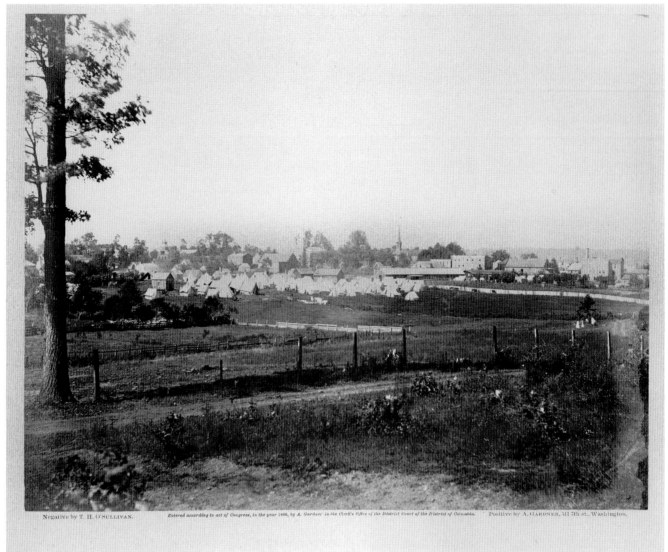

Negative by T. H. O'SULLIVAN. *Entered according to act of Congress, in the year 1866, by A. Gardner, in the Clerk's Office of the District Court of the District of Columbia.* Positive by A. GARDNER, 511 7th st., Washington.

CULPEPER, VIRGINIA.

Figure IV-27
TIMOTHY H. O'SULLIVAN.
Culpeper, Virginia. From *Gardner's Sketch Book of the Civil War.*
Albumen silver print, negative 1863, print 1866 by Alexander Gardner. Amon Carter Museum.

also included in each copy of the album. Barnard's large (twenty-pound) volume was completed in November 1866 and sold for one hundred dollars.

Oddly, the title of Barnard's album only approximates the subjects it surveys. A postwar studio portrait of Sherman and his generals is followed by fifteen plates depicting scenes in Nashville and Chattanooga associated most directly with the campaigns of 1863 directed by General U. S. Grant. Album plate 17 represents the first new territory covered in Sherman's move toward Atlanta after he assumed Grant's position as head of the Military Division of the Mississippi. Subsequent images document in geographic sequence the battlegrounds of Resaca, New Hope Church, Allatoona Pass, Kennesaw Mountain, and Atlanta. Eight plates are devoted to the defensive works around Atlanta and the city itself (see PLATE 46 in this volume), but Barnard did not record the legendary "March to the Sea." The reasons for this omission involve both the logistical difficulties of photographing on the march and, one suspects, Barnard's personal distaste for the acts of theft and violence perpetrated by Sherman's aggressive "bummers." The album concludes with photographs of Savannah, Columbia, and Charleston, and does not record the terrain covered in Sherman's subsequent movement into North Carolina.

Sherman's Campaign contains an unusual variety of subjects, including scarred battlefields, ruined buildings, scenic landscapes, and bridges, trenches, and forts. Over and above his rendering of historic sites, Barnard presents a complex symbolic meditation on history, memory, and aesthetics founded on a melancholy sense of time and cataclysmic

Figure IV-28

Geoge N. Barnard. *The "Hell
Hole" New Hope Church, Ga.*
From *Photographic Views of
Sherman's Campaign*, plate 27.
Albumen silver print, 1866.
Amon Carter Museum.

destruction. Barnard's subtle and immensely sophisticated album draws particular strength from its synthesis of uniquely American themes: the freedom, naturalness, and sacred beauty of the natural landscape, and a sense of cultural identity as revealed in a layering of historical incident. Many people of the time believed the Civil War had finally conferred on the American populace a much-needed pantheon of national heroes, dramatic narratives, and grand ideals. At the same time, however, the war's bitterness and bloodshed clearly had cost the nation a heavy price in lost innocence and optimism. In images of blasted trees and denuded ground Barnard suggests this complex and bittersweet new cultural maturity (Fig. 28). His landscapes become symbols of fierce battles, mangled bodies, and profound social dislocations. A troubling moral ambiguity also underlies these eerily silent images, suggesting that violence cannot long be maintained as a tool for justice. Many of Barnard's photographs suggest the aftermath of a whirlwind of brute force capable only of mindless, indiscriminate destruction.

It is difficult now to grasp fully the ways in which Civil War photographs were appreciated in their own time. The inherent truthfulness of the camera's transparent, minutely detailed descriptiveness was universally accepted. The "terrible distinctness" of images of the dead at Antietam, for example, was painfully apparent to all. On viewing stereographs of these scenes, Oliver Wendell Holmes confessed that "it was so nearly like visiting the battlefield to look over these views, that all the emotions excited by the actual sight of the stained and sordid scene . . . came back to us, and we buried them in the recesses of our cabinet as we would have buried the mutilated remains of the dead they too vividly represented."[146]

Critics and viewers of the 1860s looked to most photographs for considerably more than bald facts, however. As a reviewer of Gardner's *Sketch Book* noted, fine photographs demonstrate "skill in . . . finish and . . . taste in . . . execution." The standards of professional craft called for technically perfect prints with clear, mellow tones. Taste, as defined in the

1860s, represented a general sense of aesthetic refinement and a mastery of the techniques of lighting, pose, and composition.

To a degree only partially understood today, Civil War photographs represented a seamless integration of art and information.[147] It should not strike us as curious therefore that what appear to be purely "documentary" photographs were evaluated, at least in part, on aesthetic grounds. Praise for H. P. Moore's views of troops at Hilton Head, for example, was tempered by the observation that

> with some few exceptions . . . they have [an] unfortunately common fault—all the figures introduced are staring at the camera. This is the only imperfection I can see in these otherwise excellent photographs, and, to one who has tried field photography in camp scenes, is an excusable one; for the men will look at you, no matter how much you talk to and expostulate with them and insist on artistic effect.[148]

This interest in both lenticular fact and artistic effect resulted in photographs that, by the standards of simple reportage, may seem flagrantly contrived. Barnard, for example, used combination printing to add majestic cloudscapes to the otherwise blank skies of his landscape views. These clouds were irrelevant to the "documentary" content of Barnard's photographs but were critically important to the creation of finished and aesthetically pleasing *pictures*.

The manipulation involved in Alexander Gardner's famous *Rebel Sharpshooter* presents a more extreme example of this apparent conflict between documentary and aesthetic concerns. As William Frassanito has described, Gardner's team deliberately moved and arranged the body of a Confederate infantryman killed at Gettysburg for their photographs at the battlefield on July 6, 1863.[149] This "contrived" image was accompanied in the *Sketch Book* by text that was, in itself, a poetic fiction. Although Frassanito's discovery may have distressed historical purists, it is likely that Gardner created this image and story with a clear conscience. Indeed, by exercising aesthetic and compositional control over his subjects, Gardner achieved one of the most powerful visual/textual narratives of the war.

The concept of narrative was central to the photographic aesthetic of the mid-nineteenth century. As the commentary of the period makes clear, the highest value of the photograph lay in its ability to stimulate thoughts and emotions. Successful photographs promoted understanding, empathy, and moral insight, while allowing viewers to establish connections between themselves, the depicted events, and a shared set of cultural values. Photographs of the dead at Antietam, for example, were seen to suggest naturally both the individual agonies of violent death and the existence of grieving widows and orphans. Thus, a full understanding of the meaning of death began with the stimulus of the photograph but, since "broken hearts cannot be photographed," was completed by the imagination and sentiment of each viewer.[150]

These same photographs suggested to sensitive viewers the highest moral and ethical values of the society. Ghastly views of the dead revealed "a poetry . . . that no green fields or smiling landscapes can possess. Here lie men who have not hesitated to seal and stamp their convictions with their blood,—men who have flung themselves into the great gulf of the unknown to teach the world that there are truths dearer than life, wrongs and shames more to be dreaded than death."[151] The war continued for four long years in part precisely *because* viewers were able to see a sublime "poetry" in these images. Photographed facts, no matter how horrific, were integrated into an existing cultural ideology of heroism and progress. A review of the *Sketch Book* noted without irony that the photographs "eloquently and faithfully convey an idea of the vastness of our operations, the ingenuity, the valor, and the bravery of our soldiers, the magnitude of our resources, and the wonderful improvements we have made in everything that pertains to modern warfare."[152] The *Sketch Book* was thus an "intensely National work."[153]

This interpretive process has continued unabated, as every generation invents its own artistic past. Despite their seemingly hard factuality, the apparent meanings of Civil War photographs have shifted accordingly. In the first decades of this century, for example, Mathew Brady was most useful for photographers not as a real historic figure, but as a

protean documentary myth. In his 1938 essay in Walker Evans' seminal book, *American Photographs*, Lincoln Kirstein celebrated Brady as a "selfless eye . . . not much concerned with [the] theoretical right to claim the privilege of an artist."[154] This historical fiction was created to provide a suitable lineage for the period's anti-pictorialist avant-garde.

In the past decade Civil War photographs have been interpreted as premonitions of a mood of apocalypse and annihilation generated by the nuclear and environmental threats of our era. The "new eschatology of war," in Donald Kuspit's words, shapes the way our generation thinks about itself, our landscape, and the past:

> The idea of a traditional, limited war implies the intrusion of a particular death in a general paradise; the idea of modern, total war implies the absence of the slightest hint of paradise—of pastoral retreat, of sanctuary—in a general wilderness of death.[155]

What could better describe the emotional meaning of images of the dead at Antietam, or so many of George Barnard's ravaged landscapes? It is all but impossible now to see such images as celebrations of "wonderful improvements" in the tactics and technology of war. Instead, we interpret these images as warnings of a potential "wilderness of death" in which individual identity and courage play no part and leave no trace.

Civil War photographs become endlessly "new" in a continuing process of rediscovery and interpretation. The profound importance of their themes—war, death, technology, patriotism, and nationalism—ensures that they will remain central to any understanding of American photography and history. Our challenge lies in combining hard facts on the original production and use of these photographs with a deeper awareness of our inevitable need to reshape this massive body of work in our own image.

[1] For starters, see Allan Nevins, James I. Robertson, Jr., and Bell I. Wiley, *Civil War Books: A Critical Bibliography*, 2 vols. (Baton Rouge: Louisiana State University Press, 1967-69); John Russell Bartlett, *The Literature of the Rebellion* (Boston: Draper and Halliday, 1866; reprint: Westport, Conn.: Negro Universities Press, 1970); and B. Franklin Cooling, *The Era of the Civil War 1820-1876* (Carlisle Barracks, Pa.: U.S. Army Military History Research Collection, 1974).

[2] For example, as this is being written, clothbound and paperback editions of James M. McPherson's superb *Battle Cry of Freedom: The Civil War Era* (New York: Oxford University Press, 1988) are selling steadily.

[3] For example, see "Reliving the Civil War: Why America's Bloodiest Conflict Still Grips Us 125 Years Later," *U.S. News and World Report*, August 15, 1988, cover and pp. 48-53, 56-59.

[4] E. B. Long with Barbara Long, *The Civil War Day By Day: An Almanac 1861-1865* (New York: Doubleday and Co., 1971; reprint: New York: DaCapo Press, 1985), pp. 705-712.

[5] Ibid., pp. 718-719.

[6] Ibid., pp. 721-722. For further data on this period, see Eric Foner's excellent study *Reconstruction: America's Unfinished Revolution, 1863-1877* (New York: Harper and Row, 1988); and Albro Martin, "Economy from Reconstruction to 1914," in Glenn Porter, ed., *Encyclopedia of American Economic History* (New York: Charles Scribner's Sons, 1980), pp. 91-109.

[7] See, for example, Edward Hagerman's *The American Civil War and the Origins of Modern Warfare* (Bloomington: Indiana University Press, 1988).

[8] Jan Zita Grover, "The First Living-Room War: The Civil War in the Illustrated Press," *Afterimage* 11 (February 1984): 8-11.

[9] William A. Frassanito, *Grant and Lee: The Virginia Campaigns 1864-1865* (New York: Charles Scribner's Sons, 1983), p. 257. This superb study, with Frassanito's two earlier books, *Gettysburg: A Journey in Time* (New York: Charles Scribner's Sons, 1975) and *Antietam: The Photographic Legacy of America's Bloodiest Day* (New York: Charles Scribner's Sons, 1978), outlines a very valuable approach to the study of Civil War photographs.

[10] George S. Cook apparently made a blurred photograph of Union ironclads firing on Fort Moultrie on September 8, 1863. See William C. Davis, ed., *Fighting for Time: Volume Four of The Image of War 1861-1865* (Garden City, N.Y.: Doubleday and Company, Inc., 1983), p. 203.

[11] Frassanito, *Grant and Lee*, pp. 342-343.

[12] See W. A. Swanberg, "The Guns at Fort Sumter," in William C. Davis, ed., *The Shadows of the Storm: Volume One of The Image of War* (Garden City, N.Y.: Doubleday and Co., 1981), p. 81.

[13] *Civil War Times Illustrated* 21 (April 1982): 11-13.

[14] Frederic E. Ray, "The Photographers of the War," in Davis, *Shadows of the Storm*, p. 413.

[15] Frassanito, *Grant and Lee*, pp. 286-293.

[16] Census figures cited in Ray, "Photographers of the War," p. 409.

[17] For data on the Anthonys, see William and Estelle Marder, *Edward Anthony: The Man, The Company, the Cameras* (Plantation, Fla.: Pine Ridge Publishing Co., 1982); and Reese V. Jenkins, *Images and Enterprise* (Baltimore: Johns Hopkins University Press, 1975).

[18] See copy records for the District Court of the Southern District of New York, in the holdings of the Library of Congress.

[19] For background on the carte-de-visite, see William C. Darrah, *Cartes de Visite in Nineteenth Century Photography* (Gettysburg, Pa.: W. C. Darrah, 1981); and William Welling, *Photography in America: The Formative Years 1839-1900* (New York: Thomas Y. Crowell, 1978), pp. 143-168.

[20] Letter by Charles A. Seeley of May 28, 1861, published in the *British Journal of Photography* 8 (June 15, 1861): 227. See also Welling, *Photography in America*, p. 145, for illustrations of these buttons, credited here to Brady.

[21] *British Journal of Photography* 8 (June 15, 1861): 227.

[22] For discussions of Brady's business dealings with the Anthonys, see Josephine Cobb, "Mathew B. Brady's Photographic Gallery in Washington," *Columbia Historical Society Records*, vols. 53-56; and such recent sources as Frassanito's *Grant and Lee*, pp. 13-21.

[23] Welling, *Photography in America*, p. 150.

[24] An original copy is held in the Cook Collection, Valentine Museum, Richmond, Virginia. See Conley L. Edwards III, "The Photographer of the Confederacy," *Civil War Times Illustrated* 13 (June 1974): 27-33.

[25] Welling, *Photography in America*, p. 150.

[26] Coleman Sellers' letters of April 25, 1862 and May 11, 1862, published (respectively) in the *British Journal of Photography* 9 (May 15, 1862): 199, and (June 2, 1862): 219.

[27] *New Catalogue of Stereoscopes and Views Manufactured and Published by E. Anthony*, October 1862, reproduced in facsimile in the Marders' *Edward Anthony*.

[28] *New Catalogue of Stereoscopes and Views, Manufactured and Published by E. & H. T. Anthony & Co.*, November 1862, in collection of George Eastman House, Rochester, New York.

[29] *Catalogue of Card Photographs, Published and Sold by E. & H. T. Anthony*, c. 1865, in collection of George Eastman House, Rochester, New York.

[30] A revealing biographical sketch of Gardner was published in the *Philadelphia Photographer* 20 (January 1883): 92-95; see also Josephine Cobb, "Alexander Gardner," *Image*, No. 62 (June 1958): 124-136.

[31] See Brady's recollection of this episode in George Townsend, "Still Taking Pictures," *New York World*, April 12, 1891, p. 26.

[32] *Philadelphia Photographer* 20 (January 1883): 94.

[33] The precise timing of Gardner's break with Brady remains unclear.

[34] *Catalogue of Photographic Incidents of the War from the Gallery of Alexander Gardner* (Washington: H. Polkinhorn, 1863).

[35] *Philadelphia Photographer* 20 (January 1883): 92.

[36] See Frassanito, *Antietam*, and "Brady's Photographs: Pictures of the Dead at Antietam," *New York Times*, October 20, 1862, p. 5.

[37] Frassanito, *Gettysburg*, pp. 35-40.

[38] Frassanito, *Antietam*, p. 53.

[39] Frassanito, *Gettysburg*, pp. 24-34.

[40] See Frassanito, *Grant and Lee*, pp. 216-223.

[41] See Frassanito, *Gettysburg*, and Coleman Sellers' letters to the *British Journal of Photography* 10 (September 1, 1863): 354, and (October 1, 1863): 395.

[42] Sellers' letter of February 1, 1862, published in the *British Journal of Photography* 9 (March 1, 1862): 95.

[43] Sellers' letter of May 25, 1862, published in the *British Journal of Photography* 9 (June 16, 1862): 239.

[44] Sellers' letter of September 8, 1862, published in the *British Journal of Photography* 9 (October 1, 1862): 375.

[45] Charles A. Seely letter of April 27, 1861, published in the *British Journal of Photography* 8 (May 15, 1861): 191.

[46] Sellers' letter of August 25, 1862, published in the *British Journal of Photography* 9 (October 1, 1862): 375.

[47] Dorothy Meserve Kunhardt and Philip B. Kunhardt, Jr., *Mathew Brady and His World* (Alexandria, Va.: Time-Life Books, 1977), p. 56.

[48] Davis, *Shadows of the Storm*, p. 437.

[49] Frassanito, *Grant and Lee*, pp. 28-29.

[50] William C. Davis, ed., *The Guns of '62: Volume Two of The Image of War 1861-1865* (Garden City, N.Y.: Doubleday and Co., 1982), p. 32; and Davis, *Fighting for Time*, p. 10.

[51] Davis, *Shadows of the Storm*, p. 441; Davis, *The Guns of '62*, p. 86; and *British Journal of Photography* 11 (December 2, 1864): 489.

[52] Quoted in Richard Wheeler, *Sword Over Richmond: An Eyewitness History of McClellan's Peninsular Campaign* (New York: Harper and Row, 1986), pp. 67-68.

[53] Frassanito, *Grant and Lee*, p. 27.

54 Sellers' letter of March 23, 1862, published in the *British Journal of Photography* 9 (April 15, 1862): 157.

55 Sellers' letter of October 8, 1862, published in the *British Journal of Photography* 9 (November 1, 1862): 418.

56 See, for example, Davis, *Shadows of the Storm*, pp. 133-141 and 154.

57 See Davis, *The Guns of '62*, p. 227. For similar studio images, see Davis, *Shadows of the Storm*, p. 163.

58 William C. Davis, ed., *Touched By Fire: A Photographic Portrait of the Civil War, Volume One* (Boston: Little, Brown and Company, 1985), p. 162; and Davis, *Fighting for Time*, p. 390.

59 Sellers' letter of January 23, 1864, published in the *British Journal of Photography* 11 (March 1, 1864): 86.

60 Davis, *Touched By Fire I*, pp. 137, 167-183; Margaret Denton Smith and Mary Louise Tucker, *Photography in New Orleans: The Early Years, 1840-1865* (Baton Rouge: Louisiana State University Press, 1982), pp. 100-102; and Ray, "Photographers of the War," p. 410.

61 Cited in Smith and Tucker, *Photography in New Orleans*, pp. 104-105.

62 See, for example, Sally Pierce and Temple D. Smith, *Citizens in Conflict: Prints and Photographs of the American Civil War* (Boston: The Boston Athenaeum, 1981); Mark E. Neely, Jr., Harold Holzer, and Gabor S. Boritt, *The Confederate Image: Prints of the Lost Cause* (Chapel Hill: University of North Carolina Press, 1987); and Frederic S. Voss, "Adalbert Bolck: The South's Answer to Thomas Nast," *Smithsonian Studies in American Art* 2 (Fall 1988): 67-87.

63 Sellers' letter of June 9, 1862, published in the *British Journal of Photography* 9 (July 1, 1862): 260.

64 Sellers' letter of September 5, 1863, published in the *British Journal of Photography* 10 (October 1, 1863): 395.

65 See Sellers' letters in *British Journal of Photography* 9 (March 15, 1862): 117, (October 1, 1862): 376, and (December 15, 1862): 475.

66 Sellers' letter of March 2, 1863, published in the *British Journal of Photography* 10 (April 1, 1863): 151. For comments on the Brady Tom Thumb photographs, see Leo Braudy, *The Frenzy of Renown: Fame and Its History* (New York: Oxford University Press, 1986), pp. 496-503.

67 For background on the Sanitary Commission, see McPherson, *Battle Cry of Freedom*, pp. 323, 481-487; Long and Long, *Civil War Day by Day*, pp. 476, 481, 487 and 524; and Laura Wood Roper, *FLO: A Biography of Frederick Law Olmstead* (Baltimore: Johns Hopkins University Press, 1973), particularly pp. 168-177.

68 See Coleman Sellers' letters to the *British Journal of Photography* 11 (April 1, 1864): 120-121, (July 1, 1864): 225, and (July 15, 1864): 250-251.

69 Philip Knightley, *The First Casualty, From the Crimea to Vietnam: The War Correspondent as Hero, Propagandist, and Myth Maker* (New York: Harcourt Brace Jovanovich, 1975), pp. 20-23.

70 See W. Fletcher Thompson, Jr., *The Image of War: The Pictorial Reporting of the American Civil War* (New York: Thomas Yoseloff, 1959); and Frederic Ray, "With Pen and Palette: Artists of the Civil War," *Civil War Times Illustrated* 21 (April 1982): 18-31.

71 *Photographic and Fine Art Journal* 10 (October 1857): 319, and (November 1857): 347.

72 *New York World*, April 12, 1891, p. 26.

73 See also William Stapp's discussion of these images in his "Subjects of Strange . . . And of Fearful Interest," in Marianne Fulton, ed., *Eyes of Time: Photojournalism in America* (Boston: New York Graphic Society, 1988), pp. 16-21.

74 *New York Times*, October 20, 1862, p. 5.

75 *Harpers's Weekly* 6 (October 18, 1862): 663.

76 For years the Academy was the nation's leading source for formally trained engineers. Even when Harvard, Yale, and other schools began offering programs in civil engineering in the late 1840s, the instructors at these institutions were usually West Point graduates. (William H. Goetzmann, *Army Exploration in the American West 1803-1863* [New Haven: Yale University Press, 1959], pp. 13-14.) In private life Academy graduates became leading civil engineers and occupied important positions in industry, transportation, and science.

77 Stephen W. Sears, *George B. McClellan: The Young Napoleon* (New York: Ticknor and Fields, 1988), pp. 9-10.

[78] See Henry P. Beers, "A History of the U.S. Topographical Engineers, 1813-1863," *Military Engineer* (June 1942): 287-291; and (July 1942): 348-352.

[79] The Academy's curriculum is described in such sources as Sears, *George B. McClellan*, pp. 4-10; and Russell F. Weigley, *Quartermaster General of the Union Army: A Biography of Montgomery C. Meigs* (New York: Columbia University Press, 1959), pp. 25-30.

[80] [U.S. Military Academy] *Association of Graduates*, Bulletin 3 (May 1903): 42. This club was formed on December 26, 1842, with such later notables as Richard Delafield, Irvin McDowell, and William S. Rosecrans. Lt. Theophile Marie D'Oremieulx served as the organization's treasurer.

[81] Goetzmann, *Army Exploration*, pp. 15-16.

[82] The West Point archives contain a large and impressive folio of Heintzelman's student drawings dated between 1823 and 1826. Meigs maintained his interest in sketching and watercolor painting at least through the 1850s.

[83] Wm. C. Bartlett, *An Elementary Treatise on Optics, Designed for the Use of the Cadets of the United States Military Academy* (New York: Wiley and Putnam, 1839), p. 134. Interestingly, Bartlett later published a book entitled *Nineteen Photographs of Solar Eclipse, 1854, May 26th*.

[84] See Alfred G. Bailey, *Selected Papers of Jacob Whitman Bailey, first Professor of Chemistry, Geology and Mineralogy at the United States Military Academy, West Point, New York, and President (1857) of the American Association for the Advancement of Science* (unpublished manuscript volume, 1962), in collection of West Point archives.

[85] The West Point archives contain Boynton's scrapbook, with biographic data and various clippings.

[86] Born in Paris to an aristocratic family, D'Oremieulx had traveled in distinguished circles in France and knew such noted artists as Victor Hugo in the 1830s. He came to America in 1839 and was hired the next year by Major Richard Delafield, then Superintendent of the Academy, to teach French. Although his command of English remained imperfect, D'Oremieulx was a successful teacher and highly admired by such students as Ulysses S. Grant, Philip Sheridan, and George H. Thomas. D'Oremieulx's special interests included the microscope, music, literature, and fine arts, and he made amateur pencil sketches. For biographic data on D'Oremieulx, see *Army and Navy Journal* (July 9, 1881): 1031; and *Association of Graduates*, Bulletin 3 (May 1903): 42-46.

[87] Capt. Daniel P. Whiting's prints were lithographed by the New York firm of G. and W. Endicott in 1847.

[88] William Simpson, *The Seat of War in the East* (London: Paul and Dominic Colnaghi and Co., 1855).

[89] M. A. S. Biddulph, *A Series of Topographical Sketches of the Ground Before Sevastopol, Accompanied by Explanatory Descriptions* (London: Chapman and Hall, [1855]).

[90] Lt. R. S. Smith, *A Manual of Topographic Drawing*, 2d ed. (New York: Wiley and Halsted, 1856), p. 1.

[91] Col. R. Delafield, *Report on the Art of War in Europe in 1854, 1855 and 1856* (Washington: George W. Bowman, 1861).

[92] *Philadelphia Photographer* 6 (January 1869): 5. A letter in Walker's service file at the National Archives states that the photographer spent his time during the war "preparing important military maps for the various Union armies and copying important papers and drawings for the different Depts., in addition to the general work pertaining to the Architect's Office."

[93] Sellers' letter of November 17, 1862, published in the *British Journal of Photography* 9 (December 15, 1862): 475.

[94] Sellers' letters of February 21, 1864 and November 28, 1863, published (respectively) in the *British Journal of Photography* 11 (March 15, 1864): 106, and 10 (December 15, 1863): 494. Photography was similarly used in the construction of railroad locomotives.

[95] See the *British Journal of Photography* 9 (July 15, 1862): 281, and (November 15, 1862): 438.

[96] See plate CXXX of *The Official Military Atlas of the Civil War* (1891-95; reprint, New York: Arno Press/Crown Publishers, 1978).

[97] Delafield, *Report on the Art of War*, p. v.

[98] *Official Military Atlas*, plates CXXVI-CXXIX.

[99] See Smith and Tucker, *Photography in New Orleans*, pp. 124-127.

[100] Frank Abial Flower, "General Herman Haupt," in *Reminiscences of General Herman Haupt* (New York: John R. Anderson Co., 1901), p. xv. Analytical, practical, and forceful, with an immense ability to get things done, Haupt subsequently taught mathematics and engineering at the college level, published the widely used textbook *General Theory of Bridge Construction* (1852), served as General Superintendent of the Pennsylvania Railroad, and directed work on the controversial Hoosac Tunnel in Massachusetts, the second-longest underground rail passage in the world. See also Francis A. Lord, *Lincoln's Railroad Man: Herman Haupt* (Rutherford, N.J.: Fairleigh Dickinson University Press, 1969); and James A. Ward, *That Man Haupt: A Biography of Herman Haupt* (Baton Rouge: Louisiana State University Press, 1973).

[101] Charles F. Cooney, "Andrew J. Russell: The Union Army's Forgotten Photographer," *Civil War Times Illustrated* 21(April 1982): 33. Unfortunately, this informative article is unfootnoted. A letter in A. J. Russell's file (National Archives, RG 92, Consolidated Correspondence) indicates that the order assigning the photographer to duty under Haupt was dated March 2, 1863.

[102] Cooney, "Andrew J. Russell," p. 34.

[103] Russell's later request for reimbursement for these expenses was turned down by the Treasury Department. In letters of 1871 in Russell's file at the National Archives, the dates of Fowx's service are variously given as February 18 to May 18, and March 4 to June 4, 1862 [sic]. It must be assumed that Fowx's service was, in fact, in the early months of 1863.

[104] Cooney, "Andrew J. Russell," p. 35.

[105] Three series of sixty-foot trusses were tested, the last of which could support a weight of 168,000 pounds without cracking.

[106] President Lincoln marvelled at this bridge, spanning a gorge ninety feet deep, and called it "the most remarkable structure that human eyes ever rested upon," particularly since it seemed to be composed of "nothing . . . but beanpoles and corn stalks." Ward, *That Man Haupt*, pp. 116-117.

[107] See Joe Buberger and Matthew Isenburg, *Russell's Civil War Photographs* (New York: Dover Publications, 1982), particularly plates 2-3. This volume comprises the most extensive published collection of Russell's war photographs. See also Thomas Weston Fels, *Destruction and Destiny, The Photographs of A. J. Russell: Directing American Energy in War and Peace, 1862-1869* (Pittsfield, Mass.: Berkshire Museum, 1987).

[108] See "Distribution of Photographs of Construction and Transportation Departments, as per order of Brig. Gen'l H. Haupt, Chief of Rail Roads, U.S.," in National Archives, RG 92, Box 815, "Photographs."

[109] The text for this album was printed in Boston by Wright and Potter and dated 1863.

[110] See "Distribution of Photographs of Construction and Transportation Departments . . ."; and letter of February 24, 1864 from Col. John H. Devereux (?) to Col. D. C. McCallum, in National Archives, RG 92, Box 815, "Photographs":

> . . . The Photographic Department begins and ends with him [Russell]. No salaried assistant has ever been employed, and the work is done by the Captain, the Captain's servant, and a laborer. The cost pr. month is the cost of chemicals. Including the price of a new instrument and its outfit, it will be seen by schedule that for 12 months the expenditure has been $1878.72, an average of $150 pr. month.
>
> This has provided (by Capt. Russell's estimate of ordinary trade prices) $7000 worth of pictures, which have been distributed under Gl. Haupt's order as shown; and there is now on hand to fill remaining orders (by Capt. Russell's return) 3000 pictures in sets nearly complete and of war scenes 400 large pictures, 200 of medium size, and 100 of small size.

[111] See Buberger and Isenburg, *Russell's Civil War Photographs*, plates 46-61, 65-68, etc.

[112] Much of the information in this section is drawn from Stanley B. Burns, "Early Medical Photography in America (1839-1883), VI: Civil War Medical Photography," *New York State Journal of Medicine* (August 1980): 1444-1469.

[113] Ibid., p. 1452.

[114] Ibid., p. 1453.

[115] *Philadelphia Photographer* 3 (July 1866): 214.

[116] Burns, "Early Medical Photography," pp. 1453-1459.

[117] Ibid., p. 1463.

[118] See *British Journal of Photography* 9 (October 1, 1862): 376, and (August 15, 1863): 336.

[119] For a biography of Meigs, see Weigley, *Quartermaster of the Union Army*.

[120] The aqueduct, designed to bring water to Georgetown and the capital, presented the highly technical challenge of transporting large volumes of water across miles of terrain, through tunnels and over bridges. Meigs also supervised work on the Cabin John Bridge in Washington, which remained for fifty years the largest masonry arch in the world. See Herman Hattaway and Archer Jones, *How the North Won: A Military History of the Civil War* (Urbana: University of Illinois Press, 1983), p. 122. See also references to Meigs' war service on pp. 138-139, and in Weigley, *Quartermaster of the Union Army*, p. 99.

[121] Weigley, *Quartermaster of the Union Army*, pp. 72-73; and Josephine Cobb, "Mathew Brady's Photographic Gallery in Washington," p. 20.

[122] These photographs are held in the M. C. Meigs Collection, Library of Congress.

[123] As related to Coleman Sellers; see Sellers' letter of November 19, 1863, published in the *Philadelphia Photographer* 1 (January 1864): 9.

[124] Some of these photographs are reproduced in Davis, *Shadows of the Storm*, pp. 70-71, and 210; and William C. Davis, ed., *Touched by Fire* (Boston: Little, Brown and Company, 1986), 2: 14.

[125] In a letter of November 17, 1862, published in the *British Journal of Photography* 9 (December 15, 1862): 475, Sellers noted the prominent amateur photographers in Washington. These included "the minister from Brasil [sic] and his daughter. Mr. Titian R. Peale—who has charge of the class of fine arts in the Patent-Office—is considered the leading amateur in Washington: his connection with the art dates from its very commencement. His first pictures were all large, and his outfit for this class of work was very perfect; but of late he, like others of our amateurs, has confined his operations to stereographs. . . . Before General M. C. Meigs was so much engrossed in his military duties, and while he was in charge of the extension of the Capitol and Postoffice-buildings, he, too, was an enthusiastic amateur, but now he can do but little at it."

[126] McPherson, *Battle Cry of Freedom*, pp. 324-325.

[127] Hattaway and Jones, *How the North Won*, p. 139.

[128] Letter of April 20, 1864, from Meigs to Sherman, published in *The War of the Rebellion: A Compilation of the Official Records of the Union and Confederate Armies* (Washington: Government Printing Office, 1891), Series 1, Vol. 32, part 3, p. 434.

[129] Letter of April 26, 1864, from Poe to Meigs, in National Archives, RG 92, Consolidated Correspondence File, "Photographs in Tennessee."

[130] Captain Duncan K. Major and Captain Roger S. Fitch, *Supply of Sherman's Army During the Atlanta Campaign* (Fort Leavenworth, Kans.: [U. S. Army], 1911), p. 8.

[131] Letter of June 18, 1864, from Meigs to Col. McCallum, National Archives, RG 92, Box 815, "Photographers."

[132] Ibid.; this file also includes a list of twenty-eight photographs of vessels made by Russell between March 1863 and May 1864.

[133] "Photographic Reminiscences of the Late War," *Anthony's Photographic Bulletin* 13 (September 1882): 311; and "Pages from a Veteran's Note-book," *Wilson's Photographic Magazine* 44 (1907): 106. Although these articles contain ambiguities and minor contradictions, they constitute the primary sources of information on Coonley's career.

[134] Letter of December 30, 1864, from Cooley to Meigs, in National Archives, RG 92, Box 815, "Photographers."

[135] Letter of January 9, 1865, ibid.

[136] *Anthony's Photographic Bulletin* 16 (April 1884): 145. This summary of Roche's career by friend A. J. Russell is perhaps the best such outline. See also Roche's obituary, *Anthony's Photographic Bulletin* 26 (November 1895): 367.

[137] Letter of April 15, 1865, from Anthony to Meigs, National Archives, RG 92, Box 815, "Photographers."

[138] *Anthony's Photographic Bulletin* 16 (April 1884): 145.

[139] Copyright records of the District Court of the District of Columbia, Library of Congress. It should be noted that only the most important and commercially valuable photographs were registered for copyright.

[140] Sellers' letter of May 22, 1865, published in the *British Journal of Photography* 12 (June 23, 1865): 333.

141 *Philadelphia Photographer* 2 (September 1865): 154; and Davis, *Shadows of the Storm*, 1: 451.

142 See Albert Castel, "Comrades: A Story of Lasting Friendships," in Davis, *Touched by Fire*, 1: 276-277, and 2: 301, 325.

143 Thompson, *Image of War*, p. 162.

144 Taylor's photographic holding is now in the collection of the Huntington Library.

145 Information on Barnard is drawn from Keith F. Davis, *George N. Barnard: Photographer of Sherman's Campaign* (Kansas City: Hallmark Cards, Inc., 1990).

146 *Atlantic Monthly* 12 (July 1863): 12.

147 Nineteenth-century photographers were typically admired for their adherence to accepted aesthetic standards and their contributions to public taste and social progress. Twentieth-century modernism, on the other hand, celebrates a willful violation of accepted aesthetic conventions in the name of formal experimentation and individual self-expression. Civil War photographers would have been baffled by these ideas. The word "art," as used in the 1860s and 1990s, describes vastly dissimilar attitudes, and our appreciation of Civil War photographs should not be based on superficial similarities to more recent works made for entirely different reasons.

148 *British Journal of Photography* 11 (December 2, 1864): 489.

149 Frassanito, *Gettysburg*, pp. 186-195.

150 *New York Times*, October 20, 1862, p. 5.

151 Ibid.

152 [Washington?] *Sunday Chronicle*, January 28, 1866; cited in Philp and Solomon's prospectus for Gardner album, in collection of the National Archives.

153 Ibid., from review in the *Philadelphia Press*, February 26, 1866.

154 Lincoln Kirstein, "Photographs of America: Walker Evans," *Walker Evans: American Photographs* (1938; reprint, New York: East River Press, 1975), p. 184.

TWO

Photography in the 1860s and 1870s became an even more direct mirror of American culture. The great events of the era, including the wrenching destruction of the Civil War, the growth of urban communities, and the exploration and settlement of the American West, were all recorded and communicated with the unprecedented clarity and intensity of this revolutionary medium. Collodion wet-plate negatives could be used to produce almost unlimited copies of highly detailed albumen prints, and this greatly expanded photography's potential to communicate and influence.

Photography had multiple uses during the Civil War, as Keith Davis' essay makes clear. On a personal level, ordinary soldiers greatly valued photographs and eagerly paid itinerant photographers for portraits to send home to loved ones. Photographic camp views like the ambrotype of soldiers boxing (PLATE 40), even when posed and staged, had a specificity and realism that made popular wood engravings of similar subjects seem contrived and romantic. There were also utilitarian military applications for photography, from simple copying of maps and documents to pictorial records of military engineering and armaments tests (PLATE 45 AND FIGS. IV-18, IV-19, AND IV-20). The camera was also able to record military events—such as the meeting between Abraham Lincoln and his overly cautious commander, General George McClellan (PLATE 43)—with a candor and authenticity seldom seen in other pictorial media. Many Civil War photographs were made with an understanding of their potential value as historical records, and two great collections of Civil War views, Alexander Gardner's *Sketch Book of the War* (PLATE 41 AND FIGURES IV-4, IV-6, AND IV-7) and George Barnard's *Photographic Views of General Sherman's Campaign* (PLATE 46), were published just after the war, in 1866. More than mere journalism, these pictorial documents conveyed the larger symbolic meaning of war's sacrifice. Timothy O'Sullivan's *Field Where General Reynolds Fell*

(PLATE 41) concentrates the viewer's attention on a few bodies in the foreground but suggests from its focus and composition that the battlefield horrors extend almost infinitely beyond the frame, as does Andrew J. Russell's *Stone Wall, Rear of Fredericksburg, with Rebel Dead* (PLATE 42).

If photography served as an effective witness to the near-destruction of the Union, it also was a powerful ally to American expansion. Many photographers with experience on the Civil War battlefields, including Alexander Gardner, Russell, and O'Sullivan, went west after the war to work for the railroads or the government-sponsored geological surveys. During a fall 1867 trip through Kansas, sponsored by the Kansas Pacific Railroad, Gardner recorded the developing towns and cities (PLATE 50) that were being connected by the new rail system. The resulting images were of interest to investors, prospective tourists and settlers, and even the general public who could still remember prewar news reports about "Bleeding Kansas." Russell's photographs for the Union Pacific documented not only the momentous occasion when the transcontinental railroad was completed (PLATE 49), but also provided invaluable historical records of the awesome engineering feats and the multinational labor force (PLATES 47-48) required for that enterprise.

The ostensible goal for photographing the geological surveys was to provide scientific data, but the meaning and usefulness of many of these photographs went far beyond mere identification of geological formations and information for mapping the territory. O'Sullivan's photographs, in particular, are often highly autobiographical, frequently including evidence of man and his expeditionary party's activities (SEE FIGS. III-20 AND III-23). Photographs such as *Geyser Mouth, Ruby Valley* (PLATE 52) and the claustrophobic interior of the *Cave-In at Comstock Mine* (PLATE 55) powerfully communicate man's relationship to this landscape rather than the isolated terrain itself.

The government-sponsored surveys recorded not only the terrain but also the native people of the western territories. Some of the most outstanding and informative images of southwestern native Americans, their architecture, and their crafts were made by John K. Hillers (PLATES 9 AND 59), who learned photography while serving as an oarsman on John Wesley Powell's second Grand Canyon expedition and went on to become chief photographer for the U.S. Geological Survey and the Bureau of American Ethnology.

Martha Sandweiss' essay demonstrates that many of these photographers were working in a narrative tradition, trying to develop pictorial techniques that could effectively communicate the experience of movement through these landscapes—often by creating images in series rather than as isolated fragments. The stereographs by the Wheeler Survey (PLATES 7 AND 51), which were issued in sets of fifty or more and arranged chronologically, demonstrate how sequences of images could create especially effective narratives. It was common for most expeditionary photographers to make views in multiple sizes, including stereographs, which were especially suited to a large, popular audience because of their small size and relatively low expense. When magnified in a stereoscope, these images filled the viewer's field of vision and recreated the sensation of three-dimensional sight.

While stereographs and regular-size prints were usually satisfactory for government reports documenting the basic features of the landscape and for most popular needs, many photographers turned to mammoth-plate negatives, up to twenty by twenty-four inches in size, in order to suggest the monumental scale of their western subject matter and give their works the visual impact of a painting. Eadweard Muybridge's views of Yosemite were especially innovative and responsive to the standards of contemporary painting, not only in the way he handled atmospheric effects but also in his occasional manipulation of images, as when he balanced the composition of his view of Mount Hoffman (PLATE 54) by printing in a separate negative of a rock in the water at left. Of all the western photographers, Carleton Watkins perhaps achieved the greatest artistic success and recognition, earning numerous medals in national and international competitions. He worked more independently than many photographers who were on the payroll of the railroads or government surveys, but much of his work was also driven by the need to respond to a specific patron or audience. His view of the *Wreck of the Viscata* (PLATE 53) is a great example of his ability to make a strong picture out of a newsworthy event— a shipwreck south of San Francisco that attracted tourists from all over the region until it was broken up by another storm. Watkins made more than one trip to the site and produced numerous views in different sizes to sell to the eager public; his stereo camera is visible in the foreground of this picture, and his mammoth-plate study of man's struggle against nature retains its power long after the particular details of this specific tragedy have been forgotten.

Photography provided invaluable documents of the eastern landscape and urban scene as well as the new territories of the West. John Moran, the brother of painter Thomas Moran, was an accomplished landscape photographer (PLATE 63) and produced a series of views which documented old sections of Philadelphia (PLATE 64) that were being torn down for new construction and urban expansion. Boston photographer James Wallace Black made pioneering aerial photographs of his city in 1859-60 (PLATE 66) and then recorded its devastation by fire in a dramatic panorama made in 1872 (PLATE 67). Large-scale panoramic views captured the sweep and scale of the nineteenth-century city, while small-scale, instantaneous stereographs made it possible to freeze action and capture the dynamic character of city life (PLATE 65).

182

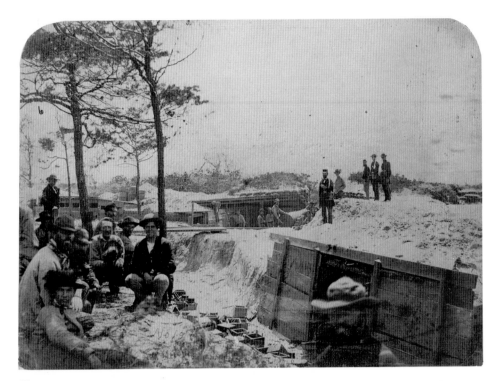

Plate 39
Jay Dearborn Edwards. *Confederate Sand Batteries, Pensacola, Florida.*
Albumen print, c. 1861. J. Paul Getty Museum.

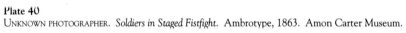
Plate 40
Unknown photographer. *Soldiers in Staged Fistfight.* Ambrotype, 1863. Amon Carter Museum.

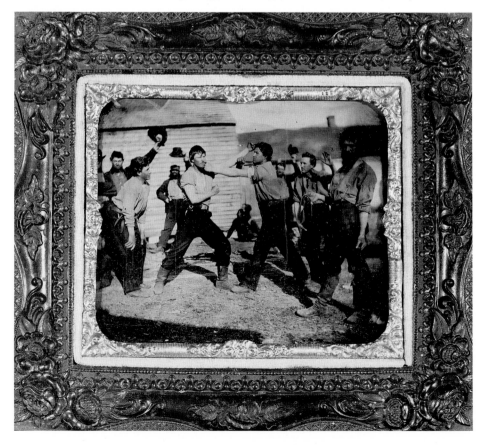

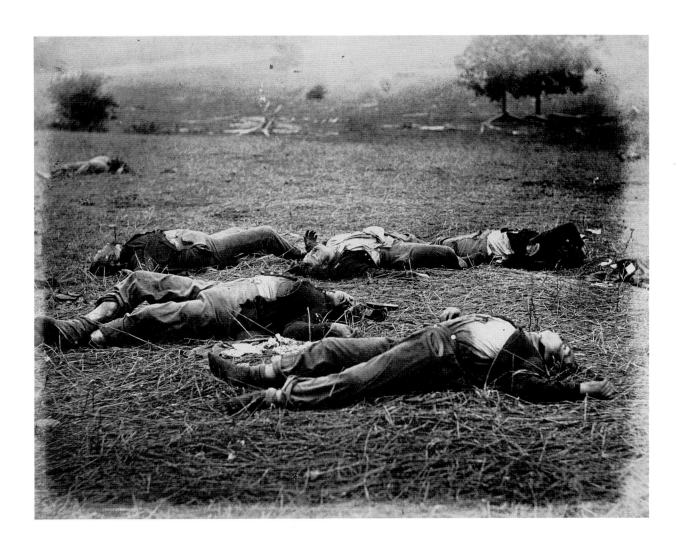

Plate 41
TIMOTHY O'SULLIVAN. *Field Where General Reynolds Fell.* In *Gardner's Sketch Book of the Civil War.*
Albumen silver print, negative 1863, print 1866. Amon Carter Museum.

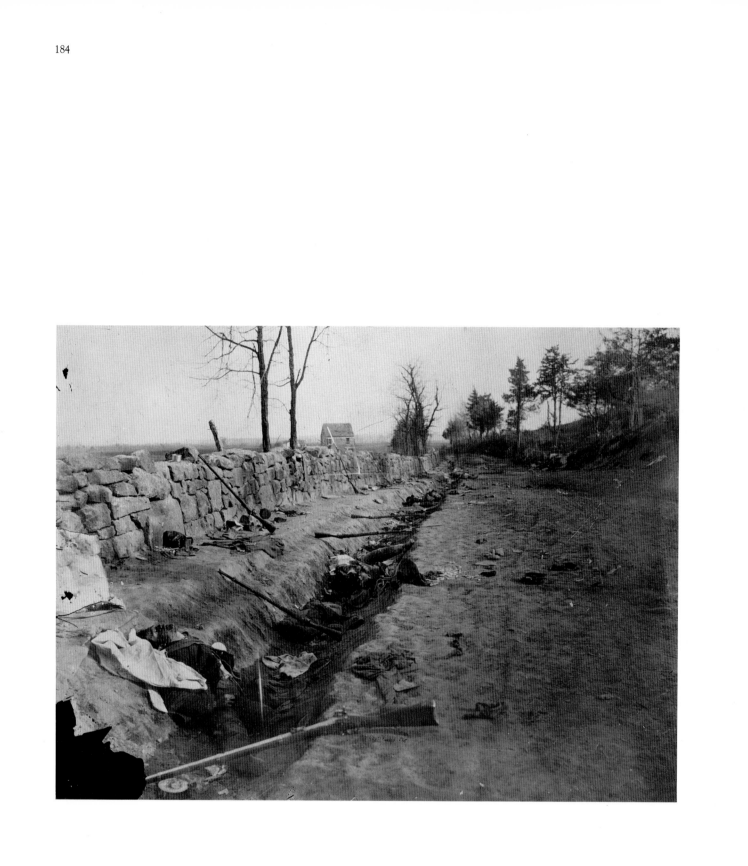

Plate 42
ANDREW J. RUSSELL. *Stone Wall, Rear of Fredericksburg, with Rebel Dead.* Salt print, May 3, 1863. J. Paul Getty Museum.

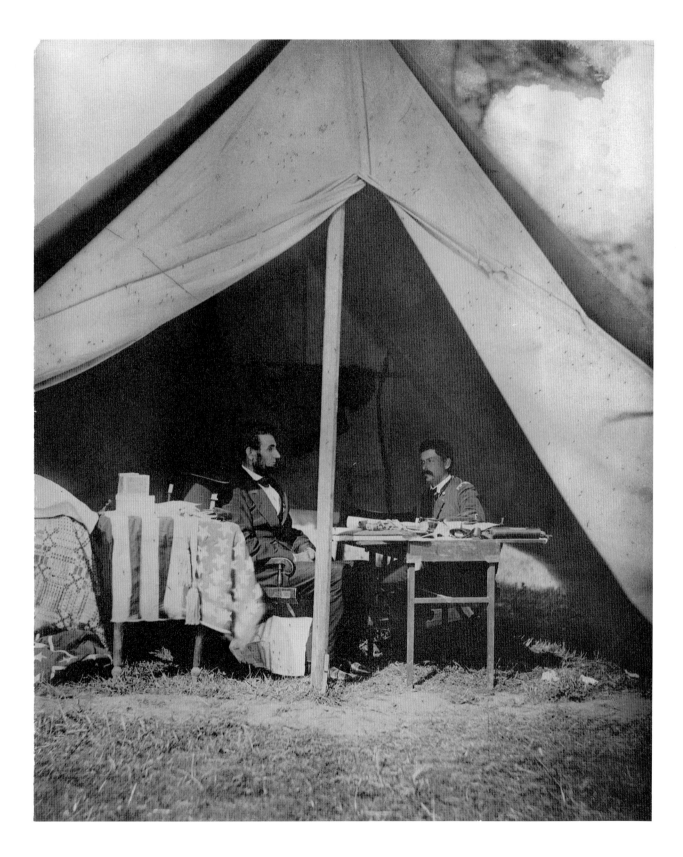

Plate 43
ALEXANDER GARDNER. *The President (Abraham Lincoln) and General McClellan on the Battlefield of Antietam.* Albumen silver print, 1862.
Museum of Modern Art, New York; gift of Carl Sandburg and Edward Steichen.

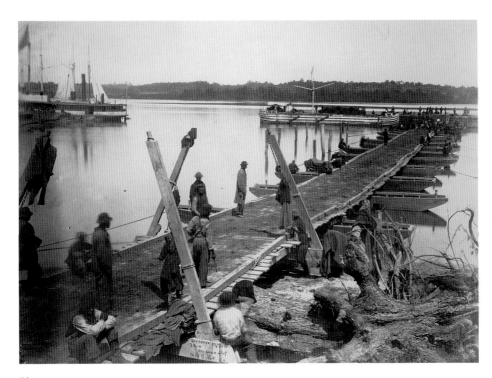

Plate 44
Andrew J. Russell. *Upper Wharf, Belle Plain.* Albumen silver print, May 16, 1864. J. Paul Getty Museum.

Plate 45
Timothy O'Sullivan. *Artillery Test Grounds, No. 59, XI inch, 10 Pound Shell.* Albumen silver print, August 24, 1864. J. Paul Getty Museum.

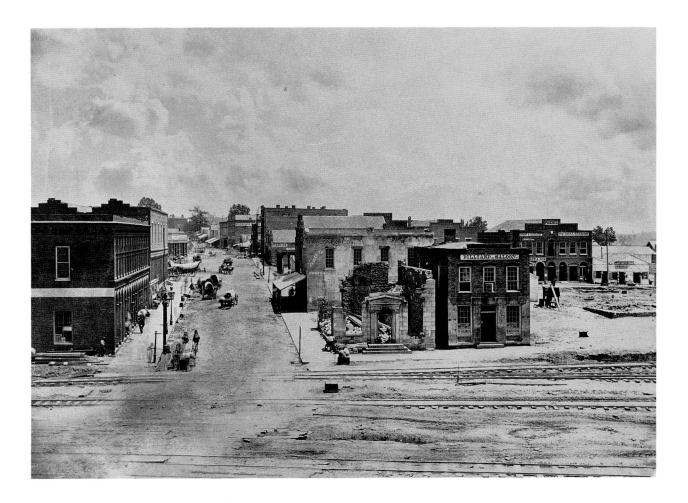

Plate 46
GEORGE BARNARD. *City of Atlanta.* From *Photographic Views of Sherman's Campaign.* Albumen silver print,
negative 1864, print 1866. Amon Carter Museum.

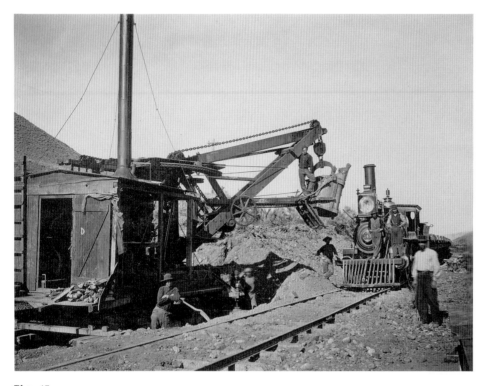

Plate 47
ANDREW J. RUSSELL. *Steam Shovel at Work, Echo Cañon.* Albumen silver print, 1868. Beinecke Rare Book
and Manuscript Library, Yale University.

Plate 48
ANDREW J. RUSSELL. *East End of Tunnel No. 3, Weber Valley.* In *The Great West Illustrated.*
Albumen silver print, 1869. Amon Carter Museum.

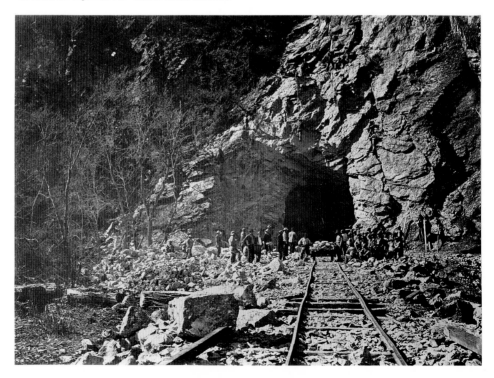

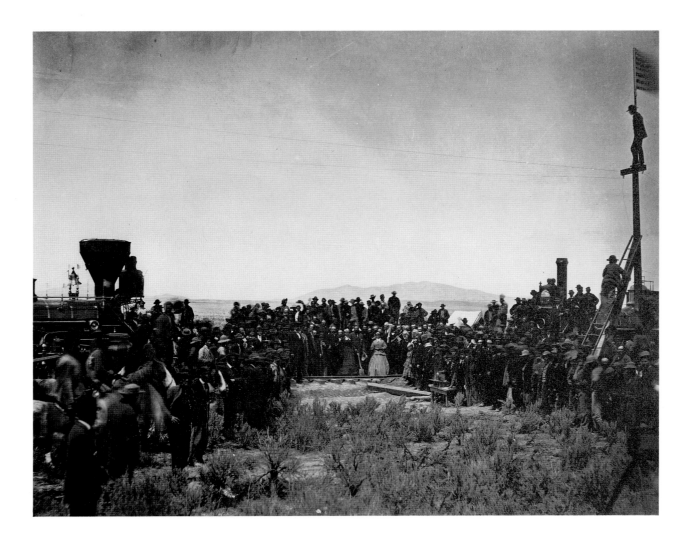

Plate 49
ANDREW J. RUSSELL. *Last Rails, Promontory Point.* Albumen silver print, 1868. Beinecke Rare Book and Manuscript Library, Yale University.

Plate 50
ALEXANDER GARDNER. *Depot, Leavenworth, Kansas.* Albumen silver print, 1867. J. Paul Getty Museum.

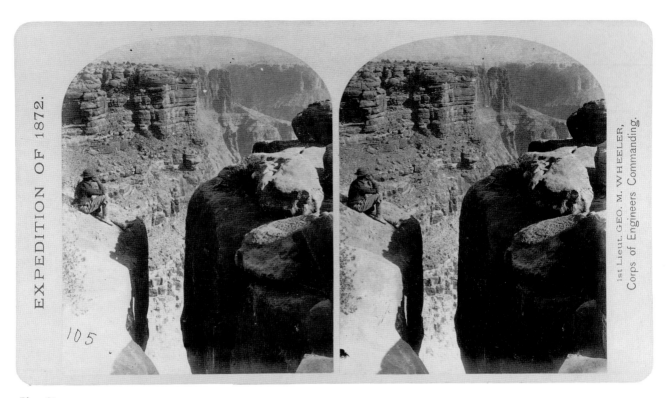

Plate 51
WILLIAM BELL. *No. 14. The Northern Wall of the Grand Cañon of the Colorado, Near the Foot of To-ro-weap Valley. The rounded rocks of the foreground are sand-stone.* Stereograph in *Geographical Explorations and Surveys West of the 100th Meridian; Expedition of 1872.* Albumen silver print, negative 1872, print 1875. Amon Carter Museum.

Plate 52
TIMOTHY O'SULLIVAN. *Geyser Mouth, Ruby Valley.* Albumen silver print, 1868.
International Museum of Photography, George Eastman House.

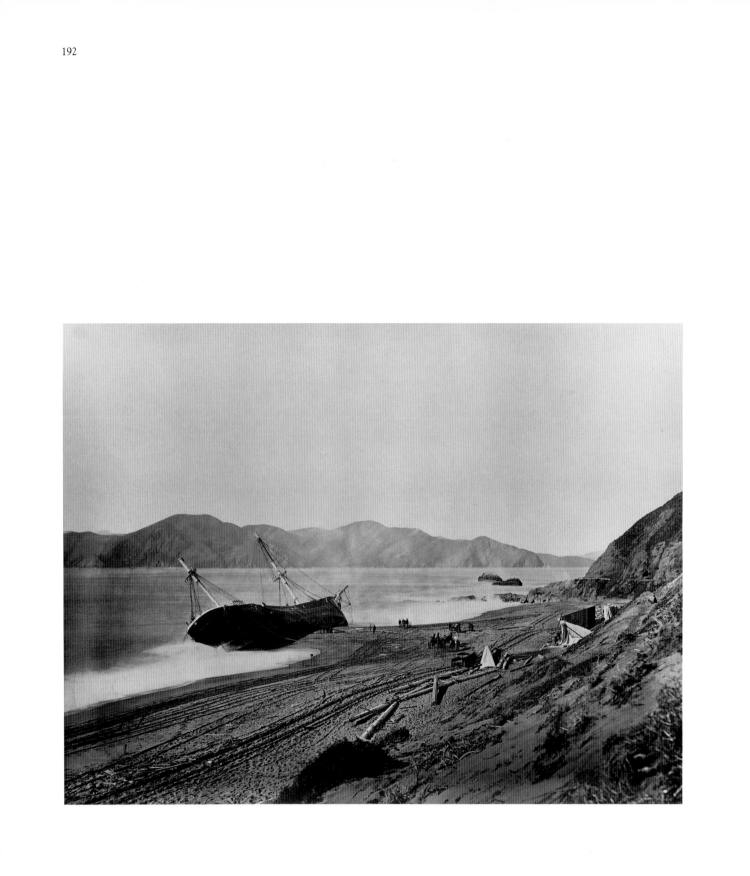

Plate 53
CARLETON WATKINS. *Wreck of the Viscata*. Albumen silver print, 1868. Amon Carter Museum.

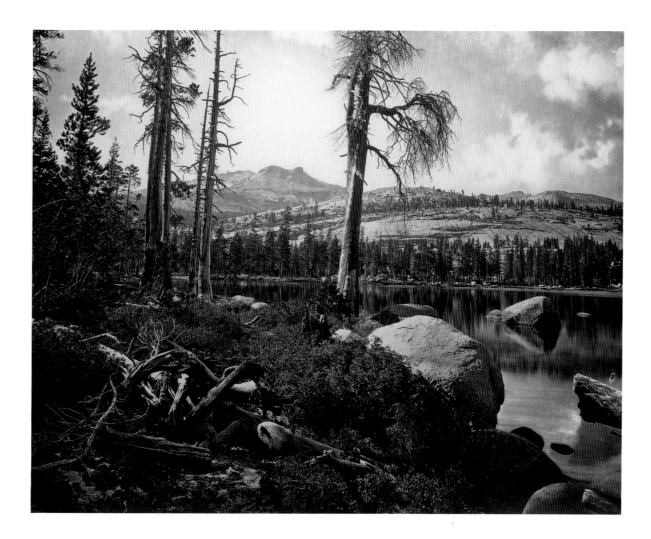

Plate 54
EADWEARD MUYBRIDGE. *Mount Hoffman, Sierra Nevada Mts., from Lake Tenaya.* Albumen silver print, 1872.
International Museum of Photography, George Eastman House.

194

Plate 55
TIMOTHY O'SULLIVAN. *Cave-In at Comstock Mine, Virginia City, Nevada.*
Albumen silver print, 1868. Amon Carter Museum.

Plate 56
WELLINGTON O. LUKE AND DANSFORD NOBLE WHEELER. *Little Giant.* Stereograph in *Rocky Mountain Views.*
Albumen silver print, c. 1879-81. Amon Carter Museum.

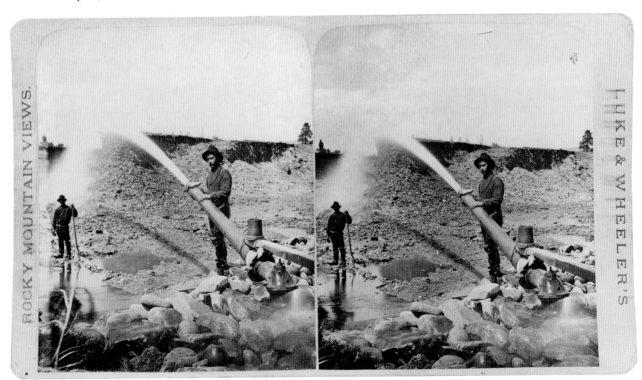

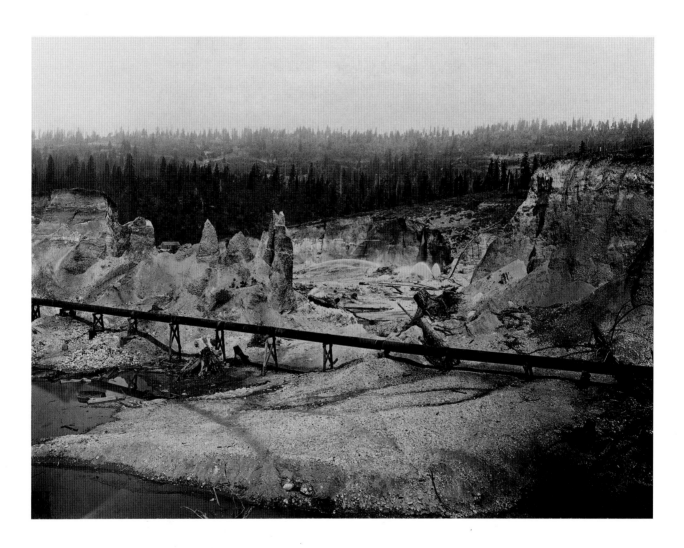

Plate 57
CARLETON WATKINS. *Malakoff Diggins, North Bloomfield, Nevada County.* Albumen silver print, c. 1871. Amon Carter Museum.

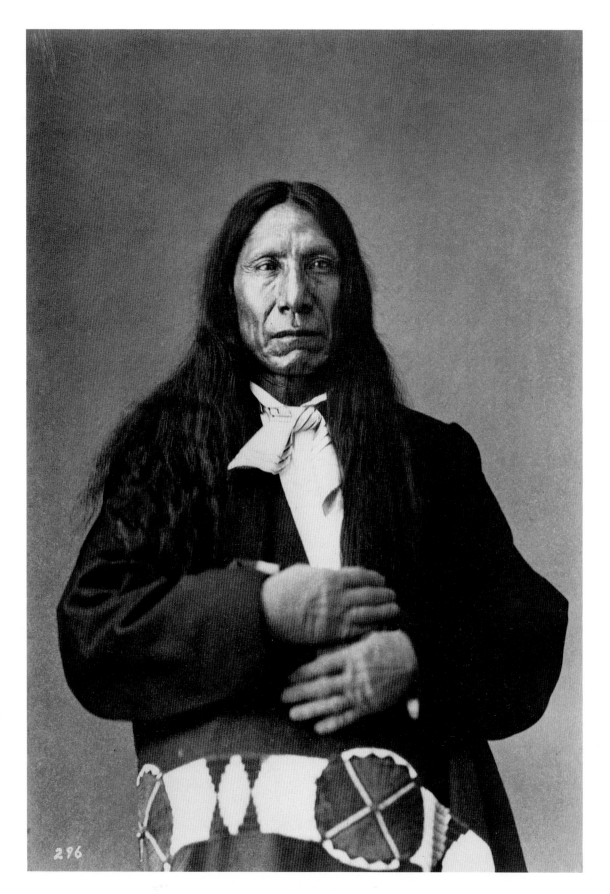

Plate 58
ALEXANDER GARDNER. *Red Cloud, Ogalalla Sioux.* Albumen silver print, 1872. Amon Carter Museum.

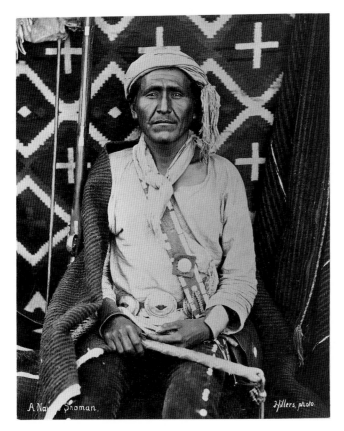

Plate 59
JOHN HILLERS. *A Navaho Shaman.* Albumen silver print, 1870s.
Amon Carter Museum.

Plate 60
ATTRIBUTED TO A. A. HART. *Piute Squaws and Children, at Reno.* Stereograph published by C. E. Watkins in *Central Pacific Railroad Series.*
Albumen silver print, negative 1867-70, print 1870 or later. T. K. Treadwell Collection.

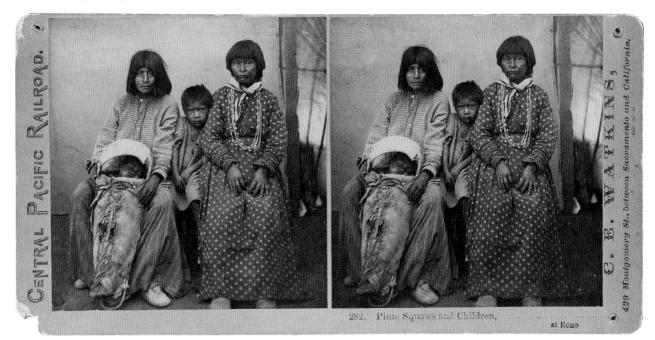

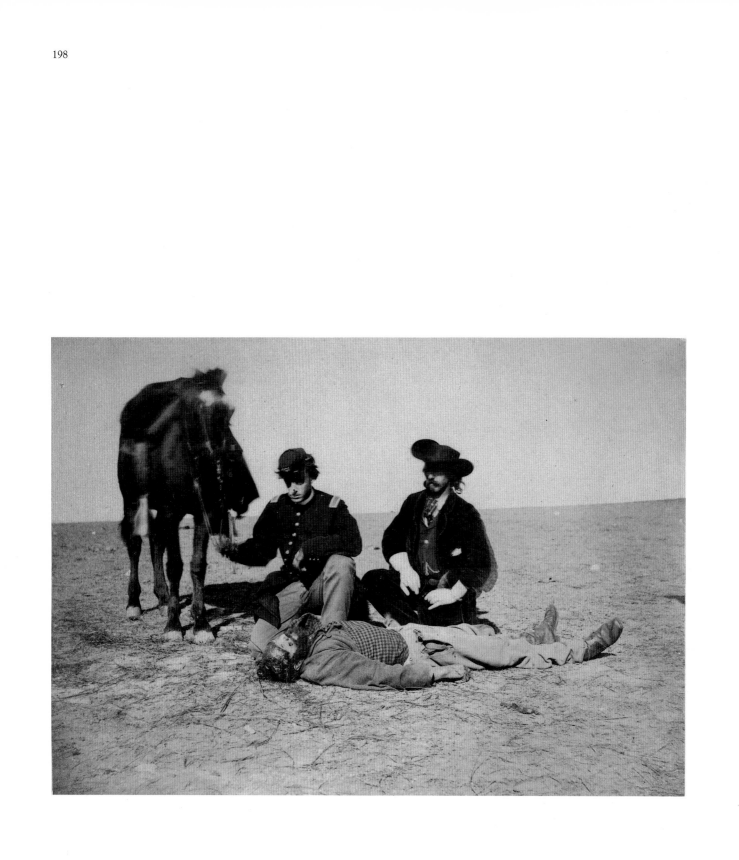

Plate 61
WILLIAM SOULE. *Scalped Hunter Near Fort Dodge.* Albumen silver print, 1868. J. Paul Getty Museum.

199

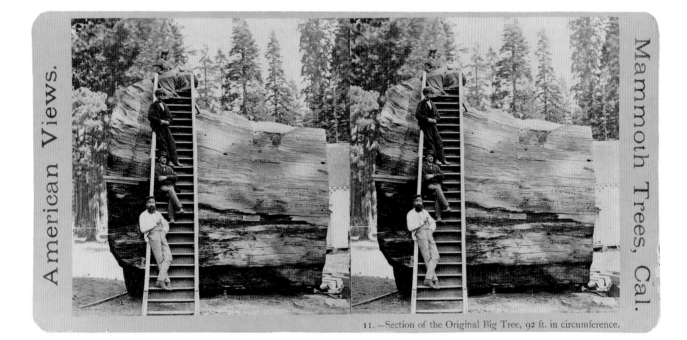

11.—Section of the Original Big Tree, 92 ft. in circumference.

Plate 62
UNKNOWN PHOTOGRAPHER, ATTRIBUTED TO T. C. ROCHE. *Section of the Original Big Tree, 92 Ft. in Circumference.* Stereograph published by E. and H. T. Anthony and Co. in *American Views, Mammoth Trees, Cal.* Albumen silver print, negative 1870-71, print c. 1872-73. Private collection.

Plate 63
JOHN MORAN. *Geddes Brook, a Tributary of Tohican, Pennsylvania.* Albumen silver print, c. 1855-65.
International Museum of Photography, George Eastman House.

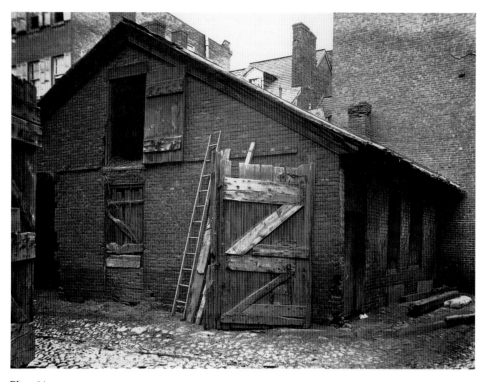

Plate 64
JOHN MORAN. *House in Mickle's Court.* Albumen silver print, 1869. Library Company of Philadelphia.

Plate 65
UNKNOWN PHOTOGRAPHER. *Looking Up Broadway from the Corner of Broome Street.* Stereograph published by E. and H. T. Anthony and Co. in *Anthony's Instantaneous Views.* Albumen silver print, negative 1868, print 1868-71. Private collection.

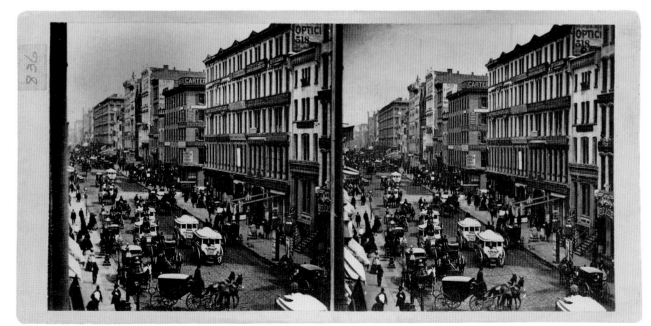

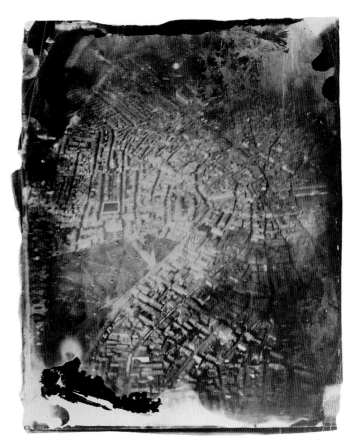

Plate 66
JAMES WALLACE BLACK. *Boston From Hot-Air Balloon.*
Albumen silver print, 1860. Metropolitan Museum of Art.

Plate 67
JAMES WALLACE BLACK. *View of the Ruins of the Great Boston Fire.* Albumen silver print, 1872. Library of the Boston Athenaeum.

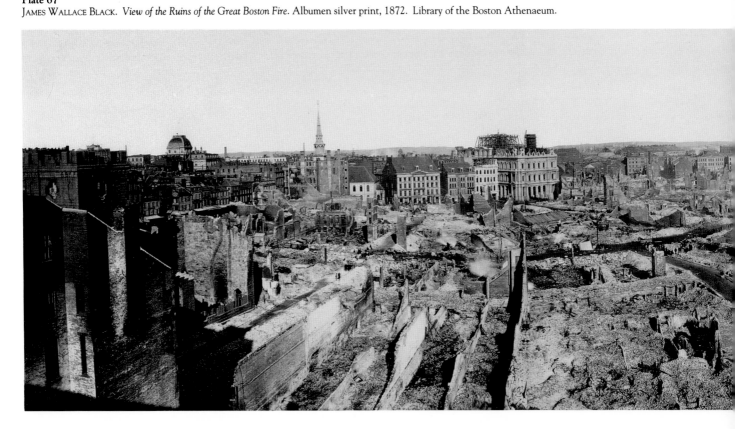

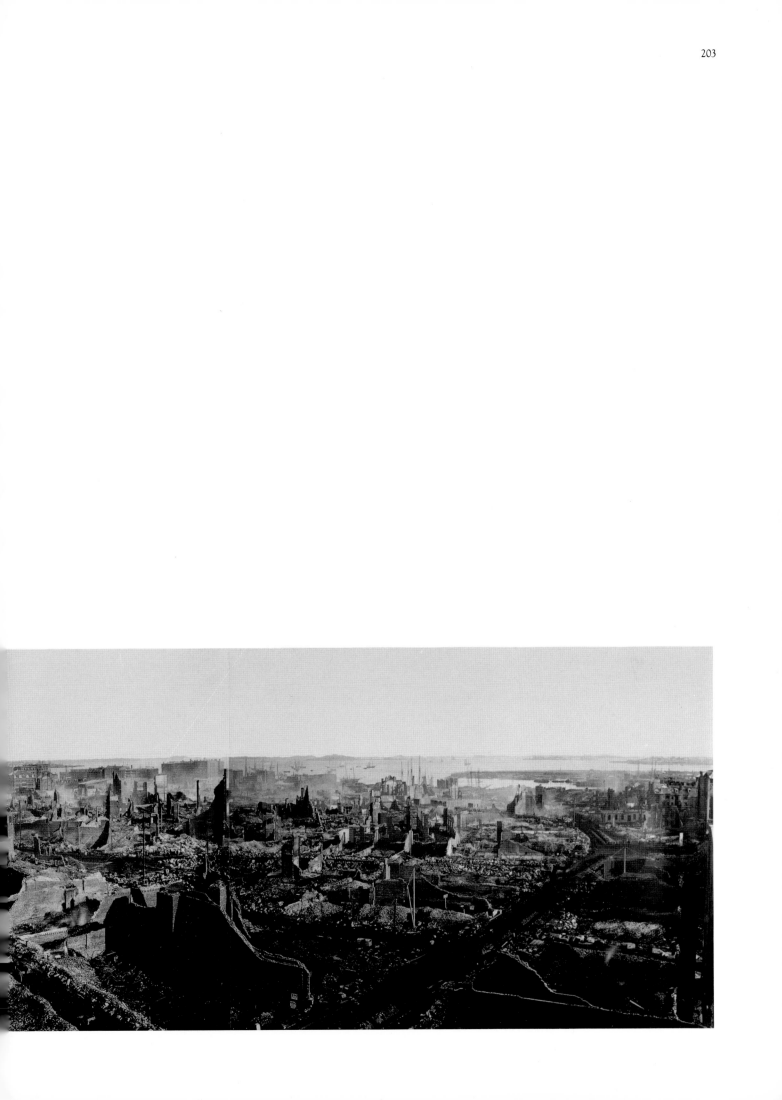

V

AMERICAN VIEWS AND THE
ROMANCE OF MODERNIZATION

Sometime in 1894, Utah photographer Charles Roscoe Savage wrote a terse entry in his diary:

PETER BACON HALES

> Not doing much viewing lately. . . . Nearly everybody is becoming a photographer. Business is changing to developing and finishing views for amateurs. Most of the magazines now published are illustrated by photo engravings—the demand for views is gradually falling off.[1]

In his morose assessment, Savage described the latest stage in a continuous process of mutations and negotiations that had defined photography and its place within American culture since 1839. This development seemed particularly important to Savage as a signal of his own expulsion to the margins of American photography; after a long and celebrated career as a "photographic artist," he saw his replacement by a new technology, a new class and type of practitioner, a new distribution system, and a new set of audiences for the medium. In the advent of dry plate negatives and, more recently, flexible films; the appearance of readily available mass-market equipment and supplies, at significantly cheaper prices; and the movement of a number of producers (including the Eastman and Anthony companies) into advertising and promotion campaigns emphasizing the ease, and the fun, of photography, Savage saw the end of his older role in the medium and a mutation in the nature of the photograph as a visual object, a carrier of meaning.

This revolution in photography's production and distribution systems touched Savage directly with a decline in the demand for "views," the form on which he had made his career. Not just counterpart to the portrait, the view was something different, for both photographer and audience: a type of visual object with its own particular territory, surrounded at its boundaries by the landscape painting, the lithographic "bird's eye," the city plat, the map, the scientific survey report, and the government topographer's panorama. Whether its subject was city, countryside, or wilderness, the photographic view had unified science, art, and capitalism; the sum of its work lay in drawing together and celebrating the divergent elements of an American culture undergoing the stresses of rapid change. More than reflecting the tensions surrounding it, the photographic view helped to resolve them—at least within the visual fiction of the photographic frame.

Savage himself was one of the most famous and most successful viewmakers of that era. Born in England in 1832, he had emigrated to America, setting up his first photography business in Council Bluffs, Iowa, then traveling with the Mormons to Salt Lake City in 1861, where he established a thriving western photography studio. His tour of North America in 1866 took him nearly nine thousand miles, and his report on the trip for the *Philadelphia Photographer* made him a recognized name among photographers.[2] In partnership as Savage and Ottinger, Savage traveled extensively along the nearly completed transcontinental railroad, photographing (with his competitor, A. J. Russell) the golden spike ceremony at Promontory Point in 1869. His photograph became the predominant image of that event; reproduced as a woodcut and wood-engraving in newspapers and magazines, it also anchored his stereo series. By the early 1870s, he was a major figure

Figure V-1

JOHN MORAN. *Indian Ladder Bluff (Delaware Water Gap).* Albumen silver print. From *Philadelphia Photographer* 1 (September 1864): opp. p. 129.

among the photographers of the West, publishing an extensive series of "Views of the Great West From the Missouri River to the Pacific Ocean" as stereos, card photographs, and larger-scale prints. William Henry Jackson studied his pictures in 1869 and learned many of the more experienced photographer's strategies for encompassing and lending significance to the strangeness of the western landscape.[3] In the pages of photographic journals, in the retail emporiums of major cities where thousands of stereographic photographs were sold every day, in the annals of westward expansion and the growth of western cities, Savage's name since the 1860s had been synonymous with "beautiful and instructive views" of the western territories.[4]

Unlike many photographers who flourished in the 1870s but found themselves outmoded by revolutions in the publication and distribution of visual information in the two ensuing decades, Savage was able to adapt. As early as 1871, he found a market for his photographs as the visual sources for the engravings used in *Nelson's Pictorial Guide-Books for Tourists*, a series published in England. In the 1880s, when direct reproduction of photographs in books became feasible, Savage formed a partnership with Denver publisher Frank S. Thayer, whose Colorado tourist books had drawn from William Henry Jackson's photographs, and produced a series of guidebooks and tourist remembrances of Utah that ran into the twentieth century.[5]

But by the end of the century, Savage believed he finally had been bested by changes in the production side of the photographic industry. Like many of his counterparts, he had based his career on a fragile balance of economic, artistic, and cultural factors. The new amateur camera, which converted a significant portion of the viewing audience into practitioner-viewers, depleted his clientele and transformed the tradition of outdoor view photography on which his career rested.

The decline in Savage's business reflected a broader reemphasis of the photographic view tradition as the nineteenth century became the twentieth, just as his earlier success had demonstrated the fortunes of that tradition. Though it drew many of its characteristics from the general reputation of the nineteenth-century photograph, the view had been a peculiar class of photography, defined not simply by subject or style or function, but by the particular way that it integrated all three. Born in the earliest outdoor photographs of the daguerreian era, developed into a significant historical phenomenon during the Civil War, the view had reached its peak during the seventies and eighties, when government and business sponsorship and the development of more efficient modes of reproducing and distributing photographs vastly increased photographic production. To see their country, to understand not just its topography but its underlying values and beliefs, nineteenth-century Americans increasingly turned to the photographic view. What they found in its evolving tradition is one subject of this essay.

But this view tradition was neither static nor permanent. By the end of the century, it had largely disintegrated, in some ways a victim of its own success. As efficient business practices became an accepted part of view photography, as the technologies of dry-plate and mass reproduction served to demystify the photographer and deemphasize his craft, the view became, increasingly, an anonymous image nearly identical to hundreds of others. Devalued by the inflated currency of the photograph, increasingly stripped of its novelty and the mysticism that accompanied its place as an entirely new mode of picture-making, inserted into increasingly intrusive contexts for interpretation, the American photographic view lost its originality and its claims to a unique place as a vehicle for American cultural self-consciousness. By the turn of the century, the American view tradition had disintegrated, and its parts reintegrated into new wholes—in photojournalism, in reform photography, in advertising, in a host of other communication "industries" that came to dominate twentieth-century visual culture and found photographs useful or necessary to their work.

Still this reformation of photography in the twentieth century only points up the deeply intertwined relationship between the nineteenth-century American photographic view and the culture within which it found its meanings. The view was a potent American tradition, deeply intertwined in the larger processes by which American civilization reached into new spaces, organizing, colonizing, exploiting, and transforming them. That the view tradition was colonized, exploited, and transformed in turn is a measure of the

synergy between nineteenth-century photography and the broader American culture, a synergy we shall trace over the pages that follow.

The roots of an American photographic view tradition can be found in the beginnings of photography in America—in works like John Plumbe's daguerreian views of the major monuments of growing cities (SEE PLATE 32), or John Wesley Jones' now-lost views of the American continent and the unknown lands west of the settlements and east of California. A series of innovations during the Civil War made a broadly based, culturally ambitious program of outdoor photography possible, and at its close, the view attained a more public and visible place within American photography. The postwar economy unified industrial production, raw materials, and markets and freed capital, labor, management, and government for new forays into the undeveloped regions of the West, South, and Southwest. At the same time, the war and its aftermath further accelerated the dominant movements of the nineteenth century toward urbanization, industrialization, and the dominion of man over nature, generating new spaces, literal and figurative, that demanded inclusion in American culture.

The colonization of these new landscapes, both urban and wilderness, required more than simple expropriation: they had to be ordered, made sensible, judged, and then inserted in their proper places in the dominant visions of American life and purpose. American view photographers assumed important roles in this process: accompanying American explorations of these new spaces; inscribing their strangeness; celebrating the process by which science, art, and philosophy together provided the means for understanding and exploiting wilderness and city space; and then invoking the myths, themes, and images of the American and European past to render the strangeness of these newly human spaces comprehensible and even tempting to a wide audience of Americans.

American photographers of this era were in a particularly advantageous position to speak to, and for, their culture. They were able to build on a wave of enthusiasm concerning their medium that had begun with the arrival of Daguerre's instructions in 1839 and had continued, even increased, over the next decades. The medium itself had become almost personified (or perhaps deified), as the central forces of American culture—literature, painting, journalism, science, and the universities—accepted the increasingly hyperbolic claims for photography and even exploited them as metaphor and as evidence. As historian Richard Rudisill has pointed out, the daguerreotype was a particularly appropriate tool for the rhetoric of American democracy.[6] But whereas the daguerreotype implied a democracy of ownership, making precious miniatures available to a mass population, the new negative/positive process offered a democracy of sight, allowing a wide range of viewers to share the same image of Lincoln, of Niagara Falls, of Yellowstone or the field where General Reynolds fell.

By the end of the Civil War, American photographers had achieved a position midway between a craft and a profession. Often very well paid, they were businesspeople who frequently enjoyed the reputation of the urban professions. But the Civil War had also brought about a crisis in the perception of photography in general and outdoor photography in particular. The technology of mass-produced, low-cost images like the tintype and the carte-de-visite, while bringing photography to a far wider audience, seemed at the same time to threaten photography's reputation, institutions, and mythologies. Mass production not only stripped photography of its aura of rarity and preciousness, but also vastly expanded the pool of photographers (from 309 in 1860 to 1,650 by 1870[7]) and drew that pool from sources that were often far outside the previous training systems of the medium. Whereas daguerreotypes had arguably served within the province of the elevated arts, tintypes and cartes-de-visite were unabashedly the products of technology, mass-production, and business.[8] The role of photography was thrown into question once again, generating a new and fertile discourse on its place as a cultural process in America.

These disruptions in photography's self-image, resulting from the many changes in the medium and its surroundings, entered the literature of American photography toward the end of the Civil War. The pages of the *Philadelphia Photographer* provided an important outlet for discussions of this issue, even as its founding in 1864 was itself a symptom of this

disturbance. Originally conceived by editor-publisher Edward L. Wilson as the voice for a new, ennobled photography, the journal sought to unite professionals and amateurs around this banner and to serve as the spearhead that would move photography into every home and place of business as a ubiquitous, universally uplifting part of American life. Quickly gaining respectability among professional and amateur photographers as well as a wider audience of American and European readers, by the 1870s it was the most-respected and most-read journal on the medium in the United States.[9]

The *Philadelphia Photographer*'s self-defined goal during its early years became one of bridging the set of dualities implicit in the postwar photographic community—between amateur and professional, the portrait and the view, description and artistry, streamlining the flow of information and teaching moral discrimination of that very flow. This attempt to refine the general understanding of photography's potentials repeated itself often in the early pages of the *Philadelphia Photographer*—in editorials by Wilson, in excerpts of books like Marcus Aurelius Root's *The Camera and the Pencil*, in critical analyses of particular photographs that served as frontispieces to each volume, and in letters and articles by photographers around the country and in Europe as well.[10]

As Wilson, Root, and others sought to raise photography's purpose above mere business and into a more significant cultural role, the *Philadelphia Photographer* sought to unite the threatened schism between business and art by drawing a utopia in which photography served every viewer's every need—"the walls adorned with elegant photographic views and portraits . . . the album . . . on the centertable . . . the lampshade . . . made of six or eight beautiful positive transparencies . . . the cologne bottle in the toilet chamber even . . . ornamented with a real photographic label . . . the library adorned with sundry books illustrated with photographs. Oh! for the power to write of all the beauties Photography has added to the household stock."[11]

This process, American photography's utopians argued, made possible a uniting of science, art, and business into a new, synergistic photographic practice that could inform portraiture, but it also had particular force in that arena of photography that they variously called the "view," the "landscape," and the "outdoor photograph." This argument required two further elements: championing photography as a fine art without at the same time negating its business potential, and defining outdoor photography to conform with, or even confirm, this notion, arguing for both the amateur's personal reward in making such views and the commercial photographer's marketplace reward.

Out of this search, the *Philadelphia Photographer* devised a basic argument for the American photographic view as early as 1865. On one side, photography's place in the pantheon of the fine arts was argued most cogently by Philadelphia landscape photographer John Moran, brother of the landscape painter Thomas Moran. In an essay titled "The Relation of Photography to the Fine Arts," Moran made what would become a dominant argument for photography's place as a fine art in nineteenth-century America:

> It is our simple and unselfish delight in the contemplation of nature, which is the foundation of all the beautiful or fine arts, and which distinguishes them from science or mechanic arts. . . . It is the power of seeing and deciding what shall be done, on which will depend the value and importance of any work, whether canvas or negative. Dryden says, "The most important thing in art is to know what is most beautiful." . . . We may claim for the photograph the ability to create imagery which calls forth ideas and sentiments of the beautiful.[12]

If photography was an art by dint of its rhetorical capacity to "call forth ideas and sentiments of the beautiful," outdoor photography was its finest expression; there, as Wilson phrased it, photography could "elevate the heart and soul, and make one bless and praise the Great Creator."[13] Wilson's argument in this regard dovetailed with Moran's; he was in fact speaking of Moran's own *Indian Ladder Bluff (Delaware Water Gap)* (FIG.1) when he wrote that "the experienced view-hunter knows best where to find beauty and magnificent effect combined." "How beautiful and pleasant it looks in this our view," he wrote, "and how the heart longs to be there, and climb to the very peak of so inviting a spot." Since the climb is too difficult for most, he continued, the photographer could complete

it and, taking special care "not to falsify and distort the work of the Creator," transmit a simulacrum that allows the homebound viewer to share the experience of the accomplished philosopher of nature.[14] The Reverend H. J. Morton, D.D. (as his name appeared above his essays) encapsulated the reasoning:

> Photography started up like a spirit, and came into the midst of the toiling group [of painters], bending painfully over their work, and said, "stand aside, gentlemen, if you please. Let me show you how to paint Nature."... What is [portraiture] in comparison with representing and actually reproducing the etchings of the Almighty on the rocks, and His mouldings, and carvings, and textures in cliffs, and hillsides, and velvet mosses?[15]

Thus the arguments of Wilson and his colleagues, as early as 1864, presented a new vision of photography in which the outdoor view took pride of place; in which business, Nature, and art were united in the production of culturally significant, ennobling, and inspiring works, for a newly empowered democratic audience, to be consumed in forms the daguerreotypist could not have conceived.

Arguments like the Reverend Morton's only communicated one approach to the photographic view in post-bellum American culture—a conservative position reclaiming the legacy of high intellectual discourse from the antebellum era. Other writers, critics, and photographers (including Oliver Wendell Holmes, whose works appeared in the *Atlantic Monthly* in 1859, 1861, and 1863) saw outdoor view photography as an agent of modernization and a necessary part of American life, uniting a rapidly dispersing nation, providing its citizens access to the vast and steadily increasing body of information in modern systems of knowledge, drawing together and shrinking the globe into its orderly frame, and affording a means of leisurely, intellectual analysis of these new phenomena outside the press of events.[16]

The institutional contexts of business practices also counterweighed the conservative pull of older traditions, within and outside photography. As historian William Culp Darrah has pointed out, by 1860 the carte-de-visite had begun to impose universal standardization on the American photographic industry; there were strong pressures toward conglomeration and monopoly both in supplies of raw materials and in national distribution, and the literature of photography and its practice had become nationalized (even internationalized).[17] The clientele for these photographs—whether sponsors like the Anthony Company, which commissioned photographers to make views for their extensive catalogue, or viewers of the final product—pressured photographers to produce work that celebrated its subjects and reassured its audiences.[18]

The view tradition that grew up after the Civil War, then, reconceived the medium of photography around goals that were concurrently conservative and modernizing— accepting, even celebrating the new conditions of the photography business in an era of competition, standardization, and vast expansion, but embracing the new subjects of postwar American life within older, more conservative traditions.

Just how this process worked in the actual production, distribution, consumption, and interpretation of views is demonstrated in the career of the California photographer Carleton Emmons Watkins during the period immediately after the Civil War. Of the mammoth-plate Yosemite photographs Watkins sent east in a campaign to have his pictures recognized as the preeminent views of the Yosemite region, *Philadelphia Photographer* editor Edward L. Wilson wrote in 1866 that "no pen can describe such wonders of art faithfully . . . [for] *the camera is mightier than the pen.* . . ."[19] Wilson's descriptions of the photographs did not simply celebrate the photographer's abilities to adapt painterly landscape devices to the photographic medium but, rather, focused on how they conveyed Transcendentalist experience with "Dame Nature" so that the Eastern viewer might experience "our wonder and our delight." Simultaneously collecting, interpreting, and celebrating Nature and the American landscape, Watkins' pictures became, under Wilson's less-mighty pen, models for the successful outdoor view.[20] The Reverend H. J. Morton continued Wilson's argument, extending it further into the reaches of prophecy in an issue of the *Philadelphia Photographer* later in 1866. For Morton, Watkins' photographs were

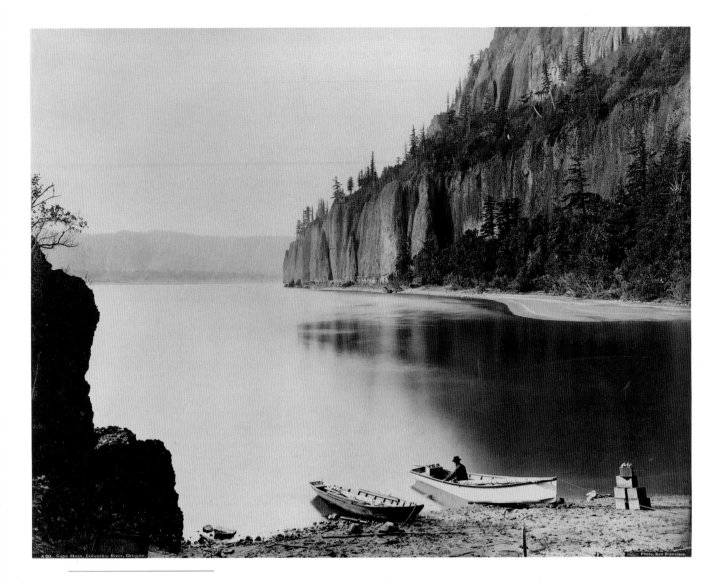

Figure V-2

CARLETON EMMONS WATKINS.
*Cape Horn, Columbia River,
Oregon.* Albumen silver print,
negative 1867, print by Taber
after 1875. J. Paul Getty Museum.

"superb . . . illustrations" designed to induce "grand impressions." Watkins' views, he said,

> open before us the wonderful Valley whose features far surpass the fancies of the most
> imaginative poet and eager romancer. The magic of art is here truly exercised for our
> accommodation and delight. Without crossing the continent . . . we are able to step,
> as it were, from our study into the wonders of the wondrous Valley, and gaze at our
> leisure on its amazing features.[21]

These accounts typified the central tension of the photographic view in its first incarnation after the Civil War—the belief that its power, its art, lay in its transparency and facticity, even as that transparency required active reconnaissance, sensitive capturing, and educated interpretation. When these ingredients combined, celebrants argued, the best views connected the mind of man directly to the lessons of Nature.

The production, distribution, and marketing of these views occurred, however, within a seemingly more mundane realm of commerce and commission. Consider Watkins' mammoth-plate photograph of *'Cape Horn,' Columbia River, Oregon*, made in 1867 (FIG. 2). Like his Yosemite views, this picture and the series it came from elevated photography into the discourse of landscape and of the high arts more generally. Indeed, more than a century later, Watkins' picture seems the very model of the artistic landscape photograph of the nineteenth century, at least as twentieth-century connoisseurs, curators, and critics have tended to demarcate it.[22] Its subject is a scene of vast scale, high cliffs, and deep spaces, touched by stillness. Watkins' Cape Horn seems, to twentieth-century viewers, a place where man is subsumed by space and nature and yet is in control of them. Every aspect of the picture seems to press it away from its roots in topographical study and

toward a different role as a cue for the viewer to meditate on the harmonious relationship possible between Romantic man and a sublime land. Perhaps most important, nature is bounteously benevolent, giving up her fruits to the American settlers. Watkins carefully included eight crates overflowing with apples—six stacked up on shore, one hidden in the deep shadows to the left, one in the back of a startlingly white and perfectly maintained skiff. Behind this skiff, the treacherous waters of Cape Horn are lightstruck, smooth, and peaceful. Thus the picture advertises its subject even as it expands that subject from a specific topographical scene to a celebration of Oregon's fertility to a commemoration of the transacted destiny of the American settling and reawakening the Garden of Eden.[23] These apples, in their crates, are emblems reminding viewers (including Wilson's and Morton's type, familiar with the destinarian rhetoric of popular Jacksonian oratory) of nature's bounty in this claimed and transformed portion of the American West. The arrangement of the boxes on the sandy beach, too, is architectural, though the pyramid is just disordered enough to be *picturesque*—a favorite word in the criticism of the view. Thus arranged, the boxes stand like an icon or a shrine at the river's edge—a reminder that the photographer has adapted painterly traditions of landscape and that photography thereby can attain the lofty ambitions of art even as it serves the ends of cultural boosterism and commercial advertising.

But Watkins' view was not made simply to be sent to the *Philadelphia Photographer*, or to a New York gallery, or even to be hung upon the walls of his own studio. Instead, his pictures were produced from a characteristic heterogeneity of pressures and traveled to their audiences through an equally heterogenous set of distribution channels. Indeed, this view illustrates how complex was the tradition within which it lay, and how deeply imbedded it was in the particular circumstances of marketplace and audience, of cultural ideology and artistic convention that more generally defined nineteenth-century American photography.

Cape Horn was one of an extensive series of mammoth-plate photographs Watkins made of the Columbia River region in the summer and fall of 1867. All were defined, at least in part, by the complex systems of patronage that brought Watkins to the region at that time, and that dictated the subjects and the styles of the resulting images. Watkins originally planned to support the trip with income from previous print sales but found himself unable to raise the funds. The eminent scientist and government surveyor Josiah Dwight Whitney helped to make up the difference rather than lose the opportunity to acquire valuable images of the geography and geology of the northwest coast. Once there, Watkins apparently took on a more direct sponsor for the trip up the Columbia: the Oregon Steam Navigation Company, the transportation conglomerate that controlled not only the passenger and freight traffic on the Columbia River, but also the railroad line that paralleled the river. The latter also appeared prominently in Watkins' most celebrated photographs of this 1867 trip—pictures which showed track as ribbons of light rather than as carriers of the locomotive, that great nineteenth-century symbol of industrialization and modernization.[24]

This particular picture also introduces the question of sponsorship by a Mr. Stevenson, owner of the orchard which produced the apples in those two crates. Whether Stevenson actually sponsored Watkins remains a question; Watkins may well have picked the spot purely for its picturesque virtues. But he still chose to include Stevenson's apples, crates of them, and to present the skiffs as if they were the predominant mode of transportation, thereby emphasizing the yeoman farmer's idyllic life and deflecting attention away from the other carrier of agricultural products from the region, the steamship. This decision had larger implications: as the tracks in the railroad views signified the railroad and its development, but without associations to steam, smoke, noise, and instrusion, so here the substitution of two sailboats for the steam packets of the OSNC deflected the viewer, particularly the nineteenth-century viewer, from a conception of industrial intrusion and toward a sense of harmonious synergy.[25]

Watkins' view, in which picturesque natural beauty is inscribed across the surface of the photograph, also defines through its seeming absence (by the aversion of the camera's gaze) another vision of the American West—one which presages human development and

exploitation. Yet the message was not a denial or rejection of that future, but rather an apologia. Wherever the typical Watkins viewer of the period immediately after 1867 contemplated such an image, whether in a ticket office or freight office for the OSNC, in an exhibition such as the Mechanic's Fair in Cleveland in 1870 or the San Francisco Mechanics' Institute, or in an album of mammoth-plate views seen in a studio or gallery in urban San Francisco, the context of viewing assumed the inevitable and necessary development and exploitation of the West by the forces of capitalism and incorporation.

Watkins' own photographic production during the post-Civil War era exemplifies this intersection of seemingly contradictory visions of American development and suggests the role of photography in that process, for he made mammoth-plate views of industry as well as sublimity. He photographed mines like the New Almaden works in Santa Clara County, California, as early as 1863, and several carefully made, highly professional pictures of the products of foundries and factories in the northern California region ended up in advertising cards for the companies that hired him. By the eighties, he had produced a new series of western views that celebrated the interpenetration of industrial manufacturing, large-scale mining, logging, and agricultural enterprises with the spectacular landscapes and wild scenery of the region they despoiled.[26]

In part, we might see in these very different productions how a wide variety of clients could make diverse demands on a small-scale entrepreneur desperate for work. In a sense that would be true, but to say that alone would be to miss how that production system reflected and influenced the entire matrix of nineteenth-century American culture. After all, Watkins himself participated willingly in this heterogeneous marketplace for picture making: he exhibited his views amid jars of canned fruits and vegetables at industrial fairs, he sent his pictures of the Mariposa mining area to the London Exposition in 1862, and he sent copies of his views of Yosemite to the East, where they were exhibited in New York.

Nor did Watkins limit himself to the huge mammoth-plate views that are now his trademark; he also produced an extensive set of stereographs, as if to guarantee that his work could be seen by a wide and heterogeneous American audience. As with most stereographs, Watkins' small views often negated the very qualities of picturesqueness that the mammoth-plate views were designed to enhance. With their magnified optical realism and their recreation of deep space, these stereo views appealed to a scientific rhetoric even as they tended (particularly in their early years, or when rudimentarily made) to cancel the cues to artistic seriousness found in the larger views. Stereo cards were distributed and sold in a very different manner than the mammoth plates; they were usually distributed through national marketing channels, where they competed with views of other natural wonders, in stereo emporiums and bookstores.

So Watkins the view maker was simultaneously a private entrepreneur, producing pictures to be placed on gallery walls and sold as works of landscape art; a government-sponsored scientific evidence-gatherer, whose works would be pored over, assessed, and perhaps eventually published as part of a broader scientific survey; and a mass artist, producing stereo images for broad public consumption. His pictures, in their passage from photographer to audience, moved through a wide variety of distribution channels that increasingly applied the techniques and technologies of modernization to streamlining the transmission process.

Watkins' work, then, serves as a marvelous example (and in some ways an anticipation) of the pressures and products of the American view tradition during the era immediately following the Civil War. The images integrated painterly and literary landscape ideals and traditions into the making of photographs; their heterogeneous production allowed some pictures to serve as satisfactorily picturesque landscape views, while others advertised products or provided legal evidence in land disputes; they served multiple audiences; and finally, they maintained continuous, synergistic relation with the larger strands of American cultural transformation during the era. Watkins was a favorite of those urging a newly elevated tradition of American view photography during the 1860s. By the following decade, he had a host of coparticipants in this new tradition—thanks, at least in part, to the championing arguments of the photographic journals and the development of a more sophisticated set of professional institutions within the ranks of American photography, as

well as popular support for work by men like Watkins and Moran and sponsorship and encouragement by significant forces in American government and business.

The immense popularity of the stereo view immediately after the Civil War accelerated all the elements modernizing and streamlining photographic production. By the 1870s, for example, the Anthony Company had introduced a huge number of stereo series, containing some ten thousand individual pictures. Virtually all of them were views bringing the most popular symbolic American spaces—like Niagara, the Catskills, the White Mountains, the Rockies, New York's Broadway and Central Park, "Glimpses of the Great West," and "Public Buildings in New York City and Brooklyn"—into the parlors of nearly every American home.[27] When the nation's largest photographic house commissioned, distributed, and produced so many stereo views, that meant employment and a national audience for hundreds of photographers throughout the nation, although many of these views went into American parlors stripped of their original photographers' names. Partly as a result of this, and partly because the Anthony Company sparked and fed the market for stereo views, a significant number of photographers took to producing their own stereo series, including John Moran, who in 1866 began marketing his stereo views of eastern scenery. By the seventies stereo view production became a staple for professional photographers, from William Henry Jackson in the West to Seneca Ray Stoddard in New York's Adirondacks.

The success of stereo views by professional view photographers meant an equivalent surge in outdoor photographs generally. The *Philadelphia Photographer* noted this in 1866, when it praised the work of the Kilburn Brothers, a little-known team of neophyte photographers from Littleton, New Hampshire, whose firm within two decades would rival the Anthony Company in large-scale production and distribution of views. The view in general, and the stereo view in particular, underwent steadily rising standards of technical and artistic excellence, even as the marketplace and the professional establishment pressed to assure that no region of the country went unrepresented in the catalogue.[28]

Concurrent with this consolidation and expansion of marketing and distribution forces came the first really successful professional organization in American photography, the National Photographic Association. Founded in 1868 as a result of the bromide patent controversy (which threatened to require virtually every photographer to pay a licensing fee to the holders of a general patent on commonly used photochemicals), the National Photographic Association held its first national meeting in 1869 in Boston. With its annual conventions, its "official journal" (the *Philadelphia Photographer*, of course), and its steadfast championing of photographers' rights of free access to technological developments in the medium, the National Photographic Association was a crucial fixture in the world of American professional photography during the 1870s.[29]

The association was more than a cheerleader, however. It was an important champion of the view tradition, which was central to professionalizing and elevating the reputation of photography in America. As early as 1869, the association's conventions had included speeches extolling the importance of outdoor photography. By 1871, the chairman of the "Committee on the Progress of Photography" was "earnestly entreating" American photographers to follow the example of Europe and expand the importance of landscape photography; speech after speech at the convention in Philadelphia declared the view tradition essential to the success of photography in America.[30]

Another impetus to the view tradition lay at the production end. As government and business expanded into the West, important representatives of these forces decided to use photography to document their incursion, reconnaissance, and transformation of the American landscape. The head of the United States Geological and Geographical Survey, Ferdinand Vandeveer Hayden, while not the first to use photography for these purposes, showed the direction that government support would take. As early as 1868, he used a series of original photographic prints by Andrew J. Russell, the official photographer of the Union Pacific Railway, to illustrate his *Sun Pictures of Rocky Mountain Scenery*. In 1869, Hayden commissioned Omaha photographer William Henry Jackson to join him as the agency's official photographer. He justified that decision in his annual report for 1875, suggesting some ways in which the view might serve the needs of government institutions mapping

and opening the West. Hayden's detailed defense considered "what return they have made for the time and money expended upon their production, and entirely aside, too, from their aesthetic qualities, and the pleasure which lovers of the beautiful and picturesque may derive from them." Beginning with the assumption that readers might consider the pictures "merely" art, Hayden asserted that they were more:

> They have done very much, in the first place, to secure truthfulness in the representation of mountain and other scenery . . . to represent correctly the surface of the country upon his map. . . . Securing faithful views of the many unique and remarkable features of newly explored territory [photography] gives us faithful portraits of the varied families of our great Indian population, representing with unquestioned accuracy the peculiar types of each. . . . These photographs can be sent all over the world, and practically answer the purpose of a personal inspection. . . . In the office, the uses of photography are manifold. . . .[31]

Hayden's argument focused on the scientific, technical, and practical elements of survey photography. But in these areas he was describing an incomplete success; not until the nineties, with the appearance, concurrently, of easy-to-use flexible film cameras and methods for inexpensively mass-producing halftone reproductions, would the medium actually provide the sorts of ubiquitous, universally transportable *simulacra* that he described. Although his defense acknowledged only one set of reasons why photography was important to his survey, Hayden had other, unspoken purposes that in some ways were far more important. Photographic views served as excellent propaganda materials in approaching Congress for further appropriations. Year after year, Hayden sent elaborately packaged versions of Jackson's most spectacular pictures to those officials responsible for appropriations, with exactly the desired effect. Further still, by publicly distributing Jackson's views, Hayden extended to individual citizens and voters his argument for government involvement in the West.

The pictures thus entered the high intellectual discourse of their time and also served more mundane functions. In the scientific fastnesses of institutions like Harvard, Yale, or the Smithsonian, these photographs were treated as a new form of evidence, to be fawned over and praised in scientific outlets like the *American Journal of Science and Arts*. Engraved reproductions in the more popular magazines and journals, like *Harper's* and the *Century*, or in potboiler publications like *Frank Leslie's Illustrated Weekly*, extended these pictures to the mass, democratic audience. As stereographs and card photographs, too, the original images transformed *terra incognitae* into parlor education, to be consumed with the Bible, Tennyson, and other artifacts of middle-class culture.

Although Savage's famous photograph of the Golden Spike ceremony was exemplary, celebrating the triumph of technology, capitalist organization, and controlled contract labor over an inhospitable Nature, another photograph by the Utah photographer may offer more. Rather than showing a moment of celebration or formality, his picture of men quarrying granite for the Mormon Tabernacle in Salt Lake City, probably made in 1872 (FIG. 3), characterizes men at work, in various poses of labor. Evidently meant to illustrate the various tasks involved in quarrying the granite, the picture has a curious formality to it, partly because of the stilted illustrative poses of the men. This formality also came about because of the picture's intended audiences. A religious icon for a purely Mormon audience, the photograph also was meant to carry the message of Mormonism to a larger and more suspicious arena. It succeeded, as its subsequent history suggests. William Henry Jackson, official photographer for Hayden's United States Geological and Geographical Survey, saw the picture, probably while visiting Savage in 1872 on his way from the railhead to the Yellowstone region, and acquired it for the survey. It appeared, without either Jackson's or Savage's name on it, in that year's offerings to the public.[32]

Jackson's description of the picture for the government's *Descriptive Catalogue* of 1875 suggests in its own understated way how completely Savage's work of piety melded with the larger destinarian vision of the survey:

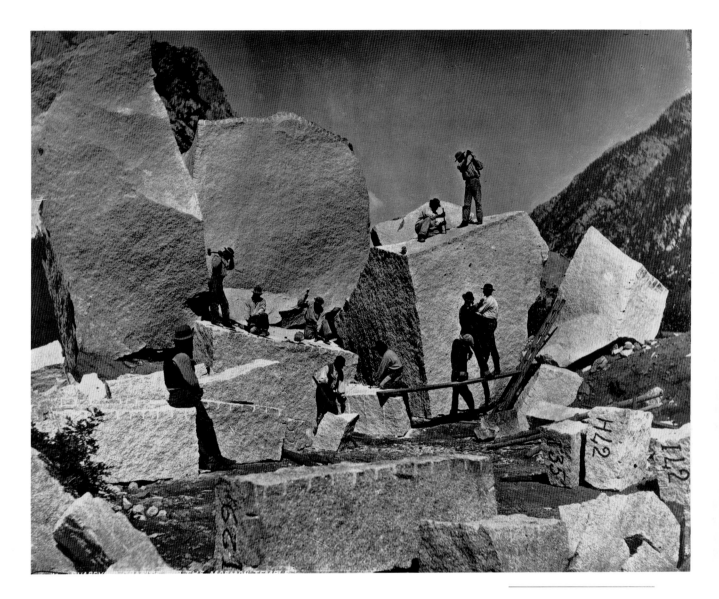

QUARRYING GRANITE in Cottonwood Cañon, seventeen miles south of Salt Lake City, for the Mormon Tabernacle. The ground is completely strewn with immense bowlders and detached masses of granite, which have fallen down from the walls of the cañon on either side, some of which are from thirty to forty feet square. All the quarrying is confined to splitting up these blocks.[33]

Thus, Jackson's caption made explicit what was implicit in Savage's photograph— implicit for Mormons, that is, who knew that these boulders had "fallen down from the walls of the cañon on either side," rather than being blasted off with dynamite, and who believed that such phenomena showed divinity intervening on their behalf. By clarifying this small detail for a broader audience and giving over the rest of the caption to dry factuality, Jackson enlarged the photograph's meaning beyond its Mormon significance, to encapsulate the ideology of the westering experience. The immense power of Nature, and yet its benignity to humankind; the implicit responsibility of man to labor well, and respectfully, and to a good cause: these were the concepts implicit in Jackson's caption, concepts native to nineteenth-century Americans who might view this picture. Jackson's caption also signalled the perfection of the original photograph, for the viewer, returning to the picture after reading the caption, could see how powerful the forces of divinity or nature really were, how orderly the result, and how well human society could insert itself into that order.

Figure V-3

CHARLES ROSCOE SAVAGE.
Quarrying Granite for the Mormon Tabernacle, Cottonwood Cañon, Utah, c. 1870-72. Copy print from original glass negative, 1872. William Henry Jackson No. 146, U.S. Geological Survey, Denver.

Equally significant is the way this picture reached its various publics. As a view of this particular subject, it was a work of piety for its primary audience, a confirmation to Savage's fellow-Mormons that their cause was righteous. As a Savage and Ottinger picture, sold along the route of the transcontinental railway and in the partnership's own Salt Lake City studio, the photograph presented an image of industriousness and piety to an audience of tourists and passers-by. As part of the Hayden Survey catalogue, it took up company with Jackson's first views of the Yellowstone, with panoramas of the Tetons and studies of the badlands, and with photographs of hydraulic mining whose captions implied barely tapped richness in the barely occupied West. In the process, the photograph touched on national themes to gain national symbolism and a national audience as well. It became a work of historical significance, a record of one element in the inevitable process of occupying the wilderness, respectfully modifying it to the needs of man, then extracting its riches to create the new American civilization.

Even the apparent final irony—that Jackson appropriated this photograph—suggests some outlines of the view tradition. First, it is extremely doubtful that Jackson stole the picture; instead, he appears to have added it to a series he himself made of Cottonwood Cañon on and around June 20, 1872. But even in early summer, Jackson wrote, "the snow lies so thickly as to render the roads nearly impassable,"[34] and though no quarrying was likely to take place in that season, Jackson had a pressing need for a picture such as Savage's. There is much evidence that Hayden, with Jackson as active collaborator, had defined the survey photography archive as a comprehensive work to explore, catalogue, order, and then disseminate the accumulating mass of information about the West—information that was geological and geographical, as the survey's title indicated, and also sociological, economic, metaphysical, spiritual, and philosophical. Hayden and Jackson had conceived a vast, Humboldtean task: to contain all the elements of this moment in human history in an accessible, visual form, using the medium with the most powerful rhetoric of truth and the greatest capacity for suggestiveness. Without Savage's photograph, the project was diminished; with it, it was complete. Who can wonder that Jackson purchased the print from his friend and mentor, or traded an equivalent example of his own work?

As to the matter of authorship: here, Jackson served primarily as publisher, not as author. Purchasing or trading the picture was accepted practice in photographic circles at the time, but most significant here is why such practice was generally accepted. In the mythology of the camera, Savage was not the maker of the image; Nature, the "perfect work of God" (as the Scottish photographer David Octavius Hill termed it in 1848) was responsible for the image. Selling the picture or trading it for one of Jackson's meant losing little or nothing in those terms, but in return Savage gained entrance into that larger world that Hayden and Jackson's majestic project could reach. Far from diminishing the author or his work, the process participated in a central mythology of the view: the notion that photographer, medium, subject, and eventually viewer were all locked into a transcendental experience, an august moment in the history of humankind. Savage's photograph contained many essential elements of the view tradition, satisfying the demands of reconnaissance and celebration, transparent communication and artistic transformation. Concurrently a work of scientific evidence, historical reportage, philosophical speculation, and religious piety, this view reached its audiences through a wide variety of distribution channels. Not an isolated work of visual delectation, it was instead part of a complex, interwoven fabric of cultural production, meant to be understood, to serve its purpose, within that context.

The elaborate cooperative enterprises of government-sponsored photographers on the exploration surveys serve to illustrate the institutional structures surrounding the photograph and the photographer. William Henry Jackson's eight-year sojourn with Hayden's United States Geological and Geographical Survey of the Territories was the longest-lived and most productive of these combinations. Working with Hayden, with the Survey's scientists and mapmakers, and with such artists as Hudson River school landscapist Sanford Robinson Gifford, high-Romantic landscape painter Thomas Moran, and scientific artist Henry W. Elliott, Jackson produced a large archive of "views," ranging from specimen studies of individual geysers to multi-plate panoramas of mountain ranges, all

intended to aid or even substitute for the labor of geographers. Through the network of survey figures and the assiduous work of Hayden and Jackson themselves, these views also appeared in an extraordinary range of publications, from the annual official *Scientific Reports* of the survey to such popular western booster books as *Crofutt's Transcontinental Tourist Guide* (1877) or Hayden's own *The Great West...* (1880).[35]

But Jackson's history is only one of many that are essentially similar; E. O. Beaman, William Bell, John Hillers, Carleton Watkins, Timothy O'Sullivan, and others were involved in similar government projects, as were Andrew J. Russell and A. A. Hart with the Union Pacific and Central Pacific railroads, respectively. These men participated actively in giving meaning to what had previously been *terra incognita*, and their work found wide audiences. The process involved no single heroic creator, but rather a network of interlocking causes, in which not only the photographers but also the consumers of views, the distributors, and the commissioners (including Hayden, the Anthony Company, and even the *Philadelphia Photographer*, with its ever-repeated exhortations to its readers to go out and make views), all contributed to the development of the view tradition. Other, far smaller enterprises also produced similarly inclusive, ordered results. In the cities, those who helped determine the implications of the urban space were not scientists and government explorers, but architects, businessmen, entrepreneurs, journalists—and photographers. In Buffalo, Chicago, Cleveland, Louisville, New York, Philadelphia, Utica, and many other cities, photographers or businessmen exploited a number of new genres, including photographically illustrated guidebooks, which came out in the decade after the Civil War, and photographically illustrated city directories and guidebooks. Often containing maps, texts, and portraits of leading citizens as well as views of the major urban monuments and contributing businesses, these works combined, for prominent American urban dwellers, city growth and maturity with the celebratory descriptiveness of the camera.[36]

The resulting productions were striking in their vision of a complete, ideal, progressive urban civilization being carved out in each city.[37] Berk Batchelor, photographer and

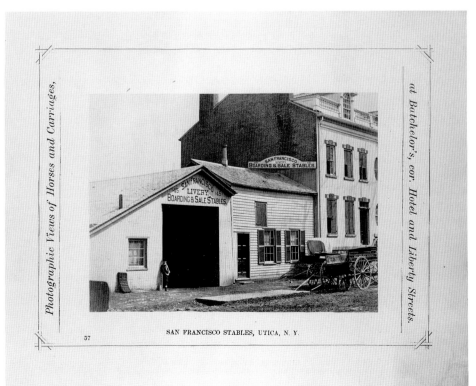

Figure V-4
Berk Batchelor. *San Francisco Stables, Utica, N.Y.* Probably 1874. From *Batchelor's Pictorial Business Directory for the City of Utica, N.Y.,* 1874-75. Library of Congress.

Figure V-5

JAMES CREMER. *Three Views of Philadelphia.* Albumen silver print, 1871. From *Illustrated Guide to the Leading Wholesale and Retail Business Houses...of Philadelphia* (1871). Library of Congress.

publisher of *Batchelor's Pictorial Business Directory of the City of Utica, N.Y., 1874-75,* defined the necessary conditions in his introduction; his work was "dedicated to the millions who believe in the value of judicious advertising, and to those who find that the true Road to Fortune is to spend their money with honest merchants, who work hard and build up a Prosperous Business by Advertising and Selling Goods at a Living Profit."[38] His Utica was a business city, in which boosterism and advertising, buying and selling at "a Living Profit" would result in—indeed, had already resulted in—the creation of an ideal urbanism.

Batchelor, who advertised his willingness to make "Photographic Views of Horses and Carriages," made a view of the "San Francisco Stables, Utica, N.Y." (FIG. 4) that portrayed the stables themselves, a goodly portion of the carriage goods, a stable boy, and three buildings of evidently quite different vintages, styles, and pretension. The resulting text offered a miniature history of Utica's expansion.

Batchelor's views of building fronts and streets were typical of the majority of views contained in booster books. On their most prosaic level, they described the buildings and often their immediate context within the street. But the classical frontality of the views, the predominance of stable, rectilinear composition in the photographs, and the stillness

within the images all imparted gravity and even splendor to these places, though not all photographers were satisfied with such relatively prosaic treatments.

The elaborate layouts and sequencings of these booster books also declared to their viewers that city progress was being generated, and even defined, by a harmonious collective. Three of James Cremer's views of Philadelphia's leading urban icons, originally photographed for his *American Scenery for the Stereoscope* series, ended up across the top of a page of the *Illustrated Guide to the Leading Wholesale and Retail Business Houses and Manufacturers of Philadelphia, Containing Photographic Views of Prominent Places, Maps of the Business Portion of the City, New Park, Wissahickon [sic], etc.* (FIG. 5). Featuring four major neoclassical buildings, three of them owned by government institutions, these images lent, by their gravity and transparency, legitimacy to the commercial announcements below them. The block advertisements, three of them for banks (and each announcing the working capital available), all used elaborate type styles to imply further the solidity and safety of these institutions. The advertisement for Warburton, the "fashionable hatter," even featured a wood engraving that included the hatter's store but more prominently depicted a substantial second-Empire structure nearby: the Post Office.[39]

That page gave stability to the urban scene; a second page set the city within a geographical and natural context (FIG. 6). There three photographs by Cremer from his *Views on the Pennsylvania Central Rail Road* ran across the top, intersecting transportation technology and picturesque nature. Below, a prominent classical column anchored a complex advertisement for the Moorhead Clay Works, which boldly announced the "victory of *Peace*" in the war for international supremacy between America and the European nations, "a triumph in favor of Health, Cleanliness and Comfort." "By the unparalleled enterprise" of Moorhead's innovations in the technology of sewers, "our cities and towns are now encouraged to lead away from their doors that fruitful source of disease, 'stagnant water'." Wholesome nature, technology, business, and urbanism were united; their foes, disease and urban dystopia, were vanquished.

Virtually every page of the *Illustrated Guide* (and many others of its type) mirrored these themes of prosperity and safety, "Health, Cleanliness and Comfort," in the new urban spaces. The photographs, with their high-angle views of monumental architecture, sanitized street views, and studies of the natural surroundings of the city, were instrumental in creating this composite image of the ideal modern American city. Of thirty-six views in the *Guide*, five described cultural or benevolent institutions (including "Gilbert Stuart's Old Studio"), five featured government buildings, one showed a pair of religious institutions, one a hospital, and the remaining twenty-four were landscapes made in the city's parks or in surrounding areas. Business institutions did not appear in the photographs—they comprised, after all, the bulk of the nonphotographic portions of each page, and the photographs were evidently meant to anchor the Philadelphia economy in a context of permanence, stability, monumentality, and orderly growth. The architectural styles of the buildings themselves—monumental Neoclassicism and newly fashionable Second-Empire style, with its mansard roofs and white-stone facades—doubtless also influenced Cremer, Gutekunst, and Newell's choice of photographic subjects for the *Guide*.

The conspicuous inclusion of so many landscape photographs within a work of urban boosterism was also emblematic of the philosophy behind urban views during this era. Explorers like Hayden considered themselves point-men for an advancing civilization that would eventually dominate, transform, and overlay the wilderness regions the explorers were demarcating—but this process would not be destructive. Instead, the city (and the civilization it represented) would come to the wilderness, the landscape would be incorporated into the city, and a new civilized nature would result, benefiting all. This belief, clearly stated in the debates concerning Olmsted's Central Park in New York, was part of the larger faith in a complete civilized landscape, in which all human and natural elements could exist in fruitful symbiosis. Cremer's images of Fairmount Park in the *Guide*, or Thomas E. Marr's of Boston Commons, or J.W. Taylor's views of Chicago's Lincoln Park were the urban equivalents of William Henry Jackson's views of frontier towns like *South Pass City* (FIG. 7), made in 1870 for the Hayden Survey, or similar views of cities and towns made for other major government surveys of the wilderness.

These works of urban celebration were, in their own way, of a piece with the works of the "landscape" viewmakers; each presented the utopian mythos of a perfect civilization combining both realms in harmonious fruitfulness. By structuring the work in controlled, sequentially ordered groups of pictures and mixing high-angle comprehensive panoramas with pictures of streets and closer views of individual buildings—meant to represent the ideal architectural and commercial mix—the utopian model for city development in these books matched similarly utopian plans in the annual reports of Hayden's, Whitney's, King's, and Powell's government exploration surveys.

The era of the seventies represents a moment of particular consolidation in the view tradition. The transformations that occurred along this cycle of consolidation, culmination, disintegration, and reintegration were not neat or linear. Rather they were halting and irregular, influenced by the personal circumstances of individual photographers, by conditions of geography, cultural lag, economic cycles, and other specific factors. The changes in photography's subjects, business practices, self-image, and the dominant style

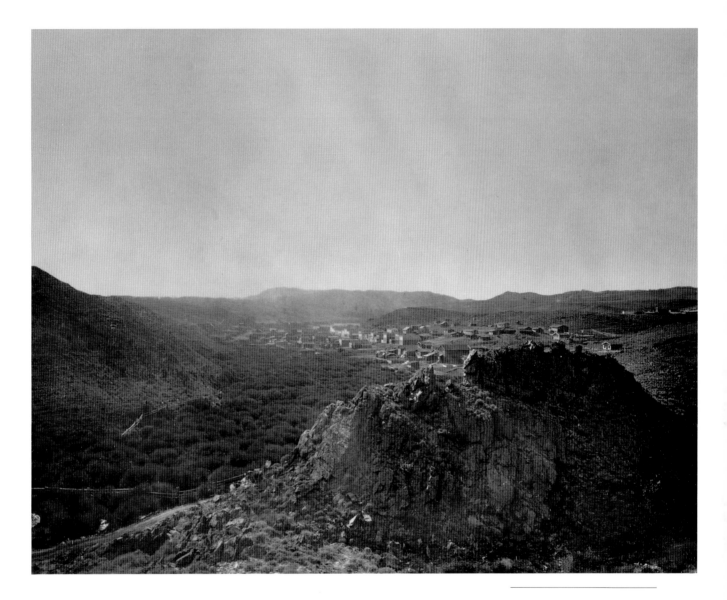

Figure V-7
WILLIAM H. JACKSON. *South Pass City.* Albumen silver print, 1871. William Henry Jackson No. 301, U.S. Geological Survey, Denver.

and iconography it employed: all were interlocked and must be considered together. But to see the process whole we must first see it in its pieces, as a set of case studies involving individuals, incidents, pictures, and sets of pictures. These in turn may provide us with the raw materials for a tentative analysis of the view and its place in American photography.

George Barker represents, in some ways, an ideal transitional figure. In a career that ran from the daguerreian years of the 1850s until his death in 1894, Barker adapted quickly to transformations in business and aesthetic practices and produced a wide range of views. Although virtually all of his images have been forgotten in the twentieth century, he was one of the most prominent American photographers during his own era; his name was linked to the single most important icon of American nature worship—Niagara Falls. Barker began with a daguerreian gallery at the falls, then sold the business in 1865 and moved aggressively into producing and marketing stereo views of the falls and other appropriate subjects, especially images of the nearby Iroquois tribe. By the mid-seventies, his name had become synonymous with Niagara. Having won prizes at a number of expositions, he was ready to branch out aggressively, and did so. In 1876, he flaunted a ban on unauthorized photographs of the Centennial Exposition in Philadelphia and published the results in stereo form, under his own imprint; this was just one of a number of subjects he chose to expand his market share and his practice beyond New York State.[40]

In his quest for a larger stage, Barker began making urban views. In 1883, he produced a set of eight-by-ten city views of Buffalo, New York, and added to the set in 1885. These photographs applied the urban "grand style" of city boosterism, but Barker also transferred his trademark moody views from Niagara Falls to the river at Buffalo. In studies of boats and grain elevators, and even in one "moonlit" view of a sailboat, he knit together city and landscape into a unified touristic vision with pictures that were both souvenirs and delights to the eye.

Barker's major change occurred in 1884 or 1885, when he began to make mammoth-plate views. The rising popularity of "mammoths" in the eighties itself indicated that photography's audiences were demanding changes. A strong market for mammoth-plate views had existed before the eighties, but almost exclusively in California, where photographers like Watkins (SEE PLATE 6) and his competitors C. L. Weed and Eadweard Muybridge (SEE PLATE 54) competed for a share in the tourist market with images of the fabled regions of California, particularly Yosemite (SEE PLATE 73). In the East, where mammoth-plate views had been a relative rarity, the move in the eighties toward larger and larger plates reflected a more general deflation of the photographic image itself, as a result of overproduction and a change in viewing habits. Whereas the viewer could actively handle stereos and the smaller cabinet cards and whole-plate views in albums, mammoth-plate views were meant to serve as wall decorations, as substitutes for paintings and chromolithographs. As a result, good mammoth-plate photographers made pictures that increasingly conformed to picturesque norms—that looked, in a sense, more and more like the mammoth-plate views coming from California and, by this time, Colorado—rather than extending the more severe aesthetic of evidence.

Barker was in a particularly good position to make this shift from the starker, more nakedly descriptive stereo view toward the larger, more picturesque landscape. He had an ideal location from which to work: Niagara was a built-in subject for spectacular views, nationally recognized for generations as a uniquely sublime symbol of American scenery. More importantly, it attracted throngs of visitors, who quite naturally expected to carry away photographic remembrances of their sojourns. Barker was in an ideal location to circumvent the national marketing systems that enforced the supremacy of the stereograph as the method of viewing. His audience came to his studio for views and, once there, became dazzled by the larger images, which were valuable as home decoration could be shipped by mail from Niagara to anyplace in the United States.

Competition from other photographers also goaded Barker to innovation. By the eighties, Niagara had become a stock subject in virtually every mass-market stereographer's catalogue, rivalling Yosemite as the absolutely necessary subject for every ambitious maker of views in a major (or even not-so-major) American center. Time and again in the pages of journals like *Anthony's Bulletin* or *Photographic World*, editors noted representative samples of work by up-and-coming photographers, almost all of whom included views of Yosemite and Niagara as proof of their national scope. Furthermore, a number of photographers had studios in the region immediately around Niagara; even after Barker became the preeminent regional photographer following the demise of Platt D. Babbitt in the 1870s, he still faced constant competition from other studios in the region. Again, his spectacular productions brought him both reputation and clients; his photograph of Niagara from below was a trademark Barker with its darkened sky, contrasts of white water with dark rocks, and emphasis on spectacular scale (FIG. 8).

Like many viewmakers of the seventies and eighties, Barker read the photographic journals of the time and made a point of getting his name into the most influential one, Edward L. Wilson's *Philadelphia Photographer*. In the mid-1870s, Wilson's journal began publishing a series of articles that urged a new place for photography in the pantheon of the fine arts—a different place from the one that had so signally influenced the American view tradition in the sixties. The argument about the relationship of photography to scientific truth on the one hand and artistic truth on the other had changed, and the *Philadelphia Photographer* had become one outlet for the discussion. Writers in the sixties had emphasized that the outdoor photograph could transmit the truths of nature and thereby act as an instrument for human improvement. Even John Moran, presenting perhaps the

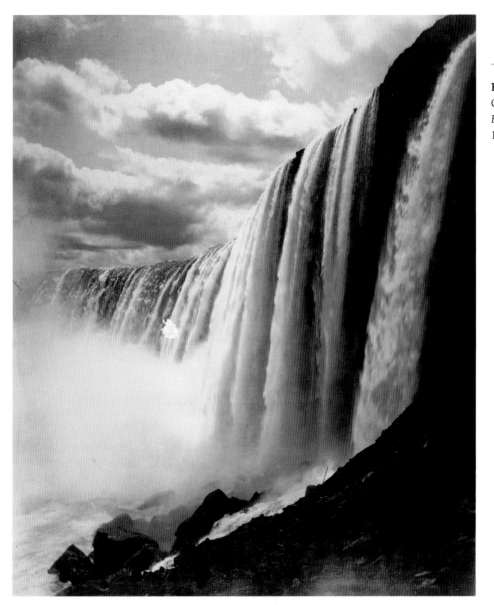

Figure V-8
George Barker. *Niagara from Below.* Albumen silver print, 1886. Library of Congress.

most extreme of the earlier arguments for the "art" of landscape photography, located the photographer's ability to "create imagery" in his capacity to *choose* beauty that would "call forth ideas and sentiments of the beautiful." In the seventies Wilson's authors stressed a different construction, in which the photographer's capability to choose a scene became only the earliest stage; they attached increasing importance to defining mood and meaning through choice of lighting, then modifying the view through manipulations in the camera and the darkroom. Done together, done well, these stages made photography an art of creativity akin to painting. Thus one reader, replying to Henry Hunt Snelling's rather vitriolic attack on photographic criticism, contended that

> copying from nature in sculpture, painting, or photography, is not necessarily art; it may be merely the skill of the stonecutter, draughtsman, or manipulator; in either case it may be a perfect copy of nature, and not, in any sense, a work of art. Anything that aspires to consideration as a work of art, must be measured by certain rules of design, composition, and execution . . .[41]

But this critic's argument with Snelling was largely moot, for Snelling had begun his diatribe against critics with an homage to the National Academy of Design.[42] Concurrent calls for the development of a national academy of photography, which the *Photographic News* had argued as early as 1872, began by the later seventies to include calls for

Figure V-9
AFTER AELBERT CUYP. Engraving,
1875. In Edward L. Wilson, "Our
Picture," *Philadelphia Photographer*
12 (May 1875): 138.

" What a lovely little gem of a picture it makes, possessing nearly all the elements of the large entire composition. The artist

has conformed strictly to the customs of art, and we will soon see how his picture gains in value by such a course, when we remove part of it, and it presents the shape shown in the second figure. You will observe that the two figures are identical, with the exception that the dark group of shrubs, etc., on the right foreground, and a part of the river-bank, which appear in the one, are removed in the other.

" It will be observed in the first figure that there are two diagonal lines nearly parallel with each other, which rise from the right-

hand lower corner of the picture—the one starting from the dog behind the man firing at the ducks, following on over his head,

over the shrub to his left, behind which he is kneeling, across the stream to the old castle nearest the water, over the church spire, on up to the mountain top. The other starts in the highest shrub on the right, whence the eye is carried across the picture by the white cloud in the sky, which completes the second diagonal line. Now, in the second figure, these shrubs and the figures of the man and dog are removed, with a part of the river-bank, and observe the wondrous difference. Our lines are destroyed; the necessary balance is removed, and the group of buildings looks as if it had nothing to stand upon, and was about to topple over into the water. The lines running to a point in the distance, appear to want collecting together and regulating; the distance itself comes forward into the foreground, and the parts do not take their proper relation to each other. There is a sense of completeness and finish in the one which we cannot recognize in the other. Mr. Cuyp, the painter of the original picture from which our model is engraved, almost always adopted this form of composition, and it is quite easy in most cases for the photographer to follow it or nearly approach it. In his pictures, it was his habit to place the point of dark near to, and opposed to the point of the greatest illumination, thus securing the extremest value to his highest lights. Many illustrations of this will be found in our model picture."

We now leave the matter with you.

As to our illustrations proper they come from the large series of views published by Messrs. W. A. Mansell & Co., of London. No fifty of our readers will get the same view, for the reason that we are compelled to use a great

certification and training in artistic practices—in "the rules of art and laws of composition," as William Heighway declared.[43]

Even Edward Wilson, once the chief spokesman for a transcendentalist interpretation of landscape photography, moved increasingly toward focusing instead on the photograph's conformity to the "rules of art and laws of composition." Wilson's argument for a commercial trade in outdoor photographs was no longer linked to philosophical or moral demand but instead was part of a more general call for "the exercise of artistic principles." "We should learn to select and combine and arrange the material before us, so as to secure the most pleasing result," Wilson wrote in 1875.[44] The previous year, the *Photographic World* had published a series of "Landscape Lessons," illustrated with wood engravings from well-known paintings and fine-art prints, which explored each aspect of the compositional strategy. Now Wilson repeated this strategy, publishing two engravings from a painting by Cuyp—one with, the other without the requisite foreground trees—to illustrate ways for photographers to integrate their work with the painterly traditions of the fine arts (FIG. 9).[45]

Wilson's argument was straightforward: the ambitious photographer should not be satisfied with portraits or views drawn from the formulae of current photographic practice but instead should study the relevant masters of painting, apply their techniques, and thereby elevate his work to the level of fine art. This elevation now occurred not so much because photography could communicate the sublime truths of nature, but rather because the photographer had learned the strategies of manipulation which could make the photograph a rival of painting. The truth that Wilson argued for with increasing force during the later 1870s and 1880s was a truth less of Nature than of Art. Henry Peach Robinson's collaged composite photographs began to grace the monthly photographic illustrations, and his urgings toward a more "artistic" photography found increasing place on the journal's pages. Wilson's journal both reflected and stimulated that transformation in ideals among American photographers, by declaring that good art was the road to good business, to increased sales and heightened status in an era now inundated with stereo views and less excited by the photograph's reconnaissance capacity.

Barker had already been moving in the direction of larger and more artistically derived photographs in the early 1880s, and toward a heavily stylized sublimity in his treatment of Niagara Falls. His earliest mammoth-plate views, however, were extremely primitive; their problems of focus, sharpness, and depth of field are all the more pointed in comparison with eight-by-tens he made concurrently at each site. Such problems stemmed from the leap in difficulty inherent in the mammoth-plate process; the lenses were far less easy to manipulate, their greater length shortened both depth of field and focus, and far greater care was required in composition. By 1886, however, Barker had mastered the camera and was producing views to appeal to every tourist (SEE PLATE 69). His view of *Luna Island in Winter*, copyrighted in 1888, offered the tourist a lovely souvenir photograph that substituted for a cold and unpleasant reality (FIG. 10).

Views like these won Barker the Grand Gold Medal and six first prize medals at the Saint Louis Exposition in 1886. The same year, the photographer made another aggressive move into the national marketplace, taking his first trip to the South—to Virginia, Georgia, and Florida—with his whole-plate and mammoth-plate cameras (SEE PLATES 68 AND 74). Over the next four years, Barker established a second venue in the newly opened tourist regions of northern Florida. Railroad and steamer travel and the development of new hotels and resorts in Saint Augustine, Silver Springs, Fort George Island, and along the Saint Johns and Oklawaha Rivers, had stirred a vogue in winter vacations in the region. This novelty could not have been more fortuitous for Barker, who apparently garnered contracts with some of the better resorts and hotels and who also produced an elaborate thematic set of views of the region.

Barker was quick to see the romantic appeal of this region; working within natural settings, he focused on the exotic flora and fauna that attracted tourists. His photographs

Figure V-10
SMALL-CAPS GEORGE BARKER. *Luna Island in
Winter.* Albumen silver print,
1888. Library of Congress.

Figure V-11
George Barker. *Spanish Moss on the Banks of St. Johns River, Florida.* Albumen silver print, 1886. Library of Congress.

celebrated the strangeness of Spanish moss (FIG. 11) and showed avenues of coconut palms strewn with coconuts in a display of natural extravagance. But by far the most baroque of Barker's views was his picture of the Oklawaha River, copyrighted in 1886 (FIG. 12). Vertically organized, this photograph set on one side a stand of huge trees that culminated in a webwork of Spanish moss. To the right, the sky was pierced by an absurdly tall palm tree rising out of the dense riverside growth. In the center of the river, silhouetted against the dark water, a flamingo perched at the end of a sand bar, one leg up, the other leg carefully retouched for clarity. The entire picture seems impossible today—it resembles a museum diorama, not a photograph of an American landscape. And this quality, more or less extravagantly, reflects the entire body of Barker's views of Florida; they colonized the area

Figure V-12
GEORGE BARKER. *Oklawaha River,*
Florida. Albumen silver print,
1886. Library of Congress.

Figure V-13
GEORGE BARKER. *The Wonder Oaks of Ft. George Island, Florida.* Albumen silver print, 1888. Library of Congress.

for the viewer, converting it into a series of stage-sets through which the tourist could wander, as in his view of *The Wonder Oaks of Ft. George Island, Florida*, with its well-dressed men in suits, women with parasols, and the figure in a chair in the tree-branches themselves (FIG. 13).

Barker's adaptation of the call for a more "artistic" photography ingeniously upended the older view tradition, in which the power of the subject had dominated the viewer's response and the composed, artificial nature of the photograph itself had been suppressed in favor of clarity and communication, scientific accuracy and truth. Now the artifice of the picture, the staged quality of its result, invoked for the viewer an ideology of human control over nature and the subject, and the photographer's manipulations of the raw material of the scene refracted a larger process of human consumption of the American spaces.

If nature in Barker's Florida views was an overflowing cornucopia of visual and sensual riches, the populated regions revealed a history as exotic to northern viewers as was the landscape. Barker directed his most concerted effort at Saint Augustine, Florida, where his mammoth-plate views focused on picturesque historical qualities and southern romance.

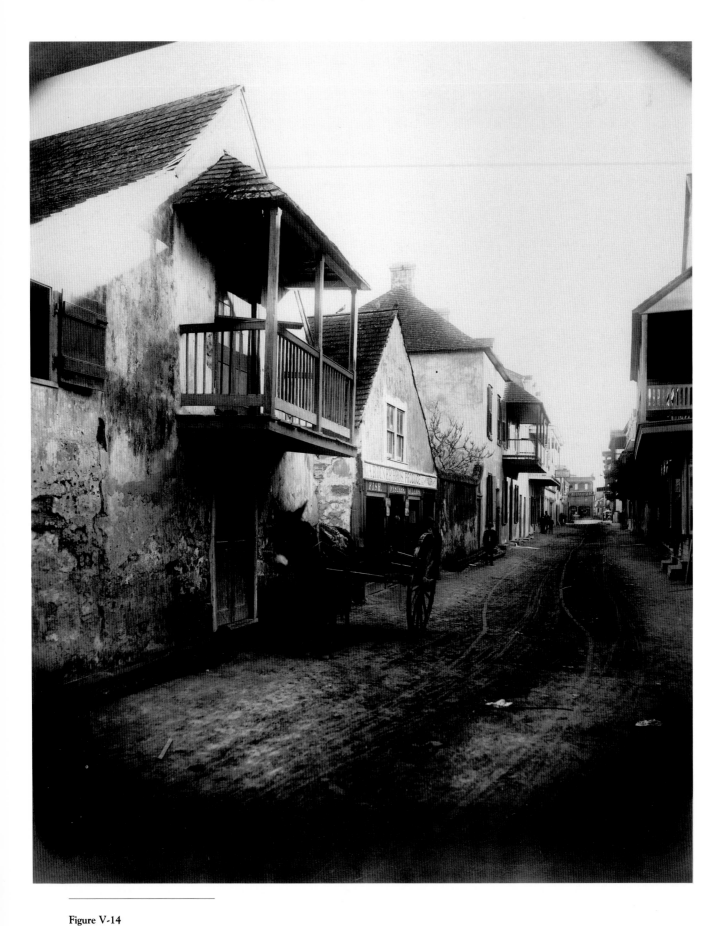

Figure V-14
Georg Barker. *Charlotte Street—*
St. Augustine, Florida. Albumen
silver print, 1886. Library of
Congress.

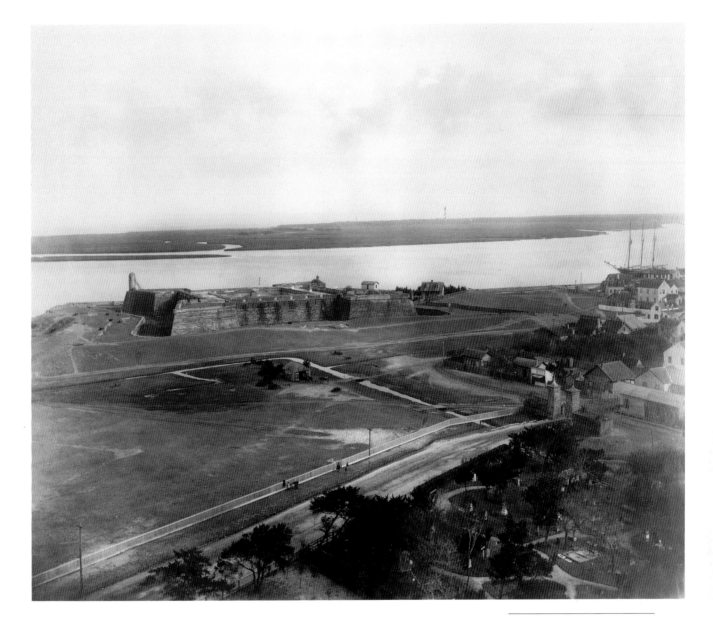

Figure V-15

GEORGE BARKER. *Bird's Eye of Fort Marion and City Gates, St. Augustine, Florida.* Albumen silver print, 1886. Library of Congress.

His view of *Charlotte Street—St. Augustine, Florida* (FIG. 14), copyrighted in 1886, portrayed a dirt street, old buildings, his black guide with a donkey cart, and other carefully posed figures, both black and white. Its theme (reflecting the tourist literature of the time) was the atmosphere of historic decay that surrounded Saint Augustine and especially Charlotte Street, which ran along a single block and had the city's "oldest house" on it. Barker's view, made in deep shadow with sunstruck highlights and a hazy, brilliant sky, used this contrast of darkness and light eloquently. Saint Augustine's rich history as perhaps the oldest Euro-American settlement on the continent, occupied since 1565 by Spanish, English, Confederate, and Union forces, combined with its mixture of black, creole, foreign-born and southern white cultures, offered Barker much to work with. He exploited his chances in a number of ways: a mammoth-plate *Bird's Eye of Fort Marion and City Gates, St. Augustine, Florida* (FIG. 15) offered a sweeping range of evocative subjects, each relegated to a slice of the picture, and a high-angle view *Looking Across the Plaza* focused on the restored slave market in the town's center. The resulting composite celebrated a romantic southern past of tourbooks and romance novels and a sleepy, redolent present, perfect for the tourist who might buy the picture in the lobby of her hotel or from a concessionaire on the steamer up the Saint John's River.

Barker further celebrated human dominion over nature by directing his attention to points where human and natural exotica meshed and intermingled. A marvelous example is his series of views of *Silver Springs, Florida From the Morgan House, Steamboat Approaching*

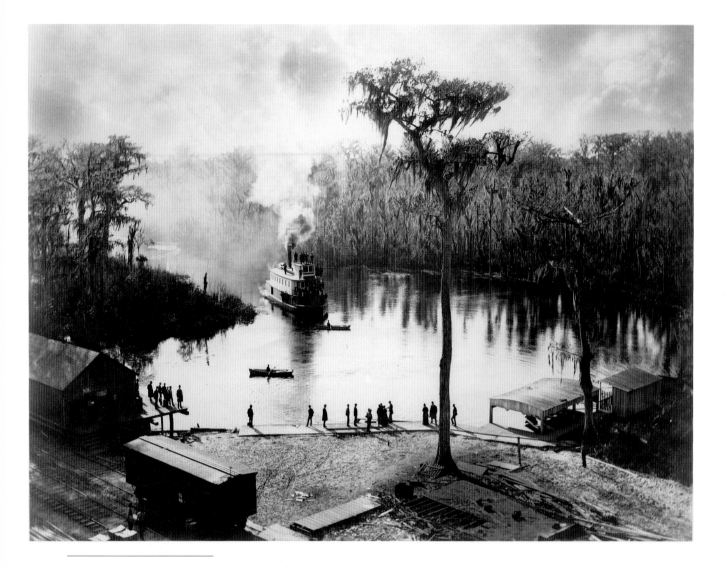

Figure V-16

GEORGE BARKER. *Silver Springs, Florida From the Morgan House, Steamboat Approaching Dock.* Albumen silver print, 1886. Library of Congress.

Dock (FIG. 16). In all, Barker made four views of the vessel's arrival and departure; each image marked an engrossing intersection between human habitation—complete with railroad boxcar, piles of lumber, a half-built ice house, and waiting tourists on the dock, on the steamboat, and even in rowboats—counterpoised against the decayed, gloomy swampland of huge trees, overhung and smothered by Spanish moss, that lay just across the river.

By 1888, Barker was advertising his stock of views as "Niagara, Florida, and Other American Scenery," and much may be read into this last word. Like others during the fifteen years before the turn of the century, Barker treated landscape, cityscape, and their marriage as *scenery* first—not as landscape, not as metaphor. His attitude reflected changes in language in journals like *Anthony's* and the *Philadelphia Photographer* during the period after 1876, as the word *scenery* appeared with increasing frequency, eventually seeming to press *nature* from the vocabulary of outdoor photography. Barker's pictures exemplified the adaptation of older modes of vision to these new cultural marketplaces.

Similar adaptations applied to the generation of photographers whose subject was the American West after it had been explored and the frontier pressed further into the background. Perhaps the most successful was F. Jay Haynes, the official photographer for the Northern Pacific and the sole photographic concessionaire for Yellowstone National Park until the 1920s. Haynes entered the profession of photography just over a decade after the Civil War. Like many of his predecessors, he apprenticed in a small commercial studio, in his case in frontier Wisconsin. But whereas William Henry Jackson received his visual training from nearby landscape painters and his intellectual training from reading Emerson's essays and Whittier's poems, Haynes learned from the chromolithographs he sold by subscription in the raw, rural countryside north and west of Milwaukee.[46]

Between these two sources lay a world of difference. In Jackson's approach, the concept of landscape came imbedded within a complex and continuing discourse involving artists, writers, philosophers, journalists, politicians, and scientists. In Haynes' case, the debate already had been resolved; the artifacts he worked with were themselves works of mass culture—open, accessible, more firmly fixed in meaning.

Haynes' business training was circumscribed by geography as well as time. Setting up his first studio in 1876 in Moorhead, Minnesota (a railhead for the Northern Pacific Railroad), Haynes in many ways reproduced Jackson's circumstances in Omaha a decade earlier. But by 1876, the first great wash of public curiosity concerning the West had generated a sweeping response in photographic artifacts. Haynes could not count on the newness of medium and subject that had eased Jackson through his apprenticeship in landscape photography. And the marketplace had also dried up to some extent as dissemination channels for western views were established and contracts with photographers of an earlier generation were settled.

Haynes was lucky, however; as one of the very few competent photographers in a sparsely settled region, he found himself under contract to the Northern Pacific railroad within months after his arrival in Moorhead. His own ambition meshed with the desires of a ruthlessly ambitious corporation and its managers, and Haynes' assignments nearly always focused on stimulating a wider American interest in the Northern Pacific's territories.

Haynes' first views for the railroad were essentially reportorial in intent, picturing the great news of the Northwest—the gigantic, heavily mechanized, mass-production farms that (in good years) turned the marginal lands of northern Minnesota and the Dakotas into breadbaskets. This first subject (to which he would return for the next few years to record each stage in the process of converting farming into an efficient industry) is emblematic of

Figure V-17

F. JAY HAYNES. *Harvesting, Dalrymple Farm, Red River Valley, Dakota Territory, 1877.* Collodion print. Montana Historical Society; Haynes Foundation Collection.

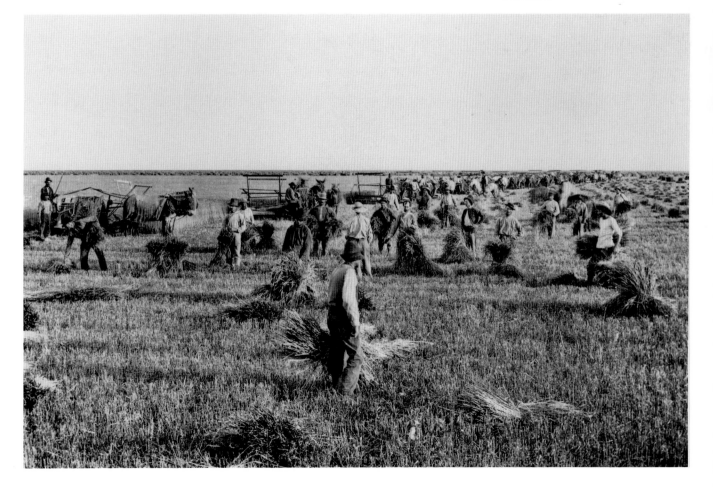

Haynes' early role, in which satisfying the corporate farming client predominated. So successful was Haynes by the second year that one of his stereos, cropped and enlarged (FIG. 17) was converted to a wood-engraving which graced the railroad's advertisements for its Dakota enterprise and appeared as well in the Dakota booster publication, *Smalley's Northwest Magazine*.

Haynes' work on the bonanza farms tapped a well of interest among tourists and easterners alike. The Northern Pacific had begun running excursion trains out to its own Dalrymple Farm so that tourists (and prospective investors, who might buy farms of up to one hundred thousand acres from the railroad) could observe this successful mass-production farm firsthand. Haynes' photographs not only served as souvenirs of these excursions but also advertised both the excursion and the land that was for sale—a marriage of photography and capitalism that argued the railroad's case to individual viewers in images that appeared to relay straightforward facts about the region.

Haynes quickly garnered a contract guaranteeing steady, long-term work with the Northern Pacific. This work was always defined in terms of the requirements, often quite explicit, of his corporate client. For an earlier photographer, one of the Northern Pacific's publicity agents had written:

> We want good farm scenes, prairie views, reception houses, bridges, and above all the photographer must go to the end of the line and "take" the process of track laying. We want good views of Ottertail Lake from its most interesting point of vision. Don't let him spend his time on humdrum subjects. Get in a few homesteads surrounded by stacks and cattle.[47]

This combination of subjects—celebrations of the triumphant progress of technology over the hostile terrain, views of picturesque landscapes, and prosperous working sample farms—was the one likely to make the railroad the most money from investors, tourists, and potential settlers. Throughout his career, Haynes continued to aim his views toward those audiences. But by the early 1880s, he determined that steady income would best come from a committed investment of time and money in one particular locale: Yellowstone National Park.

By Haynes' time, the park was just entering its first phase as an organized mass-shrine for tourists. As early as 1879 Haynes (who kept perhaps the most precise accounting books of any nineteenth-century photographer in America) reported he had managed to sell almost nineteen thousand views in the summer months alone; in 1883 he supplied the Northern Pacific with thousands of mammoth-plate prints for exhibition and promotion, and an even larger number of smaller prints to be inserted in various brochures and the like. Now he saw the park as a perfect locale for a permanent studio and curio emporium.[48]

Haynes' approach to Yellowstone, from the beginning, blended business acumen and aesthetic pleasure. While he reported to his fiancée as early as 1877 that "there is something that makes my blood run cold when standing where the view suits me exactly,"[49] his aggressive pursuit of an official government franchise represented his appreciation of Yellowstone's commercial possibilities. In this case, satisfying his primary client, the Northern Pacific, meant also satisfying his immediate tourist clients (who bought souvenir pictures at his Yellowstone curio gallery) without requiring that he modify his landscape style.

In 1884 Haynes received the first concessionaire lease officially granted at Yellowstone, then spent the next thirty-two years devoting most of his attention to the park (SEE PLATE 72). By the end of the 1887 season, he had sold well over 100,000 views in the park and could claim total sales of more than 540,000 views since he began work with the Northern Pacific a decade earlier.

Haynes' photographs of Yellowstone are extremely interesting pictures, especially to one steeped in the Yellowstone photographs of his predecessor and mentor, William Henry Jackson, with whom he competed for contracts to make mammoth plates. Haynes' decision to move into mammoth-plate views was apparently motivated purely by business instincts. At the end of the 1883 season, he reported in a letter to his wife that "I expect . . . we will get more dollars out of the Big Views than from the small ones."[50] Haynes' principal agent

at the Northern Pacific had urged him to compete with Jackson for a mammoth-plate contract the railroad was soon to propose, so the following season, Haynes took an unwieldy studio portrait camera in an absurd shipping box up from the Saint Paul studio.[51] Laboring without Jackson's vast experience with larger cameras and his survey-era customized Anthony equipment, Haynes did the smart thing and made a small number of views—possibly fewer than thirty.[52] Evidently he carefully assessed the most likely candidates for Northern Pacific and tourist interest; Charles Fee, the Northern Pacific's representative, reported that Haynes showed the railroad "some very fine views especially of the Grand Cañon and Old Faithful Geyser."[53]

Haynes' views won the competition. "Mr. Lamborn, O'Dell and Davis all say they beat Jackson's higher than a kite," Haynes exulted, but he was careful to find out Jackson's financial bid and undercut it.[54] In all likelihood he needn't have shaved his prices; his pictures were more appropriate to the needs of tourists and the Northern Pacific than were Jackson's. They were stunning works of nineteenth-century landscape art, in which every convention and artifice had been mastered with such skill that the result seems utterly unforced and natural. In that sense, they were vindications of Edward L. Wilson's repeated calls in the *Philadelphia Photographer* for a new photography that could appropriate and adapt the fine arts' strategies of mediation and imagination. The mammoth-plate view of the *Grand Canyon of the Yellowstone* (FIG. 18), which Fee doubtless saw, was masterful: a

Figure V-18

F. JAY HAYNES. *Grand Canyon of the Yellowstone (Looking East).* *Yellowstone National Park.* Copy print from copy negative made from glass plate negative. Haynes Foundation Collection, Montana Historical Society, Helena.

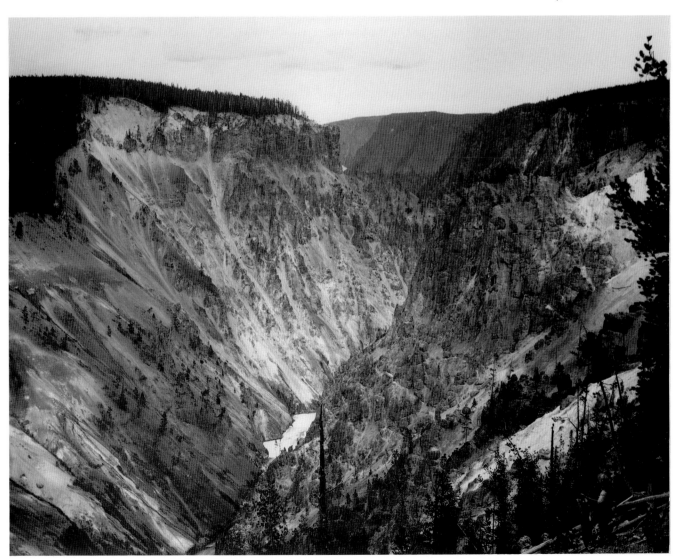

sweeping horizontal view of the entire scene, with the extraordinary striping of the canyon walls and the glimmering river winding its way below. It was a baroque work, worthy of a painter like Frederic Edwin Church, and showed how completely Haynes had learned the lesson of the American landscape painters from chromolithographs, from the endless articles in his favorite journal, the *Philadelphia Photographer*, and even from that earlier generation of American views.

A subtle drama in the lower right corner exemplifies Haynes' entire body of work from the 1880s forward—his relationship to his subject and the circumstances of this transition from romance to modernity in landscape. There, sharply focused, is a man who looks outward at the scene. The stand-in for the photographer, and for the viewer as well, he has just thrust an axe into the stump of a tree he has toppled to clear the field of view for the camera and for us. His is an "improvement" of nature, meant to increase the vista and cultivate the empire of sight over which Haynes' giant, unwieldy studio camera presides—and over which we, too, now preside. Looked at too long, the picture begins to resemble more and more a pure production of visual effect, studiously Turneresque, artful, painterly. The figure on the right has done whatever was necessary to complete the view—but the view is now independent of its subject. It is no longer a call to nature, no longer a "study" at all. It is the end, instead, to which nature has been bent.

Huge, extraordinarily sensual, this view was perhaps the best of Haynes' mammoth-plate productions, of which he made a studious few—perhaps no more than sixty during his career, all carefully tracing the tourist's path from spectacle to spectacle and recording with scrupulous care the most perfect rendering of the picturesque sensibility.[55] Haynes was right about the market potential for his mammoth plates. The Northern Pacific's contract became, in Fee's words, "an annual affair," and Haynes himself reported that in 1886 and 1887 alone the studio had sold over eight thousand mammoth-plate views.[56]

The rest of Haynes' production in smaller formats changed steadily during the 1880s and 1890s from miniature copies of the larger views to contract photographs of individuals and groups posed in front of the major natural monuments of the park (Fig. 19). He developed a concurrent and lucrative business running tour buses through the park, and his negative registers record the sale of mixed packs, portfolios, special groups, and mammoth-plate views to tourists from all over the country. By the turn of the century, Haynes had discovered that he could also market his views as postcards, and his business reflected this new publishing innovation. The result was a photographic dynasty of sorts, spanning two generations and lasting into the 1920s.

Haynes' shift toward postcards reflected another important change in photography's relation to the larger American culture, for it occurred at almost exactly the same time as Charles Roscoe Savage, William Henry Jackson, Carleton Emmons Watkins, and many others of that earlier generation of viewmakers saw their practices as individual entrepreneurs come to an end. Jackson's solution was to sell out, taking himself and his negative stock to the Detroit Photographic Company, where he supervised its conversion into mass-market chromolithographs and postcards.[57] Haynes' views went primarily to the Photochrom Company, the postcard division of the Detroit Photographic Company, thus reflecting that significant alteration in marketing and distributing photographs that Savage had hinted at. As reproduction technologies increasingly circumvented the need for mass-produced original views, most photographers found their businesses significantly shrunken or converted to retail houses, for they could not themselves become printing houses nor adequately compete with publishing companies in producing books of views.[58] Those city-view booster books which had represented such an innovation in the photographer's practice in the 1870s now were supplanted by the works of companies like Chicago's Rand, McNally—companies that often bought halftone printing plates of photographs from printers and publishers rather than actual photographs from photographers.

The postcard was another aspect of this revolution in distribution and marketing, in which huge publishing conglomerates pressed smaller entrepreneurs out of the marketplace or relegated the photographer to the role of employee. The Detroit Photographic Company and its Photochrom division were emblematic. Born out of revisions in postcard regulations in the late 1890s, Photochrom marketed a wide variety of postcards from throughout

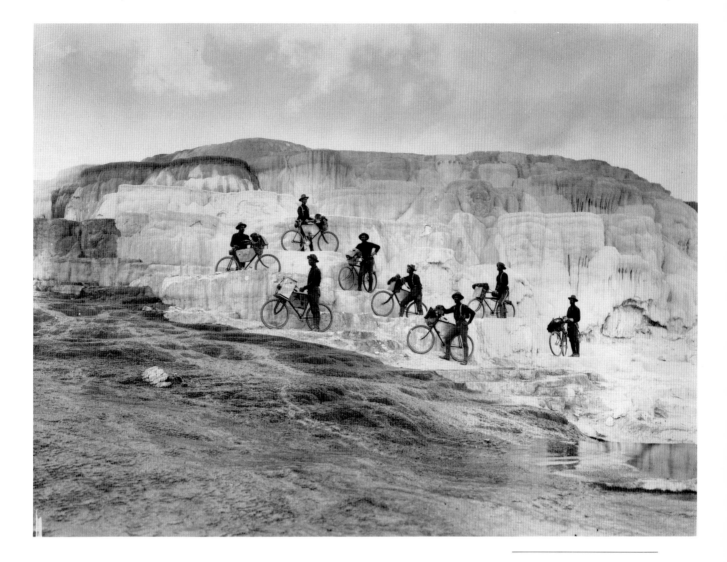

Figure V-19

F. JAY HAYNES. *Bicyclists Group on Minerva Terrace, James A. Moss Party, Fort Missoula, Montana. Yellowstone National Park, Oct. 7, 1896.* Copy print from copy negative made from glass plate negative. Montana Historical Society; Haynes Foundation Collection.

the nation but focused especially on the West, not least because of Jackson's negative stock and his contacts with western photographers. But Photochrom's West, developed between 1898 and 1910, was a severely truncated version of Detroit Photographic's broader and more varied offerings. Scenery—that is, tourist sites that had already been set by tradition—represented the primary category, but often these images really described the tourist's commercial haven, not the scenery itself. For example, the text on a postcard of *Grand Canyon from El Tovar* reported: "From the wide comfortable porch of Hermit's Rest, the most recent building erected by the Santa Fé for the convenience and comfort of the traveler at Grand Canyon, a far reaching and most interesting view can be had," and the picture showed the *porch*, not the view.

As the landscape was increasingly hemmed in by commercial exploitation and the photographer increasingly relegated to supplying negatives to the large mass-reproduction companies, or retailing their products, so also the photographs themselves became increasingly hemmed in and diminished by texts. This resulted in part from the halftone printing process itself, which made it possible to interject a photograph into a text page without great effort. In older publications using texts and photographs, such as the urban booster books or the reports of the government surveys, individual photographs were either tipped into the text on a separate page or were made into wood-engravings, which usually produced such primitive illustrations that the original photograph's facticity, transparency, and immediacy disappeared under the rough evidences of the engraver's manipulation. By the 1890s, however, photographs could serve as diminished illustrations to text, and one result of this new influx of photographic illustrations was that photographs were devalued both as immediate scientific truth and as artistic truth and were relegated more completely to a role of confirmation rather than declaration.

Figure V-20
*Grand Canyon National Park,
Arizona. Cloud Shadows from Hopi
Point.* Harvey/Detroit Co.
Postcard, H1515; n.d. Colorado
Historical Society.

Even in the marketing channels where photographs remained prominent, texts increasingly intruded, as the Detroit Company's postcards illustrate. When the company contracted with the Santa Fe Railroad's concessionaire, Fred Harvey, to produce an elaborate series of Photochrom postcards, Harvey arranged for lengthy explanatory texts on the backs of the cards—explanations that, not coincidentally, often focused on the accessibility of scenery to the resorts and tourist comforts:

> Hermit Rim Road is a driveway 30 feet wide, built of crushed stone rolled to a smooth hard surface and sprinkled with crude oil, and leads from El Tovar Hotel to the head of Hermit Trail. From there a wide bridle path that can hardly be called a trail, of a comfortable grade and with a substantial wall on the outer edge, leads into the Canyon. At the first level is Hermit Camp, maintained for those desiring to remain a while in the depths of the Canyon.[59]

Another text was even more grandiose. "The finest effects at the Grand Canyon are altogether uncommunicable by brush or pen," reported Harvey's writer (using, one presumes, a typewriter):

> They give themselves up only to the personal presence, and no painter or writer can do more than suggest what they are. You cannot paint a silence, nor an emotion, nor a sob. If you are skillful, you can suggest them to the imagination, but that is all. Here every silence seems to have dimension and color.[60]

With such attention paid to written texts, the camera was supplanted by the copy writer's pen and the retoucher's brush. The transformation from photograph to brightly colored postcard was so astonishing that Harvey's writer simply forgot the camera in his description. The pictures were so heavily painted over, the Phostint process so impressionistic in general, and the reduction of the image to postcard size so great that the resulting postcards confirmed the writer's argument about the impossibility of description (FIGS. 20 AND 21). At the same time, the postcards in some ways accurately complemented the text's abstraction and sensualizing of the scene; the impression on the viewer became essential, while the scene itself was diminished or gone except as icon.

Harvey's West was a place of manufactured romance, but a romance capable of modifying the reality. In catalogues of Detroit, Phostint, and other postcard companies, stagecoaches, buffalo, false-front saloons, prospectors, and cattle drives vied with more prosaic scenic views. Cowboys and Indians played a prominent role in the Harvey sets and in western postcards more generally. By 1906, photographers for the Harvey groups were posing Indians in "authentic" garb and coaching them to act out scenarios for the camera, as in *First Santa Fe Train*, made around 1907 (FIG. 22). About that time, Detroit also published a quite elaborate series of views of cowboy life.[61]

Figure V-21
*The Grand Canyon of Arizona, from
Grand View Point.* Harvey/Detroit
Co. Postcard, 7429; n.d. Colorado
Historical Society.

Figure V-22
First Santa Fe Train. Harvey/
Detroit Co. Postcard, 10947;
c. 1907. Colorado Historical
Society.

Urban views, as well, reflected this tendency toward stereotypes and fictionalized icons in place of urban realities. Postcard companies increasingly purchased photographs of the same few scenes in each town—the county courthouse, the post office, the main street, the park with its gazebo by the stream. These images reduced the earlier "grand-style" urban photographic iconography in the same way that Harvey's images of the West reduced the expansive explorations of the survey generation. This new set of formulae represented, too, another sort of text that overlaid the photographic source, and replaced it, for buyers did not look particularly hard at the photograph—the publishers chose their

garish sunset tones and intensely aquamarine blue waters to attract purchasers' attention, not to correspond to experience or offer it up for recall.[62]

One more text overwrote the photograph—that of the purchaser's message. The earliest postcards had only a tiny strip across the front upon which one might write, but within a decade, the open-backed format had become common. One effect was that the writer could appropriate the scene; in 1903, one woman wrote on the back of a prosaic view of Denver's City Park: "Have been taking the best care of Tootsy. Have had a hard time to keep her from running off with a cowboy, but hope to land her safe back in Marquette without any much calamity." Taking the hyperbolic mythology of the West, personalizing it, and treating it with irony, this woman utterly ignored the picture itself. So also did Emma, writing to Mrs. Mary H. of Storm Lake, Iowa, on the back of a view of "Prospectors": "Dear Mrs. H., Am all right, can walk again, was never so despondent as when Storm Lake but presume it was my own fault." Mailed from Los Angeles after "Emma's" trip was completed, the card lost its symbolic specificity, becoming instead a free-floating sign of American mass culture and a mysterious index of personal pain, with no connection between the two realms.[63]

By 1900, the photograph itself largely disappeared from these views. The Amon Carter Museum and the Colorado Historical Society hold copies of the paste-up cards for a series of postcards, which give some indication of just how little remained of the nineteenth century's Romantic rhetoric concerning the photograph's authenticity and piercing truth (FIG. 23). The collection of the Curt Teich Postcard Company of Illinois likewise contains examples of the elaborate process by which company technicians

Figure V-23

WILLIAM HENRY JACKSON. *Second Tunnel, Cañon of the Grand River, D. & R.G. RR.* Photographic collage, 1907. Amon Carter Museum.

converted the original image into a postcard. Teich's files show that the photograph was but one of a number of raw materials used to create the final product—in some cases, the Company insisted that clients send samples of drapery and carpeting so that the retouching "artists" could match them.

Teich's entire production and distribution chain is suggestive of business practices at the turn of the century. Curt Teich himself began the postcard business in Chicago in 1897, with a series of views of that city's standard sites—the Masonic Temple, the Auditorium Theatre, the Lincoln Park Boat House, and the major hotels. The company became a national distributor sometime thereafter, when Teich took one of the new, simple, flexible-film cameras for amateurs and boarded a train. At each stop, Teich exited, reconnoitered the town, photographed its points of interest, then sold a local retailer on the idea of stocking the resulting cards. A minimum order was one thousand per subject, and Teich himself reported that on his first, ninety-day trip, he sold some $30,000 worth of business.[64]

Teich's success was based on two premises. The first was geographical—he and his salesmen for the most part avoided the heavily "worked" areas, where competition was stiff, and focused on smaller towns and newly discovered·or developed resort areas. The second was economic: Teich's salesmen rarely made a photograph that was not already contracted for by a retailer. In that way, they could guarantee sales and avoid speculation.

Teich was successful in the regions he blanketed because he held a virtual monopoly there, as a result of "trust" agreements worked out with competing postcard companies. In the northern Midwest, Teich controlled Chicago, and by agreement did not market views of Milwaukee.[65] The company even destroyed other sets of views, especially of resort regions in the West, apparently to satisfy trust agreements that allowed them to market views in some resorts if they would remain out of others.[66]

Because clients determined the subjects and the photographers were salesmen first, there were almost no genre scenes, adventurous views, slum views, and the like in Teich's catalogue. Clients during these years were themselves conservative institutions—souvenir companies like Sanborn Souvenir of Denver, small-scale publishing houses like Majestic Publishing of Indianapolis, and local retailers, like the Jackson Drug Company of Faunsdale, Alabama, or Brown's Book Store in Jackson, Michigan. The result was a sanitized, uniform vision of American life and American space, a vision that reached its peak in a series of anonymous landscapes and cityscapes that the Teich Company began to offer to retailers in 1910—lakeside scenes that worked as well when titled for a New Hampshire town as for one in northern Wisconsin, or urban park scenes with rowboats on small waterways, or a view of a *Sunset Harvest Field* that sold as well in Minnesota, Wisconsin, or the state of Washington.[67]

All of this reduced the photographer below all else; the occupation in effect disappeared entirely from Teich's production chain. Because the salesmen *were* the photographers, the medium itself became little more than a rudimentary sketching process, and all the "artistic improvement" occurred within the factory, according to stereotyped specifications devised by the company itself.[68]

Teich's style was similar to that of the vast majority of early twentieth-century view-production companies, whether they turned out postcards, travel brochures, chamber of commerce materials, advertising pamphlets for resorts, or souvenir books for vacation regions or major cities (FIG. 24). In these images, the subject lost its specificity, became a type to be overlaid by the colors and texts necessary to sell the product. In effect, one logical result of the search for a democratic American photography was to make images of the nation accessible to all its citizens. But in turn this reflected back on the culture itself with the creation of a bland, uniform iconography, vaguely boosterish, vaguely grand when confronting the city, vaguely picturesque when aimed at nature.

This modernized system of manufacturing visual artifacts became a sort of caricature of the earlier view tradition and its emphasis on the transparency of the medium and its accessibility to universal Truths of human, natural, and cultural destiny. Once again the photographer's presence was of lesser importance in the transaction the view offered. But now the photograph had undercut its older Romantic role as window on a transcendent reality or as stage setting for a vast drama not of the photographer's making. Instead, the

242 *Photography in Nineteenth-Century America*

Figure V-24
WILLIAM HENRY JACKSON. *Salt Air Pavilion, Great Salt Lake, Utah.* Photographic collage, negative c. 1902-12, paste-up before 1922. Amon Carter Museum.

highly keyed colors and inadvertently simplified composition of the pictures masked the original scene, stripped it of that sort of significance, and made the final paper rectangle into a medium of social exchange more similar to a dollar bill than a work of scientific or artistic truth.

The larger movements in business, art, and cultural practice behind Teich's postcard views pressed photography toward a new self-conception and role in the larger culture. By the turn of the century, the tenuous alliance between business and art that had helped make possible the great nineteenth-century successes of the photographic view tradition began to deteriorate, as did that other alliance between the view tradition and the celebratory themes of expansion and modernization. Out of this disintegration, new alliances formed, within photography and between photography and other threads of American culture. From the unraveling of the American photographic view tradition, two divergent strands of photography emerged. Both had roots in the older practice of the view; both were in some ways conservative, even as they were also, in different ways, "modern."

Seen today, the visual style of the early Teich postcards is striking. In the heavy retouching, in the extremes of added color and tint, the photographic quality disappears; though they are preeminently the products of the modernized business of commercial images, many of them bear a strange resemblance to the work of the high-art and camera-club amateur photographers of the same decades. A view like *Chicago Harbor By Night* of 1897 (FIG. 25) and a photograph like amateur Henry L. Rand's *Moonlight on the Upper Saranac*, made in 1898 (FIG. 26), both interpret certain popular conceptions of "artistic" lighting, mood, subject, and theme. Both also involve "artistic" alterations to the original

116 Chicago Harbor by Night

Figure V-25

UNKNOWN PHOTOGRAPHER. *116. Chicago Harbor By Night.* Postcard, 1897. Lake County Museum, Wauconda, Illinois; Curt Teich Postcard Collection.

Figure V-26

HENRY L. RAND. *Moonlight on the Upper Saranac.* Platinum print, 1898. Southwest Harbor Public Library, Southwest Harbor, Maine.

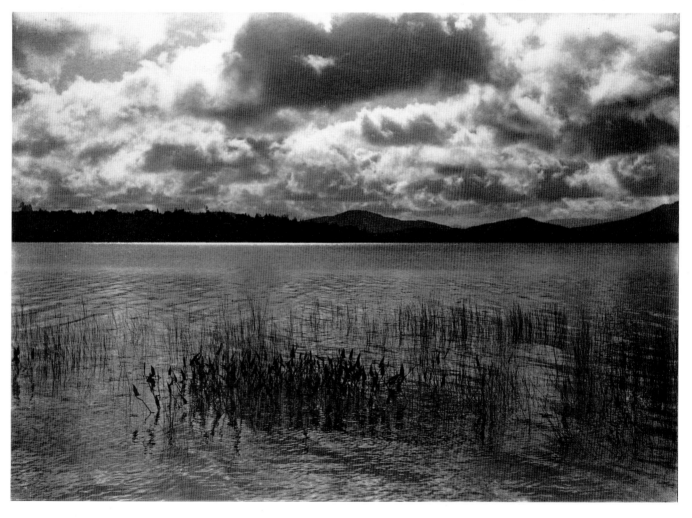

scene to produce the final view—Teich's by retouching, Rand's by overexposure and overdevelopment of an afternoon scene to approximate moonlight.[69]

Or compare Teich's *177. Night on the Illinois Central Railroad* (FIG. 27) with Alfred Stieglitz's *The Hand of Man* (FIG. 28). In both, the subject is the same—a railroad scene at night—and the producers have used similar techniques to modify and aestheticize the

Figure V-27

UNKNOWN PHOTOGRAPHER. *177. Night on the Illinois Central Railroad.* Postcard, 1897. Lake County Museum, Wauconda, Illinois; Curt Teich Postcard Collection.

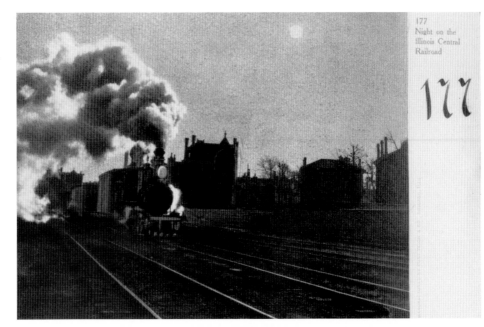

Figure V-28

ALFRED STIEGLITZ. *The Hand of Man.* Photogravure, 1902. Amon Carter Museum.

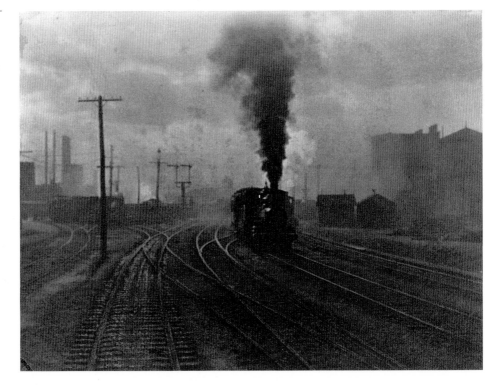

scene, emphasizing the steam and smoke as atmospheric effects, lighting the rails so that they are radiant stripes.

But in a larger sense, each pair of pictures is an opposite. The purpose behind the Rand's picture and its stylization was dual—to hearken back nostalgically to an earlier painterly landscape tradition, and to elevate the photographer's own status from "snapshooter" to serious *amateur*, in the sense of one who makes art for the love of it, disdaining its sordid business aspects. Stieglitz' view, too, was based on tearing photography away from its commercial associations and elevating it to art.

Stieglitz' photograph was part of the discourse of his Photo-Secession, a group of amateur and professional photographers, critics, collectors, and artists interested in the medium. All of them were devoutly committed to a new ideal of art photography, which appropriated the subjects of the view tradition to the ends of aesthetic pleasure and formal transformation. Much of the photography emanating from this group around the turn of

the century reflected this reorientation. Now the subjects so dominant in the catalogues of commercial view photography would have to be resuscitated at the hands of the devout amateur—or so Stieglitz and his cohorts argued. Many of Stieglitz' earliest successful pictures had been landscape views; his studies of New York and Paris recapitulated not just the subjects of the grand-style photographers, but their specific icons (like the Flat-Iron Building) and even their angles of view. This was a matter of recapturing the city and the landscape as fit subjects for art, as places of beauty and grace. When the artist could not *find* these qualities in the subject, he or she could make them, by introducing the hand of man—that other meaning Stieglitz implied in his limpidly beautiful atmospheric study of the same name.

Stieglitz' entire campaign depended upon separating the business of photography from its art, a separation largely latent in America at the end of the Civil War and one which might not have come into currency afterward but for the amateur's relentless quest for an alternative to the bureaucratized image-production that had come to dominate American photography as represented by the Detroit and Teich companies.

Figure V-29
GERTRUDE KÄSEBIER. *French Landscape.* Gum photoprint, 1898. Library of Congress.

Figure V-30
GERTRUDE KÄSEBIER. *The Heritage
of Motherhood.* Copy print from
original glass plate negative, 190?
Library of Congress.

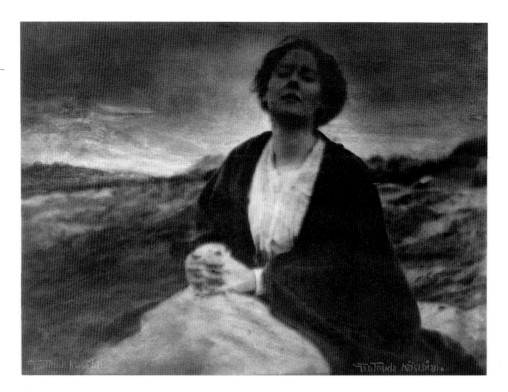

For some amateurs, the quest by no means reached toward modernism. Henry L.
Rand, a Cambridge amateur, member of the Old Cambridge Photographic Club, and a
summer resident of Maine's Mount Desert Island, spent decades patiently mastering the
dominant landscape mode, poring over the same articles in *Wilson's* and the like that had
served Haynes or Barker. Rand's seascapes, with their moody shorelines and diagonal
reaches of land, their attention to light and air, were typical of the amateur of the 1890s.
His true subjects were nearly always anecdotal, personal: the stretch of land on which he
built his summer cottage; the trees which he passed on his walks; the gardens, beaches,
boats, and activities of his friends. His ambitions for aesthetic quality lay with "improving"
his treatment of these subjects, bringing them into greater conformity with accepted
photographic practice.

Within amateur circles in Rand's time, that conception of "accepted practice" was
changing, corresponding in many ways with those changes in commercial view photogra-
phy that had begun two decades before. This "improvement" in photography involved
corresponding the camera image more closely with painterly conventions, developing and
communicating a uniform set of genres, pictorial types, and themes, and devising and
maintaining an available iconography. Among amateurs, however, the activity of
photography had moved from a broadly cultural activity to a narrowly social one; the
desired end was "regular association with other craftsmen," by which "many were induced
to take up the art as a recreation," as a privately published *History of the Old Cambridge
Photographic Club* described the movement.[70] The club's meetings, exhibitions, and debates
were responses to the stress and anomie of turn-of-the-century urban life, just as the
"recreation" of photography was meant to be. Rand's subject list reveals how well amateur
photography fit in with contemporary theories about healthful recreation and the dangers
of an overcivilized existence. Beyond his family and personal friends, Rand photographed
boats, flowers, trees, and women, usually posed indoors.

The work of more celebrated, more ambitious, and more centrally located amateur
photographers like Gertrude Käsebier and Alvin Langdon Coburn represented a more
elaborate and forward-looking version of the same set of inclinations—to use the camera
as a tool for appropriating and beautifying portions of one's surroundings, to bend a weapon
of modernization to one's own will, to sequester a region of personal life from the incursions
of modernity.

Käsebier responded to modernization with a form of exile—to a fictitious European
landscape found in the French Impressionists and Symbolists (FIG. 29) and to the estates

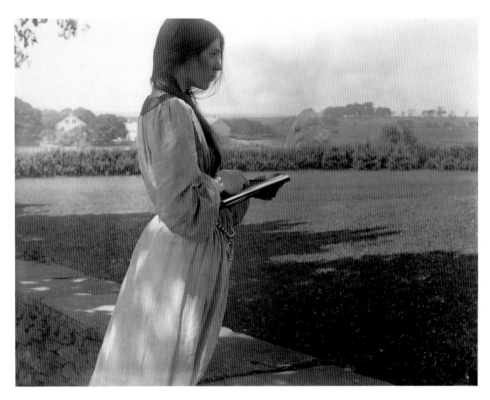

Figure V-31
GERTRUDE KÄSEBIER. *The Sketch.*
Copy print from original glass
negative, 1902. Library of
Congress

of New England, Newport, Rhode Island, or the Long Island shores. Her vision of the landscape, and of social activity on and within it, was utterly at odds with the American traditions, not simply in photography but in the arts generally. It emphasized a more trenchant sort of exile, in which the photograph became an alternative, modulated by the hand of the artist, imbedded with that artist's obsessions and desires.[71]

Käsebier's landscapes tended to externalize the internal, deeply personal states of her subjects, which, in turn, externalized the artist's persona, obsessions, and concerns. In *The Heritage of Motherhood* (FIG. 30), posed by Mrs. Francis Lee of Boston, the harsh shores reflected the stark face of abandonment and the furrowed hands of self-sacrifice. In *The Sketch*, posed by Beatrice Baxter in Newport, Rhode Island (FIG. 31), Käsebier drew her viewers' attention to the woman and the intent process of creativity that was entailed in her work. The land behind her—bucolic, sun-dappled—was pressed out of the plane of focus, becoming itself a sketch.

Käsebier's photographs restored, in muted form, the open spaces that had once formed an essential part of the American outdoor photographer's subject. She also redrew the natives of those spaces, to ends not conceivable to that earlier era. Alvin Langdon Coburn did the same with the city; his photographs published as *New York* in 1910 presented the typical Photo-Secessionist treatment. Like his colleagues Stieglitz and Steichen, Coburn was shameless about appropriating the celebratory themes, the architectural and technological subjects, and even the iconography of city life from the earlier generation of grand-style urban photographers. Coburn included high-angle views of streets and buildings, details of architectural and engineering wonders, scenes of parks and rivers. The result was an unwavering symphony celebrating the modern urban space.

But Coburn's treatment of these subjects and themes was foreign to the grand style of the nineteenth-century view; the artist-photographer redefined the urban style in a manner that befit its new purposes and audiences. Where his predecessors had chosen the panorama, with its overtones of orderly comprehensiveness, Coburn chose broken details that disintegrated the city. His high-angle views disconcerted and disoriented his viewers, rather than bringing them the clarity and omniscience of the bird's-eye view. Instead of the bright, raking light of the grand style (a light that informed the architecture, gave it mass and substance, but irradiated it with a divine glow at the same time), Coburn worked in obscurity—at night, or in late afternoon, when looming shadows cut holes in the pavement and made caverns of doorways. His frames cut buildings into pieces; his foregrounds obscured the monuments at which his camera was aimed. Elements of the

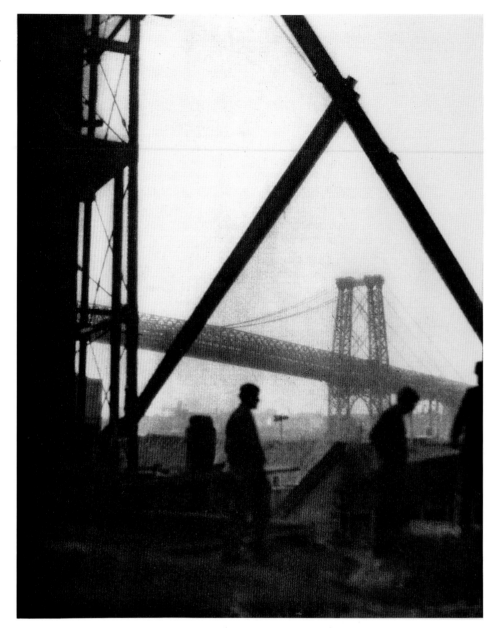

pictures invoked, then confounded, the grand style, setting in its place a deeply personal, poetic, expressive vision, one that inscribed itself on the urban scene through surveillance, intuition, meditation.

Consider Coburn's photograph of the Williamsburg Bridge next to the Detroit Photographic Company's view of the Brooklyn Bridge (FIGS. 32 AND 33). The Detroit Company's view is as sharp as broken glass, and as transparent; every detail sings, but as part of the major tonic chord that is the bridge and its relation to the city that surrounds it, uniting technology, machinery, people, businesses, advertisements, clouds of smoke. Coburn's view, one of four bridge views in a book of twenty pictures, seems to have been made at night. Murky light illuminates the bridge in the background; it is itself obscured by the silhouettes of workers and machinery in the foreground, workers made faceless by the darkness, just as the machinery on which they work has been reduced to geometric abstraction.

This is a picture held to the other pictures in Coburn's book not by subject, nor even by theme, exactly, but rather by style—by the abstraction that dominates the composition, by the dark obscurity of his hand-pulled gravures, by the obscurantism of the view itself. But this was the central theme of the book: the city, for Coburn, was not a unity. Unmediated, it was a chaotic, unfeeling diversity; what drew it into unity was the artist's appropriation of it as subject, his transformation of it by style, and his expression of it as the projection of the private self onto the shadowy world of external things.

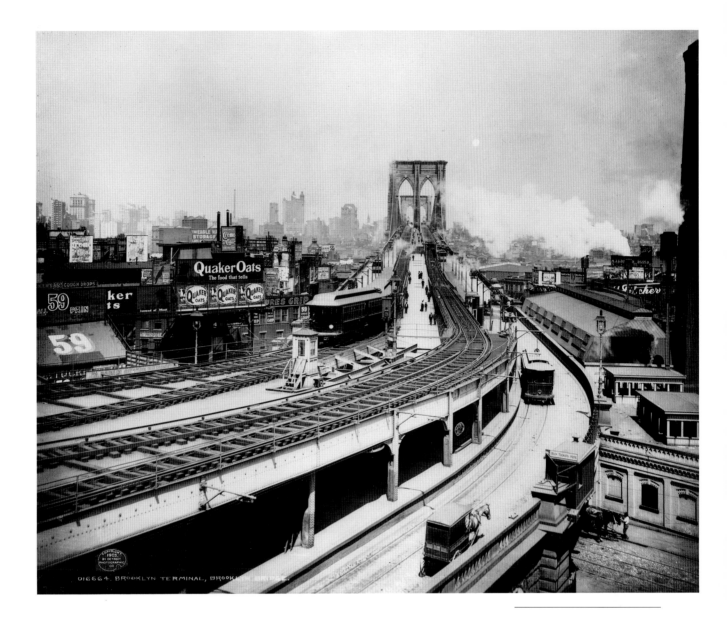

That Coburn's *New York* was a book also invoked the grand style, only to overturn it. The elaborate guidebooks of the decade after the Civil War, with their hand-tipped original photographs as text, or the gravure books of the city boosters of the following decade, had been adaptations to half-developed production systems that, with the advent of halftone reproduction, finally could deliver on the promise of universal availability. Coburn's book contained only a short text by H.G. Wells, and twenty eccentrically shaped, hand-pulled gravure prints, each one mounted on rough-cut black paper, which was itself hand-mounted into the book. Coburn rejected the ideal of visual democracy: his book flaunted its limited appeal and its shrunken marketplace, setting up a new, aesthetic elitism as the salvation of humankind in the dark streets of modernity.[72]

Coburn and Käsebier represented one way in which turn-of-the-century photographers applied their medium to the American landscape as subject and theme. But there was an opposite, equally indebted to the previous visual traditions of the nineteenth century, yet equally bent upon upending those traditions: the "business" photography that Stieglitz so dreaded, and toward which Savage, Jackson, and the survivors saw their traditions extend. Here the utopian vision of an empire of sight enlarged to global dimensions, the rhetoric of objectivity reached new heights, and the promise of photography as information-gatherer and disseminator was fulfilled in unrelenting completeness. This photography found its epitome in the sets of mass-production stereographs manufactured by Keystone, Underwood and Underwood, the American Stereoscopic Company, and others, concurrently with the Photo-Secession's individualist experiments. These sets, ranging upwards of a thousand individual stereos, were sold as educational aids to schools, settlement houses,

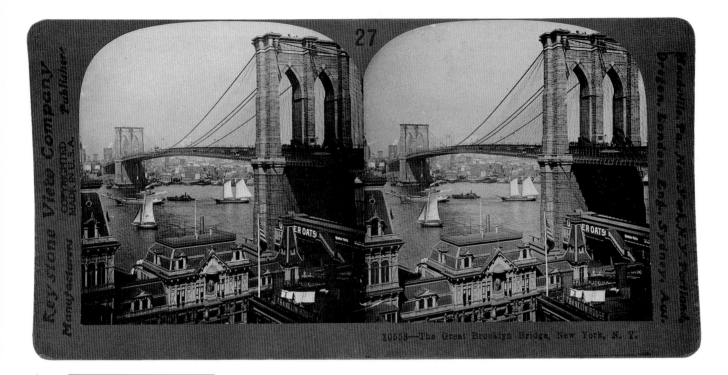

Figure V-34

Unknown photographer. *The Great Brooklyn Bridge, New York, N.Y.* Stereograph published by Keystone View Company, 27-10558. Gelatin silver print, negative 1900, print 1905-25. Amon Carter Museum.

libraries, and other institutions for children, immigrants, and the unfortunate, and also by subscription through the same traveling salesmen who, decades later, would crisscross the country selling encyclopedias with virtually the same pitch.

These stereo sets were equivalent to visual encyclopedias. A complete Keystone educational set, called the "600," in fact, came with a *Stereoscopic Encyclopedia,* complete with elaborate cross-referencing to the various views. Underwood sets came with an astonishingly complex system of maps, so the viewer could not only locate the subject of each picture within a global context, but could also pinpoint the vantage point and the precise framing area of each stereo's angle of view.[73]

For the "600" set, Keystone had its own systematic approach. Company founder B. L. Singley assembled over fifty authorities to serve on an editorial board; the crown jewel was Harvard's President Emeritus, Charles W. Eliot. These educators were responsible for the captions and the essays that adorned the backs of each stereo card, including the "study questions" that accompanied many of the texts. After 1907, these were keyed to a teacher's guide entitled *Visual Education.*

The result was to produce a comprehensive yet fanatically detailed vision of the world, seen as a mechanistic environment of statistics, laws, taxonomic systems, and moral arithmetic. The subjects of most views were industrial and technical, focused on "labor-saving" devices in factories, the engineering of skyscrapers, the extraction of ores, the transportation of urban workers to and from their homes. The treatment, too, was mechanistic; the didactic emphasis was on memorization of facts, particularly of statistics.

Stereo number 27, *Brooklyn Bridge, New York City Lat. 41° N., Long. 74° W.* is typical (Fig. 34). The text on the back began, "Here is a wonderful view of a remarkable structure." The first paragraph alone gave its length (5,989 feet), width (85 feet), height (135 feet), the depth of its piers (80 feet on one side, 45 feet on the other), number of cables (4), their diameter (16 inches) and weight (3,600 tons). The second paragraph explained the concept of the suspension bridge, ending with an estimate of the number of people crossing it daily (300,000). The final paragraph was historical, describing the cost ($5,000,000), time of construction (thirteen years), and dates (1870-1883), and the name of its engineer-designer (John A. Roebling). The entire essay ended with an expansion of view into the facts concerning the nearby Brooklyn Naval Yard, finishing with an estimate of its area (about 144 acres).[74]

These obsessive statistical enumerations underscore the rationality as well as the rationale of the Keystone educational plan. The student was expected to memorize these statistics; implicitly, these numbers *signified,* even encompassed or comprised the subjects. They allowed the student to "get the measure" of the Brooklyn Bridge, but they also superceded the bridge itself, stepping into its place as the ground of understanding, the

Figure V-35

UNKNOWN PHOTOGRAPHER.
Lasting Machine Shaping Shoes,
in a Massachusetts Shoe Factory.
Stereograph published by
Keystone View Company,
12-22189. Gelatin silver print,
negative 1900-15, print 1905-25.
Amon Carter Museum.

subject itself. In this respect, the written text had fulfilled the often-repeated celebrations of nineteenth-century photography's capacity to unify the globe: "Do you wish to travel around the world and not leave your own household? — photography will give you hill, valley, mountain, plain and river, city and hamlet, and the inhabitants, too, of every nation, placing all before you for your examination," as Abraham Bogardus, President of the National Photographic Association, had declared in his address before the association's convention in 1871.[75] Now this role of information-gathering was more finely tuned and parceled out into various media, with photography providing one form of evidence, text another, context a third.

The scientific plan of education contained within the Keystone set imposed a geographical grid on the globe. The series marched around the world in relentlessly uniform steps of longitude and latitude. It gave one sort of order, but at a sacrifice of others. Hence a view titled *Domestic Art— Dining Room and Living Room* (also titled *"The House Beautiful"— Brooklyn, New York Lat. 41° N; Long.74° W*) appeared between *Immigrants Landing at Ellis Island, New York* and *Conveyor with Trays of Loaf Sugar, New York*. Students may have considered this combination to be nothing more than random, outside the direct logic of longitudinal proximity. But in a more complex and unconscious way, the student viewer would find that *The House Beautiful* completed its two surrounding cards—describing the desirability of America, its richness and luxury, while treating individuals and sugar equally as the products of machine-made mass production. Now pleasure and domesticity, even "art" became products of an unerring rationality, as the text of *The House Beautiful* made clear:

> Making a home attractive is one of the finest of arts. Nothing so makes life worth while and full of richness as a well appointed place to live. . . . *Observe the placement of each piece.* Each is put where it is because it was selected to fit into the scheme of these rooms.[76]

Immigrants, sugar loaves, and furnishings, equally amenable to rationalistic manipulation, became the objects of study. The seeming randomness of the pictures, one after another, arranged solely according to geographical plan, was in fact the map of a larger order. The coherence that resulted in each sequence was not "accidental," "eccentric," or irrational. Indeed, it was the opposite. The coherence, the overarching completeness of modernization had successfully subsumed disorder. Any card in the Keystone set, properly texted, intersected with any other; all were parts of the rationalized grid.

The stereo photographs themselves were perfect visual agents in this project. *Number 12. Lasting Machine Shaping Shoes in Shoe Factory, Lynn, Mass.* (FIG. 35) is utterly coherent, schematic, illustrative. The machine, shown at the moment when it performed

"in a few seconds . . . the most difficult task of the shoemaker," was transformed by the stereo effect from a welter of confused machine parts to an elegant functionality. On its left, the row of completed shoes stepped from the foreground back, showing the result of the machine's labors. Behind, the student could see an equivalent row of identical work stations marching into the background. Only the human operator seems, today, out of place—thin, lax-muscled, slope-shouldered, a not-quite-logical part of the machinery of production.

The oddities of the stereograph's visual nature also contributed to the overall effect. While capable of rendering a convincing illusion of spatial dimension, the stereographic system never really could overcome its tendency to make the scene seem like a *tableau-vivante* or a diorama. People, like the "skilled workmen cutting leather for High Quality Shoes" in Number 11, looked like cardboard cut-outs propped up in a real workroom. In part, this was a result of the stereo camera slicing a thin section of time from the continuum. In part it was an effect of subtleties of contrast and shading, lens placements, and other technical elements, all slightly out of register thanks to the necessities of production-line printing, mass-production camera manufacturing, and the like.

But the result, if unrealistic in one sense, pressed the realism of the assembly-line stereo view further into the region of the dominating ideology of modernism. People became dummies, but each element in the production of shoes was clarified by the heightened, exaggerated three-dimensionality of the stereo view. People, shoe-leather, machinery, all became specimens in the specimen-case of the stereo view held by the dutiful student, instructed by the teacher reading from the *Educational Guide* or from *Visual Education*.

This, then, may be the obverse of the Photo-Secession, whose members appropriated photography to the personal, while subverting and modifying mass-production and the democracy of sight to fit their own, far more rarified and elitist visions. But Keystone and the Photo-Secession alike shared a historical trait: both had evolved from the celebrations of the nineteenth century's view tradition, from the vast, unitary vision of America and its future that its practitioners accepted, celebrated, and communicated to generations of Americans. The roots of Keystone's "600" lay in the great scientific reconnaissances of the nineteenth century, surveys in which photography had played an integral role as evidence, decoration, celebration, and carrier of ideologies better suited to the visual rhetoric of the photograph than the dry language of the scientific reports or the more poetic discourses of texts like Hayden's, Wheeler's, King's, and Powell's. In the impulse to order all the information of the globe within a scientific and geotechnical grid, Keystone's educational sets brought the survey tradition into the twentieth century, where it would continue to flourish, most visibly in the photographically illustrated journal of city science and city reform, the *Survey*.

But there were vast differences between the ideologies of the surveys and the *Survey*, and between the photographic traditions each represented. The nineteenth-century view had integrated the rhetoric of expansionism, the economics of laissez-faire capitalism, and the visual conventions of landscape discourse to represent a new culture coming gloriously into being within a special landscape of virtue and hope. The twentieth-century urban survey photograph spoke for a scientifically studied, scientifically managed and controlled urban social landscape in which the sociologist, not the explorer, was the ideal type.[77]

The new photographies into which the nineteenth-century view tradition fragmented thus held each to their own logic; like their earlier counterpart, these would be woven into a fabric that contained and revealed the patterns of their age. Charles Roscoe Savage could understand his own relative unimportance to these new strands of photographic practice and even regret the passing of an age in which he had been simultaneously creator, communicator, participant, representative, and historian. New photographers, with new practices and new beliefs, would dominate the next stages in the modernization of America.

[1] Charles Roscoe Savage, "Diaries," c. 1894, located in Harry B. Lee Library, Brigham Young University, Provo, Utah.

[2] See Savage's "A Photographic Tour of Near 9,000 Miles," *Philadelphia Photographer* 4 (September-October 1867): 287-289, 313, 315.

[3] On Jackson's apprenticeship to Savage's views, see Peter Bacon Hales, *William Henry Jackson and the Transformation of the American Landscape* (Philadelphia: Temple University Press, 1988), pp. 51, 131, 152; see also William Henry Jackson, "Diaries," July 9, 1869, pp. 23-25, located in the Manuscript Collection of the New York Public Library.

[4] A good general biography of Savage is found in Nelson B. Wadsworth's study of photography in nineteenth-century Utah, *Through Camera Eyes* (Provo, Utah: Brigham Young University Press, 1976).

[5] Savage apparently had an agreement to copublish the guide books with Nelson's British firm; *Great Salt Lake City, and Utah Territory* (London and New York: Nelson and Sons, 1871[?]) first appeared as one of "Nelson's Pictorial Guide-Books for Tourists," with an added publishers' imprint from Savage and Ottinger of Salt Lake City. Later editions appeared with Art Bazaar, Savage's studio name, as a co-publisher. Thayer's affiliation with Savage included *Picturesque Utah* (Denver: Frank S. Thayer, 1888); *Zion, Her Gates and Temple* (Denver: Frank S. Thayer, c. 1900); and *In and Around Salt Lake City* (Denver: Frank S. Thayer, 1900).

[6] Richard Rudisill, *Mirror Image: The Influence of the Daguerreotype on American Society* (Albuquerque: University of New Mexico Press, 1971), *passim*.

[7] This is William Culp Darrah's estimate, found in an appendix to *The World of Stereographs* (Gettysburg, Pa.: W. C. Darrah, 1977), p. 237.

[8] This is the argument Rudisill puts forward in *Mirror Image*; it is supported by William Culp Darrah in the introductory chapters of *Cartes de Visite in Nineteenth Century Photography* (Gettysburg, Pa.: W. C. Darrah, 1981).

[9] William Welling, *Photography in America: The Formative Years, 1839-1900* (New York: Thomas Y. Crowell Co., 1978), p. 172, calls the *Philadelphia Photographer* "the principal journalistic medium for the photographic community" and Wilson himself the "prime chronicler of photographic events throughout the rest of the nineteenth century."

[10] Marcus Aurelius Root, "Landscape Photography," *Philadelphia Photographer* 1 (September 1864): 137.

[11] Edward L. Wilson, "Photography: A Progressive Art," *Philadelphia Photographer* 1 (September 1864): 132-133.

[12] John Moran, "The Relation of Photography to the Fine Arts," *Philadelphia Photographer* 2 (March 1865): 3-5.

[13] Edward L. Wilson, "Our Picture," *Philadelphia Photographer* 1 (September 1864): 143.

[14] Ibid., p. 142. The admonition "not to falsify . . ." is taken from Wilson's 1867 essay, "Art Principles Applicable to Photography," *Philadelphia Photographer* 4 (November 1867): 337-338.

[15] Reverend H. J. Morton, "Photography in the Fields," *Philadelphia Photographer* 1 (May 1864): 65-66.

[16] The essays of Oliver Wendell Holmes have generally received the greatest play by historians of photography, not least because they were published in a prestigious national journal with a general readership; see Holmes, "The Stereoscope and the Stereograph," *Atlantic Monthly* 3 (June 1859): 738-748; "Sun Painting and Sun Sculpture," *Atlantic Monthly* 8 (May 1861): 13-29; and "Doings of the Sunbeam," *Atlantic Monthly* 12 (July 1863): 1-15.

[17] Darrah, *Cartes de Visite*, pp. 2-3.

[18] On this topic more generally, see my *Silver Cities: The Photography of American Urbanization, 1839-1915* (Philadelphia: Temple University Press, 1984).

[19] [Edward L. Wilson], "Views in the Yosemite Valley," *Philadelphia Photographer* 3 (April 1866): 107. The italics are Wilson's.

[20] Ibid.

[21] Reverend H. J. Morton, D.D., "Yosemite Valley," *Philadelphia Photographer* 3 (December 1866): 376-378.

[22] Interestingly, while these late-modern viewers of photography have tended to agree that photographs such as this one are paradigmatic, they have often disagreed as to just what they are paradigmatic *of*. See, for example, Daniel Wolf's essay for his coffee-table *American Space* (Middletown, Conn.: Wesleyan University Press, 1983), John Szarkowski's *The Photographer and the American Landscape* (New York: Museum of Modern Art, 1963), and Weston Naef's *Era of Exploration: The Rise of Landscape Photography in the American West* (Boston: New York Graphic Society, 1975).

[23] Carleton E. Watkins' work is admirably detailed in Peter Palmquist's *Carleton E. Watkins, Photographer of the American West* (Albuquerque: University of New Mexico Press, 1983); a more cursory study appears in *Carleton E. Watkins: Photographs of the Columbia River and Oregon* (Carmel, Cal.: Friends of Photography, 1979).

[24] David Featherstone speculates that the OSNC may have served as sponsor in *Carleton E. Watkins: Photographs of the Columbia River and Oregon*, p. 15. Peter Palmquist points out that Watkins' route "almost exactly paralleled that of the Oregon Steam Navigation Company's trade route, suggesting strong cooperation between Watkins and the company"; *Carleton E. Watkins, Photographer of the American West*, p. 34.

[25] For conversations clarifying the roots of this Watkins picture, I am grateful to Peter Palmquist, whose work on Watkins continues to unearth astonishing materials, and to Terry Toedtemeier, whose assiduous researches and rephotographic project up and down the Columbia have also turned up important information.

[26] Palmquist, *Carleton Watkins: Photographer of the American West*; I am grateful to the staff of the Bancroft Library of the University of California at Berkeley, where many of Watkins' most interesting photographs and documents are located, for their patience with my requests.

[27] Anthony's history is detailed in William and Estelle Marder, *Anthony: The Man, the Company, the Cameras* (Amesbury, Mass.: Pine Ridge Publishing Co., 1982); on the stereo series, see pp. 131-132. The estimate that every house in America with a parlor had a stereo viewer and cards was originally made by Robert Taft in his *Photography and the American Scene, 1839-1889* (New York: Dover Publications, 1938), pp. 167-185; it is echoed in Richard Masteller's "Western Views in Eastern Parlors," *Prospects* 6 (New York: Cambridge University Press, 1981), pp. 55-71.

[28] [Edward L. Wilson], "New Stereoscope Pictures," *Philadelphia Photographer* 3 (September 1866): 266-267.

[29] Information is scattered throughout the *Philadelphia Photographer* for this era; the journal published, for a time, all the speeches and most of the proceedings of each annual convention, as well as calls for photographs to be exhibited, exhortations to members to send in their dues, and the like.

[30] J. C. Browne, "Report of the Committee on the Progress of Photography," *Philadelphia Photographer* 8 (July 1871): 206-208; see the Proceedings in general, pp. 200-210. This argument, that landscape photography flourished in Europe far more successfully than in America, was repeated frequently by critics and photographers. Hermann W. Vogel, writing from Germany, reported that Browne's assertion was chimerical—landscape was a subsector in Europe, as well. But Vogel, too, found landscape to have its own privileged place in England, where "a few peasants' huts, a grove, a forest path, will find there not only admirers, but also purchasers. In Germany this is unfortunately different. The fine artistic effects are admired as much as in England, but they are not bought." Hermann W. Vogel, "German Correspondence," *Philadelphia Photographer* 8 (October 1871): 330.

[31] Ferdinand Vandeveer Hayden, *Ninth Annual Report of the United States Geological and Geographical Survey of the Territories. . .* (Washington, D.C.: Government Printing Office, 1877), pp. 22-23.

[32] Jackson used another photographer's work the previous year—a photographer named Crissman had accompanied the Hayden Survey into the Yellowstone, and Jackson acquired some of the resulting views. In 1872, however, Jackson made a point of crediting Crissman for some of the views, though haphazardly. In addition, for the survey's *Descriptive Catalogue of Photographs of North American Indians*, Jackson used a wide range of sources to compile the pictures, as Hayden's "Prefatory Note" explained.

[33] William Henry Jackson, *Descriptive Catalogue of the Photographs of the United States Geological Survey of the Territories. . .* (Washington, D.C.: Government Printing Office, 1875), p. 40.

[34] Jackson, *Descriptive Catalogue*, p. 39.

[35] Jackson's sojourn with the survey is detailed in Hales, *William Henry Jackson*, pp. 67-139; the vast array of published materials is described in the "Essay on the Sources," pp. 333-347.

[36] In addition to those described in my *Silver Cities*, I have recently discovered a number of photographically illustrated urban booster books held in the Prints and Photographs Division of the Library of Congress. They include: M. Joblin, *Louisville, Past and Present: Its Industrial History as Exhibited in the Life-labors of its Leading Men* (Louisville: Publisher unknown, 1875) (photographs by Klauber Photo.); E[lias] Decker, *Cleveland Past and Present: Its Representative Men. Photographically Illustrated by E. Decker.* (Cleveland: A. Vallendar, 1871); C. L. Pond, *Buffalo City Views* (Buffalo: 1975); Berk Batchelor, *Batchelor's Pictorial Business Directory of the City of Utica, N.Y., 1874-75* (Utica: Batchelor, 1875); *Illustrated Guide to the Leading Wholesale and Retail Business Houses and Manufacturers of Philadelphia. Containing Photographic Views of Prominent Places, Maps of the Business Portion of the City, New Park, Wissahickon [sic], etc.* (Philadelphia: 1871).

[37] Decker, *Cleveland Past and Present*. An earlier version, by Maurice Joblin, was published in 1869 by Fairbanks, Benedict and Co.

[38] Batchelor, *Batchelor's Pictorial Business Directory*.

[39] *Illustrated Guide to the Leading Wholesale and Retail Business Houses . . . of Philadelphia*, p. 22.

[40] Information on Barker's life is derived from "Editor's Table," *Wilson's Photographic Magazine* 32 (January 1895): 45; copyright deposit information in the Library of Congress Prints and Photographs Division; and the extensive collection of Barker photographs held by the Division. William Culp Darrah reports Barker's activities at the Centennial Exposition in *The World of Stereographs*, p. 77.

[41] F. Thorp, "A Reply to Mr. Snelling," *Philadelphia Photographer* 9 (September 1872): 312-314.

[42] Henry Hunt Snelling, "Criticism and Photography," *Philadelphia Photographer* 9 (May 1872): 135-136.

[43] See "The Education of Photographers," an essay from the *Photographic News* reprinted in the *Philadelphia Photographer* 9 (April 1872): 108-109; William Heighway, "Art and Photography," *Philadelphia Photographer* 9 (1872): 236-237.

[44] Edward L. Wilson, "Our Picture," *Philadelphia Photographer* 12 (May 1875): 137.

[45] Ibid., pp. 137-138.

[46] Information on Haynes is found primarily in the Archives and the Photography Division of the Montana Historical Society, Helena. I am deeply indebted to Lory Morrow, Curator of Photographs, for her keen interest and unfailing assistance. In addition, two excellent studies of Haynes exist, both published by the Montana Historical Society: Edward W. Nolan, *Northern Pacific Views: The Railroad Photography of F. Jay Haynes, 1876-1905* (Helena: 1983), which contains a meticulously researched historical biography of the photographer; and *F. Jay Haynes, Photographer* (Helena: 1981).

[47] Nettleton to J. G. Dudley, October 10, 1872, quoted in Nolan, *Northern Pacific Views*, p. 6.

[48] Haynes to Northern Pacific General Manager Sargent, September 6, 1879, quoted in Nolan, *Northern Pacific Views*, pp. 14-16. Haynes' business material includes an extremely detailed set of print sales and register books, accounting books, and assorted manuscript materials, all held at the Montana Historical Society.

[49] Quoted in *F. Jay Haynes, Photographer*, p. 10.

[50] Haynes to Lily Haynes, August 1883, quoted in Nolan, *Northern Pacific Views*, pp. 171-172. Information about Haynes' mammoth-plate views is contained in a variety of materials in the Montana Historical Society. In addition to many of the original negatives, the Society holds sets of Haynes' catalogues; Amy Stark, Lory Morrow, and others have culled the negatives, reporting repeats and copy-negatives, and sets made on the same days.

[51] This camera and its "case" are on exhibition at the Montana Historical Society in Helena.

[52] See Haynes' supplement to the 1884 *Catalogue*, entitled *Mammoth Photographs of the National Park*, held in the Library of the Montana Historical Society.

[53] Reminiscence by Charles S. Fee in 1923, quoted in Nolan, *Northern Pacific Views*, p. 172.

[54] Letter to Lily Haynes, September 28, 1884, quoted in Nolan, *Northern Pacific Views*, p. 172; the contract bids are found in the Haynes Collection.

[55] According to his negative registers and printed catalogues, Haynes apparently made only five sets of mammoth plates: twenty-nine of Yellowstone in 1884, fourteen views of Columbia River scenery made during his trip in 1885, eleven more Yellowstone views in "1885 or 1886", as Haynes later wrote the dates in the registers; six in 1886 or 1887 of the Boston and Montana Gold Mining Company Plant; one in 1887; and one in 1888. The registers and catalogues are in the Library and the Photography Division of the Montana Historical Society.

[56] Nolan, *Northern Pacific Views*, p. 172.

[57] A complete discussion of Jackson and the Detroit Photographic Company can be found in Hales, *William Henry Jackson*, pp. 258-281. Discussion of the postcards themselves is a major part of Jeff R. Burdick, *A Handbook of Detroit Photographic Company Postcards: A Guide for Collectors* (Essington, Pa.: privately published, 1955). A more general study of postcards is found in George and Dorothy Ryan, *Picture Postcards in the United States, 1893-1918* (New York: Crown, 1976).

[58] This occurred with Haynes, whose business eventually evolved into a combination photo-emporium, curio sales shop, and marketer of guided bus tours of the park. It occurred with Savage, too, who reported to his surprise in the twentieth century that the camera-store and photo-finishing outfit into which his family had converted his studio, was making more money as a retail store than it had ever made as a production outlet.

[59] Text on the rear of H1570, "The Towering Cliffs Above Hermit Camp, Grand Canyon," one of a huge collection of Detroit Company postcards held by the Colorado Historical Society.

[60] Detroit/Harvey postcard H-1536, "Sunrise from Hermit Trail, Grand Canyon, Arizona."

[61] This series, of which the Colorado Historical Society has at least six, appears to have been part of a set by a single photographer, possibly C. A. Kendrick.

[62] One can gauge the amount of attention paid to the views by looking at collections of cards that were written upon and then sent, and cards that served as souvenirs, upon which purchasers frequently wrote little notes to remind themselves of the time, place, and experience. But in both sorts of comments, one finds predominant attention to personal experiences, memories, and social interactions, rather than to the images themselves or even the scenes they depicted. In the case of the Detroit Company postcards, I am indebted to the Colorado Historical Society and to curator Eric Paddock for allowing me access not only to their own extensive collection, but also to the cards that served as the basis for an exhibition of postcards of Colorado and the West.

[63] These postcards are in the Colorado Historical Society's collection of Detroit Company and Phostint cards, held in the Photography Department.

[64] Curt Teich, Sr., *The Teich's Family Tree and History* (Chicago: privately published, 1958) held in the Curt Teich Museum, Lake County, Illinois; Katherine Hamilton-Smith, manuscript for exhibition design, Curt Teich Museum. Curator Hamilton-Smith's research is based in part on interviews with Teich and members of his family. My comments on the history of the company are also drawn from research in the extraordinary archive of the Teich Museum, including hundreds of thousands of postcards, an entire room of sample books, and a vast collection of negatives and other materials.

[65] This issue of "trusts" is confirmed by interviews with the Teich family and materials held in the Curt Teich Museum. My grateful thanks to Katherine Hamilton-Smith for pointing me to these materials.

[66] This is Katherine Hamilton-Smith's speculation, based upon the reports of these agreements by Teich family members she has interviewed.

[67] These lists are drawn from the sample albums held by the Curt Teich Museum; the generic landscapes and cityscapes dot the collection after 1910. See A7203, for example, or 5AH2324.

[68] On the view company, see Jay Ruby, "Images of Rural America: View Photographs and Picture Postcards," *History of Photography* 12 (October-December 1988): 327-342.

[69] Rand's work is primarily located in the Southwest Harbor Public Library, Southwest Harbor, Maine. Rand's exposure diaries reveal his fondness for late-afternoon water-scenes converted by darkroom treatment into nighttime scenes.

[70] James A. Wells, *A Short History of the Old Cambridge Photographic Club* (Boston: privately published, 1905), p. 7. I am deeply grateful to archivist-historian Meredith Hutchins of Southwest Harbor, Maine, for sharing her own research on Rand, and for pointing me in the direction of many materials I might otherwise never have found—including this volume.

[71] Käsebier's modernism is only one side of this important transitional figure; after all, she did break with Stieglitz and form the Pictorial Photographers of America. This side of her is celebrated in Charles H. Caffin's essay on her portraits, first published in 1901 in *Photography as a Fine Art* (republished, Hastings-On-Hudson: Morgan and Morgan, 1971), pp. 55-81. The Library of Congress holds a valuable archive of Käsebier's original negatives and a set of master prints in the Prints and Photographs Division, as well as significant further information. I am indebted to Barbara L. Michaels for a paper she delivered at the College Art Association in 1982; it was an electrifying reinterpretation of Käsebier's work, and the completed book promises many riches.

[72] Alvin Langdon Coburn, *New York* (London: Duckworth and Co., New York: Brentano's, 1911), unpaginated.

[73] Information on these sets is drawn in part from sets held by the Amon Carter Museum, the Gernsheim Collection of the Humanities Research Center of the University of Texas at Austin, the Prints and Photographs Division of the Library of Congress, and numerous private collections. William Culp Darrah, the world's authoritative source on stereography, provides detailed information on the Keystone and Underwood sets in *The World of Stereographs*, pp. 46-51. The '600' set's *Encyclopedia* began with the 1906 issue of the pictures.

[74] This description is drawn from No. 27 in the Amon Carter's Keystone '600' set.

[75] Bogardus' address is quoted in full in the *Philadelphia Photographer* 8 (July 1871): 202-203.

[76] This and all other quotes from the texts of the Keystone set are taken from the collection at the Amon Carter Museum.

[77] On the sociological and reform photography of the first decades of the twentieth century, the best source is Maren Stange, *Symbols of Ideal Life: Social Documentary Photography in America, 1890-1950* (Cambridge and New York: Cambridge University Press, 1989), esp. pp. 1-87.

"OF CHARMING GLENS, GRACEFUL GLADES, AND FROWNING CLIFFS"

VI

The Economic Incentives, Social Inducements, and Aesthetic Issues of American Pictorial Photography, 1880-1902

In 1889 photographers somewhat cautiously celebrated the jubilee anniversary of Daguerre's and Talbot's announcement of their inventions. No longer regarded as a mysterious hybrid with unclear application and unknown potential, photography at the age of fifty was an accepted fact of modern life, and photographers and photographic images were commonplace. Having demonstrated its usefulness to astronomer and artist, geologist and geographer, historian and politician, photography also had been embraced by a middle class eager to have visual records of the people close to them. The medium's jubilee was commemorated with speeches recalling the early days, when practitioners struggled with both an uncertain medium and an amazed audience; demonstrations of antiquated processes; and exhibitions charting the rapid leaps of technological innovations. A monument to Daguerre was also commissioned.[1] These activities were intended to validate the medium not only in the eyes of the public but also, and perhaps more importantly, in the minds of its practitioners by giving photography recognition and conferring on it a sense of maturity—by making it, in short, a medium with a history. In fact, however, the celebration did little to calm the deep sense of malaise that pervaded the field.

The 1880s were a decade of dramatic change. Although the medium had assumed the weight and authority of history, photographers could not draw comfort from this new-found maturity, for the technological improvements made during these ten years profoundly and irrevocably altered the nature, structure, and practice of photography. In 1880 the field was composed almost exclusively of professionals who made their living selling cabinet cards, cartes-de-visite, or stereographs of landscapes, individuals, and social, political, and military events. During the last fifty years they had formed a tight and by now clearly defined structure, consisting of the photographers themselves, who actually made the images either in the field or studio; assistants who prepared, developed, and printed the plates; technicians who mounted and finished the photographs; and distributors. Supported by a large group of stock manufacturers who perfected materials to suit the professionals' needs, and encouraged by periodicals that reflected their concerns, they were, for the most part, a cohesive group who were able to extract a moderate living from their businesses. But this structure was severely shaken during the last two decades of the nineteenth century. Improvements in the gelatin dry plate process, the introduction of small, portable hand-held cameras, and the advent of a photo-finishing industry during the 1880s changed photography from a messy and complicated process to one so simple that anyone, even a child, could master its technique. Once a business with clearly defined roles and objectives, photography became a pastime, a hobby, and by 1890 the field was dominated by amateurs. As the process became simpler, the cost of photographic equipment and materials also dropped so that late in the century many people of middle-class means were able to own a camera and make their own photographs. For the first time, they did not have to accept visual information prepared by someone else but could create their own images, recording what was important to them in a manner that suited their tastes and requirements.

As the field of photography expanded to encompass new practitioners with widely different social, political, and aesthetic agendas, it was also severely tested. Generalizations

SARAH GREENOUGH

Figure VI-1

LOUISE DESHONG WOODBRIDGE. *Outlet of the Lake.* Platinum print, negative 1885, print 1898. Janet Lehr, Inc.

of who the photographer was, where and how he (or increasingly, she) made photographs, and for what purpose, were radically altered. The very definition of the medium itself was also challenged. Before the 1880s photography had been conveniently and comfortably classified as part science, part art, and accorded some of the respect of both professions. Photographs, if they were not given the status of the fine arts, were admired for the craftsmanship and knowledge that produced them. But as the science and procedure of photography were rendered inconsequential, its art also seemed diminished.

Pictorial photography, the movement to demonstrate the artistic merit of the medium, developed directly in response to this economic, social, and aesthetic chaos of the 1880s. It was not, as it has so often been portrayed, a European style merely appropriated by Americans, but rather an indigenous response to a very specific set of circumstances.[2] It served the needs not only of newly emerging amateurs, particularly the serious and devoted practitioners who wished to distinguish their work from that of the more common Sunday hobbyists, but also of professional photographers, many of whose businesses had eroded almost to the point of obliteration in the 1880s. Strictly defining and limiting the art of photography gave amateurs a set of rules against which they could measure their accomplishments, while cultivating and declaring the artistic nature of the medium provided professionals with a rationale for higher prices and a means to regain lost stature in their communities. For both groups, pictorial photography became a way to impose order on a confused and rapidly changing situation.

In his 1889 address before the Photographers' Association of America, the famed photographer Abraham Bogardus lamented that when he began to make photographs in the days of the daguerreotype, "it was a scientific business. A man who made a good daguerreotype was looked upon as something. The difficult, delicate, mystic art was considered something for a man to accomplish." He wistfully noted that "it was not as it is to-day." In an impassioned speech, he urged his fellow workers to rise up and combat the "enemy with octopus arms, reaching in every direction," that with "its slimy touch and deadly grasp is destroying our beautiful art."[3] The enemy was all too well-known to the five hundred professional photographers who attended the convention in Boston and enthusiastically received Bogardus' speech. The "cancer of the profession" were the so-called "cheap johns," commercial photographers who used the declining cost of materials and processing to sell photographs at dramatically reduced prices. When they could attract and maintain a steady, high volume of business through creative promotional schemes and advertising, these unscrupulous professionals forced more established businesses to lower their prices, and thus cut their margin of profit, or risk losing all their clients.[4] Even worse, in the eyes of the commercial photographer, some photographers masqueraded as amateurs but used their social and political connections to sell their photographs and inventions. Bogardus warned that in 1889 the cut-throat business of photography was "low enough," and if efforts to raise it and transform it into an ethical profession with a higher moral tone and purpose were unsuccessful, it would be "beyond redemption."[5]

In addition, true amateurs were another problem for the professional photographers. Describing them as the children of the "directors of the grab-all bank on Wall Street," Bogardus believed they were degrading the art with their technically and aesthetically inferior images. These amateurs, who delighted in making their own photographs of friends and family, landscapes and city vistas, also had little reason to buy the landscape views of the large stereo companies and even less occasion to patronize the studios of commercial portrait photographers. Just as importantly, as these new amateurs learned how to make their own photographs, they had little respect for the professional's skills. They gleefully proclaimed that anyone could take a photograph and perpetuated the notion that photography required little skill or intelligence. By 1890 the commercial photographer was no longer viewed as something of a magician, the sole possessor of the secrets of drawing with light, but instead was often seen by the public as little better than an amateur hack who pushed the button and let Kodak do the rest.

During the 1880s the entire economic structure of photography changed. Stock manufacturers, scrambling to get a portion of the burgeoning amateur market, looked for

products that would suit the needs of these new enthusiasts. Directing much of their advertising to this new market, dealers gave discounts to the newly equipped amateur to attract his business and in general displayed far less interest in the needs and concerns of the professionals. Photographic periodicals also turned their attention to the amateur, adding columns that extensively covered the activities of the amateur clubs and that addressed issues of concern to these hobbyists. The large manufacturers of stereo views continued to supply work to government, university, and library accounts, but portrait photographers, whose business was based almost exclusively on middle-class patronage, suffered badly. As studio after studio was forced to cut its prices or close, professionals struggled to save not just their businesses from collapse, but also their position within the community, and their sense of self-esteem. Prices came to be understood as a reflection not just of the photographer's economic livelihood, but also of the medium as a whole: its relative importance to society, its utility and rarity, and the skill it required. Railing against the pitiful state of photography, H. McMichael, the president of the Photographers' Association of America, concluded that by 1889 the price of photographs had fallen so low and the field had been so demeaned that most photographers were no more than "mere machines, like sewing girls who make shirts for ten cents apiece and live in garrets with scarcely enough food to keep soul and body together."[6]

During this time commercial photographers directed many of their activities towards elevating the position of photography from a somewhat marginal trade to that of a respected profession, equivalent in stature and in monetary compensation to that, for example, of medicine or law. Among the most effective were the activities of the Photographers' Association of America (PAA). Formed in 1880, the PAA was specifically intended to "reach out beyond the chemistry, optics, art, and mechanics of our art-science, and take hold of the morals of the craft," to make all those engaged in the profession "respect themselves more, and the public to honor us in a larger degree than they have."[7] Reviving the defunct National Photographers' Association, whose last meeting had been held at the Centennial in 1876, the PAA organized annual conventions to exchange ideas and information, display new products and inventions, exhibit the work of its members, and debate issues of concern. All of these activities were designed to promote a sense of unity and brotherhood among professional photographers throughout the United States, to dissipate feelings of ill-will and diffuse unnecessarily competitive business practices in an effort to "see our profession take the place it so justly deserves beside the highest of the liberal pursuits."[8] The establishment of colleges and schools of photography was another effort designed to enhance the professionalism of the medium. The Chicago College of Photography, founded in 1881, had courses of instruction on the chemistry, optics, and art of photography and provided its students with certificates to verify their skills and training. It was hoped that a graduate of such an institution would "possess the art, character, and tone" of a professional, and could thus command "a higher money value . . . for his work."[9] The photographic press also became involved in the cause, publishing instructive lessons. Numerous articles cautioned photographers on the need to be astute businessmen and to manage their studios effectively, while others urged them to use proper language to instill respect. Noting that slang expressions lower the public's estimation of the art "to the level of the itinerant seaside tintyper," these writers cautioned their readers to recognize that the public "can see nothing of an elevating character in the science when professors talk of it after the manner of a street arab with a pea-shooter."[10]

Commercial photographers seeking stature and financial stability in the 1880s found two other widely divergent, but not necessarily mutually exclusive, paths open to them. The first were unions, associations, or co-operatives designed to act as advocates for professionals and to fix or regulate prices. In a decade preoccupied with the question of unions in general, that saw the rapid unionization not only of the craft professions but also of light industry, that witnessed the remarkable rise of the Knights of Labor from 42,000 members in 1882 to 700,000 members in 1886, and that experienced one of the most notorious labor incidents in this country's history, the Haymarket Square riot in 1886, it is hardly surprising that photographers should also consider unions as a means to combat threats to their livelihood.[11] Throughout these years photographers frequently debated the merits of establishing mutual

aid societies to provide job security and fire, health, and life insurance to the profession. Some, including the Association of Operative Photographers of New York, which was founded in 1881 and made up entirely of studio employees, were viable organizations that, in addition to providing a forum for the exchange of scientific information, helped their members obtain jobs and gave financial aid to those in need.[12]

More numerous and widespread, however, were the attempts to establish a uniform scale of prices for photographers across the country to charge for different kinds of photographs. Recognizing that there would be a wide range in the cost of production between, for example, Topeka, Kansas, and New York City, the PAA rejected most plans as being unfeasible and impossible to regulate, although some state organizations did adopt uniform price lists.[13] Secret organizations, including the Secret Order of Scientific Photographers, founded in 1886 on the model of the Freemasons, were chartered specifically "to elevate the profession and to stop the low prices that are pulling it down."[14] Another group that attracted a great deal of attention because of the number of its members, their stature within the field, and its methods was the Photographers' and Artists' Mutual Benefit Association. Organized in 1889 with Abraham Bogardus as president, a New York judge as secretary, and two established New York photographers, Philip S. Ryder and N. B. Thayer, as treasurer and general manager of the "traveling agents," the association sought to build a strong union of employers and employees. Its ambitious objectives were:

1. To *stop* ruinous cutting in prices.
2. To *establish* a higher and more equitable scale of prices.
3. To *secure* enough compensation to the photographer to enable him to do first-class work.
4. To *oblige* parties to serve a three years' apprenticeship, and to have a certificate of service from a master before being qualified to engage in the profession.
5. To organize a *Bureau of Information* for the employer who wishes help, and for the employee wishing a position—their standing in all respects to be supplied.
6. To organize a *secret service* for the quick assistance of the membership.[15]

Although the secret association was intentionally unclear about how it would bring "quick assistance" to its members or stop price-cutting, the photographic press recounted instances where agents from the association met with "low-priced men" and within "twenty-four hours broke up the club-peddling business and brought about a satisfactory adjustment of prices among all the photographers of that city."[16] However, in part because the process of photography was now so easy, in part because the field had for so long been characterized as one that encouraged the independent and often quixotic entrepreneur, in part too because photography, in this country at least, had always been open to all to try their hand, these efforts to form strong, centralized, and secret organizations with regulations designed to limit access to professional practice of the medium met with little success.

Yet for those professionals who did not consider their work as a commodity that could be regulated and who did not see themselves as manufacturing a product for public consumption, such phenomena as unions, mutual benefit associations, and uniform price rates were not an acceptable or necessary path to respect and financial security. For these practitioners the way to keep prices from falling and to maintain stature within the community was to stress the artistic merit of photography and to educate the public to its creative potential. "Art," they explained, is and must be "different from manufacture."[17] It was the antidote to both the cheap johns and the amateur snapshooter. "Elevate your art," J. F. Ryder told the members of the PAA, "and it will elevate you. Make your prices high, and make your work worth all you charge for it."[18] From its inception in 1880, the PAA had firmly demonstrated its allegiance to the art of photography—it announced its first convention in Chicago in 1880 with a drawing, not of a camera or a photographer, but a palette (FIG. 2). As the decade progressed it became increasingly clear to many professional photographers, and particularly those who made portraits, that the practice of photography had become extremely mechanized, its images cheapened through rote repetition of poses and stock backgrounds, its prints diminished through assembly-line production. These practitioners believed that during the first fifty years of its existence, the science of

Figure VI-2
Convention announcement.
In *Philadelphia Photographer* 17
(September 1880): 261.

THE

Philadelphia Photographer.

Vol. XVII. **SEPTEMBER, 1880.** **No. 201.**

Entered according to Act of Congress, in the year 1880,
By EDWARD L. WILSON,
In the office of the Librarian of Congress, at Washington, D. C.

PHOTOGRAPHERS' ASSOCIATION OF AMERICA.

FIRST ANNUAL CONVENTION HELD IN CHICAGO, ILL., AUGUST 23D, 24TH, 25TH, 26TH, AND 27TH, 1880.

AGREEABLY to the call made repeatedly in these pages, a large body of the photographers of the United States and Canada assembled at the above time and place, in convention, for the permanent organization of a new national association, and for mutual improvement and good.

A great number had arrived in the city by Monday, the 23d inst., and of these some were busily engaged all day placing their specimens of work in the exhibition rooms.

As arranged, the entire exhibition and all the meetings were held in the apartments of the Grand Pacific Hotel (Messrs. John B. Drake & Co., proprietors), whose magnificent dining-hall was given free for exhibition purposes, an adjoining hall for those having articles for sale, and a third —known as the Appellate Court-room—was set apart and used for the meetings of the Convention.

During Monday, the arrangement and inspection of the exhibition took the time of the photographic pilgrims until 9 P.M., when *business* was regularly opened by a grand banquet—a new and most agreeable feature in these convocations. Each member of the Photographic Association of America was provided with a beautiful ticket of admission, in the form of a palette, handsomely decorated and printed, a reduced photo-engraving of which we give.

It was artistically and tastefully gotten up, and reflected great credit upon the Committee, as did everything pertaining to the whole grand affair.

photography had been extensively explored and amply perfected, while its art had yet to be investigated. "The mechanical and chemical manipulations are now so well understood," a photographer wrote in the early 1880s, that "the way to improvement lies in a purely artistic channel. . . . This is the road to financial improvement. . . . Photography pursued in purely artistic channels will more nearly bring its worth and value; but pursued in a mechanical groove will never bring more than what we may call commercial prices."[19]

Just as the push to unionize photography was symptomatic of the period, the desire to liberate the craft of photography from its mechanical application and to use it as a means to bring culture to a broader audience was part of a much larger phenomenon. As a reaction against its increasingly industrialized nature, late-nineteenth-century America experienced a widespread movement to banish low-quality, mass-produced, machine-made objects and to inject art back into the production of its crafts. In an effort to restore the craftsman to a position of dominance over the machine, many sought to reinvigorate the production of ceramics, furniture, books, glass, or metal works with a sense of creativity and individuality. At the same time the Centennial Exposition, which Isaac Edwards Clarke declared in 1886 had "taught the people of this country how beauty enriches all the appliances of life," helped to spur a strong belief that culture—the arts, education, and religion—could bring personal refinement and fulfillment to the American middle class.[20] The cult of science and positivism which had dominated so much of the nineteenth century with its promise to explain all of life's mysteries through rational, scientific investigation, waned during these years. People began to place more faith in the power of art to enlighten and enrich their lives. Numerous magazines were published, and societies, clubs, museums, and schools were founded in an effort to bring art to the middle class and to demonstrate that the appreciation of beautiful objects and their integration into the home could enhance daily life. Most of these efforts were far more idealistic and far less motivated by the pressing monetary concerns that preoccupied the commercial photographers. Nevertheless, the example set by the artists and writers associated with the Aesthetic movement, Symbolism, or, somewhat later, the Arts and Crafts movement influenced and encouraged the professional photographers; their rhetoric was a useful addition to the photographers' arguments, and their exhibitions, periodicals, and organizations were invaluable models.

The key attribute of this new style of artistic photography was individuality. "He who succeeds in stamping his own individuality on his work," John Nicol told the annual convention of the PAA in 1887, "lifts himself out of the arena of trade and into that of a profession, and may then fix his prices to suit himself without regard to competition."[21] Believing that "true art," is an outward expression of "individual thought and aspiration," E. K. Hough noted in an article titled "The Ideal in Art and Its Relation to Photography" that many professional photographers were beginning to recognize that something more was needed than a "difference in the style and cost of studios, or the difference of prices charged . . . something which is like electricity, powerful though imponderable, which is the soul of the artist, and puts its impress upon all his work."[22] Individuality and the cultivation of a distinctive style became a way not only to distinguish one photographer's work from another, but also, and perhaps more significantly, to make the name of the photographer as important as his product. As the cult of personality grew, professionals hoped it would become fashionable not simply to have a photographic portrait of oneself, but to have a Sarony, a Ryder, or a Cramer. What was important was not simply to render a physical likeness of the sitter or even to record his character, but rather to use the portrait as a way to express the individual artistic temperament of the photographer.

Clearly the economic motivation for this new kind of photography was very strong: one member of the PAA even suggested that "art censors" be established as civil servants in every town to price works according to their artistic merit, settle disputes between customers and artists, and to minister to "the cultivation of a correct taste."[23] For some professionals this was a blatant promotional scheme, as artistic photographs, with limited editions or elaborate mounts, became just another kind of image to sell along with landscapes or portraits. For others the promise of creating artistic studies seemed an excellent way not only to raise prices, but also to entice a new kind of customer into the commercial studios. Believing that the cheap johns served "a class that cannot appreciate good work," many

thought the artistic photographer would make more expensive photographs for more elite customers, images that "all the rich and fashionable people will want." Higher prices dignified the practice, bringing the commercial photographer in contact with a "higher class of individuals" and making him equivalent in stature to other master craftsmen.[24]

It is also clear, however, that there were many other professional photographers, perhaps those more securely established in their businesses, who were seriously committed to improving the profession by formulating a new, viable aesthetic for photography. No longer satisfied with producing mere "likenesses or literal representations of figures or objects," these photographers wanted to demonstrate thought, selection, and inspiration in their uses of the camera.[25] This new style, described as "poetical art," "pictorial photography," and "modern photography," stressed the depiction of subjective states of being over objective facts. "It subordinates matter to mind," Charlotte Adams explained in an 1885 review of professional work that had recently been published in the *Philadelphia Photographer*, "and never allows the balance of a proper relation between expression and the idea expressed, to be altered."[26] Freely sacrificing what one reviewer called "trifles," poetical art "insists that the feelings shall be reproduced rather than the tangible facts." As "a distillation of Nature's essences through a human soul" it must thus "represent nature as it is presented to our senses, not as things actually are."[27] As photographers placed greater emphasis on expression, the precise, literal description of the subject in front of the camera became far less important; the photographic subject became primarily a vehicle for stating an idea or emotion. Long before any significant discussion of Peter Henry Emerson's idea of differential focus appeared in the American press, critics urged simplification and declared that details could be overlooked and focus softened. "The eye cannot take a distinct impression of more than one thing at a time," Elbridge Kingsley explained in 1887. "Why should we try to make a picture on any other principle?" Only what is "necessary to convey to the mind the character of the scene attempted" should be included.[28]

In shifting the balance toward the art of photography and away from its science, these professionals also began to alter the definition of the medium. They tentatively suggested that the attributes of photography were not or need not necessarily be precision, accuracy, or verisimilitude, that the medium was not merely a transparent window on the world or an objective utilitarian tool for the replication of reality, but that it could also function as a screen, a decorative surface on which the artist could project his deepest thoughts and feelings. In this way, they believed, photography could truly become an art, for it would, as a critic wrote in 1887, create "something that did not before exist except in the mind of the designer." To this end they abandoned accuracy for impression, fact for expression, detail for effect, and scientific truth for creative intuition. "The modern mind," Charlotte Adams perceptively wrote in 1885, "perceives the fallacy of the conventional statement that truth is absolute. Truth, and particularly artistic truth, is relative."[29]

Through demonstrations in their studios, articles in the popular press, and exhibitions, professional photographers sought to educate the middle class about the creative potential of photography. It was certainly in their financial interest to do so, yet many also expressed a desire to use their work, which was brought into the home and seen every day, to mold and elevate public taste. Because photography could keep beautiful things in contemplation, the president of the PAA told his audience in 1888 that it could be a "safeguard against materialism . . . a safety-valve of the community" whose inclinations might otherwise lead it into "channels less refining, and perhaps into dissipation and crime."[30] As an antidote to vice, photography could, like painting, literature, or music, be a morally, spiritually, and intellectually uplifting force in society.

Many of the ideas proposed by American professional photographers in the 1880s were quite advanced and would not be fully developed or systematically explored until the late 1890s and even the early 1900s. However, while their theories were innovative, their art, on the whole, was not. The aesthetic they were beginning to formulate depended on capturing a moment of time that seemed pregnant with meaning and emotion, on recording looks, gestures, or vistas that were redolent of sentiment. Although it was not an aesthetic that celebrated the spontaneous or decisive moment, it did demand a direct impression rather than a studied construction. Nonetheless, the most highly praised photographs at the

Figure VI-3
C. H. Stoddart. *Basil, the Blacksmith.* Reproduced in *Anthony's Photographic Bulletin* 20 (October 26, 1889): facing p. 609.

annual PAA exhibitions, those that were thought to be the most artistic, were carefully preconceived, elaborately staged events. Like the highly acclaimed photograph at the 1889 PAA convention, *Basil, the Blacksmith* by C. H. Stoddart, they were far from spontaneous (Fig. 3). The PAA further aggravated the situation by decreeing that photographs entered in many competitions must illustrate lines of poetry or scenes from novels. Although many professionals professed a love of Corot, it is clear that their models were more often drawn from mid-nineteenth-century genre painting and photographs by the revered English Victorian photographer Henry Peach Robinson. With these theatrical creations, the expression of feeling and sentiment quickly descended into artificiality and sentimentality.

In portrait photography, professionals of the 1880s continued to explore well-trodden paths. Some abandoned ornate Victorian constructions and searched for a simpler and more aesthetically economical way to convey character. Yet many others, no doubt in an effort to please their customers, took few risks and continued to employ generic poses, backgrounds, and expressions in order to appeal to popular notions of beauty.

Landscape photographs seemed ideally suited to pictorial or poetic photography. The subject allowed the photographer to express his individuality freely and directly, to reveal the "thoughts and feelings experienced by ourselves when contemplating Nature" and to touch "a higher and deeper source of feeling in the human soul."[31] But even though some writers urged professionals to leave their studios and reinvigorate themselves with the clearer atmosphere of nature, "where the intellect is quickened, the mind cultured, and the soul brought into nearer relationship with the Supreme Creator of all beauty and goodness," only a few professionals appear to have made extensive or productive experiments with "artistic" landscape photographs.[32] This is largely because professional photographers appear to have adopted a hierarchy of subjects, ranked according to their perceived difficulty and importance. Portrait photography was thought to be the most significant application of photography and to demand the most skill to record character; thus it was the highest, most noble subject. Second was the genre tradition, which although it entertained rather than enlightened, was sanctioned both by the pre-eminent examples of Robinson or O. G. Rejlander and by the effort required to construct the scenes. Landscape photographs were simply deemed too easy. Anyone could stumble across a quaint nook or charming vista on an outing in the country. Landscape views seemed to require no skill in drawing out character, no knowledge of literature or poetry, and thus they were presumed to be a subject only suitable for the beginner. As professionals readily ceded landscape subject matter to less skilled amateurs, these novices explored it with great enthusiasm, alacrity, and profit.

In point of fact, however, by the early 1890s professionals had ceded not only artistic landscape photography but the whole art movement to the amateurs. Although Charlotte Adams had predicted in 1883 that "artist-photographers" would be able to support themselves solely by their artistic productions, and *Wilson's* concurred in 1889 that the day was rapidly coming "when the public will demand and willingly pay *for pictures* . . . [and] the photographic artists who are prepared to meet [these demands] will reap rich rewards," this did not happen.[33] By the early 1890s art photography proved no more able than secret orders or unions to raise prices or even stem the decline. Although the economic crisis stabilized somewhat in the 1890s, professional photography was dealt a severe, almost fatal blow by the technological developments of the 1880s. With the advent of hand cameras and the photofinishing industry, never again would professionals have exclusive reign over the field, and never again would they be as numerous or financially successful as they were before the 1880s.

Although art photography was not the balm that the professionals had hoped for, their ideas reached another receptive audience: the amateurs. Nurtured on the discourses of the professionals in the 1880s, many amateurs, as they came into maturity in the 1890s, ardently championed the new aesthetic of pictorial photography. Freed from the economic constraints that hampered the professionals, they were able to devote themselves to the study of artistic photography. For these amateurs artistic photography elevated the stature of their chosen avocation, and perhaps equally important, it also provided them with a congenial, supportive, safe social structure and a clearly defined aesthetic that enabled them to distinguish "good" from "bad" photographs. With this new aesthetic they could separate themselves and their work, as Alfred Stieglitz wrote in 1897, from "every Tom, Dick and Harry" who "could, without trouble learn to get something or other on a sensitive plate." And they could emphatically proclaim their individuality, "boldly stand forth," as the Boston photographer F. Holland Day asserted in 1900, "and declare, 'Behold it is *I*.'"[34]

F. C. Beach and W. H. Burbank, the editors of the *American Amateur Photographer*, the first American periodical devoted exclusively to the needs of amateur photographers, regretfully noted in the first issue (July 1889) that "we very much fear that in some respects photography is being belittled by its friends." Acknowledging that a fairly decent camera could now be purchased "for a song," they wrote that "it has become a popular belief that all the difficulties have been removed, and that any one can take pictures. Photography has been degraded to the level of a mere sport, and many take it up, as they do lawn tennis, merely for an amusement, without a thought of the grand and elevating possibilities it opens up to them."[35] The equation between lawn tennis and photography was apt, for the burgeoning middle class of the late nineteenth century eagerly embraced many new fads and hobbies to fill their leisure time: tennis, swimming, bicycling, and hunting became extremely popular, and so too did photography. Perceived as a healthy pastime because it got people out-of-doors—"it needs the sunshine and they are happiest who count life by its sunshiny days"—photography, cameras, and the act of taking pictures became commonplace occurrences in the 1880s.[36] With this explosion of interest came an avalanche of poorly exposed, poorly printed images with chaotic, fragmented compositions of seemingly inconsequential subjects. Sunday snapshooters, disregarding all conventions of civility and decorum, were "omnivorous," an author complained in 1884; they "will photograph *anything*," and "no man is safe."[37] Another noted in 1889 that they exercised no self-censorship and violated all rules of what, where, when, and how to photograph; at best their work was "aimless," at worst it threatened the integrity of the medium as a whole.[38]

It was this degradation and trivialization of photography that the editors of the *American Amateur Photographer* saw as a rampant problem and a serious threat to the medium. Like Bogardus, they warned that there was a compelling need for education, for moral and aesthetic direction. "We submit that our art has a higher side," they wrote, that "there is a moral element in the practice of the art picturesque." Although the editors were concerned with educating the general public to the merits of photography, their primary focus was the amateurs themselves. Through a series of articles and reviews, they wanted to formulate an aesthetic of fine art photography that would enable workers to reveal both their own

individual personalities and the poetry of their surroundings; through reproductions, they wanted to show the kinds and intensity of expression that photography could allow; and through precept they wanted to instill in the refined and serious amateur a respect for their medium. Beach and Burbank concluded that the *American Amateur Photographer* would be devoted to developing and fostering "the moral element in the practice of the art picturesque . . . to dignify and elevate our art."[39]

Although the *American Amateur Photographer* was the first American periodical directed towards the special needs, concerns, and problems of the amateur, others quickly followed, including *Photo-Americans; An Illustrated Monthly Magazine Devoted to Amateur Photography*, also in 1889, and *Photo-Era* in 1898. Some were aimed solely at the hobbyist, but most sought to capture the attention of the more committed amateur and fuel his enthusiasm for (and presumably also his expenditures on) his newly adopted passion. However, periodicals were not the only or even the primary source of information and education for amateurs; that function was most effectively served by the numerous camera clubs scattered across the country. Just as the push to unionize professional photography was symptomatic of the more general concerns of the time, so too was the rise of camera clubs part of a larger phenomenon. As they adopted new hobbies to fill their leisure time, late-nineteenth-century middle- and upper-middle class Americans also joined clubs with great alacrity. Whist clubs and yacht clubs, musical groups and furniture clubs were filled with members eager to learn more about their hobbies and to associate with others of similar interests in a relaxed, well-appointed environment.[40]

Camera clubs, founded with the explicit purpose of advancing knowledge of the art and science of photography, also provided a convenient framework within which those photographers who wished to elevate and dignify the medium could easily and efficiently work. With similar organizational structures, shared goals, and a fraternal nature, these societies formed a tight network with frequent and timely communication and became a vital conduit for the rapid spread of pictorial photography. Like the PAA, the camera clubs' primary purpose was educational, encouraging an active and free exchange of information among those amateurs who wished to know more about photography and make better pictures. Like the PAA, they tried to promote education within a congenial social structure, fostering a sense of unity and fraternity among their members. It was, however, a mixed agenda, requiring a delicate balance of art and science, education and entertainment, theoretical or aesthetic investigation and camaraderie. Camera clubs attracted a variety of people, some interested more in the social benefits, others keenly devoted to the aesthetic issues. This blend of interests was both the reason for the initial success of the camera clubs, and also the root of their divisive political squabbles and their eventual demise.

In 1880 there were fewer than ten camera clubs or societies in the United States, all of them composed mainly, if not exclusively, of commercial photographers, scientists, chemists, or opticians. (Among others these included the Photographic Section of the American Institute, founded in 1859; the Photographic Society of Philadelphia, 1862; the German Photographic Society of New York, 1867; and the Chicago Photographic Association, 1870.) Yet only nine years later, at the time of the jubilee celebrations, there were over fifty clubs consisting almost entirely of amateurs. By 1894 *The Blue Book of Amateur Photography* (itself a product of the phenomenal growth in photographic organizations) listed 118 societies, while another source noted that in 1895 there were over 150, with a total of more than 5000 members.[41] These clubs were located not only in major metropolitan areas—in 1894 New York had six clubs and Philadelphia five—but also in small towns such as Colfax, Colorado, or Adrian, Michigan, or Waterbury, Connecticut. Some had as few as a dozen members, while the California Camera Club in San Francisco had 180 in 1894 and the Society of Amateur Photographers of New York was among the largest with 260 members. Almost all provided darkrooms for their members, many had libraries containing not only standard technical manuals but also current American and European periodicals, several published minutes of their meetings, and some even had small collections of photographs and photogravure reproductions for exhibition and study. Larger clubs, like the Camera Club of New York, sent out engraved announcements of exhibitions, meetings, and lectures and had lavish facilities with several darkrooms, preparation areas, cameras and studios, exhibition areas, lounges, and facilities for lantern slide projection (Fig. 4).

Figure VI-4
Arrangement of the Camera Club Rooms. In *The Camera Club of New York*, brochure, c. 1898. Courtesy of The Camera Club of New York.

Financially secure, most of the club members were from the upper-middle class. By profession they were doctors, lawyers, bankers, college professors, teachers, clergymen, and businessmen able to afford the initiation fees of fifteen to twenty-five dollars and the annual dues, which averaged ten to fifteen dollars but could easily rise as high as twenty-five dollars.[42] The number of women photographers increased dramatically during these years. Because the gelatin dry plate process was not as messy as the wet collodion, many suggested that photography was a suitable pastime for women now that they could make photographs without fear of staining their fingers and clothes. Women were admitted to most clubs, occasionally with a provisional status, sometimes with separate darkroom facilities.[43]

By temperament, club members were not casual snapshooters. They committed a great deal of time and money to both photography and their clubs, and they were anxious to justify these expenditures. During the 1880s and 1890s numerous articles suggested that there should be three classifications of photographers: commercial practitioners, rank amateurs, and "true" amateurs who "work with a definite view in mind" to elevate the art.[44] While "true" amateurs were determined to distinguish themselves from less serious hobbyists, they also did not want to be associated with professionals. Only a few clubs allowed commercial photographers to join. Many club members professed a belief that professionals would use

the societies as a forum to promote their own work or inventions, but this was not the only reason professionals were excluded. Celebrating their own financial and aesthetic independence, amateurs began to suggest that professional work, by the very fact that money exchanged hands, was tainted, compromised, and inferior.

Regular club activities offered a varied and balanced diet of art, science, and social events. Extensive and detailed technical discussions dominated most monthly meetings as members and invited guests recounted their latest experiments. Photographic chemicals, optics, and apparatus were changing rapidly during this time, so these meetings undoubtedly served an important need. To foster aesthetic advancement, prominent local photographers, painters, and designers were often asked to lecture or critique members' work; some clubs arranged regular lecture programs on the fine arts, while almost all devoted an evening a month to aesthetic discussions. To bring members into "closer social intercourse," informal gatherings, "smokers" or "smoking concerts" usually consisting of musical entertainment, lantern slide presentations, and occasional humorous skits, were often held, as were annual dinners. "To stimulate good health, good photography, and good friendship," almost every club organized annual or semiannual outings.[45] Although the Photographic Society of Chicago visited the State Insane Asylum in 1886 on its excursion, most outings took members into the country.[46] "Charming glens, graceful glades, and frowning cliffs" were the clubs' desired objectives; like the Photographic Section of the Rochester Academy of Science, most clubs sought a destination with a "creek, which, with its rustic bridges, cozy nooks, picturesque mill dams, and aqueduct makes it a little paradise for the enthusiastic amateur."[47]

While camera club outings encouraged members to photograph similar subjects, without doubt the most important factors in spreading the style of pictorial photography and in homogenizing its look were traveling lantern slide presentations, postal exchange clubs, and large group exhibitions. Long before halftone reproductions were common in photographic periodicals, these presentations served to make not just the rudiments of the style but the intricacies of its aesthetics well known from big cities to small communities. These public showings defined the look of "artistic" photography, clearly delineated—perhaps even codified—the scope of its subjects, and conferred status on the participants.

With the perfection of the gelatin dry plate process in the 1880s, lantern slides became extremely popular with amateurs. Their luminosity, size, and presence offered new opportunities for displaying sequenced images, occasionally accompanied by music, to a captive audience. Lantern slide presentations were ideally suited to camera clubs because they provided a special event—an occasion of interest and importance—for showing work yet were easy and economical to arrange. Most camera clubs had regular monthly, even bimonthly lantern slide presentations of members' work; several frequently showed slides of works by well-known painters, including Turner, Sir David Wilkie, and Dore; and many participated in national and international exchanges.[48] In 1885, largely as a result of the efforts of its president, F. C. Beach, the Society of Amateur Photographers of New York organized an exchange of lantern slides between its members and the Camera Club of London, the Boston Camera Club, the Cincinnati Camera Club, the Photographic Society of Philadelphia, and the Pittsburgh Amateur Photographers Society. By 1888 the American Lantern Slide Interchange, as it was called, also included the Baltimore Amateur Photographic Society, the Chicago Lantern Slide Club, the Saint Louis Association of Amateur Photographers, the Brooklyn Camera Club, and the Philadelphia Amateur Photographic Club; by 1894 twenty-one clubs across the country were members.[49] Each club selected one hundred slides representative of its members' best work and circulated the collection to all the other participating clubs. Although it often took over a year and a half for the collection to make the full circuit of clubs, these lantern slide exchanges enabled members to see a great deal of the most advanced work of the period very soon after it was made and without leaving their hometowns. For example, in 1889 members of the Pittsburgh Amateur Photographers Society saw and critiqued work by London Camera Club members H. P. Robinson and George Davison, only a year or so after the images were made, while in 1886 and 1887 members of the Society of Amateur Photographers of New York saw slides by members of the Pittsburgh Camera Club, the London Camera Club, the Cincinnati Camera Club, the

Boston Camera Club, as well as their own members' work. In addition, clubs frequently exchanged sets of lantern slides devoted to specific issues. Favorite subjects, generated both by civic pride and congenial club rivalry, were sets depicting the picturesque sites of the societies' hometowns: members were often asked to make photographs that could be included in "Illustrated Cincinnati" or "Illustrated New York." It may have been this kind of request that encouraged someone like John Beeby of the New York Camera Club or even Alfred Stieglitz to make lantern slides of that city at night and in the snow and rain (Figs. 5 and 6). When the slide collections were presented at a participating club, one or two members usually were charged with the responsibility of introducing each work and critiquing its merit. Undoubtedly the discussions that accompanied the presentations of lantern slide exchanges as well as those of members' work served to sanctify and encourage certain styles and subjects, rapidly spreading the aesthetics of pictorial photography.

Although not as pervasive and influential as the lantern slide exchanges, the Postal Photographic Club functioned in much the same way. Founded in 1885 by C. W. Canfield and E. L. French of Aurora, New York, the Postal Photographic Club was designed to educate amateurs in rural areas or those who were without the benefit of a local photographic club.

Figure VI-5
Alfred Stieglitz. *Winter—Fifth Avenue, New York.* Carbon photograph, negative 1893, print 1894. National Gallery of Art, Washington; Alfred Stieglitz Collection.

Figure VI-6
JOHN BEEBY. *New York.* Lantern slide, c. 1893. Collection of the Tokyo Fuji Art Museum.

Figure VI-7
ROBERT REDFIELD. *A New England Watering Place, Near Salisbury, Conn.* Platinum print, 1887. Janet Lehr Collection.

It consisted of one hundred members, each of whom contributed prints annually; these were mounted into albums and circulated through the club. Accompanying each album was a notebook where members critiqued each photograph.

Exhibitions also significantly directed the focus of American pictorial photography. As camera clubs grew in both number and popularity, they increasingly arranged exchanges of one-person and group shows. In addition to attracting new members, these highly successful and well-reviewed exhibitions gave active members a public forum in which to demonstrate their skills. For many they were a clear signal "marking the dawn of a new era in American photography."[50] Their success led several clubs in the middle of the 1880s to organize large exhibitions open to members and nonmembers, Americans and Europeans. Hosting the first such show in 1884, the Boston Society of Amateur Photographers established many of the patterns and issues that would dominate future exhibitions. With a jury composed of an artist, a designer, and an architect, the exhibition included over six hundred photographs by amateurs from all over the country, divided into numerous categories (landscape, figure studies, genre, marine views, for example) with distinctions made between images that were entirely the work of the amateur and those that were developed, printed, toned, or mounted by a professional.

In 1887 these scattered shows were regularized and codified with the establishment of the Annual Joint Exhibitions of the camera clubs of Boston, New York, and Philadelphia. Held annually from 1887 to 1894 (with the exception of 1890), these enormous exhibitions of American and European amateur and professional work were widely credited with elevating "the standards of taste and the quality of work among the membership and the amateur public generally."[51] They did more than that, however, for they also gave public definition to the concept of artistic photography, something that previously had been confined to camera clubs, photographic periodicals, and a few commercial studios. It is true that these exhibitions included a wide variety of work—artistic, scientific, and industrial photographs as well as technical inventions—representing the diverse nature of the camera clubs. But the artistic photographs had the greatest impact. In addition to displaying the talents of such Europeans as Henry Peach Robinson, Frank Sutcliffe, or Peter Henry Emerson, the Annual Joint Exhibitions established the reputations of such American amateurs as Robert Redfield (Fig. 7), George Wood (Fig. 8 and Plate 9), John Dumont, Rudolph Eickemeyer (Plate 100), Alfred Stieglitz, and Catherine Weed Barnes. Widely reviewed not just in the photographic press but also in popular periodicals and newspapers, the joint exhibitions also defined the style of early American pictorial photography. This can, perhaps, best be typified by Stieglitz' prize-winning photograph *Weary* from the 1891 exhibition (Fig. 9). Somewhat stiff and posed, although not as contrived as many other celebrated photographs from the day, this detailed image, with its picturesque subject matter, clearly shows Stieglitz' appreciation of late-nineteenth-century German genre painting. Titles of images by other exhibitors from this same exhibition indicate a similar sentimental and anecdotal nature: *The Spinning Wheel, In Confidence, Stalking a Trout, The Farmer's Daughter,* and *The Last Load.* It should be noted that these works were very similar in character to those shown at the PAA's annual convention.

The Annual Joint Exhibitions, however, also raised serious concerns about how photography exhibitions should be organized. They called into question whether amateurs and professionals should both be allowed to participate; who should judge submitted work; whether work should be separated into categories and awarded prizes; and, most important, what kinds of photographs should be exhibited—artistic, scientific, mechanical, or industrial. Although they were originally conceived as encouraging "friendly rivalry and intercourse between clubs," a highly competitive spirit entered into the exhibitions and began to politicize and fractionalize the clubs in the early 1890s.[52] Stimulated by the examples being set in Europe, where only the best artistic work was shown and no prizes were awarded, many photographers and reviewers suggested in 1893 and 1894 that only the finest examples of the art of photography should be shown; all other kinds, including scientific and technical, should be excluded. Stieglitz, recently returned from his schooling in Berlin, was among the most vocal champions of this new direction. Urging an end to the Annual Exhibitions, he implored his fellow photographers to "start afresh with an *Annual Photo-*

Figure VI-8
GEORGE BACON WOOD. *Elsie.*
Platinum print, c. 1886. Library
Company of Philadelphia.

graphic Salon, to be run upon the *strictest* lines. Abolish medals and all prizes—the acceptance and hanging of a picture should be the honor." He concluded, "There is no better instructor than public exhibitions."[53] The last Joint Exhibition organized by the Society of Amateur Photographers of New York in 1894 was not a success. Described as "the most conservative of the leading societies, in other words, the least progressive," the New York club was criticized by the press for showing too much "leniency" toward club members and allowing too many "trivial," unoriginal works to be exhibited.[54]

Despite their highly competitive nature, these exhibitions were seen as having benefits that stretched far beyond the medium of photography to the welfare of the community at large. Exhibitors were praised as people who "show their artistic tastes, desire for advancement, and love for the beautiful in nature and art, by their devotion, as a pastime, to a science which is peculiarly unselfish, progressive, and elevating to the mind."[55] The idea that photography, and particularly "artistic" photography, could be a progressive, even moral force was a common one. Far from simply being an expression of the photographer's musings or a means for self-aggrandizement, artistic photography seemed to offer a powerful instrument for public education, refinement, and cultivation. "Fine art" photography "would be a rapid trainer in the direction, which is receiving so much attention now, of a dissemination of art culture," a reviewer predicted in 1885, while another noted several years later that as artistic photography taught people to appreciate the beauty around them, it developed in them "a new, elevating, refining, and ennobling sense."[56] Others saw artistic photography as a force, capable of divining the spiritual in the natural world. Imploring their readers to recognize the "moral element in the practice of the art picturesque, which should be felt and followed by every worker with the camera," Beach and Burbank insisted in the first issue of the *American Amateur Photographer* that photography's "high mission" was

> the earnest and untiring search for the beautiful. . . . Such an earnest purpose as this lifts photography above the levels of a mere pastime: It makes it an inspiration; an interpreter of the thoughts of God. He who has this purpose will not trouble himself overmuch about the vexed question, 'Is photography art?' He will become a diligent and thoughtful seeker after the beautiful in nature, and so far as lies in his power, an interpreter of it. . . . His highest aim will be to interpret aright the grace and charm of field and forest, lane and hedge-row, brook-side and sea-shore. Technical manipulation will be to him only a means to an end, and that end the interpretation of beauty.[57]

The interpretation of beauty, whether to show the poetics of one's surroundings or to reveal the presence of higher powers in the natural world, became the goal of many amateur photographers by the middle of the 1890s. An appreciation of nature was not, they believed, an innate response but an acquired skill, indicative of a refined, cultured mind. Quoting John Burnet, amateurs insisted that "nature unveils herself only to him who can penetrate her secret haunts"; it appeals to "higher, not lower classes of men."[58] Critics urged them to make their photographs a "reflection of even some of the thoughts and feelings experienced by ourselves when contemplating Nature," to represent the "ideal" in their imagery.[59] This could not be done when imagery was too specific, too clearly documenting an identifiable person, time, or place, or when it was "too 'photographic' in the technical sense." Rather, critics encouraged amateurs to recognize that "in the rendering of a certain poetic sentiment of nature, a phase of quiet melancholy, produced, it is true, by many sacrifices of local truth, there is no doubt that he touches a higher and deeper source of feeling in the human soul."[60]

Artistic photography became a mission—almost a crusade—for many amateur photographers. In a very real sense, they believed it validated both the medium and their It was

Figure VI-9
ALFRED STIEGLITZ. *Weary.* Gelatin silver photograph, 1890. National Gallery of Art, Washington, D.C.; Alfred Stieglitz Collection.

involvement with it. It conferred status upon them, separating them from the Kodak snapshooter, distinguishing them as cultivated individuals. As a mission it became fiercely contested, and battle lines were drawn against "the triple burden of the conservatism of a public ignorant of the possibilities of photography, the opposition and intolerance of the conventional commonplace photographer and the flippant sneers of the whole world of artists."[61] The issues were clear: "Wherein [photography] presents facts, it is a science," James Laurence Breese wrote in the *Cosmopolitan* in 1894. "Wherein it presents ideas, it is an art."[62]

In the last few years of the nineteenth century, this aesthetic of photography, which prized individuality and was by its very nature both exclusive and militant, challenged the very institution that had nurtured its growth. Numerous camera clubs across the country were embroiled in controversies pitting artist against scientist, crusader against clubman. And nowhere was this aesthetic more cogently expressed or forcefully argued than in the pages of *Camera Notes*, the organ of the Camera Club of New York. Although its editor, Alfred Stieglitz, did publish an occasional scientific or technical article, from the very first issue in July 1897 the critical position of *Camera Notes* was clear: only those photographs that represented the development of an idea, "the evolution of an inward principle, a picture rather than a photograph" would be reproduced.[63] Throughout *Camera Notes* essayists implored photographers to reject the illusory world of objectivity in favor of a deeper and more universal truth residing in the vision of the artist. William Murray reiterated a common theme when he wrote in 1898 that "something more is required than truth to nature"[64] in making a photograph; it must transcend finite reality if it is to reveal, as Dallett Fuguet stated, "the truth of the universal."[65] "The aim of pictorial art," the English critic A. Horsley Hinton wrote in *Camera Notes*, "is not to copy nature, but to appeal to the imagination," which is most profoundly stimulated by suggestion rather than delineation. This suggestive art, which appealed not to reason but to intuition, would, Hinton asserted, "make one feel—Feel what? . . . Has not my reader listened to music which has thrilled him through, and could he not have said that such and such music made him feel—Simply this, it made him *feel!*"[66]

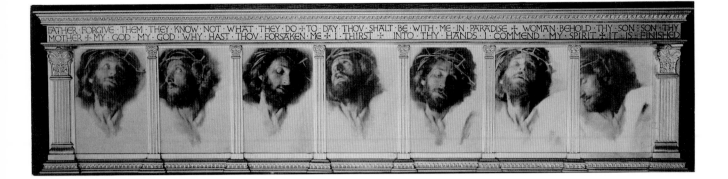

Figure VI-10

F. HOLLAND DAY. *The Seven Last Words of Christ.* Metropolitan Museum of Art; Alfred Stieglitz Collection, 1949 (49.55.222).

It was this aesthetic of photography that Stieglitz and others tried to represent in the Philadelphia Photographic Salons, hosted by the Pennsylvania Academy of Fine Arts and the Philadelphia Photographic Society from 1898 to 1901. The jury for the first exhibition—which included Stieglitz, Robert Redfield, and artists William Merritt Chase, Robert Vonnoh, and Alice Barber Stephens, stated that they would select "only such pictures produced by photography as may give distinct evidence of individual artistic feeling and execution."[67] Modeled after European photographic exhibitions, the Philadelphia Salon abandoned all subject categories and awarded no prizes. Over 1,500 photographs were submitted, 259 works by one hundred photographers (seventeen of whom were women) were hung, and 16,000 people visited the exhibition.[68] Although many of the photographs were by people who had exhibited in the Annual Joint Exhibitions or were well-known amateur photographers, several younger workers made their debuts, including Clarence H. White, Gertrude Käsebier, and F. Holland Day, who exhibited his *Seven Last Words of Christ* (FIG. 10), a picture that, as one critic noted, "excites hearty praise and severe criticism."[69] Eduard Steichen made his debut at the Second Philadelphia Salon in 1899.

Reviews for the first exhibition were generally enthusiastic—Charles H. Caffin in *Harper's Weekly* called it "an unqualified success"—but the Second Salon was not universally praised.[70] "There is a morbidity of sentiment," Charles R. Pancoast complained, and he sarcastically continued, "Originality seems to be at a premium, and certainly what the modern photographer will not think of no one else need try."[71] It was not simply the "originality" of these photographs that annoyed critics; it was also their style. In their quest to make suggestive, evocative images that alluded to universal themes, many pictorial photographers working toward the end of the 1890s, and particularly those associated with Stieglitz, sought to suppress the specificity of photography in favor of its more abstract, decorative qualities. As Steichen did in *Woods—Twilight* (FIG. 11), they used a soft focus to negate details, and a compressed, muted tonal range to emphasize a few key elements of pattern or design.[72] However, as Osborne Yellott lamented, this style cast a pall "of gloom, of despondency, almost of decadence.... There was a dreary monotony about the tier on tier of weak, fuzzy, washed-out looking photographs which stared listlessly at me from gloomy frames as only a weak, fuzzy, washed-out photograph can stare."[73] It is interesting to note that the American Lantern Slide Interchange was racked by the same controversies in the late 1890s, as several clubs tried to pass a resolution that a slide submitted for the exchange "must be rejected, no matter how great an artistic value it may possess, if it does not approach ... perfection in technique.[74]

But it was more than style and subject matter that provoked the negative reviews of the Philadelphia Salons; it was also the fact that only one kind of photography—artistic photography—was exhibited. "There should be more variety in photographic exhibitions," a critic insisted in 1900.[75] Although the camera clubs had spawned these exhibitions, many members felt that they were now being shut out, not just from the Philadelphia Photographic Salons but also from their own clubs. Daniel K. Young warned his fellow members of the Camera Club of New York that "a growing and very dangerous Tarantism has inoculated the club, and it appears that nothing is artistic which is not *outré*, nothing beautiful which is not *bizarre*, nothing worthy of attention which is not preposterous, nothing serious unless untranslatable."[76] Camera clubs had been founded with the explicit purpose of advancing both the art and science of photography, but by the turn of the century many members across the country felt that the emphasis on pictorial photography had unjustly overshadowed

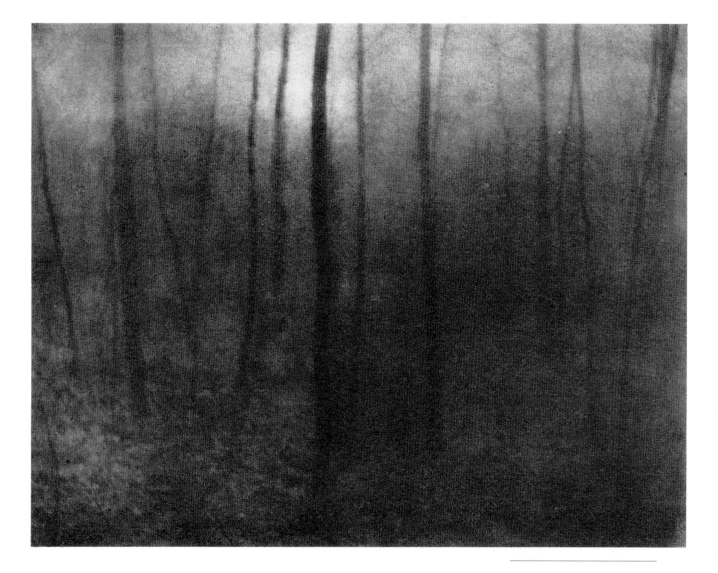

Figure VI-11

Eduard Steichen.
Woods—Twilight. Platinum print,
1898. Metropolitan Museum of
Art; Alfred Stieglitz Collection,
1933 (33.43.14).

other valid approaches. Particular criticism focused on the Camera Club of New York's publication, *Camera Notes*. Described as "limited in scope and too much devoted to a prolonged polemic, which to most of its readers was simply tiresome," *Camera Notes* was berated for not addressing the issues of concern, both "technical as well as pictorial," to photographers at large."[77]

By 1901 these opposition forces gained control of both the Photographic Society of Philadelphia and the Camera Club of New York. Newly elected officers who took a more pluralistic approach changed the direction of both the Philadelphia Photographic Salons and *Camera Notes*. As a consequence, Stieglitz resigned as editor of *Camera Notes* in the summer of 1902, while a new president of the Photographic Society of Philadelphia ensured that the 1902 Photographic Salon included a much wider representation of photographic styles and applications. It was, however, a hollow victory: the last Philadelphia Photographic Salon was held in 1902 and *Camera Notes* ceased publication in 1903. In reaction Stieglitz became even more exclusive, separating himself more emphatically from the concerns and needs of the average amateur. In 1902 he formed the Photo-Secession, a group he carefully selected to demonstrate the artistic merit of the medium, and he began to publish *Camera Work* to expound his cause.

The desire to prove that photography was capable of expressing more than superficial appearances, that it could be an embodiment of the photographer's thoughts and emotions, and could reveal his individuality, had given a creative edge to the camera club movement. It had drawn many interested people into its domain, photographers and critics alike, and had stimulated them to formulate a viable aesthetic for photography. But the events of 1901 and the extreme rancor that preceded them created the perception that camera clubs did not

want to be challenged in their understandings about the nature and function of photography, that they were essentially conservative—albeit democratic—structures, unreceptive to new ideas, unwilling to take risks. American camera clubs continued to function, and some to thrive, after the turn of the century, providing invaluable facilities to their members, but never again would they be so influential over the course of American photography. Because they continued to be perceived as unimportant, conservative organizations, historians have, until only recently, neglected to study their history and instead have discussed the development of pictorial photography through the actions and work of only one group of individuals—specifically Stieglitz and the Photo-Secession. Thus the complex economic, social, and aesthetic issues that gave birth to the movement in the first place have not been properly assessed.[78]

Finally, it should be pointed out that the social and economic incentives which encouraged photographers to promote the artistic value of their medium had been present ever since 1839. Yet they gained added urgency in the 1880s and 1890s. The pitch was raised in part by the jubilee anniversary, which brought with it a re-evaluation of past practices and future directions; in part by the phenomenal growth in the number of amateurs who sought to justify and legitimize their pursuits; in part by the severe economic problems of professional photographers; and in part too because the basis of the argument—the elevation of the craft of photography to an art form—perfectly suited the tenor of the times. All of these forces, which had their roots not in Europe or European aesthetics, but deep within the American economic, social, and cultural milieu, combined to make the last two decades one of the strongest periods of aestheticizing ever seen in the history of photography.

NOTES

[1] The monument to Daguerre was designed by Scott Hartley, paid for by contributions from the Photographers Association of America, and installed in 1890 at the National Museum in Washington. It was reinstalled in 1989 at the National Portrait Gallery to commemorate the 150th anniversary of the announcement of the process of photography. It is a curious coincidence that this monument was resurrected in the 1980s, a decade that, like 1880s, was fraught with radical changes in the technology of the medium as it evolved from a chemically based process to one increasingly dependent on electronic and computer-generated imagery.

I would like to thank Diane Dillon for the diligent and creative research she contributed to this essay; Tony Troncale, archivist of the Camera Club of New York for granting me access to the club's papers; and Marni Sandweiss for her patience and guidance throughout this project and for her constructive comments on earlier drafts of this manuscript.

[2] Most accounts of the period discuss pictorial photography as a movement that began in Europe in the 1880s, fostered by Peter Henry Emerson's publication *Naturalistic Photography for Students of the Art* and spread to the United States under the guidance of Alfred Stieglitz. See, for example, such standard histories as Beaumont Newhall, *The History of Photography* (New York: Museum of Modern Art, 1982): 141-160, or Robert Doty's *Photography as a Fine Art* (Rochester, N.Y.: George Eastman House, 1960).

[3] "Mr. Bogardus on the Mutual Benefit Association," *Anthony's Photographic Bulletin* 20 (August 24, 1889): 499.

[4] Ibid., pp. 498-502. During the 1880s many studios offered time payment plans and raffles to induce reluctant customers, as well as instituting drastic price reductions: for example, in 1889 a studio offered to sell cabinet cards that usually cost five dollars per dozen for only ninety-nine cents. Ibid., p. 503.

5 Ibid., p. 500.

6 "The Photographers and Artists Mutual Benefit Association," *Wilson's Photographic Magazine* 26 (June 1, 1889): 346.

7 "Society Gossip," *Philadelphia Photographer* 17 (March 1880): 98. The PAA was open to professional photographers: employers paid dues of two dollars, employees one dollar.

8 "Untitled," *Photographic Times and American Photographer* 12 (August 1882): 327.

9 "Photographers' Association of America," *Philadelphia Photographer* 17 (September 1880): 275.

10 J. Fortune Nott, "Photography as a Practical Art," *Wilson's Photographic Magazine* 26 (June 15, 1889): 376.

11 See Richard Hofstadter, William Miller, and Daniel Aaron, *The United States: The History of a Republic* (Englewood, N.J.: Prentice Hall, 1957), pp. 534-539.

12 *Philadelphia Photographer* 18 (January 1881): 27.

13 "A Happy New Year," *Practical Photographer* 5 (January 1881): 3. In 1881 the Iowa State Society adopted a uniform price list for the entire state; however, there are no published accounts that indicate whether the prices were honored by PAA members or if they were successful in thwarting cheap johns.

14 *Photographic Times and American Photographers* 16 (February 12, 1886): 103. Like other fraternal societies, the Secret Order of Scientific Photographers had signs, grips, passwords, and an initiation ceremony.

15 "The General Council of the Photographers' and Artists' Mutual Benefit Association," *Wilson's Photographic Magazine* 26 (July 20, 1889): 440-444. The "Artists" noted in the title of this organization probably were the people in photographic studios who retouched photographs. Membership in the Photographers' and Artists' Mutual Benefit Association cost two dollars to join and fifty cents a month.

16 Ibid. See also *Wilson's Photographic Magazine* 26 (June 1, 1889): 345-346, and (August 17, 1889): 502-503.

17 "A Photographic Trust," *Anthony's Photographic Bulletin* 20 (July 27, 1889): 441.

18 "Cincinnati Convention," *Philadelphia Photographer* 21 (September 1884): 270.

19 *Practical Photographer* 5 (February 1881): 38.

20 Isaac Edwards Clarke, *The Democracy of Art*, quoted in *In Pursuit of Beauty: Americans and the Aesthetic Movement* (New York: Metropolitan Museum of Art and Rizzoli, 1986), p. 30.

21 John Nicol's Address to the PAA convention in Chicago, 1887, as reported in the *Philadelphia Photographer* 24 (September 17, 1887): 573.

22 E. K. Hough, "The Ideal in Art and Its Relation to Photography," *Philadelphia Photographer* 24 (April 16, 1887): 229-230.

23 "Art Censorship," *Photographic Times and American Photographer* 16 (August 13, 1886): 426.

24 "A Happy New Year" and "A Suggestion for More Art and Better Prices," *Philadelphia Photographer* 24 (January 1, 1887): 3 and (December 17, 1887): 752.

25 "Photo-Art Among the Studios," *Philadelphia Photographer* 20 (June 1883): 179.

26 Charlotte Adams, "Review of Photographs in *The Philadelphia Photographer* for 1884," *Philadelphia Photographer* 22 (February 1885): 55.

27 Elbridge Kingsley, "Art in Photography," *Anthony's Photographic Bulletin* 18 (March 12, 1887): 146-148; and John Bartlett, "The Shortcomings of Photography in Relation to Art," *Anthony's Photographic Bulletin* 19 (January 14, 1888): 21.

28 Elbridge Kingsley, "Art in Photography," *Anthony's Photographic Bulletin* 18 (February 26, 1887): 113-114. Kingsley's paper, the first section of which was printed in the February 12, 1887, issue of *Anthony's*, pp. 86-88, was read before the Photographic Section of the American Institute in New York. Although Emerson exhibited in the First Annual Joint Exhibition in 1887, significant discussion of his work and ideas did not appear in the American press until he published his book *Naturalistic Photography for Students of the Art* in 1889.

29 A. J. Treat, "Fine Art and Photography," *Philadelphia Photographer* 24 (December 17, 1887): 743, and Charlotte Adams, "Review of Photographs," p. 60.

30 "President Walker's Address to the Society of Amateur Photographers," *Anthony's Photographic Bulletin* 19 (May 12, 1888): 265-268.

[31] J. F. Mostyn Clarke, "The Present Value of Art in Photography," *Philadelphia Photographer* 25 (April 21, 1888): 248, and "Prepare for Art," *Philadelphia Photographer* 25 (February 4, 1888): 66.

[32] Enoch Root, "The Artistic Spirit in Photography," *Philadelphia Photographer* 24 (January 15, 1887): 35.

[33] "Art at the Exhibition in Boston," *Wilson's Photographic Magazine* 26 (December 7, 1889): 45.

[34] Alfred Stieglitz, "The Hand Camera—Its Present Importance," *American Annual of Photography and Photographic Times Almanac for 1897*, as quoted in *Alfred Stieglitz: Photographs and Writings*, ed. by Sarah Greenough and Juan Hamilton (Washington, D.C.: National Gallery of Art and Callaway Editions, 1982), p. 182, and a report of a lecture given by F. Holland Day in "Pictorial Photography from America," *Amateur Photographer* 32 (October 12, 1890): 283.

[35] F. C. Beach and W. H. Burbank, "The Present Aspect of Amateur Photography," *American Amateur Photographer* 1 (July 1889): 5.

[36] "Photography as a Recreation," *Photographic Times and American Photographer* 13 (May 1883): 207.

[37] "Organization of the Amateur Photographers," *Anthony's Photographic Bulletin* 15 (April 1884): 164, and "Amateur Photography," *Photographic Times and American Photographer* 15 (October 23, 1885): 602.

[38] "The Drift of Amateur Photography," *Anthony's Photographic Bulletin* 20 (May 25, 1889): 289.

[39] Beach and Burbank, "The Present Aspect of Amateur Photography," p. 5.

[40] *The Boston Club Book for 1888* (Boston: E. E. Clark, 1888), noted that there were seventy-seven social, athletic, political, and art clubs in existence in the city in 1888. Art clubs were described as a particular "craze" of the time; see *Anthony's Photographic Bulletin* 17 (October 9, 1886): 590.

[41] Walter Sprange, *The Blue Book of Amateur Photographers* (Boston: Collins, 1894); see also "Amateur Photography of To-Day," *Cosmopolitan Magazine* 20 (January 1896): 253-254. The total number of photographic clubs founded before 1895 was significantly higher than 150. However, because of financial problems many clubs during the late 1880s and early 1890s either dissolved entirely or merged with other societies in order to provide their members with the best possible facilities.

[42] In 1889 the New York Camera Club had an entrance fee of twenty-five dollars and annual dues of forty dollars. Consisting only of amateurs, it was founded in December 1888 and by April 1889 had between sixty and seventy members who were able and willing to pay such high fees—a rapid growth that many of these camera clubs experienced. See *Anthony's Photographic Bulletin* 20 (April 6, 1889): 197, for further discussion.

[43] For a discussion of the practice of photography by women in the 1880s and 1890s and their participation in camera clubs, see W. S. Harwood, "Amateur Photography of To-Day," *Cosmopolitan* 20 (January 1896): 253-255.

[44] "The Drift of Amateur Photography," p. 289.

[45] *Anthony's Photographic Bulletin* 19 (June 9, 1888): 323. For an interesting summary of the meetings and outings of a camera club, see "Annual Report of the President of the Society of Amateur Photographers of New York," *Anthony's Photographic Bulletin* 18 (April 23, 1887): 237-240.

[46] See *Photographic Times and American Photographer* 16 (August 1886): 444.

[47] "The Summer School of Photography," *Philadelphia Photographer* 21 (November 1884): 349, and *Anthony's Photographic Bulletin* 19 (June 23, 1888): 375.

[48] For example, at the regular meeting of the Philadelphia Amateur Photographic Club on April 18, 1887, Xanthus Smith presented a paper on "Hints on Composition and Selection of Subjects" and included slides of work by Turner, Sir David Wilkie, and Dore. Following the lecture, Smith critiqued work by club members. See "Philadelphia Amateur Photographic Club," *Anthony's Photographic Bulletin* 18 (May 14, 1887): 282.

[49] The founding date for the American Lantern Slide Interchange has incorrectly been noted as 1881 (Mary Panzer, *Philadelphia Naturalistic Photography* [New Haven: Yale University Art Gallery, 1982], p. 7). However, although the name was not officially adopted until 1885, as F. C. Beach noted in "The International Club Lantern Slide Exchange," *Photographic Times and American Photographer* 16 (September 3, 1886): 459, the exchange began to take shape in late 1884 as a result of his work and that of George Bullock of the Photographic Section of the Cincinnati Society of Natural History.

[50] Charlotte Adams, "Exhibition of the Society of Amateur Photographers," *Philadelphia Photographer* 22 (December 1885): 397.

51 "The Fifth Annual Joint Exhibition at Boston," *Photographic Times* 22 (May 18, 1892): 250. The Fifth Annual Joint Exhibition showed 1300 prints in 660 frames by 115 exhibitors. The exhibition, which was shown in the Art Club of Boston, included the society portrait painter I. M. Gaugengigl as one of its judges.

52 F. C. Beach, "Inaugural Address," *Anthony's Photographic Bulletin* 16 (May 9, 1885): 279.

53 Alfred Stieglitz, "A Plea for a Photographic Art Exhibition," *American Annual of Photography and Photographic Times Almanac for 1895*, p. 28.

54 "The Joint Exhibition at New York," *American Amateur Photographer* 6 (April 1894): 153-156.

55 *The Blue Book of Amateur Photographers*, 1894, n.p.

56 Xanthus Smith, "Photography and Art," *Photographic Times and American Photographer* 15 (April 10, 1885): 184, and Reverend George M. Searle, "Every Man His Own Photographer," *Anthony's Photographic Bulletin* 13 (April 1882): 113-121.

57 "The Present Aspect of Amateur Photography," *American Amateur Photographer* 1 (July 1889): 5.

58 Richard Hines, "Artistic Photography: Paper Read Before the Art League of Mobile," *American Amateur Photographer* 10 (July 1898): 302, and John Burnet, "Practical Essays on Art," *Philadelphia Photographer* 25 (June 2, 1888): 333.

59 J. F. Mostyn Clarke, "The Present Value of Art in Photography," *Philadelphia Photographer* 25 (April 21, 1888): 248.

60 "Prepare for Art," *Philadelphia Photographer* 25 (February 4, 1888): 66.

61 Stieglitz quoted in "The 'Photo-Secession' at the Arts Club," *Camera Notes* 6 (July 1902): 33.

62 "The Relations of Photography to Art," *Cosmopolitan Magazine* 28 (December 1894): 140.

63 Publication Committee, untitled article, *Camera Notes* 1 (July 1897): 3.

64 William Murray, "Picturesque Tonality in Photographic Work," *Camera Notes* 2 (October 1898): 6.

65 Dallet Fuguet, "Truth in Art," *Camera Notes* 3 (April 1900): 190.

66 A. Horsley Hinton, "Both Sides," *Camera Notes* 2 (January 1899): 79.

67 Exhibition catalogue quoted in *American Amateur Photographer* 10 (December 1898): 549.

68 Panzer in *Philadelphia Naturalistic Photography*, p. 14, notes that 16,000 people visited the salon.

69 "The Philadelphia Salon," *Photographic Times* 31 (January 1899): 9.

70 Charles Caffin, "Philadelphia Photographic Salon," *Harper's Weekly* 42 (November 5, 1898): 1037.

71 "The Second Photographic Salon," *American Amateur Photographer* 11 (December 1899): 519-520.

72 See "The Work of the Year," *Photograms of the Year 1900* (London: 1900), pp. 65-72, for a stylistic criticism.

73 "Lessons of the Salon," *Photo-Era* 5 (December 1900): 165.

74 "American Lantern Slide Interchange," *American Amateur Photographer* 10 (1898): 473-474.

75 Charles Mitchell, "The Third Philadelphia Photographic Salon," *American Amateur Photographer* 12 (December 1900): 567.

76 "The Other Side—A Communication," *Camera Notes* 2 (October 1898): 46.

77 *Camera Craft* 6 (November 1902): 34.

78 See Doty, *Photography as a Fine Art*, and Weston J. Naef, *The Collection of Alfred Stieglitz* (New York: Metropolitan Museum of Art, 1978). One of the few exceptions is Mary Panzer, who in *Philadelphia Naturalistic Photography* examines the development and activities of the Philadelphia Photographic Society in the 1880s and 1890s.

THREE

The last decades of the nineteenth century witnessed radical changes in photographic technology and vastly greater appreciation of photography as an independent art. The introduction of the gelatin dry plate and of the hand camera and roll film in the late 1880s and 1890s made it possible for even amateurs to produce photographs with a spontaneity and informality that was previously impossible. Ellen Andrus was perhaps more free to play and experiment than the average amateur—her uncle, George Eastman, gave her a sample of each of the new Kodak cameras his company produced—but her snapshots (PLATE 81) are a good representation of the new hand camera's ability to capture the hitherto unrecorded moments of daily life. The simplicity of the new processes and equipment led to a proliferation of images as photography became available to a whole new class of amateurs who did not need the skills or perseverance of their earlier wet-plate predecessors.

Many professional photographers, in turn, began to reexamine and redefine their purposes and their markets—a process Peter Hales thoroughly analyzes in his essay. As the tourist audience and market grew, recreational activity became more evident in photographers' work. F. Jay Haynes' view of the Columbia River (PLATE 11), which emphasizes the bountiful harvest of the salmon fishermen, is a marked contrast to the wilder appearance of the same scene photographed decades earlier by Watkins (PLATE 6). In Isaiah West Taber's and George Barker's photographs from the 1880s, tourists posing on the overhanging rock at Glacier Point in Yosemite (PLATE 73) and playing on the frozen ice bridge at Niagara Falls (PLATE 69) appear oblivious to, or even defiant of, the power of nature.

The railroads continued to be an important sponsor of fine photography, but rather than the construction and expansion images that dominated railroad photography in the 1860s and 1870s, the focus of later views by William Henry Jackson, William Rau, and others was directed instead toward depicting the landscape through which the trains and tourists would be passing. Scenes like Jackson's *On the Valley Division, New Market, On the Picturesque B&O* (PLATE 75) and his panoramic *Excursion Train and Niagara Rapids, Lewiston Branch, N.Y.* (PLATE 12) were bucolic and promotional, while Rau's views of communities and mining activities (PLATE 79) showed a developed and highly industrialized landscape, one that differed markedly from earlier idyllic images of the natural wilderness. Many of these later views pushed photographic technique to its limits—perhaps as a way for professional photographers to distinguish their work from the less ambitious images that amateurs had become able to make for themselves. Photographers had long been attracted to the potential of panoramas, but late in the century they produced such impressive views as Henry Hamilton Bennett's huge 17-by-58-1/2 inch photograph of the Wisconsin Dells (PLATE 78).

Photography was not just focused on natural wonders and tourist scenes. Countless photographers created unidealized records of the way people really lived. Solomon Butcher's documents of Nebraska pioneering families and their crude sod houses (PLATE 90) reflect his perceptive understanding of the unique situation of his time and the historical value his images would have for later generations. The documentation of native American cultures by photographers Adam Clark Vroman, Ben Wittick, and Frank Rinehart (PLATES 76, 77, AND 94) reflected contemporary popular interest as well as the need to create a lasting historical record of cultures they understood to be threatened. When Arnold Genthe used a hidden camera to document the old customs and sights of San Francisco's Chinatown (PLATE 95), he knew he was recording a way of life that even then seemed exotic and was destined to change rapidly. Many of the most evocative images of the period, however, were created less self-consciously, out of the routine of everyday activities—including Alice Austen's personal records of family and friends in Staten Island (PLATE 84) and Joseph Byron's remarkable records of upper-class

urban life, which were created as a part of the routine commercial business of the Byron Studio in New York (PLATE 83).

Jacob Riis pioneered a more active approach to photographs as documents when he and his assistants, using new, more mobile cameras and flash powder that allowed photography in lower light and less desirable conditions, recorded the disgraceful living conditions of New York's booming immigrant population (PLATE 91). His direct, unsentimental photographs gave persuasive authority to his seminal book, *How the Other Half Lives*, which provided the foundation for socially concerned photography in America. Riis' images derive much of their power from their crude immediacy, but mastery of craft and composition gives a similar passion and social concern to Frances Benjamin Johnston's photographs of children working in a Pennsylvania mine and of students at the Hampton Institute (PLATES 92 AND 93).

As photographic technologies became simpler and more accessible to an untrained audience, applications of the medium became more diverse than ever. Thomas Eakins used photographs as an important source of information for his paintings and as an analytical tool that helped him be true to nature. Inspired by the motion studies of Muybridge (PLATE 86) and the French photographer Etienne Marey, Eakins began to pursue such concerns in his own photography (PLATE 85). Although he valued the realism and accuracy of his photographic sources, which he used for paintings such as *The Swimming Hole* (PLATE 71), he always transformed his sources rather than slavishly copying them. It is a testimony to Eakins' careful observation of nature that his 1883 painting, which shows a diver caught in midair, is more spontaneous in its representation of the instantaneous moment than any of his source photographs.

As Sarah Greenough's essay describes, the last decades of the century saw a flurry of activity among photographers committed to promoting photography's acceptance as an art. Art photography of the period had diverse concerns, but much of it was closely allied with the strong American tradition of genre painting and with photographic precedents and aesthetic theories from Europe. Sarah Eddy's *A Welcome Interruption* (PLATE 98) is representative of the period's pictorial narratives, which can be traced back to the influence of the English photographer H. P. Robinson. The impact of P. H. Emerson's naturalistic style is evident in Rudolf Eickemeyer's 1892 *The Lily Gatherer* (PLATE 100), which looks almost like a quotation of Emerson's similar *Norfolk Broads* image of the previous decade. Literary and historical narratives, such as Frank Eugene's *Arthur and Guinevere* (PLATE 102), were especially popular and gave photographers freedom to experiment with studio settings and unusual processes at the same time that they were allying themselves to established fine art subject matter.

The styles of the leading turn-of-the-century art photographers were highly diverse; often the photographers were united only by personal friendships and a generally shared commitment to elevating the medium's status as art. Many prided themselves on experimental techniques that made their work look like an impressionist painting or drawing, and most were concerned with symbolic meaning rather than literal reportage. Dramatic differences in style and concerns can even be seen in images by a single photographer: Clarence White's *Telegraph Poles* (PLATE 96), with its evidence of the modern urban landscape, is quite different from the seemingly timeless narrative of *The Hillside* (PLATE 101), but both works reflect his strong sense of composition and his communication of emotions through the expressive values of light and form. While the categories between amateur and professional photographers were often firmly drawn, there are numerous interesting ways in which art and documentary photography of the period overlapped, as in Genthe's pictorial photograph of Chinatown (PLATE 95) and Joseph Keiley's highly expressive and reworked Indian portrait (PLATE 14).

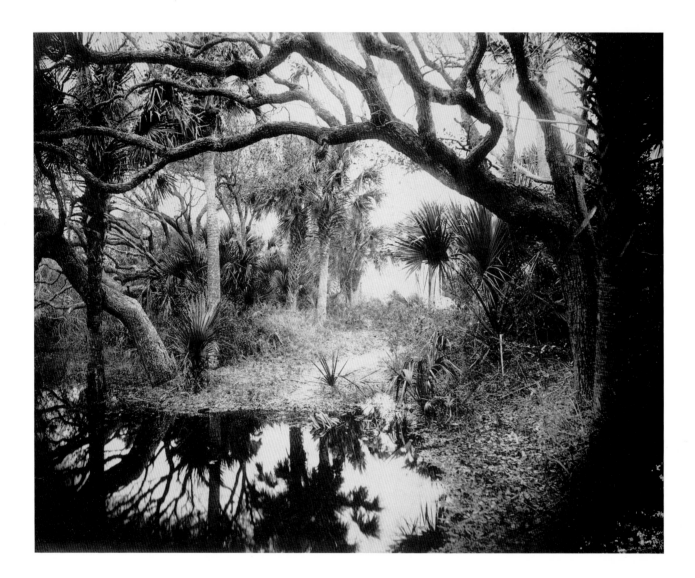

Plate 68
GEORGE BARKER. *Untitled Landscape, Florida.* Albumen silver print, 1886. J. Paul Getty Museum.

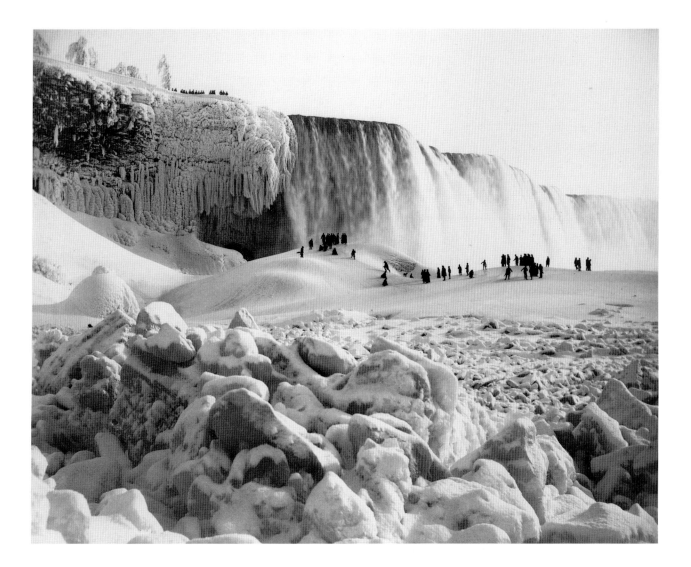

Plate 69
GEORGE BARKER. *Ice Bridge, Ice Mound and American Fall, Niagara, Instantaneous.* Albumen silver print, 1883. Library of Congress.

Plate 70
George Cox. *Walt Whitman.* Platinum print, 1887. Amon Carter Museum.

Plate 71
CIRCLE OF EAKINS. *Eakins' Students at the Site of "The Swimming Hole."* Albumen silver print, 1883.
Hirschhorn Museum and Sculpture Garden, Smithsonian Institution.

Plate 72
F. Jay Haynes. *Gibbon Falls, 84 Feet.* Albumen silver print, 1884-88. Amon Carter Museum.

Plate 73
ISAIAH WEST TABER. *Glacier Point Rock, 3201 Ft. Yosemite Valley, Ca.* Albumen silver print, c. 1885.
International Museum of Photography, George Eastman House.

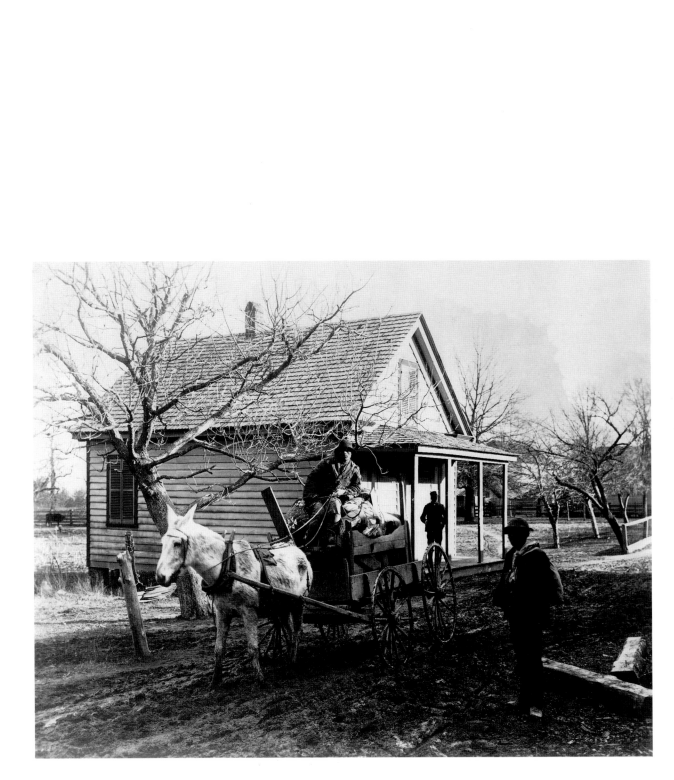

Plate 74
GEORGE BARKER. *Wayside Scene, Stoney Creek, Va.* Albumen silver print, 1887. Library of Congress.

Plate 75
William Henry Jackson. *On the Valley Division near New Market, On the Picturesque B&O.* Albumen silver print, c. 1886.
International Museum of Photography, George Eastman House.

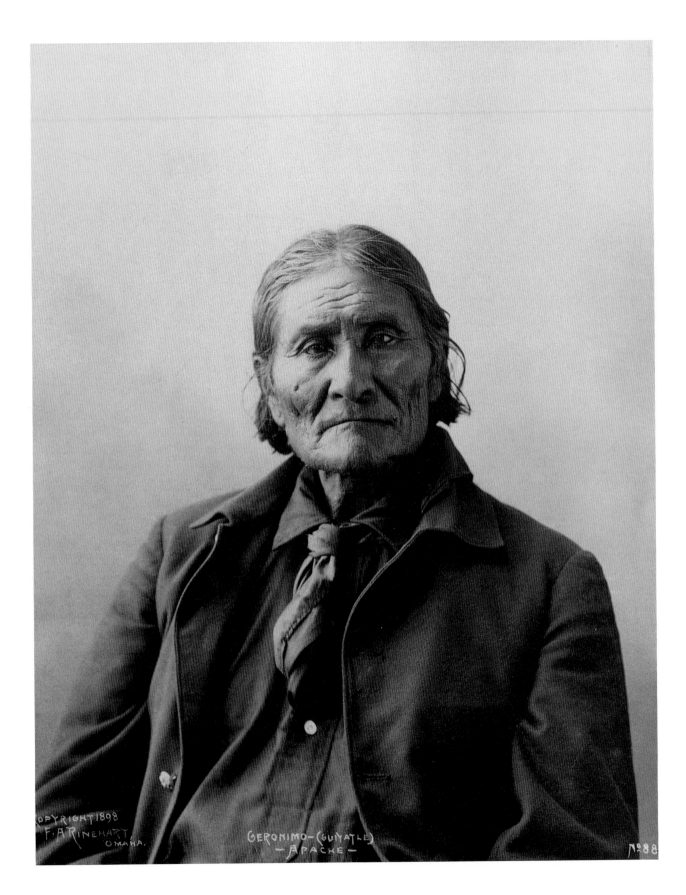

Plate 76
FRANK A. RINEHART AND/OR ADOLPH MUHR. *Geronimo (Guyatle), Apache.* Platinum print, c. 1898. Amon Carter Museum.

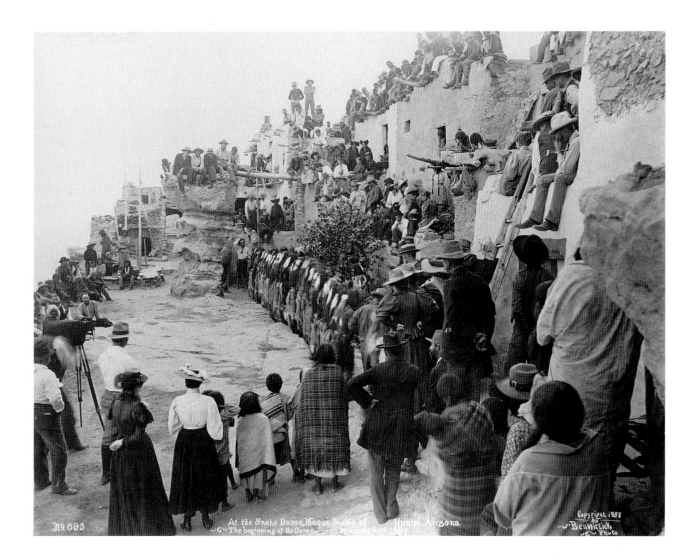

Plate 77
BEN WITTICK. *At the Snake Dance, Moqui Pueblo of Hualpi, Arizona.* Gelatin silver print, 1897. Amon Carter Museum.

Plate 78
HENRY HAMILTON BENNETT. *Panorama From the Overhanging Cliff, Wisconsin Dells.* Albumen silver print, c. 1891 (printed before 1907).
Museum of Modern Art, New York; gift of the H. H. Bennett Studio.

Plate 79
WILLIAM RAU. *Maunch Chunk, From the Mountain Line, L.V.R.R.* Albumen silver print, 1891-93.
International Museum of Photography, George Eastman House.

Plate 80
WILLIAM RAU. *Lattimer Strippings and Coal Breaker*. Albumen silver print, after 1895. Canadian Centre for Architecture.

298

Plate 81
ATTRIBUTED TO ELLEN ANDRUS. *Man Jumping Fence* and *Pier Ditto*.
Gelatin silver prints, 1889. International Museum of Photography,
George Eastman House.

Mill Creek

1878

Plate 82
JOHN C. BROWNE. *Mill Creek, 1878.* In album of albumen silver prints, 1878-79. Library Company of Philadelphia.

Plate 83
JOSEPH BYRON. *Sitting Room Interior (Relaxing in the Parlor)*. Gelatin silver print, 1897. Museum of the City of New York.

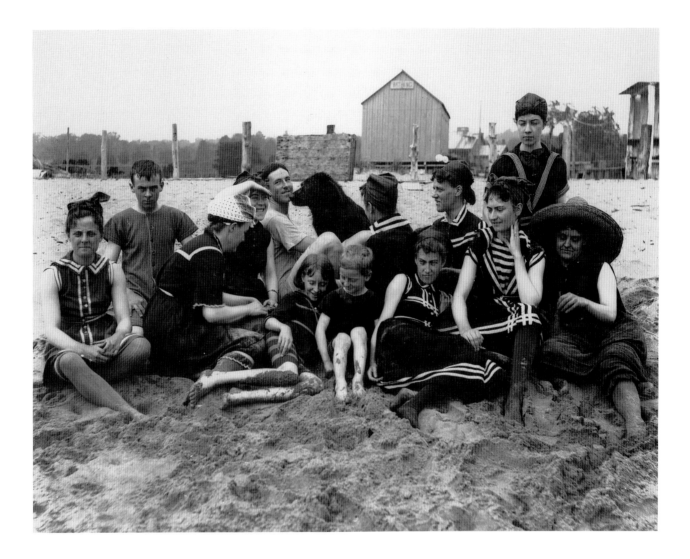

Plate 84
ALICE AUSTEN. *South Beach.* Gelatin silver print, 1886. Staten Island Historical Society.

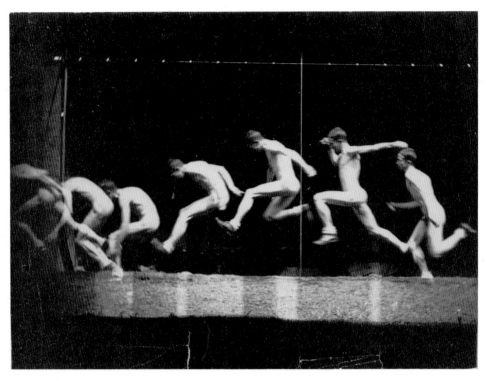

Plate 85
Thomas Eakins. *Marey Wheel Photographs of Unidentified Model.* Albumen silver print, 1884.
Hirschhorn Museum and Sculpture Garden, Smithsonian Institution.

Plate 86
Eadweard Muybridge. *Woman Pirouetting (.277 second).* Collotype, 1887. Amon Carter Museum.

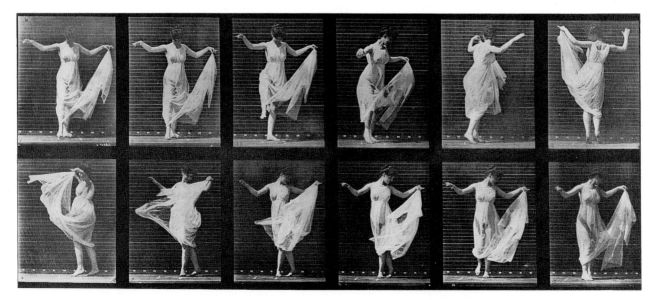

Plate 87
FREDERICK A. WENDEROTH, WILLIAM TAYLOR, AND J. HENRY BROWN. *E. Clinton & Co. Manufacturers and Importers of Brushes, No. 908 Chestnut St., Philadelphia.* In *Gallery of Arts and Manufacturers of Philadelphia* album. Albumen silver print, 1871. Library Company of Philadelphia.

Plate 88
SENECA RAY STODDARD.
Big Game in the Adirondacks.
Albumen silver print, 1889.
International Museum of
Photography, George
Eastman House.

Plate 89
SOLOMON BUTCHER. *Canyon on Peter Forney Land Near Merna, Nebraska.* Albumen silver print (altered), c. 1890.
Custer County Historical Society, Nebraska.

Plate 90
SOLOMON BUTCHER. *John Curry House Near West Union, Custer County, Nebraska.* Albumen silver print (altered), 1886.
Custer County Historical Society, Nebraska.

Plate 91
JACOB RIIS. *A Cave Dweller—Slept in This Cellar Four Years.* Gelatin silver print, c. 1890. Museum of the City of New York.

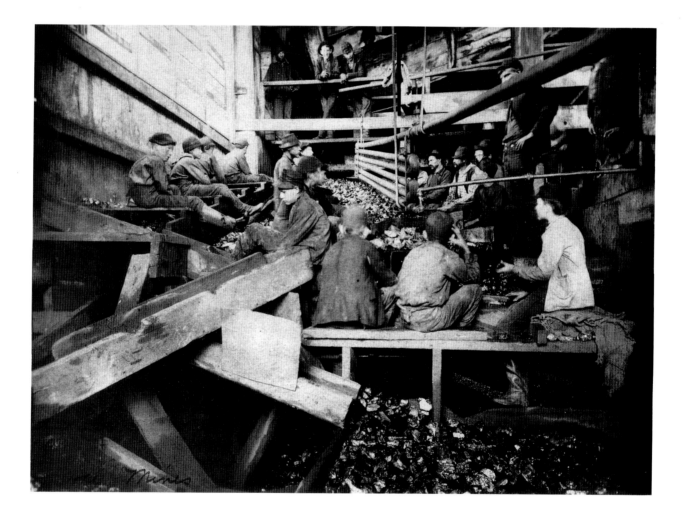

Plate 92
FRANCES BENJAMIN JOHNSTON. *Kohinore Mine, Shenandoah City, Pa.* Gelatin silver print, 1891. Library of Congress.

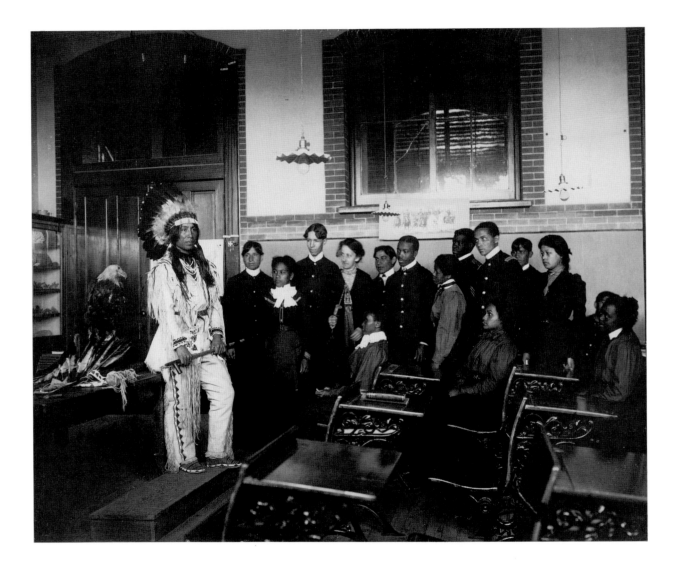

Plate 93
FRANCES BENJAMIN JOHNSTON. *Class in American History.* Platinum print, 1899-1900. Museum of Modern Art, New York.

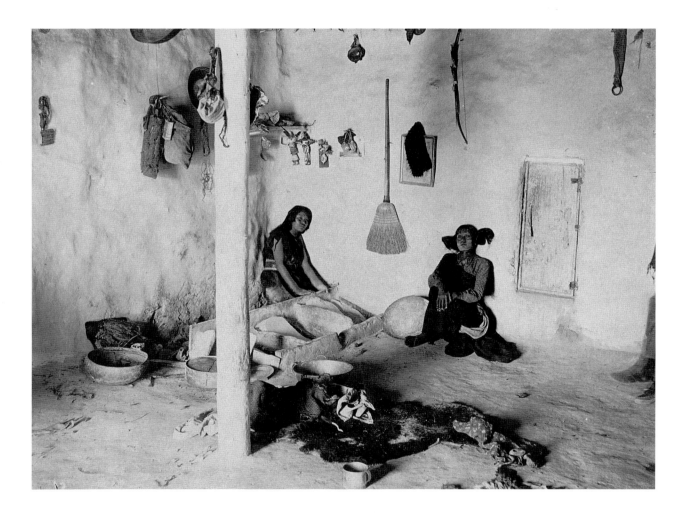

Plate 94
ADAM CLARK VROMAN. *Indian Girls Grinding Corn, Moqui Town.* Albumen silver print, 1895. Amon Carter Museum.

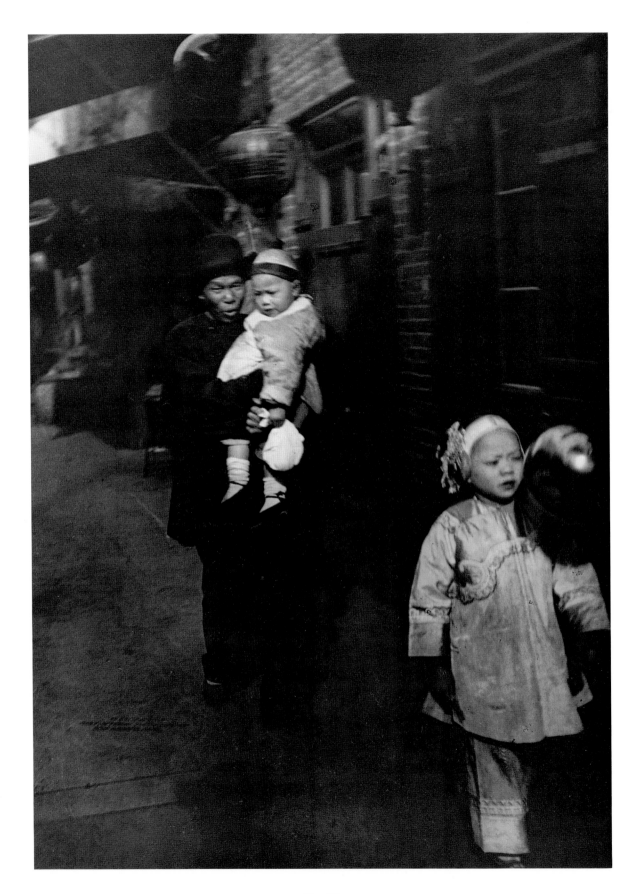

Plate 95
ARNOLD GENTHE. *Holiday Visit, Chinatown, San Francisco.* Platinum print, c. 1897. Museum of Modern Art, New York.

Plate 96
CLARENCE WHITE. *Telegraph Poles, Newark, Ohio.* Platinum print, 1898. Museum of Modern Art, New York.

Plate 97
GEORGE BACON WOOD. *Aren't They Beauties?* Platinum print, c. 1885.
Library Company of Philadelphia.

Plate 98
SARAH J. EDDY. *A Welcome Interruption.* Platinum print, c. 1899.
Division of Photographic History, National Museum of American
History, Smithsonian Institution.

313

Plate 99
JOHN BULLOCK. *Young Anglers.* Platinum print, 1896. Museum of Modern Art, New York; gift of the John Emlen Bullock estate.

Plate 100
RUDOLF EICKEMEYER. *The Lily Gatherer*. Carbon print, 1892.
Division of Photographic History, National Museum of American History, Smithsonian Institution.

Plate 101
CLARENCE WHITE. *The Hillside*. Platinum print, c. 1898. Museum of Modern Art, New York; gift of Mr. and Mrs. Clarence H. White, Jr.

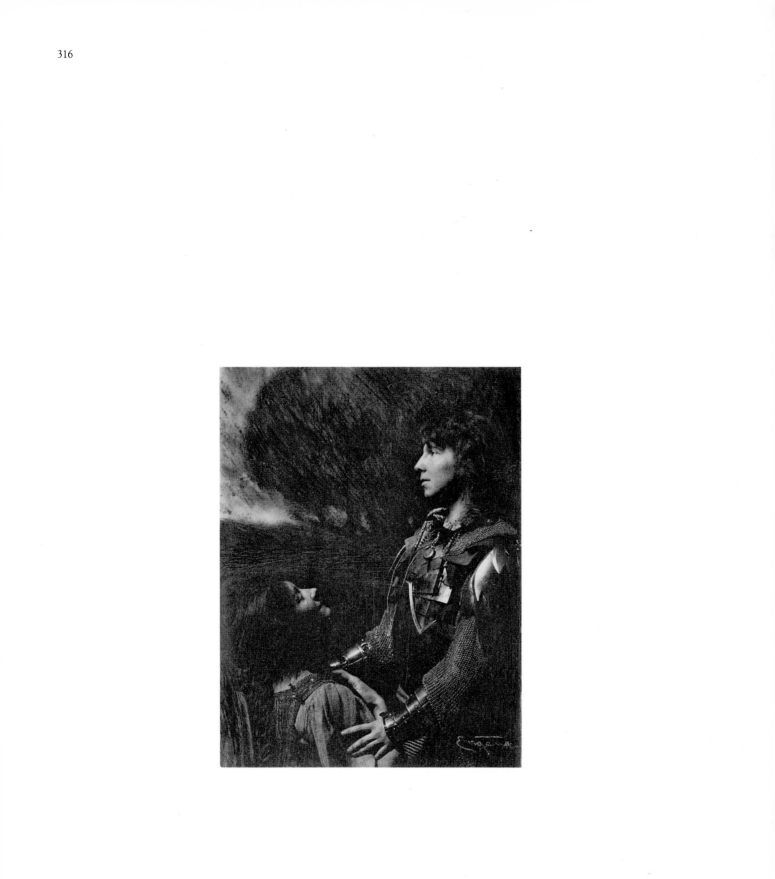

Plate 102
FRANK EUGENE. *Arthur und Guinevere.* Platinum print, 1899. Metropolitan Museum of Art.

Plate 103
Gertrude Käsebier. *Silhouette of a Woman*. Platinum print, c. 1899. J. Paul Getty Museum.

APPENDIX

The works listed below have been selected for the exhibition *Photography in Nineteenth-Century America*, at the Amon Carter Museum, Fort Worth, Texas (October 26, 1991 - January 5, 1992) and the Mead Art Museum, Amherst College, Amherst, Massachusetts (February 1 - March 29, 1992).

Many of the following artists are discussed at length in the essays, and the information that follows is intended merely to complement such discussions. Please consult the index for additional references to these artists and other examples of their work.

ELLEN AMANDA ANDRUS (1871-1950)

Ellen Andrus Dryden was the daughter of George Andrus and Ellen Eastman Andrus and the niece of George Eastman. The latter gave her ample opportunity to experiment with photography; she received samples of each new camera produced by the Eastman company and used them to record the events of daily life.

> PLATE 81. *Man Jumping Fence* and *Pier Ditto*. Gelatin silver prints, 1889. International Museum of Photography, George Eastman House.

CHARLES DUDLEY ARNOLD (1844-19?)

C. D. Arnold, a Buffalo photographer, is best known for his photographs made at the World's Columbian Exposition in Chicago (1893). An architectural photographer who operated a studio in New York, Arnold was first hired as the official photographer of the exposition's Construction Bureau. As such, he documented the process of building the "White City," not for publicity but to record the realization of a concept. He printed large platinum prints to give to the architects, designers, and directors and in 1892 organized the images into a two-volume album tracing the Exposition's development. Impressed by Arnold's work, officials gave him the photographic concession for the Exposition. In return Arnold produced photographs that embodied the values and ideas of the planners and directors. He carefully framed each view to highlight the grandeur of the modern urban architecture of this model city. In addition, outside photographers had to seek his permission and pay a steep fee for each image made; newspapers and journals could only use images made or approved by Arnold. However, public outrage at this autocratic control eventually forced fair officials to revoke his concession, and William Henry Jackson was hired to make a set of views for the final report. After the Columbian Exhibition, Arnold continued his career as an architectural photographer and was appointed official photographer of Buffalo's Pan-American Exposition in 1901.

> PLATE 13. *World's Columbian Exposition, Chicago.* Platinotype, 1893. Gernsheim Collection, Harry Ransom Humanities Research Center, University of Texas at Austin.

ALICE AUSTEN (1866-1952)

Alice Austen was introduced to photography at the age of ten when a relative, Oswald Muller, brought home a camera and allowed her to use it. Austen exhibited a natural ability with the camera, and her uncle, Peter Austen, taught her how to use chemicals to develop the glass-plate negatives she exposed. Austen never practiced photography as a career but rather as a serious hobby. She carried her camera with her, taking photographs wherever she went. Her meticulously composed images record her family, visits with friends, and vignettes of daily life around her Staten Island home. Although not a professional photographer, Austen copyrighted about 150 images with the Library of Congress, printed postcards, published a small portfolio of "street types" taken in New York, and took photographs for the engraved illustrations for a friend's book on bicycling for young women.

> PLATE 84. *South Beach.* Gelatin silver print, 1886. Staten Island Historical Society.

GEORGE BARKER, born Canada (1844-1894)

Landscape photographer George Barker first studied to be a landscape painter, but he took up photography after a family financial setback in 1857 canceled his plans to study art in Europe. In 1862 Barker moved to Niagara Falls, New York, where he briefly worked for another photographer before coming upon the idea of producing paper prints of the falls and opening his own studio. One of the most prolific photographers in the area, Barker made over eight hundred negatives of Niagara Falls, although his work was not limited to that subject; he also traveled to other states, including Florida, Georgia, and Kentucky, photographing landscapes and the aftermaths of disasters. In addition to making studio portraits during the winter months, Barker also operated a stereo card manufacturing company and a variety store that sold photographs, curios, and souvenirs. He won numerous awards for his work, including successive awards at the Professional Photographers of America conventions of 1886 and 1887; his photographs were the only ones in the convention of 1886 to receive a perfect score of thirty. Barker also supplied the photographs that accompanied a state survey report on the terrible effects of industrial and commercial development along the Niagara River; the survey led to the establishment of park lands along either side of the river.

PLATE 68. *Untitled Landscape, Florida.* Albumen silver print, 1886. J. Paul Getty Museum.

PLATE 69. *Ice Bridge, Ice Mound and American Fall, Niagara, Instantaneous.* Albumen silver print, 1883. Library of Congress.

PLATE 74. *Wayside Scene, Stoney Creek, Va.* Albumen silver print, 1887. Library of Congress.

GEORGE BARNARD (1819-1902)

George Barnard began his photographic career in Oswego, New York, in 1847, and became secretary of the New York Daguerrean Association in 1853. His daguerreotype of the Ames Mills fire was one of the first photographs of a news event. He also photographed Lincoln's inauguration in 1861 while working for Mathew Brady, then served as a Union Army photographer during the Civil War. Barnard's photographs of Civil War battlefields and Sherman's campaign were published as line engravings to accompany articles on the war in *Harper's Weekly,* and his *Photographic Views of Sherman's Campaign* and *Gardner's Photographic Sketchbook of the War* appeared in 1866. After the war, Barnard worked in Chicago and South Carolina before returning to New York, where he helped George Eastman establish his photographic business.

> **PLATE 2**. *Fire in the Ames Mills, Oswego, New York.* Daguerreotype, with applied color, 1853. International Museum of Photography, George Eastman House.

> **PLATE 46**. *City of Atlanta.* From *Photographic Views of Sherman's Campaign.* Albumen silver print, negative 1864, print 1866. Amon Carter Museum.

WILLIAM BELL, born England (1836-1902)

Liverpool native William Bell moved to the United States at an early age. He served in the war between the United States and Mexico in 1846-48, then went to work for his brother-in-law, Philadelphia daguerreotypist John A. Keenan. After working independently and with several other studios, Bell opened his own studio in Philadelphia in 1860. From 1862 to 1869 he served in the military, first as a member of the First Regiment of Pennsylvania Volunteers and then as part of the photographic team at the Army Medical Museum in Washington, D.C. Bell's images made at the museum provide clinical documentation of the physical injuries soldiers suffered during the Civil War and often reflect the mental suffering these survivors endured. Bell continued to do commercial photography during and after his service at the museum. In 1872 he accompanied Lt. George M. Wheeler's expedition of Geographical Explorations and Surveys West of the 100th Meridian, and in the 1880s he became one of the first photographers to use dry-plate negatives.

> **PLATE 51**. *No. 14. The Northern Wall of the Grand Cañon of the Colorado, Near the Foot of To-ro-weap Valley. The rounded rocks of the foreground are sand-stone.* Stereograph in *Geographical Explorations and Surveys West of the 100th Meridian; Expedition of 1872.* Albumen silver print, negative 1872, print 1875. Amon Carter Museum.

> **FIGURE IV-21**. *Gunshot Wound of Left Femur.* Albumen silver print, 1865-67. Gilman Paper Company.

HENRY HAMILTON BENNETT (1843-1908)

Henry Bennett's family moved from Vermont to Kilbourn City, Wisconsin, in 1857. He received a crippling wound to his right hand while serving with the Wisconsin River Volunteers in the Civil War; unable to do carpentry work, he bought a Kilbourn City studio in 1865 and took up photography. Bennett struggled as a portraitist but found his niche in landscape photography. While his wife ran the portrait studio, he photographed in and around Kilbourn and the Dells of the Wisconsin River. Much of his work was tied to the tourist trade: he photographed for the railroad and allowed his images to be used to promote local attractions, such as the Dells and river boat rides. Bennett also is known for his 1880s Milwaukee series, his images made at the 1886 Saint Paul Ice Carnival, and his stereo views of the Winnebago Indians. In 1883 he issued a successful catalogue, *Wanderings Among the Wonders and Beauties of Western Scenery,* that listed between four hundred and five hundred views. However, a second catalogue issued in 1890 was not successful, and his business suffered when the public's taste turned from scenic and stereo views in the mid-1890s. Bennett's work was distinguished by technical achievements; in addition to his oversized panoramas, he also perfected a shutter for instantaneous photography and was the first photographer to capture an image of fireworks. His studio, built in 1875, had a revolving print room on top; the room could be turned by a crank so the printing windows would catch sun all day. After his death, his family kept the studio open, and in 1976 the Bennett Studio was placed on the National Register of Historic Places as the oldest studio to be run by members of the same family.

> **PLATE 78**. *Panorama From the Overhanging Cliff, Wisconsin Dells.* Albumen silver print, c. 1891, printed before 1907. Museum of Modern Art, New York; gift of the H. H. Bennett Studio.

JAMES WALLACE BLACK (1825-1891)

New Hampshire native James Black was a prominent photographer for more than sixty years. After studying daguerreotypy from 1846 through 1848 in the primitive Boston studio of John A. Lerow, Black began making daguerreotypes on his own in neighboring towns. Back in Boston, he worked in turn for L. H. Hale and Company, Loyal M. Ives, and John Whipple. Black's successful association with Whipple began in about 1850-51; the two men operated the studio as a partnership from 1856 to 1859. An innovator, Black worked with Whipple to produce "crystalotypes," the first paper prints made from glass negatives, and used this process in 1854 for his photographs of the mountains and valleys of New Hampshire—among the earliest landscape views made using the glass negative/paper positive process. In 1861 Black experimented with "porcelain transparencies" on white glass. Throughout his career, Black photographed outside the studio. In 1860 he made the first aerial photographs in the United States, and in November 1872, he and Whipple photographed the aftermath of the great Boston fire.

> **PLATE 36**. *Head of Artist's Falls, North Conway, New Hampshire.* Salt print, 1854. Metropolitan Museum of Art.

> **PLATE 66**. *Boston From Hot Air Balloon.* Albumen silver print, 1860. Metropolitan Museum of Art.

PLATE 67. *View of the Ruins of the Great Boston Fire.* Albumen silver print, 1872. Library of the Boston Athenaeum.

MATHEW BRADY (1823-1896)

New York native Mathew Brady is one of the best-known nineteenth-century photographers. Having learned the daguerreotype process from Samuel F. B. Morse and John William Draper, two of the earliest American daguerreians, Brady opened his own daguerreotype studio in New York City in 1844. He immediately began receiving acclaim for his work, his business flourished, and he soon was one of the nation's leading portrait photographers. Many of Brady's clients were among the social and intellectual elite, and he amassed a large collection of portraits of the country's political leaders and other notable personalities. In 1850 he published the *Gallery of Illustrious Americans*, a compilation of lithographs taken from daguerreotype portraits. Throughout his career, Brady employed assistants, including such well-known photographers as Alexander Gardner and Timothy O'Sullivan, to do most of the photographic work, although when the prestige of a portrait subject merited his personal attention, Brady acted as designer and creative genius and had his assistants trip the shutter and develop the image. When the Civil War began, Brady obtained permission for his staff to accompany the troops, photograph military leaders, battle sites, and camp life, then published the images under his name, without crediting the actual photographers. During the war many of his employees left him over this practice of not giving credit. Financial mismanagement forced Brady to declare bankruptcy by 1868, and a few years later he lost his collection of portraits and Civil War photographs to his creditors. While his peers traveled west to document the American frontier, Brady remained in the East, making portraits, and died in relative obscurity.

PLATE 28. *James Brooks*. Salt print, c. 1857-59. Amon Carter Museum.

FIGURE II-7. *John Cabell Breckenridge*. Salt print, c. 1857-59. Gilman Paper Company.

FIGURE II-9. *Oliver Wendell Holmes*. Published by E. and H. T. Anthony in *Brady's National Portrait Gallery*. Albumen silver print, c. 1860. Photography Collection, Harry Ransom Humanities Research Center, University of Texas at Austin.

See also **FIGURE II-5**, lithographed by Francis D'Avignon.

JOHN C. BROWNE (1838-1918)

Amateur photographer John C. Browne was a founding member of the Photographic Society of Philadelphia. Browne not only participated in the Society's salons but also served as an informal historian for the group and in 1884 wrote the *History of the Photographic Society of Philadelphia*. During the 1870s he frequently contributed photographs to the *Philadelphia Photographer*, and in the 1880s and 1890s he and Samuel Castner, Jr., documented historic architecture in and around Philadelphia. Experimenting with artificial lighting, Browne was among the first to try magnesium lights. His research into dry-plate negatives was commemorated by manufacturer John Carbutt, who named his fastest plates "J.C.B." Browne was a teacher as well, including among his pupils John G. Bullock.

PLATE 82. *Mill Creek, 1878*. In album of albumen silver prints, 1878-79. Library Company of Philadelphia.

JOHN G. BULLOCK (1854-1939)

After graduating with a doctorate from the Philadelphia College of Pharmacy in 1879, John G. Bullock joined his family's drug and chemical firm of Bullock and Crenshaw. After attending a lecture by John Carbutt, Bullock became fascinated with photography and bought his first camera in 1882. He began studying photography with John C. Browne and soon became active in the Photographic Society of Philadelphia. A Quaker by background, Bullock loved rural subject matter, illustrating pastoral countrysides in which idealized rural people lived in harmony with nature. He exhibited his works in many of the pictorial salons between 1886 and 1910 and won numerous awards. He was a founding member of the Photo-Secession in 1902, and with Louise Deshong Woodbridge, Henry Troth, John C. Browne, and Robert S. Redfield, he formed the "Bullock Group," known for its members' eastern landscapes. In 1915, Bullock provided the photographic illustrations for Charles F. Jenkins' *Guide to Historic Germantown*. Although a leader in the pictorialist movement around the turn of the century, Bullock was overshadowed by other photographers as they moved on from pictorialism to experiment with modernism. In 1923 he became curator of the Chester County Historical Society.

PLATE 99. *Young Anglers*. Platinum print, 1896. Museum of Modern Art, New York; gift of the John Emlen Bullock Estate.

SOLOMON D. BUTCHER (1856-1927)

Solomon Butcher, an itinerant photographer known for his images of Nebraska sod farmers, had a brief apprenticeship with a tintypist in 1874 but did not practice photography until 1882. In 1880 Butcher decided to leave his job as a traveling salesman based in Clyde, Ohio, and accompanied his family to Custer County, Nebraska, where they planned to homestead. After enduring and disliking the first hardships of homesteading, he gave up his claim and left to attend medical school in Minneapolis. However, Butcher grew restless and only stayed in Minnesota for the winter and spring of 1881-82. In 1882, he returned to Nebraska with his new wife. Using money saved and borrowed, Butcher acquired some land, built a structure that served as both home and studio, and purchased photographic equipment. His was the first photographic gallery in Custer County. Through the years, few of Butcher's business endeavors really succeeded. An exception was his photographic history of Custer County. For seven years, he traveled throughout the county, photographing the families who lived there. More than personal portraits, these photographs record the pioneers' way of life. Butcher included the family, the house, and as much of the surrounding landscape as possible in his photographs, and when unable to capture the scene he wanted, he did not hesitate to stage events or to draw in figures that added to the image or covered flaws. Despite several financial setbacks, *Pioneer History of Custer County and Short Sketches of Early Days in Nebraska* was published in 1901. Butcher enjoyed his success and planned to publish similar books on other counties, but he eventually abandoned these books and gave up photography by 1917.

PLATE 89. *Canyon on Peter Forney Land Near Merna, Nebraska*. Albumen silver print (altered), c. 1890. Custer County Historical Society, Nebraska.

PLATE 90. *John Curry House near West Union, Custer County, Nebraska*. Albumen silver print (altered), 1886. Custer County Historical Society, Nebraska.

JOSEPH BYRON, born England (1846-1923)

Joseph Byron learned photography from his father and grandfather and worked in his family's successful photographic business, where he came to specialize in cartes-de-visite. Byron also worked as a news photographer and documented coal mines for the British government prior to moving to the United States. In 1888 he started a photographic operation in New York. His wife and children helped in different parts of the business, and his son Percy, who was already photographing by the age of eleven, also became a photographer. Although Byron was most widely recognized for his studio portraits and the theatre photographs he made after 1891, he also amassed almost thirty thousand large-format views recording life in New York. These images include domestic scenes from homes of all classes, business interiors and exteriors, and street scenes. After his father's death, Percy Byron continued to manage the firm until 1942.

PLATE 83. *Sitting Room Interior (Relaxing in the Parlor)*. Gelatin silver print, 1897. Museum of the City of New York.

GEORGE COX (1851-1903)

Although his reputation has faded in the twentieth century, George Cox was once considered one of the finest portrait photographers in America. He operated a photographic studio in New York from 1883 to 1897. Contrary to contemporary portraiture conventions, he posed his subjects in a natural manner, frequently in their own homes, and used neither artificial backgrounds nor props. Nor did he retouch negatives to eliminate facial wrinkles or lines. Because he had a wealthy clientele, Cox rarely mass-marketed reproductions of his portraits. However, in an attempt to aid Walt Whitman when the poet was near poverty, Cox did market several photographs he made following Whitman's New York lecture on Abraham Lincoln. Whitman, who was photographed more than any other author in the nineteenth century, was quite pleased with the images and with Cox, who unlike most photographers, regularly sent Whitman royalties for the sales of these portraits. Cox counted many artists among his friends, frequently supplying them with photographs to work from. Augustus Saint-Gaudens described him as "a photographer, made by God, especially for artists."

PLATE 70. *Walt Whitman*. Platinum print, 1887. Amon Carter Museum.

FRANCIS D'AVIGNON, French (1813-after 1870)

Although lithographer and printer Francis D'Avignon based his portrait prints on daguerreotypes by numerous photographers, it is his work for Brady's *Gallery of Illustrious Americans* which brought D'Avignon most recognition. A native of France, D'Avignon grew up in Saint Petersburg, Russia, and was educated at the Russian military academy. During a three-year tour of Europe, he decided to become a painter and studied with Horace Vernet and "the best artists of Paris." In 1834 D'Avignon returned to Saint Petersburg and operated a studio until 1840, when he left on a twelve-month tour of Great Britain. He settled in Hamburg rather than return to Saint Petersburg, but a few months after his arrival, the city was almost totally destroyed by fire. Having lost all of his possessions, D'Avignon moved to the United States and established himself as a lithographer. Although his work included small book illustrations and sheet music covers, his best-known work became his large portrait prints, which with few exceptions were taken from portraits by prominent daguerreotypists. From 1849 through 1853

D'Avignon operated his own press and during this time joined with Brady, forming Brady, D'Avignon and Company to produce the *Gallery of Illustrious Americans*. Although the book received critical acclaim, it failed financially; only twelve of the proposed twenty-four volumes were completed. However, the prints of notable Americans remained the finest examples of D'Avignon's ability to translate daguerreotype portraits into lithographs. D'Avignon continued working as a lithographer and printer through 1860. He moved from New York, finally settling in a suburb of Boston. He enlisted as a corporal in Company I, Second Massachusetts Volunteers during in the Civil War but served only briefly before returning home to live the remainder of his life in obscurity.

FIGURE II-5. *John Frémont*. From *Gallery of Illustrious Americans*. Lithograph after daguerreotype by Mathew Brady, c. 1850. National Portrait Gallery, Smithsonian Institution.

F. HOLLAND DAY (1864-1933)

Pictorialist F. Holland Day began photographing about 1887. As a member of a wealthy Norwood, Massachusetts, family, he had the resources to practice his craft, and he became quite active in the pictorialist movement in both the United States and Europe. He participated in salons and organized exhibitions in addition to actively campaigning for the acceptance of photography as an art. A member of the Boston Camera Club and the third American elected to The Linked Ring, an exclusive British photographic society, Day refused to join the Photo-Secession despite several invitations from Alfred Stieglitz, with whom he competed for leadership of the pictorialist movement. Much of Day's work recreates allegorical, legendary, and biblical scenes; perhaps the best-known work is his series of about 250 photographs recreating the last days of Christ. Day also made portraits of friends and employees. The exotic male nudes of his Nubian series—allegorical photographs depicting the nobility of the African-American—shocked the public. In these images of his chauffeur and servant, Alfred Tanneyhill, attired in African costumes and ornaments, Day experimented with tonal qualities and contrast. After an active career in photography and publishing, Day experienced extreme depression and remained voluntarily bedridden at his family home from 1917 until his death in 1933.

PLATE 16. *Ebony and Ivory*. Platinum print, 1897. Metropolitan Museum of Art.

JOHN WILLIAM DRAPER, born England (1811-1882)

John Draper, who emigrated to the United States in 1832, was a scientist, teacher, and author as well as a daguerreotypist. A graduate of the University of Pennsylvania, he was appointed professor of chemistry at the University of the City of New York in 1838 and remained there until 1881. Draper began experimenting with daguerreotypy in 1839 and was a colleague of Samuel F. B. Morse. His efforts to overcome the lengthy exposure time required by the early daguerreotypes resulted in totally frontal portraits, and he is frequently credited as one of the first American daguerreotypists to make a successful portrait. Draper was particularly interested in using photography for scientific documentation of minute details and attached microscope lenses to cameras to capture images barely visible to the naked eye. In 1856 Draper published *Human Physiology*, which contained woodcuts based on microphotographs. In addition to his contributions to the advancement of photography, Draper also made numerous contributions to science with his research on light and heat.

PLATE 29. *Photomicrographic Daguerreotype.* 1856. Division of Photographic History, National Museum of American History, Smithsonian Institution.

THOMAS EAKINS (1844-1916)

Although how or when artist Thomas Eakins began photographing is not documented, he may have become interested in the medium while studying at the Ecole des Beaux Arts in Paris (1866-70). The use of photographs as teaching tools was commonplace in Europe, and Eakins later incorporated photographs in his own teaching in Philadelphia and as sources of visual information for his paintings. In the early 1880s he acquired a four-by-five-inch camera and began photographing family members, friends, models, and students from the Pennsylvania Academy of Fine Arts, where he taught. Understanding human anatomy and how the body moves was critical to Eakins, so he normally focused on the form of the body and paid little attention to the background. His photographs for teaching showed nude models in traditional poses, frequently positioned next to statues for contrast. For his more personal work, Eakins photographed models and scenes to capture body movement and gestures, and experimented with stop-action photography to obtain casual rather than posed scenes. He also invented two multiple-image cameras for recording human motion. The second and more successful camera, based partially on the theories of French photographer E. J. Marey, was important for the accuracy of its time intervals between exposures; this made it possible to calculate absolute and relative velocity of motion in any part of the body. Most of Eakins' photographs, including a series for his commissioned painting *The Swimming Hole*, were made for study purposes; nevertheless, several images appear to be finished pieces. He never documented his photographic work, however, and it is unclear whether or not he considered his photographs to be among his artistic achievements.

PLATE 71. Circle of Eakins. *Eakins' Students at the Site of "The Swimming Hole."* Albumen silver print, 1883. Hirschhorn Museum and Sculpture Garden, Smithsonian Institution.

PLATE 85. *Marey Wheel Photographs of Unidentified Model.* Albumen silver print, 1884. Hirschhorn Museum and Sculpture Garden, Smithsonian Institution.

THOMAS M. EASTERLY (1809-1882)

Thomas Easterly was a calligrapher and teacher of penmanship before becoming a daguerreotypist. A native of Vermont, Easterly began traveling around the western frontier in 1845, working as an itinerant photographer. In 1846-47 he was associated with F. F. Webb in Liberty, Missouri. During the spring and summer of 1847 Easterly operated a gallery in Saint Louis; he left the city in late summer, then returned several months later to establish another studio that he operated through the late 1870s. Throughout his career, he explored the possible uses for photography. Having photographed the landscape as early as 1845, he was among the first to use the daguerreotype to make purely scenic views and to document local landmarks and events. In his studio Easterly not only photographed residents but made portraits of visiting notables as well. He continued to make daguerreotypes long after others had abandoned the process.

PLATE 26. *Na-che-ninga, Chief of the Iowas.* Daguerreotype, 1845. Missouri Historical Society.

PLATE 31. *Choteau's Mill Creek, East from 13th and Gratiot, Construction of Sewer.* Daguerreotype, c. 1855. Missouri Historical Society.

SARAH J. EDDY (active 1890s-1900s)

Providence, Rhode Island, amateur photographer Sarah Eddy specialized in images of children, flowers, and animals as well as genre scenes. She was reluctant to provide information about herself or her work; however, it is known that she belonged to a camera club, exhibited her photographs, and won a number of prizes. In 1900 Frances Benjamin Johnston included Eddy in her Paris exhibition of women photographers.

PLATE 98. *A Welcome Interruption.* Platinum print, c. 1899. Division of Photographic History, National Museum of American History, Smithsonian Institution.

JAY DEARBORN EDWARDS (1831-1900)

A native of New Hampshire, J. D. Edwards arrived in New Orleans as early as 1857 and produced some of the earliest extant paper photographs of the city. Edwards' subjects included Canal Street, the levee, residential areas, and public buildings. Several government offices hired him to document the construction or repair of buildings. Although specializing in outdoor views, Edwards also made portraits, maintained a gallery where he sold views made by himself and other photographers, and gave lessons in photography. For a while, Edwards was partners with E. H. Newton, Jr. During the Civil War, he traveled throughout the South, photographing the Louisiana troops and later serving as a spy for the Confederate secret service. Edwards did not return to New Orleans after the war; instead he stayed a while in Virginia and in 1886 settled in Atlanta, where he opened a photographic establishment.

PLATE 33. *Princess Steamboat.* Salt print, 1857-60. Historic New Orleans Collection.

PLATE 39. *Confederate Sand Batteries, Pensacola, Florida.* Albumen silver print, c. 1861. J. Paul Getty Museum.

RUDOLF EICKEMEYER, JR. (1862-1932)

A leader in the pictorialist movement, Rudolf Eickemeyer, Jr., took up photography in 1884 while working in his father's machine company. Eickemeyer used the camera to record his father's inventions but soon began photographing in his spare time as well. His work was greatly influenced by Peter Henry Emerson, who campaigned against the pictorial effects of multiple printing, the fake staging of scenes, and manipulation of negatives in favor of a straightforward, naturalistic manner of photographing; many of Eickemeyer's images, including *The Lily Gatherer*, approximated Emerson's compositions. By the end of the century Eickemeyer had emerged as one of the leading American photographers. His landscapes, genre studies, and portraits earned numerous international awards and received critical praise. In 1895 he and colleague Alfred Stieglitz became the first Americans elected to The Linked Ring, a select British group. In the same year, Eickemeyer left the family business to devote his time to photography. Unlike many of his colleagues, he took on commercial jobs to support his personal work and became known for his portraits of wealthy women. He was among the first to publish inexpensive books of his work and with Sadakichi Hartmann produced what Hartmann later described as the first literary article illustrated by photographs. Eickemeyer also worked for Kodak, providing images for the company's pamphlets

and advertisements. Despite his reputation and popularity at the turn of the century, he faded into obscurity as he continued to make natural and often romantic images rather than following modern trends. Upon retiring, he donated all of his photographic plates and cameras to the Smithsonian Institution, along with fifteen thousand dollars for the care of the collection and the establishment of a department of photography.

> PLATE 100. *The Lily Gatherer.* Carbon print, 1892. Division of Photographic History, National Museum of American History, Smithsonian Institution.

FRANK EUGENE (1865-1936)

Frank Eugene was one of the first photographers to gain recognition for an expressive, nonrepresentational style of photography which used manipulated negatives to create prints with artistic effects similar to a drawing or engraving. Born Frank Eugene Smith in New York City, he had begun photographing for his amusement around 1885. In 1886 Eugene traveled to Munich to study at the Bavarian Academy of Fine Arts, and he began a career as a theatrical portraitist in 1895. It was not until 1899, after he had been photographing for several years and had accumulated a large number of exhibition prints, that Eugene first exhibited his photographs at the Camera Club of New York. His work was lauded as "unphotographic photography," and almost overnight he earned a reputation for his work. Eugene brought his training as a painter to his photography; he manipulated negatives by rubbing oil onto them and adding cross-hatching with an etching needle. Those advocating pure photography normally condemned manipulation of photographs; however, many purists admired and accepted Eugene's work for its expressive nature. By the turn of the century he had become quite active in photographic groups. He was the seventh American elected to the Linked Ring, an exclusive British photography group, and helped found the Photo-Secession. In 1906 Eugene moved permanently to Germany, where he continued to photograph and began teaching. In 1913 he was appointed Royal Professor of Pictorial Photography by the Royal Academy of the Graphic Arts of Leipzig—a position created especially for him and the first chair of pictorial photography at any art academy.

> PLATE 102. *Arthur und Guinevere.* Platinum print, 1899. Metropolitan Museum of Art.

GEORGE ROBINSON FARDON, English (1806-1886)

Although George Fardon only spent ten years photographing in San Francisco before moving to Victoria, British Columbia, in 1859, he greatly affected western American photography. Fardon introduced the wet-collodion negative process in California and produced some of the earliest paper prints of the area. In 1856 he published one of the earliest photographic series on urban America, his *San Francisco Album: Photographs of the Most Beautiful Views and Public Buildings of San Francisco*; with this album of thirty-three views, Fardon introduced the photographic booster book. He continued photographing until the early 1870s.

> PLATE 37. *Kearny Street, San Francisco.* Salt print, 1856. International Museum of Photography, George Eastman House.

ALEXANDER GARDNER, born Scotland (1821-1882)

Alexander Gardner trained as a jeweler and worked on a newspaper and in a utopian community while pursuing his outside interests in optics, astronomy, and chemistry. He had experimented with and

was accomplished in the difficult wet-plate negative/paper print process when he met Mathew Brady, who convinced Gardner to work for him. He moved to New York in 1856 and two years later became manager of Brady's Washington studio. Gardner began photographing the Civil War as part of Brady's team of photographers; however, after a dispute over print attribution, he left Brady's employ and established his own business photographing the war. In 1866 he published *Gardner's Photographic Sketch Book of the War*, an ambitious two-volume work combining text with one hundred images taken by Gardner and a number of other photographers, including Timothy O'Sullivan, and printed by Gardner. After the war, Gardner joined other photographers working in the West. In 1867 the Kansas Pacific and Union Pacific railroads hired him to document the building of a rail route to California; the following year he photographed the Fort Laramie Treaty Council. Gardner returned to Washington, D.C., in the 1870s and operated a studio where he photographed members of Indian treaty delegations.

> PLATE 5. *Wilderness Battlefield Scene.* Albumen silver print, 1863. Gilman Paper Company.

> PLATE 43. *The President (Abraham Lincoln) and General McClellan on the Battlefield of Antietam.* Albumen silver print, 1862. Museum of Modern Art, New York; gift of Carl Sandburg and Edward Steichen.

> PLATE 50. *Depot, Leavenworth, Kansas.* Albumen silver print, 1867. J. Paul Getty Museum.

> PLATE 58. *Red Cloud, Ogalalla Sioux.* Albumen silver print, 1872. Amon Carter Museum.

C. H. GAY (active 1850s)

Little is known about C. H. Gay. Working as a daguerreotypist in New London, Connecticut, Gay advertised that he sought to provide "entire satisfaction" in his work and claimed that "from his long experience in the business" he could please the most fastidious person.

> PLATE 34. *Panorama of New London, Connecticut.* Six half-plate daguerreotypes, c. 1851. J. Paul Getty Museum.

ARNOLD GENTHE, born Germany (1869-1942)

Arnold Genthe is best known for his turn-of-the-century photographs of life in San Francisco's Chinatown and views of the 1906 earthquake and fire, which mixed pictorial aesthetics with documentary concerns. Trained in literature and linguistics, Genthe began to make photographs as a hobby shortly after he moved to the United States in 1895. He often worked with a concealed camera to avoid disrupting his subjects' activities. In 1911, Genthe moved to New York City, where he made portraits of leading stage personalities. He worked in the pictorialist mode and published several books of his photographs.

> PLATE 95. *Holiday Visit, Chinatown, San Francisco.* Platinum print, c. 1897. Museum of Modern Art, New York.

JEREMIAH GURNEY (1812-after 1886)

Trained as a jeweler, Jeremiah Gurney took up daguerreotypy in 1840 after exchanging a watch for a camera. An early student of Samuel F. B. Morse, Gurney opened a studio in New York and soon expanded his operation to include several studios. He was among

the leading portraitists, joining Mathew Brady, Martin Lawrence, and the Meade Brothers, who also ran large studios on Broadway. Although Gurney only received an honorable mention for his work shown at the New York Crystal Palace in 1853, that same year he won the Anthony pitcher, the top prize in America's first strictly photographic competition, for a whole-plate portrait of his daughter.

FIGURE II-9. *Henry Ward Beecher and Harriet Beecher Stowe.* Albumen silver print, c. 1870. Photography Collection, Harry Ransom Humanities Research Center, University of Texas at Austin.

PHILIP HAAS (active 1837-1857)

Philip Haas was a lithographer from 1837 to 1845, making technical prints and portraits, including a portrait of Martin Van Buren, as well as views of Washington and Mount Vernon. From 1846 to 1857 he worked as a daguerreotypist in New York; his daguerreotypes were exhibited at the American Institute in 1846 and at the New York Crystal Palace in 1853. During the Civil War, Haas served as a lieutenant in the 1st New York Engineers and, along with Washington Peale, as a photographer attached to General Gilmore's army at Charleston, South Carolina.

FIGURE II-2. *John Quincy Adams.* Daguerreotype, c. 1843. Mead Art Museum.

GABRIEL HARRISON (1818-1902)

Thespian and daguerreotypist Gabriel Harrison worked in the galleries of John Plumbe, Jr., and Martin M. Lawrence before opening his gallery with George Hill in 1852. Harrison was among the few early photographers seeking to demonstrate the artistic value of photography. He studied the works of contemporary European and American genre painters to improve his compositions and often chose allegorical or patriotic themes for his images. Harrison received numerous awards for his work, and two of his images, *California News* and *Past, Present and Future*, were exhibited under Lawrence's name at the 1851 Crystal Palace Exhibition in London. His portrait of Walt Whitman served as the basis for Whitman's engraved portrait in *Leaves of Grass*. It is not known why Harrison stopped working as a photographer, but after 1863 he spent his time acting, writing, painting, and teaching elocution and acting.

PLATE 27. *California News.* Daguerreotype, c. 1850. Gilman Paper Company.

ALFRED A. HART (1816-1908)

In 1840 Alfred A. Hart began his career as an itinerant portrait painter working out of Norwich, Connecticut. Soon after he moved his family to Hartford in 1848, he expanded his work to include painted moving panoramas, particularly those with religious themes. Despite his success, Hart was forced by economic necessity to take up photography. In 1857 he entered a partnership with Henry H. Bartlett, the prominent Hartford daguerreotypist, and used his painting talents to produce repainted photographs and hand-tinted images. The partnership with Bartlett was brief, and by 1863 Hart had become an itinerant portrait photographer. While maintaining an art supply business in Cleveland, where his family had moved, Hart traveled throughout California. In January 1866 the directors of the Central Pacific Railroad purchased thirty-two of his stereoscopic negatives of the railroad's construction. Hart then became the official photographer for the CPRR, a position he

held until 1869. Although he officially worked for the railroad, the CPRR directors only required the right to first selection, thereby enabling Hart to offer the remaining railroad negatives to the large publishing house of Lawrence and Houseworth. After Carleton Watkins became the official photographer of the CPRR, he continued to print Hart's negatives but without crediting Hart. Hart never entirely gave up photography, but after 1869 he focused his attention on painting landscapes and portraits.

PLATE 60. *Piute Squaws and Children, at Reno.* Stereograph published by C. E. Watkins in *Central Pacific Railroad Series.* Albumen silver print, negative 1867-70, print 1870 or later. T. K. Treadwell Collection.

F. JAY HAYNES (1853-1921)

Frank Jay Haynes' views of Yellowstone scenery and park activities were instrumental in publicizing the wonders of the park landscape throughout the country. His photographic career began in 1874 when he apprenticed with photographer S. C. Graham in Beaver Dam, Wisconsin, and later with William H. Lockwood. Soon after opening his own studio in Moorhead, Minnesota, in 1876, Haynes received a lucrative contract to make views along the lines of the Northern Pacific Railroad; until 1905 he traveled the NPRR route operating a Palace Studio Car. An 1881 trip to the Yellowstone region convinced Haynes to pursue a concession as the park photographer, and by 1884 he had built a seasonal studio on the park grounds. His profitable business was transferred to his son Jack in 1916.

PLATE 11. *Cascades of Columbia.* Albumen silver print, c. 1885. Amon Carter Museum.

PLATE 72. *Gibbon Falls, 84 Feet.* Albumen silver print, 1884-88. Amon Carter Museum.

JOHN K. HILLERS, born Germany (1843-1925)

German-born John K. Hillers arrived in the United States in 1852. At the outbreak of the Civil War he enlisted in the New York Naval Brigade, later joining the Union army and remaining in the military until 1870. On a return trip from San Francisco, he met Major John Wesley Powell in Salt Lake City, Utah, and joined on as a boatman for the second Powell expedition down the Colorado River. He soon learned photography by assisting the expedition photographers and became the expedition photographer in early 1872. Hillers continued to work under Powell's direction at the Bureau of American Ethnology in 1879 and later for the United States Geological Survey.

PLATE 9. *Tewa, Cicomavi, Wolpi, Mokitowns, Arizona.* Albumen silver print, c. 1879. Amon Carter Museum.

PLATE 59. *A Navaho Shaman.* Albumen silver print, c. 1879. Amon Carter Museum.

HOFELINE and ADAMS
[ALBERT D. HOFELINE (1848?-1928) and CHARLES H. ADAMS (active 1882-1892)]

The firm of Albert D. Hofeline, an engraver and printer, and Charles D. Adams, a photographer, published *Photographic Views of New Orleans*, a business and advertising directory, in 1883. Since neither man's listings in the New Orleans city directories gives the other as a partner, it is supposed that this is the only venture the two undertook jointly. The album contains sixty cyanotypes featuring straightforward exterior shots of businesses.

NOT REPRODUCED IN CATALOGUE. *Photographic Views of New Orleans*. Album of cyanotypes, 1887. Historic New Orleans Collection.

OLIVER WENDELL HOLMES (1809-1894)

Physician and author Oliver Wendell Holmes was an active promoter and collector of photography. Holmes believed that a photograph provided an objective, and therefore truthful, record whose details could be studied. He promoted the stereograph as an educational tool and designed an inexpensive stereograph viewer that would allow ordinary people access to these tools. Foreseeing the need to establish comprehensive libraries of images where a person desiring to view any object could locate a photograph of it, he began collecting stereo cards. Although Holmes is most frequently recognized for his efforts to popularize the medium, he also briefly practiced photography. Most of his images were made in 1864 and 1865, several years after he learned photography from James Wallace Black and began writing about the medium. Holmes' genre scenes of people and places close to him reflected his fascination with detail. Intrigued with the ability to produce multiple images from a single negative, he also photographed items not ordinarily available in multiples, such as daguerreotypes, paintings, and books. Holmes continued writing and collecting stereographs, but by the end of 1867 he was too involved with other projects to devote time to his own photography.

FIGURE I-10. *At the Doorway*. Albumen silver print, c. 1864. Museum of Fine Arts, Boston; bequest of Mrs. Edward Jackson Holmes, Edward Jackson Holmes Collection.

LATON ALTON HUFFMAN (1854-1931)

Laton Huffman is known for his photographs of the closing days of the western frontier, chronicling Indians, ranch life, and cattle drives on the Montana grasslands. He learned photography while working for his father in his Waukon, Iowa, photographic studio, beginning in 1865. By 1878 Huffman had established his own business while working as an unpaid post photographer at Fort Keogh, Montana. His Miles City, Montana, studio became the base of his operations for many years. Huffman's views were widely distributed, first as albumen prints and later, around the turn of the century, as collotypes and gelatin silver prints.

PLATE 10. *The Night Hawk in His Nest*. Gelatin silver print, c. 1885-90. Amon Carter Museum.

WILLIAM HENRY JACKSON (1843-1942)

In his lengthy career as one of the best-known and most prolific nineteenth-century American photographers, Jackson found his calling making views of the exploration and settlement of the western United States. After a brief period as a studio photographer in Omaha, Nebraska, he became the official photographer on the Hayden United States Geological Survey from 1870 until 1879. He also printed Indian portraits made by himself and other photographers for the Bureau of American Ethnology. In 1879 he opened a Denver studio and received commissions for spectacular mammoth-plate views of the landscape and towns along the rail routes. He also distributed thousands of smaller views and stereographs. In 1897 Jackson acquired part interest in the Detroit Publishing Company, which distributed and published his photographs. It is difficult to determine a date or attribution for a Jackson photograph because of the size of his publishing operation, his use of numerous assistants, and the fact that he sometimes published other photographers' work as his own.

PLATE 12. *Excursion Train and Niagara Rapids, Lewiston Branch, N.Y.* Albumen silver print, 1890. Amon Carter Museum.

PLATE 75. *On the Valley Division near New Market, On the Picturesque B&O*. Albumen silver print, c. 1886. International Museum of Photography, George Eastman House.

FRANCES BENJAMIN JOHNSTON (1864-1952)

Johnston was one of the first women press photographers. Although she had studied art, she began as a writer and took up photography only because she needed illustrations for her articles. Eventually she gave up writing to pursue a photographic career. She opened a studio in Washington, D.C., during the 1890s and received many commissions from the government, school systems, and magazines. She began a series of photographs documenting historic buildings and gardens in the southern United States about 1909. Her work falls within the documentary tradition, but she was a supporter of women pictorialists and a close friend of the pictorialist photographer Gertrude Käsebier. Although Johnston frequently choreographed her group shots, her views were straightforward and her negatives and prints were unmanipulated.

PLATE 92. *Kohinore Mine, Shenandoah City, Pa.* Gelatin silver print, 1891. Library of Congress.

PLATE 93. *Class in American History*. Platinum print, 1899-1900. Museum of Modern Art, New York.

GERTRUDE KÄSEBIER (1852-1934)

In a career which she began only after her children were grown, Käsebier devoted herself to portraiture, frequently photographing mothers and children as well as fellow artists and the Indians of the Buffalo Bill Wild West Show. Her portraits have a natural and direct quality, although they are pictorial in terms of tone and technique. A founding member of both the Photo-Secession and the Pictorial Photographers of America, she ended her close professional relationship with Alfred Stieglitz, who frequently published her work in *Camera Notes* and *Camera Work*, in 1916 over his commitment to straight photography.

PLATE 103. *Silhouette of a Woman*. Platinum print, c. 1899. J. Paul Getty Museum.

JOSEPH KEILEY (1869-1914)

Brooklyn-born Joseph T. Keiley, an active member of the New York Camera Club, was a pictorialist photographer and associate editor of the club's publication, *Camera Notes*. In 1900 his work won him election to the Linked Ring, an exclusive British photography group, and he became active on their salon committee. He developed a close relationship with Alfred Stieglitz in 1898, and when Stieglitz resigned from the New York Camera Club a few years later and founded his own publication, *Camera Work*, Keiley became associate editor. Over the years he contributed many articles and reviews, traveled widely, and exhibited his prints in salons throughout the United States and Europe.

PLATE 14. A *Sioux Chief*. Glycerine platinum print with wash, c. 1898. Metropolitan Museum of Art.

LUKE and WHEELER
[WELLINGTON O. LUKE (active 1879-1893) and DANSFORD NOBLE WHEELER (1841-1909)]

The partnership of Wellington O. Luke and Dansford Noble Wheeler lasted from 1879 through 1881. Operating a studio in Leadville, Colorado, the pair published stereographs of local scenes. Luke also ran an independent studio in Leadville from 1882 to 1892 and in New Castle in 1893. From the 1870s until just after the turn of the century, Wheeler had studios in Del Norte, Grand Junction, San Juan, and Colorado Springs.

PLATE 56. *Little Giant*. Stereograph from *Rocky Mountain Views*. Albumen silver print, c. late 1870s. Amon Carter Museum.

SAMUEL MASURY (1818 or 1820-1874)

Born in Salem, Massachusetts, Samuel Masury worked in a store and studied carriage-making before taking up daguerreotypy. He studied with John Plumbe, Jr., in 1842, and in 1855 traveled to France, where he reportedly studied with the Bisson Freres. From 1847 to 1850 Masury and S. W. Hartshorn were partners in Providence, Rhode Island. After selling the business to Manchester and Brothers, Masury moved to Boston, where he operated studios independently (1858-67), as partners with George M. Silsbee (1852-55), and with Silsbee and J. C. Case (1857-58). Masury and Silsbee experimented with making daguerreotypes by artificial light; however, their attempts came to an end when the gaslight they were using caused the chemicals to explode and destroyed the front of their business. Silsbee lost an eye, and Masury broke a leg. Around 1856-57, Masury photographed at the Beverly, Massachusetts, estate of Charles Loring. The images of family members about the house and grounds incorporate many compositional elements found in contemporary American genre and landscape painting.

PLATE 35. *Loring Estate, Beverly, Massachusetts*. Salt print, c. 1857. Worcester Art Museum.

JOHN MORAN (1831-1903)

Although generally less well-known than his famous brothers, Edward and Thomas, John Moran was a prominent nineteenth-century photographer who made a significant contribution to American landscape and architectural photography. Moran championed the acceptance of photography as a fine art and applied artistic principles to his photographs. He is listed as a photographer in the 1859 Philadelphia city directory, but his earliest known work dates to 1863. Moran produced two series of architectural photographs made in Philadelphia. The first series, made between 1863 and 1865, was a literal record of buildings. However, the series made from 1866 to 1869 provided more intimate views as Moran used his understanding of point of view to highlight specific characteristics of each building. Included in this second series were images of historically important structures. Moran also made landscape views, photographing on private estates, in scenic areas in Pennsylvania, and in the White Mountains of New Hampshire; his views were similar to the work of many landscape painters of the time. From December 1870 until July 1871, he served with Timothy O'Sullivan as an official photographer for the Darien Expedition, which surveyed the Isthmus of Panama looking for a canal route. He also accompanied an expedition to Tasmania and

South Africa in 1874 and photographed the transit of Venus. Moran continued to work in Philadelphia in the 1870s but later gave up photography to devote himself to landscape painting.

PLATE 63. *Geddes Brook, a Tributary of Tohican, Pennsylvania*. Albumen silver print, c. 1855-65. International Museum of Photography, George Eastman House.

PLATE 64. *House in Mickle's Court*. Albumen silver print, 1869. Library Company of Philadelphia.

EADWEARD MUYBRIDGE, born England (1830-1904)

Muybridge, born Edward Muggeridge, came to the United States in 1850 as a commission merchant representing book publishers, and by 1856 had opened an antiquarian book shop in San Francisco. A trip to England in about 1860 became a long convalescence because of a serious accident. When he returned to the States in 1867, he was an accomplished photographer who did a substantial amount of work in San Francisco and along the Pacific Coast and made his first trip to Yosemite. He accompanied General Henry W. Halleck's expedition to Alaska in 1868, and in 1875 traveled to Central and South America as a photographer for the Pacific Mail Steamship Company. Commissioned by California Governor Leland Stanford to make photographs of his horse Occident in motion in 1872, Muybridge published his first instantaneous photographs of a horse in motion six years later. At the University of Pennsylvania, where he moved his work in 1884, he made over twenty thousand negatives of people and animals in motion. In 1887 his work entitled *Animal Locomotion* was published as a series of 781 collotype plates. His pioneering experiments with motion in photography led him to invent the zoopraxiscope, a forerunner of the modern motion picture machine.

PLATE 54. *Mount Hoffman, Sierra Nevada Mts, From Lake Tenaya*. Albumen silver print, 1872. International Museum of Photography, George Eastman House.

PLATE 86. *Woman Pirouetting (.277 second)*. Collotype, 1887. Amon Carter Museum.

TIMOTHY H. O'SULLIVAN, born Ireland (1840-1882)

Timothy O'Sullivan, a young Irish immigrant, began his training in the Mathew Brady studio, photographing early Civil War battles as Brady's assistant. In the studio he worked for a time under Alexander Gardner, who soon left Brady because of a dispute over attribution of photographs. From 1862 through the close of the Civil War, O'Sullivan worked for Gardner, whose firm published several of his photographs. From 1867-69 and in 1872, he worked as an expeditionary photographer for Clarence King's Geological Survey of the Fortieth Parallel. In 1870, he documented a Navy Department expedition, led by Commander Thomas O. Selfridge, Jr., in search of a route for an interoceanic canal through the Isthmus of Darien (Panama). Joining the Wheeler Survey of Nevada and Utah in 1871, O'Sullivan was commissioned to document the terrain from a military point of view. His last western expeditions with Wheeler were in 1873 and 1874. O'Sullivan continued to print negatives from his expedition work and pursued his own commercial business when he returned to Washington. In 1880, after several extremely lean years, he was finally appointed Photographer of the Treasury Department. Only six months later he discovered that he had tuberculosis and died shortly after resigning his post.

PLATE 7. *No. 21. Ruins in Cañon de Chelle, N. M., in a cavity in the wall, 69 feet above present bed of Cañon. Height of walls about 700 feet. The present race of Indians knows nothing of the age of these buildings or who occupied them.* Stereograph in *Geographical Explorations and Surveys West of the 100th Meridian.* Albumen silver print, negative 1873, print 1875. Amon Carter Museum.

PLATE 41. *Field Where General Reynolds Fell.* From *Gardner's Sketch Book of the Civil War.* Albumen silver print, negative 1863, print 1866. Amon Carter Museum.

PLATE 45. *Artillery Test Grounds, No. 59, XI inch, 10 Pound Shell.* Albumen silver print, August 24, 1864. J. Paul Getty Museum.

PLATE 52. *Geyser Mouth, Ruby Valley.* Albumen silver print, 1868. International Museum of Photography, George Eastman House.

PLATE 55. *Cave-In at Comstock Mine, Virginia City, Nevada.* Albumen silver print, 1868. Amon Carter Museum.

FIGURE III-20. *Shoshone Falls, Looking over Southern Half of Falls.* Albumen silver print, 1868. International Museum of Photography, George Eastman House.

JOHN PLUMBE, JR., born Wales (1809-1857)

The originator of the chain studios concept, John Plumbe, Jr., has been called the greatest promoter of photography. Plumbe, who emigrated to the United States with his family in 1821, had an assortment of jobs, including working for the railroad, running a store, and dabbling in land speculation, before he moved to Washington, D. C., in 1839. He opened what perhaps was that city's first permanent daguerreotype studio and specialized in producing inexpensive portraits. He soon opened a second studio, in Boston, and by the mid-1840s operated a successful chain with daguerreotype studios in most major U. S. cities. In 1846-47, to promote the galleries, he published *The National Plumbeotype Gallery* and the *Plumbeian*, both of which contained engravings of his portraits of national figures. In 1846 Plumbe also started making daguerreotypes of the public buildings in Washington, D.C.; he later expanded this project to include other major cities. He planned to reproduce these images as "Plumbeotypes," the term he coined for his lithographic copies, and mass-market them. Poor management of the galleries led to financial disaster for Plumbe; he sold many of his galleries to the operators in 1847 and left the photographic business. Despondent over his failure to achieve his primary dream, building a transcontinental railroad from his photography profits, Plumbe committed suicide in 1857.

PLATE 32. *U.S. Capitol.* Daguerreotype, 1846. Matthew Isenburg Collection.

WILLIAM RAU (1855-1920)

The son of active photographer George Rau, William H. Rau was best known for his eastern landscape views. He was also one of the photographers on the 1874 expedition to record the transit of Venus. In 1877 he formed a partnership with his father-in-law, William Bell, a survey photographer with the United States Geological Survey. Rau purchased Bell's stereograph company in 1877 and continued to publish stereographs under his own name until the company was acquired by Underwood and Underwood in 1901. During the 1880s he did some work in the West. His 1881 views taken in Colorado and New Mexico, when he worked with William Henry Jackson, were published as original tipped-in plates in the *Philadelphia Photographer*. Rau gained a reputation as a railroad photographer when he was hired in the 1890s by the Pennsylvania Railroad and the Lehigh Valley Railroad to make views along their lines. He also made notable photographs of the Johnstown, Pennsylvania, flood and the 1904 Baltimore fire.

PLATE 79. *Maunch Chunk, from the Mountain Line, L.V.R.R.* Albumen silver print, 1891-93. International Museum of Photography, George Eastman House.

PLATE 80. *Lattimer Strippings and Coal Breaker.* Albumen silver print, after 1895. Canadian Centre for Architecture.

ROBERT REDFIELD (1848-1923)

Born in New York but raised in post-war Philadelphia's scientific community, Redfield was introduced to photography in 1866 by Coleman Sellers. With the advent of dry-plate negatives in 1881, Redfield began photographing and soon became a leader in the movement to establish photography as a fine art. He supported the New School of American Photography's attempt to persuade people to accept photography not only as a way to record fact but also as a way to convey emotion. He served as secretary of the Photographic Society of Philadelphia in 1893 and as president in 1898. He was also one of the founding members of the Photo-Secession, but he did not accept either organization's premise that it was the sole arbiter of artistic standards of photography.

FIGURE VI-7. *A New England Watering Place, Near Salisbury, Conn.* Platinum print, 1887. Janet Lehr Collection.

JACOB RIIS, born Denmark (1849-1914)

Jacob Riis is acknowledged as the first person to use photography as a tool for social reform. The son of a town schoolmaster, Riis immigrated to the United States in 1870. He joined the thousands of poor, unskilled immigrants already in New York; plagued by poverty during his early years there, he nevertheless persevered and worked his way into a job as a news reporter. Riis' position as a police reporter for the New York *Tribune*, and later the New York *Evening Sun*, exposed him to the squalid slums of the lower East Side. Outraged at what he saw, Riis sought to bring about reforms. His first attempts failed; however, he captured people's attention when he began illustrating his words with photographs. The public thought of photographs as objective and completely truthful, and the images made Riis' words more effective. He first worked with other photographers but soon began making the photographs himself, determining what vantage point and arrangement of people best suited his cause. His titles also underscored the degradation of the inhabitants of the slums; a man sleeping in a cellar became "A Cave Dweller." Riis' "The Other Half: How It Lives and Dies in New York" started as a lantern slide lecture in 1888, evolved into an article for *Scribner's* magazine, and eventually was expanded and published as the important reform book, *How the Other Half Lives* (1890).

PLATE 91. *A Cave Dweller—Slept in This Cellar Four Years.* Gelatin silver print, c. 1890. Museum of the City of New York.

FRANK A. RINEHART (1861-1928)

Illinois native Frank Rinehart began his career in the late 1870s, working at Charles Bohm's studio in Denver with his brother, Alfred Evans Rinehart, until 1881. By 1885 he had established his own photographic studio in Omaha, Nebraska. Rinehart is best known as the official photographer for the Trans-Mississippi International Exposition held in Omaha in 1898. His photographs record the fair buildings and many of the five hundred Plains Indians who attended the Indian Congress held in conjunction with the Exposition. His camera operator during the Exposition, Adolph Muhr, is widely believed to have made many of the portraits credited to Rinehart.

PLATE 76. *Geronimo (Guyatle), Apache.* Platinum print, c. 1898. Amon Carter Museum.

ANDREW J. RUSSELL (1830-1902)

Russell joined the 141st New York Infantry Volunteers as a captain in 1862 and shortly thereafter became the the the first member of the army officially assigned to photograph the Civil War. He did most of his work for General Herman Haupt of the United States Military Railroad, photographing devices used to transport troops and the destruction and construction of roads and bridges. Russell left the army in 1865 and began his most famous work photographing construction along the lines of the Union Pacific Railroad. This culminated in a series of photographs made at the joining of the transcontinental railroad at Promontory Point, Utah, in May 1869. That year the UPRR published an album of Russell's photographs of railroad construction in Wyoming and Utah; a number of his photographs for the UPRR also were published in a volume entitled *Sun Pictures of Rocky Mountain Scenery.* Russell left the UPRR during the early 1870s and returned to New York, where he ran a studio.

PLATE 42. *Stone Wall, Rear of Fredericksburg, with Rebel Dead.* Salt print, 1863. J. Paul Getty Museum.

PLATE 44. *Upper Wharf, Belle Plain.* Albumen silver print, 1864. J. Paul Getty Museum.

PLATE 47. *Steam Shovel at Work, Echo Cañon.* Albumen silver print, 1868. Beinecke Rare Book and Manuscript Library, Yale University.

PLATE 48. *East End of Tunnel No. 3, Weber Valley.* From *The Great West Illustrated.* Albumen silver print, 1869. Amon Carter Museum.

PLATE 49. *Last Rails, Promontory Point.* Albumen silver print, 1868. Beinecke Rare Book and Manuscript Library, Yale University.

FIGURE IV-18. *General Haupt Crossing Stream on a Pontoon.* Salt print, March 1863. J. Paul Getty Museum.

NAPOLEON SARONY, born Canada (1821-1896)

Napoleon Sarony moved with his family from Quebec to New York when he was ten and was soon apprenticed to a lithographer. The lithography studio he opened in New York in 1848 was highly successful. He and his brother Oliver then spent eight years traveling throughout Europe, visiting artists and photographers, but the lithography studio collapsed during his travels. Sarony opened his own photographic studio, first in Edinburgh and then in Birmingham. Despite his success in Great Britain, he was homesick and returned to New York in 1866 to open a photography studio on Broadway. Sarony's creative use of poses and settings earned him a reputation as one of the most original theater photographers. Personalities sought him out, and he reportedly posed and photographed over 200,000 people, many of then actors and celebrities of the time.

FIGURE II-14. *Edwin Booth as Iago in Othello.* Albumen silver print, c. 1870. Albert Davis Collection, Theatre Arts Collection, Harry Ransom Humanities Research Center, University of Texas at Austin.

FIGURE II-17. *Lillie Langtry.* Albumen silver print, c. 1882. Albert Davis Collection, Theatre Arts Collection, Harry Ransom Humanities Research Center, University of Texas at Austin.

WILLIAM STINSON SOULE (1836-1908)

Although best known for his photographs of Plains Indians, photographer Will Soule spent only seven years in the West. At the end of the Civil War, Soule began working in a photography studio in Chambersburg, Pennsylvania. The studio burned while he was still recovering from an injury received at Antietam, and Soule opted to move west for his health. In 1868 he took a job as chief clerk in Tappin's Trading Company, the post store in Fort Dodge, Kansas. Using equipment he had brought with him, he also established himself as a part-time photographer. His first published image appeared as an engraving in the January 16, 1869, issue of *Harper's Weekly.* The caption claimed that the image of a scalped hunter, found dead about a mile outside of Fort Dodge, was taken "within an hour after the killing." From Fort Dodge, Soule went to Camp Supply and then to Fort Sill, where he served as post photographer for the newly built fort. Although never hired to photograph the Indians who passed through any of the forts where he lived, Soule in his personal work documented the southern Plains Indians at a troubling time of transition. Soule's Indian images were commercially successful in the East, where his brother, John Soule, photographer and founder of the Soule Photographic Company in Boston, sold individual prints and albums. In 1874 or 1875 Will Soule returned to Boston and operated a studio until he retired in 1902.

PLATE 61. *Scalped Hunter near Fort Dodge.* Albumen silver print, 1868. J. Paul Getty Museum.

SOUTHWORTH and HAWES
[ALBERT SANDS SOUTHWORTH (1811-1894) and JOSIAH JOHNSON HAWES (1808-1901)]

Southworth and Hawes, who left their respective careers as druggist and painter in 1843 to pursue the newly discovered art of photography, concentrated on portraits and some landscape views. Their priority was to produce natural portraits, sensitive to the character of the individual sitter, and the quality of their work led many notable individuals to the Southworth and Hawes daguerreotype studio in Boston. In 1853 Hawes paid John Adams Whipple for the right to use his process for making paper prints, and these crystalotypes became a good portion of their studio work. Their salted paper prints were exhibited in 1856 at the Massachusetts Mechanics' Fair.

Work they produced individually, after their partnership dissolved in 1862, is not as well known as that done during the partnership.

> PLATE 18. *Young Girl*. Daguerreotype, c. 1845. Matthew Isenburg Collection.

> PLATE 21. *Daniel Webster*. Daguerreotype, c. 1845. Museum of Fine Arts, Boston; gift of Edward Southworth Hawes in memory of his father, Josiah Johnson Hawes.

EDUARD STEICHEN, born Luxembourg (1879-1973)

In helping to gain recognition for photography as a fine art, Eduard Steichen drew on his own background as a painter and his close contacts with artists in other media, such as Rodin, Matisse, and Picasso. Steichen, whose family moved to the United States in 1881, was apprenticed to a Milwaukee lithography studio at the age of fifteen. He worked there four years, also trained as a painter, and, with several friends, formed the Milwaukee Art Students' League. He began using a camera in 1895, first to photograph his family and friends and then to make photographic studies for his lithographic work. He finally began to explore the artistic possibilities of photography itself when he made romantic, soft-focused images. Three of Steichen's prints were included in the Second Philadelphia Salon in 1899, and several appeared in the Chicago Photographic Salon in 1900. Clarence White encouraged Steichen to visit Alfred Stieglitz, who purchased several prints. Steichen became a founding member of the Photo-Secession and worked with Stieglitz on publishing *Camera Work* and opening the "291" gallery. After supervising aerial photography for the United States Army during World War I, Steichen switched from the pictorial style to a straightforward approach. He joined the staff of Condé Nast publications, which published many of his fashion and portrait photographs in *Vogue* and *Vanity Fair*. Although he gave up commercial work in 1938, he directed combat photography for the Navy during World War II. In 1947 Steichen became director of the Photography Department at the Museum of Modern Art in New York, where he organized the influential "Family of Man" exhibition in 1955. After retiring from the museum in 1962, he continued to experiment with color photography.

> FIGURE VI-11. *Woods—Twilight*. Platinum print, 1898. Metropolitan Museum of Art; gift of Alfred Stieglitz, 1933.

ALFRED STIEGLITZ (1864-1946)

Alfred Stieglitz, one of the most influential figures in the history of photography, spent his early years in New York but moved to Berlin in the early 1880s to study engineering. While in Germany he purchased his first camera. Although he took some courses in photochemistry, he was primarily a self-educated photographer. He won several prizes exhibiting his photographs in Europe. Stieglitz returned to the United States in 1890 and joined two friends as a partner in a photoengraving firm. Dissatisfied with the work, however, he left to promote photography as an art form. His own early photographs of bustling urban life exploited the flexibility of the new hand-held cameras and more light-sensitive dry plates. He frequently shot in the fog, snow, or rain to capture dramatic effects of light and atmosphere and made some of the earliest photographs at night. Stieglitz published *Camera Notes*, the official journal of the Camera Club of New York, from 1897 until 1902, when he broke with the club. He and several other prominent photographers founded the pictorialist group, the Photo-Secession. In 1905 Stieglitz established the Little Galleries of the Photo-Secession or "291," and in January 1903 began publishing *Camera Work*, a journal in which he reproduced work of the leading artists. *Camera Work* ceased publication in 1917 when Stieglitz turned from pictorialism to straight photography. Although no longer publishing a journal, he continued to operate galleries, exhibiting not only photographers' work but the work of modern American artists such as Arthur Dove, John Marin, Charles Demuth, and Georgia O'Keeffe.

> PLATE 15. *Savoy Hotel, New York*. Platinum with pigment, 1897. National Gallery of Art, Washington; Alfred Stieglitz Collection.

> FIGURE VI-5. *Winter—Fifth Avenue, New York*. Carbon print, negative 1893, print 1894. National Gallery of Art, Washington; Alfred Stieglitz Collection.

SENECA RAY STODDARD (1843/44-1917)

Stoddard began his career in the visual arts as a nineteen-year-old ornamental painter of railroad cars. It is not known whether he received formal art training or when or how he began photographing, but he is first mentioned as a landscape photographer in an 1867 Glens Falls newspaper. Over his career he produced thousands of images, but he is remembered for his work in the Adirondacks. While the area became increasingly dependent on tourism, the entrepreneurial Stoddard continually promoted it through his activities as a painter, photographer, publisher, surveyor, cartographer, and lecturer. Eschewing the studio for the outdoors, Stoddard aimed most of his work at tourists. He produced both stereo and single views and published a view book with original prints as well as souvenir albums of lithographed reproductions. Stoddard also accepted commissions from survey companies, railroads, and individuals. He used hand-tinted lantern slides in an 1892 address to the New York State Assembly as he urged passage of a bill to preserve the Adirondack region.

> PLATE 88. *Big Game in the Adirondacks*. Albumen silver print, 1889. International Museum of Photography, George Eastman House.

ISAIAH WEST TABER (1830-1912)

Massachusetts native Isaiah W. Taber was one of the most successful nineteenth-century photographers and photographic publishers. He worked as a gold miner, rancher, and dentist before learning daguerreotypy and opening one of the first photographic studios in Syracuse, New York. Taber moved to San Francisco in 1864 and joined the photographic publishing firm of Bradley and Rulofson. In 1871 he opened his own studio and photographic publishing company and soon was operating a successful portrait, landscape, and urban photography business. Like photographers promoting other cities, Taber linked much of his work to the tourist trade. His landscapes and views of San Francisco appeared in publications such as Hartwell and Mitchell's souvenir city-view book and his own two album set, *California Scenery* and *California Scenery and Industries*. The albums were part of a commercial endeavor and contained images from Taber's extensive files, surrounded by advertising text. Taber employed numerous staff photographers whose work he published under his own name. He also published, under the Taber imprint, images by Carleton Watkins after acquiring negatives from the bankrupt photographer in 1876. By the 1890s Taber was internationally famous, with studios in London and on the Continent.

PLATE 73. *Glacier Point Rock, 3201 Ft. Yosemite Valley, Ca.* Albumen silver print, c. 1885. International Museum of Photography, George Eastman House.

ADAM CLARK VROMAN (1856-1916)

Vroman, who began as a railroad worker in Rockford, Illinois, changed careers when he moved to Pasadena, California, in 1892. Working as a book dealer, he traveled and pursued his interest in photographing Indians. With the encouragement of his friend and fellow photographer Charles F. Lummis, Vroman spent fifteen years photographing the daily life and special ceremonies in southwestern Indian villages. He respected Indian tradition and spoke out against attempts to assimilate Indians into white culture.

PLATE 94. *Indian Girls Grinding Corn, Moqui Town.* Albumen silver print, 1895. Amon Carter Museum.

GEORGE WARREN (1834-1884)

Portrait photographer George K. Warren produced cartes-de-visite and cabinet cards in his Boston-area studios. Warren is considered one of the first photographers to specialize in graduating-class photographs. From 1859 until the mid-1870s, he dominated the business of taking class photographs for universities such as Harvard, Yale, and Princeton.

FIGURE II-9. *Frederick Douglass.* Albumen silver print, May 1876. Photography Collection, Harry Ransom Humanities Research Center, University of Texas at Austin.

AUGUSTUS WASHINGTON
(born early 1820s, active mid-1840s - mid-1850s)

Augustus Washington took up daguerreotypy as a way to pay debts he incurred while attending college. Washington was born in Trenton, New Jersey, to an Asian mother and a father who was once a slave. His early exposure to abolitionist literature and meetings was reflected in his later life. He was concerned with the education of African-Americans and supported the abolitionist movement, photographing many of its leaders. Washington taught briefly in Brooklyn, New York, before moving to Hartford, Connecticut, where he taught school and operated a daguerreotype studio, reportedly the oldest in the city. Washington's elite clientele included numerous academicians, and his studio dressing room had female attendants for women clients. Washington left his studio in 1848 to travel but returned there to work from 1850 until 1854. Discouraged by the conditions he and other African-Americans faced, he came to believe that educated blacks could never be happy anywhere in the United States. He abandoned his abolitionist views and began to favor black emigration, first to Mexico, then to Liberia. After arguing for colonization of Liberia and photographing many of the new Liberian dignitaries, Washington moved there himself in 1854. He supported himself by working as a teacher, farmer, and store proprietor, and also continued a successful daguerreotyping business there.

PLATE 20. *Liberian Diplomat.* Daguerreotype, c. 1853. Library of Congress.

CARLETON WATKINS (1829-1916)

Watkins began his long photographic career in Sacramento, California, after moving from his birthplace of Oneonta, New York, in 1851. Having learned from Robert Vance to make daguerreotypes, he opened his own studio, doing portrait work and commercial photography for ranchers, mine owners, and businessmen. His special interest and skill was in landscape photography. The photographs he made in 1861, on the first of several trips to Yosemite, gained him great professional acclaim. In 1870 he worked with Clarence King on the California Geological Survey expedition to Mount Shasta. Watkins was one of the first photographers to have a mammoth-plate camera, yielding negatives as large as eighteen by twenty-two inches, constructed for his use. His lack of business skill and the intense competition in the photography business forced him into bankruptcy in 1876. After photographic publisher I. W. Taber bought his negatives, Watkins was forced to rephotograph many of the scenes depicted in earlier views. He continued traveling to the Columbia River in Oregon, to Tombstone, Arizona, along the route of the Southern Pacific Railroad, and throughout California. Tragically, his negatives were destroyed by the San Francisco earthquake in 1906; a few years later Watkins was declared mentally incompetent and spent the last years of his life in the Napa State Hospital for the Insane.

PLATE 6. *The Rapids with Indian Block House, Cascades.* Albumen silver print, 1867. Amon Carter Museum.

PLATE 53. *Wreck of the Viscata.* Albumen silver print, 1868. Amon Carter Museum.

PLATE 57. *Malakoff Diggins, North Bloomfield, Nevada County.* Albumen silver print, c. 1871. Amon Carter Museum.

FIGURE V-2. *Cape Horn, Columbia River, Oregon.* Albumen silver print, negative 1867, print by Taber after 1875. J. Paul Getty Museum.

CHARLES WEED (1824-1903)

In 1854, New York-born Charles Weed moved west to Sacramento, California, and began work in George J. Watson's daguerreotype studio. He formed a partnership with one of California's foremost early photographers, Robert Vance, in 1858, and made the first photographs of the Yosemite region in June of 1859. By 1860 he decided to establish a business in Hong Kong for one year, leaving the partnership with Vance. He purchased the Vance studio on his return to California but sold it in 1863. The next year he photographed Yosemite for Lawrence and Houseworth, a photographic publishing firm. Weed then moved to Hawaii and back to Hong Kong, then rejoined the Houseworth firm on his return to California about 1869. Weed probably made another photographic trip to Yosemite with Eadweard Muybridge in 1872, although most facts about the expedition are obscured by a switch in employers. Because most of his images were not signed or credited to him, Weed faded into relative obscurity. From the 1880s until his retirement in the 1890s he worked as a photoengraver.

PLATE 38. *Poverty Bar, Middle Fork Mining Series.* Salt print, 1859. International Museum of Photography, George Eastman House.

WENDEROTH, TAYLOR and BROWN
[FREDERICK A. WENDEROTH, WILLIAM TAYLOR, and J. HENRY BROWN] (active 1866-1884)

The photographic studio of Wenderoth, Taylor and Brown was located in the middle of Philadelphia's business district, an appropriate location for photographers specializing in advertising images

of company wares. In 1871, the firm published *The Gallery of Arts and Manufacturers*, a directory showing the wares of fifty-six businesses. Traveling salesmen carried the impressive volume of albumen silver prints, bound in an embossed leather cover, to show prospective customers items too large or too specialized to carry from town to town. Forerunners of the window display, the images presented artistically arranged stoves, carpets, iron work, musical instruments, cameras, chemicals, boxes, ledgers, candy, perfume, brooms, brushes, and special goods, as well as views of Philadelphia's hotels, to entice the viewer.

> PLATE 87. *E. Clinton & Co. Manufacturers and Importers of Brushes, No. 908 Chestnut St., Philadelphia.* In *Gallery of Arts and Manufacturers of Philadelphia* album. Albumen silver print, 1871. Library Company of Philadelphia.

JOHN A. WHIPPLE (1822-1891)

The diverse possibilities of photography interested John A. Whipple, an innovator who began in the photographic business working for a manufacturer of photographic chemicals. He soon began manufacturing chemicals for daguerreotypists and making daguerreotypes himself. Whipple went beyond the daguerreotype to experiment with glass negatives, microphotography, vignetting, and the use of artificial light. He and his partner James Wallace Black were responsible for numerous advances in photography, including the development of the process for making paper prints from glass negatives (crystalotypes). Whipple's special interest was celestial photography. Beginning in 1848, he made daguerreotypes and crystalotypes of the moon and sun. In 1851, after three years of experimentation, he successfully made daguerreotypes of the moon, and in 1867 he photographed a solar eclipse. Whipple's celestial photographs earned him world-wide acclaim, including the compliments of the Royal Academy of Arts and Sciences in London.

> PLATE 30. *Moon.* Daguerreotype, 1852. Harvard College Observatory.

> FIGURE I-1. *Henry Winthrop Sargent and Family.* Daguerreotype, 1855. Library of the Boston Athenaeum.

CLARENCE H. WHITE, JR. (1871-1925)

Clarence White began experimenting with photography while working as a bookkeeper in Newark, Ohio. His early photographs were concerned with life in a small town and human interrelationships. Using only a few subjects, mostly family members, White concentrated on the formal composition of the images. After winning the Ohio Photographers Association gold medal in 1896, White began exhibiting his work in salons. In 1899 he was named an honorary member of the Camera Club of New York, and in 1902 he and Alfred Stieglitz established the Photo-Secession movement. White taught for a while at Columbia University, establishing one of the first university fine art photography programs in America, but he was most influential as the founder and director of the Clarence H. White School of Photography, established in 1914. White continued as a pictorialist, even after Stieglitz began advocating straight photography, and in 1916 became a founding member and the first president of the Pictorial Photographers of America.

> PLATE 96. *Telegraph Poles, Newark, Ohio.* Platinum print, 1898. Museum of Modern Art, New York.

> PLATE 101. *The Hillside.* Platinum print, c. 1898. Museum of Modern Art, New York; gift of Mr. and Mrs. Clarence H. White, Jr.

EDWARD L. WILSON (1838-1903)

Photographer, lecturer, and publisher Edward L. Wilson was among the leading advocates for the photographic medium from the 1860s until after the turn of the century. Best known for his publications, he chronicled photographic events in his periodical *Philadelphia Photographer*, renamed *Wilson's Photographic Magazine* in 1889 and *Photographic Journal of America* in 1915, and in companion publications *Photographic World* and *Photographic Times.* Wilson was also active in the Photographic Society of Philadelphia and the Photographic Exchange Club of Philadelphia. He served as superintendent and treasurer of the Centennial Photographic Company during the 1876 Centennial Exposition in Philadelphia and was awarded the photographic concession at the 1884 World's Industrial and Cotton Centennial Exposition in New Orleans. As the official photographer for the WICCE, Wilson recorded the exhibits and displays for the exposition commissioners and provided illustrations for newspapers. He also published *Wilson's Lantern Journeys, New Orleans* and the *World's Industrial and Cotton Centennial Exposition*, two sets of views of the grounds, buildings, and exhibits. In addition he made an album of albumen prints, the majority of which seem to be halves of stereo pairs. Although the exact purpose of this album is unknown, it may have been produced as a photographer's sample album or for one of the exposition commissioners.

> NOT REPRODUCED IN CATALOGUE. *World's Industrial and Cotton Centennial Exposition Album.* Albumen silver prints, 1884-85. Historic New Orleans Collection.

BEN WITTICK (1845-1903)

Born in Huntingdon, Pennsylvania, Wittick opened his first photography studio in the late 1870s in Moline, Illinois, after his service in the Union army stationed at Fort Snelling, Minnesota. About 1878 he moved to New Mexico, taking a job with the Atlantic and Pacific Railway (later the Atchison, Topeka, and Santa Fe). From 1880 until 1884 he formed a photographic partnership with R. W. Russell, Wittick specializing in outdoor views while Russell handled most of the studio portrait work. Many of the Indian portraits made during this period can probably be attributed to Russell. Wittick eventually moved to Gallup, New Mexico, after the partnership dissolved. In 1900 he sold his studio to the Imperial Photograph Gallery and moved his operation to Fort Wingate, New Mexico. Assisted by his son, he ran the business until his death in 1903.

> PLATE 77. *At the Snake Dance, Moqui Pueblo of Hualpi, Arizona.* Gelatin silver print, 1897. Amon Carter Museum.

GEORGE BACON WOOD (1832-1910)

George Wood was born into a prominent Quaker family in Philadelphia. Despite the disapproval of his family and the Quaker community in general, Wood started a career as a painter, studying at the Pennsylvania Academy of the Fine Arts. Because of his religious beliefs, he limited himself at first to landscape paintings; he eventually branched out into genre paintings as well. Wood was a successful painter, but he took up photography in 1882 and immediately became an active member of the Photographic Society of Philadelphia. The development of the dry-plate negative, which made photography easier, and the documentary ability of the photograph, which appealed to Wood's religious and artistic sensibilities alike, led to his change of medium. One Quaker objection to art was that it was subject to artistic interpretation. Therefore, Wood adhered to Ruskinian philosophy and sought to capture even the most minute details of a scene. He began

photographing in the 1870s, and by the mid-1880s he was an established photographer, making small albumen and platinum prints and cyanotypes. He continued to include landscapes and genre scenes among his subjects, but his photographic subjects expanded to include portraits, architectural views, interiors, seascapes, coastal views, and clouds. Wood displayed his work widely and won numerous national and international awards. Although he occasionally photographed in the 1890s and 1900s, he had retired by the time of his last major photographic exhibition in 1893.

> PLATE 97. *Aren't They Beauties?* Platinum print, c. 1885. Library Company of Philadelphia.

JOSEPH T. ZEALY (1812-1893)

During the 1850s daguerreotypist J. T. Zealy operated galleries in Columbia, South Carolina (1851, 1859), and Petersburg, Virginia (1856). While in Columbia, Zealy was hired to photograph slaves for Louis Agassiz, the father of American natural science, who had formulated the theory of polygenesis or the separate creation of each race. In an attempt to advance his theory, Agassiz traveled to South Carolina to study African-born slaves and their first-generation offspring. Once his studies were completed, he needed corroborative photographic evidence. Dr. Robert W. Gibbes, his host in South Carolina, hired Zealy to photograph the slaves Agassiz had studied. The slaves were posed in the nude to point up anatomical features that had interested Agassiz; for example, the profile of a slave named Jack, who came from the Guinea Coast, shows the ritual scars on his cheek. Gibbes then labeled the daguerreotypes with the slave's name, occupational role, and the plantation. The images are among the earliest of Southern slaves and the earliest in which the subjects are identified.

> PLATE 25. *Jack (Driver), Guinea. Plantation of B. F. Taylor, Esq. Columbia, S. C.* Daguerreotype, 1850. Peabody Museum, Harvard University.

UNKNOWN PHOTOGRAPHERS

PLATE 1. *Two Men.* Daguerreotype, c. 1840. Amon Carter Museum.

PLATE 3. *California Forty-Niner.* Daguerreotype with applied coloring, c. 1850. Amon Carter Museum.

PLATE 4. *Officer and Manservant.* Daguerreotype with applied coloring, c. 1851. Amon Carter Museum.

PLATE 8. *The Brigade de Shoe Black—City Hall Park.* Stereograph published by E. and H. T. Anthony and Co. in *Anthony's Instantaneous Views.* Albumen silver print, 1867 or before. Private collection.

PLATE 17. *Samuel Clemens.* Daguerreotype, c. 1850. Mark Twain Papers, Bancroft Library, University of California, Berkeley.

PLATE 19. *John Brown.* Daguerreotype, c. 1856. Library of the Boston Athenaeum.

PLATE 22. *Dentist, Pulling Teeth.* Daguerreotype, c. 1845. Matthew Isenburg Collection.

PLATE 23. *Farrier, with His Clients.* Daguerreotype, c. 1848. Matthew Isenburg Collection.

PLATE 24. *Machinist's Apprentice with File and Gear.* Daguerreotype, c. 1850. Matthew Isenburg Collection.

PLATE 40. *Soldiers in Staged Fistfight.* Ambrotype, 1863. Amon Carter Museum.

Plate 62. *Section of the Original Big Tree, 92 Ft. in Circumference.* Stereograph published by E. and H. T. Anthony and Co. in *American Views, Mammoth Trees, Cal.* Albumen silver print, c. 1860s. Private collection.

PLATE 65. *Looking Up Broadway from the Corner of Broome Street.* Stereograph published by E. and H. T. Anthony and Co. in *Anthony's Instantaneous Views.* Albumen silver print, c. 1860s. Private collection.

FIGURE I-3. *The Smiling Man.* Ambrotype, c. 1860. J. Paul Getty Museum.

FIGURE II-1. *Edgar Allan Poe.* Daguerreotype, 1848. J. Paul Getty Museum.

FIGURE II-9. *Phineas T. Barnum.* Albumen silver print, c. 1870. Gernsheim Collection, Harry Ransom Humanities Research Center, University of Texas at Austin.

FIGURE III-1. *Gold Miners.* Daguerreotype, c. 1850. Amon Carter Museum.

FIGURE IV-1. *Soldiers' Photographs Received at Dead Letter Office.* Albumen silver prints and tintypes, 1861-65. International Museum of Photography, George Eastman House.

INDEX

Bold numbers indicate an illustration of or by the subject.

ABOUT THE AUTHORS MARTHA A. SANDWEISS is Director of the Mead Art Museum and Adjunct Associate Professor of Fine Arts and American Studies at Amherst College. ALAN TRACHTENBERG is the Neil Gray, Jr., Professor of American Studies and English at Yale University. BARBARA MᶜCANDLESS is Assistant Curator of Photographs at the Amon Carter Museum. KEITH F. DAVIS is Chief Curator of the Fine Art and Historical Collections at Hallmark Cards, Inc. PETER BACON HALES is Associate Professor in the Department of Architecture and Art at the University of Illinois, Chicago, and SARAH GREENOUGH is Curator of Photographs, Department of Photographs, National Gallery of Art.

Design and Production Art by DUO Design Group, Fort Worth

Type output by LinoTypographers, Inc., Fort Worth

Printed and bound by Mitsumura Printing Company, Tokyo